The Museum of Augustus

The Museum of Augustus

**The Temple of Apollo in Pompeii,
the Portico of Philippus in Rome,
and Latin Poetry**

PETER HESLIN

Los Angeles, The J. Paul Getty Museum

© 2015 J. Paul Getty Trust

Published by the J. Paul Getty Museum, Los Angeles
Getty Publications
1200 Getty Center Drive, Suite 500
Los Angeles, California 90049-1682
www.getty.edu/publications

Dinah Berland, *Project Editor*
Julidta C. Tarver, *Manuscript Editor*
Jim Drobka, *Designer*
Elizabeth Chapin Kahn, *Production*

Printed in Hong Kong

Library of Congress Cataloging-in-Publication Data

Heslin, Peter, author.
 The Museum of Augustus : the Temple of Apollo in Pompeii, the Portico of Philippus in Rome, and Latin poetry / Peter Heslin.
 pages cm
 Includes bibliographical references and index.
 ISBN 978-1-60606-421-4 (hardcover)—
 ISBN 1-60606-421-5 (hardcover)
 1. Mural painting and decoration, Roman—Themes, motives. 2. Trojan War—Art and the war. 3. Mythology, Greek, in art—Influence. 4. Latin poetry—History and criticism. 5. Art and literature. 6. Temples, Roman. 7. Rome—History—Augustus, 30 B.C.-14 A.D. I. J. Paul Getty Museum, issuing body. II. Title.
 ND2575.H47 2015
 759.937—dc23
 2014032557

FRONT JACKET: Mosaic with the Removal of Briseis, second century (detail, fig. 70)
BACK JACKET: François Mazios, Reconstructed view of north elevation of the Temple of Apollo in Pompeii, n.d. (detail, fig. 46)
TITLE PAGE: Félix Emmanuel Callet, Elevation of the East Wall of the Portico of the Temple of Apollo in Pompeii, early nineteenth-century (detail, fig. 28)
PAGES 24–25: Wall Painting of the Taking of Briseis from the Atrium of the House of the Tragic Poet, Pompeii (detail, fig. 69)
PAGES 194–95: Giuliano da Sangallo, Drawing of the Ruins of a Roman Portico, late-fifteenth or early sixteenth century

Illustration Credits
Every effort has been made to contact the owners and photographers of objects reproduced here whose names do not appear in the captions or illustration credits listed below. Anyone having further information concerning copyright holders is asked to contact Getty Publications so this information can be included in future printings.

Figures 1, 2, 52, 57: Bibliothèque numerique de l'INHA
Figures 3, 54, 58: www.lucianopedicini.com
Figures 4, 16, 23, 38, 48, 53, 55: Heidelberg University Library, CC by SA 3.0
Figure 5: Getty Research Institute, Los Angeles, 93-B5991
Figures 6, 13, 14, 17, 22, 27, 46, 47, 61: Bibliothèque national de France
Figures 7, 12, 18, 19, 21, 28, 29, 35, 37, 42, 44: © Beaux-Arts de Paris, Dist. RMN-Grand Palais / Art Resource, NY
Figures 8, 11, 15, 25, 32, 33, 43, 45, 49, 50, 59, 64, 67, 72, 73–76a, 76b, 80, 81b: courtesy of the author
Figures 9, 20, 24, 30, 31, 40, 41, 56, 77–79, 81a: Getty Research Institute, Los Angeles
Figures 10, 26, 34, 36: Getty Research Institute, Los Angeles, 88-B13102
Figure 39: Alinari / Art Resource, NY
Figure 51: Getty Research Institute, Los Angeles, 89.R.14
Figures 60, 62: Getty Research Institute, Los Angeles, 2002.M.16
Figure 68: Gianni Dagli Orti / The Art Archive at Art Resource, NY
Figure 69: Scala / Art Resource, NY
Figure 70: The J. Paul Getty Museum
Figure 71: Erich Lessing / Art Resource, NY
Figure 82: © The Trustees of the British Museum / Art Resource, NY

For Gracie (this one has pictures)

Generalizations as expansive as these: that there is a universal poetry that is reflected in everything or that there may be a fundamental aesthetic of which poetry and painting are related but dissimilar manifestations, are speculative. One is better satisfied by particulars.

—Wallace Stevens, *The Necessary Angel*

Contents

ix	Foreword	*Claire Lyons*
xi	Acknowledgments	
1	Introduction	Temples Real and Imaginary

Part I ART IN POMPEII

27	Chapter 1	Sources for the Temple of Apollo
51	Chapter 2	The Temple's East Wall
101	Chapter 3	The Remainder of the Portico
139	Chapter 4	Copies and Models

Part II ART AND POETRY IN ROME

197	Chapter 5	The Portico of Philippus
255	Chapter 6	Imaginary Temples

321	Conclusion	Art, Architecture, and Poetry

328	Abbreviations Used in Notes and References
329	References
340	About the Author
341	Index

Foreword

Nostoi (myths of return) recount the journeys of warriors who set sail after the fall of Troy. The war's end hastened an ill-fated homecoming for some survivors, yet for others it launched a diaspora to new destinations and destinies. The mythical exploits of Odysseus and his companions narrated in Homer's *Odyssey* were a prequel to the exploration of the western Mediterranean by Greek merchant sailors. Throughout the Italian peninsula, at his ports of call and in places where his tales were told, colonial and native communities alike adopted the hero as their founder. Rome claimed descent from the Trojan prince Aeneas, whose settlement on the Tiber River gave birth to a city and an empire. As the forefather of the Julio-Claudian line, Aeneas figured large in the Roman cultural imagination. Italy was thus already a thoroughly Homeric landscape by the time Virgil accepted a commission from Augustus to compose the *Aeneid*, which transformed Aeneas's adventures from a dynastic legend to Rome's national epic.

In *The Museum of Augustus*, literary scholar Peter Heslin explores the nexus of connections between Latin poetry written during the Early Empire and paintings of the Trojan War displayed in prominent Roman buildings. It cannot be coincidental that three such pictorial cycles were created over the first two decades of the emperor's reign, between about 29 and 10 BC. All of them adorned temple precincts and illustrated climactic events of the ten-year Trojan War from the *Iliad* of Homer. Only two of these cycles existed in reality, however, while the third was the product of Virgil's literary imagination. Fragmentary frescoes discovered in the Temple of Apollo at Pompeii, Heslin argues, reproduce forty or so originals that had been on view in the surrounding colonnade since the late first century BC. Featuring several episodes with Aeneas, the Pompeian pictures reflect a Roman sensibility. Their apparent model was an influential metropolitan precedent—a series of paintings by Theoros installed in the Porticus Philippi in Rome. This portico, constructed as a frame for the Temple of Hercules Musarum around 29 or 28 BC by a relative of Augustus, survives only in its foundations; its artistic program is lost. Pliny the Elder made brief note of the many panels, which shared the gallery with a famed old master painting depicting another Iliadic theme, Zeuxis's *Helen*.

Although physical vestiges are scant, the significance of the actual Trojan cycles lies in their relationship to the third sequence, which is described in Book I of the

Aeneid, when Aeneas tearfully beholds scenes of the Trojan War in the Temple of Juno in Carthage. From these elusive remains, Heslin has proposed a painstaking reconstruction of two major monuments that occupied crucial urban and ideological spaces. Poets and artists reacted to the saturated visual environment of imperial building projects and their embellishment, but rather than simply copying earlier Greek sources, they experimented with the devices of allusion and quotation to create an innovative artistic language.

Viewers brought their own layers of association to pictorial representations of glorious battles and ancestral heroes that informed their historical consciousness and identity, multiplying the complex resonances among them. To paraphrase Heslin, domestic images that were familiar to the residents of Pompeii could have quoted local temple paintings that imitated a fictional ecphrasis in the *Aeneid,* which in turn was inspired by a monument in Rome containing a cycle of Hellenistic paintings that illustrated Homer's *Iliad,* a compilation of remembered songs, pictures, and texts. In considering how such a proliferation of imagery conditioned responses, Heslin tackles the "uneasy marriage" between words and pictures, as well as reproductions and originals, reversing the usual subordination of art to literature, and Roman visual culture to Greek paradigms.

Parts of the present study were advanced while the author was in residence at the Getty Villa during the 2010–2011 scholar year, which engaged "The Display of Art" as a research topic. His project relied on the burgeoning pool of digitized drawings, plans, photographs, and archives that supported a reconstruction of the buildings and their fresco cycles. At the Getty, the Research Library and Museum collections chronicle three hundred years of Pompeian excavations and the history of archaeology in Italy. Peter Heslin's recuperation of the archaeological remains through intertextual readings of contemporary poetry and art offer intriguing insights into patronage and image making in the age of Augustus.

 Claire L. Lyons
 Curator of Antiquities, J. Paul Getty Museum

Acknowledgments

This book is a product of the digital revolution that is transforming the study of the material culture of antiquity. Literary scholars can carry copies of their texts around in their pockets, but until recently art historians had to rely on having direct physical access to archives, collections, and specialized libraries and on possessing an acute visual memory. Now, however, the Internet provides instant access to a multitude of images of ancient artifacts, to scans of expensive and rare books, and even to many archival documents. Images can be stored and manipulated on a computer so that working with objects no longer needs to be much more inconvenient than working with texts. The recent so-called material turn in the humanities is in part a response to this explosion of access to visual evidence. Whatever one thinks of the consequences of opening the study of material culture so suddenly to a wider range of nonspecialists, my experience has been that art historians and archaeologists are very welcoming and generous with their expertise to an author such as myself coming from a background as a literary critic. Whether the interpretations advanced in this book are right or wrong, it is surely remarkable that a newcomer to this material has been able to discover new images of genuine importance to the reception of Homer in Roman Italy without leaving his office and using only a Web browser.

Most of the research for this book was thus done online rather than in museums, at sites, and in archives. I could not have written it without access to a wide range of digital resources and I am very grateful to the pioneers who have taken the risk of investing their time and money in assembling these resources for the study of visual culture in antiquity, and also to those rights holders who have understood that digital access is an opportunity rather than a threat. One hopes that more cautious institutions will soon follow suit. In particular, I wish to thank the people behind the following online projects, which were essential to my research: *Bibliothèque numérique* (Institut national de l'histoire de l'art); *Blogging Pompeii*; *Cat'zArts* (École nationale supérieure des Beaux-Arts); *Digital Collections* (Getty Research Institute); *Digital Collections* (The Warburg Institute); Digital *Forma Urbis Romae* Project (Stanford University); *Digital Library for the Decorative Arts and Material Culture* (University of Wisconsin–Madison); *Digitale Bibliothek* (Universitätsbibliothek Heidelberg); *Gallica* (Bibliothèque nationale de France); *La fortuna visiva di Pompei* (Scuola Normale Superiore); and *Pompeii in Pictures*. I also wish to record my debt to those libraries and archives that have

permitted patrons to photograph images for their own scholarly use, especially the Warburg Institute, the Institute of Classical Studies, and the Getty Research Institute.

The crucial step in my initial exploration of this material came when I consulted the expertise of Amanda Claridge, who first pointed me toward many potential sources of evidence. If it had not been for her extensive help and guidance, this project would have foundered at the outset; my awareness of almost all the archival sources I eventually consulted was in some way due to her initial assistance and encouragement. Frank Salmon was equally generous with his knowledge and advice about archives of architectural drawings. Valentin Kockel kindly shared his expertise on the early cork models of Pompeii.

As this project matured, I had the extraordinary opportunity of spending a semester, in 2010, as a Getty Villa Scholar under the rubric of the Display of Art theme of the Getty Research Institute. Being able to consult the special collections of the GRI was extremely useful, but even more valuable was the knowledge of the expert curatorial staff at the Villa. In particular, I have benefited from the generosity and advice of Kenneth Lapatin in matters large and small. I happened to arrive at the Getty Villa in Malibu at the same time that the bronze statue of Apollo Saettante, which appears prominently on these pages, arrived in the Villa's conservation lab from its home in Naples. I was fortunate to be able to compare notes with David Saunders, who was curating the exhibition of that statue and had investigated some of the same questions regarding the excavation of the Temple of Apollo in Pompeii; he kindly shared his results with me. My fellow Getty scholars Gertrud Platz, Alessia Zambon, John North Hopkins, and Felipe Rojas were delightful companions, and Devon Harlow and Peter Bonfitto were ever helpful. Presenting my work to the community of Getty scholars was invaluable for refining my ideas, and I am very grateful to them and to Thomas Gaehtgens, Katja Zelljadt, and the staff of the GRI Scholars Program for making this extraordinary experience possible.

A generous grant from the Loeb Classical Library Foundation funded a period of leave from teaching that enabled me to write up this material and also financed a trip to Naples and Rome, where I collected the final pieces of evidence. I am very grateful to the Loeb Foundation for its crucial support. Father Stephen Ambrose, procurator of the Benedictine Congregation of Subiaco, kindly showed me around the monastery of Sant'Ambrogio della Massima in Rome and shared his extensive knowledge of the archaeology and history of the site. For various items of bibliographical and logistical help I am grateful to Anna Leone, Pier Luigi Tucci, Cammy Brothers, Robert Coates-Stephens, Gianfranco Adornato, Francesco de Angelis, Peter Fane-Saunders, and David Petrain.

I finished revising this book while spending the first half of 2013 as Joan Palevsky Visiting Professor in Classics at the University of California at Los Angeles; my colleagues and students there made it a wonderful experience. I have profited from the

reaction of the audiences in many places where I have presented aspects of this material, including UCLA (twice), Durham (several times), the Virgil Society, St. Andrews, Dublin, and Manchester. A 2009 workshop in Durham on the subject of image and text in antiquity was particularly useful; I thank my co-organizers, Edmund Thomas and Ted Kaizer, and all the participants, especially Katharina Lorenz and Michael Squire, who were also discussing Iliadic visual narratives in Roman contexts. I have often knocked on the door of my next-door-office neighbor at Durham, Edmund Thomas, for advice on Roman topography and have always come away enlightened. Many other colleagues at Durham, the Getty, and UCLA have offered support and advice.

I am grateful for the feedback of a number of anonymous peer reviewers of both the book proposal and the first draft. Amy Russell read chapter 5 and convinced me to make some important changes to my conclusions there. Marco Fantuzzi read a full draft of the book and I have benefited greatly from his comments throughout. Kathy Coleman and Zara Chadha proofread my solecism-strewn manuscript with enormous care, and they improved its accuracy and clarity on every page. Finally, I am obliged to Kenneth Lapatin, Sarah Morris, Barbara Graziosi, Ted Lorsbach, and Gregory Britton for their enthusiastic advocacy of this book. Also, at Getty Publications, I offer my thanks to Kara Kirk, publisher, and Robert T. Flynn, editor in chief, for their flexibility and understanding, and to the publications team of Dinah Berland, project editor; Jim Drobka, designer; Elizabeth Chapin Kahn, production; and Pam Moffat, photo researcher, along with editorial consultants Julidta C. Tarver, manuscript editor; Karen Stough, proofreader; and Harvey L. Gable Jr., indexer, for bringing this book into being.

Peter Heslin
Durham, June 2014

Introduction

Temples Real and Imaginary

THIS BOOK IS ABOUT THREE TEMPLES, each of them surrounded by a portico decorated with a cycle of paintings representing the Trojan War: two of them are real temples, one in Rome and one in Pompeii; the third is fictional, and it is the most famous of the three. In the first book of Virgil's *Aeneid*, the hero Aeneas arrives in Dido's newly founded city of Carthage. He enters the temple dedicated to the city's patron goddess, Juno, and in its portico he sees a series of paintings depicting the Trojan War.[1] This precipitates a tearful and intense emotional response as Aeneas sees his own experiences transformed into art. He reads (or misreads) the artwork as promising that the inhabitants of the city will be sympathetic to his people's suffering.[2] By showing so early in his epic an example of an intense emotional response to a work of art depicting the Trojan story, Virgil apparently provides a key for reading his own poem, which is a depiction in words of that same story. He also, perhaps, provides a model for the perils of misreading it.[3]

About ten years later (for the revised dating, see chapter 4), the people of Pompeii decorated the portico of their Temple of Apollo in a strikingly similar fashion, with scenes from the Trojan War. This coincidence has been remarked upon before. F. H. Sandbach, for example, says:

> Virgil does not specifically say where Aeneas found the pictures of the Trojan War which brought him comfort, but they seem to be *in luco* [1.450] and *sub ingenti templo* [1.453]. A Roman could hardly help applying his own experiences and imagining them as a colonnade enclosing the sanctuary; this was pointed out already by Heyne. By a strange chance paintings (now lost) of Trojan scenes were found at Pompeii on the walls of the colonnade of Apollo's temple there.[4]

In this book I set out to explore the circumstances of that "strange chance." In fact, the paintings mentioned by Sandbach have not been completely lost. Some aspects of them have long been familiar to a specialist audience, and in a recent book surveying the subject of ancient temple painting, E. M. Moormann usefully sets out what has traditionally been known of the decoration of the Pompeian temple portico.[5] He briefly considers the possibility of a link between Virgil's imaginary temple and the real one in Pompeii but dismisses it. Like Sandbach, Moorman is at a loss to make much more of the possibility, in part because the evidence previously available was

1

not very extensive or suggestive. The first four chapters of this book are devoted to using archival sources to extend considerably our knowledge of the Trojan paintings that decorated this temple.

The third portico I discuss is the least known of the three. The Portico of Philippus was built by a very close relative of the Roman emperor Augustus, but nothing of it has survived. Sources say that in this temple portico there was, yet again, a series of paintings depicting the Trojan War. This structure is generally passed over without comment in studies of Augustus's massive building program, under the assumption that it was a minor work of a minor imperial hanger-on. In fact, the evidence suggests that it amounted to a complete remodeling of Rome's de facto Temple of the Muses, or "Museum." (The word "Museum" is capitalized throughout this book to indicate a place of worship for the Muses, either in Rome or in Alexandria. It should not be confused with the word "museum" in the modern, generic sense, as a secular institution for the display of art; all ancient temples were places for the display of art, but only incidentally so.) This would seem, then, to be the perfect point at which to ask whether there was a connection between the poetic and architectural patronage of the regime. In fact, there has been a recent explosion of scholarly interest in the building that the Portico of Philippus surrounded and recontextualized: the Republican Temple of Hercules of the Muses. It is now widely agreed that there was an important symmetry between the patronage of Fulvius Nobilior in constructing the temple and decorating it (probably) with a copy of the Roman list of annual magistrates (the *fasti*) and his patronage of the poet Ennius, author of Rome's first hexameter epic, the *Annales*, which detailed in similarly annual fashion the exploits of those magistrates. Thus it is no coincidence that the decorative scheme of the Portico of Philippus articulated precisely the same relationship to the *Aeneid* as had once existed between Fulvius's temple and the *Annales*. The Portico of Philippus is the public justification in the language of Roman architecture of Augustus's patronage of poetry; it is his importation of the Museum of Alexandria into a Roman context.

The potential connections between these three Augustan temple porticoes have been noted in passing often enough before. What makes this book different is that it brings to bear a large mass of new evidence for reconstructing the Pompeian portico. It turns out that a great deal more can be established beyond the prior state of research as illustrated in Moormann's general survey: there are more Trojan images that can be attributed to it than were previously known, and, crucially, many of these can, for the first time, be situated in precise locations on the walls. This in turn permits us to show that a number of the traditional identifications of subjects of those images are mistaken. So, for example, it turns out that Aeneas was a prominent figure in the Pompeian portico, which reinforces the argument that there is a link between it and the imaginary temple of the *Aeneid*. The huge popularity of Virgil in Pompeii is attested to by the frequency with which quotations appear in graffiti.[6] By contrast,

there is only a single painting in the town that is certain to depict a scene from the *Aeneid*, so the conclusion has been drawn that Latin poetry did not have much impact on Roman painting.[7] And yet the oldest and perhaps the most prestigious cult sanctuary in the town was remodeled in a way that made it strikingly reminiscent of an imaginary building in Virgil's poem. Perhaps in hunting for fleas one omits to notice the dog. The subjects of the individual paintings in the temple are Homeric, but the installation as a whole is Virgilian. Moreover, the paintings in that sanctuary display a special interest in the figure of Aeneas. The frequency with which the townspeople of Pompeii copied images from this pictorial cycle for use in their domestic spaces attests to its importance. It may be that the people of Pompeii employed an iconographical vocabulary that remained firmly Greek, but they combined those elements to create a Roman visual language, which surely was influenced by the Latin poetry they were reading and scribbling onto those same walls. To put it in terms borrowed by Norman Bryson from Roland Barthes, the denotative elements in Roman painting were almost exclusively Greek, but the connotative dimension was very Roman.[8]

Images of the Trojan War were, of course, ubiquitous in the Greek and Roman world, both in and out of porticoes. The distant ancestor of the Roman painted portico, the Stoa Poikile in Athens, included a painting by Polygnotus of Ajax and Cassandra after the fall of Troy. The same artist made the Lesche of the Cnidians at Delphi famous for his paintings of the sack of Troy and of Odysseus in the underworld.[9] Homeric paintings were equally popular in the Roman world. Pompeii offers several examples of extensive Iliadic friezes in domestic contexts, both painted and relief. Vitruvius recommends Trojan themes for galleries, and, in the city of Rome, the fresco known as the Odyssey Landscapes was fitted with a framing device that represents the pictures as if being seen from a portico. Petronius testifies to the popularity of such scenes by attributing to his grotesque fictional creation Trimalchio a particular taste for painted Homeric subjects.[10] Despite this evidently widespread distribution of Homeric paintings in the Roman world, the three monuments dealt with in this book form a distinctive group: they all feature a cycle of discrete panel paintings that narrate individual episodes from the Trojan War and are mounted as a series in a temple portico. This is what the painted plaster of the Pompeian portico imitates, and this is what Virgil visualizes in his imaginary Carthage. Furthermore, my demonstration (in the second half of chapter 4) that the fourth-style decoration of the Pompeian monument was a renovation of the original Augustan second-style pictorial cycle reveals that all three Trojan cycles, real and imaginary, were created within a span of about twenty years: between 29 and 10 BC. It does not look like a coincidence.

It is not possible to prove in absolute terms that there was a connection among these three porticoes, since direct visual evidence from the Portico of Philippus, which was the bridge between the other two, is lacking. Nevertheless, I show that circumstantial evidence for a link is very strong. This becomes less surprising once it

is clear just how important that Roman portico was in the ideological program of the first Roman emperor. Accordingly, I trace other responses to the Portico of Philippus as the new Roman home of the Muses in Latin poetry beyond the *Aeneid*. This monument was a matter of concern to all poets, not just writers of Trojan epic, since it was the headquarters of Rome's guild of writers and poets. In chapter 6 I examine not only the relationship of the *Aeneid* to the Portico of Philippus but also the ways in which a variety of Roman writers, including Horace, Propertius, Ovid, and Petronius, responded to that relationship.

In order to explore the links among these three porticoes, I need to deal with a large number of technical questions. How reliable are the nineteenth-century sources for lost Pompeian artworks? Can they reveal what paintings were mounted in which places in the Pompeian monument? What is the correct date for the construction of the portico relative to the Hellenistic Temple of Apollo it surrounded? What is the pre- and postearthquake chronology of its painted decoration? What was its meaning in its local context and what was its impact upon domestic decoration? Moving to Rome, what can I reconstruct of the layout of the Portico of Philippus? How extensive were the renovations of the Temple of Hercules Musarum within it? What was its ideological function in its historical context? Where did its Trojan panel paintings come from? What was the building used for? These methodological issues of a historical, an archaeological, and an art-historical nature regarding the reconstruction of the Pompeian and Roman porticoes and their relationships are addressed as they come up in the course of the rest of the book. But before proceeding any further I must address a set of major controversies that attend the introduction into this mix of Virgil's imaginary, textual portico.

Does the Pompeian temple respond to Virgil's text? Does the Virgilian text respond to the Roman temple? Does the text of the *Aeneid* mediate the response of the post-Virgilian Pompeian monument to the pre-Virgilian Roman one? When Virgil's first audience encountered his text, were they supposed to think, in part, of the Roman temple's decorative program and its relationship to the new ideology of Augustus? Did Virgil's provincial readers have the same or a different experience when they encountered a local version of this type of monument? Does the popularity of images from this Trojan cycle in domestic contexts in Pompeii reflect the impact of the local monument, of the Hellenistic originals displayed in the metropolitan monument, of Virgil's text, or of all of the above? These questions all have to do with two areas that have always been and continue to be of enormous methodological controversy: the relationship between images and texts in antiquity and the relationship between "copies" and "originals" in Roman art. Those two questions are related in that both are driven by a sense that scholarship has been distorted by parallel prejudices: on the one hand, the dismissal by traditional, classical philologists of classical art as mere illustration of textual master-narratives and, on the other, the dismissal by traditional classical art historians of Roman art as entirely derivative.

In demonstrating that the Romans used the whole range of Greek art as a palette of styles from which they chose quite deliberately and from which they created a language for articulating their own concerns, Tonio Hölscher has led in the work of rehabilitating the phenomenon of the copying of Greek models in Roman art.[11] This work is of fundamental importance but it does leave one class of phenomena unaddressed. In Campanian painting there are many examples of copying not on the level of style but of particular figural compositions. The temptation has always been to see these commonalities as being due to their status as "copies" of Greek masterpieces. The idea that domestic Roman paintings reproduced Greek "old masters" has been slow to die despite the complete absence of evidence for the practice. In chapter 4, I try to drive another nail into the coffin, by, for example, giving a better explanation for the proliferation at Pompeii of the same scene of the discovery of Achilles at the palace of Lycomedes. The traditional explanation has been to link this with Pliny's description of a famous Hellenistic painting. In fact, a better explanation is that these are domestic copies of a painting that was found in the portico of the local Temple of Apollo, which in turn had fresco copies of a particular series of Hellenistic panel paintings that hung in the Portico of Philippus in Rome.

In other words, there is indeed a Hellenistic painting behind the proliferation of Pompeian copies, but not because local householders wanted copies of "old masters" and not because journeyman painters had to work mechanically from pattern books filled with such compositions. At first glance, this approach may not seem like such a win for the cause of rehabilitating Roman art from the charge of being dull and derivative. Does it help matters to see domestic paintings as copies of local models rather than of distant, transcendent Hellenistic originals? In fact, it does, because it permits us to understand the intertextual dynamics at play in such acts of quotation and reappropriation. The evidence under review in this book offers a very special opportunity to examine how copying works, because the same compositions appear both in an important public context and in a variety of domestic contexts (both indoor and outdoor). Furthermore, very similar compositions of the same figures appear on the *tabulae Iliacae* (Iliadic tablets), which come from the neighborhood of Rome. This suggests a metropolitan model, and hence a further level of copying. This is therefore a particularly rich locus for examining the practice of copying in a Roman context.

I offer in chapter 4 a model of intertextuality in Campanian figural painting in which it is not the style that speaks, as for Hölscher, but the content. This approach permits me to infer from each instance of copying its full cultural significance. First, Rome appropriates a set of Hellenistic panel paintings of the Trojan War and gives them a new home and a completely new meaning in the context of the emerging ideology of the emperor Augustus. Then the leading men of the city of Pompeii put a new portico around their old Temple of Apollo and advertise the particular, local nature of their alignment with the emperor and his patron god by decorating their portico in a

way that recalls the Roman monument and its meaning. Then the same compositions appear in domestic contexts in Pompeii, where they have a wide array of meanings, from the erudite display of learning in the atrium of the House of the Tragic Poet to the whimsy of the mosaics on the garden building in the House of Apollo. The correct answer to the charge of banal copying in Roman art is intertextuality: a theory of reappropriation of cultural artifacts that describes the meaning created by the dialogue between the context(s) of the original(s) and the new context. When the owner of the House of Apollo decorated a tiny refuge at the bottom of the garden, he or she was probably thinking most immediately of the local Temple of Apollo, but also, perhaps, of the Portico of Philippus in Rome and the Temple of Juno in Virgil's Carthage. The more layers of context that come into view, the clearer becomes the mock-epic character of the building and the better the viewer can appreciate the wit of the joke.

Futher details of this discussion of the issue of copies and models in Campanian figural painting are deferred until chapter 4, which is largely devoted to the subject of copying, or, to put it more usefully, to the subject of visual intertextuality, in Pompeii. But the issue of the relationship of art and text is so broad, so controversial, and so fundamental to the subject of this book that it needs to be addressed in more detail at the very outset. The very act of putting Virgil's fictional temple portico in the same book as a discussion of two real porticoes might be seen as evidence of an inability to distinguish the properties of the material from the textual, the real from the imaginary. Once again, the way forward is via a theory of intertextuality, but this time across the divide between texts and images. Viewers of the Pompeian temple portico would have experienced it in the light of previously experienced paintings and monuments but also in the light of their familiarity with the texts of both Homer and Virgil. Conversely, ancient readers of the *Aeneid* would have brought to that text their knowledge not only of Homer but also of the myriad visual representations of the Trojan War that surrounded them. The key to developing intertextual strategies of relating art and text is, of course, to avoid subordinating one to the other, a problem that has a long history.

Ecphrasis between Text and Artifact

There are two opposing tendencies in the study of art and text in antiquity: first, to separate them into "parallel worlds" of distinct discourses, and second, to see them as mutually complementary ways of framing myth and history. As with most such binarisms, there is much to be said for both ways of looking at the relationship, and controversies are often really just a matter of emphasis. It is undoubtedly true that visual and textual works require completely different modes of reading and that, in order for a visual artifact to be legible, the viewer must situate it within a realm of iconographical parallels and visual cues that are quite separate from what one might have learned from texts. On the other hand, it should be equally obvious that an

ancient audience did not experience visual art in isolation from whatever it knew from texts, either through reading or orally, about the figures represented there.

The study of antiquity has a long history of treating visual art dismissively, as if it were nothing more than mere illustrations of the master narrative embodied in the text. Some readers may therefore be wary of a book that professes to treat once again the relationship between mere painted plaster and two poems that were the most canonical texts of the Greco-Roman world. But this can be done without subordinating the images to those texts. Many of the readings I offer suggest that the paintings took a playful, and occasionally even a critical, posture toward the epic tradition. When art is isolated from texts, one is deprived of the opportunity to appreciate this playful intertextuality. The urge to separate art from text in order to give visual works space to be appreciated in their own right as autonomous objects has been motivated by noble intentions and has been a reaction to the particular philological bias of the study of classics. Today, however, it should be possible to discuss questions of intermedia intertextuality without being accused automatically of blindly imposing a retrograde and old-fashioned philological worldview.

The tendency to isolate art from text does not apply only to the study of material artifacts; it has also affected the study of texts. In recent years, there has been an explosion of interest in ecphrasis; in this book I use this term in the narrow sense of the figure of speech, whereby a visual work of art is described within a poem. As is well known, one of the usual functions of this trope is to provide a meta-commentary on the surrounding text. By embedding a description of a work of art in its texture, verbal narrative turns a mirror on its own mimetic strategies. It therefore corresponds not to some real, visual object external to the world of the text but to the text itself. The ur-ecphrasis in classical culture is, of course, the shield of Achilles in the *Iliad*. Its description occupies nearly a whole book of the epic and it quite obviously is not meant to describe a "real" shield. It is an ideal object, and in some ways an impossible one.[12] Scholars have reacted strongly against the tendency in previous generations to treat ecphrasis naively, as if its point were to describe a real object as accurately as possible.[13] For this reason, many recent discussions of ecphrasis have emphasized that it cannot, by its nature, have any relation to a particular, real object. For such critics, the present book might seem to be making a fundamental category error in confounding the fictional world of Virgil's Carthage with the real world of Rome. As Barchiesi says, quite reasonably, "There is no reason to suspect that Virgil attempts to describe actual artifacts in any of these passages."[14] But this objection is something of a red herring: I doubt that anyone would be so naive as to claim that Virgil was describing real objects in his ecphrases, which form part of a distant, heroic, fictional world. The more interesting question is whether he might have alluded, in the spirit of intertextuality, to famous objects in the real, Roman world, just as he alluded to texts well known to his audience.

An example of the excessive concern to isolate ecphrasis from real objects can be found in a review by Jaś Elsner of *The Captor's Image: Greek Culture in Roman Ecphrasis*, a recent book by Basil Dufallo. Discussing a particular chapter, Elsner makes an objection to linking literary and real temples in Augustan Rome:

> The focus is on temples, rather than statues, at the opening of *Georgics* 3.13–36 and in the temple of Phoebus at Propertius 2.31. My one hesitancy here is Dufallo's keenness to read these complexes in relation to Augustus' Palatine temple of Apollo; he is of course right that the context of this monument is significant, but it is surely reductive to tie a fictional and hence deliberately open ecphrastic account too narrowly to a specific monument, known to us only through fragmentary archaeology and much speculation.[15]

That proviso of "too narrowly" is self-evidently reasonable; but in reality Dufallo is not doing anything excessive or out of the ordinary here. Propertius presents his poem as a description not of a fictional, poetic monument but of the very real, recently completed portico around Augustus's new Temple of Apollo. This is not to say that his description of that monument is unbiased or lacking in tendentiousness—far from it; but he does present it as a genuine description of a real object and the poem cannot be understood in isolation from it (see chapter 6).[16] The meagerness of the archaeological evidence for the temple does not change that fact. Virgil's temple in *Georgics* 3 is different. It is a clearly imaginary temple, located in his hometown of Mantua, but generations of scholars have associated it, on account of its gleaming marble and aspects of its iconography, with the Temple of Palatine Apollo in Rome.[17] I happen to agree with Elsner here that it is reductive to equate these two monuments, but that is because the Palatine parallel leaves many features of the appearance of Virgil's imaginary Mantuan temple unexplained. I argue in chapter 6 that Virgil is merging allusions to the Portico of Philippus and the Palatine temple, which is a natural consequence of the unified ideological function of these two buildings. I do not agree, however, that it is automatically a reductive gesture to link an imaginary Augustan temple with a real one (or two), provided that the link is made in the spirit of intertextuality rather than of description. Elsner himself has been a leader in the integration of textual and visual approaches to Roman culture and has written eloquently of the need to give play to both text and image in the study of ecphrasis. As he says, "Bringing to mind the described object with *enargeia* required listeners or readers to have sufficient familiarity with the kinds of art that were the subjects of ekphrasis."[18] The question is whether, in some cases, the audience is expected to have familiarity with something more particular than merely a "kind of art": that is to say, with a specific visual intertext rather than a genre. In his own work, Elsner has put literary ecphrasis in bold juxtaposition, if not frank dialogue, with specific works of visual art; but even this is too much for some art

historians.[19] Objections seem to arise when one connects an ecphrasis not merely with the visual in general or with a kind of visual art but with a specific, real object. Does an allusive, intertextual link between an ecphrasis and one particular, famous artifact necessarily collapse the text into mere description and drown out the voice of the artifact itself?

The limitations of the current ecphrastic orthodoxy can be demonstrated by the way Virgil modifies and extends Homer's practice of ecphrasis. After Homer's extensive description of the shield of Achilles in the *Illiad*, its new owner has no interest in reading its images. He takes a quick, appreciative look but does not respond in detail to the decoration; he is consumed with anger and simply wants to use it as an implement with which to avenge Patroclus (19.15–20). Virgil makes a small but crucial change when he adapts this scene in the *Aeneid*. After the extended description of Aeneas's new shield, Virgil says that the hero gazed in wonder and appreciation at it but stipulates that he was unable to understand it (8.729–31). In other words, Aeneas's failure to engage with the ecphrasis is modeled upon Achilles's reaction, but with this difference: his total lack of an intellectual or emotional response is explicitly justified not in terms of angry impatience or a lack of interest, as might be presumed in the case of Achilles, but on the grounds of the object's unintelligibility within the story. Without the reader's knowledge of the future narrative of Roman history and its iconographical language, the images on the shield are totally mute. Aeneas's ignorance here contrasts strongly with his firm knowledge of his own past that he calls upon when reading the images in the Temple of Juno in Carthage. There, he seems to be an authoritative interpreter, since he knows the story of the fall of Troy, as opposed to the rise of Rome, all too well. Or is he authoritative? His interpretation of those images has a strongly pro-Trojan and anti-Greek bias, which may or may not be how the people of Carthage intended them.

Since the legibility of the Temple of Juno for Aeneas contrasts so strongly with the way neither Achilles nor Aeneas reads his own shield, it seems wrong to insist that the temple must belong to the same category of ecphrasis. The temple is not an impossibly dense object, *non enarrabile textum* (8.625), like the Homeric and Virgilian shields.[20] Given the allusive interplay between Virgil and the Greek poems from the epic cycle that described the episodes from the Trojan War depicted in the fictional paintings, why should we not bring to bear our knowledge of well-known paintings of those events as well as textual versions? Virgil, in fact, encourages us to do this by another important way in which the ecphrasis of Juno's temple contrasts with the shield of Aeneas. An orderly, comprehensive, and objective catalogue of the shield's contents is given for our benefit, but the temple ecphrasis is none of those things. Instead, we get an account of Aeneas's tearful and impulsive emotional reactions to a disordered and incomplete set of images. The account is so strongly focalized through his viewpoint that we seem to have no access of our own to the reality of the temple's

decoration. This is the opposite of the situation with the shield, where we know and understand far more than Aeneas does.

In other words, Virgil divides ecphrasis into subjective and objective varieties that demand different strategies for reading and that may call for different levels of engagement with one's knowledge of real monuments. Objective ecphrasis is textually self-sufficient, but subjective ecphrasis depends in part on the reader supplying knowledge from outside the text, to fill in a sense of what it is that the internal viewer is responding to. The subjectivity, disorder, and incompleteness of the Carthage ecphrasis invites the reader to fill in the resulting blank spaces in order to construct a sense of the temple. In so doing, one would naturally call upon knowledge of temples with similar decorative programs. By encouraging the reader to compare a fictional temple portico with a similar program of decoration in a recently constructed building in Rome, Virgil opens up the possibility that Aeneas's identifications and interpretations may not have appeared completely reliable to a Roman audience. To reiterate, this is not to reduce the ecphrasis to an account of the real portico; rather, introducing a material intertext increases the polysemy of Virgil's text.

Scholarly wariness in keeping ecphrastic texts separate from real artifacts and the desire to protect the autonomy of visual narratives from the tyranny of the text are both rooted in a fear of reductive philological readings of artifacts as mere illustrations of canonical, authoritative texts. But there is a cost to this intertextual apartheid for both objects and texts. In this book I hope to show that, just as an awareness of real Trojan temple porticoes can help to unlock important ambiguities in Virgil's account of Aeneas's reaction to a fictional portico, Trojan images from Pompeii and elsewhere in Roman Campania can often benefit greatly from being considered as witty and sophisticated commentaries on Homeric and Virgilian texts. Fortunately, a powerful argument against this "apartheid" in the study of ancient art and text has recently been made in an important book by Michael Squire.[21] It should be clear that I wholeheartedly endorse Squire's call for a return to joining up the study of art and text and that I would like to present this book as a contribution to that project. Squire gives a compelling account of the bias against the visual and in favor of the verbal in the modern German intellectual tradition that has influenced the philological study of the ancient world so decisively. Squire's emphasis on the modern oppression of image by text leaves a small gap in the picture, one that, however, is crucial for the argument of this book. As a result I, perhaps perversely, spend more time in the next few pages discussing the one minute point where I disagree with Squire than the much larger areas on which we agree entirely.

The problem with focusing on the tyranny of what Squire calls "Protestant art history" is that one can document the denigration of the visual in most branches of the Western intellectual tradition.[22] This points to a deeper root than Martin Luther; iconoclasm and logocentrism have long histories before the Reformation. Ultimately, the distrust of visual mimesis in Western thought goes back at least to Plato. Of

course, Squire knows all this, but his choice of emphasis tends to leave the reader with a picture of antiquity as a prelapsarian paradise in which images were free from textual oppression.[23] For my purposes, however, it is crucial to see how this conflict between the visual and the verbal extends back into antiquity. This is because the Portico of Philippus was the forum in which the agon between poetry and the plastic arts played out, quite self-consciously, in Augustan Rome.

In order to see just how strong the impulse to denigrate the plastic arts could be in some corners of antiquity, it is useful to glance at an anecdote surrounding one of the wonders of the ancient world, Pheidias's massive chryselephantine statue of Zeus at Olympia. It is reported that when he was asked where he got his model for the statue, the artist said that he took his inspiration from a few lines of the *Iliad*: "The son of Cronos spoke, and bowed his dark brow in assent, and the ambrosial locks waved from the king's immortal head; and he made great Olympus quake" (1.528–30). This anecdote need not imply a particular hierarchical relationship between the media of poetry and sculpture; indeed, it is reported by the geographer Strabo (8.3.30) in quite neutral terms, with the sculptor simply referring to Homer as the canonical authority on the Greek gods. Another ancient author, however, used this anecdote as the starting point for a denigration of the visual arts that is far more scornful and dismissive than the writings of Martin Luther or G. E. Lessing on which Squire focuses his criticisms.[24] Dio Chrysostom delivered a speech at Olympia in front of Pheidias's statue in which he takes the story of Pheidias's Homeric inspiration as an admission of the insufficiency of the visual arts in expressing the divine as compared to poetry (*Or.* 12.49–83).

Dio imagines putting the (long-dead) sculptor on the witness stand and compelling him to defend his masterpiece against the charge that it is an inadequate representation of the divine majesty of Zeus. In the speech he puts in the sculptor's mouth, "Pheidias" does not defend his work as a representation of divinity on its merits but rather accepts the charge of its insufficiency without demurral; instead he takes the approach of blaming the poverty of his artistic medium. This fictional sculptor defends himself by claiming that he did the best he could to represent the divine with the meager resources available to a visual artist. He contrasts the limitless ability of the poet to say anything his imagination fancies with the mute, lumpish, uncooperative materials with which the sculptor is forced to work. Most things that are possible with poetry are simply impossible to express with his materials. In the end, "Pheidias" is acquitted, but only because he has abased himself as a visual artist before the power of the word. What lies behind Dio's extraordinary gesture of contempt toward a supremely famous and venerable work of plastic art, which was considered a wonder of the world, is not just sophistry and straining for paradox. Dio's view is rooted in a Platonic hierarchy of being and mimesis: words can approximate pure ideas and so adumbrate the divine, but visual art can only imitate dumb objects and so it is doubly removed from the realm of truth.

Another amusing example of this ancient attitude of contempt toward the visual arts can be found in the "Dream" of Lucian. In this pseudoautobiographical narrative, the author tells us that his father had the idea of apprenticing him as a young man to his uncle, who was a sculptor, so that he could learn a profitable trade. Unfortunately, the narrator gets off to a bad start: having been given a piece of marble to work, he strikes too hard and shatters it. His uncle whips him and he runs home in disgrace. That night, he has a dream, in which two women appear to him and each attempts to win him over. The first is a personification of sculpture (Ἑρμογλυφικὴ τέχνη, 7); she is dirty and masculine and bears the signs of hard physical labor; she speaks like a barbarian. The other is a personification of education (Παιδεία, 9); she is beautiful, elegantly dressed, and eloquent. She warns the narrator that as a sculptor, no matter how successful he might become, he would always be considered a lowly manual laborer, and she convinces him to follow her in the study of wisdom and eloquence toward a future of wealth and honor. There is an absolute contrast between the dull, dirty, and mechanical trade of the sculptor and the creative autonomy of the orator who works with words and ideas. It was once believed that this tale was genuinely autobiographical and that Lucian came from a family of sculptors, but we need not be so naive. The fictitious incident in which the narrator shatters a block of marble clearly arises out of the same tradition found in the apology of Dio's Pheidias, where he blames the awkwardness and intractability of the sculptor's materials in contrast with the poet's. Here, the implicit contrast is with the raw materials of the rhetorician: words, which are characterized by their infinite malleability and plasticity.

So contempt for the mimetic capabilities of material art already had a firm place in ancient thought. But what of the other side of the debate? Are there any artists whom one can place in counterpoint to Dio's condescending prosopopoeia of Pheidias and Lucian's contemptuous personification of sculpture? Would any visual artist in antiquity dare to suggest that his materials were equal to Homer's, or even in some respects superior? It happens that there is such a figure, the great painter Zeuxis, and the work in which he challenged the capabilities of Homer's art, his portrait of Helen, came to be put on display at Rome in the Portico of Philippus. This curatorial gesture indicates the self-consciousness with which that building was made in the place in Augustan Rome where architecture, sculpture, and painting came into dialogue with history and poetry, especially epic. The irony is that the correct interpretation of this painting as a vindication of the capabilities of the visual arts was first expressed by none other than Gotthold Ephraim Lessing in his *Laocoön*, a work that is nowadays viewed as one of the chief instruments of modern Western logocentrism and its subjugation of the visual.[25] So in order to explain how the present book fits into contemporary debates about the relationship between art and text, I need to take a closer look at Lessing's *Laocoön* and the way it has been reduced to a caricature in much recent scholarship.

Lessing and Zeuxis's Helen

The *Laocoön*, an essay "on the limits of painting and poetry," is one of the foundational texts for the study of art, and some art historians have never forgiven Lessing for writing it. His central test case is, of course, the famous ancient sculptural group depicting the death of the Trojan priest Laocoön and his sons. He begins by contesting the earlier interpretation of that sculpture by J. J. Winckelmann, who he claims gave insufficient respect to the particular virtues of Virgil's textual account of the same episode. Lessing then goes on to use this as the starting point for his famous distinction between the textual, which has the ability to represent ideas and duration in time but can only represent the physical world indirectly, and the visual, which has a complementary set of strengths and weaknesses.[26]

The shout or groan of Laocoön, whose full articulation Virgil could represent and the sculptors allegedly could not, on account of both its temporal dimension and its incompatibility with the demands of physical beauty, has become synonymous with the limits of the plastic arts. Many of Lessing's modern readers are thus content to read him as a polemicist against the power of the visual.[27] And it is true that he shared the general Enlightenment bias toward canonical classical texts and saw himself as reasserting the priority of words over pictures, which he dubiously claimed had been lost.[28]

Given Lessing's polemical stance toward Winckelmann and others, his failure to distinguish between various physical media, his overriding concern with correcting literary practice so that it conformed to his own standards, and his fundamental lack of interest in visual art except as a foil for literature, it is not surprising that he has become something of a bête noire for art historians, just as he has been an icon for those who admire him.[29] Despite Lessing's polemics and his total indifference to actual works of visual art, it is unfair to rebuke him for failing to deliver a perfectly balanced assessment of the claims of the two kinds of media, for he was a playwright and a literary critic and, as E. H. Gombrich has pointed out, was interested in material culture not for its own sake but only as a tool to use against the sort of literature he did not like. Nevertheless, there is another, rarely remarked, aspect to Lessing's essay, where he speaks of the power of the visual and the corresponding limitations of words.

Lessing presents the power of the visual more obliquely, so it is easy to overlook it. An important example of this ungenerous approach is found in an article by W. J. T. Mitchell that has been widely influential on the contemporary negative view of Lessing.[30] The first half of that article is mainly an effort to disprove the universality of Lessing's distinction between the temporal dimension of texts and the spatial dimension of images.[31] The force of this demonstration is undermined by Lessing's prior admission of many of these very same exceptions, as Mitchell himself has to acknowledge.[32] As a critic, Lessing was a gadfly and the antithesis of the doctrinaire taxonomist that he has become in art-historical demonology.[33] The second part of Mitchell's article develops a theory that Lessing's purported dichotomy assigns opposite sex

roles to the two media: that he assigns visual art to a subordinate, feminine position while privileging poetry as active, male, and dominant. However, Lessing never says or implies anything remotely like this, as Mitchell again has to acknowledge.[34] This latter part of the article is based upon mere inferences from a passage in the *Laocoön* that Mitchell takes to be an "unguarded moment of free association" in which Lessing betrays his anxiety at a beautiful divine image obscenely adulterated by a monstrous phallic snake fetish that invites respectable women to dream of scandalous sexual unions. Mitchell completely misunderstands and misrepresents both the ancient anecdotes and what Lessing is trying to say with them.[35]

Since this passage has been so misunderstood, and since it is an important witness to Lessing's respect for the power of images, it is worth taking a moment to examine it:

> Aus diesem Gesichtspunkte glaube ich in gewissen alten Erzählungen, die man geradezu als Lügen verwirft, etwas Wahres zu erblicken. Den Müttern des Aristomenes, des Aristodamas, Alexanders des Großen, des Scipio, des Augustus, des Galerius, träumte in ihrer Schwangerschaft allen, als ob sie mit einer Schlange zu tun hätten. Die Schlange war ein Zeichen der Gottheit; und die schönen Bildsäulen und Gemälde eines Bacchus, eines Apollo, eines Merkurius, eines Herkules, waren selten ohne eine Schlange. Die ehrlichen Weiber hatten des Tages ihre Augen an dem Gotte geweidet, und der verwirrende Traum erweckte das Bild des Tieres. So rette ich den Traum, und gebe die Auslegung preis, welche der Stolz ihrer Söhne und die Unverschämtheit des Schmeichlers davon machten. Denn eine Ursache mußte es wohl haben, warum die ehebrecherische Phantasie nur immer eine Schlange war.
>
> (From this point of view I believe I can find some truth in some of the ancient tales which are generally rejected as outright lies. The mothers of Aristomenes, Aristodamas, of Alexander the Great, Scipio, Augustus, and Galerius all dreamed during pregnancy that they had relations with a serpent. The serpent was a symbol of divinity, and the beautiful statues and paintings depicting Bacchus, Apollo, Mercury, or Hercules were seldom without one. These honest mothers had feasted their eyes on the God during the day, and their confused dreams recalled the image of the reptile. Thus I save the dream and abandon the interpretation born of the pride of their sons and the impudence of the flatterer. For there must be some reason why the adulterous fantasy was always a serpent.)[36]

Lessing is saying that a god did not father those mighty sons, as the flattering versions of the stories claim, but that the mothers' dreams on the nights of conception were nonetheless true, though confused. During the day, each mother went to the temple of the respective god and viewed his statue, and "feasted her eyes" on its beauty. That

night, while having intercourse with her less-than-godlike husband, she kept an image in her mind not of him but of the god she had been gazing at during the day. Her dream preserved a confused memory of her fixation on the image of the statue during intercourse. Instead of the whole statue, her dream recalled only the snake that was a part of the statue. The greatness of character exhibited by Alexander, Augustus, and the others was due to the power of the image of the divine statue in the mind of their mothers during their conception. This is an extraordinary thing to say—statuary is stronger than semen—and it is not surprising that it has been misunderstood. Naturally, Lessing had to veil his meaning in a certain amount of circumlocution, but he is simply explaining the sexual mechanism by which beautiful art produces beautiful men and the inverse, as he had just finished saying:

> Erzeugten schöne Menschen schöne Bildsäulen, so wirkten diese hinwiederum auf jene zurück, und der Staat hatte schönen Bildsäulen schöne Menschen mit zu verdanken. Bei uns scheinet sich die zarte Einbildungskraft der Mütter nur in Ungeheuern zu äußern.
>
> (If beautiful men created beautiful statues, these statues in turn affected the men, and thus the state owed thanks also to beautiful statues for beautiful men. With us the highly susceptible imagination of mothers seems to express itself only in producing monsters.)[37]

The erroneous assumption that Lessing always and automatically privileged writing over painting accounts for the misinterpretation of his startling statement of the power of images in sexual intercourse and human reproduction.[38] It also explains why critics have neglected one of the most important parts of his treatise. In addition to giving that account of the power of visual beauty at the moment of conception, Lessing spends a large part of his essay dealing with an area in which painting was far more powerful than poetry: the representation of physical beauty. For Lessing the greatness of a poet is revealed in the way he finessed this inherent weakness of his medium. Just as the mute and immobile statue of Laocoön and his sons exemplified the limits of the plastic arts in comparison with Virgil's narrative, so Lessing adduces again and again a particular work of ancient art to exemplify the opposite: Zeuxis's *Helen*. It functions in the treatise as the inverse of the Laocoön statue, an anti-Laocoön, marking out the limitations of poetry and its inability to venture into the territory where painting reigns supreme. Ironically, this Greek painting survives only as a textual description; or perhaps it is natural, given Lessing's near-total lack of interest in actual, surviving ancient art. Like the Laocoön, this painting is of a Trojan subject. In this case, the textual point of comparison is not Virgil but Homer. Zeuxis's *Helen* was a painting that accumulated anecdotes; stories were told about it by many Greek and Latin authors.[39]

The particular anecdote that is crucial for Lessing's purposes is preserved by the Roman moralist Valerius Maximus:

> Zeuxis autem, cum Helenam pinxisset, quid de eo opere homines sensuri essent expectandum non putauit, sed protinus hos uersus adiecit:
>
> οὐ νέμεσις Τρῶας καὶ ἐυκνήμιδας Ἀχαιοὺς
> τοιῇδ' ἀμφὶ γυναικὶ πολὺν χρόνον ἄλγεα πάσχειν.
>
> Adeone dextrae suae multum pictor adrogauit, ut ea tantum formae conprehensum crederet, quantum aut Leda caelesti partu edere aut Homerus diuino ingenio exprimere potuit?

> (When Zeuxis painted Helen, he did not think he should wait to see what the public would think of that work, but then and there added these verses himself:
>
> No blame that Trojans and well-greaved Achaeans
> Should suffer pains so long for such a woman.
>
> Did the painter claim so much for his hand as to believe that it had captured all the beauty that Leda could bring forth by divine delivery or Homer express by godlike genius?)[40]

Valerius uses this anecdote to illustrate artistic arrogance (*adeo... adrogauit*) but does not explain precisely why it was arrogant to inscribe these lines. The other ancient source for this aspect of the painting likewise views it as hubristic. In a speech defending himself from the charge of egotism, Aelius Aristides includes the Homeric tag on Zeuxis's painting likewise to exemplify artistic insolence.[41] Both Valerius and Aelius seem to draw upon the same ancient tradition that interpreted Zeuxis's Homeric tag as an act of shocking arrogance. Why? Aelius says that it was because Zeuxis was comparing himself with Zeus, who had fathered the "real" Helen. Valerius gives a version of that explanation but then offers the alternative that it was because Zeuxis was daring to rival Homer. This is closer to the truth, but it took the genius of Lessing to first understand precisely the nature of the jibe Zeuxis was throwing at Homer here.

The two lines Zeuxis quoted, together with their original context, show that Homer does not in fact give a verbal expression of Helen's beauty that compares with the artist's visual image. Lessing saw that Homer's virtue is that he, contrary to what Valerius implies, refused to attempt to "express by godlike genius" the beauty of Helen. Instead of reciting a vague and insipid catalogue of physical features, he describes Helen's effect on the withered old men of Troy, and it is this Homeric evasion of any serious attempt at description that Zeuxis inscribed on his painting:

> Eben der Homer, welcher sich aller stückweisen Schilderung körperlicher Schönheiten so geflissentlich enthält, von dem wir kaum einmal im Vorbeigehen erfahren, daß Helena weiße Arme und schönes Haar gehabt; eben

der Dichter weiß demohngeachtet uns von ihrer Schönheit einen Begriff zu machen, der alles weit übersteigt, was die Kunst in dieser Absicht zu leisten imstande ist. Man erinnere sich der Stelle, wo Helena in die Versammlung der Ältesten des trojanischen Volkes tritt. Die ehrwürdigen Greise sehen sie, und einer sprach zu den andern:

> οὐ νέμεσις Τρῶας καὶ ἐϋκνήμιδας Ἀχαιοὺς
> τοιῇδ᾽ ἀμφὶ γυναικὶ πολὺν χρόνον ἄλγεα πάσχειν·
> αἰνῶς ἀθανάτῃσι θεῇς εἰς ὦπα ἔοικεν·

Was kann eine lebhaftere Idee von Schönheit gewähren, als das kalte Alter sie des Krieges wohl wert erkennen lassen, der so viel Blut und so viele Tränen kostet?

Was Homer nicht nach seinen Bestandteilen beschreiben konnte, läßt er uns in seiner Wirkung erkennen. Malet uns, Dichter, das Wohlgefallen, die Zuneigung, die Liebe, das Entzücken, welches die Schönheit verursacht, und ihr habt die Schönheit selbst gemalet.

(The same Homer, who so assiduously refrains from detailed descriptions of physical beauties, and from whom we scarcely learn in passing that Helen had white arms [*Il.* 3.121] and beautiful hair [3.329], nevertheless knows how to convey to us an idea of her beauty which far surpasses anything art is able to accomplish toward that end. Let us recall the passage where Helen steps before an assembly of Trojan elders. The venerable old men see her, and one says to the other:

> Small blame that the Trojans and well-greaved Achaeans should for a long time suffer misery for such a woman; she is marvelously like the immortal goddesses to look upon.

What can convey a more vivid idea of beauty than to let cold old age acknowledge that she is indeed worth the war which had cost so much blood and so many tears?

What Homer could not describe in all its various parts he makes us recognize by its effect. Paint for us, you poets, the pleasure, the affection, the love and delight which beauty brings, and you have painted beauty itself.)[42]

The juxtaposition that Zeuxis contrived between the strategic evasion of Homer and his own portrait of Helen is noteworthy for the way it undermines this tidy equivalence of poetry and painting. For he makes the viewer see that Homer pointedly does not attempt to describe Helen's beauty, because he lacks the adequate resources to do so, but instead simply describes the consequences it has had. The true force of Zeuxis's Homeric quotation is that it highlights the *difference* in the way poetry and painting achieve their effects and hence the painter's originality and independence from the canonical text of Homer. This was Lessing's crucial insight.

Lessing's bias toward the textual is evident in the way he declares the contest between Homer and Zeuxis a draw, even though on his own analysis Homer's strategy is to refuse combat:

> Zeuxis malte eine Helena, und hatte das Herz, jene berühmte Zeilen des Homers, in welchen die entzückten Greise ihre Empfindung bekennen, darunter zu setzen. Nie sind Malerei und Poesie in einen gleichern Wettstreit gezogen worden. Der Sieg blieb unentschieden, und beide verdienten gekrönt zu werden.

> (Zeuxis painted a Helen and had the courage to write at the bottom of his picture those famous lines of Homer in which the delighted elders confess their feelings. Never were painting and poetry engaged in a more even contest. The victory remained undecided, and both deserved a crown.)[43]

For Lessing, this anecdote is more important for what it says about the genius of Homer than about the arrogance of Zeuxis. In keeping with the literary focus of his essay, Lessing frames this as a parable about great poetry: Homer's virtue lies in the way he negotiates one of the serious, inherent limitations of language, the vagueness of its descriptive powers. This becomes the launchpad for Lessing's attacks on excessively descriptive passages in modern literature, such as his famous critique of Ariosto's description of the beauty of Alcina. Lessing's real target in the *Laocoön* is never the visual arts; it is always bad modern poetry. Visual art, as Gombrich wisely shows, Lessing simply did not care about. He did understand, however, that the inscription on Zeuxis's painting was the painter's critique of the inevitable silence of words in the face of beauty. It was thus the perfect antithesis for the silent scream of the Laocoön statue.

The point of this discussion of Lessing's *Laocoön* has been to emphasize that the agon between visual art and the text goes back to antiquity. Moreover, even in the Enlightenment there was a realization that there were two voices in that ancient debate. Even though Lessing was firmly in the textual camp, he did leave room in his treatise for the visual arts to make their own limited claims for beauty and mimetic power. His identification of Zeuxis's *Helen* as an intervention in the ancient debate was a major insight, but it has been ignored; this is a consequence of the extreme caricature of his work as purely antivisual. This is not to deny that the text has reigned supreme in modern classical scholarship. Indeed, the same hierarchy existed in antiquity. It is noteworthy that Dio could safely ridicule the chryselephantine statue of Zeus at Olympia in his prosopopoeia of Pheidias. Zeuxis, by contrast, found his gesture toward the insufficiency of Homer's language in the face of Helen's beauty treated as an *exemplum* of artistic hubris and arrogance. There is no doubt that verbal discourse had the upper hand over the visual both in antiquity and in modern

scholarship. But that makes it all the more important to listen carefully for the other side of the debate.

At this point I turn back toward ancient painting to consider what the painting and inscription of Zeuxis came to mean in its Roman context. Valerius says that Zeuxis put the lines on his painting and there is no good reason to doubt it.[44] He was making a subtle intervention against the ancient *ut pictura poesis* tradition. Plutarch attributes to Simonides the original observation that painting is silent poetry and poetry speaking painting.[45] Zeuxis surely examined Homer's descriptions of Helen before commencing his portrait of her; he will have found, as Lessing did, that they are remarkable in their vagueness. In its original context, Zeuxis's Homeric quotation was not a compliment to Homer or an empty boast. It was a statement that his portrait confronted and solved an aesthetic problem that Homer could only throw up his hands at. In the absence of adequate guidance from Homer, Zeuxis had to face a different problem: what model could he use for a painting of a woman who was by definition more beautiful than any other mortal? His famous solution was to make a composite portrait, combining the best features of the five most beautiful girls in Croton. Appearing on the painting of the composite Helen in all her splendor, Homer's words must have seemed an evasion and a provocative accusation of the inadequacy of words in the face of an image.

How well did ancient viewers understand Zeuxis's gesture? Valerius and Aelius, though they report his attitude as hubristic, do not clearly show that they understand that the painter was juxtaposing the power of the visual and the insufficiency of Homer's words, so one might wonder if Lessing's interpretation is a modern construct. The best demonstration I can offer that Lessing's interpretation was current in antiquity is an elegy of Propertius (2.3), which I discuss in chapter 6 in connection with the impact of the Portico of Philippus on contemporary poetry. Zeuxis's painting was an ironic and provocative presence in that building, which housed a famous set of statues of the Muses. Each of the daughters of Memory in that temple symbolized a different modality of remembrance, with an important exception: there was no muse of the visual arts. In its Roman setting, Zeuxis's painting drew attention to that oversight, pointing out the general limitations of the verbal forms of remembrance presided over by the Muses. This juxtaposition of image and text was the theme of the building's decoration, with its cycle of paintings depicting the Trojan War.[46] When Virgil's first readers encountered the Temple of Juno in Carthage, they would have been prompted to think of the Portico of Philippus, not only by the similarity in decoration, but more importantly by the way Virgil's ecphrasis continues the same dialogue between epic art and epic text that was begun with the Roman monument.

Virgil's ecphrasis of the Temple of Juno is usually taken to be a purely literary trope, but this is incorrect on two levels. In a basic sense, one has to realize that,

beyond the literary treatments of the Trojan War that Virgil engages with here, there is a Roman temple with a series of Trojan paintings that also acts as an important intertext. On a more fundamental level, the presence of Zeuxis's *Helen* in that particular Roman monument implies that Virgil's use of this space to contrast the verbal and the visual was no coincidence. The intimate relationship between Virgil's first major epic ecphrasis and a real Augustan building illustrates how the *Aeneid* participates in a dialogue with the visual arts in general and, more specifically, with the ideological aspects of the Augustan building program.

The Structure of This Book
In this book I attempt to understand the relationship between material culture and text in Augustan representations of the Trojan War, not in the traditional sense of the subordination of painting to the master narrative of epic poetry, but in the spirit of Zeuxis, to see the two media acting in a dynamic tension of rivalry, supplement, and symbiosis. Since nothing of the Trojan cycle of paintings from Rome survives, I begin by expending a considerable effort in the first four chapters to reconstruct the cycle of Trojan paintings from the portico of the Temple of Apollo in Pompeii. I must stress that the Pompeii portico does not stand as a proxy for the Roman portico, which had its own very particular agenda in its local context, but it does provide a sense of how Virgil's readers in one provincial Roman town constructed a local analogue of the very sort of fictional portico that Aeneas encountered in Carthage. The Pompeian cycle has not received much attention for the simple reason that the paintings were exposed to the weather and rapidly disappeared in the first decade after the monument's excavation in 1817. It turns out, however, that very early nineteenth-century archival sources can reveal a great deal of new information about these Trojan paintings. Chapter 1 provides an overview of these disparate nineteenth-century sources, assessing their usefulness and their problems for the project of reconstruction. Chapter 2 reconstructs the placement of paintings on the east wall of the portico, where the paintings were best preserved after excavation. Chapter 3 considers the much more exiguous evidence for the other three outer walls of the sanctuary. The Temple of Apollo was arguably the most venerable cult site in the city of Pompeii, so the pictorial cycle that decorated its portico was of particular importance to the inhabitants. Chapter 4 examines the impact of the temple's decorative program on Pompeian houses, and on this basis I tentatively suggest a few more scenes that might have been drawn from the temple but did not survive there. This chapter also has a full reexamination of the archaeological evidence for the dating of the portico and for the several phases of its decoration. It concludes by suggesting some links between this building project and the Portico of Philippus as its Roman model, taking into consideration current debates over the relationship between Roman provincial and metropolitan culture. This Pompeian half of the book, consisting of the first

four chapters, does, I hope, stand on its own as a contribution to the knowledge of one of the most important public buildings in Pompeii and also of Roman temple decoration more generally.

Part 2 of the book moves from Pompeii to Rome. In chapter 5 I attempt to reconstruct what can be known about the Portico of Philippus. The nature of this project is very different, however, for I am dealing with a monument that is completely lost and for whose decorative program there is no direct visual evidence. Even to discern the basic architectural form of the portico is a challenge. Nevertheless, there is a great deal of interesting information to be discovered about it and its relationship to the Temple of Hercules of the Muses that it surrounded and reframed. In recent years, there has been a great deal of scholarly interest in that Republican temple; I bring that scholarship together with a field that has been equally productive recently: the ways the ideology of the emperor Augustus was articulated in his building projects and how this complemented the literature produced under his patronage. Such studies have hitherto focused on more famous monuments; the Augustan Portico of Philippus does not even appear in the index of Zanker's *Power of Images*, the classic work on this subject.[47] The Portico of Philippus deserves to be studied alongside its better-known contemporaries like the Temple of Palatine Apollo and Augustus's Mausoleum and Forum, for its program is every bit as sophisticated and its connection with the literature of the period is, if anything, even more profound. The construction of this portico entailed a complete renovation of Rome's ersatz Temple of the Muses, or "Museum" (see page 2), a place long associated with the craft of Latin poetry. I propose that the Portico of Philippus was a key part of the Augustan building program and was of particular importance for the intersection of poetry and the plastic arts.

The focus of chapter 6 remains on Rome but shifts from visual art to literature. I reexamine several of the most famous passages of Augustan poetry to discover that the Portico of Philippus is an important presence. These are texts in which the metaphor of the poetry book as a temple serves to outline the poet's program and his relationship with the Augustan regime. The most fundamental of these passages is the metaphorical description in Virgil's *Georgics* of his future *Aeneid* as a temple, in a manner that derives from the iconography of the Portico of Philippus as well as of the Temple of Palatine Apollo. This fictional temple therefore foreshadows the *Aeneid*'s Temple of Juno in Carthage with its very different decorative program. When I turn to that ecphrasis, I show that many of the hermeneutic problems found in Pompeii are also present in Virgil's account, in a way that destabilizes Aeneas's confident identification of those scenes. Other Augustan poets were engaged with the portico in different ways. Horace adopted the persona of "priest of the Muses," responding to Augustus's renovation of the nearest thing Rome had to a proper institutional home for such a priest. Propertius responded in turn to Horace by setting up an alternative model of

the poet's relationship with the Muses that critiqued in a quite detailed fashion Virgil's imaginary temple and Horace's imaginary priesthood. Rarely did the Augustan poets allude to the home of the Muses or the topography of Mount Helicon without having one eye on the Portico of Philippus and its artworks. This building, the Museum of Augustus, was the blueprint for the relationship between poetry and power in the newly established principate.

NOTES

1. For the position of the images in the sanctuary and their status as paintings, see the detailed discussion of Virgil's language in chapter 6.
2. "What, precisely, is Aeneas so happy about?" Johnson 1976, 99–105; "It is a touching mistake by Aeneas," Barchiesi 1999, 336; for a full discussion, see Putnam 1998, 23–54; and, more recently, Kirichenko 2013, 66–67.
3. For the diversity of approaches in Virgilian scholarship to Aeneas's misreading, see the bibliography cited by Fowler 1991, 32n45.
4. Sandbach 1965–66, 29. For Heyne's identification of paintings in a portico rather than sculptures, see his fifteenth excursus on Book 1 of the *Aeneid* as printed by Wagner 1830–41, 2:247–48. Sandbach's observation is cited by Austin 1971, *ad* 1.456, who makes a further connection to the Portico of Philippus.
5. Moormann 2011.
6. Hoogma 1959.
7. Thus Wallace-Hadrill 1983.
8. Bryson 1983.
9. Pausanias 1.15.2 and 10.25–31.
10. On the Pompeian cycles, see Spinazzola 1953; on the Odyssey Landscapes, see O'Sullivan 2007 with Vitruvius 7.5.2; on Petronius, see *Satyricon* 29.9.
11. Hölscher 2004.
12. Though this, of course, did not dissuade artists from representing it; for some examples, see P. R. Hardie 1985 and Squire 2011, 305–24.
13. See, for example, Bryson 1994 on Philostratus's *Imagines* and Squire 2011, 337–49, on the shield of Achilles.
14. Barchiesi 1997c, 271.
15. Elsner 2013.
16. On the dangers of overstating the difference between "notional" ecphrasis of fictive objects and "authentic" descriptions of real objects, see Squire 2009, 145–46; on Propertius "blurring the difference between objects and representations of objects" in this poem, see Laird 1996, 85.
17. For a thorough account, see S. Lundström 1976.
18. Elsner 2002, 15, and see amplification by Squire 2009, 145.
19. See Elsner 2007, 67–109, and the response of Kampen 2009.
20. On the phrase, see Putnam 1998, 187–88. On the impossibility of the shield of Aeneas, see Heinze 1993, 313, and Eden 1975, *ad* 8.634. For a more optimistic view, see D. A. West 1990, 337–38.
21. See Squire 2009, 96.
22. For a well-known example, see Jay 1993 on this theme in twentieth-century French philosophy.
23. Squire 2009, 117–20, prefers to emphasize the side of Plato that valorized vision and beauty rather than the side that was hostile to mimesis and matter.
24. Squire 2009, 101n31, does mention this speech in a footnote, though only to insist that Lessing did not know it.
25. Cf. Squire 2009, 96: "The *Laocoön*'s edict that the power of 'poetry' resides in its ability to envision

content without visual form, and likewise that the weakness of 'painting' lies in its attempt to materialise non-visual content, is wholly alien to ancient thought and practice."

26. For a concise account of the context of Lessing's response to Winckelmann, see Brilliant 2000, 50–58. It is often pointed out that Lessing knew the Laocoön only via engravings.
27. See, for example, Squire 2009, 97–113, with references to previous literature.
28. For the intellectual context of the *Laocoön*, see the wonderful essay by Gombrich 1957, who concludes that Lessing's real adversary was Corneille; his aim was to erect "a high fence along the frontiers between art and literature to confine the fashion of neo-classicism within the taste for the visual arts" (144).
29. Among those admirers, Housman, who was Lessing's equal in appetite for polemics, expressed in his 1933 lecture "The Name and Nature of Poetry" the view that Lessing was the only classical scholar in the space of several centuries worthy of being called a literary critic. Lessing would not, however, have accepted the title of scholar any more than Housman embraced that of literary critic: Gombrich 1957, 137.
30. Mitchell 1984; for the continuing influence of Mitchell's article, see Squire 2009, 105–7.
31. On the oversimplification entailed in reducing Lessing to this distinction, see Sternberg 1999, 333–35.
32. Mitchell 1984, 102.
33. Gombrich 1957, 134.
34. Mitchell 1984, 108.
35. For the persistence of this misreading, see Squire 2009, 109–11, and for a particularly extreme version, see Gustafson 1993, 1091–92.
36. *Laocoön*, chap. 2: McCormick 1962, 14–15.
37. McCormick 1962, 14.
38. This is not to say that Lessing could not be contemptuous of visual art when it suited his rhetorical purposes. For example, Squire 2009, 112–13, quotes a passage in which Lessing says that the divine is formless and only diminished by visual representations. This would contradict my reading of Lessing and align him with Dio Chrysostom. But in that part of his treatise (chap. 12), Lessing is really talking about the representation of the gods in Homer and is not concerned with the visual arts at all. His work is extravagantly polemical, and extreme statements from one context cannot be used to characterize the thrust of the whole work; perfectly weighted consistency of argument is not to be expected from the provocative style of Lessing's essay.
39. For a comprehensive overview of the ancient evidence about the painting, see de Angelis 2005, and for its postclassical reception, see Mansfield 2007. It is interesting to note that neither of these fine and lengthy studies mentions Lessing's interpretation of the painting, so suppressed has it been in modern discussions of the interface between art and text.
40. Valerius Maximus, 3.7, *ext* 3, trans. Shackleton Bailey.
41. ὁ ὑβριστὴς ἐκεῖνος, Aelius Aristides, *Peri tou paraphthegmatos* 386.
42. *Laocoön*, chap. 21: McCormick 1962, 111.
43. *Laocoön*, chap. 22: McCormick 1962, 115.
44. Thus Austin 1944, 21. The stories of the genesis of the *Helen* attest that it was a highly prestigious and expensive work commissioned by the city of Croton from the most famous Greek artist of his day. It was prized as a masterpiece from the moment it was executed until the day it was brought to Rome; it is not the sort of object to pick up odd scribbles.
45. Plutarch, *De glor. Ath.* 346–47.
46. Pliny reports a couple of other minor paintings hanging there, too, but the *Helen* and the Trojan cycle must have dominated the display, the former because of its unsurpassed fame and the latter because of its number of works.
47. Zanker 1988, 384; more recently, the Portico of Philippus is also absent from Rutledge 2012.

Part I
ART IN POMPEII

Chapter 1

Sources for the Temple of Apollo

When the building in Pompeii now known as the Temple of Apollo was excavated in 1817, visitors excitedly reported that the portico around the temple was decorated with paintings of scenes from the Trojan War. Some visitors emphasized that many images were fragmentary, faded, and difficult to make out, but other observers were taken by the beauty of the paintings. For example, Henry Wilkins's book of views of Pompeii, which was published in Rome in 1819, illustrates a general view of the newly excavated temple, and the accompanying commentary waxes enthusiastic on the subject of the decoration of the portico:

> Les murailles étoient orneés de superbes peintures à fresque, dont quelques unes sont parfaitement conservées au même endroit, et dont l'exécution feroit honneur aux meilleurs artistes modernes: puissent-elles être respectées des voyageurs!!
>
> (The walls were decorated with excellent frescoes, some of which are perfectly preserved in that same place, and whose execution would do honor to the best modern artists. May they be respected by travelers!)[1]

In the years immediately after the discovery of the monument, the paintings in the temple were therefore a fairly significant attraction for visitors to the largely unexcavated city. Unfortunately, Wilkins's wish that the paintings be preserved for posterity was not fulfilled, and the plaster, which was left exposed to the elements, before long began to weather away.[2]

Just as Wilkins appreciated the danger posed by souvenir-hunting tourists, the danger of leaving the plaster exposed to the elements was appreciated at the time. Much of the decay in the Temple of Apollo happened in the time between the publication of the first installment of Sir William Gell's *Pompeiana* in 1819 and the second in 1832.[3] In the preface to the latter, antiquarian Gell may well have been thinking of that monument in particular when he wrote, "With such an accession of new materials, the Author of the present work has thought it advisable to lay them before the public without delay, aware that time will incalculably diminish the freshness of those objects, which, when stripped of their external coats by the rains of winter

or the burning suns of summer, lose by far the greater portion of their interest and identity." In a private letter written from Naples on April 8, 1831, Gell made the point with rather more sarcasm: "A Fete at which all the inhabitants of the country assemble in Pompeii, when more than usual liberty is allowed, procured me the means of drawing and measuring many things usually watched with much jealousy till they are destroyed by the weather."[4]

Essentially none of the painted plaster in the portico survives today, and one can trace the process of decay through the drawings and photographs made by visitors throughout the nineteenth century. This process of gradual loss did not cause much scandal or attract much comment in the decades that followed, for the interest of visitors to Pompeii had already been diverted to newer discoveries. In the 1820s and 1830s, the excavation of the Houses of the Tragic Poet, of the Discouri, of the Faun, and so on provided the visitor with a dazzling array of gorgeous paintings and mosaics that survived in a much better state of preservation and with more vivid color than had been the case in the Temple of Apollo. Guidebooks continued to explain that the walls of the sanctuary had once held pictures of the Trojan War, but these comments were derived from earlier books; the images had disappeared.

When one takes into account the delicate state of the plaster when first excavated, the ravages of weather, the restrictions on visitors drawing the monuments, and the attraction of new and better-preserved paintings, it might seem impossible to recover anything of the original state of the interior walls of the portico. The evidence is indeed very patchy, but it is worth putting together. Early drawings and descriptions of the monument, especially those that were made by visitors to the site not long after its excavation in 1817, can tell a surprising amount. The first important source is a sketchbook belonging to William Gell, who visited and drew the temple as it was in the process of being excavated.

Gell vs. Gandy

The structure adjacent to the Forum in Pompeii that is today known as the Temple of Apollo was not always called by that name. Throughout the nineteenth century, the sanctuary was known as the Temple of Venus, because of an inscription that was wrongly thought to link the temple to the goddess; ultimately, the correct identification was established by the discovery and deciphering of a dedication to Apollo in the Oscan language.[5] Before the persistently erroneous identification of the site as the Temple of Venus took hold, the building was known by several other names immediately after its discovery. The most vivid picture of the uncertainties surrounding the new discovery is provided not by the excavation reports, which are extremely laconic and are more interested in recording the discovery of removable objects, but by the internal inconsistencies found in the first edition of *Pompeiana*, the popularizing work that first brought Pompeii to a wide European audience.

In the beginning, *Pompeiana* was a collaboration between William Gell, who was resident in Naples, and John Peter Gandy in London.[6] Most accounts of their work assume that they were both in Italy together, just as they had earlier voyaged to Ionia together under the auspices of the Society of Dilettanti. But this second collaboration was organized very differently. Gell had obtained a position as chamberlain to the exiled Princess Caroline of Brunswick, the estranged wife of the prince regent. Gell moved to Italy with her, while Gandy remained in London. For this publication, Gell would sketch the new discoveries at Pompeii and post his reports to Gandy, who would arrange for the lithographs to be engraved and would compose the text to be typeset by the London printer. Gandy's letters to Gell are preserved in the British Library and they present a picture of two authors rushing to get the material into print as quickly as possible in order to beat out the competition.[7] This was a mode of just-in-time book production, where the final product was being engraved and typeset in a distant country even before the complete manuscript was finished. The obvious problem was that new material was continually being discovered in Pompeii and reported by Gell, but Gandy could not easily revise the earlier text and illustrations, already written, typeset, and engraved in London, in order to take the continuing discoveries into account.

One change in the period 1817 to 1819, while the book was being produced, was the progressive excavation of the temple and its changing identification. Different passages of *Pompeiana* therefore give conflicting names to the structure—House of the Dwarfs, Temple of Bacchus, Temple of Venus—so the authors were compelled to acknowledge and explicitly discuss the issue of identification.

Gell and Gandy first called the structure House of the Dwarfs, reflecting the earliest phase of excavation, in which the portico surrounding the still-buried temple was identified as belonging to a private house. The name refers to paintings with Nilotic scenes of pygmies and crocodiles. These were apparently the first paintings discovered, and they are copiously illustrated in the first edition of *Pompeiana*. Sadly, the Trojan paintings were not given similarly extensive treatment in this work, due in large part to the difficulties in communicating between Naples and London. *Pompeiana*'s only mention of the painted decoration of the temple portico is a reference to "divers representations of architectural subjects and pygmies" (p. 227). Nevertheless, there is one hint that Gell was aware of the Trojan material, even if Gandy never understood its significance. At the start of the chapter on theaters (p. 223), there is an engraving of a painting of Bacchus and Silenus that was found in the apartments that adjoin the Temple of Apollo to the north and that is today in the National Archaeological Museum of Naples (see fig. 48).[8] This is the image that gave the temple its occasional identification as the Temple of Bacchus, one of the names used by Gell and Gandy in that chapter. At the head of the next chapter on theaters (p. 233), there is a vignette showing a heroic warrior on the right who is drawing his sword as he advances upon a seated figure on the left and is restrained from behind by the goddess Athena. Evidence discussed later

makes it clear that this is a representation of a picture from the portico of the Temple of Apollo depicting a scene from the assembly of the Greeks at the start of Homer's *Iliad*: Achilles is infuriated with Agamemnon but Athena restrains him.

At this point, the text of *Pompeiana* says nothing at all about what this image represents or where it comes from. Elsewhere in the volume, however, the key to the map of Pompeii has this discussion of the temple:

> No name has hitherto, with sufficient authority, been applied to this edifice. On the spot, a portion of a female statue, found therein, has induced the excavators to assign it to Venus; while the pictures found within its enclosure do not afford much better ground for supposing it of any other divinity. Around the walls of the porticoes, at 2 feet 6 inches from the ground, run a series of paintings, of dwarfs and architectural subjects. In one corner is a painting of Achilles and Agamemnon: in another Hector tied to the car of Achilles: and in an apartment is a picture of Bacchus and Silenus. Pygmies are from the Nile; and the latter picture may have reference to the god here worshipped, with whose rites some mixture of other ceremonies may have been celebrated. (p. 213)

A footnote later points the reader to the location where the picture of Bacchus and Silenus can be found illustrated as a vignette, but no such cross-reference is given to the image of Achilles and Agamemnon. Apart from the indication that this painting and the one of Hector were found in different corners of the portico, no precise location is given for either of the Trojan paintings, and indeed the fact that these two were part of a whole Trojan series is not made clear.

The limitations of this account of the decoration of the portico are clearly a result of the way in which the volume was produced and of the difficulties in communicating between the two authors. These issues are vividly documented in the letters that Gandy wrote to Gell at this time. Gandy constantly demanded prompt news of the new finds while cajoling Gell with promises that the book would make them both rich and threatening that competitors were about to beat them to market. In this pressurized atmosphere, tension between the two collaborators often led to conflict and insult. This is particularly evident in the letters that deal with information about the ongoing excavation of the Temple of Apollo. On October 3, 1817, Gandy writes, "If you send immediately anything relating to the Basilica, it will be just in time to come in, but if you keep it in your breeches pocket till Christmas, it must be deferred to the addenda, and until then the place must be called the House of the Dwarfs."

At this point Gandy seems reluctant to give up the identification as House of the Dwarfs, presumably because some material has already been typeset with that name, but he is aware of the new identification as a public building, possibly a basilica. A month later, he has come around to the fact that it is a temple, writing on November 25: "and also give me some sort of data by which I can apply the new

temple on W [crossed out, wrongly replaced with E] side of Forum to the Plan. This you should have done but have not done you b———."

Gandy is too much of an aspiring gentleman to write out the insult, but the sentiment is crystal clear. The new Temple of Apollo, whose position with respect to the Forum Gandy is still confused about, is at this moment being identified with Bacchus, as Gandy goes on:

> Don't forget to tell me how the new temple comes with regard to this and in your future views do be a bit careful in marking material as plaster and stone. It gives interest here and I wish you had marked on what respective views of Bacchus the several paintings were found as by giving indications in the views—is interesting to the multitude here, and affords me matter for letter press—I shall not fail returning what I don't engrave as well as all I do—but do be assured you do not so well at Naples know what will take as we on the spot.

This passage is tantalizing to one interested in the manner in which the Trojan paintings were displayed in the portico. Here Gandy demands to know where in the views of the temple the various paintings were found. This is something that has never been known. Did Gell simply fail to answer?

Gandy persistently accuses Gell of sloth, sloppiness, and tardiness:

> Pray lose no time in getting or procuring me the new discovery. . . . I must beseech you on this point not to have the gout or delay. (October 22)

> Don't be in a rage at all this, or tired or annoyed, or declare that you have made one drawing or three drawings, and won't make another. (November 28)

Gell's side of the correspondence with Gandy is not extant, but a look at the letters he wrote to his family during this period tells something of his side of the story.[9] In addition to his researches at Pompeii, Gell was very busy dealing with the affairs of Princess Caroline, which were at this moment coming to a crisis. Though persona non grata in England, Caroline was the mother of the future heir to the British throne and a royal person of undeniable importance. She was famous for her lack of discretion, and Gell, as one of her chamberlains, consequently had his hands full. In 1817, the princess was residing in Pesaro with a male companion, and Gell had retired to Naples, ostensibly on account of his gout but surely also to distance himself from the various scandals gathering around her. His correspondence with Caroline and others in this period is dominated by attempts to deal with several emergencies, including a shooting by one of her servants, but especially her dire and murky financial situation. It is clear that in late 1817 Gell's work on Pompeii would have been hampered by his need to deal with Caroline's crises, his attacks of gout, and the periodic refusal of the authorities to permit anyone to draw various parts of the ruins, especially those newly excavated.

Then in London in November 1817, just as Gandy was demanding more precise illustrations of the Temple of Apollo, Caroline's daughter, Princess Charlotte, died in childbirth. The question of whether or not Caroline should return to Britain to take advantage of the reaction of extreme national grief naturally dominated Gell's concerns. Against this immediate backdrop Gandy's charges of sloth seem extraordinarily unfair. In his letter of October 22, Gandy implies that Gell's "gout" was an ailment of convenience; but Gell's letters to his family attest to his physical agony in this period. Furthermore, the work Gell did for the princess was not unrelated to his ability to document the excavations in Pompeii. He was not a wealthy man, but he served as a point of contact for British gentlemanly scholars who wished to visit the antiquities of the area, somewhat as Sir William Hamilton had done in previous years. His connections with the exiled princess, and with other foreigners of high status, gave him a standing with the local authorities that sometimes permitted him to sketch what others were refused. Given the pressure of his other affairs and the physical discomfort that traveling to Pompeii afforded him, it is impressive that Gell drew as much as he did, though he was helped by the use of a camera lucida.[10]

Despite his constant complaints, Gandy did occasionally acknowledge that Gell gave him what he had asked for. In his letter of November 28, 1817, he allows in a backhanded way that he has been given quite a bit of detail on the new temple: "All this being the case I must take the liberty of reprehending the custom which has grown upon you of late in substituting quantity for quality—less of the former with more attention to the detail will oblige as you have done with regard to the new temple."

Gandy had asked for details of the new temple in the letter he wrote only three days earlier, so presumably their letters were crossing each other in the post. But if Gell had given the sort of detail Gandy had asked for about where the different paintings in the portico of the Temple of Apollo were found, this information did not make its way into the printed *Pompeiana*. One may then ask what happened to this information. In his letters, Gandy repeatedly reassures Gell that he will send his drawings back to him. This he apparently did, for Gell's notebooks include several that contain the original sketches for the first and second editions of *Pompeiana*. These notebooks were dispersed after his death and eventually found their way into a number of collections, including those of the National Archaeological Museum of Naples, the British School at Rome, and the Getty Research Institute in Los Angeles. The two sketchbooks of interest here, however, are those containing the original drawings for the first version of *Pompeiana*. These are part of the Jacques Doucet Collection, now in the Institut national de l'histoire de l'art in Paris and available online.

Among the sketches Gell made of the temple in 1817 are the originals for the engravings of the Nilotic and architectural scenes and reproductions of the two Trojan paintings he mentioned: the dragging of Hector behind Achilles's chariot and the quarrel of Achilles and Agamemnon. The latter sketch has some instructions to

Gandy on the reverse of the paper (f. 70), which indicate that it came from "the temple once called the house of the dwarfs." Gandy's failure to identify the origin of this painting when he had it engraved seems thus not to have been for lack of information from Gell. In fact, in another drawing from the same notebook, Gell drew a plan of the temple that tells a bit more than any other source about the location of several of its paintings (fig. 1). The annotations to the plan tell that the Nilotic scenes were found on the south wall, near the entrance: see the phrase "paintings of Dwarfs," which is legible in the enlarged detail (fig. 2). Crucially, Gell also indicates the precise location of one of the Trojan paintings—the only source to do so. On the east wall, the second painting toward the north is labeled as "picture of Achilles Agamemnon and Minerva," which is to say the quarrel of Achilles and Agamemnon.

The indication of the location of a single painting may seem a paltry help, but it provides a point of departure for reconstructing the east wall, and it serves to confirm the more indirect and quite novel methodology employed in chapter 2 for determining the location of the other paintings.

FIGURE 1 Sir William Gell (English, 1777–1836), Plan of the Temple of B[acchus] (i.e., Apollo). Reconstructed from the main part on folio 84 and a small part on folio 69 of the sketchbook (vol. 1) for the first volume of *Pompeiana: The Topography, Edifices, and Ornaments of Pompeii*, ca. 1819. Ink on paper. Paris, Jacques Doucet Collection, Institut national de l'histoire de l'art, NUM MS 180 (1)

FIGURE 2 Detail of fig. 1, showing the southeast corner on Gell's plan

CHAPTER 1 33

Steinbüchel, Morelli, and Rochette

The main source of information about the paintings in the Temple of Apollo has always been a set of engravings printed by Professor Anton von Steinbüchel von Rheinwall, an Austrian antiquarian. In 1819, Steinbüchel made a trip to Rome and southern Italy; he visited Pompeii and saw the Temple of Apollo soon after its excavation.[11] Many years later, starting in 1833, he published his *Atlas*, a large-format illustrated set of volumes on the monuments and architecture of antiquity.[12] There are a number of problems with this source: It does not show all the surviving paintings, it extrapolates to put things in the compositions that were not there, it misidentifies the subject of several paintings, and it was probably based not on the paintings directly but on an intermediate representation of them. Most important of all, the engravings show just the paintings, without context and in no particular order.

The illustrations in Steinbüchel's *Atlas*, like those from many other nineteenth-century books on antiquities, were almost entirely copied from other published sources. The plans of buildings from Pompeii were drawn mainly from Gell's *Pompeiana* (discussed above) and from Mazois's *Les ruines de Pompéi* (discussed below). One important exception pertains to the Temple of Apollo (or Venus, as Steinbüchel calls it). In the final volume, which was an appendix to his *Atlas*, there are a series of engraved drawings of the Trojan pictures from the temple portico. These drawings are all that scholarship has hitherto known of the paintings from the Temple of Apollo, and they have attracted a small amount of discussion.[13] As the only surviving effort to document the frescoes in the temple, Steinbüchel's engravings are the most important item of evidence. But they are also problematic.

Steinbüchel's engravings were apparently executed by Albert Schindler, who signed the bottom right corner of one of them (see fig. 48). Schindler was employed as an engraver by the Imperial Cabinet of Coins and Antiquities in Vienna, of which Steinbüchel was director.[14] There is no evidence that Schindler ever traveled to Italy, so he must have been working from line drawings provided by Steinbüchel. The question then is: where did Steinbüchel get these images? He does not appear to have made a regular practice of sketching monuments on his travels. His text highlights the fact that these engravings, unlike most of the other illustrations taken from published sources, were done after original drawings made on the spot; but he discreetly does not say who made them.[15] It was difficult to get permission to sketch recent discoveries in Pompeii—even a well-connected long-term resident like Gell had frequent difficulties. Restrictions had eased under French rule, but with the restoration of Bourbon power in 1815 the situation seems to have been uncertain. Given all this, it is not very likely that Steinbüchel, as a casual visitor, made the drawings himself. In fact, a strong argument can be made that they came from the pencil of the official artist attached to the excavations, Francesco Morelli, whose work has preserved copies of many now-lost Pompeian wall paintings. If so, it is natural that Steinbüchel does not

FIGURE 3 Francesco Morelli (Italian, ca. 1768–1830), Copy of painting from the Temple of Apollo at Pompeii (detail), n.d. Pencil, ink, and tempera on card. Archive of the National Archaeological Museum of Naples, ADS 696

name the source of his drawings, for Morelli would have been flouting the terms of his employment and breaking the law.

Preserved in the archives of the National Archaeological Museum of Naples are three pencil-and-tempera reproductions by Morelli of wall paintings from the Temple of Apollo. One is of Nilotic scenes with pygmies of the type that Gell and Gandy illustrated prolifically (see fig. 58); the other two are perfect matches for two of Steinbüchel's Trojan engravings.[16] One painting is of the so-called dragging of Hector (see fig. 54) and the other shows a warrior, encouraged by Athena, who seems to be casting a spear (fig. 3). These two correspond so closely to Steinbüchel's drawings that Bragantini has astutely conjectured that Morelli was their source.[17] One can make this claim even more secure by looking closely at the details of one of Steinbüchel's images.

CHAPTER 1 35

FIGURE 4 Engraving of an image from the Temple of Apollo in Pompeii. From Anton Steinbüchel, *Grosser antiquarischer Atlas* (1833), vol. 8, pl. B2

If Steinbüchel's image of Minerva encouraging a warrior (fig. 4) is compared to Morelli's, the details are nearly identical. The differences are very minor: naturally, the colors are lost; some small details are elided, such as the second soldier standing behind Minerva on the left; the head of the main warrior is the correct size, whereas Morelli's head is disproportionately small compared to the body; and Steinbüchel indicates three large cracks in the plaster on the bottom half that are not visible in Morelli's image. This similarity of detail might be regarded as the result of their closeness to the original. But this is made extremely unlikely by the way Morelli distinguishes between the surviving plaster, which he painted in tempera, and his hypothetical reconstruction in pencil of what must have been at best faint indications. That the original was in such a dreadful state is confirmed by Steinbüchel's comments. He singles out this image as having been particularly difficult to make out: "In one painting (pl. 8.B.2) the colors do not survive, as they are already too badly weathered and only the outlines of the figures are distinguishable."[18] Morelli's painting of Hector (see fig. 54) shows that this much-better-preserved fresco was rendered in tempera in full color, without recourse to guesswork indicated in pencil. If the parts of the

painting that Morelli drew in pencil were as difficult to distinguish as Steinbüchel's annotation indicates, it seems quite impossible that multiple artists could have come up independently with identical hypothetical restorations. In particular, the soldier with his back to the viewer in the right foreground appears to have been attested to by only a bit of fabric and a bit of his shield. Morelli's sketch is clearly provisional, and the difference in media makes it clear that the right half is quite speculative; the copy he made for Steinbüchel unfortunately obliterated this distinction, except in the case of the soldier's right leg, which was not copied.

I therefore conclude that the engravings published by Steinbüchel are dependent on Morelli's work and were probably even made by Morelli for the Austrian scholar when he visited in 1819. Apparently, then, Morelli had made more drawings of the portico for his own use than the ones that survive in the Naples archive. The official record of the excavation notes that he was instructed to execute a reproduction of the wall in the apartment behind the portico with the image of Bacchus and Silenus. This he did, for in the archive there is a finished, polished tempera painting of the entire wall.[19] He was further instructed to execute paintings of two other portions of the portico walls but the record does not indicate which ones. The excavation reports note that, beyond the wall paintings explicitly singled out, there were others worth copying:

> Si è stabilito poter egli il Morelli eseguire le copie delle seguenti: ... Due pareti, una lunga pal. 29, alta pal. 11, e l'altra lunga pal. 12, alta 16, poste nella parte interna del tempio ipetro a settentrione della Basilica, ove (oltre molti graziosi compartimenti architettonici ed eleganti ornati) sono delle figure, cacce, ed altri simili belle cose. Altra parete lunga pal. 14, alta pal. 12, dello stanzino posto dietro il detto tempio, nel quale stanzino trovasi il bel quadretto di Bacco col vecchio Sileno in atto di suonare la lira, e tuttociò in mezzo a bellissime riquadrature ed arabeschi, e tondi forniti di teste di Fauni; oltre a diverse altre interessanti dipinture sparse qua e là nel luogo medesimo, le quali meritano di essere copiate, avanti che la intemperie della stagione finisca di distruggerle e di consumarle.

> (It was decided that Morelli would be able to make copies of the following: ... Two walls: one 29 *palmi* [6.5 m] wide, 11 *palmi* [2.5 m] high; and the other 12 *palmi* [2.7 m] wide, 16 *palmi* [3.6 m] high; both located in the inner part of the hypaethral temple to the north of the Basilica, where (in addition to many graceful architectural sections and elegant decorations) there are figures, hunting scenes, and other such lovely things. Another wall, 14 *palmi* [3.1 m] wide, 12 *palmi* [2.7 m] high, from the little room behind that same temple, in which was found the beautiful little painting of Bacchus with the aged Silenus playing the lyre, and all of this in the midst of lovely panels and arabesques, and roundels with heads of fauns in them.)[20]

It seems that Morelli's rough sketches of the Nilotic scenes (see fig. 58) and of the two Trojan paintings (see figs. 54 and 3) were preparatory work for the other two finished paintings of full stretches of walls that he had been officially charged with making but that do not survive. Fortunately, there is an image that probably descends from one of those lost works.

The diffusion of Morelli's work as the basis for contemporary published representations can be seen again in an impressive color lithograph in Désiré-Raoul Rochette's *Choix de peintures de Pompéi* of 1844–53. The details of the figural painting at the center (fig. 5) follow Morelli's tentative penciled reconstructions as if they were gospel, including elements Steinbüchel had omitted, such as the full right leg of the soldier on the right, the head of the second soldier behind Minerva on the left, and the spiral motif on the helmet of the central warrior. Rochette was not, therefore, copying Steinbüchel's earlier publication. Further evidence is provided by the coloring. Morelli's example is followed where he used paint to indicate the color of surviving plaster. The bluish tinge of the skirt of the central warrior and the greenish tinge of his greaves are similar, as is the deep red of the shield (her own?) behind Minerva'a outstretched arm. None of these details came from Steinbüchel, so they must have derived either from Morelli or from examination of the original painting itself.

Once again it is the soldier on the right with his back to the viewer, where the original painting was very hard to read, that is most helpful for establishing the influence of Morelli's reconstruction. The right leg, which is not shown by Steinbüchel, might show the direct influence of Morelli, but it could equally be claimed that this was an inevitable extrapolation by Rochette. The left leg, however, with the crisscross pattern at the back of the greave, is much more distinctive. Steinbüchel showed the backward angle of the leg and the raised heel, but he did not show the soldier's armor. Rochette's perfect agreement with Morelli on this hypothetical, reconstructed detail can only be explained by their interdependence, since such details were no longer distinguishable in the portico at the late date when Rochette visited.

Rochette discussed the state of the temple and the source of his drawings of it in an earlier work that was published in 1840. He noted then that at the time of his most recent visit to Pompeii, in 1838, the painted plaster had already undergone serious decay.[21] Like Steinbüchel, he came away from Naples bearing drawings of the Trojan paintings, and he likewise discreetly suppresses the name of the person who supplied them:

> Ceux des sujets qui sont encore reconnaissables, dans l'état de dégradation très-avancée où se trouvent aujourd'hui ces peintures, ont rapport à l'histoire d'Achille; ils représentent, l'un Achille retenu par Minerve, l'autre Hector traîné au char d'Achille; j'en possède des dessins, exécutés avec toute l'exactitude possible à une époque où les peintures originales subsistaient encore presque dans toute leur intégrité.

FIGURE 5 Lithograph showing an image from the Temple of Apollo in Pompeii. From Désiré-Raoul Rochette, *Choix de peintures de Pompéi* (1844–53), pl. 8 (detail)

> (Those of the subjects which are still able to be distinguished, in the very advanced state of decay in which these paintings are today to be found, are related to the story of Achilles. One represents Achilles held back by Minerva, another Hector dragged from the chariot of Achilles. I possess some drawings of them, which were executed with all possible accuracy at a time when the original paintings were still preserved nearly intact.)[22]

Rochette essentially admits that the precise drawings he acquired showed more of the paintings than he himself could see at the time of his second visit. These drawings must have been Morelli's. This explains why Rochette's illustration is so similar to Steinbüchel's but contains elements that are independent of it. It seems that Rochette acquired from Morelli not merely a line drawing of the Trojan picture but a color painting of the entire decorative panel in which the Minerva painting was situated, for his chromolithograph shows the full context of the painted plaster that surrounded the figural composition (see fig. 5).[23] The sketch by Morelli that survives in Naples (see fig. 3) would have been a preparatory study for his fuller treatment of the full panel, a copy of which must have been given or sold to Rochette. Unfortunately, Rochette never published the drawings of the two subjects he mentioned above, so it is not known if they were similarly complete, full-color illustrations of the entire panel, or if they were just line drawings of the figural panels, like Steinbüchel's source.

All of this is important, because it turns out that the right half of the painting of Minerva encouraging a warrior is in fact completely inaccurate. It is only by looking closely at the common origin of these visual sources that one sees that the three witnesses are not independent; rather, it is the same hypothetical reconstruction by Morelli repeated by two closely related sources. The line drawings reproduced by Steinbüchel and the view of the wall given by Rochette are all derived from the work of Morelli, who seems to have discreetly supplied copies of his official work to contemporary visitors. The derivative drawings, however, tend to obscure the distinction between actually preserved plaster and Morelli's more speculative reconstruction. Thus Steinbüchel's evidence may contain extrapolations.

The Architects

The next piece of the puzzle comes from an unexpected source. It is well known that many architects from all over Europe came to draw the newly excavated ruins in Pompeii, and their work has been the subject of important recent scholarship. Their principal concern, as architects, was to represent the state of the buildings as a whole, but they also often recorded the appearance of the decoration on the walls. These images have been widely used to reconstruct the overall appearance of walls whose painted plaster has disappeared. What I do below is take this process even further and blow up the minute details of the figural Trojan compositions at the center of the decorative scheme.

These are usually tiny and too small to be legible in lithographs. But the originals often show enough detail that, in combination with the information from Steinbüchel, I can determine the position and subject matter of quite a few of these paintings. This methodology, to use extreme enlargements of very small details of architectural drawings, is somewhat novel, so it is fortunate that in one case, the plan of the temple in Gell's sketchbook that indicates the original location of one of the Trojan paintings, there is external confirmation that these small details can in fact be reliable evidence.

I start with François Mazois, the most important of the illustrators of Pompeii in the early nineteenth century.[24] Whereas Gell's *Pompeiana* was the great popularization of Pompeii, Mazois inaugurated the scientific and systematic study of the ruins. His carefully measured drawings are still frequently used, not only because of their value as historical documents, but also because of their accuracy and precision. Mazois's last trip to Pompeii was in 1819, and it was then that he must have executed his studies of the Temple of Apollo, excavated two years earlier.[25] These images were published as lithographs posthumously, in the fourth volume of his great work, *Les ruines de Pompéi*. His published elevation of the east wall of the sanctuary makes apparent both its potential and its problems.[26] The lithograph shows the general appearance of the decoration of the wall, and the location of several figural paintings on the far left and far right. But a close zoom shows only the wavy lines of the lithograph, like a pixellated digital image. Lithography has an inherently limited resolution, and it does not help that these were executed after Mazois's death by men who had never seen the original. Fortunately, however, the original watercolors from which the lithographs were executed are preserved in the Bibliothèque nationale in Paris.[27] The original (fig. 6) shows the same view in color and with considerably more detail. In the next chapter I demonstrate the uses that can be made of enlargements of the areas showing the painted plaster.

Mazois is not the only, or even the best, architectural source for this temple. A stream of French architects who had won the Prix de Rome made their way to Pompeii, and they sent back their work as envois to the École des Beaux-Arts. Many of these presentation drawings, including several of the Temple of Apollo, were included in an important exhibition in 1981 and its subsequent publication.[28] Also notable is the British architect John Goldicutt, who visited Pompeii after studying in Paris. The archive of the Royal Institute of British Architects preserves some useful drawings under his name, some of which were executed by an unnamed Frenchman. The most interesting document for my purposes, however, is an elevation of the same east wall of the sanctuary by Félix-Emmanuel Callet (fig. 7). This was published in the catalogue of the 1981 exhibition, but the particulars of the wall painting are far too small to be legible. Close-ups of the original reveal that Callet recorded even more detail than Mazois, though he was in Pompeii a few years later, as his drawing is dated 1823. As the catalogue observes, an elevation of the same wall made by François-Wilbrod Chabrol a few decades later, in 1867, can provide nothing more than eloquent testimony to the rapid degradation of the plaster.[29]

FIGURE 6 François Mazois (French, 1783–1826), Elevation of the east wall of the portico of the Temple of Apollo in Pompeii, n.d. Watercolor original for the lithograph shown in *Les ruines de Pompéi* (1812–38), vol. 4, pl. 19 (detail). Paris, Bibliothèque nationale de france, RES GD-12 (G)-FT 4

FIGURE 7 Félix-Emmanuel Callet (French, 1791–1854), Elevation of the east wall of the portico of the Temple of Apollo in Pompeii (detail), 1823. Watercolor and ink on paper. Paris, Archive of the École nationale supérieure des Beaux-Arts, EBA 3275-003

CHAPTER 1

One objection that might be raised at this point is that these architects never intended the tiny details of their work to have such documentary value, and that they will have filled in these spaces with arbitrary brushstrokes rather than trying to represent the figural parts of the decoration accurately. Ultimately, the reliability of these architectural drawings on such small points of decorative detail cannot be proved in the general case. It is always possible that a given drawing might take liberties, and it is certainly true that some architects paid more attention than others. Scale also made a difference; some drawings allowed more scope for rendering detail. But the next chapter shows that there are some remarkable coincidences between the details of different architectural drawings and between these details and the images in Steinbüchel. More generally, it should be observed that these renderings tend to fall into two classes: (1) drawings that show an ancient monument as it was, and (2) fanciful reconstructions of how the integral monument might once have appeared. The latter class of drawings are full of pure fantasy and frequently do include spurious decorative details on a grand scale. One example was produced by Chabrol, but, as noted, there was little original plaster left in 1867 for him to work with.[30] It is true that architects sometimes mixed the two genres, showing some parts of an elevation as it was and other parts as it might be reconstructed, and I show one such rendering by Mazois at the start of chapter 3, but even there the boundary between documentary evidence and reconstruction is fairly clear.

Another architect who provides both documentary evidence and speculative reconstruction is Luigi Rossini. He is most famous for his engravings of the antiquities of the city of Rome, but he also produced a volume of engravings of Pompeii. This was published around 1831, but he probably visited the site earlier than that, as he is the only witness to document one painting from the Sanctuary of Apollo. His first engraving of the temple belongs to the most popular type, which is a slightly romantic view of the ruins, as if emerging from the landscape, with figures strolling about. This is the sort of scene depicted in nearly every picture book from the period: Gell, Mazois, Wilkins, and many, many others. Some of these give no hint of the presence of painted plaster on the portico walls; a few do give some very hazy indications, of little use for the task of reconstruction. Rossini's view is the most detailed of this genre, for it shows a partial view of the pattern of breakage in the plaster on the rear wall, though nothing of the figural paintings themselves.[31] In another engraving, he gives a restoration of what the temple might have looked like, and here the Trojan pictures are represented by identical squiggles, which are clearly not meant to have any meaning.[32] By contrast, in another engraving he records the exact state of preservation of an otherwise unattested figural painting (see fig. 65). In captions and commentary, Rossini clearly identifies the difference between images of the monument "in its current state" and "as restored." The romantic ambiance of some of his lithographs and the fanciful invention of his restorations do not undermine the reliability of his testimony elsewhere, for he keeps these carefully distinct.

The Plastico di Pompei

Visitors to the Archaeological Museum of Naples are often struck by the sprawling and minutely detailed scale model of Pompeii that occupies a very large gallery. Felice Padiglione began constructing it in 1861 on a scale of 1:100 out of cork, plaster, and paint, and the work was continued by other hands after his death in 1864 (fig. 8).[33] For the purposes of this book, the interesting thing is that it shows quite a bit of the painted decoration of the temple portico. Once again, the reproduction is on a very tiny scale, and the problem is compounded by the vast size of the model, which puts the viewer at a considerable distance. Fortunately, the temple is situated near enough to the western side of the model that the painting on the east wall of the portico is clearly visible; the orientation of the model also permits the spectator a reasonable view of most of the north wall. The south and west walls have much less painting on

FIGURE 8 Felice Padiglione (Italian, died 1864), Plastico di Pompei, 1:100 scale cork model of Pompeii, with the Temple of Apollo and the Forum in the foreground, begun 1861. National Archaeological Museum of Naples, room 96

them, and what there is can be seen only with the aid of a telephoto lens, since one must stand on one of the far-distant sides of the model. All the photographs showing details of the model (see figs. 11, 15, 32, 33, 43, 45, 49, 50, 59, and 67) were shot under less than ideal conditions, and it is to be hoped that the museum will eventually publish comprehensive images of this unique resource, taken with proper lighting and at close proximity.

Padiglione's model does not show much detail of the Trojan paintings themselves. These are represented by dark-colored squares, and it is difficult to make out any of the shadowy figures represented therein. This does not make the evidence useless, however, for what the model does document exceptionally well is the decorative scheme of the portico as a whole. In the architects' elevations, the view of the walls of the portico is constantly interrupted by other architectural elements in the foreground, such as the columns of the portico. The cork model allows the viewer to see around those obstructions, and it is particularly valuable in documenting the part of the north wall hidden behind the temple podium. As the only comprehensive view of the whole monument, it is the best evidence for the unity of the decorative scheme into which the Trojan paintings were set. It can also show what parts of the portico walls did have figural paintings that survived and this can help to assess the probabilities of where to locate the evidence available from other sources.

It is a striking feature of the model in the Naples museum that, although it is dated to the 1860s, it shows much more plaster surviving than one would expect from the state of the monument as witnessed in architectural drawings from the 1840s and after.[34] This fact is explained by the research into these models by Valentin Kockel, who has shown that the surviving 1:100 scale model of Pompeii by Felice Padiglione was based upon earlier 1:48 scale models, since lost, which were made by his father, Domenico, his predecessor as an official model maker to the Royal Museum in Naples.[35] There is documentation indicating that such a model of the Forum and Basilica area was made around 1822–26, shortly after the excavation of that area; it is probable that the existing model was based upon it. This comes closer in time to the period when the plaster was still legible, but it brings up the possibility that distortions and omissions may have been introduced in the process of copying and scaling down the model by a factor of approximately two. It is important to note that these models were made with the explicit intention of preserving information about the exact state of the site and are not contaminated by the instinct of the architect to reconstruct lost parts of the structure. As Kockel says, "Strict attention was paid to documenting the condition of the ruins of Pompeii, rather than presenting a reconstruction of them."[36]

In providing the only clear visual representation of the north, west, and south walls of the portico, the cork model also refutes the general opinion that the portico was uniformly decorated in the fourth Pompeian style after the earthquake. It is easy to see how this belief arose, for those who documented the portico were naturally

drawn to the most detailed and elaborate part of the decoration. Thus both Rochette (see fig. 5) and Mazois (see fig. 36) devoted expensive color lithographs to illustrating different panels drawn from the fourth-style decoration. But on the east wall this variety of decoration was reserved for the large pillars; the niches formed by the walls connecting the pillars were decorated in a simpler style. This might be explained away as a mere example of variety within an overall fourth-style framework, except for the testimony of the cork model. There, the three flat walls are also articulated into panels of different styles, and not always in strict alternation. In particular, the model of the north wall (see fig. 49) shows that the elaborate, illusionistic fourth-style panels were irregularly mingled with much simpler, flat panels in which the central figural painting is surrounded not by trompe-l'œil architecture but a plain white ground. The presence on the north and south walls of the cork model of second-style and fourth-style decoration side by side demonstrates the superimposition of two different chronological phases of the decoration, Augustan and Flavian, respectively.

Other Sources

In addition to the visual documentation provided by early visitors to the Temple of Apollo, there are also numerous textual accounts in early guidebooks. These usually list the Trojan paintings as one feature of the sanctuary but never describe them in great detail. The most common subjects to be identified are the quarrel between Achilles and Agamemnon, the dragging of Hector's body by Achilles, and the ransoming of Hector's body by Priam. Others are sometimes identified as the Greek embassy to Achilles, Achilles and Minerva, or the theft of the Palladium by Diomedes. These six identifications tended to be repeated in whole or in part, even as the paintings decayed. When the Niccolini brothers described the temple in 1862, they named those same six subjects but spoke of them clearly as belonging to the past.[37] None of the early guidebooks specify the precise location of any of these paintings.

Other sources provide some small hints. Pompeii was often a subject of early photography, which might have offered another witness to the location of the Trojan paintings. Unfortunately, by the middle of the nineteenth century the paintings were already decaying, and photographers were content to show a general view of the sanctuary, with the portico walls largely obscured by the colonnade that stood in front of it, just as in the romanticized engravings of the previous generation. An example is a photograph from the studio of Giacomo Brogi that shows a bit of plaster on the far wall, beyond the temple (fig. 9). This is useful confirmation of the cork model, which shows a very similar pattern of plaster decoration in this position.

The final source of evidence for the sanctuary is, of course, the site as it stands today. But this can be deceiving. From the moment of its excavation, the site has been tidied up, restored, and rebuilt. Most seriously, the temple was badly damaged by Allied air bombardments in 1943, which destroyed a large part of the west wall and

FIGURE 9 Giacomo Brogi (Italian, 1822–89), Detail of photograph of the Temple of Apollo, n.d.

the northeast corner of the portico, and the apartment adjoining the north wall.[38] The structure as it exists today is therefore the result of successive phases of reinterpretation, from the moment it was excavated through to the twentieth century. This is particularly problematic for the location of the statues, altars, and other such objects inside the portico. These were certainly tidied up somewhat, as can be seen most clearly in a plan by John Goldicutt, which shows the sanctuary as it was while still partially excavated.[39] It must be borne in mind that the objects may have been moved considerably from their findspots.

Another problem is the status of the openings in the east wall into the Forum. Many of the architects who were early witnesses assumed that this wall was intended to be complete and that the gaps between the pillars were the result of damage in the eruption. Archaeological data have tended to confirm the commonsense observation that these pillars were part of an earlier phase of building.[40] The question of whether, when the present temple portico was constructed, the gaps between the pillars were filled in completely or in part is necessarily a difficult one, but further archaeological investigation may help to clarify it. Other important archaeological investigations have also been made around this area, which is one of the oldest cult sites in Pompeii. These digs have corroborated the epigraphic evidence that this old temple received

its new portico in the Augustan period. The visual evidence indicates that some parts of the Trojan cycle date to that period, whereas other parts of the cycle are due to renovations in later decades in the aftermath of seismic activity. The Augustan date of the Trojan cycle has long been obscured by two erroneous assumptions: that the portico was built at the same time as the pre-Augustan temple, and that the entirety of the portico was decorated in the post-Augustan fourth Pompeian style.

NOTES

1. Wilkins 1819, 17.
2. On the decision not to remove the plaster, see the discussion by Bragantini in *PPM Disegnatori* 112.
3. The second edition of *Pompeiana* was effectively an entirely new book and does not contain the material on the Temple of Apollo discussed here.
4. Letter to William Richard Hamilton, secretary to the Society of Dilettanti, Derbyshire County Records Office, Matlock: D3287/3/2.
5. For the inscription, see below, chapter 4.
6. John Peter was the less talented but far more successful brother of the great architectural draughtsman Joseph Michael Gandy, who is best known for his collaborations with Sir John Soane.
7. For example, in a letter of 1815 or 1816, Gandy speaks gleefully about the growing list of subscriptions to their project: "So you will become very rich as well as myself." This fascinating collection of letters, from which the quotations below are taken, is part of the papers of Keppel Craven, Gell's companion (BL MSS Add. 63617).
8. On this painting (fig. 48), see García y García 2006, 110–12.
9. These are preserved with the Gell family papers in the Derbyshire Record Office in Matlock. Particularly useful are the volume of letters written in this period to his brother (D258/50) and the whimsical letters from Princess Caroline to Gell (D3287/4).
10. See Wallace-Hadrill 2006.
11. A. Bernhard-Walcher in *Österreichisches Biographisches Lexikon,* s.v. "Steinbüchel," vol. 13, fasc. 60, p. 163.
12. Steinbüchel 1833.
13. For bibliography, see *LIMC,* s.v. "Achilleus," 428, 436, 465, 672 [Kossatz-Deissmann].
14. S. Kehl-Baiere in *Österreichisches Biographisches Lexikon,* s.v. "Schindler," vol. 10, fasc. 47, p. 144.
15. "Sämmtlich nach Originalzeichnungen an Ort und Stelle." The engravings of the terracotta tiles used on the west wall of the temple portico are likewise emphasized as original: "Nach Originalzeichnung" (Steinbüchel 1833, vol. 7, pl. 42, figs. 1a, 1b).
16. These images are published and discussed in *PPM Disegnatori,* 112–44 [Bragantini]; they are also reproduced in Baldassarre 1981, 138.
17. *PPM Disegnatori,* 112: "Le tavole riprodotte nell'Atlas di Steinbüchel infatti sono così vicine, non solo iconograficamente, ma anche 'stilisticamente' a queste, da far pensare che ne siano una copia."
18. "Bei dem einen Gemälde (8.B.2) sind keine Farben angegeben, weil sie schon zu sehr verwittert und nur mehr die Umrisse der Figuren kenntlich sind" (Steinbüchel 1833).
19. *PPM Disegnatori,* 115, fig. 57.
20. Fiorelli 1860–64, 1:211–12 (Aug. 12, 1818).
21. Rochette had also been in Pompeii earlier (1826–27): Mascoli 1981, 294.
22. Fiorelli 1860–64, 1:211-12 (Aug. 12, 1818).
23. This element does not derive from Mazois, who shows a similar tableau but without a central figural painting (see fig. 36); there are enough small differences in the illusionistic architecture and large differences in the coloring to conclude that the two men were showing different sections of the wall.
24. On Mazois and Pompeii, see Mascoli 1981, 31–37, and Bouquillard 2000, 28–31.

25 Mascoli 1981, 291.
26 Mazois 1812–38, vol. 4, pl. 19.
27 Some of Mazois's watercolors have been published in Bouquillard 2000, 34–48.
28 Mascoli 1981.
29 See Mascoli 1981, pls. 18, 19, with commentary.
30 See Mascoli 1981, pl. 16.
31 Rossini ca. 1831, pl. 43.
32 Rossini ca. 1831, pl. 44.
33 On these models, see Kockel 1993.
34 Compare *PPM Disegnatori*, 801, fig. 29a (Veneri, 1843), and Mascoli 1981, pls. 18 and 19 (Chabrol, 1867).
35 Kockel 2004, 144–49.
36 Kockel 2004, 147.
37 Niccolini and Niccolini 1854–96, 2:51.
38 See García y García 2006, 110–12.
39 See Salmon 2000, 83, fig. 58.
40 See Dobbins et al. 1998, 755.

Chapter 2

The Temple's East Wall

THE NATURAL PLACE TO BEGIN A DISCUSSION of the painted decoration of the Pompeian portico is the east wall (fig. 10), where Steinbüchel indicates that most of the Trojan pictures were found.[1] This wall was the most visually striking and architecturally complex part of the perimeter, incorporating a series of massive pillars that once must have belonged to a monumental entrance into the Forum. At a later point, the wall was created when most of the pillars were connected along their external side. In this way, the pillars were incorporated as piers into the interior, creating a series of niches between them. Another distinctive feature of this wall is the way the size of the pillars increases from south to north, so that the niches grow progressively deeper. This is a result of the divergence of the axis of the temple from that of the Forum, which it predates.[2] The final pillar is a false one: it looks as solid as the others from the inside, but it is hollow on the Forum side and provided a place to keep the *mensa ponderaria* (weights and measures table) for the official units of measure.

Over the course of the next three chapters and in the key to the plan of the Temple of Apollo (see fig. 10), I use the terms *pillar style* and *niche style* to describe the decorative painted plaster within which the Trojan paintings were set. The pillar style is an exuberantly three-dimensional, fourth-style scheme in which the Trojan painting is illusionistically suspended from above by a ribbon and supported from below. On both sides is an elaborate architectural setting with a female figure, possibly a Muse, holding an instrument. The bottom register consists of a yellow base with a black inset panel. This pillar-style decoration comes in two color schemes. The blue scheme is shown by the cork model to belong to the north wall (see chapter 3). The red scheme is shown on the pillars of the east wall by both the cork model and the architectural elevations. The red version of the pillar-style scheme comes in two further variants. Usually, the Trojan painting is supported by a horizontal lintel, beneath which a passageway leads to a sacral landscape beyond (see fig. 5). On some pillars of the east wall, however, the Trojan painting rests upon a candelabrum.

The niche style, by contrast, is much less elaborate. The bottom register is dark red and usually has a single figure at the center. Above that is a long, low, horizontal panel with architectural landscapes and pygmies. Above that is a very large, thick, red frame surrounding a white field. The Trojan painting simply floats in the middle of

FIGURE 10 Plan of the Temple of Apollo. Adapted from François Mazois, *Les ruines de Pompéi* (1812–38), vol. 4, pl. 17

STATUARY

A Marble statue of Venus on base with effaced Mummius inscription
B Marble Hermaphroditus
C Bronze bust of Diana the Archer
D Bronze statue of Apollo the Archer
E Marble Herm?
F Marble Herm

WALL PAINTING

1. Shallow niche: Calchas addresses Achilles; ornate niche style. See figs. 11, 12, 13, and 23.
2. Narrow pillar with a tripod; no figural painting; pillar style modified because of lack of width. See figs. 11 and 14.
3. Shallow niche: Achilles quarrels with Agamemnon; ornate niche style. See figs. 11, 16, 17, 18, and 19.
4. Pillar; no plaster surviving.
5. Niche; only bottom register of niche-style decoration survived. See figs. 6 and 43.
6. Pillar; no plaster surviving.
7. Niche; only bottom register of niche-style decoration survived. See figs. 43 and 44 (right side). Fig. 6 shows the wall blank here, which must be an oversight.
8. Pillar with pillar-style decoration in the narrow variant (in which the figural painting is supported by a thin candelabrum rather than a mantel with a landscape beneath); here the plaster is broken off below the point where the figural painting would have been. See figs. 6 and 44 (left side).
9. Niche; only bottom register of niche-style decoration survived. See fig. 43 (leftmost niche).
10. Pillar with candelabrum variant of pillar-style decoration; surviving plaster ended just above the bottom of the figural composition atop the central candelabrum. See figs. 42 and 43 (far left).
11. No wall; possibly left open as an entrance into the Forum.
12. Pillar with candelabrum variant of pillar-style decoration; diagonal break across figural composition: Menelaus and Machaon? See figs. 33 (center) and 37.
13. No wall; possibly left open as an entrance into the Forum.
14. Only the bottom register of pillar-style decoration is attested, showing black panel on yellow background. See fig. 32 (far right).
15. No wall; possibly left open as an entrance into the Forum.
16. Pillar-style decoration, probably candelabrum variant; what appears to be raw, unpainted plaster inside the frame where the figural decoration ought to be. See figs. 32 (center) and 35; compare fig. 36, though it has the landscape variant of the pillar style; intended site for a remounted painting of Diomedes and Athena?
17. No wall; possibly left open as an entrance to the Forum. See figs. 7 and 32.
18. Hollow pillar with *mensa ponderaria* within on the Forum side; pillar-style decoration, variant with landscape view; the figural composition shows Diomedes wounding Aphrodite. See figs. 3, 5, 27, 28, 29, and 32.
19. Niche with a doorway into the Forum.
20. Half panel with a half-destroyed small figural painting on a plain background. See fig. 15.
21. Half panel with illusionistic decoration with some similarities to the pillar style, but apparently without a figural centerpiece.
22. Panel with some similarities to the candelabrum variant of the pillar style, but uncertain if it held a figural painting. See fig. 15.
23. Plain niche-style panel. See fig. 49.
24. Blue variant of the pillar style. See figs. 36 and 49.
25. Plain niche-style panel, apparently largely intact. Possible location for the painting of the dragging of Hector's body. See figs. 49 and 54.
26. Plain niche-style panel. See fig. 49.
27. Blue variant of the pillar style. See figs. 36 and 49. Probably blank, though the space for the figural composition on the cork model seems to show a shadowy figure on the left (Hermes or Priam?). See fig. 45.
28. Plain niche-style panel. Most probable location for the painting of the supplication of Achilles by Priam. See figs. 49 and 55.
29. Probably plain niche-style panel (burial of Hector?). See fig. 50.
30. A small piece of terracotta embedded in plaster, perhaps a remnant of the *tegulae mammatae* on the west wall. See fig. 64.
31. Vestiges of a pillar-style panel. See fig. 59.
32. Vestiges of a niche-style panel. See fig. 59.
33. Vestiges of a pillar-style panel. See fig. 59.
34. Vestiges of a niche-style panel. See fig. 59.
35. Vestiges of a pillar-style panel. See fig. 59.
36. Niche-style panel. Probable location of painting of the handing over of the young Aeneas to Anchises. See figs. 66 and 67.
37. Vestiges of a plain niche-style panel. See fig. 67.
38. Plain niche-style panel. See figs. 11 and 67.

FIGURE 11 Detail of the Plastico di Pompei (fig. 8), showing the southeast corner of the Sanctuary of Apollo

that white area without any illusionistic support. This niche style also comes in two variants. On the east wall, the top of the large red frame is flanked by a glimpse of illusionistic architecture. This element may be enough to indicate a fourth-style date. By contrast, the north and south walls are entirely decorated, with the exception of a few scattered, blue-tinted, pillar-style panels, with an even simpler version of the niche style. The illusionistic architecture flanking the large red frame is absent in this plainer version of the niche style, which contains nothing at all to indicate a fourth-style date.

The east wall of the portico, then, presented the appearance of a series of alternating piers and niches. The design of the painted decoration took its cue from this physical articulation. In the niches there was a very flat, restrained design, which contrasted with a three-dimensional and exuberant scheme on the inwardly projecting piers. The dominant effect in the niches was of large, flat panels of color with delicate ornament and a very limited use of perspective, whereas the piers took advantage of the way they were thrust into the interior by presenting a fully illusionistic impression of delicate architecture existing in three-dimensional space. The flatness of the niche-style decoration can be seen on the southeast corner of the cork model (fig. 11). On the left side of the image are the first two niches of the east wall, separated by a thin, shallow pillar (see fig. 10, nos. 1–3); the right side of the image shows a similar frame on the south wall (see fig. 10, no. 38). Each niche has a figural composition, or *pinax*, at the center, all of which in this view have already been destroyed; fortunately there is other evidence for these. Each of these figural panels is centered on a large white field surrounded by a thick red frame. This red frame rests upon a low, wide mantel, below which there is a bottom register in dark burgundy consisting of three

FIGURE 12 Detail of fig. 7, showing the rightmost niche on Callet's elevation of the east wall

FIGURE 13 Detail of fig. 6, showing the rightmost niche on Mazois's elevation of the east wall

FIGURE 14 Detail of fig. 6, showing the rightmost column on Mazois's elevation of the east wall

panels with a figure at the center. To corroborate this evidence, compare the views of the first niche on the east wall given by Callet and Mazois (figs. 12, 13). These differ slightly in the intensity of the color but are in good general agreement on the details of the overall scheme. They also give a better view of the decoration along the sides of the large red frame. This makes moderate use of trompe-l'œil architecture in the upper part on the level of the figural tableau. But the general impression is of flatness and restraint, with the figural *pinax* floating in the middle of a very large white field.

The decoration of the piers, on the other hand, is exuberantly three-dimensional and celebrates its own fictiveness. A small example of this can be seen on the narrow pillar that separates the first two niches on the east wall (see the pillar on the left of fig. 11; fig. 10, no. 2). The cork model preserves enough to show that here was painted a perspective view of a tall, thin object, perhaps a tripod, standing in white space; Mazois gives a partial view of it, lurking behind the first pillar (fig. 14). This pillar was the narrowest of the series: it did not leave much scope for decoration and was not wide enough to accommodate a figural composition of its own. It is therefore unrepresentative of the other pillars except insofar as it has a similar style and color scheme. Rochette's color lithograph (see fig. 5) provides a sense of what the pillar style of decoration looked like in its full elaboration (it is the rightmost pillar in fig. 15). As noted in the preceding chapter, there are some issues with the reliability of the central image, but it is a reasonable overall view of what the larger pillars looked like. In the fully elaborated pillar-style scheme the figural composition is embedded in a much more elaborate design. The "painting" is, as Rochette shows, in an illusionistic frame, apparently suspended from a faux ribbon attached to the wall high above and resting upon a mantel, beneath which there is a view into a distant landscape with an altar and a figure, perhaps a Priapus. This central part of the pillar is surrounded by a very

FIGURE 15 Detail of the Plastico di Pompei (see fig. 8), showing the northeast corner of the Sanctuary of Apollo

elaborate architectural setting in which women, possibly Muses, are in attendance on either side. All this rests upon a light-yellow base in which a long black rectangle is set. Sometimes this black insert is rectangular, but sometimes its top rises slightly to a point at the middle; sometimes it is decorated, sometimes not.

Regardless of whether direct access to the Forum was maintained through the east wall, the principal entrance to the compound is in the middle of the south wall where it opens onto the via Marina. This entrance lies on the axis of the temple, facing the steps up the podium and the entrance to the cella. Upon entering the sanctuary here, one sees the temple straight ahead with Vesuvius rising behind it. Standing in the portico, turning to the right, the visitor sees the southern end of the east wall. There are two good reasons to start here. First, this corner of the portico can be reconstructed with particular confidence, leading to a working methodology that can then be applied to the other parts of the sanctuary, where the evidence offers less in the way of independent sources of confirmation. Second, it becomes evident that the painters themselves took this as an important corner, beginning the narrative of the *Iliad* here.

Achilles and Agamemnon
I begin not with the very first niche on the east wall, but with the second, thus taking the first two Trojan paintings in reverse order. I choose this order because of the plan of the temple in William Gell's sketchbook and its annotations for the paintings at the southern end of the east wall (see fig. 2). The southernmost annotation says unhelpfully "picture of...." Apparently, Gell could not decide what this image represented; and little wonder: early visitors and later scholars have continued to be divided on this question. So I leave this painting aside for the moment and start instead with the niche immediately to the north (see fig. 10, no. 3), which Gell identifies positively. His caption reads, "picture of Achilles Agamemnon Minerva." This corresponds to the sketch in that same notebook labeled "Agamemnon & Achilles" (folio 70). The reverse of the sketch reads, "This is the picture of Achilles quarreling with Agamemnon in the temple once called the house of the dwarfs. It is almost ruined but this is what can be made of it. Don't lose it and if engraved do it smaller and rectify the feet where I could not distinguish."

This composition is also shown by Steinbüchel (fig. 16), whose engraving limns the entirety of a composition that reappears in fragmentary form in smaller Trojan cycles from several other locations in Pompeii—the Houses of the Tragic Poet, the Dioscuri, and Apollo—which are discussed in chapter 4. The identification of the scene is clear by the way Athena/Minerva on the far right, distinctive in her helmet, holds back a warrior as he menacingly approaches the seated figure, drawing his sword out of his scabbard. It can only be the famous scene from the first book of the *Iliad* in which Athena stops the furious Achilles from killing Agamemnon.

To review the plot briefly, Achilles has summoned the Greek army to assembly to discuss the cause of the plague that has afflicted them, and Calchas explains that

FIGURE 16 Engraving of an image from the Temple of Apollo in Pompeii. From Anton Steinbüchel, *Grosser antiquarischer Atlas* (1833), vol. 8, pl. B1

FIGURE 17 Detail of fig. 6, showing the second niche from the right on Mazois's elevation of the east wall

Apollo has been angered by Agamemnon's refusal to accept a ransom from the priest Chryses for the return of his daughter. Agamemnon angrily announces that he will compensate himself by taking a prize from another warrior; he trades bitter insults with Achilles and declares that he will take Achilles's prize, the slave girl Briseis. At this, Achilles is on the point of violence (*Il.* 1.188–200):

> Ὣς φάτο· Πηλεΐωνι δ' ἄχος γένετ', ἐν δέ οἱ ἦτορ
> στήθεσσιν λασίοισι διάνδιχα μερμήριξεν,
> ἢ ὅ γε φάσγανον ὀξὺ ἐρυσσάμενος παρὰ μηροῦ
> τοὺς μὲν ἀναστήσειεν, ὃ δ' Ἀτρεΐδην ἐναρίζοι,
> ἦε χόλον παύσειεν ἐρητύσειέ τε θυμόν.
> ἦος ὃ ταῦθ' ὥρμαινε κατὰ φρένα καὶ κατὰ θυμόν,
> ἕλκετο δ' ἐκ κολεοῖο μέγα ξίφος, ἦλθε δ' Ἀθήνη
> οὐρανόθεν· πρὸ γὰρ ἧκε θεὰ λευκώλενος Ἥρη,
> ἄμφω ὁμῶς θυμῷ φιλέουσά τε κηδομένη τε.
> στῆ δ' ὄπιθεν, ξανθῆς δὲ κόμης ἕλε Πηλεΐωνα
> οἴῳ φαινομένη· τῶν δ' ἄλλων οὔ τις ὁρᾶτο·
> θάμβησεν δ' Ἀχιλεύς, μετὰ δ' ἐτράπετ', αὐτίκα δ' ἔγνω
> Παλλάδ' Ἀθηναίην·

(So he spoke and grief came upon the son of Peleus, and within his shaggy breast his heart was divided in counsel, whether he should draw his sharp sword from his side and break up the assembly, and kill the son of Atreus, or whether he should check his wrath and curb his spirit. While he pondered this in his mind and heart, and was drawing his great sword from its sheath, Athena came to him from heaven, sent by the goddess, white-armed Hera, for in her heart she loved them both alike and cared for them. She stood behind him, and caught the son of Peleus by his tawny hair, allowing herself to be seen by him alone, and no one else saw her. And Achilles was struck with wonder, and turned round, and at once recognized Pallas Athena.)

Gell's attestation of the precise location of this painting can be confirmed from examining the other visual sources. This agreement helps to validate the methodology I have developed for examining the visual evidence, for here, uniquely, there is independent and unambiguous confirmation of what was actually there. I can then move on to discuss with greater confidence other parts of the wall where Gell's notebook is not able to help.

The most important witnesses to the appearance of the Trojan paintings in situ on the east wall are the elevations produced by Mazois and Callet (see figs. 6, 7). A blow-up of the part of Mazois's original watercolor elevation of the east wall that ought to show the second niche yields disappointing results (fig. 17). A column blocks

FIGURE 18 Detail of fig. 7, showing the second niche from the right on Callet's elevation of the east wall

the view of the central vignette, although there is some good evidence for the painted plaster that surrounded it, which is clearly niche style. Mazois displays some awkwardness in the draftsmanship: the wall panel fails to protrude as it should from behind the right side of the column and it seems much too narrow to contain a figural composition. When Mazois's elevation is compared with Callet's, which does not put the column in this position, the reason for this awkwardness becomes apparent. An elevation is an orthographic projection, where the wall is supposed to be shown as if viewed from directly in front at every point simultaneously. The tension between this requirement and the fact that in practice an observer will sketch the wall from a finite and limited selection of viewpoints is what gives rise to the different treatment of the problem of parallax in Mazois's representation when compared with the supposedly identical view given by Callet.

In an enlargement of Callet's elevation for this part of the wall (fig. 18), the column is happily no longer in the way and the figural painting is given its proper, full

FIGURE 19 Detail of fig. 18 (and further detail of fig. 7), showing the figural painting at the center of the second niche from the right on Callet's elevation of the east wall

width. As for the elements of pseudoarchitectural painting the two elevations have in common, apart from the intensity of the colors they are in remarkable agreement. Callet shows more detail, but they are clearly showing the same wall. In some cases, Callet can explain particulars that are obscure in the Mazois; for example, Callet reveals the faint scribble in the white field below the figural frame to be a garland. What is really interesting, though, is the figural centerpiece. Figures are clearly discernible in the place where Gell's plan puts the painting of the quarrel of Achilles and Agamemnon. Can the outlines of that composition be discerned in Callet's shadowy figures?

An enlargement that isolates the central painting (fig. 19) allows a comparison with Steinbüchel's drawing (see fig. 16) of the painting that Gell's plan says was there. Although the details may at first glance appear hopelessly obscure, several items emerge for which the match is excellent when one bears in mind how little space Callet was working with. One can clearly see on the right of Callet's representation the figure of Achilles, who is reaching across his body with his right hand to pull his

sword out of its scabbard, which is marked by a dark line that runs down and to the right from his left hip. Achilles's stance is unmistakable; his legs are clearly visible and they are just as in the sketch: he stands with his right leg forward and bent at the knee and his left leg straight back. There is a red mass behind Achilles, which corresponds to the cloak he has over his left arm.[3] Not much can be made of Athena, but there is certainly a shadowy figure behind Achilles on the far right where she should be. On the far left side of the image, right where Agamemnon should be seated, Callet has shown the outlines of a throne very clearly. There is an indistinct figure seated on it who has a red cloak on his lap and seems to be wearing some sort of headgear. Standing behind Agamemnon, between him and Achilles, is a figure with another long red cloak, who corresponds to the figure in the middle of Steinbüchel's drawing. Callet does not give much attention to the other soldiers lurking in the background, but that is understandable.

The identifications of Achilles drawing his sword, Athena restraining him, and Agamemnon on his throne are self-evident; but what of the standing figure between Achilles and Agamemnon? Even apart from the details of Homer's account of this scene, a very precise visual parallel can provide the answer. In 1894, Brüning wrote an important article in which he noted some close similarities between Steinbüchel's drawings and the Trojan scenes represented on the so-called Iliadic tablets, or *tabulae Iliacae*.[4] These enigmatic tablets, which juxtapose engraved text and tiny sculpted reliefs, narrate a variety of subjects, most but not all of them from Homer. The iconography of all the paintings in the portico is closely related to that on the tablets, providing an important clue to their common source. The largest and best known is the Capitoline tablet, whose visual treatment of the quarrel of Achilles and Agamemnon is, as Brüning noted, very similar.[5] Otto Jahn's drawing of the relief (fig. 20) shows the four main figures in the same configuration and the same poses, with a crowd of soldiers in the background. All are labeled: from the right of the figure are the names of Athena, Achilles, and Agamemnon; squeezed in below Agamemnon's name is the identification of the intermediate figure: Nestor. This corresponds to Homer very well, for after Athena stays Achilles's arm he delivers a stinging diatribe to Agamemnon; at this point Nestor intervenes in a vain effort to make peace.

On the Capitoline relief, Achilles's legs are in the same distinctive posture as he reaches across his body for his sword; and Agamemnon is seated in the same orientation. It is harder to make out the details of Athena, but she does seem to be reaching out to put her right hand on Achilles's shoulder, as in Steinbüchel's drawing. Nestor appears to be bent over a bit in Jahn's interpretation of the relief: perhaps stooped with age, left hand on a walking stick, or perhaps rising from his chair to speak. This is the only aspect of the composition that is not perfectly reflected in the Pompeian monument, but the artist of Steinbüchel's drawing, probably Morelli, seems to have hesitated over whether Nestor's face should be turned to Agamemnon or to the

ΟΙΜΟΣ ΚΑΛΧΑΣ ΑΓΓΑΜΕΜΝΩΝ ΑΧΙΛΛΕΥΣ ΑΘΗΝΑ
 ΝΕΣΤΩΡ

FIGURE 20 Detail of a drawing of the center of the top row of the *tabula Iliaca Capitolina*. From Otto Jahn and Adolf Michaelis, *Griechische Bilderchroniken* (1873), pl. 1

viewer. Furthermore, his lower body is much less explicitly drawn than those of the other characters. As these drawings elide the distinctions between the well-preserved and conjectural parts of Morelli's originals, it is easy to imagine that the figure of Nestor, especially his lower body, derives from Morelli's hypothetical reconstruction. The iconographic link between this scene on the Capitoline tablet and the Morelli paintings cannot be doubted; it proves crucial for identifying the topic of the painting in the adjacent niche.

Calchas and Achilles

It was Gell's identification of the subject of the painting in the second niche of the east wall that caused me to start my reconstruction of the portico of Apollo there. Gell's plan also shows an abortive effort to identify the painting in the first niche (see fig. 10, no. 1). As I note earlier, his legend reads "picture of ..." (see fig. 2), implying that there was no obvious answer. Fortunately, in this case both Callet and Mazois show the niche, with no columns in the way. As before, Callet gives more detail, as can be seen from an enlargement of this area of his elevation (see fig. 12). The pseudo-architectural painting within this niche is similar in style to the adjacent one, with the figural painting suspended on a light-colored ground surrounded by a thick, dark border. This is confirmed by Mazois's view of the same niche, similarly enlarged (see fig. 13). Again, the motifs surrounding the central image are roughly the same, though the colors are a bit different and Mazois tends to simplify somewhat.

At first sight, the details of the figural composition at the center of the niche seem completely unintelligible. But further enlargements of the details of the eleva-

FIGURE 21 Detail of fig. 12 (and further detail of fig. 7), showing the figural painting at the center of the rightmost niche on Callet's elevation of the east wall

FIGURE 22 Detail of fig. 13 (and further detail of fig. 6), showing the figural painting at the center of the rightmost niche on Mazois's elevation of the east wall

FIGURE 23 Engraving of an image from the Temple of Apollo in Pompeii. From Anton Steinbüchel, *Grosser antiquarischer Atlas* (1833), vol. 8, pl. C1

tions of Callet (fig. 21) and Mazois (fig. 22) show that they have one very distinctive detail in common. They both show a large circular object in the bottom right corner. As it happens, one of Steinbüchel's drawings has this same feature. His sketch (fig. 23) shows a standing figure gesturing to the left while addressing a seated figure on the right. Whatever that soldier is sitting on is hidden from view by his shield, which occupies the bottom right of the painting. The two architects clearly show that shield, and they also offer some other corroborating details. Mazois's simpler design has two main figures, both dressed in cloaks that stand out against the light background. The one on the left is standing and the one on the right is seated. The drapery of the cloak on the seated figure is very like Steinbüchel's, which runs up from the knees to the shoulder, where a gap shows the soldier's left arm emerging, and the arm hangs down with the hand resting on the shield. Mazois's standing figure likewise has a knee-length cloak, but the dramatic gesture to his right cannot be discerned. In fact, Mazois shows that the plaster broke off just above the torso of the standing figure. The figure's left hand seems to hold a staff that runs from his foot upward, slanting slightly to the right. This corresponds exactly to Steinbüchel's drawing, where,

CHAPTER 2 **65**

despite some awkwardness in the draftsmanship, it is clear that someone is indeed holding a spearlike object in that position.

Callet's painting is much busier and harder to read; he seems to have made an effort to indicate not only the two main figures but also the other soldiers in the background. One can just about make out the outlines of the bent legs of the seated figure and the presence of a standing figure in the center. Callet shows an apparently complete figural painting, even though the elevation of Mazois shows that the plaster had broken away at the top several years earlier. So the treatment by Callet must have entailed some speculative reconstruction.[6] This would explain why he does not show the standing figure gesturing to the left; if anything, he may be gesturing to the right. Steinbüchel apparently shows the whole painting, but I have already indicated that his images incorporate some speculative reconstructions. It seems likely, therefore, that the top part of the painting was missing or poorly legible along with most of the standing figure's gesturing arm, just as Mazois attests. There must have been nevertheless enough there for Steinbüchel's artist, probably Morelli, to reconstruct the gesture.

Steinbüchel identifies this gesturing figure as Nestor. It is not an implausible guess. The standing figure is clearly haranguing the others, and Nestor certainly does a lot of talking in the *Iliad*. Nestor does appear in the adjacent scene (see fig. 20), where he is about to intervene between Achilles and Agamemnon; Steinbüchel suggests that this is the subsequent moment, when Nestor stands up and urges reconciliation.[7] That identification would imply, wrongly as it turns out, that the narrative on the east wall of the portico ran from left to right. Other scholars, not knowing as Steinbüchel did the close connection between the scene of the quarrel and the first book of the *Iliad*, have suggested other identifications, such as Phoenix addressing Achilles as part of the embassy in the ninth book.[8]

Fortunately, another piece of evidence can solve the puzzle. Once again, it is the same scene from the Capitoline tablet (*tabula Iliaca Capitolina*) that comes to the rescue: its representation of the quarrel of Achilles and Agamemnon (see fig. 20). Just to the left of the seated Agamemnon is a standing figure, labeled as Calchas. He gestures to the right and stands in the same posture as Steinbüchel's figure. On the basis of this similarity of pose, Brüning argued that Steinbüchel's drawing shows Calchas; Brüning did not know that in Pompeii the paintings were adjacent, a consideration that makes his identification a near certainty. The main difference is that, in the temple, Calchas is on the right of the quarrel rather than the left, so the narrative reads in that direction: right to left. This suggests that the paintings were carefully arranged to have the *Iliad* begin with Calchas at the start of the long east wall.

It seems likely that this particular retelling of the *Iliad* begins with Calchas. The embassy of Chryses to the Greeks and the sending of the plague are both omitted. This selectivity is typical of the portico, which was not large enough to narrate the whole story of the epic and so selected a few crucial episodes. The gesture of Calchas

is supposed to allude to the events that have gone before; on the Capitoline tablet he is gesturing at Apollo to explain the reasons for the god's anger. He addresses Achilles, a reminder that it was Achilles who summoned the assembly (1.53–54), commanded Calchas to speak, and guaranteed his freedom to tell the truth without fear of repercussions from the powerful (1.85–91).[9] The painter then skips over Agamemnon's reply and the exchange of insults between him and Achilles and goes straight to the next dynamic, visual moment: after Calchas finishes his speech and sits down (1.101), there is no movement described until Achilles half unsheathes his sword (1.194).

The close links between the first two paintings on the east wall and between them and the text of Homer is evident in the way they represent one particular attribute. At the assembly of the Greeks summoned by Achilles, several references are made to the staff or scepter that was held by the person speaking as an indication that he had the floor: this culminates in the moment at the end of the assembly when Achilles swears a vehement oath by it (1.234–39). This scepter must be the long, spear-like object Calchas is holding in his left hand. Its top is not visible, but at the bottom there is an ornament that seems out of place on a spear, and indeed the shaft held by Achilles has no such decoration. In the next image, Agamemnon holds a shaft that seems to have the same item on the top and bottom. Homer does not explicitly say that either Calchas or Agamemnon was holding the scepter when they were speaking at these precise points, but the artist has extrapolated from the scepter's use elsewhere in the assembly in order to emphasize the shift in speaker from one painting to the next. The continuity highlights the very different reaction of Achilles to the two speeches as reflected in the stark variation in his posture on the right of each painting. Listening to Calchas describe the cause of the plague, he reclines, confident and at ease; listening to Agamemnon say that he intends to compensate himself by taking Briseis, he leaps up, ready to strike. Achilles's shift from sitting to standing is emphasized by the way the sitting Achilles is juxtaposed with the standing Calchas, whereas the standing Achilles confronts a seated Agamemnon. The double transition from sitting to standing and vice versa amid the continuity established by juxtaposing Achilles and a figure holding a staff creates a strongly dynamic narrative.[10]

Apollo the Archer

One consequence of inverting the direction in which the visual narrative is read compared with the version on the Iliadic tablet is that Calchas no longer appears to be pointing at anything in particular. On the tablet, he is clearly gesturing to the prior scene to the left, which is labeled "plague" (ΛΟΙΜΟΣ; see fig. 20). Calchas is telling Achilles and the rest of the Greeks that Apollo has sent the plague in retribution for the dishonor they have shown to his priest. Homer represents this plague as arrows from Apollo (1.48–52):

FIGURE 24 Detail of a reconstruction of the center of the top row of the *tabula Iliaca Capitolina*. From Otto Jahn and Adolf Michaelis, *Griechische Bilderchroniken* (1873), pl. 1

ἕζετ' ἔπειτ' ἀπάνευθε νεῶν, μετὰ δ' ἰὸν ἕηκε
δεινὴ δὲ κλαγγὴ γένετ' ἀργυρέοιο βιοῖο
οὐρῆας μὲν πρῶτον ἐπῴχετο καὶ κύνας ἀργούς,
αὐτὰρ ἔπειτ' αὐτοῖσι βέλος ἐχεπευκὲς ἐφιεὶς
βάλλ' αἰεὶ δὲ πυραὶ νεκύων καίοντο θαμειαί.

(Then he [Apollo] sat down apart from the ships and let fly an arrow: terrible was the twang of the silver bow. The mules he assailed first and the swift dogs, but then on the men themselves he let fly his stinging shafts, and struck; and constantly the pyres of the dead burned thick.)

The plague scene in the *tabula Iliaca Capitolina* shows a dog dying and a man in distress. It seems inevitable that it must also have shown Apollo the archer, but that cannot be discerned clearly in the drawing. Jahn's reconstruction, however, does confidently include the god drawing his bow and it is at him that Calchas is gesturing, naturally enough (fig. 24). Apollo sending the plague against the Greek army by means of his arrows figures in two other Iliadic cycles in Pompeii.[11]

In the reconstruction of the Pompeian portico, however, Calchas seems to be pointing in the wrong direction, to the north, off into the future of the story, which makes little visual sense. At first glance this might seem the result of a careless adaptation of the original to its new context, but perhaps there is something else going on here. As it happens, there was indeed a representation of Apollo the fearsome archer

FIGURE 25 Modern replica of the statue of Apollo Saettante in situ, with the first (Calchas) niche of the east wall in view behind it. Bronze, 147 × 55 × 114 cm

FIGURE 26 Detail of fig. 10, showing the relative positioning of the painting with Calchas and the statue of Apollo Saettante

CHAPTER 2

near the portico of his temple; but it was not in a painting. In this part of the sanctuary there was a bronze sculpture of the god, known today as the Apollo Saettante, or Apollo the Archer. Today there is a replica of the original, on top of its ancient base, standing in front of the third column on the eastern side of the portico (fig. 25; see fig. 10, *D*). The result of this juxtaposition is that Calchas in the painting will have been gesturing, more or less, at the statue of Apollo (fig. 26). The photograph of the statue (see fig. 25) shows in the background the niche on which Calchas was painted and demonstrates the clear line of sight from one to the other. This interplay between the different elements in the temple's decor shows an impressive level of wit, and this kind of multimedia coordination suggests that the decorative program of the monument was very carefully thought out. It also indicates that the scenes from the *Iliad* represented here were not chosen at random. There is a density of emphasis on Book 1 that could not have been sustained for the subsequent twenty-three books. The first book may have been particularly familiar, but it also seems likely that this emphasis was due, in part, to the important role played by Apollo, god of the temple, in this part of the narrative.[12]

This is not to say that the original purpose of the bronze statue of Apollo Saettante was to play a role in the plot of the *Iliad* as articulated by the wall paintings. It may well have been an earlier dedication, predating the existing walls (the date of the statue is not clear), which was only later moved into this position, directly across the sanctuary from the matching statue of Artemis, also drawing her bow. The statues of Apollo and his sister are clearly in close dialogue, and they have often been taken to allude to their joint punishment of Niobe, killing her children for having boasted of being greater than their mother, Leto. It is not necessary to view these as mutually exclusive alternatives. It may be that the phase of decoration introducing the Trojan pictures to the sanctuary incorporated the statue of Apollo as a preexisting element of its design. Or the statues may have been introduced to the sanctuary at the same time as the paintings. Or perhaps the statue was installed during a subsequent phase of renovations to accord with the gesture of Calchas.

Since this part of the argument depends on the precise location of the statue of Apollo the Archer, it is important to note that the statue was not found in situ; it was reassembled from pieces found in scattered locations around Pompeii. Nevertheless, there are grounds to be reasonably confident that the statue has been situated more or less correctly. First, the statue of Artemis was found in the sanctuary. The statue of Apollo is clearly its partner: the heads of the two are identical, apparently cast from the same mold. Second, the distance between the attachments under the feet of the statue was a precise match for the mounting hardware on the pedestal that was found (more or less) in situ.[13] This is not to say that the positioning of Apollo and Artemis, each standing on a pedestal on the step in front of the third column of the east and west side of the portico respectively, did not undergo a bit of tidying up.[14]

Most early plans, including Mazois's, show the pedestals in their present position, but the plan that may claim to be the earliest tells a slightly different story. In *Building on Ruins*, Salmon reproduces a series of early plans of the Forum area; it is instructive to compare them. The first, by John Goldicutt, indicates with a green wash those areas that are incompletely excavated, including most of the Temple of Apollo.[15] What is curious is that at the southwest corner there are two dotted circles appearing among the columns. None of the subsequent plans show anything in these precise positions. Instead, there is a collection of altars and statues in the southwestern corner, all positioned very neatly: Artemis in front of the third column of the west side and a marble statue of Venus in front of the second column of the south side. One suspects that the circle almost but not quite in front of the third column on the west side is the original findspot of Artemis and that the circle between the first and second columns on the west side is the original findspot either of the statue of Venus or of one of the altars from that corner of the sanctuary. This is hardly surprising: the eruption of Vesuvius, the associated seismic activity, and hasty human intervention at that time all left a city that was quite a mess. But allowing for a bit of tidying up, it is likely that the current position of the modern replica of the statue of Apollo is approximately correct.

Diomedes and Aphrodite

The nature of the first two Trojan scenes on the southern end of the east wall has now been established, but northward the evidence immediately becomes scantier. The wall's narrative is most clearly revealed when its northernmost painting at the far end of the wall is considered first. Once it is clear how the narrative of the wall begins and ends, the middle becomes easier to address. The right side of the photograph of the northeast corner of the cork model clearly shows that the last pillar, which is the hollow one that housed the *mensa ponderaria* on the other side, had a great deal of plaster remaining (see fig. 15; fig. 10, no. 8). It is decorated in a much different style than the two niches examined so far: this is a full elaboration of the pillar-style motif; at its center there is an apparently well-preserved figural painting. Both Mazois and Callet show this last wall pillar without any obstruction in the way (see fig. 6). The blown-up detail of Mazois's elevation shows all the features one would expect of the pillar style (fig. 27). The figural composition is disappointing, however, as Mazois shows markedly less color and detail here than he did for the Calchas painting. On the left is a shadowy figure leaning forward, one leg straight back, the other leg bent forward. He is possibly grappling with the figure on the right, who is in a similar but slightly more upright stance. There is not much here to work with, but, fortunately, Callet makes up the deficit.

A blown-up detail of Callet's elevation shows a comparative wealth of specifics and color in its representation of the pillar-style trompe-l'œil architecture (fig. 28), so similar to Rochette's chromolithograph (see fig. 5) that they must represent the same

FIGURE 27 Detail of fig. 6, showing the leftmost pillar on Mazois's elevation of the east wall

FIGURE 28 Detail of fig. 7, showing the leftmost pillar on Callet's elevation of the east wall

FIGURE 29 Detail of fig. 28 (and further detail of fig. 7), showing the figural composition at the center of the leftmost pillar on Callet's elevation of the east wall

part of the wall. A further blow-up shows that Callet has three or four figures rather than Mazois's two (fig. 29). On the extreme left there are one or more figures in red. Toward the center is another figure; this one has legs that are clearly defined in blue. One is straight and extended to the rear; the other is bent forward. This posture would seem to correspond to that of the figure on the left of Mazois's version. On the right is a standing figure with some relationship to something like a shield; this presumably corresponds, though not very well, to the figure on the right of Mazois's image. The crucial identifying feature, however, is the central figure with the blue-green strokes that represent his bronze greaves, or leg armor. In the previous chapter, I looked at the origins of Steinbüchel's engravings and showed that they probably derived from the work of Francesco Morelli, the official artist of the excavations. I now turn again to Morelli's pencil-and-tempera drawing of Athena encouraging a warrior, who is wearing greaves that are a similar shade of blue-green (see fig. 3). The figure is similarly positioned in the center left of the composition, and the posture of the legs is identical. In both images, the right leg of the soldier extends straight back from the torso toward the lower left corner of the painting, while the other leg is drawn up

in front of the body, bent at the knee. In both images, the torso leans back to the left while a circular object, presumably a shield, is held in front. It must be remembered that the parts of Morelli's image that are most securely attested to are shown by the use of color in tempera, while his guesswork is sketched lightly in pencil. Thus the lower body of the central warrior, along with Athena behind him, is the most likely to be correct, and this is precisely where Callet agrees. Callet's representations of the paintings of Calchas and the quarrel of Achilles and Agamemnon have established his basic reliability with respect to the details of the figured panels. The important difference here is that Callet disagrees with Morelli, Rochette, and Steinbüchel on the composition of the right side of the painting, for reasons that now become clear.

A version of this Trojan painting is shown in Steinbüchel's *Atlas* (see fig. 4). He suggested that the scene shows Athena encouraging Diomedes. Other scholars have disagreed, interpreting the warrior in this scene as Achilles.[16] The location of this painting suggests that Steinbüchel here was correct, for the painting appears on the same wall as the one depicting the beginning of the *Iliad*, indicating that the Diomedes episode in Book 5 is a more likely candidate than, for example, the scene near the end of the epic where Athena helps Achilles in his final combat with Hector. What did Steinbüchel see that made him come to the correct conclusion? His engraving has nothing to suggest Diomedes. As I have shown, both Steinbüchel's image and that of Rochette (see fig. 5) followed Morelli's hypothetical reconstruction of the right side of the painting but elided the difference between the well-attested parts of the painting in tempera and his guesswork in pencil. But the right half of Morelli's hypothesis is implausible. The left side of the painting is full of action: Athena gestures dynamically to encourage the warrior who is about to throw his spear. By contrast, the right side of Morelli's version is pointless. Several warriors mill about aimlessly. The one in the foreground, with his back to the viewer, contributes nothing. And what is he doing with his left arm? He seems to be holding two shields, one above his elbow and the other in front of him.

Compare the pair of paintings examined above. In the first of those (see fig. 23), the standing Calchas gestures dynamically to the casually reclining Achilles, and in the next scene (see fig. 16), Achilles has leaped to his feet to confront the seated Agamemnon. In both of these compositions there is a very strong tension and contrast between figures on either side of the painting. The left side of this other painting (see fig. 4) clearly belongs to this series. Athena appears behind the active warrior, but this time she urges him on rather than restraining his violence, as she does with Achilles; this switch of roles is echoed in the way she now stands at the far left rather than the far right. So the other side of the painting should hold a figure in narrative tension and visual contrast, not a pointless mob of bystanders. Whom is the warrior aiming at? Morelli would have him throw his spear out of the frame, into empty space. This seems strangely lacking in point. By contrast, Callet seems to show someone carrying something or someone on the right side of the composition. But who? Once again,

FIGURE 30 Drawing (top) of Sarti *tabula Iliaca* (now lost), with detail (bottom). From Otto Jahn and Adolf Michaelis, *Griechische Bilderchroniken* (1873), pl. 2

Brüning has identified the crucial parallel in the *tabulae Iliacae*.[17] Unfortunately, the part of the Capitoline tablet that would have depicted this scene has not survived, so other tablets instead must be considered. Several of them show the episode in Book 5 of the *Iliad* when Diomedes wounds Aphrodite as she attempts to rescue her son Aeneas. The Sarti tablet has been lost, but its contents are known from a drawing, and it affords a particularly clear view of this scene (fig. 30).[18] Here Athena (not labeled) is standing behind Diomedes and reaching out to encourage him with her right arm, just as in Morelli's painting. Diomedes is standing in that same distinctive posture: his right leg drawn straight back behind him, foot and knee twisted toward the viewer; left leg raised forward, bent at the knee, foot elevated. The key difference is that the Sarti tablet shows why that foot is up in the air: it is resting on the neck of a dead Trojan, Pandarus.

In this light, several peculiarities in Morelli's reconstruction stand out. The tiny head of the warrior is completely out of proportion with the torso. His posture is wrong for a warrior about to hurl a spear: he holds the weapon at chest height, next to his body. To throw it effectively, the hand should be above the shoulder, not below it and off to the side. Once again, the Sarti tablet explains the problem. Diomedes holds his spear with an overhand grip, not underhand, as Morelli had tentatively guessed in pencil. The spear is down low, next to his body, because he is using it as a thrusting weapon; he is not trying to throw it. The end of the spear ought therefore to be threatening or indeed be stuck into the body of an enemy, and that is what needs to be on the right side of the painting, not a group of Greek soldiers idling about. The Sarti tablet tells us who was at the receiving end of Diomedes's spear: Aeneas. Or, rather, he is one of the two figures at the right side of this composition. The other is not labeled, but her presence can be deduced from the flowing robes into which the sharp end of Diomedes's spear disappears: Aphrodite, mother of Aeneas.

The scene on the tablet depicts with great precision the moment in the *Iliad* when the goddess is wounded. The scene begins when Aeneas and his companion Pandarus confront Diomedes and Sthenelus. Pandarus exchanges spear throws with Diomedes, resulting in the death of the former. Aeneas approaches to prevent the body of his friend from being taken away, but Diomedes throws a massive stone that gravely injures Aeneas (5.311–17):

Καί νύ κεν ἔνθ' ἀπόλοιτο ἄναξ ἀνδρῶν Αἰνείας,
εἰ μὴ ἄρ' ὀξὺ νόησε Διὸς θυγάτηρ Ἀφροδίτη
μήτηρ, ἥ μιν ὑπ' Ἀγχίσῃ τέκε βουκολέοντι·
ἀμφὶ δ' ἑὸν φίλον υἱὸν ἐχεύατο πήχεε λευκώ,
πρόσθε δέ οἱ πέπλοιο φαεινοῦ πτύγμ' ἐκάλυψεν
ἕρκος ἔμεν βελέων, μή τις Δαναῶν ταχυπώλων
χαλκὸν ἐνὶ στήθεσσι βαλὼν ἐκ θυμὸν ἕλοιτο.

(And now would the lord of men, Aeneas, have perished, had not the daughter of Zeus, Aphrodite, been quick to notice, his mother, who conceived him to Anchises as he tended his cattle. About her dear son she flung her white arms, and in front of him she spread a fold of her bright garment to be a shelter against missiles, lest any of the Danaans with swift horses might hurl a spear of bronze into his breast and take away his life.)

Earlier, when Athena gave Diomedes the ability to discern mortal from immortal, she gave him explicit permission to wound Aphrodite (5.130–32). Accordingly, Diomedes presses on (5.334–39):

ἀλλ' ὅτε δή ῥ' ἐκίχανε πολὺν καθ' ὅμιλον ὀπάζων,
ἔνθ' ἐπορεξάμενος μεγαθύμου Τυδέος υἱὸς
ἄκρην οὔτασε χεῖρα μετάλμενος ὀξέϊ δουρὶ
ἀβληχρήν· εἶθαρ δὲ δόρυ χροὸς ἀντετόρησεν
ἀμβροσίου διὰ πέπλου, ὅν οἱ Χάριτες κάμον αὐταί,
πρυμνὸν ὕπερ θέναρος· ῥέε δ' ἄμβροτον αἷμα θεοῖο

(But when he caught up with her [Aphrodite] as he pursued her through the great throng, then the son of great-hearted Tydeus thrust with his sharp spear and leaped at her, and cut the surface of her delicate hand, and immediately through the ambrosial raiment, which the Graces themselves had toiled over making for her, the spear pierced the flesh on the wrist above the palm, and out flowed the immortal blood of the goddess.)

The Sarti tablet does not have space to label explicitly either Athena or Aphrodite, but their presence here is certain. Athena is clearly visible, while Aphrodite is represented by the voluminous garment in which she has wrapped herself and Aeneas, which is emphasized so clearly in the two Homeric passages above. Another of the *tabulae Iliacae*, the first Verona tablet, gives a view of Diomedes wounding the goddess, but without labeling the participants (fig. 31). This confirms the arrangement of figures, particularly the distinctive posture of Diomedes's legs, with one of them resting on the corpse of Pandarus. Brüning adduces another piece of evidence that does label Aeneas's mother, a clay seal showing Diomedes stabbing Aphrodite (labeled) as she attempts to support her son.[19]

I am now in a position to revisit the version of this scene found in the Pompeian portico. Morelli's tentative reconstruction of the right side of the composition has been shown to be unreliable, despite being repeated by the derivative images of Steinbüchel and Rochette, and Mazois's view of it is too murky to help much. Callet's elevation (see fig. 29), however, provides a striking match with the *tabulae Iliacae*. The left side matches perfectly, with Athena behind Diomedes, whose legs are in the usual posture.

FIGURE 31 Drawing (top) of the first Verona *tabula Iliaca*, with detail (bottom). From Otto Jahn and Adolf Michaelis, *Griechische Bilderchroniken* (1873), pl. 3

78 ART IN POMPEII

But whereas Morelli has Diomedes's raised foot hanging pointlessly in the air, Callet shows a body extending out from it, up and to the right. There are two arms, the left foreshortened and the right horizontal in the foreground. The rest of the body extends indistinctly into the background to the right. This is Pandarus. Another feature of Diomedes's posture on the tablets is the way he raises his shield on his left arm as he stabs with his right. Morelli seems to show two shields: one rendered in pencil on Diomedes's arm, and just below that another outlined in pencil and partially painted in. This doubling seems to be a symptom of Morelli's difficulty in getting the scale of Diomedes's body correct when connecting the lower half to the upper. Callet, by contrast, shows an elevated circular object in front of Diomedes, which would correspond to his shield.

To turn now to the figures on the right margin of Callet's view of the painting: Callet obviously meant to show two figures here: one carrying another. The head, torso, and two legs of the standing figure are clearly shown. It is a bit harder to make out the other one, whose horizontal torso crosses in front of the torso of the upright figure. The legs of this helpless person are squeezed a bit by the frame but can be seen dangling next to the right edge, where they descend alongside the legs of the standing figure. The upper part of the horizontal body is obscured by a semicircular object, which in this context must be a shield. In view of the parallels, this must be Aphrodite attempting to rescue her son; the goddess is the target of Diomedes's spear thrust.[20] There are two main differences from the other versions of this composition. The first is the presence of Aeneas's shield instead of his mother's ambrosial, Grace-woven garment. These are not incompatible, however, and Homer makes it clear that Aeneas kept his armor even when his mother dropped him after being wounded and he was rescued again by Apollo; for he says that even then Diomedes continued to try to strip his armor (*Il.* 5.435). The second difference is that Aphrodite seems here to be carrying Aeneas, whereas in the other versions he is on the ground, staggering but supported by his mother. It may be that the painter of the Pompeian version took a different approach, or it may be that Callet had difficulties similar to Morelli's in reconstructing this part of the painting, which was singled out by Steinbüchel as being in a poor state of preservation. Several years later, when Callet visited, it would have decayed even more. The Calchas painting shows that Callet was willing to indulge in some speculative reconstruction of the wall painting, and he must have done so here as well. The parallels show, however, that his deductions in this case were more accurate than Morelli's.

Entrances to the Forum

Now that the subject of the northernmost Trojan painting on the east wall has been established, it is time to move southward to examine the middle of the wall. One can say something about the decoration of the other pillars in the northern half of the wall, but it is not certain if niches existed between them. The sanctuary in its present state has no walls at all between the pillars in the northern half of the wall. It is not

clear how many of these gaps, if any, were left deliberately open when the southern pillars were joined together. Some of the gaps may have been caused by seismic damage rather than deliberate omission. Furthermore, the northeast corner of the building was destroyed by Allied bombing in 1943 and subsequently rebuilt, so its present appearance should be taken with a grain of salt. There is clear evidence of sills that served as steps into the Forum, but that is not definitive, either. The pillars are most likely a vestige of an earlier monumental entryway into the Forum and the openings might have retained elements of that former usage even if subsequently blocked off.[21]

In marked contrast to the state of the east wall today, the evidence of nineteenth-century architects seems to indicate unanimously that all the pillars were connected in such a way that there was no direct access to the Forum at all through this wall. Mazois's plan of the temple (see fig. 10), his elevation (see fig. 6), Callet's elevation (see fig. 7), and the cork model (figs. 32, 33) present a clear picture of an unbroken, half-height, undecorated wall filling in all the spaces between the pillars in the northern part of the wall. The first problem with this apparently straightforward testimony is that Mazois contradicts himself. Whereas his plan of the temple has an unbroken wall, his larger plan of the general Forum area shows a doorway into the Forum in the middle of the northernmost niche (fig. 34; see fig. 10, no. 19). Another early plan of the Forum area, drawn by John Goldicutt in 1816, provides independent confirmation that there was a narrow doorway here.[22] Admittedly, Goldicutt's plan has some bad inaccuracies (the thickness of the pillars is uniform and the axes of the sanctuary and Forum are parallel), but he is unlikely to have indicated the same feature as Mazois by pure accident.

The problem is that all the early architectural plans assume to a greater or lesser extent that the intention was always to seal the sanctuary off from the adjacent Forum. The architects thus tended to assume that the parts of the wall that they found missing had been destroyed by seismic activity and they accordingly reconstructed walls there. Hence the disagreement over the presence of deliberate gaps in the wall, even in plans drawn by the same hand. A very different view of the original state of the east wall is given by the rough plan in Gell's sketchbook, which shows no wall surviving between any of the pillars in the northern half of the wall (see fig. 1). On the other hand, Gell's plan goes too far and wrongly shows one gap where the wall has survived (see fig. 10, no. 9). In this case, the roughness of Gell's plan may be an asset, in that he did not bother to tidy up the architecture, putting in walls where his own judgment thought they ought to be.

As a compromise between the two extremes of a continuous wall and no wall at all in the northern half, August Mau asserts that three and only three spaces between pillars were left open (see fig. 10, nos. 11, 13, 15), which seems plausible enough at first glance.[23] But it seems very likely that Mau was basing his judgment that "they were all walled up except the three opposite the side of the temple" on Mazois's lithograph of the east-wall elevation, which is demonstrably unreliable in this regard as it wrongly

FIGURE 32 Detail of the Plastico di Pompei (see fig. 8), showing the northern end of the east wall of the Sanctuary of Apollo

FIGURE 33 Detail of the Plastico di Pompei (see fig. 8), showing the middle of the east wall of the Sanctuary of Apollo

FIGURE 34 Detail of Mazois's general plan of the Forum area, showing the northeast corner of the Sanctuary of Apollo. From François Mazois, *Les ruines de Pompéi* (1812–38), vol. 3, pl. 14

reconstructs at least one wall segment where, by his own testimony elsewhere, there was a doorway. It is a bit suspicious that Mau is confident that there existed wall segments in all places except in precisely those places where his view of it in the early elevations was obstructed by the podium.

The suspicion that the temple plan in Gell's notebook, precisely because of its lack of polish, is closer to what was really found, can, in fact, be supported. There is a note on the back of a drawing from that same notebook that gives a series of measurements Gell made of the Forum (see fig. 52). He began at the southwest corner and proceeded up the west side, past the Basilica and then past the outer wall of the Temple of Apollo, marking distances "with a 50 foot line, beginning at SW angle." For each fifty-foot segment, Gell recorded what he found to the immediate right and left. At first, he tried to record the distances of each object from the start of the fifty-foot segment, but then he gave up. In the fourth segment he writes "on L[eft] begins the great steps to cell of T[emple of] Bacchus." Then, as if he has realized that he should note why he can in fact see this temple from the adjacent Forum, his next entry is "Cell of Bacchus and an opening to it having passed 3 ditto. 7 openings in all." The "opening to it" is a gap between the massive piers, and there were three others before that that permitted Gell to see the steps up to the podium. In the fifth segment, he notes the presence of the "last pier of T of Bacchus," in which the *mensa ponderaria* was kept. After that, he says, "there is another opening yet to T of Bacchus." This note confirms that the last niche did indeed also have a doorway into the Forum. The picture that emerges is that there was one gap with three others before that, then another, thus giving five gaps in the east wall, which is what exists today. Gell says "7 openings in all," because he adds the other two openings in the portico wall: the main entrance on the via Marina and the small doorway into the private apartment along the north wall. Another plan in the same notebook, much more polished than the crude plan of the temple, shows the larger Forum area.[24] This plan clearly shows the five expected gaps between piers in the east wall. It is thus likely that all the gaps presently existing have been there since the original excavation. Of course, the extrapolations of the architects may in fact be correct, and the loss of some parts of the wall may have been caused by seismic damage. It is therefore not certain exactly how many gaps were intentionally left open in the northern half of the wall or how many Trojan pictures filled in the narrative between the beginning of Book 1 and the middle of Book 5 of the *Iliad*.

An Empty Frame

Whatever the situation with the niches/gaps may have been, it is certain that the pillars on the northern half were decorated and carried Trojan images, even though the view of them is badly obstructed. In the elevations, the temple podium stands in front of the bottom half of the pillars, and the cella entirely obscures part of the portico wall. Columns also get in the way: not only the columns of the portico but also the

FIGURE 35 Detail of fig. 7, showing the leftmost of the three pillars with empty picture frames from the central part of Callet's elevation of the east wall

colonnade of the temple itself. As a result of these difficulties, Mazois does not make any effort to represent the plaster remaining on the wall behind the obstacles, which is hardly surprising. Remarkably enough, however, Callet does show glimpses of the decoration peeking out from behind the temple podium. It was surely a conscious choice to resolve the parallax of his elevation so that the upper parts of three pillars happen to be visible between the columns (see fig. 10, nos. 10, 12, 16). Only one pillar (see fig. 10, no. 14) is completely obscured, as it must be, by the walls of the cella. Callet thought this aspect of the portico wall important enough to document.

All three partially visible pillars show similar decoration, which is clearly meant to represent a variant of the pillar style from the Diomedes pillar. In each of them, a red picture frame is surrounded by thin lines that correspond to the pseudoarchitectural framework. Of these three similar pillars, the northernmost has the most plaster preserved (fig. 35; see fig. 10, no. 16). The enlarged detail shows the distinctive red frame surrounded by colorful vertical lines to suggest the illusionistic architecture surrounding it. There are also a few horizontal lines running across these verticals and behind the picture frame; these correspond very nicely to the faux entablature that in the pillar-style decoration runs on top of the first story of the architecture and thence behind the picture frame. The figural painting that provides the frame for the trompel'œil reveals something quite surprising.

As Callet shows most of the frame around the figural painting apart from the very top, one might be tempted to expect that, in light of the amount of detail he gives ear-

lier, there is a good chance of identifying the contents of the painting. So the result is all the more startling. All that appears is a brownish-gray wash without any of the densely packed, colorful detail customary in Callet's depictions of the Trojan paintings (see fig. 35). It is true that there is some variation in the darkness of the wash at the bottom, but this is not patterned in such a way as to represent human figures or their shadows. There are also two pencil lines, but, again, these are not figural. If anything, they seem to approximate the letters D and M, though the vertical line of the D is missing on the left. The first puzzle is why in this instance alone Callet omitted any attempt to represent the Trojan painting. Having decided, unlike Mazois, to include these three pillars in his elevation, and having taken the trouble to show the outlines of the trompe-l'œil architecture on this pillar, why did he omit the figural composition that it served to frame? Callet thought the figural decoration on these pillars was important enough to record elsewhere on the wall, so one should expect him to record it here.

One might be tempted to leave this as an unexplained anomaly, except for another piece of evidence, which suggests that here, too, Callet was recording with his usual meticulous attention the actual appearance of the wall painting in the portico. One of the color lithographs of the Temple of Apollo in Mazois's deluxe publication shows a version of the familiar pillar-style decorative scheme, with the black-on-yellow base, the three-dimensional architecture with an architrave running behind the picture frame, a lintel with a distant landscape below, and an illusionistic ribbon suspending the picture frame (fig. 36). The odd thing is that the picture frame is completely blank. This volume of *Les ruines de Pompéi* was published posthumously and the text was supplied not by Mazois but by Gau and Barré, who were compelled to speculate as to why this was so. They guessed that the idea was to provide a frame for a genuine *pinax*, a figural composition painted directly on wood and then mounted on the wall.[25] Rochette, who had been to the sanctuary, agreed, confirming that there were sometimes blank spaces instead of figural paintings in the portico.[26] Rochette discussed this aspect of Mazois's publication years later, but from the perspective of someone who had been to the portico himself not long after its excavation. It is curious that scholarship on the portico has largely ignored one of its most interesting features: the presence of elaborate fourth-style decorations around blank spaces intended to house separately composed, embedded paintings.[27]

There is no need to infer, as Rochette did, that what was lost from these spaces were panel paintings executed in encaustic directly upon wood. There is plenty of evidence from elsewhere in Pompeii and from Vitruvius for the practice of preserving old figural paintings on plaster when redecorating a wall. The old painting was cut out, mounted on wood, and then inserted in the fresh plaster. When Vesuvius erupted, the wood was carbonized and the mounted plaster fell out (see chapter 4 for a fuller discussion). But it is important to realize that the empty space in Callet's elevation and in Mazois's chromolithograph must reflect a genuine feature of the decoration.

FIGURE 36 Color lithograph of part of the decoration of the Temple of Apollo in Pompeii. From François Mazois, *Les ruines de Pompéi* (1812–38), vol. 4, pl. 22

There are several discrepancies between Callet's and Mazois's representation of the blank frame. For example, Mazois presents a gleaming and flawless white square, whereas Callet's dull, uneven, brownish-gray wash suggests unfinished plaster. It is unlikely that the pure, unblemished white square in the color lithograph represents a point of genuine disagreement with Callet; rather, it must be a tidying up of reality by Mazois or his lithographer. There would be little reason for an ancient painter to waste paint and time polishing to a high finish a space that was designed to be covered by another surface.

There are other indisputable discrepancies, which indicate that Mazois's image was drawn not from the east wall but from another part of the portico where there were blank panels. For example, Mazois shows a lintel under the picture frame that reveals a sacred landscape underneath. Callet, by contrast, shows instead three vertical lines beneath the frame: two thin blue lines on the outside and a more elaborate yellow one in the middle. This corresponds quite well to the variant of the pillar-style decoration in which the picture frame is supported by a gold candelabrum.[28] This can be seen in the picture of the pillars on the cork model a bit farther down (see fig. 33; fig. 10, nos. 12, 10). The final discrepancy concerns the coloring of the architecture. Callet's elevation indicates roughly the same colors as in the Diomedes panel, mostly red and yellow, whereas the Mazois panel has quite a different scheme, in which blue takes the place of red. The blue variant is confirmed by the cork model for the pillar-style panels on the north wall (see next chapter).

Before leaving this missing painting, one can speculate about what might once have been intended for this space. Everything seen so far suggests that the visual narrative on this wall was linear and adhered closely to the plot of the *Iliad*. If the gap between this pillar and the one to the north was left open as an entrance to the Forum, then this pillar should depict the scene immediately before Diomedes wounds Aphrodite. If I am right in seeing the letters *D* and *M* scratched into the raw, unfinished plaster, they could be annotations designed to tell the painters and decorators where in the portico to put the various Trojan images. Do the letters stand, perhaps, for Diomedes and Minerva (aka Athena)? If the positions of the letters stand for the positions of the figures, then a composition with Athena on the right and Diomedes on the left would reverse their relative positions in the next painting. Such a painting could depict the moment when Athena responds to the hero's prayer and bestows courage upon him and the gift of being able to distinguish between god and mortal on the battlefield (*Il.* 5.121–32). This is the point when she instructs him to attack Aphrodite if he sees her, so it would serve as an introduction to the more violent image that follows, much as the painting of Calchas addressing Achilles sets up the violence of that warrior in the following scene. All this must remain, however, nothing more than speculation.

Menelaus and Machaon?

Moving south, I pass over the pillar completely hidden by the cella walls (see fig. 10, no. 14) to the next pillar, which Callet shows peeking out above the front of the podium (fig. 37; see fig. 10, no. 12). There is less plaster surviving here, but enough to see that there is a fragmentary figural painting surrounded by pillar-style decoration. The right side affords a particularly good view of the ceiling of the lower story of the fantasy architecture. It is quite clear here, more so than on the previous pillar, that the central painting is supported by a thin vertical, circular object rather than a long horizontal lintel. This candelabrum indicates the narrower variant of the pillar-style decoration. The central frame is not blank, but nearly half of the plaster is missing, having broken off on a diagonal from top left to bottom right. All that can be made out are a few details of a figure in the foreground. There are a few confused strokes of color at the bottom center that may represent legs and, toward the left side, a clear outline of a right arm hanging down beside a torso across which the plaster break cuts diagonally. The head of this figure is missing, as is whatever was on the right side of the painting.

FIGURE 37 Detail of fig. 7, showing the middle of the three pillars with empty picture frames from the central part of Callet's elevation of the east wall

FIGURE 38 Engraving of an image from the Temple of Apollo in Pompeii. From Anton Steinbüchel, *Grosser antiquarischer Atlas* (1833), vol. 8, pl. D2

There is far less detail to work with here than in the other three places where Callet gives us a view of a Trojan painting. There is, however, one image in Steinbüchel's collection that has a very similar pattern of breakage (fig. 38). This drawing likewise shows the bottom-left triangular portion of an image with the line of breakage running from top left to bottom right. The slant of the breakage line is very similar if not perfectly identical, as are some aspects of its contours, being somewhat convex at the top, concave in the middle, and flat at the bottom. In contrast to Steinbüchel's other drawings, there is very little content to work with. A figure reclines somewhat awkwardly on a rectilinear object, arm hanging down and across the straight lines of the angular object. On close observation one can perhaps see reflections of these items in the detail of Callet's elevation. First, the arm: about one-quarter of the width of the painting from its left side, Callet shows us what appears to be an arm hanging down from a shoulder. It is true that this arm is straight while Steinbüchel's is slightly bent at the elbow, but the general position of the arm corresponds well. The next feature is the rectilinear object on which this figure sits. Again, Callet shows just enough to suggest a match. Near the midpoint of the bottom of the painting there are several up-and-down strokes, two of which are notably vertical and straight. These end at the break in the plaster, at which point they seem to meet at right angles the end of another straight line that runs horizontally. If one follows that line leftward, it seems to pass behind the bottom end of the arm hanging down. These perpendicular lines correspond to the edges of the object that Steinbüchel's figure sits on. Callet's detail is hard to read, but it seems that the hand of the main figure extends down, just past the top, horizontal edge of the seat.

It must be admitted that these fragmentary images rest on weaker ground than in the other cases, where I could make fairly convincing matches between aspects of Steinbüchel's drawings and the details of Callet's elevation. Nevertheless, I think there

is just enough evidence to claim a match here as well. Look at the relative positions of the line of broken plaster, the corner of the seat, the hand and the top edge of the seat. The correspondences do not leap out, but they are there.

Part of the problem, of course, is that it is far from obvious what Trojan scene figure 38 represents. Steinbüchel suggests that it was supposed to show Diomedes stealing the Palladium. That may seem an oddly specific guess, but it is not hard to reconstruct his reasoning. The Austrian scholar was the Keeper of the Imperial Cabinet of Coins and Antiquities in Vienna, and he published works on ancient coins and medals. In light of his expertise in miniatures from antiquity, it seems likely that he interpreted the scanty detail preserved here in terms of a motif common in intaglios and cameos of the Augustan period. These show the theft of the Palladium with Diomedes on the left, ready to leap over an altar to make his escape, and Ulysses on the right.[29] Diomedes's posture in that scheme has enough general similarity to figure 38 to suggest that these were the parallels Steinbüchel had in mind, but not enough to make it a convincing identification. When stealing the Palladium, Diomedes has one foot planted firmly on top of the altar, ready to spring over it, knee fully flexed, whereas here he is reclining languidly against the object, both feet on the ground. Diomedes holds out the Palladium in his left hand, while his right arm extends downward and his hand holds a sword. In figure 38 the right arm is extended downward alongside the altar-like object in the same way, but it holds no sword. Several other visitors to the portico also include Diomedes stealing the Palladium as the subject of one of the paintings, so this seems to have become an established identification. One of these publications came out, also in Vienna, several years before Steinbüchel's, so his idea must have begun circulating even before the publication of his *Atlas*.[30]

One can reject the Palladium identification out of hand because the visual parallels are so poor, but a much stronger one is proposed by Diepolder, from a painting found in Pompeii in the Casa di Sirico (vii.1.25).[31] This painting (fig. 39) shows Poseidon on the left, reclining against an altar and engaged in a discussion with Apollo on the right.[32] In the background are workers engaged in building a wall, and some cattle. The subject refers to the time Poseidon and Apollo were obliged by Zeus to serve King Laomedon of Troy for a year: in the *Iliad*, Poseidon recalls that he built the walls of the city while Apollo herded cattle for the king on Mount Ida (21.441–57). This picture corresponds to what survives of figure 38 better than does the picture of Diomedes about to leap with the Palladium. The position of the feet and the right arm are correct, as is the general attitude of repose. There are no obvious problems with the visual correspondences, but there is a big problem in terms of the narrative of the east wall. Poseidon recalls this episode at the end of Book 7 of the *Iliad*, and again in Book 21, but even so, to include it in the midst of an Iliadic narrative would be an oddity. A verbal text can easily mark episodes as belonging to the past relative to the narrative present, but it is much harder to do so in a visual tableau.

One can accept that the painting of Poseidon provides a good indication of what the posture of the character in the portico figure must have looked like, but perhaps he was not the only one in this Trojan cycle to recline atop a square object. Indeed, this general posture, where a warrior sits facing right on an improvised object, supporting his left arm on his spear and letting his right arm hang down, is paralleled in a number of other Trojan scenes, including one from elsewhere in this same portico (see fig. 55). Another problem with Diepolder's identification is that the object Poseidon sits on is a perfectly rectangular block, which in the context of the painting must be one of the blocks he is using to build the walls of Troy. The object in figure 38 is clearly elaborated with a base at the foot and so would not be a suitable object for wall building.

All these considerations argue against identifying Steinbüchel's fragment as a painting of Poseidon and Apollo. So what is it? The object could be an altar, which might indicate divinity, but not necessarily. The figure is barefoot, which might again

FIGURE 39 Wall painting from the Casa di Sirico in Pompeii (vii.1.25), showing Apollo and Poseidon building the walls of Troy

be taken to indicate a god, but Steinbüchel's drawings routinely omit mortal footwear (as for both Achilles and Agamemnon in his image of their quarrel), so that is not a safe deduction. If the features of Steinbüchel's drawing are not distinctive enough to identify the scene on its own, how can one proceed? At this point, a different avenue of exploration suggests itself. From its position on the east wall, this ought to be a scene from Book 2, 3, or 4 of the *Iliad*. Three of the *tabulae Iliacae* have furnished very good parallels for the three Homeric scenes discussed above. In the scenes on those tablets depicting episodes between Books 1 and 5 of the *Iliad*, are there any images in which a figure on the left reclines upon an object?

One would like to begin with the Capitoline tablet, but unfortunately the relevant part does not survive. This leaves the two tablets that have been useful so far: the Sarti tablet and the first Verona tablet. On the latter, there is a scene immediately prior to the wounding of Aphrodite by Diomedes that shows the healer Machaon attending to the wounded Menelaus (fig. 40).[33] Both are seated, facing each other, Menelaus on the left and Machaon on the right. Machaon is seated on a rock-like object and leans forward, reaching out toward his patient. It is more difficult to make out the details of Menelaus; he may be sitting on something, but it is not clear what. When we compare this tablet with the image in figure 38, the main difference is that Menelaus leans forward rather than back. But if Menelaus is supposed to be receiving treatment to a wound in the abdomen, the posture in Steinbüchel's drawing makes better sense. Menelaus sits to rest but leans back to show his wound to the healer, who would be leaning over him in the part of the painting that was lost. Does the right arm in figure 38 begin to show the tension of a man in pain, or is that the product of an overactive

FIGURE 40 Detail of a drawing of the first Verona *tabula Iliaca*. From Otto Jahn and Adolf Michaelis, *Griechische Bilderchroniken* (1873), pl. 3

FIGURE 41 Detail of a drawing of the now-lost Sarti *tabula Iliaca*.
From Otto Jahn and Adolf Michaelis, *Griechische Bilderchroniken* (1873), pl. 2

imagination? There is a rigidity in the arm and especially in the fingers not seen, for example, in Diepolder's Poseidon parallel, whose fingers lightly graze the stone block. These fingers appear to grip the edge of the block, spread apart, forearm tense. It is not hard to imagine that the owner of this arm was having an arrow pulled out of his abdomen.

This interpretation is not without its problems. The lost Sarti tablet, which agreed so well with the Verona tablet when it came to the wounding of Aphrodite, has a rather different version of this scene (fig. 41). Menelaus on the left and Machaon on the right are both labeled, but Machaon is down on one knee as he treats Menelaus, who is standing up, though he does have one knee bent. Since the Sarti tablet is lost, there is no way of knowing how secure this part of the surviving drawing is, and in any case the *tabulae Iliacae* surely had multiple sources of inspiration; the tablets frequently do give different conceptions of the same Homeric scene. So this is not a fatal problem. If it is correct that there were no walls between these pillars, then there would be just two paintings before the one depicting the wounding of Aphrodite in the middle of Book 5. The painting of the healing of Menelaus from the middle part of Book 4 can be plausibly positioned here. If the preceding panel showed his wounding, a nice link is set up with the painting of Diomedes, whose foot rests on the head of Aeneas's companion Pandarus, for it was Pandarus who treacherously broke the truce and shot Menelaus. So the subsequent picture that shows the wounding of Aphrodite also incidentally shows the comeuppance of the villain behind this earlier scene.

The Rest of the Wall

Very little plaster survived further south; unfortunately, no more figural paintings can be reconstructed on the east wall. First comes the last of the three pillars partially hidden by the podium that Callet shows peeking out through the temple colonnade (fig. 42; see fig. 10, no. 10). Only the bottom margin of the figural painting survived here, and a few vertical lines to indicate once again the candelabrum variant of the pillar style. Not enough remains to tell whether this is the remnant of a blank space for mounting a separate image or whether it is the bottom of a painting. The cork model confirms Callet's depiction precisely and shows the bottom part of the pier, with its candelabrum (fig. 43, leftmost pillar). To the south is the first interpillar space where it is absolutely certain that there was a wall present (see fig. 10, no. 9). The same image

FIGURE 42 Detail of fig. 7, showing the rightmost of the three pillars with empty picture frames from the central part of Callet's elevation of the east wall

FIGURE 43 Detail of the Plastico di Pompei (see fig. 8), showing the middle to south part of the east wall of the Sanctuary of Apollo

FIGURE 44 Detail of Callet's elevation of the east wall (see fig. 7), showing on the left the pillar behind the temple steps and on the right the adjacent niche

of the cork model shows the bottom register of the niche-style decoration in red with a figure at its center. The cork model shows nothing but a pillar-style base on the next pillar (see fig. 43, second pillar from the left), but the earlier sources attest that it, too, once had candelabrum-style decoration. Callet (fig. 44) and Mazois (see fig. 6) show this pillar appearing from behind the temple steps (see fig. 10, no. 8), and figure 44 clearly shows the candelabrum variant of the pillar-style decoration. A similar view of this pillar is shown in the background of Mazois's lithograph of the herm that stood in front of an adjacent column.[34] The wall continues southward in this unpromising vein; both Callet and the cork model confirm that the red plaster with a central figure, which indicates the bottom register of the niche style, continued to feature at the bottom of the next two niches (see fig. 10, nos. 5, 7). The next two pillars, however, appear to have lost all their plaster (see fig. 10, nos. 6, 4). After that come the first two niches at the southern end of the wall, which have already been discussed.

 The main thing to be learned from this part of the wall is that the niche-style and pillar-style decoration alternated regularly on the niches and pillars, both of them

bearing Trojan paintings. Most of the pillars here have the candelabrum variant, presumably because it was more suitable to these narrower spaces. These nevertheless held figural paintings, except for the very first pillar (see fig. 10, no. 2), which was unusually narrow. One can make a guess as to how many paintings continued the narrative of the *Iliad* between the quarrel of Achilles and the healing of Menelaus. There are seven likely places for paintings that are unaccounted for and there could be more, if the places where there are now gaps between the piers once were decorated niches. This implies a very thickly illustrated narrative of the first five books of the *Iliad*. It would be rash to speculate about the exact contents, but it seems likely that the Catalogue of Ships in Book 2 did not feature as prominently as more visually exciting episodes such as, perhaps, the taking of Briseis from Achilles.

Conclusions

I would like to close this chapter by drawing a few conclusions about the remarkable care with which the east wall of the portico was decorated. First, it is clear that this east wall, with its distinctive architecture, was particularly important. The alternation of pillar style and niche style, which is irregular on the three other flat walls, is here strict and conforms to the architecture. Its southern end seems to have been chosen at the point where the Iliadic narrative should start, for indirect evidence suggests that there were probably pre-Iliadic episodes represented on the south wall (see chapter 3). The commencement of the Homeric poem was important enough to align carefully with one of the corners of the portico. This alignment would have helped the viewer interpret the scenes, for there were almost certainly no labels identifying the figures in the Trojan paintings. As noted, the picture of Calchas addressing Achilles was not easy for modern visitors to interpret in a vacuum. Presumably an ancient audience would have had a much richer stock of iconographic knowledge to draw on when situating Calchas's gesture, but it seems likely that even a reasonably well-informed visitor might have needed to glance to the left at the painting of the quarrel of Achilles and Agamemnon to be sure of what he or she was seeing. In this way, even a seemingly linear visual narrative depends upon the viewer being able to "read" the text in two directions.

The painting of the quarrel, representing as it does a memorable and distinctive moment from the first book of the *Iliad*, provides the visual cues to orient the viewer with respect to that literary narrative, and from there a good memory of Homer would allow one to identify the preceding speaker in the Greek assembly as Calchas. It would be a mistake to view that scene as mere space filler, however, for the two paintings work in tandem by means of a series of pointed contrasts. Both juxtapose a standing and a seated figure, but they swap sides; Achilles appears on the right of both scenes. In the first, he is languid, confident and casual in repose, an attitude highlighted by the contrast with Calchas's intent and focused standing posture. Then, in the next scene, Achilles has changed completely. He stands instead of sitting, leans aggressively

forward instead of back. What has changed is that Achilles and Agamemnon have traded the most vicious insults, effectively a contest for leadership, which culminates in Agamemnon's threat to humiliate Achilles by taking away Briseis, his prize. The visual artist cannot convey the text of those speeches, but the change in posture speaks eloquently of what has happened between the first and second pictures. If one can trust Steinbüchel's drawing (see fig. 16), Achilles's cloak has slipped from his shoulder onto his arm (presumably the loss of a sandal is the copyist's error); this reveals the sword and baldric that were hidden beneath. The heroic nudity of Achilles's stance as he confronts Agamemnon highlights the nonchalance of his appearance when seated in the earlier scene. Then, he was confident enough to summon the entire Greek army to assembly and command a prophet to explain the cause of the plague; now he has been publicly humiliated by Agamemnon for "declaring himself my equal and likening himself to me to my face."[35] The other contrast in posture is between the seated Agamemnon and the seated Achilles. Agamemnon's torso is twisted in rage as he grips the scepter that indicates that he has just finished the speech in which he drops the bombshell of his threat to take Briseis.

By contrast, in the previous scene (see fig. 23) it is Calchas who holds the scepter while Achilles is listening placidly.[36] This shift of the scepter visually reinforces the sense that at the start of the *Iliad* Agamemnon is not in control. The fact that Calchas holds a scepter in the first scene as he addresses Achilles, the man who summoned the assembly, highlights the absence of the king from command of these events.[37] Presumably the artist is not thinking that Calchas has taken Agamemnon's own scepter, as Odysseus later does, but rather has in mind the scepter that another priest, Chryses, bears when he comes to meet Agamemnon at the very start of the first book (1.15).[38] Agamemnon angrily wielding his own scepter in the next image provides a vivid sense of his belated effort to wrest control of the situation from Achilles and Calchas. The calmness with which Calchas holds his scepter in contrast to the anger of Agamemnon bears witness to the fact that he is the real leader in this scene.

Another pointed contrast lies in what the two seated warriors are resting on in the two images. Agamemnon is seated upon a throne, and it is apparent that there was a certain amount of ornate carving on it. Achilles is presumably seated on an improvised seat, which is concealed from view by his shield. This highlights the lack of official status he enjoys when compared to Agamemnon. He may summon the assembly, but he is not the king of kings. Additionally, the shield that obscures Achilles's seat may signify something more than a randomly placed object. Achilles appears almost to be balanced precariously upon the edge of the shield, which at first glance seems a serious compositional awkwardness. As with the best poets, so with the best artists, those moments of inexplicable strangeness reveal, when examined closely, not a lack of technique but the lineaments of a larger purpose. The very oddness of Achilles sitting on the edge of his shield on the right margin of the right painting invites the

viewer to explore the mirror image of Agamemnon sitting squarely on his throne on the left margin of the left painting. This sets up a symbolic polarity between Achilles's shield and Agamemnon's throne, which serves to illustrate the crucial difference between them as they vie to be considered "best of the Achaeans": Achilles's position rests precariously upon his skill as a warrior, while Agamemnon's rests upon his royal authority. The throne versus the shield: there is, in a nutshell, the plot of the *Iliad*. This is an artist capable of a sophisticated analysis of the tensions in the first book of the *Iliad* and of rendering that analysis visible by means of striking visual symbolism.

Who devised this symbolism? Which artist created this clever visual interpretation of the first book of the *Iliad*? In a later chapter, I suggest that the installation of this series of images was inspired by a monument in Rome, but one must beware of falling into the trap of discounting the creativity of the local imitation in pursuit of a lost metropolitan model. It is likely that everywhere in Pompeii there is an inextricable combination of the quotation of motifs familiar from the metropolis and creative, intelligent reinvention of those motifs to suit a local purpose. In the absence of independent evidence, it is usually not possible to tell the difference, so it is necessary to be always aware of both possibilities. At this point, it would be useful to think back to the way the designers of the Pompeian portico integrated the statue of Apollo Saettante (see fig. 25) into the narrative on the walls. Apollo and his sister Diana simultaneously belong to a different context: the series of sculptures and altars around the inside perimeter of the portico. This must be a purely local phenomenon: someone in Pompeii took a series of paintings and a pair of locally significant sculptures and created a brilliant visual pun by means of intersecting them. This is a cautionary tale against assuming that quality and intellectualism are a sign of nonprovincial origin. At the same time, the presence of these Trojan scenes on the *tabulae Iliacae* from the suburbs of Rome is an indication that these local artists were working with an iconographic vocabulary drawn from elsewhere.[39]

The painting of Diomedes wounding Aphrodite (see figs. 3, 29) shows a similarly sophisticated reading of Homer. The east wall begins with Athena, standing on the right side of a painting near the right end of the wall and holding back Achilles as he deliberates over using his weapon against someone of higher status whom he probably should not attack. It ends with Athena, standing on the left side of the painting on the left end of the wall, urging on another Greek warrior, Diomedes, as he deliberates over using his weapon against someone of higher status whom he probably should not attack. Once again there is a mirroring of images and attitudes. Just as the mirroring of the seated Achilles and Agamemnon highlighted the difference between them, so here the contrasting visual elements suggest a careful analysis of the characters of the *Iliad*. The mirroring of Athena does not indicate a change in the goddess's attitude: she helps both Greek warriors, but they require opposite kinds of help. Achilles and Diomedes are two of the greatest fighters on

the Greek side, but they are made of very different stuff. Achilles arrogates the right to break all normal rules, whereas Diomedes is a hero with the inverse flaw: if anything, he is too cautious.

The ancient commentators on Homer wondered why the *Iliad*'s first important *aristeia*, a warrior's period of sustained excellence on the battlefield, should be given to Diomedes, who is less than integral to the rest of the plot of the epic.[40] The east wall of the portico gives an interesting answer: because he serves as a foil for Achilles's disdain for rules and hierarchy. Diomedes wounds Aphrodite only because he has been told explicitly by Athena that she is the only god he may attack (5.129–32). It is true that he is momentarily carried away in the effort to finish off Aeneas and attacks Apollo, who has taken Aphrodite's burden. But when the god tells him to back off, he does so (5.440–54). Later, Athena rebukes him for having less spirit than his father, Tydeus, because he has refrained from attacking the god Ares (5.800–813). Diomedes replies that he is simply following her instructions. The contrast with Tydeus is instructive: he, like Achilles, was a hero whose anger knew no bounds. His life ended when, mortally wounded, he sank his teeth into the brains of his adversary. Athena, on the point of rewarding his heroism with immortality, turned away in disgust.[41] This background story fatally undermines her rebuke to Diomedes, indicating that he has learned self-mastery and is a wiser man than his father. He obeys Athena's instructions to the letter, even to the point of frustrating her. The point of inserting this portrait of Diomedes early in the epic is to demonstrate that there is another mode of heroism available apart from Achilles's rule breaking.

The painter of the portico's Trojan images understood this, and the effect of the mirroring of Athena at the northern and southern extremities of the east wall is to highlight the way Homer's Diomedes serves as a foil for Achilles. In order to achieve this mirroring, the painter has in fact departed slightly from the Homeric narrative. The precision with which the visual narrative usually follows Homer highlights the fact that Athena does not really belong next to Diomedes here. At this moment in the narrative, she is elsewhere. She is said to help guide Diomedes's spear when he kills Pandarus (5.290–91), but her next appearance is on Olympus, mocking the injured Aphrodite to Zeus (5.418–19). The reason for her sudden and unexplained disappearance from the battlefield is easy enough to guess: if she had directly helped Diomedes injure the unwarlike Aphrodite, there would have been less glory in it for him. By contrast, later in the book Athena stands by Diomedes's side and leans on the end of his spear when he drives it into the war god Ares (5.856–57); this greater feat demands closer assistance. The portico painter created a fusion of the early scene in which Athena urges Diomedes to attack Aphrodite and the later scene in which he does so; the plausibility of this amalgamation is boosted by the viewer's memory of the later scene, in which Athena does stand by Diomedes's side and helps him to wound Ares.

Once again, this thoughtfulness can be attributed either to those who decorated the portico in Pompeii or to the painter of the Roman cycle that it may have been based on; once again this is a false dichotomy. The fact that the painting of Diomedes is positioned at the end of the east wall in such a way as to highlight the impetuosity of Achilles near the other end of that wall suggests that the Pompeian designers were at the very least aware of the mirroring and chose to highlight its importance. The other local aspect of this sophisticated visual analysis of the *Iliad* is the expectation that at least some of the visitors to the portico would have enough education to appreciate this commentary. For some, perhaps, it would have been enough to identify the unlabeled scenes, and to map these onto a dim memory of the epic. But it seems clear that others would have appreciated the cleverness with which the designers interwove the painted and sculptural decoration and the way they highlighted and framed the paintings' commentary on the character of Achilles. Finally, the presence of the wounded Aeneas on this wall is clearly a matter of particular interest for a Roman audience, but I defer discussion of that aspect, for it turns out that this is not the only painting in the portico in which he figures.

NOTES

1. Steinbüchel 1883, notes to figures 8B, 8C, and 8D: "Diese Gemälde befinden sich in dem, das eigentliche Tempelgebäude umfassenden Hofraume und Säulengange, an der Wand rechts vom Haupteingange."
2. Cf. Overbeck and Mau 1884, 636n41, and Mau 1904, 49.
3. It is true that Gell makes this cloak blue in his sketchbook (fol. 70), but there is other evidence to support Callet here: the detail of the red cloak is confirmed by the small fragment of this composition that survived in the atrium of the House of the Tragic Poet.
4. Brüning 1894.
5. Cf. *LIMC*, s.v. "Achilleus," 543 (with drawing).
6. I owe this point to John North Hopkins.
7. Steinbüchel's caption reads, "Der Alte Nestor, die erzürnten Fürsten zur Ruhe und Eintracht mahnend."
8. E.g., Spinazzola 1953, 983. This identification goes farther back: Niccolini and Niccolini 1854–96, 2:51, list "l'ambasceria degli Achei ad Achille" among the subjects of the paintings in the portico.
9. Thus Brüning 1894, 147, was wrong to suppose that Agamemnon must be the addressee, and the objection of Kossatz-Deissmann (*LIMC*, s.v. "Achilleus," 436) to the identification of Calchas here because of the absence of Agamemnon is groundless. Calchas addresses the whole assembly, but it is Achilles who has commanded him to speak. It is only after the end of the speech represented here that Agamemnon bursts in angrily. See also Bulas 1929, 79–80.
10. By way of contrast, consider the methodology of Rodenwaldt 1909, 229–30, for whom the phenomenon of juxtaposing a sitting and a standing figure is not the result of a Roman painter's compositional choices but rather the sign of a Greek original shining through its degenerate Roman copy.
11. See Spinazzola 1953, 908–10 and 976–77.
12. As noted by Moormann 2011, 80.
13. This fact was rediscovered and its importance was identified by David Saunders, to whom I am grateful for the information; the report is in Overbeck and Mau 1884, 637n45.
14. Van Andringa 2012, 109, says of the statues that "their original location is far from certain," but

it is not clear whether he is aware of the information about the matching mount points given by Overbeck and Mau.

15 See Salmon 2000, 82–85; Goldicutt's plan of 1816 is Salmon's fig. 58. Salmon also shows (his fig. 59) a plan of 1818 in which the Artemis appears to be missing; this may be a simple error, as the other statues are in their proper positions.
16 E.g., Fiorelli 1875, 239; Bulas 1929, 106; and Schefold 1957, 192.
17 Brüning 1894, 148.
18 *LIMC*, s.v. "Achilleus," 459 (with drawing).
19 Brüning 1894, 148, fig. 10, which is drawn after *Wiener Vorlegeblätter für archaeologische Übungen* 1889, pl. 8, fig. 5. It appears likely that the object was lost when the Reims archaeological museum was destroyed by a German bombardment in 1914: see Jadart 1914, 593.
20 See Brüning 1894, 148, and Six 1917, 189.
21 See Dobbins et al. 1998, 752.
22 Shown by Salmon 2000, fig. 58, p. 83; for a contemporary plan that shows no doorway here, compare his next figure (fig. 59, p. 85).
23 Mau 1904, 81, with fig. 29.
24 Vol. 1, fol. 89, of Gell's Paris notebooks.
25 Mazois 1812–38, 4:44.
26 Rochette 1840, 195–98.
27 For an exception to that neglect, see Van Buren 1938, 72.
28 An example of one of these candelabra is probably pictured on fol. 61r of Gell's notebook, where it is labeled "T. of Bacchus, wall next the Forum."
29 See J. Boardman and C. E. Vafopoulou-Richardson in *LIMC*, s.v. "Diomedes 1," 42–61, with 46 being the portico painting.
30 See the report of another Austrian, Goro von Agyagfalva 1825, 128.
31 Diepolder 1926, 70; the identification is approved by Thompson 1960, 70n8. The alternative parallel proposed by Six 1917, 189–91, is implausible.
32 See *LIMC*, s.v. "Apollon/Apollo," 485, with illustration.
33 Sadurska 1964, 41, glosses the content of this scene as "Les soins aux plaies. Ménélas et Machaon sont assis l'un en face de l'autre penchés en avant."
34 Mazois 1812–38, vol. 4, pl. 20.
35 ἴσον ἐμοὶ φάσθαι καὶ ὁμοιωθήμεναι ἄντην (*Il.* 1.187).
36 Admittedly, the left arm holding the scepter is a bit awkwardly attached to Calchas's body in Steinbüchel's drawing, but the arm could not belong to anyone else.
37 I owe this point to Marco Fantuzzi, who compares the way Odysseus takes Agamemnon's scepter in Book 2 when he acts as the leader in putting to right the consequences of Agamemnon's foolish loyalty test.
38 As Marco Fantuzzi points out to me *per litteras*: "The scepter that Chryses is holding is intended to represent his religious authority, in a moment when he needs all the authority he can show off in dialogue with a sceptered king. Someone who intended to represent Calchas on the verge of expressing an authoritative prophecy, and again was going to do that in front of an Agamemnon who was not going to be pleased with the contents of that prophecy, may have liked to reproduce the iconography of another religious figure connected to Apollo who had dared to contradict Agamemnon's plans."
39 Squire 2011, 165–76, has shown that the *tabula Capitolina* similarly displays sophisticated iconographic juxtapositions.
40 On Homer's "partiality" for Diomedes, see van der Valk 1952.
41 On the probable antiquity of this story, see Gantz 1993, 518.

Chapter 3

The Remainder of the Portico

For reconstructing the east wall of the Pompeian portico, there are two architectural elevations, both clearly intended to represent the actual state of the ruins. For the other walls of the portico, alas, there is no such elevation at all. This means that the primary source for the appearance of these walls is the cork model in the National Archaeological Museum of Naples (see fig. 8). The model shows a great deal of plaster surviving on the north wall, perhaps more even than on the east wall, with apparent indications of three fully preserved figural paintings in its western half. Unfortunately, it does not seem likely that this part of the model preserves any reliable detail about the particulars of those paintings. From a distance, they appear to be simply dark squares intended to do no more than to indicate the presence of a painting. If one stares intently at a greatly magnified detail of one of those squares, the ghostly presence of figures may be detected (fig. 45; see fig. 10, no. 27). But the nearly monochrome darkness of the squares suggests that they were not meant to be meaningfully legible. These images were presumably drawn at third hand: Felice Padiglione's 100:1 cork model was a copy of his father, Domenico's, 48:1 original, whose painted decoration was presumably copied in a workshop from a drawing that was made onsite. So, even if the Naples museum were to publish properly lighted, close-up photographs of the murky squares, any details therein would have to be treated with great caution. The result is that the position of the paintings on the other three walls is much more a matter of guesswork. Nevertheless, it is still worth examining the evidence.

FIGURE 45 Detail of fig. 49, from the Plastico di Pompei (see fig. 8), possibly showing the vestiges of a figural composition on the west side of the north wall of the Sanctuary of Apollo

The next wall to be examined is on the north side of the portico. The cork model shows more plaster there than anywhere else, so this is the most likely location for the two Steinbüchel drawings left to place, both of which seem to come from the end of the *Iliad*. As I indicate, Gell's notebook tends to confirm that one of these was on the north wall. One consequence of this inference is that the Iliadic narrative was not continuous around the walls. The east wall had the beginning of the epic and the north wall its end; the middle was presumably on the west and south. This is in fact quite normal; all the other Iliadic cycles in Pompeii display a similar tendency to jump from wall to wall at various points in the narrative.[1]

Mazois and the Northeast Corner

Before I proceed further, it is important to eliminate from consideration a piece of evidence for the surviving plaster on the north wall that looks extremely promising but turns out to be worthless. Mazois printed a large lithograph with a view of the front elevation of the temple, and on either side of it one can see the north wall of the portico. On the far right, there is a quite complete panel of pillar-style decoration with a detailed representation of a figural composition at its center. One might hope it would be easy to follow the same methodology here as for the east wall: find the original watercolor, blow up the detail, and match it to Steinbüchel's drawings. Unfortunately, this lithograph belongs to a genre completely different from the elevations of the east wall. Architects visiting Pompeii generally produced two kinds of work: detailed studies of the ruins as they were and elaborate reconstructions of how the buildings might originally have been. Mazois's view of the north wall belongs firmly to the latter category, as can be seen from his original watercolor, which is preserved in Paris at the Bibliothèque nationale (fig. 46). It is true that this watercolor is not as exuberant as the fanciful reconstructions of some other artists in its treatment of the painted decoration, but all the architecture is presented in its imagined pristine state. Some artists would have supplied an equally invented and full set of wall paintings, extrapolated from what did survive.[2] Mazois chose not to do that but presented a wall with crumbling plaster and only one panel partially preserved. This seems to be a strange hybrid of restored architecture and unrestored painting. Is it possible that, despite the improvements made to the state of the architecture, the representation of the state of the painting is accurate?

Other evidence directly contradicts Mazois's treatment of the eastern panel in the north wall, showing that it is, unfortunately, completely without value as documentary evidence. That is, it was designed for a different purpose: as an imaginative tool to give the viewer a general idea of what the sanctuary as a whole looked like. This corner in the cork model shows a very, very different picture (see fig. 15), not a single pillar-style panel but something not seen on the east wall. The area to the right of the small doorway is not a unified composition but is divided in half, with the wall

FIGURE 46 François Mazois (French, 1783–1826), Reconstructed view of north elevation of the Temple of Apollo in Pompeii, n.d. Watercolor original for the lithograph shown in *Les ruines de Pompéi* (1812–38), vol. 4, pl. 18. Paris, Bibliothèque nationale de france, RES GD-12 (G)-FT 4

itself being divided into two surfaces. Just to the right of the midpoint of this area, the wall thickens considerably and breaks the compositional plane. The presence of this feature is confirmed by Mazois's own plan (see fig. 10, nos. 20, 21) and by a number of other contemporary plans.[3] It is hard to see how a unified composition, such as Mazois shows in his reconstruction, could have been accommodated on an uneven wall surface. The discontinuity would have run through the figural composition. The cork model shows a decorative scheme that responds to the physical nature of the wall. The right side (see fig. 10, no. 20) is flat with large planes of a single color in the manner of the niche style, but the particular colors, with a white field above a yellow base, recall the pillar style. There is a figural painting at the center, but it appears to be slightly smaller than those seen on the east wall. To the left of the discontinuity in the north-east corner wall, continuing toward the small doorway, exuberantly three-dimensional trompe-l'œil architecture very strongly recalls the pillar style but seems to have a distinctly different design. In particular, it does not have a *pinax* as its focal point, for the plaster survived to a sufficient height to reveal the absence of a picture frame.

These are two contradictory views of the north wall between its eastern end and the small doorway. Mazois's is from a self-evidently speculative and imaginitive work, while the cork model is expressly documentary. The former flies in the face of the surviving fabric of the wall and the latter respects it. If that is not enough, there

are some late-nineteenth-century photographs of the northeast corner of the temple in which parts of the portico wall can be glimpsed through the columns. Several of these show blurred and shadowy lines on the wall just to the right of the small doorway.[4] These indistinct shadows are not very legible on their own, but they agree with the cork model, confirming its reliability here. The rest of Mazois's reconstruction of the north wall is equally unreal. Apart from the rightmost panel, he implies that the rest of the painting was destroyed, except for a series of pillar-style bases running across the wall, conveniently centered precisely within each intercolumniation. This contradicts all the other evidence, which shows that the pillar style and the niche style tend to alternate irregularly. The cork model shows a much messier and more realistic picture, which, although based on data from considerably later, shows much more plaster surviving. If one accepts that Mazois's image here is truthful, the implication is that the Padigliones not only misrepresented the truth but invented large areas of painted plaster on their cork models.

The necessary conclusion is that Mazois's elevation of the north side of the sanctuary is not meant to be realistic at all, despite the crumbling plaster he puts on the rear wall. The whole reconstruction is meant to give a sense of the original dignity and grandeur of the monument. Perhaps Mazois sensed, rightly, that the fancy that many artists expended on the elaboration of wall paintings in their reconstructions was excessive. So, instead of reconstructing a busy and invented extrapolation of what was on that wall, he carefully depicted a single, well-preserved pillar-style panel from elsewhere in the portico and then provided the lower register running across to the left to encourage the viewer to reconstruct in the mind's eye a whole series of similar panels across the wall. In a way, this was a more sophisticated and restrained technique than to force upon the viewer the artist's own reconstruction. But this approach requires the presence of a particularly well-preserved and representative section of plaster on a part of the wall that is not obscured for the viewer. The cork model makes it clear that the wall as it existed did not provide this section, so Mazois tidied up the messy reality and he imported a well-preserved and impressive bit of decoration from elsewhere. But from where? He might have slid rightward a part of the wall hidden behind the cella, but he did not do that. The cork model shows that the two pillar-style panels on the north wall were of a slightly different type, which correspond to a different image by Mazois.

The panel that Mazois transports to the eastern end of the north wall bears a striking similarity to a part of the portico already examined: the pier decorated with the picture of Diomedes wounding Aphrodite (see fig. 5). If a magnified detail of Mazois's watercolor (fig. 47) is compared with the northmost pillar of Callet's elevation of the east wall (see fig. 28), or indeed with the northmost pillar on Mazois's own elevation (see fig. 27), the correspondences are uncanny. The Diomedes pier was by far the best-preserved example of the pillar style with an intact figural composition.

104 ART IN POMPEII

FIGURE 47 Detail of fig. 46, showing the eastern (rightmost) end of Mazois's elevation of the north wall of the portico

For this reason, Mazois may have been tempted, when faced with the irregularity of the north wall and the fact that none of its pillar-style panels were ideally impressive in their state of preservation, to slip the Diomedes pillar around the corner to the north wall, where it could represent by synecdoche the decorative program of the portico as a whole. The cork model does show that there were two pillar-style panels on the north wall, but these are quite different in their bluish coloring. The reddish coloring of the panel Mazois shows on the north wall belies its true origins on the east wall.

If this argument is correct, then the figural painting on the north wall ought to show Diomedes wounding Aphrodite. The image is not easily legible, but this does seem to be the case (see fig. 47). Mazois shows what seem to be two figures, a male on the left and a female on the right, with a large circular object, presumably a shield, between them. The warrior is in a stance that looks very like that of Diomedes: his right leg drawn straight back toward the lower left of the painting and right leg forward, bent at the knee, foot apparently elevated. His right arm is drawn behind him, grasping his spear overhand at waist height. The female figure on the other side is carrying something, but in this image it is not clear what. It certainly could be Aeneas. The most surprising thing about Mazois's version is the complete absence of Athena on the left, particularly in light of Morelli's testimony that her upper body was the best-preserved part of the painting. Presumably this was a deliberate omission to simplify and conserve space.[5]

The North Wall

If Mazois's reconstructed elevation is not reliable documentary evidence in this case, there is only the testimony of the cork model to rely on. I now examine the model's representation of the north wall, continuing westward from the east corner. As noted, the part of the wall to the right of the small entrance is physically divided into two halves (see fig. 10, nos. 20, 21), and the left side has some illusionistic wall painting with similarities to the pillar style, but apparently no figural painting. Next comes the small doorway into the apartment to the north of the portico (see fig. 15). This area has generally been assumed to have been for the use of the priests of the sanctuary and this seems a reasonable guess. Early visitors often commented on its painted plaster decoration, which consisted of small round tondi showing fauns on large planes of color with delicate decorations. The main surviving feature of these rooms, which early visitors frequently commented upon and illustrated, was a painting of Bacchus leaning upon Silenus, who is playing the lyre (fig. 48).[6] It was this feature that gave the temple its short-lived designation as the Temple of Bacchus, an attribution Gell was particularly fond of. I do not dwell upon the apartment, for the decorative scheme was different and the Trojan theme apparently did not extend as far as this. Indeed, Dionysus does not appear in the Homeric pantheon, so it is appropriate that he does not make a public appearance in the portico itself. Nevertheless, the lyre that Silenus plays in this picture is the instrument of Apollo, god of the temple, as Virgil reminds in the *Eclogues* (6.82–84):

> Omnia, quae Phoebo quondam meditante beatus
> audiit Eurotas iussitque ediscere lauros,
> ille canit.
>
> (All the songs that of old Phoebus [Apollo] rehearsed, while happy Eurotas listened and bade his laurels learn by heart—these Silenus sings.)

If the main temple portico came to remind the people of Pompeii of the first book of the *Aeneid*, perhaps it is not entirely fanciful to connect Silenus in this small apartment with the *Eclogues*.

Back at the portico proper, to the left of the small doorway into the priests' apartment are two panels that would be visible to a viewer standing within the central area of the sanctuary to the right of the temple podium (fig. 49). Because they are not obscured from the front by the temple podium, their state of preservation has been recorded many times over many decades. From the very first sketches of the sanctuary to the advent of photography, many artists chose to record a view of the monument from a point inside the portico to the right of the temple. One of the most pleasant and detailed of these views is by Rossini.[7] He, like most other artists, shows a line of plaster fairly low to the ground, with only the bottom of a figural painting surviving in

FIGURE 48 Engraving of an image from the Temple of Apollo in Pompeii. From Anton Steinbüchel, *Grosser antiquarischer Atlas* (1833), vol. 8, pl. D3

FIGURE 49 Detail of the Plastico di Pompei (see fig. 8), showing the western side of the north wall of the Sanctuary of Apollo

the panel just to the right of the temple podium (see fig. 10, no. 23). Early photographs from this angle, such as one by Giacomo Brogi (see fig. 9), tell much the same story, with a bit of plaster loss so that the bottom of that figural painting is gone, if indeed it was ever there.[8] These sources agree in general terms with the cork model, which can provide some additional detail. Just to the left of the doorway there is yet another variant on the pillar-style scheme (see fig. 10, no. 22; fig. 15). The yellow-and-black base is clearly present at the bottom, as is a certain amount of trompe-l'œil architecture on either side. In the middle is a vertical object that may be a candelabrum intended to

CHAPTER 3 **107**

FIGURE 50 Detail of the Plastico di Pompei (see fig. 8), showing the northwest corner of the Sanctuary of Apollo

support a frame for a figural painting, but it has the unique feature of two figures, one on either side of it. The Brogi photograph confirms the accuracy of the cork model here. No trace of a figural painting survived, even though the plaster break on the cork model runs fairly high. The second panel to the left of the doorway is in the niche style (see fig. 49; fig. 10, no. 23). Here the bottom of a figural painting does appear. Brogi's photograph shows some plaster loss but adds the information that there were three objects or figures atop the heavy red frame, below the Trojan painting.

Moving to the left again: early photographic views of the north wall are obstructed by the temple podium, so the only available evidence is from the cork model. This shows four panels with a variation on the regular pattern of alternation of niche- and pillar-style panels (see fig. 10, nos. 24–27; fig. 49, third to sixth panels from the small doorway on the right). The first of these panels (see fig. 10, no. 24) is pillar style, as one would expect, but then there are two consecutive niche-style panels (see fig. 10, nos. 25–26) and then another pillar-style panel (see fig. 10, no. 27). Then there is another niche-style panel (see fig. 10, no. 28) and one more before the end of the wall. To get a view of this last panel on the north wall (fig. 50), one needs to look from a different angle; the expanse of white ground around the space for the figural painting shows that this was also a niche-style panel (see fig. 10, no. 29). So here again there are two consecutive niche-style panels and the principle of alternation is broken again. Another interesting thing about this stretch of wall is that the cork model promises that three of the five panels on the western side of the wall had figural paintings mostly intact. The problem is that there are only two more Steinbüchel drawings to fill those three locations. The probable explanation for this apparent inconsistency is that at least one of those three dark squares represented not a surviving painting but empty, unfinished plaster. This becomes apparent when I compare the two pillar-style panels on this stretch of wall with a lithograph from Mazois.

More Blank Panels

Two pillar-style panels on the north wall (see fig. 10, nos. 24, 27; fig. 49: third and sixth panels from small doorway on the right) are very similar to each other, though the one on the left has more plaster surviving. They exhibit some differences from the types of pillar-style decoration seen on the east wall, the most important of which has to do with the use of color. In particular, there is little to no use of red here; instead there is a prominence of blue. This color scheme does, however, correspond very well to Mazois's panel with the blank space at the center that was discussed in the previous chapter (see fig. 36). To appreciate the difference, compare Mazois's color lithograph and that of Rochette (see fig. 5). Apart from the absence of a central panel and a few very small divergences in the ornamentation on the architecture, the main distinction between them is in their utterly different coloring. In both lithographs the main architectural elements in the foreground are yellow, but the detailing in Mazois's is purple while in Rochette's it is dark red. The architecture in the background is shown as light blue by Mazois but light red and dull brown by Rochette. The dominance of red in the east-wall version of the pillar-style decoration is confirmed by Callet's elevation (see fig. 28), except that the browns in the background are given a more greenish hue. The dominance of blue in Mazois's version is shown to be a genuine variant by the agreement of the cork model (see fig. 49).

There are also some differences between Mazois's color lithograph and these panels of the cork model. The miniature panels appear to be missing the lintel on which the picture frame sits and which should surround the landscape at the bottom. There does seem to be a tree there in both panels, but the architectural element framing it is missing. The main picture frame in both panels is also too big. Instead of sitting comfortably within the illusionistic niche created by the apparently protruding architecture on either side, the figural painting overlaps them. This would make nonsense of the illusion, and it must be the result of a mistake in the process of multiple copying that led to the present model. The biggest difference is, of course, that Mazois put a blank white square at the center, whereas these panels have darker squares. The one on the right preserves only the bottom part of the central frame, which is filled with a bluish color. The central frame in the panel on the left is mostly intact, except for some damage along the right side (see fig. 49). Of Steinbüchel's two remaining drawings (see figs. 53 and 55), one shows damage on the right side, the other along the top. At first glance, the damage on the right side of the central *pinax* on the cork model might suggest that this could be a good match for the former. But a nineteenth-century photograph of the cork model in an earlier phase of its construction does not appear to show any damage at all there (fig. 51).[9] The model, which has undergone extensive conservation work, presumably sustained this minor damage at some later stage in its existence. One can surmise that the main model for Mazois's lithograph was the panel on the left, which the cork model suggests was in a much better state

FIGURE 51 Detail of a nineteenth-century photograph of the Plastico di Pompeii (see fig. 8), showing the north wall of the sanctuary of Apollo in an earlier state of the model

of repair. It follows that it had unfinished plaster in the central picture frame. That featureless, unfinished plaster was represented as pure white in the lithograph and as a darker square in the cork model.

It is possible that the cork model may show a shadowy figure in the painting that was third from the west end (i.e., see fig. 49, the second surviving painting from the left). There could be a seated figure on the left, but this detail is very hard to read (see fig. 45). On balance, it seems best not to press this detail of the cork model too closely, as it is several removes away from the original. The publication of better photographs of the model might make it possible to make further progress. For the moment, I conclude that both blue-variant pillar-style panels on the north wall were blank, as Mazois shows one of them. This implies that the two remaining Steinbüchel drawings came from the two remaining niche-style panels: one near the center of the north wall and the other toward the west end (see fig. 10, nos. 25, 28).

The Position of the Figural Paintings

Recall the set of measurements of the Forum, which Gell kept on the back of a drawing that was later put into his sketchbook (fig. 52). These are divided into fifty-foot sections, and Gell recorded what he saw to his right and left as he walked up the western side of the Forum. In the fifth section, Gell recorded the final, hollow pier of the Temple of Apollo with the *mensa ponderaria* (see fig. 10, no. 18) and noted that there was another opening into the sanctuary beyond it (see fig. 10, no. 19). The next section, the sixth, reads as follows: "In this 50, 5 col[umns of the Forum] in place. At 3rd the T[emple] of Bacchus ends L[eft] with Achilles picture." The next entry for this section records the street to the north of the temple and the start of the large warehouse beyond that. What is the "Achilles picture"? The vagueness of the description is extremely frustrating.

FIGURE 52 Sir William Gell (English, 1777–1836), Verso of folio 61 of the sketchbook (vol. 1) for the first volume of *Pompeiana*, ca. 1819. Ink on paper. Paris, Jacques Doucet Collection, Institut national de l'histoire de l'art, NUM MS 180 (1)

There are two remaining Steinbüchel drawings that still need locations: the supplication of Achilles by Priam (see fig. 55) and the dragging of Hector's body (see fig. 53). It is unfortunate that Gell did not refer to either the "Priam picture" or the "Hector picture"; in the context of the *Iliad*, "Achilles picture" is inevitably ambiguous. The cork model suggests that the likeliest positions are two niche-style panels on the western side of the north wall (see fig. 49), and considerations of symmetry would favor the panel closest to a corner for the end of the narrative of the *Iliad*. It is therefore safest to guess that the Priam painting was the penultimate one at the western end of the north wall. The painting in the very final northwest corner was destroyed (see fig. 50), so it may have shown the burial of Hector, or even a scene from after the events of the *Iliad*. The remaining Steinbüchel drawing, the dragging of Hector, would then have been near the middle of the north wall.

This reconstruction is given some additional support by the verbal reports of early visitors to the portico, who tend to report the paintings in narrative order with the suggestion that they ran counterclockwise. For example, there is an account of the subjects of the paintings in the portico in the *Viaggio pittorico nel Regno delle due Sicilie* (Illustrated journey in the Kingdom of the Two Sicilies) of Domenico Cuciniello and Lorenzo Bianchi, a heavily illustrated work that appeared in three volumes in the period 1829–33. The plate illustrating the Temple of Venus (i.e., Apollo) at Pompeii does not show any useful detail, but the accompanying text has some fairly explicit information, which presumably dates to the 1820s, at which point the figural paintings were still legible.[10] They say that in one place (*Qua*) is the quarrel of Achilles and Agamemnon, in another place (*Là*) is the dragging of Hector's body, and finally in another place is the supplication of Priam (*Finalmente in altro luogo*). Another apparently counterclockwise reading is given by Callet, for he not only painted the sanctuary but also sent back to Paris a written account of the forum area:

> Le Portique est décoré de belles peintures. Les tableaux qui forment le milieu de la décoration des panneaux sont rapportés et représentent différents sujets tirés de l'Illiade [sic] d'Homère, tels que la colère d'Achille, son combat avec Hector, et celui-ci traîné par Achille autour des murs de Troyes [sic].
>
> (The portico is decorated with beautiful paintings. The tableaux which form the centerpieces of the decoration of the panels are preserved and represent different subjects drawn from the *Iliad* of Homer, such as the anger of Achilles, his combat with Hector and the latter dragged by Achilles around the walls of Troy.)[11]

Like many other viewers, Callet seems to have misidentified the combat of Diomedes with Aeneas as the combat of Achilles with Hector. This error would have been reinforced by the position of that painting near the north wall, which did in fact show events near the end of the poem.

112 ART IN POMPEII

Unfortunately, most texts with lists of the subjects of the paintings date from a period in which they had already disappeared, and so their orderings do not constitute independent evidence: they simply recite a list of topics, many of which we can now show to be misidentifications that had been handed down over the years.[12] Errors in this traditional catalogue of topics include the killing of Hector (i.e., the wounding of Aphrodite), the theft of the Palladium (i.e., Machaon healing Menelaus), and the Greek embassy to Achilles in Book 9 (i.e., Calchas addressing Achilles). Furthermore, there was also at least one early visitor to the sanctuary who had seen the paintings when they were still legible and lists the contents of the Trojan pictures in an apparently random order.[13] The point is not that every observer gave the same order of paintings, but that some early viewers seem to have tried to make sense of the order by constructing a reading that went counterclockwise around the east and north walls. The suggestion is that the events of the *Iliad* concluded in the northwest corner, opposite from the southeast corner where they began.

The Dragging of Hector

I can now discuss in detail the content of the two paintings that were probably on the western half of the north wall. The first of these is the painting most commonly identified as showing the dragging of Hector's body. In addition to Steinbüchel's line drawing (fig. 53), there is also the original from which it was probably copied, a color painting in tempera by Morelli (fig. 54), which is on the same sheet as his pencil-and-tempera reproduction and extrapolation of the painting of Diomedes and Athena (see fig. 3). An important difference between the two Morelli paintings is that this one does not have any areas in pencil where the artist has indicated speculative reconstruction. On the other hand, the entire top part of the image is missing. The colors and details of Morelli's painting are confirmed by a sketch in Gell's notebook (folio 63v). The first problem is that there is a great deal to be said for interpreting the inverted figure, viewed in its own right, as a warrior being thrown from a chariot rather than a corpse being dragged.

Others have seen the problem. Steinbüchel himself refrained from identifying this image as anything other than "a battle-scene" (*eine Kampfscene*), which is remarkably vague in comparison to his other very specific identifications. It is probable that he knew of the vulgate identification of this painting as showing Hector's body and silently rejected it. Several subsequent scholars have struggled with the difficulty of reconciling the details of Steinbüchel's drawing with the persistent reports of a painting showing the dragging of Hector's body.[14] Both Helbig's and Schefold's catalogues of Pompeian paintings note the contradiction, stating plainly that Steinbüchel's image shows a "falling warrior" and not a body being dragged.[15]

The issue here is the posture of the inverted figure (see fig. 54), which is sprawled in a very naturalistic way: his hips are above the level of the floor of the chariot, and

FIGURE 53 Engraving of an image from the Temple of Apollo in Pompeii. From Anton Steinbüchel, *Grosser antiquarischer Atlas* (1833), vol. 8, pl. D1

his right arm is raised above his head as if to break his fall. His knees are in midair and, if we follow the greaves on his shins leftward, his feet must be likewise in midair, inside the chariot, where they are obscured from view. The ankles do not come near the axle or the floorboard. The knee of the right leg is drawn a bit farther back, to the point where we can see the midpoint of the calf just inside the chariot. It looks as though the foot of this leg is suspended in midair. The basic problem with identifying this body as Hector being dragged is that most of the body is in midair and it is not at all clear that the ankles are tied to anything.[16]

If this is not the dragging of Hector's body, what is it? One strategy would be to follow Steinbüchel and call it a generic battle scene. There are plenty of episodes in the *Iliad* where warriors are killed and thrown from a chariot. The fact that the falling figure does not appear to be pierced by a spear is not necessarily an insurmountable objection, as he could have been wounded some other way. For example, in Patroclus's final confrontation with Hector, he kills the Trojan's charioteer, Cebriones, by throwing a stone. Homer describes how Cebriones falls like a diver from the chariot, and Patroclus taunts Hector about how the charioteer dove as if fishing for oysters (16.726–50). This is near to a climactic moment in the epic and there is an emphasis on Cebriones's fall, so could this be what the painting shows? If so, the seated figure would have to be another of Patroclus's Trojan victims, for his dejection suggests that

FIGURE 54 Francesco Morelli (Italian, ca. 1768–1830), Copy of painting from the Temple of Apollo at Pompeii, Pencil, ink, and tempera on card, n.d. Archive of the National Archaeological Museum of Naples, ADS 696

he is a captive or wounded; he is wearing trousers and so must be Trojan.[17] In this interpretation, the standing warrior in the background with one foot in the chariot would be Hector in the act of dismounting to confront and kill Patroclus. But that figure seems to be moving forward into the chariot as the horses set off. Without any context or clearer indication, it would be hard to pinpoint this or any particular battle scene with confidence. There are a number of other places in the *Iliad* in which a figure falls from a chariot. Athena knocks Sthenelus from Diomedes's chariot and mounts it herself (5.835–41). The problem here is that the figure in the background, who would be Athena mounting, has bare legs and greaves, whereas one would expect a full-length peplos, as usual. Also, the dejected Trojan would be out of place. Another possibility is the chariot race in the funeral games for Patroclus, where Eumelus is thrown from his chariot after Athena breaks his yoke.[18] Against that, there is the figure in the background, who cannot be Athena, and the fact that the charioteers raced solo. Also, the seated figure would again be hard to explain.

At this point, the dragging of Hector appears to be the least problematic answer, and help with the problem of the figure's posture is available from two sources: the text of Homer and the *tabulae Iliacae*. Homer does not say to what part of Achilles's chariot Hector's ankles were fastened, but many ancient artists visualized it, naturally enough, as being somewhere near the bottom rear. The dragging of Hector was a very

popular motif in ancient art, and often a stiff and horizontal corpse is a prominent feature, even in those images that clearly show, via the walls of Troy in the background, that this was the first dragging of the body immediately after Hector's death rather than one of the subsequent trips around the funeral mound of Patroclus.[19] There is a problem with those representations, however. Presumably, Homeric chariots did not come with a trailer hitch, and tying a body to the spinning axle would pose difficulties. So where did Achilles tie the thong that he put though Hector's ankles?

There is, in fact, a place on the Homeric chariot to which one might tie a leather strap. When Diomedes wants his own charioteer, Sthenelus, to steal the horses of Aeneas while he engages him in battle, he instructs him to tie the reins of his own chariot to the rim (ἄντυξ) to keep it steady while he is away (Il. 5.262 and 322). The necessary implication is that this rim was raised, so as to permit the reins to be tied around it.[20] If Achilles tied Hector's ankles to this front rail, then his body would naturally have been inverted with only his head and shoulders trailing on the ground behind, just as Morelli shows it. Three of the *tabulae Iliacae* seem to show precisely this arrangement. The Capitoline, New York, and Tarentine tablets all show Hector's legs fully inside the chariot, with his torso hanging out its rear and only his head and shoulders and arms clearly touching the ground.[21] Furthermore, both tablets show Achilles's horses rearing up and about to take off, as in the Pompeian painting. It is true that all the tablets show the chariot moving to the right, whereas in the painting it is moving to the left; but I have already shown the order of scenes reversed between the cycle of paintings and the *tabulae Iliacae*, so it would not be too surprising if the direction within individual scenes were reversed as well. The presence of city walls on the tablets indicates that this depicts the first dragging of Hector's body immediately after his death.[22]

On this reading, the surprisingly elevated posture of Hector's lower body is not a problem, but a result of the artist paying close attention to the nature of the Homeric war chariot and also to the text of the *Iliad* (22.397–98):

ἐς σφυρὸν ἐκ πτέρνης, βοέους δ' ἐξῆπτεν ἱμάντας,
ἐκ δίφροιο δ' ἔδησε, κάρη δ' ἕλκεσθαι ἔασεν

(He pierced the tendons of both his feet from heel to ankle, and fastened thongs of oxhide, and bound them to his chariot, but left the head to trail.)

The artist here rightly saw that Homer's emphasis on the trailing of Hector's head is not just a pathetic detail but also a consequence of attaching the thongs to the only available place, at the inside front.[23] The subsequent lines of the epic emphasize the fouling of Hector's once-beautiful head and hair (22.399–405), which is likewise both pathetic and physically necessary. The artist's interpretation also leads to a striking visual image. When the body of Hector lies thus half inside the chariot and half

hanging out of the back, while the mounting Achilles has one foot in and one foot out, it emphasizes that they are in a sense traveling the same journey as companions: Achilles knows that his own death will follow shortly after Hector's. The problem is that this leads to a visual composition that, in the absence of narrative cues, could easily be taken to show a stricken warrior falling out of his own chariot. This may have been a source of confusion even in antiquity, which has implications for a notorious interpretive problem in Virgil's *Aeneid*.

Priam and Achilles

The remaining Steinbüchel drawing (fig. 55) has always been identified as showing Priam's supplication of Achilles from Book 24 of the *Iliad*. It appears to show a bearded man in a posture of supplication before a seated warrior. The trace of a beard excludes the possibility that this is Patroclus begging Achilles to intervene on behalf of the hard-pressed Greeks. A possibility that would have to be taken more seriously is that it shows Phoenix supplicating Achilles in Book 9.[24] If the kneeling figure in Steinbüchel's drawing were obviously wearing headgear, a diadem or a Phrygian cap, as Priam normally does, there would be no ambiguity.[25] On the other hand, the

FIGURE 55 Engraving of an image from the Temple of Apollo in Pompeii. From Anton Steinbüchel, *Grosser antiquarischer Atlas* (1833), vol. 8, pl. C2

kneeling figure does wear a garment with sleeves, which should mean that he is a non-Greek.[26] In the *Iliad,* Priam must kneel before Achilles to clasp his knees (24.478), whereas Phoenix is not explicitly said to kneel. Priam seems a safe identification for this scene, for his apparently bare head is a plausible accident of copying.[27] The figure standing in the background behind Priam would then be Hermes, still in disguise as a soldier. The missing right side of the painting might have shown the ransom that Priam brought with him.

Once again, this is a composition of figures very common in the *tabulae Iliacae.*[28] The figure of Priam kneeling before the seated Achilles often serves as the climax of the narration of the events in the *Iliad.* Sometimes, as on the Capitoline tablet, the position of the figures is reversed, depending on the needs of the visual narrative. Sometimes the figures are shown as they are in this painting, with Priam approaching from the right. The freedom with which the artists of the *tabulae* inverted scenes such as this to their mirror image suggests that the fresco artist(s) might well have done the same. This in turn provides some collateral support for our guess that the events on the north wall ran from right to left, for in both of these paintings the implied motion is in that direction: the horses of Achilles drag Hector out of the painting to the left and Priam approaches the seated Achilles from the right.

All the representations of this scene on the *tabulae* are generally similar to the painting, but one stands out as particularly close. On the tiny tablet in Paris that shows this scene alone, Achilles is seated in his tent on a throne in an identical posture

FIGURE 56 Drawing of the small *tabula Iliaca* with the ransom of Hector.
From Otto Jahn and Adolf Michaelis, *Griechische Bilderchroniken* (1873), pl. 4F

118 ART IN POMPEII

(fig. 56). His upper body is bare and is turned toward us; his right hand hangs by his side, slightly bent at the elbow; his left hand must grasp a spear or staff resting on the ground, with that forearm vertical and the elbow bent. In front of him Priam kneels and stretches both hands out, the right hand higher than the left. The only significant difference in the depiction of the figures is that here Priam is wearing a mantle over his head.[29] It should also be noted that the posture of the seated Achilles, with one hand grasping his staff, is identical on the Capitoline tablet (not shown), except that here he is facing in the opposite direction. So once again there is a composition of figures identical to that in the *tabulae Iliacae*. The next painting from the portico I examine is from outside the story of the *Iliad*, so it is worth pausing here to emphasize that there are extremely close parallels in the *tabulae Iliacae* for all the well-documented Iliadic paintings in the portico. It is hard to avoid the conclusion that both the tablets and the portico took, in some degree, very important inspiration from the same Iliadic cycle.

The Dwarfs

Before I turn to the meager evidence for the west and south walls of the portico, I should say a few words about one minor feature that is securely attested to there and elsewhere, the Nilotic landscape scenes with architecture and pygmies that gave the sanctuary its original name of House of the Dwarfs. One of the peculiar features of the first volume of *Pompeiana* is that Gell and Gandy provide many lithographs of these Nilotic scenes, but despite their clear interest in the painted decoration of the monument, their book pays relatively little attention to the Trojan paintings. It seems that Gell transmitted his record of the temple to Gandy in London at a time before the Iliadic theme of the temple had been clearly recognized. The sketches in Gell's notebook do record the quarrel of Achilles and Agamemnon and the dragging of Hector, but nothing beyond that, and the text never discusses the Iliadic theme. On the other hand, Gell and Gandy provide the best documentation of these Nilotic images that other sources, more focused on the Trojan theme, tend to ignore (e.g., fig. 57).

Gell's notebook gives some information on the location of these images, mainly on the west and south walls. Labels indicate that several of the originals came from the west wall.[30] The plan in his notebook labels the east side of the south wall as containing "paintings of Dwarfs," and several of the labels on individual drawings confirm this.[31] It would be wrong to think that these features were only on the west and south walls, however, as one of these architectural landscapes is indicated as coming from the east wall.[32] So it seems that these were a minor element in the general decorative scheme and they are mainly associated with the west and south walls precisely because little else survived there.[33] In terms of content, they seem to show pygmies at a variety of occupations, some peaceful, some not. In addition to Gell's drawings are some

FIGURE 57 Sir William Gell (English, 1777–1836), Folio 62 of the sketchbook (vol. 1) for the first volume of *Pompeiana*, ca. 1819. Ink on paper. Paris, Jacques Doucet Collection, Institut national de l'histoire de l'art, NUM MS 180 (1)

FIGURE 58 Francesco Morelli (Italian, ca. 1768–1830), Copy of paintings from the Temple of Apollo at Pompeii, n.d. Pencil, ink, and tempera on card. Archive of the National Archaeological Museum of Naples, ADS 697

sketches in color made by Morelli (fig. 58). Other images in this vein simply show architecture in a landscape, and it is not clear if these represent a different element in the overall design or are only a variant.

Where in the overall pillar- and/or niche-style decorative scheme did these images feature? The predominant shape of the panels seems to be both long and short. It is possible that these came from the black insert at the base of the pillar-style panels, but the evidence does not point in that direction. Rochette shows the north pillar of the east wall as having a still life with tableware in that insert (see fig. 5), while Mazois renders it as blank in his elevations of both the east and the north walls (see figs. 27 and 47). Gell and Gandy's *Pompeiana* adds a bit of useful information: "Around the walls of the porticoes, at 2 feet 6 inches from the ground, run a series of paintings, of dwarfs and architectural subjects."[34] This strongly suggests that the architectural and pygmy scenes were variants of a design element that appeared at that height. A little under a meter from the floor seems too high for the bottom register of the pillar style. But there is a register of the niche style higher up from the ground that would fit very well with this account, for Callet's elevation of the east wall shows a number of long, low panels whose contents are a good match for these Nilotic landscapes. Directly beneath the large red frame that surrounds the white field around the central picture frame is another red frame, low and rectangular, which rests in turn upon the top of the bottom register of the panel. In Callet's view of the Calchas panel, there is something that looks like architecture in a landscape (see fig. 12). In the next niche, with the quarrel of Agamemnon and Achilles, he shows the outline of some shadowy figures fighting and perhaps hunting (see fig. 18). This corresponds to the other major theme of those paintings: battles of pygmies against each other and against animals, such as crocodiles. It seems most likely, therefore, that Gell took these "dwarf" scenes mainly from the lower parts of surviving niche-style panels around the four walls, including the west and south walls, where his notebook attests that they survived and where the lack of evidence suggests that, higher up, the Trojan pictures did not, by and large, survive.

Did the pygmies mean anything? One approach would be to dismiss the figures as simple examples of the Nilotic genre scenes found widely in Pompeian painting.[35] But even the commonest design element can take on a pointed meaning when used in a context that activates its latent significance. This is what happens when the subepic struggles of the pygmies are juxtaposed with the grand, epic themes of the Trojan paintings. Bonucci, who saw the portico before the frescoes had been destroyed, understood brilliantly the point of the contrast:

> Nelle altre [pitture] si vede ricordata qualche scena delle battaglie de' Pigmei conto le Grù. Comico contrapposto, col quale il Pittore ha voluto forse tradurci in diverso linguaggio l'ironia con cui Omero solea contemplare la gagliardìe de' topi e de' ranocchi.

(In the other pictures are recorded several scenes from the battles of the pygmies versus the cranes. A humorous counterpoint, by means of which the painter meant perhaps to translate into a different language the irony with which Homer used to contemplate the heroic exploits of the frogs and mice.)[36]

In other words, the struggles of the pygmies were more than a random subepic element but belonged to a long-existing tradition of generic play. Pygmies at war had been used as an ironic counterpoint to the Trojan War ever since the simile at the start of the third book of the *Iliad* (lines 1–8), where the noise of the advancing Trojans is compared to that of the cranes when they attack the pygmies. From a Roman point of view, equally important was the passage from the prologue to the *Aetia* in which Callimachus applied the noise of the cranes attacking pygmies to bad, long-winded poetry.[37] Callimachus was criticizing not Homer, of course, but rather his incompetent epigones. In the present context, therefore, the Nilotic scenes have a particularly satirical meaning: not merely a mock-epic juxtaposition, but a pointed allusion to the dangers of quasi-Homeric bombast. Does this reminder of the perils of following Homer too closely as a model apply to painters, or only to poets? Perhaps, like the Homeric tag on Zeuxis's *Helen*, these pygmies serve to point out that there are limitations on poets that do not apply to painters. A poet who follows Homer too closely risks seeming puny in comparison, whereas the painter of the large panels in this portico was able engage with that model as a peer.

The West Wall

The west wall poses particular problems, and there is no evidence that any Trojan paintings survived there. It generally rises to a lesser height than the other walls of the sanctuary, and the cork model shows almost no painted plaster along its length. The position of the temple within the large cork model of the city makes it difficult to get a clear view of this wall, but there is a very small bit of plaster near the floor at the southern end (fig. 59).[38] This shows only the very bottom register, but there is

FIGURE 59 Detail of the Plastico di Pompei (see fig. 8), showing the southern end of the west wall of the Sanctuary of Apollo

enough to confirm that the decorative theme of this part of the wall had alternating pillar-style and niche-style panels. Starting from the south end and moving north, we find the yellow base with black insert of the pillar style, then a hint of the deep-red base of the niche style; the pattern repeats with vestiges of the pillar style, then niche style, then pillar style (see fig. 10, nos. 31–35). Gell's information that there were dwarf paintings on this wall suggests that, at least for some niche-style panels, the plaster on the west wall survived to a somewhat greater height when he visited than is shown on the cork model. But was it high enough to preserve any figural paintings?

The only early view of the west wall I have been able to find comes from the papers of John Goldicutt in the archives of the Royal Institute of British Architects, an institution he helped to found.[39] A peculiarity about this set of Pompeian drawings is that they are annotated in two different hands. One artist has tiny, precise handwriting and always writes in French. The other forms much larger and sloppier letters and prefers to write in English but occasionally clarifies in French the minuscule writing of the first hand; this is presumably Goldicutt. He was in Pompeii in 1816–17, after a period of study in Paris; until shortly before that, Naples had been under French rule. One explanation that has been offered for the French annotations on these drawings is that, as an Englishman, Goldicutt may have found it more difficult than a Frenchman to obtain permission to sketch the ruins, and that he may therefore have acquired the work of another artist to supplement his own.[40]

One French sketch in Goldicutt's collection, which is labeled in the minute hand "temple de Venus" (as it was then called), has at the bottom a very hasty, informal view of the west elevation of the sanctuary (fig. 60). On either side of the temple podium one can see squares between the columns of the portico, which might at first glance seem to be figural paintings. A closer look, however, shows that the tops of these squares are below the level of the top of the temple podium, whereas the elevations of the east wall show that over there the bottoms of the figural panels were just above the top of the podium. So the squares on the elevation of the west wall are too low and hence must designate not figural paintings but merely the presence of

FIGURE 60 Detail of a photograph of an undated drawing of the western elevation of the Temple of Apollo in Pompeii (labeled "temple de Venus") by an anonymous hand, possibly a French acquaintance of John Goldicutt. Drawing in the archives of the Royal Institute of British Architects: RIBA SD100/3/16 (original numbering 46). Los Angeles, Getty Research Institute, 2002.M.16, Box 428, 611

decorated plaster. Both south and north of the podium, the plaster seems to rise to a point just below the level of the top of the podium, but there is some uncertainty as to which line represents the top of the wall and which represents the plaster break. Nevertheless, this sketch offers fairly good evidence that immediately after excavation the plaster survived to a level just below the figural paintings along a considerable length of the wall. This fits with the rest of the evidence: Gell attests that there were "dwarf "paintings here, which seem to have come from a level a bit below the Trojan paintings; and no paintings from the middle part of the *Iliad*, which might have gone here, seem to have survived.

The reason the plaster decayed so rapidly in the period before the state represented by the cork model was probably related to its unusual construction: this is one of the features of the sanctuary that early visitors note most frequently. I have already observed that there were places in the portico where the figural paintings were mounted separately on the wall. This was apparently the practice on the west wall, and for more than just the Trojan pictures. Many reports indicate that the entire wall was provided with a second surface on which the painted plaster was mounted. Callet says:

> La manière dont est construite la partie du mur, du côté de la petite rue, est ingénieuse et très propre à garantir les peintures de l'humidité. Le stuc sur lequel ces peintures existent pose, en cet endroit, sur de grandes tuiles qui laissent entre elles et le mur un espace de 4 à 5 pouces. Ces tuiles sont attachées par des grandes clous et isolent ainsi les peintures de toute espèce d'humidité.

> (The way the part of the wall on the side of the little street is built is ingenious and very appropriate for protecting the paintings from moisture. The stucco containing these paintings rests in this location on large tiles which leave between them and the wall a space of 4 to 5 inches. These tiles are fastened with large nails and thus isolate the paintings from any kind of moisture.)[41]

That this false surface was designed for the purpose of keeping the plaster away from moisture is the explanation inevitably offered by those who report this feature. The blind alley behind the west wall was thus frequently assumed by early visitors to have been an aqueduct. This seemed to provide an explanation for why all the plaster on this wall needed particular protection from damp. As the British architect Joseph Woods noted: "The west wall has a coat of tiles to receive stucco on account of aequeduct [sic] behind."[42] Gell's plan annotates the west wall with "Tiles nailed on to prevent damp," and the space behind the wall has the words "supposed[?] watercourse."[43] The Austrian military engineer Ludwig Goro von Agyagfalva waxes enthusiastic about the technology:

An der westlichen Seite der Umfassung sind die Malereien auf hohle,
mit kachelartigen Ziegeln gemachte Wände angebracht, um sie von der
Feuchtigkeit des daranstossenden Wasser-Canals zu sichern. Eine nachahmung-
swürdige Vorsicht bei Wandgemälden!

(On the western side of the precinct the paintings are fitted on hollow walls made
with tile-like bricks in order to protect them from the moisture of the water canal
running behind. A precaution for wall paintings well worth imitating!)[44]

Steinbüchel likewise supposes that the purpose of the false wall was to guard against
dampness. In an earlier volume of his *Atlas*, he gives an illustration of what one of these
wall tiles looked like. It shows a square tile with a boss at each corner to act as a spacer.
The text explains that the tiles were nailed to the wall, with the bosses creating a gap
between tile and wall, so that the paintings on the tile were protected from damp. Stein-
büchel is unclear as to how much of the west wall was covered thus: he says that the
enclosing wall of the whole portico was constructed in this way and then notes that the
double wall is clearly visible on the left (i.e., the west side) of his elevation of the north
wall, which was copied from Mazois.[45] Mazois's original watercolor (see fig. 46) for the
published engraving that Steinbüchel copied shows that the Austrian was quite right. On
the far left, one can see in profile the little blind alley, then the portico wall, and then a
cross section of the false wall; even the nails holding the tiles are visible (fig. 61). So here
is more evidence, even if Mazois's elevation is a reconstruction rather than documentary,
that there were indications that the entirety of the west wall was once covered in tiles.

FIGURE 61 Detail of fig. 46, showing the western end of Mazois's north
elevation of the portico, where one can see *tegulae mammatae* affixed to
the west wall and the blind alley next to it

FIGURE 62 Photograph of an undated drawing of the tiles attached to the western wall of the Sanctuary of Apollo in Pompeii (labeled "temple de Venus") by an anonymous hand, possibly a French acquaintance of John Goldicutt. Drawing in the archives of the Royal Institute of British Architects: RIBA SD100/3/7 (original numbering 37). Los Angeles, Getty Research Institute, 2002.M.16, Box 428, 611

Fortunately, there is an even more precise account of how the tiles were arranged on the west wall, in the form of another sketch by the unidentified French acquaintance of John Goldicutt (fig. 62). This sheet has cross-sectional views of the tiles from various sides that fully document their mode of attachment. Each tile was 490 square millimeters with a spacer and nail at each corner. One view shows a grid of three tiles wide by four tiles high, which, if it began at the ground, would be about 2 meters high, or a bit below the height of the temple podium, which the elevation of the west wall by the same artist gives as 2.5 meters. Thus the French architect's indication of the height of the tiles agrees in general with his indication of the maximum surviving height of the plaster. The main annotation on the right side seems to read as follows, where the words in parentheses indicate clarifications in the second hand that I presume belong to Goldicutt:

> detail des tuiles du mur d'enceinte opposé a celui du forum il est (revêtu) [dans?] toute sa longu[eur]. Je présume qu'on (aura) employé ce moyen p[our] (préserver les) peintures qui sont dessus de l'humidité dernière ce mur il existe un chaineau.

> (Detail of the tiles on the perimeter wall across from the Forum side. It is covered all along its length. I presume that this means was employed to protect the paintings which are on top from moisture. Behind the wall there is an aqueduct.)[46]

126 ART IN POMPEII

What is most interesting about this annotation is the explicit indication that this extraordinary method of rendering the west wall was carried out throughout its entire length, which confirms the implications of the accounts quoted above. That is not to say that the full length of tiles survived. A plan of the temple in the same collection of Goldicutt's drawings shows two thin lines along the west wall that may indicate the tiles. If so, there may have been two gaps in the tiling. In any case, there was clearly enough of it surviving for Goldicutt's French informant to infer that it originally ran the full length of the wall.

The images provided by Steinbüchel and Goldicutt clearly show a variant of tiles that are a standard part of Roman construction: these are often given the name *tegulae mammatae*, or nippled tiles. The "nipple" is the spacer or boss on the rear that creates the uniform gap between the course of tiles and the wall to which they are nailed.[47] These were used in the construction of baths, to extend the channel of warm air from the hypocaust up along the walls in order to radiate heat sideways into the room. This is the context in which Pliny speaks of them; but Vitruvius mentions them in the context of wall painting.[48] In the following passage, the Roman architect is discussing methods to defeat dampness when decorating a wall, and he seems to recommend precisely the practice that was observed in the temple portico: "sin autem aliqui paries perpetuos habuerit umores, paululum ab eo recedatur et struatur alter tenuis distans ab eo, quantum res patietur. (But if any wall is constantly damp, then a small gap should be left and a second, thin wall should be constructed, as far apart from the first wall as the project permits)."[49]

As a consequence of the natural assumption that this feature of the west wall was to protect against dampness, many observers in the early nineteenth century thought that the narrow, blind alley that separates the wall from the adjacent private houses was part of an aqueduct. The "chaineau," or aqueduct, that Goldicutt's sketch notes as running behind the west wall is clearly labeled as such on a cross section on the far left side of the same sheet of paper (see fig. 62), where it is clear that what is meant is the very narrow space on the far side of the wall. This is Callet's "petite rue" and it must be the same feature behind all the allusions to an aqueduct or "Wasser-Canal." It seems almost absurd now that this blind alley might once have been thought to be an aqueduct, for it has two obvious dead ends into via Marina at one end and the vicolo del Gallo at the other (fig. 63). What needs to be remembered, however, is that at this early stage the *insula* (city block) to the west of the temple, where the Casa di Trittolemo (vii.7.2) is located, had not yet been excavated, so the length and nature of this dead space and the fact that it has no opening on either end may not have been apparent, as they are today. An explanation for this remarkable aspect of the fabric of the west wall is discussed in chapter 4.

Nineteenth-century reports of the sanctuary ccase to make prominent mention of the false terracotta wall at a fairly early stage, so most of it presumably succumbed

FIGURE 63 Photograph of the blind alley behind the west wall of the Sanctuary of Apollo in Pompeii, looking south. Reproduced from Dobbins et al., "Excavations in the Sanctuary of Apollo at Pompeii" (1998), 742, fig. 3

FIGURE 64 Terracotta embedded in plaster at the northwest corner of the Sanctuary of Apollo in Pompeii

to the elements and disappeared quite early on. Nevertheless, there seem to be a few traces left. In her discussion of the temple, V. Sampaolo identifies *tegulae mammatae* in a photograph of the west wall.[50] I could not see this on a more recent visit to the temple, but it may be hidden behind some large architectural fragments that obscure part of the wall. However, at the very north end of the west wall, at the corner where it meets the north wall, there are two pieces of terracotta embedded in the wall down near the floor. There is an empty space behind one of them, large enough to insert one's hand into, as can be seen in figure 64. This is presumably a trace of a genuine feature of the sanctuary, which seemed to the earliest visitors to the temple compound to be one of its most remarkable features.

The Upbringing of Aeneas

All the figural paintings transmitted by Steinbüchel have now been assigned to locations in the portico. There is one more engraving to consider, however, which comes from another source. This image seems never to have been discussed in the scholarship, perhaps because Steinbüchel is presumed to have provided a comprehensive list of the surviving paintings. Since he took the trouble to show a very small fragment of the Machaon painting, it may seem surprising that he omitted a fully preserved figural

painting. It is possible that he lost one or more images in the years before the publication of his *Atlas*, or that Morelli never got around to sketching one of the paintings. Or perhaps it was the first painting to succumb to the elements. It may be that its obscure and apparently non-Iliadic content caused it to be overlooked.

This additional composition is from a plate in Luigi Rossini's *Le antichità de Pompei*, published around 1831. While discussing the nature of the sources for the temple, I noted that Rossini's two views of the temple illustrate the genres of picturesque ruin and imaginative and hypothetical reconstruction, respectively. But here I am concerned with the contents of a third plate from Rossini's book, which contains miscellaneous views of decorative items from several monuments. The engraving at the top right of the page is entitled *Pittura nel tempio di Venere* (i.e., the Temple of Apollo) and shows a well-preserved instance of the familiar pillar-style panel with a very unfamiliar figural composition (fig. 65). It is perfectly clear that this scene, which seems to show a young boy being presented by one female figure to another, cannot come from the plot of the *Iliad*. It does, however, belong to the Trojan theme.

FIGURE 65 Detail from Luigi Rossini, *Le antichità di Pompei* (1831), pl. 52

FIGURE 66 Further detail of fig. 65, showing the figural composition at the center of Rossini's illustration

The painting (fig. 66) shows a young boy who stands at waist height to the other figures, so he is presumably around four to six years old. A standing female figure urges him gently forward with a hand on the back of his head. She is nude from the waist up, so, as her motherly gesture indicates that she is not meant to represent a prostitute, she must be a divine or semidivine figure. The gentleness of her touch establishes the closeness and mutual trust between her and the boy. The seated female figure whom the boy is being urged to approach is likewise bare-breasted. The fact that she is seated while the others stand and the hesitancy of the others' approach to her probably indicates that she is a higher-status divinity. The male figure on the left is heroically seminude, but one cannot make any inferences about his mortality from that. An effort to relate this image to the plot of the *Iliad* fails: the only episodes that center upon a young boy have to do with Astyanax, who is an infant, a babe in the arms of his mother, father, and nurse (*Il.* 6.400). The *Odyssey* features a boy more prominently, but Telemachus is much older, on the verge of manhood. I am not aware of any obvious visual parallels for the composition.

The only remaining path is to try to puzzle out what is happening in the image, which offers a number of clues. There are very few episodes in myth concerning boys of this age, but there is one quasi-Homeric poem with a scene in which one goddess is to present a boy to a higher-status goddess in the presence of a male figure. In the *Homeric Hymn to Aphrodite*, after the goddess has lain with Anchises, she tells him about the future of the son they have just conceived. She stipulates that Aeneas be taken at birth to be raised by the mountain nymphs; it would not do for the goddess of love to be encumbered by the unromantic duties of childcare. As the goddess observes,

these nymphs are not fully immortal, but they do live for a very long time. With them Aeneas would not learn to live, as he must, a brief and mortal life. So Aphrodite changes her mind and decrees that, when he is five, the nymphs will bring the child to Anchises to be raised. This future prospect is, I believe, the moment represented in Rossini's lithograph.[51] The presence of Aphrodite in the scene is explained by the words of the goddess herself, who seems to change her mind in midspeech, adding that she herself will preside in person over the transfer of Achilles to Anchises (273–77):

"αἳ μὲν ἐμὸν θρέψουσι παρὰ σφίσιν υἱὸν ἔχουσαι·
τὸν μὲν ἐπὴν δὴ πρῶτον ἕλῃ πολυήρατος ἥβη,
ἄξουσίν σοι δεῦρο θεαὶ δείξουσί τε παῖδα.
σοὶ δ' ἐγώ, ὄφρα ‹κε› ταῦτα μετὰ φρεσὶ πάντα διέλθω,
ἐς πέμπτον ἔτος αὖτις ἐλεύσομαι υἱὸν ἄγουσα."

("They [the nymphs] will keep my son among them and raise him. As soon as lovely youth comes upon him, the goddesses will bring him here to you and show you your son. And I—to go over all this in my mind—will return in the fifth year from now, bringing our son.")

At first glance, these lines seem to present two distinct predictions of the future that are contradictory and chronologically disordered. In the first statement, the nymphs bring Aeneas to Anchises at a vaguely defined point in his adolescence; in the second, Aphrodite brings him herself when he is precisely five years old. Textual critics have attempted to resolve the perceived problem by bracketing one or the other of these sentences as an interpolation or by reordering the lines.[52] If, however, these lines are considered not as an exercise in formal logic but as the dramatic expression of the evolution of Aphrodite's improvised thinking on the spot, then they make perfect sense from a psychological point of view.[53] The first thought of the goddess is to keep the baby Aeneas at arm's length from her for as long as possible, hidden away from the world with the nymphs, because of her embarrassment about the circumstances of his conception. Then she thinks about it further and refines her plans; this is why she awkwardly interrupts her musings with the strange phrase "to go over all this in my mind" (ὄφρα ‹κε› ταῦτα μετὰ φρεσὶ πάντα διέλθω): she is temporizing and indicating that she is rethinking what she just said. She changes her mind about hiding Aeneas away from the world until he is a nearly grown young man, for she realizes that the boy, as a mere mortal, will have to be brought up in the world of mortal men, so she changes tack and specifies that he will be handed over to his father much earlier, at the age of five.[54] She also realizes that, much though she would prefer to avoid it, she will need to be present on the occasion of the five-year-old Aeneas's presentation to Anchises. The reason for this becomes evident as her speech proceeds, for the very next thing

she does is to emphasize to Anchises is that he must at all costs pretend to his fellow Trojans that his son was born not to her but to one of the nymphs. She then concludes her speech with a warning that if Anchises drags her name into it Zeus will strike him with a thunderbolt (281–90). Aphrodite has suddenly realized that the moment of greatest danger to her reputation is not now but five years hence when Anchises returns from Mount Ida to Troy with a previously unknown five-year-old son. It is at this point that he will be questioned most intently about the origins of this mysterious child. Aphrodite knows that she will need to be present on that crucial occasion to reiterate her warnings about the importance of keeping her motherhood secret. This is why she revises her original thoughts regarding the handover. It has nothing to do with fondness for the boy, whom she regards as an embarrassment.[55] Regardless of whether these lines were originally composed this way or suffered interpolation, it is very likely that they were read in antiquity just as they are now and were interpreted accordingly. The ancient painter understood these lines of the *Homeric Hymn* in this way and had a deep appreciation of the ironies and tensions involved in the encounter.

The painting shows the future moment Aphrodite had ordained. A nymph has been raising Aeneas for five years, and she brings him back to Mount Ida to present him to Aphrodite and Anchises so that his mother can supervise his being handed over into the care of his father. The tenderness of the nymph's gesture and the hesitancy of Aeneas in approaching his mother are eloquent testimony to her absence from her son's life over the previous five years. Anchises stands on the opposite side of the painting from the goddess, which similarly illustrates her estrangement from her erstwhile lover. His position next to the nymph alludes to the fiction that he will be required to maintain, that the boy was the result of a union with this mountain nymph. It is remarkable that Aphrodite, who is meeting the boy Aeneas as much as Anchises is, completely ignores the child who is being presented to her and fixes her gaze instead sternly on Anchises. Her serious bearing and unsensuous posture reflect the sternness of the warnings she must reiterate to him. As she did five years earlier, she is telling him to keep her name completely unconnected with the child (281–90):

> "ἢν δέ τις εἴρηταί σε καταθνητῶν ἀνθρώπων
> ἥ τις σοὶ φίλον υἱὸν ὑπὸ ζώνῃ θέτο μήτηρ,
> τῷ δὲ σὺ μυθεῖσθαι μεμνημένος ὥς σε κελεύω·
> φασίν τοι νύμφης καλυκώπιδος ἔκγονον εἶναι
> αἳ τόδε ναιετάουσιν ὄρος καταειμένον ὕλῃ.
> εἰ δέ κεν ἐξείπῃς καὶ ἐπεύξεαι ἄφρονι θυμῷ
> ἐν φιλότητι μιγῆναι ἐϋστεφάνῳ Κυθερείῃ,
> Ζεύς σε χολωσάμενος βαλέει ψολόεντι κεραυνῷ.
> εἴρηταί τοι πάντα· σὺ δὲ φρεσὶ σῇσι νοήσας
> ἴσχεο μηδ' ὀνόμαινε, θεῶν δ' ἐποπίζεο μῆνιν."

("And if any mortal man should ask you what mother bore you a dear son beneath her girdle, remember to tell him as I command you: say he is the offspring of one of the blushing nymphs who inhabit this forest-covered mountain. But if you tell all and foolishly boast that you made love to richly girdled Aphrodite, Zeus will smite you in his anger with a smoking thunderbolt. Now I have told you all. Take care: restrain yourself and do not name me, but respect the anger of the gods.")

Of course, Anchises fails to heed this warning. He returns to Troy, boasts of having lain with Aphrodite, and is blasted by a thunderbolt. Thereafter he is lame and is pictured endlessly in Roman art with a crippled back, carried by his son. Here we see the proud, young Anchises, and it is no coincidence that the painter emphasizes his bare back, ramrod straight and undeformed. The contrast with the usual posture of Anchises is striking, and it is tempting to speculate that, if the portico contained a few post-Iliadic paintings to complement these pre-Iliadic ones, it might have shown the iconic image of Aeneas carrying his disabled father out of the burning Troy. In other words, the viewer knows that the moment of happy fiction represented here will not last long.

The South Wall

If the painting of Aeneas as a boy comes from the portico, as Rossini's evidence insists, where was it located? The elevations of Callet and Mazois show that the east wall depicted the early books of the *Iliad*. Gell's comment that there was at least one painting of Achilles in line with the northern boundary of the sanctuary suggests that the paintings of the final books of the *Iliad* should be placed on the north wall. The evidence for the west wall, whose upper part was destroyed, suggests that nowhere on it did any plaster survive above waist height. This leaves the south wall. The cork model confirms that enough plaster survived here to preserve a figural painting. There is a problem, however: the model shows only plain niche-style panels, whereas Rossini shows the painting in the middle of an elaborate pillar-style panel.

The cork model shows no substantial surviving plaster on the half of the south wall that lies to the west of the main entrance on via Marina, but there is quite a bit on the eastern half (fig. 67). There, next to the main entrance, the model shows a figural painting with a vertical crack down the middle set in the midst of a niche-style panel (see fig. 10, no. 36). Moving east, there is a lost panel, then the vestiges of a panel that is probably niche style (see fig. 10, no. 37), and finally a niche-style panel with its figural painting lost (see fig. 10, no. 38; fig. 11). The prevalence of niche-style panels is supported by the annotation on Gell's plan of the sanctuary, which says that there were "paintings of Dwarfs" on the east half of the south wall (see fig. 1). As I have shown, the most likely place for those horizontal registers was below the red frame

FIGURE 67 Detail of the Plastico di Pompei (see fig. 8), showing the eastern half of the south wall of the Sanctuary of Apollo

of the niche-style panels. Finally, at the corner, just before the east wall, the excess space is occupied by an object that may be a torch or a cornucopia standing on its end.

So the cork model shows that there were a series of niche-style panels just to the east of the main entrance and that at least one of them may have preserved a figural painting. This is the natural place to put a pre-Iliadic episode: just before the start of the *Iliad* at the southern end of the east wall. But there is no indication of Rossini's elaborate pillar-style panel. There is a simple solution to this apparent contradiction: Rossini created a composite illustration. On the south wall, he found an intriguing figural composition that was set in the middle of an utterly boring and extremely plain, flat, and white niche-style panel. On the north wall, he found a well-preserved example of an extremely complex and rich three-dimensional setting that had a blank space where its figural painting should have been. Combining the two was an elegant way to give a sense of the décor of the portico in a single image.

If Rossini's image were in color, the preponderance of red or blue would show whether it came from the east or north wall, but in the absence of that, other details can be diagnostic. At first glance, the pillar on the east wall with the Diomedes painting might seem a good match for Rossini's panel, when compared with Rochette's lithograph (see fig. 5). Many of the details match, but one does not. The female figure holding an instrument in the lower story of the architecture on the right side faces inward and holds her instrument on that side. The posture of this figure is roughly confirmed by Callet's elevation (see fig. 28). By contrast, Rossini shows the figure facing the other way and holding her instrument on the other side (see fig. 65). Now compare the same figure in Mazois's illustration of an empty pillar-style panel, probably from the north wall (see fig. 36). Her posture and clothing are identical to Rossini's; indeed, every significant detail in these two images is identical. One might even suspect that one published engraving was copied from the other rather than reproducing a common model, but the dates make that impossible. Mazois recorded the monument when he last visited Pompeii in 1819; Rossini published his engraving

around 1831; Mazois's illustration was engraved posthumously and was published by his executors in 1838. The editors were working diligently from the illustrations Mazois had left behind and in their commentary pondered over the reason for the blank space in the middle of this panel; there is no chance they plagiarized this from Rossini and then removed the figural painting.

The likely conclusion is that Rossini and Mazois reproduced the same architectural detail, and that Rossini "improved" it by importing into its blank space a figural painting from elsewhere in the portico. There is no reason to believe that he invented this figural composition out of whole cloth; where Rossini indulges elsewhere in speculative reconstruction of the portico, he leaves no doubt of what he is doing. This measure of poetic license is similar to the freedom taken by Mazois in his elevation of the north wall, when he moved the brilliantly preserved decoration of the Aphrodite pillar from the east wall onto the north wall, using it as a *pars pro toto* example of the portico decoration as a whole (see fig. 46). Rossini had no investment in the Trojan theme: the only subjects he identifies in his text are the dragging of Hector and the battles of the pygmies against the cranes, and he draws no inferences from these about the overall theme of the portico. He therefore was free to select an image that others may have rejected as thematically problematic. The other possibility is that this figural painting really did come from a pillar-style panel on the south wall or elsewhere, where the plaster had degraded by the time the original of the cork model was recorded.

Conclusions

The likeliest place for the scene from the childhood of Aeneas was immediately on the right as one entered the sanctuary from the via Marina. As I show in the next chapter, there is some fairly strong circumstantial, indirect evidence for another pre-Iliadic scene in the portico, possibly also located on the east side of the south wall. What of the west half of the south wall, on the other side of the main entrance? It might have contained episodes from the middle of the epic, just as the west wall presumably did, but it is clear that there was not enough room to narrate the events of the epic in as much detail as the east wall lavished upon the first five books and as the north wall did upon the last three books. There must have been a principle of selection at work, and the most interesting one is the attention paid to Aeneas.

For this Roman audience, the Trojan story begins with the conception and birth of Aeneas. It is tempting to imagine that the flanking image on the left side of the main entrance might have concluded the series with Aeneas leading his crippled father and his own son Ascanius from the ruins of Troy.[56] The images would have been linked not only by the figures of Aeneas and Anchises and by the theme of the disability of the latter but also by the presence of a boy of similar age. In addition, there is another image of Aeneas elsewhere in the portico: his rescue from the battlefield by Aphrodite.

In that painting, her attitude to her son is reversed: from indifference to solicitude. Both Aeneas paintings were next to entrances and at the end of a wall, so that the proto-Roman hero appears at significant junctures. The effect is to highlight a man who is a minor character for Homer, thus reframing the *Iliad* so that it becomes subsumed within the Roman national narrative. The question of how it happened that the portico in Pompeii reflected an agenda set in Rome is a complex one and cannot be addressed until I have established some general principles regarding the relationship of copies and models, center and periphery, which is the subject of the next chapter.

NOTES

1. See Squire 2011, 145–47.
2. See, for example, Chabrol's reconstruction: Mascoli 1981, fig. 16.
3. See, e.g., Salmon 2000, 82–85, figs. 58 and 59.
4. Two albums in the collection of the Getty Research Institute have photographs with similar views of the northeast corner of the portico. One photo is by Giorgio Sommer (numbered 1281 in a travel album of images from Germany, Czechoslovakia, Austria, and Italy between 1860 and 1899, GRI accession number 89.R.30). The other is by Michele Amodio in an album of his photographs of Pompeii that is dated to 1874 (GRI accession number 93.R.111).
5. If this painting were to have existed in a vacuum, another possible identification of a composition with a warrior on one side and a female on the other with a shield between them could be the delivery of Achilles's armor by Thetis, as in the now-lost painting from the Macellum as described by Helbig 1868, no. 1322: "L. steht ein Jüngling mit rother Chlamys, in der L. einen Speer, vermuthlich Achill, ihm gegenüber eine weibliche Figur in Chiton und bläulichem Mantel, vermuthlich Thetis. Sie hält in der L. eine goldfarbige Beinschiene und stützt mit der R. einen Schild auf eine Basis, an welcher die andere Beinschiene lehnt. Der Jüngling betrachtet bewundernd den Schild, indem er die R. erhebt."
6. For illustrations of the decorative context, see *PPM Disegnatori*, 115, fig. 57 (Morelli), and, slightly different, Mazois 1812–38, vol. 4, pl. 42; these presumably document different parts of the wall. The cork model also records the decoration of the apartment. Mazois's view is corroborated by a watercolor by Henri Labrouste, which is printed by Bouquillard 2000, 51; see also the version of E. Peroche (Mascoli 1981, no. 20). Morelli's agrees with a watercolor by Prosper Barbot in the Louvre (RF 27304, recto), 1820–22. For a description, see Fiorelli 1860–64, 1:211–12. There are also illustrations of this room in the archives of the Royal Institute of British Architects by Goldicutt (SD100/2/24) and by Woods (SE2/11/9).
7. Rossini ca. 1831, pl. 43.
8. A similar view, but in color, is provided in a painting by Theodor Groll (Pompeii: Blick zum Apollo-Tempel, 1891, Stiftung Sammlung Volmer).
9. Valentin Kockel points out to me that this photograph seems to show the model at a similar stage of construction as an engraving in Overbeck and Mau 1884, 40–41.
10. Cuciniello and Bianchi 1829–33, part 1, vol. 2, p. 78.
11. Mascoli 1981, 307.
12. For example, see Niccolini and Niccolini 1854–96, 2:51; d'Aloe 1851, 29; Dyer 1868, 131; Engelhard 1843, 15; Bonucci 1827, 153; Fiorelli 1875, 238–39; Overbeck and Mau 1884, 103.
13. Goro von Agyagfalva 1825, 128.
14. For example, Bulas 1929, 96, supposes that in the portico there was another painting of the dragging of Hector's body that was not reproduced by Steinbüchel, but Gell's notebook makes it clear that it is this image that was thus identified from the start.

15 Schefold 1957, 192: "Hector geschleift?... Vielleicht Steinbüchel D.1, wo aber ein herabstürzender Krieger dargestellt ist. Tod des Troilus?" See also Helbig 1868, 1324 with p. 462.

16 Compare the Roman mosaic discussed by Bulas 1950, 118, with pl. 20B, where the posture of the body makes it similarly difficult to tell if this is the dragging of Hector's body or someone falling from a chariot.

17 I owe this point to an anonymous reviewer.

18 *Il.* 23.391–97; a suggestion of another anonymous reader.

19 See *LIMC*, s.v. "Achilleus," 584–641.

20 See *LSJ*, s.v. ἄντυξ.

21 Sadurska 1964, pls. 1, 2, and 13; Hector's body is not clearly visible on the second Verona tablet.

22 The walls are apparent on the New York and second Verona tablets: Valenzuela Montenegro 2004, 82–83, 188, 195.

23 The word used (δίφρος, *Il.* 22.398) must in this context simply indicate the chariot as a whole.

24 Various catalogues of the Iliadic paintings in the portico list the embassy to Achilles in Book 9 as one of the subjects, but these probably refer to the painting I have identified as Calchas addressing Achilles; see, e.g., Schefold 1957, 192.

25 See *LIMC*, s.v. "Achilleus," 670–716. The supplication of Priam is an extraordinarily popular scene in Roman art, and in the vast majority of representations Priam is wearing a Phrygian cap. In a few he has his head covered in another way, such as with a fold of his cloak, and in some examples it is impossible to distinguish. A good parallel for a bare-headed Priam in this scene is very hard to find. On the other hand, Steinbüchel's drawing of the head of the kneeling figure is vague enough that headgear cannot be ruled out.

26 As an anonymous reader has pointed out to me.

27 The difficulty in differentiating these two scenes is illustrated by their very close similarity in an Iliadic cycle elsewhere in Pompeii. In the House of M. Loreius Tiburtinus, there is a well-known room with two Trojan cycles painted one above the other, the lower one of which is based on the *Iliad*. The layout of the scenes in this cycle is helpfully illustrated by Clarke 1991, 204, fig. 118. In the lower cycle, the chronological sequence of events in the *Iliad* is violently disrupted after the scene of Phoenix's embassy to Achilles: it jumps to the starting point on the opposite wall and then circles around in the opposite direction to finish back at this same point. It may be that the purpose of this narrative disjunction was to stage a meaningful juxtaposition of the embassy to Achilles and Priam's supplication of Achilles in order to make a comment about the symmetry of the plot of the *Iliad* (for a different explanation, see Clarke 1991, 206). Both scenes show a man on his knees in an identical manner before the seated hero. The visual puzzle is to identify the repetition, figure out the difference, and use it as a clue to the disrupted narrative order.

28 The ransom of Hector's body is shown on the Capitoline, Froehner 21, New York, and second Verona tablets as well as the small fragment with only this scene: see Valenzuela Montenegro 2004, 89–91, 183–84, 190, 196, and 214–15.

29 Valenzuela Montenegro 2004, 214n1268, notes that the tablet is now so badly worn that the covering of Priam's head can no longer be seen, so we have to trust the testimony of Jahn and Michaelis 1873, pl. 4F.

30 E.g., on folio 64, "West side, Temple of Bacchus," and on the verso, "Temple of Venus, W. Side."

31 Folio 61: "In the Temple of Bacchus, wall next the Basilica"; folio 71: "In Temple of Bacchus, near S.E. angle."

32 Folio 19, verso: "Painting on the piers dividing the T. of Bacchus from the Portico of the Forum."

33 In addition, several are identified as coming from the chamber of Bacchus, which presumably means the apartment to the north.

34 Gell and Gandy 1817–19, 227–28 (pls. 54, 55).

35 Thus Moormann 2011, 81–82. See also Rostovtzeff 1911, 57–58.

36 Bonucci 1827, 153.

37 As Marco Fantuzzi has emphasized to me; see Harder 2012, 2:44–47.
38 There is another tiny trace of decoration behind the cella of the temple, but it is very hard to distinguish; see the left side of fig. 50.
39 SD100/3(1-26): "Drawings of Pompeii: Temples of Aesculapius, Serapis and Venus, the Amphitheater, Basilica and Comic Theater, also views of the ruins in the Forum, 1816."
40 Thus Salmon 2000, 81.
41 Mascoli 1981, 307.
42 RIBA drawings archive, SE2/11/9. On Woods in Pompeii, see Salmon 2000, 78–86.
43 See fig. 1, where the first word is written upside-down relative to the second and its reading is uncertain.
44 Goro von Agyagfalva 1825, 1283.
45 "Zeigen die Seitenwände des umgebenden Säulenganges ganz diesen Bau, und auf der einen Seite (auf unserer Abbildung dem Betrachter links) ist diese Doppelwand deutlich erkennbar" (Steinbüchel 1833, vol. 7, pl. 42, figs. 1a and 1b). In the words that follow, stating that this was where the figural paintings were found ("Da sind auch die Frescomalereien noch erhalten, welche die Tafeln VIII, B. C. D. im nächsten Hefte enthalten"), one can infer that Steinbüchel was speaking loosely of the portico in general, for in the next volume he more accurately notes that the paintings were mainly found on the right of the main entrance ("an der Wand rechts vom Haupteingange"), which is the east wall.
46 See fig. 62: the supplements in square brackets are mine.
47 For illustrations, see Adam 1999, figs. 629–31, 268–69.
48 Pliny, NH 35.159; the text of Vitruvius (7.4.2) might also read *hamatae tegulae*, or hooked tiles. It is possible that both names are valid alternatives, however, for some such tiles have curved flanges at the edges rather than nipple-shaped bosses near the corners. See Ginouvès 1985–92, 3:108, and Liou, Zuinghedau, and Cam 1995, 120–21.
49 Vitruvius 7.4.1.
50 PPM 7:295n13.
51 Another possible subject of this painting is the presentation on Scyros of Neoptolemus to Thetis by Achilles and Deidamia, though this would be equally unparalleled visually. The age of the boy would also imply a much longer stay on the island for Achilles than is usual, and one would not expect to find Deidamia seminude.
52 For an overview of the various solutions to the alleged problem, see Faulkner 2008, 291–93.
53 The claim of Smith 1979, 39–41, to have made exhaustive efforts to make sense of the transmitted text fails because he presumes that Aphrodite must have a single, constant idea in these lines, rather than an idea that evolves before our eyes.
54 Since, as many critics (such as Olson 2012, 270–71, and Smith 1979, 40–41) rightly insist, the phrase "lovely youth" (πολυήρατος ἥβη) should mean early adolescence and cannot easily stretch to a five-year-old, Aphrodite has quickly changed her mind not only about her own need to be present but also about Aeneas's age at the handover.
55 Compare Richardson 2010, 254. At least Aphrodite realizes that she cannot hide Aeneas with the nymphs indefinitely, and that he will need to be raised among mortals.
56 A parallel would be the Iliadic cycle in the House of the Cryptoportico, which ends with such a scene: Spinazzola 1953, 955–56. The escape of Aeneas from Troy also plays a crucial role in the *tabulae Iliacae*.

Chapter 4

Copies and Models

So far, I have looked at evidence that is highly fragmentary and often difficult to interpret, but the general approach has been straightforward: to build up a coherent account of the portico of the Temple of Apollo by comparing early descriptions of the walls of the portico in word and image. In this chapter, I move from that direct evidence to items of more indirect relevance to the Portico of Apollo. In so doing, I unavoidably encounter a series of ongoing methodological controversies, all of which have to do with the fundamental art-historical question of the relationship between copies and models. The first question to ask is why one of the images found in the Apollo portico was found again and again in a variety of domestic contexts elsewhere in the city. E. M. Moormann assumes that this is an indication that the temple portico was unimportant and was thus given mundane decoration evocative of a private home.[1] But could this be the wrong way around? Might it be that the domestic contexts were imitating the portico, as a testament to its local influence and importance? The payoff for starting from this more optimistic premise is that it may be possible to identify lost paintings from the Apollo portico on the basis of several of these quotations of subsets of the cycle in other places in Pompeii.

A different but related question of copying has to do with the relationship of art in provincial Pompeii to models in metropolitan Rome. I conclude with an analysis of the construction of that portico, the dating of its paintings, and the phases of its decoration. This demonstrates the likelihood that the edifice reflects a fourth-style reinstallation of a cycle of Trojan paintings that themselves go back to the construction of the Pompeian temple portico, which I date, against the current consensus, to approximately 10 BC. This means that the Pompeian cycle was originally assembled less than a decade after the publication of Virgil's *Aeneid* and less than two decades after the installation of a cycle of Trojan paintings in the newly built Portico of Philippus in Rome. All of this leads to the highly suggestive, if ultimately unprovable, hypothesis that the common source of the iconography that appears both on the Pompeian paintings and on the *tabulae Iliacae*, which were mostly found in the near neighborhood of Rome, was the Portico of Philippus. If it is right to see a connection between a temple portico in Rome with a cycle of paintings of the Trojan War and a similarly furnished portico in Pompeii, the dynamics of visual emulation and

quotation must not fall back on outmoded notions of diffusion from the center. If the Pompeian monument appropriates aspects of the Roman one, what was the meaning of that gesture in the local context?

Copies or Intertexts?

The specter that haunts the study of Roman painting is the question of its dependence on the lost history of Greek painting. Earlier generations of scholars had reduced the dynamic process of reappropriation in Roman art to a mechanism of simple duplication of Greek originals that could be only more or less accurate, never having its own agenda. Roman copies could be used to reconstruct the outlines of lost Greek masterpieces, but nothing more. Scholars of Roman art are still trying to vindicate the object of their study against this prejudice and there may still be some reluctance to discuss the phenomenon of copying that has so often been used as a stick for their backs. The problem is that it is impossible to understand the particular brilliance of Roman art without appreciating the way it transformed the elements of Greek visual culture into a language whose elements could be recombined in infinite variation to articulate its own concerns.[2]

The study of Roman fresco painting in the cities buried by Vesuvius suffered particularly from this problem. For many decades, the main purpose of many scholars working on this material was to reconstruct the lost history of Greek and Hellenistic painting on wood panels from these "copies," an approach that has been called copy-criticism, or *Kopienkritik*. To put it bluntly, this methodology started from an idea of what the development of Greek painting ought to have looked like and then illustrated it by picking and choosing bits of Campanian painting. Any elements in these paintings that did not accord with this preconceived notion could be disregarded, either, in the case of allegedly high-quality works, because of the independent imagination of the copyist or, in the case of allegedly lower-quality works, because of his incompetence. Of course, the scholars pursuing this approach imagined that they were doing something far more rigorous and less circular than that, analogous to the procedures of textual criticism. If meticulous scholarship could deduce well-founded conclusions about a lost archetype of a text from its flawed copies, why not do the same for images? There were two problems.[3] The first is that direct visual evidence for the development of Greek panel painting is almost entirely nonexistent. A couple of isolated images have survived along with textual accounts, such as that of Pliny the Elder. There is effectively no independent, direct evidence to rescue the indirect approach from complete circularity.[4] Whatever one may think of the analogous practice of postulating unattested Greek sculptures to explain similarities between surviving Roman pieces, at least the history of Greek sculpture is directly documented by some surviving originals.[5] This provides a standard against which potentially circular logic can be tested. No such independent framework exists for Greek painting.

The other big problem with this approach is that visual artists were often, perhaps usually, making neither exact copies nor completely autonomous artworks, but rather creating a new synthesis by drawing on a range of visual idioms to produce the effect desired by a buyer or patron.[6] This differs from the textual world, where the roles of the notionally exact copyist and the original writer were in principle utterly distinct. Cicero, who had his own team of slaves to copy texts exactly for him, once famously wrote a series of letters to his friend Atticus, who was in Athens, to ask him to buy some art for his villa which was "gymnasium-ish" (γυμνασιώδη), an invented neologism Cicero liked so much he used it twice (*ad Att.* 1.6.2 and 1.9.2). It has often been observed that in describing the art he would like Cicero repeatedly asks for statuary appropriate for particular locations rather than examples of particular works or artists; he speaks in terms of re-creating particular visual environments.[7] This attitude seems likely to have been typical of the requirements of the market in which art for elite Romans was made. This is not to say that there were not occasional efforts to make exact copies of famous works of art, both as acknowledged copies and as forgeries: the number of alleged Greek masterpieces circulating in Rome defies belief. But it seems likely that the average Pompeian homeowner would not usually demand, nor would his or her artists generally claim to provide, copies in fresco or mosaic of the masterworks of particular Greek artists.[8] Instead, they might speak of creating a certain atmosphere or of treating certain themes. They might also use as a reference point a nearby public monument well known to both parties. Of course, famous works of Greek art flowed into the great mass of common imagery that informed that discussion, but there is no particular reason to expect that any one classic work of Greek painting on wood should necessarily emerge on fresco centuries hence in a room in a city in Campania except as one element of a dynamic synthesis.

To put it in the terms of textual criticism, the norm is for any given work of Campanian painting to have a highly contaminated tradition. It is quite rare to have a set of very similar paintings whose common elements can be attributed to an identifiable archetype. There are exceptions, however, and multiple copies of the same fundamental composition with only minor variations are sometimes found in a variety of domestic contexts in Pompeii. Frequently these are of subjects connected with the Trojan War. It is no coincidence that scholarship attempting to reconstruct Greek originals from Campanian copies, such as G. Lippold's *Antike Gemäldekopien*, has focused especially on paintings of Trojan subjects.[9] The fact is that the appearance of multiple versions of paintings on these particular topics has little to do with the distant influence of Greek or Hellenistic art from a different land and era; rather, it had a great deal to do with the nearby presence of a Trojan cycle in the local Temple of Apollo, which perhaps constituted the most important public pictorial cycle in the city.

There persists a general feeling that there must be a special relationship between Hellenistic panel painting and Campanian fresco painting and mosaics. It would be

foolish to deny that, if independent evidence for Hellenistic panel painting were discovered, almost certainly its influence would be seen to be refracted at Pompeii in myriad ways. But as a tool for making sense of the phenomenon of Campanian painting in general, *Kopienkritik* has been an utter failure. It has even been a failure in that more narrow field where it ought to have had some limited applicability: in explaining the appearance of very nearly identical copies of the same figural composition in different domestic contexts. In addition to the methodological problems noted above, there has been a fatal bias toward linking such copies to famous names from the history of Greek painting. This runs against what we know from Cicero of the way Romans procured art and ignores the mechanism of transmission via Rome, which was much more important to the people of Pompeii than the abstract considerations of the history of Greek art. The Pompeians who put copies of a Hellenistic painting on their walls did not care who the painter was so much as they cared about the way the image had been appropriated at Rome and integrated into the fabric of Augustan ideology, from which it was appropriated and woven into an important place in Pompeii's civic ideology. The copying of Hellenistic painting in Campania was an incidental and secondary by-product of the dissemination of metropolitan models from the city of Rome, where many of those paintings came to be put on show.

In reaction to the general failure of *Kopienkritik*, many scholars have in recent years turned sharply and understandably away from the assumption that Roman painting should be viewed in any way through the lens of copying.[10] They have rightly seen that tearing Roman painting to pieces in a vain search for lost Greek masterpieces leaves neither as worthwhile objects of study. They have rightly insisted that these Campanian works be viewed in their local context, as productions with their own motivations and interpretive framework. This reaction against the excesses of the past has, however, left many contemporary scholars very wary of discussing the phenomenon of copying at all. The challenge is to do so without slipping back into the old habit of thinking of Roman art as secondary. As noted above, multiple versions of the same basic composition do exist at Pompeii, but current trends in scholarship give us very few tools to explore and explain that fact. A proper understanding of the phenomenon of copying, however, does not rob these paintings of their local significance but treats copying itself as a local phenomenon, which is an integral part of the meaning of these paintings in a particular time and place. We copy what we see around us. It turns out that the people of Pompeii, like us, decorated their walls with copies of works on display in the local museum or place of worship, though of course they had to order copies rather than browse through the poster display in the gift shop. This might seem at first a rather crude and superficial form of local reappropriation. In some cases the dynamic at Pompeii may indeed have been crude, but in other cases one can identify rather sophisticated thought at work behind the recombination and recontextualization of public art in a domestic context.[11]

These same issues crop up in a different form in the broader question of the relationship of art in provincial Pompeii to art in metropolitan Rome. Just as the study of classical antiquity has long been focused on texts more than objects, so has it tended to privilege the elite experience of major, imperial urban centers over the provincial and the marginal. Again, this historic bias has produced a backlash, and recent initiatives in the study of those peripheral zones have rightly stressed that people outside the metropolis had their own concerns and agendas.[12] In today's postcolonial world, it may be hazardous to suggest that the decoration of the Portico of Apollo in Pompeii may have been inspired in part by the art of the Portico of Philippus in Rome. The danger that looms is of falling into the trap of *Quellenforschung*, where one is so intent on reconstructing a lost original that the independence and originality of the surviving adaptation are ignored. Nevertheless, it is demonstrably the case that public buildings in Pompeii adapted elements from well-known monuments in Rome, and one needs to ask why.[13] The key thing is to remember to interpret the local monument as a coherent and meaningful space in its own right and to treat the deliberate gestures toward Rome as only one part of the language it spoke toward the people who used it.

In all these contexts, the methodological problem is similar: how to do justice to an artwork that incorporates elements derived from elsewhere, especially from a source of higher prestige, be it Homer, the local Temple of Apollo, or a monument in Rome. The answer is to speak not of copying, with its connotations of exactitude, passivity, and subservience, but of allusion. The viewer was meant to identify the origin of the quotation as a clue to its meaning. Part of the visual pleasure was in tracing the source and the nature of the transformation. Adapting a different philological metaphor is a phenomenon of intertextuality rather than scribal copying, so it calls for an approach analogous to literary rather than textual criticism.[14] This viewpoint should allow the flexibility to understand why there are multiple versions of the same pictorial composition at Pompeii while giving due credit and consideration to the differences between them and to the context in which each was reused.

The discussion in this chapter also serves to highlight the laziness of explaining similarities among paintings in Pompeii by resorting to that old chestnut, the pattern book. It is entirely plausible that the *pictor imaginarius* (figural painter) who executed figural paintings on wet plaster would have kept a personal sketchbook, as artists have always done. Such books may have some local circulation, such as from master to apprentice. The problem arises when scholars imagine that there were canonical pattern books, for which there is no evidence at all. This approach to the evidence reduces local artists to more or less competent robots, slavishly attempting to imitate artistic forms that they scarcely understood. A better model can be constructed, that which fully explains the striking similarities between some compositions in Pompeii while fully allowing for the autonomy of painters and private patrons, for they creatively evoked the resonance of familiar, public compositions in order to articulate their own particular, private concerns.

Achilles on Scyros

Of all the surviving figural paintings in my reconstruction of the Temple of Apollo, the single image that best sums up the trajectory of the plot of the *Iliad* is the quarrel of Achilles and Agamemnon. Apparently, the people of Pompeii felt that way, too, for very similar versions of this composition, or rather fragments of it, are found in three other places in the city. In at least two, and perhaps three, of those houses, the image is paired with another image from the life of Achilles, his discovery by Ulysses and Diomedes on Scyros. That is to say, in distinct and very different domestic contexts the same two compositions appear together. This is a remarkable coincidence and brings into sharp focus the more general question that is formulated by J. Trimble in an important article on these pictures: "If the formal authority of a lost Greek masterpiece did not wholly determine the appearance and significance of repeated mythological pictures at Pompeii, how are these to be explained?"[15]

My answer to Trimble's question is simple, but it has not, to my knowledge, been suggested before: it is known that one of the paired images was on display in a very important public building in the town, so one might guess that the pairing itself originated there. The images appear together in multiple Pompeian houses because these houses were quoting their juxtaposition in that locally well-known monument. This is, of course, an unprovable hypothesis in absolute terms, but it is by far the most economical explanation for the coincidence.

The first house exhibiting this pairing is the House of the Dioscuri (vi.9.6), whose name comes from the paintings of Castor and Pollux that are found on either side of the front entry hall. Proceeding into the house, one comes to the atrium, and then on the far side is the *tablinum*. On either side of that room is a pair of damaged but very high-quality paintings of Achilles.[16] The presence of the twin Dioscuri facing each other across the entrance predisposes one to look for paintings that are paired on opposite walls across this axis, so the two Achilles paintings form a twin-like unit not only by their content and mirrored placement but also by their function within the overall decorative scheme of the front part of the house.[17] On the left wall of the *tablinum* is the bottom-right fragment of a version of the quarrel of Achilles and Agamemnon. The fragment shows the bodies, but not the heads, of Achilles, who is drawing his sword and advancing to the left, and Athena, who restrains him from behind. This remnant of the painting corresponds so exactly to Steinbüchel's drawing from the Apollo portico (see fig. 16) that there can be no doubt that they are versions of the same composition.

On the opposite wall of the *tablinum* is the other painting of Achilles (fig. 68). This image shows the young hero on the island of Scyros, where he has been disguised as a girl and hidden away from the Trojan War by his mother.[18] Odysseus and Diomedes have arrived and are using a trick to induce Achilles to drop his pretence. They bring gifts for the daughters of the king of Scyros, but include some weapons. Achilles is

FIGURE 68 Wall painting of Achilles on Scyros from the *tablinum* of the House of the Dioscuri, Pompeii (vi.9.6). National Archaeological Museum of Naples, inv. 9110

drawn to these and, as he hesitates, Odysseus's trumpeter blows his horn to signal an attack. Achilles seizes the weapons and his cover is blown. These two images complement each other beautifully: both depict Achilles being restrained from violent action as he reaches for a weapon, but the contexts could not be more different.[19] In the quarrel, Achilles is held back by Athena when on the point of killing his leader and sets in motion a chain of events that leads directly to the death of his closest friend. On Scyros, Odysseus and Diomedes hold the cross-dressed hero back from responding to the false signal of war from an imaginary enemy that they themselves have staged as a provocation. Disguised as a female and duped, Achilles is a less than intimidating presence on Scyros, but his impulsiveness and latent violence hint of darker things to come. The question to ask now is, did multiple people in Pompeii independently come up with this brilliant juxtaposition of otherwise unrelated images, or did one private owner plagiarize the other, or was the juxtaposition already there in a public monument for two or more to appreciate, savor, and quote? The last seems by far the most likely scenario.

 I have shown that in the Apollo portico there was at least one pre-Iliadic painting dealing with the childhood of one of the heroes. If I am right in putting the picture of the young Aeneas (see fig. 66) just to the right of the entrance from via Marina in the south wall, then it would have been natural to find the painting of Achilles on Scyros in one of the other panels on the south wall just beyond that (see fig. 10, nos. 37, 38).[20] If so, the pointed juxtaposition of this image with the quarrel picture will have been present there, too, as the two paintings would have faced each other across the southeast corner.[21] This is precisely the sort of contrast already shown to exist in that monument: for example, the east wall having Athena restraining a warrior at one end (see fig. 16) and encouraging another to violence at the opposite end (see fig. 4). The Scyros image would fit well on the same wall with the handing of the five-year-old Aeneas to Anchises. Both paintings depict a feminine milieu that contrasts with the military scenes on the other walls, and both deal with a young hero crossing a threshold away from the world of women toward manhood: Aeneas moves from the care of his surrogate nymph-mother to that of his father, while Achilles moves from the women's quarters on unwarlike Scyros to the company of his fellow soldiers.

 It seems that the owners of the House of the Dioscuri wanted to evoke the portico of the Temple of Apollo for visitors to their *tablinum*. Perhaps they had some special connection with the sanctuary that they meant to highlight. Or it may simply be that they wished to borrow some of the seriousness and cultural heft of a major public monument. Trimble considers the paintings as a backdrop for the morning *salutatio*, at which a patron met his clients, so the evocation of a public space right next to the Forum might have seemed appropriate. The *tablinum* marked the endpoint and culmination of the public area in a Roman house; behind it was private.[22] In the House of the Dioscuri, these public areas were decorated in a consistent manner. First

came the demigods Castor and Pollux, and then the atrium area, which was mainly decorated with very dignified images of individual gods depicted, like the Dioscuri, against a red background: Jupiter, Saturn, Apollo, Bacchus, and so on.[23] The Achilles pictures in the *tablinum* might seem to mark a change of tone by introducing an element of mythical narrative, but if they are thought of as an evocation of the Temple of Apollo, then they fit very well with the dignified, sacral feel of the front part of the house. In this context, the apparently undignified costume of Achilles on Scyros and his near miss with regicide at Troy do not lower the tone. Together these paintings link the public part of this grand and spacious house, whose owner was apparently a person of consequence, with one of the most important public spaces in the town.

The second Pompeian residence where this same pairing of images was found provides an even clearer idea of why an owner chose to evoke the local Temple of Apollo in his or her own home. This particular dwelling has come to be called the House of Apollo (vi.7.23), and the name is no coincidence. Throughout the house the decor emphasizes the importance of that god, who must have had a special meaning for the people who lived there. Of particular significance is an isolated, elegant room located well away from the main part of the house at the most distant rear corner of the garden. Its most likely purpose was to serve as a refuge or retreat from the hustle and bustle of the main house.[24] (Even the emperor Augustus had an isolated room where he could go to be alone and work.[25]) The visitor to this room would step down into the sunken garden, cross it, and then step up into the room, whose painted decoration was a celebration of Apollo.[26]

Inside, opposite the entrance, is a very elaborate, theatrical pseudoarchitectural vista of the *scaenae frons* type with Apollo enthroned in glory at the center, flanked by two other deities.[27] The dramatic setting of this episode, if indeed it has one, has been identified as a beauty contest between the evening and morning stars, Hesperus and Venus, with Apollo in his role as the Sun acting as judge. This is a very uncertain identification, and indeed it is not clear that this is a real myth at all; but it is certain that Apollo enthroned is at the center, dominating the room.[28] The architectural framework continues on the other walls, which depict elements from the story of Marsyas, who challenged Apollo to a musical contest and was defeated and punished. The god appears on both the north and south walls, as does his victim, along with minor characters, such as Olympus, who was either Marsyas's father or student, and Athena, who invented the pipes he played.[29] It is clear that the theme of the room is the glory of Apollo. It may be significant that elsewhere in Pompeii, fragments of what may be the discarded second-century BC pediment of the Temple of Apollo have been found, which also feature the story of Marsyas.[30] The room advertised itself, therefore, as a kind of sanctuary for the harassed homeowner that was dedicated to the god.

A Roman temple often has a portico, and this small Apolline sanctuary has a miniature version. The roof of the room continues out in front of the structure, where

three columns support it, forming a porch or a very small portico. This is where the other pair of Achilles pictures was situated, but in the medium of mosaic rather than painted plaster. On the outside wall to the left of the entrance to the room, a simplified version of the discovery of Achilles on Scyros may still be seen in situ.[31] The only figures shown are Achilles, Odysseus, and, on the left, Deidamia, lover of Achilles, but the positions of the first two are very closely identical to those in the surviving portion of the painting in the *tablinum* of the House of the Dioscuri. The mosaic also illustrates the device on the shield that Achilles is trying to pick up, which shows him being taught to play the lyre by his tutor, the centaur Chiron. This detail is more muted in the *tablinum* fresco, but it is clearly present; and in both representations the point of Odysseus's spear emphasizes it. On the other side of the entrance to the garden room, still within the miniature portico, was a simplified version of the quarrel scene in mosaic, which is now in the National Archaeological Museum of Naples.[32] Again, only three figures are shown: Agamemnon, Achilles, and Athena restraining the latter. The posture of these figures leaves no doubt that this is a version of the painting recorded by Steinbüchel (see fig. 16). The fact that the pictures in the *tablinum* and in the garden portico are in different media, painting and mosaic respectively, refutes the simplistic explanation that the duplication of the paired images was merely the result of automatic repetition.

The garden portico is remarkable for its wit. The mosaic images clearly signal to anyone approaching that this is a domestic version of the public Sanctuary of Apollo. The outer wall of the garden room on the south side apparently was painted with Nilotic scenes, which may have been part of the allusion to the same portico. It seems likely that this was meant in a lightly humorous vein rather than as a serious point of religion. If this room was a refuge for someone from the hectic activity in the house, the nature of the images gave notice that this was a space consecrated and set apart. Let all who approach think twice before bursting in with mundane domestic trivialities. If this analysis is correct, it is an interesting irony that the message conveyed by the pictures in this context is precisely the opposite of the one conveyed in the House of the Dioscuri. There, the Apollo portico was solemnly invoked in the *tablinum* as an example of a dignified, public space. Here, its sacred character is jestingly invoked as an example of consecrated space set apart for private, higher purposes. There is no contradiction, for the portico of the real sanctuary of Apollo was a liminal space between the more public space of the Forum next door and the privacy of the temple cella. It was public but also belonged to the god. The point to take from this is that the act of quoting imagery from local monuments does not imply a simplistic act of mimicry; its meaning is determined by its new context.

In addition to the House of the Dioscuri and the House of Apollo, there is yet another house, not discussed by Trimble, that may have also juxtaposed variations on these two compositions in the same room. In the Casa della Caccia Antica (vii.4.48),

there is a room off the atrium with fictional architecture of the *scaenae frons* type around its three sides. Standing in front of the architecture, as if onstage, there were once figures that are now badly degraded. There are enough early illustrations of the west wall, including one by Rochette, to confirm that the figures here were freely adapted from the familiar typology of Achilles on Scyros. This is a loose adaptation of the theme, for the figures have broken out of the frame of the figural painting and have emerged into the world of the fictive architecture. The positions and attitudes of the figures are only loosely related to the original, but there is enough to identify the scene from which they have escaped.[33] The architecture behind them has some elements in common with the wall painting from the Temple of Apollo, though it is busier and lacks the focus on the central figural painting.

On the other two walls, the figures in front of the architecture are just as badly degraded, and there are no early illustrations to help identify them. In his catalogue of the wall paintings of Pompeii, Schefold says that in the architecture on the north wall there was a figure who might be Venus and that "darunter soll Streit von Achill und Agamemnon sichtbar gewesen sein" (underneath the quarrel of Achilles and Agamemnon ought to have been visible).[34] The tentative nature of this assertion and the fact that he gives no reference to a source for the identification have led P. M. Allison to suppose that Schefold made an unsupported "presupposition" on the basis of the parallels from the Houses of Apollo and the Dioscuri, but there must have been traces on the north wall on which he thought he could base an identification.[35]

Allison astutely notes that there seems to be a reference to this room in the Casa della Caccia Antica in a passing comment made by Schulz in 1841, though the latter mistakenly assigned it to the Casa della Parete Nera. Schulz says that on the wall to the right (i.e., north) of the one showing Achilles on Scyros in the midst of an architectural setting, there were three figures from the story of Marsyas in the foreground. In the middle was Apollo; on one side was a warrior with a spear in his hand and a helmet on his head; on the other was Pallas playing the flute.[36] In fact, this could easily have been Achilles in the center, Agamemnon holding his scepter on one side, and Athena restraining him on the other, though this means rejecting the presence of a flute. There is at least as much reason to suspect Schulz of wrongly presupposing the Marsyas theme for these figures as there is to suspect Schefold of making an unsupported inference, and perhaps the presence of the soldier should be decisive in Schefold's favor: it is very hard to see what the warrior could have been doing in the story of Marsyas. The heroically nude Achilles could easily have been mistaken for Apollo. On balance, one should probably give Schefold the benefit of the doubt and allow that he saw enough to confirm his hunch.[37]

Schefold's identification of the scene can be reconciled with the documented traces of the figures, though the matter is very uncertain.[38] The rightmost figure, located near the center of the wall, standing with a shield and spear or scepter, could

be Agamemnon. Achilles would then be in the center, turning to confront him, with Athena at the far left, rushing to intervene. This would mean that the order of the figures was reversed with respect to the painting in the portico and some details changed, but that is just the sort of freedom one should expect on the basis of the loose adaptation of the figures from the Scyros scene.

In conclusion, there are two or possibly three separate rooms in the town where the same two compositions are paired. Coincidence on this scale is impossible. The only sensible explanation is that in the fourth—public—place where the quarrel scene appeared, it was also paired with the Scyros scene. This explanation of the phenomenon of multiple copies of images in domestic contexts in Pompeii, that it largely derives from quotation of local monuments, may not be subject to ironclad proof, as there is no direct evidence for the Scyros painting in the portico of Apollo, but I think it is as near to certain as circumstantial evidence could make it. This approach is antithetical to the theory that such repetition in Pompeii is the result of a desire to copy at a distance the classics of Greek panel painting. Again, that is not to deny the probability that those great works exerted a distant influence on the visual idioms of Campanian wall painting, but where there is evidence of very close copying of an image, the obvious place to look is not Greece but the local civic center. Analagously, the place to look for models for public art in Pompeii is not Greece but the public monuments of Rome. Of course, many Roman monuments housed Greek masterpieces, but if those works were topical at Pompeii, it was largely because of their Roman context.

It is particularly instructive to be able to make this point via the picture of Achilles on Scyros, for this has long been one of the main examples put forward to demonstrate the validity of the principles of *Kopienkritik*. All of the elements are there: a large number of copies of the scene appear in various places in Pompeii, several displaying a wide range of iconography, but several agreeing very closely.[39] The common features of these four, from the House of the Dioscuri, the House of Apollo, the Casa della Caccia Antica, and the Domus Uboni (discussed below), are usually taken to represent the uncorrupted branch of the transmission of the Greek original. The traditional argument is sometimes taken further to claim that because one of those three, the Dioscuri version, is of particularly high quality, it might conveniently stand in for that original. Finally, there is confirmation from Pliny the Elder that Athenion of Maroneia, a Greek master of the fourth century BC, did paint this scene.[40] This line of argument has been so firmly established that even skeptics have accepted it. For example, in the standard work on Roman painting in English, R. Ling eloquently describes the futility of attempting to work back to Greek originals from Roman adaptations; but on the same page he happily accepts that the Scyros pictures derive from Athenion.[41]

Scholars who have rightly rejected the connection to Pliny's vague account of Athenion's painting have been left with no alternative but to leave the origin of the

repeated images unexplained.[42] Trimble set out to account for the even more striking coincidence of the double pair of Achilles pictures, but the answer she gives is telling in its vagueness:

> Arguably, these two images responded to a model of *contemporary* popularity and interest and were made precisely because of that contemporary significance....
>
> Arguably, then, this particular pairing of scenes from the life of Achilles had contemporary popularity and appeal; the two scenes could then be made to interact in different ways.[43]

This is not so much a new model for addressing the question of copying as a new way of avoiding it. Things do not become popular spontaneously; people do not simultaneously and independently get the idea of putting the exact same thing on their walls without having been inspired by some common source. I hope it is clear that I am making this point not to criticize Trimble's excellent article but rather to highlight that an avoidance of the issue of copying is symptomatic of even the best contemporary work on Roman art. It was wrong for an earlier generation of scholars to situate the model for the multiple copies of the Scyros painting in Pliny's text on Greek painting; but it is equally wrong to evade the issue. This leaves scholarship unable to address one of the most important features of Roman art in its local context: its allusivity. The creative copying and reappropriation of earlier, especially Greek, forms was the essential modality of all forms of Roman culture. Out of that reuse was created a distinctive and vibrantly original synthesis. Athenion's painting may be, many generations back, one of the ancestors of the Scyros image. But the immediate place to look for the meaning of the repetition of an image in the houses of Pompeii is in Pompeii itself.

The House of the Tragic Poet

Another domestic context in which the painting of the quarrel of Agamemnon and Achilles was reproduced is one of the most famous rooms in Pompeii, the atrium of the House of the Tragic Poet (vi.8.5). Several of the six figural paintings that decorated this room were removed to the National Archaeological Museum of Naples, including the iconic image of the taking of Briseis from Achilles (fig. 69), while the others have been lost and are mainly documented in tempera reproductions by Francesco Morelli.[44] This room also demonstrates the effects of the backlash against studying the models on which Pompeian domestic painting is, in part, dependent, though the models in this case are textual rather than visual.[45] In the years after its discovery, this house was often called the "Homeric House" and the atrium in particular was lazily identified as having a "Homeric" theme. B. Bergmann rightly stresses the inadequacy of this description, noting, for example, that one of the paintings shows

FIGURE 69 Wall painting of the taking of Briseis from the atrium of the House of the Tragic Poet, Pompeii (vi.8.5). National Archaeological Museum of Naples, inv. 9105

us the marriage of Amphitrite to Poseidon, which is not ever alluded to by Homer.[46] Nevertheless, two of the paintings are extremely close in content to the text of the *Iliad* and four are on a Trojan theme, so Homer must be central to the account.

The six paintings in the atrium divide naturally into three thematically linked pairs, but they are arranged around the room in such a way as to disguise this fact; in each case the two members of the pair lie on different walls and face each other across asymmetrical diagonal axes. I start with the quarrel of Achilles and Agamemnon, which forms half of the Iliadic pair. Very little of it survived, and that little is now documented only indirectly. Nevertheless, Morelli's painting shows enough of the feet, legs, and clothing of several of the characters to be sure of an exact match

with Steinbüchel's engraving of the scene (see fig. 16), and thus to be sure that it is fundamentally the same composition.[47] The other clearly Iliadic picture is the removal of Briseis from the tent of Achilles by the heralds of Agamemnon. This scene follows immediately upon the quarrel and the breakup of the Greek assembly. Just as in the *Iliad*, Achilles is seated and does not rise to greet the heralds sent by Agamemnon; he commands Patroclus to lead Briseis away (*Il.* 1.327–48). It is worth pausing to notice Bergmann's account of this narrative in her excellent account of the paintings in their original context: "In the *Iliad*, the violent encounter between Achilles and Agamemnon was the direct aftermath of the taking of Briseis, and the two scenes were combined in Aeschylus' Achilles trilogy, the *Nereides*."[48] It is not pedantry to insist that this is not quite correct: the quarrel arose not from the taking of Briseis but from the threat thereof, which was only carried out after the assembly; this point directly affects the order in which one reads these two images. I do not mean to be unfair to Bergmann, who is perhaps speaking loosely here, but I think that very looseness along with her hurry to cite Aeschylus alongside Homer is indicative of an unwillingness to confront the importance of Homer here, in an understandable reaction against readings of the room as entirely Homeric. The key to interpreting the atrium lies in doing justice to the Homeric specificity of these two images while resisting the urge to reduce the room to a simplistic illustration of the canonical text.

Identifying the subjects of the other four paintings in the room has been more controversial; for the sake of brevity, I simply accept the judgment of Bergmann, who reports current scholarly consensus, so far as it exists, and who provides references to earlier scholarship.[49] It was a desire to assimilate the other paintings in the room to a narrative of the first book of the *Iliad* that led to the identification of a woman being escorted onto a ship as the departure of Chryseis, but the consensus is now that it shows the departure of Helen with Paris from Sparta.[50] This painting is paired thematically with another fragment of a painting recorded by Morelli, which shows a nude Aphrodite revealing her charms. The image is of uncertain identification, but it seems most likely to have been the judgment of Paris.[51] Bergmann convincingly points out the parallel with the previous pair of images: a contest leads to the abduction of a woman as a prize.[52] Indeed, Achilles himself makes precisely this point in the *Iliad* when he compares the wrong done to him by Agamemnon with the wrong done to Menelaus by Paris (*Il.* 9.337–43). Just as Agamemnon asserts his authority by commanding that Briseis be taken away, so the victorious Aphrodite asserts her authority in matters of the heart by commanding that Helen be taken away from her rightful man.

The final pair of images seems at first glance to be quite different; neither has an obvious connection to the Trojan War. They do, however, form a clear pairing: the brothers Zeus and Poseidon with their respective wives. The wedding of Zeus and Hera is preserved largely intact in the Naples museum; the subject can be identified by comparison with other depictions of the sacred marriage.[53] The final painting is

again a fragment recorded by Morelli, showing a marine procession in which Poseidon carries off his bride, Amphitrite. Even though the top half of the painting was lost, the subject can be securely identified by means of a closely identical parallel from nearby Stabiae.[54] This pair of divine images seems at first quite different from the other two pairs, which, as Bergmann points out, are linked by the theme of abduction. In general terms, it is clear, as K. Lorenz puts it, that the pictures in the atrium "thematize the union of man and wife."[55] It is precisely the contrast between the eternal stability of the divine marriages and the instability of the mortal ones that shows the way toward a more specific reading of the room.

The atrium presents a puzzle that the viewer must solve by drawing equally on his or her knowledge of visual and textual sources. First, the images must be identified and sorted into pairs, which is not very easy and is made particularly difficult by the carefully disjoint placement of the paintings on the three walls of the atrium. Then the theme of a man taking another man's woman must be identified. Finally, the marriages of Zeus and Poseidon must be integrated into the theme. The last step is perhaps the hardest, for it depends on identifying the one factor that unites all three pairs, but that is never represented explicitly. What could these two gods contribute to the theme of men squabbling self-destructively over possession of a woman? As it happens, there is a story that these two brother gods were not always happily married, that there was a time when they came close to contesting violently over a female, and if they had pressed their pursuit, the result would have been every bit as devastating to the hegemony of the Olympians as the Trojan War proved to be for both sides. The story is told by Pindar (*Isth.* 8.26–40):

> ταῦτα καὶ μακάρων ἐμέμναντ' ἀγοραί,
> Ζεὺς ὅτ' ἀμφὶ Θέτιος ἀγλαός τ' ἔρισαν Ποσειδᾶν γάμῳ,
> ἄλοχον εὐειδέ' ἐθέλων ἑκάτερος
> ἑὰν ἔμμεν· ἔρως γὰρ ἔχεν.
> ἀλλ' οὔ σφιν ἄμβροτοι τέλεσαν εὐνὰν θεῶν πραπίδες,
> ἐπεὶ θεσφάτων ἐπάκουσαν· εἶπε δ'
> εὔβουλος ἐν μέσοισι Θέμις,
> οὕνεκεν πεπρωμένον ἦν φέρτερον γόνον ἄνακτα πατρὸς τεκεῖν
> ποντίαν θεόν, ὃς κεραυνοῦ τε κρέσσον ἄλλο βέλος
> διώξει χερὶ τριόδοντός τ' ἀμαιμακέτου, Δί τε μισγομέναν
> ἢ Διὸς παρ' ἀδελφεοῖσιν — "ἀλλὰ τὰ μέν
> παύσατε· βροτέων δὲ λεχέων τυχοῖσα
> υἱὸν εἰσιδέτω θανόντ' ἐν πολέμῳ,
> χεῖρας Ἄρεΐ τ' ἐναλίγκιον στεροπαῖσί τ' ἀκμὰν ποδῶν.
> τὸ μὲν ἐμὸν Πηλέϊ γάμου θεόμορον
> ὀπάσσαι γέρας Αἰακίδᾳ,
> ὅντ' εὐσεβέστατον φάτις Ἰωλκοῦ τράφειν πεδίον."

(All this was remembered even by the assembly of the blessed gods, when Zeus and splendid Poseidon contended for marriage with Thetis, each of them wanting her to be his lovely bride; for desire possessed them. But the immortal minds of the gods did not accomplish that marriage for them, when they heard the divine prophecies. Wise Themis spoke in their midst and said that it was fated that the sea-goddess should bear a princely son, stronger than his father, who would wield another weapon in his hand more powerful than the thunderbolt or the irresistible trident, if she lay with Zeus or one of his brothers. "No, cease from this. Let her accept a mortal's bed, and see her son die in battle, a son who is like Ares in the strength of his hands and like lightning in the swift prime of his feet. My counsel is to bestow this god-granted honor of marriage on Peleus son of Aeacus, who is said to be the most pious man living on the plain of Iolcus.")

Thetis is the missing link between the three pairs. Unlike the mortals in the atrium, Zeus and Poseidon had the foresight (with the help of a prophecy) to understand the consequences of continuing to vie with each other for a woman. The stability of the unions of Zeus and Hera and Poseidon and Amphitrite do not just contrast with the instability of the sublunary unions; they are the ultimate cause of that instability, as the act of divine self-restraint led directly to the events of the Trojan War.

In order to ensure that no son of Thetis would threaten him, Zeus forced her to marry a mortal, hence the birth of Achilles rather than a rival to Zeus. It was on the occasion of Thetis's wedding to Peleus that the uninvited goddess of discord threw in the apple reading "to the fairest" that occasioned the beauty contest settled by the judgment of Paris, who then took Helen as his reward, as narrated in the epic *Cypria*.[56] The removal of Helen from her husband led, after more than ten years and many tragedies, to the removal of Briseis from her master. The very next thing Achilles will do after that final scene in the atrium is call upon his mother, Thetis, for help, thus bringing the story full circle. The paintings on the three walls of the atrium circle around the subject of Thetis; perhaps the impluvium at the center of the room can even symbolize the watery goddess who is its unspoken theme. It is clear that the Homeric narrative is important to this ensemble but forms only one-third of the total. The *Iliad* is reduced to one of its elements, a squabble over a woman, which is then embedded within a supra-Homeric and indeed somewhat anti-Homeric framework.

Homer knew the story that Thetis was forced to marry unwillingly, for she complains about this to Hephaestus (*Il.* 18.429-34):

"'Ἥφαιστ', ἦ ἄρα δή τις, ὅσαι θεαί εἰσ' ἐν Ὀλύμπῳ,
τοσσάδ' ἐνὶ φρεσὶν ᾗσιν ἀνέσχετο κήδεα λυγρὰ
ὅσσ' ἐμοὶ ἐκ πασέων Κρονίδης Ζεὺς ἄλγε' ἔδωκεν;

ἐκ μέν μ' ἀλλάων ἁλιάων ἀνδρὶ δάμασσεν,
Αἰακίδῃ Πηλῆϊ, καὶ ἔτλην ἀνέρος εὐνὴν
πολλὰ μάλ' οὐκ ἐθέλουσα."

("Hephaestus, is there now any goddess, of all those that are in Olympus, who has endured as many grievous woes in her heart as are the sorrows that Zeus, son of Cronos, has given me beyond all others? Of all the daughters of the sea he subdued me alone to a mortal, to Peleus, son of Aeacus, and I endured the bed of a mortal man though very much against my will.")[57]

Homer, however, never explicitly mentions the divine quarrel over Thetis. Instead, his Hera claims that it was she who gave the goddess to Peleus (*Il.* 24.59–63), which sits somewhat uneasily with Thetis's own assigning of blame to Zeus.[58] Both Hesiod and the *Cypria* apparently had a version in which Zeus punished Thetis because she repelled his advances out of loyalty to Hera.[59] It remains for the third-century BC epic poet Apollonius of Rhodes to reconcile the various archaic epic traditions with Pindar's version of the story: his Hera claims that Thetis rejected Zeus out of loyalty to Hera, but that he nevertheless kept pursuing her until he heard the prophecy of Themis; at that point Hera rewarded Thetis by marrying her to Peleus (*Argon.* 4.790–809). Apollonius achieves this uneasy reconciliation of divergent narratives by taking his cue from Homer, cleverly putting this version in the mouth of Hera herself, who as the victim of her husband's philandering may well be somewhat deceived as to the true course of events. One is not obliged to believe that Thetis, whom she is addressing here, was quite as steadfast a friend as Hera believes; she certainly does not share the view that marrying a mortal was a lucky outcome for her.

The irony is that recognizing the Homeric antecedents of the two Iliadic paintings makes it possible to liberate the room as a whole from an excessive dependence on Homer. Understanding the riddle of the atrium depends on knowing not only the *Iliad* but also the events narrated by the *Cypria* and the tradition of the quarrel between Zeus and Poseidon over the hand of Thetis. Not only was that story transmitted by Pindar; it was perhaps even more familiar from the Aeschylean Prometheus trilogy, where the plot turns upon this prophecy of Thetis's destiny to produce a son more powerful than his father. The view of cosmic history and the relationship between gods and mortals that the atrium articulates is a bitter one. The gods secure their own eternal concord and hegemony by ejecting the potentially destabilizing female force that is Thetis from their midst, compelling her to marry a mortal. Thetis's presence in the mortal world leads immediately to havoc: the birth of Achilles, the judgment of Paris, and the Trojan War. This antitheodicy is not very Homeric in spirit, for Homer's Zeus is generally more benign toward humankind; this is the angry Zeus of the Prometheus trilogy. The argument made by the atrium cycle demands a great deal from

the viewer, and the House of the Tragic Poet, despite its small size, is clearly one of the most sophisticated domestic spaces in the city.

Before deploying a fairly deep knowledge of myth in order to solve the riddle of the atrium, the viewer would first have to decode the visual clues and sort them on that basis into pairs. This suggests that the viewer would have recognized the pairing of the quarrel painting with the Briseis painting because they were already juxtaposed next to each other in the portico of the Temple of Apollo. This cannot be proven, and the evidence is weaker here than for the Scyros painting, where the pairing was found in at least two different houses in two different media. Simply because one painting in a room was a version of a painting from the temple, that is no reason to assume the others were, too, even if they were on Trojan subjects. Nevertheless, the pairing of these two images is so fundamental to the dynamic of the ensemble, and the events depicted are so intimately connected, that it is worth considering the hypothesis.

It is not known what painting came after the quarrel on the east wall of the Apollo portico, for it does not seem to have survived. If a version of the Briseis painting did come right afterward, it would have fit well in the sequence, for it observes the details of Homer's text as scrupulously as the other portico images. The dynamic of interchanging the sitting and standing figures binds together the Calchas picture and the quarrel picture, with the languid Achilles listening to the standing Calchas in the first image and then moving to stand and leap forward to attack the seated Agamemnon in the second. The seating arrangements reflect status, but they do more work than that; if the Briseis painting was the very next scene, the posture of Achilles would be an eloquent sequel. He is seated again, once more the senior individual present, but he is not at ease, relaxed, and confident as he was when listening to Calchas. Instead, his body is angled to the left while his head is twisted awkwardly to the right as he looks over his shoulder at the departing Briseis. His blank and uncomprehending expression is the prelude to the tears he will burst into in the very next line of the *Iliad* (1.349). His tears are adumbrated by the gesture of Briseis as she wipes one eye dry with the other fixed directly on the viewer, as if to say, "You and I both know this business will end badly." If, according to this hypothesis, the presence of a picture of the seated Agamemnon and a standing Achilles between two pictures of the seated Achilles was intended to highlight Agamemnon's higher status, then his absence from the Briseis painting would also be significant, for the king is replaced by his heralds, who stand and wait, which emphasizes Agamemnon's cowardice and unwillingness to do his own dirty work.

One interesting feature of the Briseis painting in the House of the Tragic Poet is the way the shields of the soldiers standing in the background provide a frame for the heads of the figures in the foreground. The heads of both Briseis and Patroclus are outlined in this way, but the treatment of Achilles is remarkable. The sun gleams off the shield on which his head is centered, creating an effect that is very like a nimbus.

Of course, the line drawings of Steinbüchel are not capable of reproducing this, but several of his pictures show a similar compositional effect. In the Calchas picture (see fig. 23), the shield of a soldier in the background frames Achilles's head in a similar way. In the quarrel picture, it is Agamemnon whose head is framed by a shield (see fig. 16), suggesting perhaps that the quasi-nimbus effect was designed to serve, along with the distinction of remaining seated, to emphasize relative status. In the drawing of Priam kneeling before Achilles (see fig. 55), the figure behind the seated hero holds a shield that serves as a background for his torso rather than his head, but that similarly puts the emphasis on the seated figure. Furthermore, the head peeping out over the top of that shield behind Achilles is very similar to the head in same position behind Achilles in the Briseis painting. The bottom part of the Briseis painting is not well preserved, but Morelli's tempera reproduction shows a shield resting against Achilles's throne, behind the legs of Patroclus. If this is right, it matches the throne Achilles sits on when receiving the kneeling Priam (see fig. 55) and presumably also when listening to Calchas, though Steinbüchel does not show us exactly what Achilles is sitting on behind the shield in that scene (see fig. 23).

Of course, these parallels could be dismissed as commonplaces or ascribed to a general compositional strategy that any artist might share, but there are enough small similarities to suggest that the pairing of the Briseis painting with the quarrel painting in the House of the Tragic Poet was not an accident. If the Briseis painting was derived from a source other than the Apollo portico, it is remarkable that it fits so well stylistically and illustrates so perfectly the aftermath of the quarrel scene. There is perhaps enough to suggest tentatively that the Briseis painting was part of the cycle in the Temple of Apollo, but the evidence is circumstantial and certainty is impossible. Of course, it is also true that the painter of the atrium may have taken liberties with his immediate model; but if the point was to evoke the *Iliad* via the visual representation in the Temple of Apollo, one might expect as close a copy as the quarrel picture seems to have been. In fact, it is not an utter novelty to make this guess; others have suggested that the Briseis painting might derive from the Trojan War cycle in Rome, which, as is argued below, may have inspired the cycle in the Pompeian temple.[60] Nevertheless, the usual route for explaining one of the most iconic images to come from Pompeii has been to invent an otherwise unattested masterpiece of Greek painting as its immediate model.

One problem with identifying the Briseis painting as a copy of a distant Greek original is that other representations of this scene give the impression of being a series of differing interpretations drawing on a common store of interrelated iconographic elements, not a series of attempts to imitate a single masterpiece. This can be illustrated by looking at the work of ancient art that comes closest in composition to the Pompeian painting, a mosaic in the collection of the Getty Museum (fig. 70).[61] The piece is of uncertain date and unknown provenance, but the other two known

mosaics of the departure of Briseis are from second- or third-century Antioch, so a roughly similar place and time of origin might be guessed for this piece.[62] For purposes of comparison, the striking thing about this mosaic is the way Achilles is seated in a throne on the left side of the picture, looking back over his left shoulder toward the departing Briseis, as he is in the Pompeian painting. Yet there are more differences than similarities. In the mosaic, a later moment is depicted, when the heralds have crossed from left to right and have taken hold of Briseis; Patroclus has released her, has moved from right to left, and stands behind Achilles, having swapped positions with the heralds. In the background there is a tent hung with circular ornaments instead of an angular building with the sea and ships in the distance, as in the painting. All these differences may be paralleled in a representation

FIGURE 70 Mosaic with the removal of Briseis, second century. Stone mosaic and glass tesserae, 217 x 227 cm (85 7/16 x 89 3/8 in.). Malibu, J. Paul Getty Museum, 68.AH.12

of the scene from the Ambrosian codex of the *Iliad*, so they cannot be dismissed as mistakes of a poor copyist.[63] There is at least one other tradition contributing to the iconography.

In fact, things get more complicated than that, for the mosaic adds features that seem to belong better to the embassy to Achilles in Book 9 of the *Iliad*. Next to the hero's throne is not a shield but an enormous silver stringed instrument, which clearly recalls the instrument Achilles is playing when the later embassy arrives (*Il.* 9.185–88). This lyre, too, can be paralleled elsewhere, in one of the mosaics from Antioch, which otherwise has a completely different conception of the scene.[64] Furthermore, the imposing figure behind Achilles's left shoulder in the Getty mosaic would seem to be Phoenix, for want of a better identification. The same figure appears in the Pompeian painting, but in a radically different guise: short, clean-shaven, balding, and part of the background. The mosaic brings him to the front and gives him an impressive beard and head of hair. His thoughtful, worried gesture in the painting has disappeared in the mosaic, or perhaps it has been transferred to Achilles. The prominence of Phoenix seems again to evoke the embassy of Book 9. Perhaps the creator of this mosaic, or of an ancestor of the image, wished by this synchronic composition to make the point that the events of the *Iliad* are determined by the aftermath of two embassies: the one in which Agamemnon is in the wrong and a second in which Achilles is in the wrong.[65]

So there are multiple streams of iconography contributing to the Getty mosaic, among which the branch represented by the Pompeian painting is only one. This does not seem anything like a tradition in which a masterpiece of Hellenistic painting exerted such a powerful pull that all other representations were more or less successful attempts to copy it. Indeed, a recent overview of all the representations of the taking of Briseis has rightly concluded that it is impossible to create a clear and uncontaminated stemma out of the iconographical variants.[66] Both the Getty mosaic and the Pompeian painting use elements of a common fund of iconography to represent this scene, and one can imagine that some works of Hellenistic panel painting may well have contributed elements to that fund; but these works in fresco and mosaic have their own agenda. The composition in the House of the Tragic Poet was probably a copy, but not of a painting far distant in time and space. Like its companion piece, the quarrel of Achilles and Agamemnon, it could have been copied from the Iliadic cycle in the Temple of Apollo for a particular, rhetorical purpose. If that cycle was in turn copied from the Portico of Philippus in Rome, then the atrium also had a second model with which its visual dynamics resonated. The confrontation of Homeric text and Trojan image thematized there by Zeuxis's *Helen* would have provided some of the prompting for the erudite riddles of the Pompeian atrium.

Other Trojan Cycles in Pompeii

I have looked at rooms for which it is possible to argue that pairs of paintings were taken from the Apollo portico as a unit. What about other rooms in Pompeii with miniature Trojan cycles or even isolated scenes from the *Iliad*? Can one assume that any or all of them are derived from the Temple of Apollo? The answer is clearly no. There were other visual traditions and other models for paintings of the Trojan War that had little to do with the Temple of Apollo. Good examples are the three Homeric cycles from houses on the via dell'Abbondanza that were documented by V. Spinazzola and that have some similarities but no unmistakable compositional echoes of the temple.[67] Even for domestic groupings of full-scale figural Homeric scenes there are likely to have been other models available besides the ones in the Temple of Apollo. With these cautions in mind, I nevertheless attempt to read one final domestic room in Pompeii as influenced by the Apollo portico, for here, crucially, there is a link, though an admittedly indirect one, with the temple. The first step is to accept that the picture of Achilles on Scyros was part of the portico on the basis of the way it is paired in at least two separate contexts with the quarrel of Achilles and Agamemnon. Among the widely varying representations of the Scyros scene in Pompeii, there are three that are closely based on the same model.[68] I have already looked at the two that are paired with the quarrel picture; it is now time to look at the third, for it, too, is juxtaposed with other Trojan paintings. Were these paintings also copied from the Apollo portico? Clearly one must be extremely careful, for at this point the evidence is at a double remove from paintings directly attested to in the portico, but it is worth examining the hypothesis.

The room in question comes from a house that goes by various names, including the House of Achilles and the Domus Uboni (ix.5.2). In a room off the peristyle are three paintings of episodes from the story of Achilles that survived fairly complete but that are cruder in execution than the paintings in the House of the Dioscuri or of the Tragic Poet. On the central north wall, facing the entrance to the room, was a painting very clearly copied from the same model as the discovery of Achilles on Scyros in the House of the Dioscuri, despite small differences of detail. Unlike that version, of which only the right half survived, and unlike the simplified and low-resolution mosaic from the House of Apollo, this version shows the entire composition (fig. 71).[69] The other two figural paintings in this room are closely related in theme.[70] It was Thetis who hid Achilles on Scyros, and she is the focus of the other two pictures. One shows the scene from the *Iliad* where she receives Achilles's new armor from Hephaestus, and the other shows her apparently delivering armor to her son. Did either of these come, like the Scyros picture, from the Temple of Apollo? Not on the evidence presented so far. But one of the two images exhibits some interesting similarities to other paintings from there.

Thetis receiving new armor for Achilles from Hephaestus is, like the subject of Achilles on Scyros, another very popular subject throughout Pompeii. Also like

FIGURE 71 Wall painting of Achilles on Scyros from the House of Achilles/Domus Uboni, Pompeii (ix.5.2). National Archaeological Museum of Naples, inv. 116085

the Scyros paintings, some of the images are free reinterpretations of the theme, but six are very similar and are clearly copies of one original.[71] According to the hypothesis of this chapter, such close copies are usually not versions of a distant Greek masterpiece but derive from a local monument of prominence. The original can be reconstructed in general terms upon the consensus of these mutually similar copies, of which the most detailed is the version from the House of Achilles (fig. 72). That painting, like so many of the other paintings in the portico of the Temple of Apollo, juxtaposes a standing and a seated figure. Thetis, the higher-status divinity, sits on the right while Hephaestus stands on the left and holds out the shield, which rests on an anvil at the center. The shield is the centerpiece and focus of the image, corresponding to the prominence with which shields feature in many of the

FIGURE 72 Wall painting of Thetis at the forge of Hephaestus from the House of Achilles/Domus Uboni, Pompeii, in situ, ix.5.2

paintings in the temple cycle. To judge from several of the copies, the shield in the original painting bore indications of the zodiac and other cosmological symbols. A winged figure behind Thetis points to it with a thin wand; Thetis puts her hand to her mouth and reacts in horror to what she sees. This reconstruction is owed to P. R. Hardie, who has convincingly argued that what Thetis is seeing in the shield is the horoscope of Achilles and the forecast of his swiftly approaching death. This would give the nice irony that Achilles bears as emblem of his powers the image of the heavens themselves, but that this is also an image of his inevitable subjection to the laws of fate as proclaimed in the stars.[72]

The thin pointer that focuses the viewer's attention on the device on the shield functions in precisely the same way as the end of Odysseus's spear in the Scyros

painting, which highlights the device on Achilles's shield referring to his musical tuition with Chiron.[73] Given the probability that some version of the scene of Thetis and Hephaestus would have featured in the Iliadic cycle of the Temple of Apollo, the presence of no fewer than six apparently close copies of an image of this scene in domestic contexts across the city, the similarities with other paintings from the temple cycle, and its pairing with the Scyros picture, there are some reasonable circumstantial grounds to suspect that the original was found in the temple.[74] I return to the implications of this hypothesis in the conclusion to this book.

The third Trojan painting in the room of the House of Achilles shows Thetis riding a Triton as she carries armor across the sea, presumably to Achilles. At first sight, this might seem the obvious sequel to the scene in the forge of Hephaestus, but it has been suggested that it could equally represent the first set of armor that Thetis delivered to her son before he set out for Troy.[75] In that case, the painting is the sequel to the Scyros picture. Either episode might have featured in the Temple of Apollo, but not necessarily so. But there are no other features in common with those compositions: no tension between a seated and a standing figure, no drama. So there is less reason to believe that this painting was copied, like the other two in the room, from the temple. Perhaps the painter was posing a small riddle to the viewer: which set of armor is Thetis delivering? Which of the two paintings from the temple portico is this one the sequel to? These questions might have prompted the viewer to contemplate the repetition in Achilles's life, his mother twice arming him for battle. In this reading, there are potentially three distinct sets of armor for Achilles in this room: the set that Odysseus uses to lure him out of his female disguise, the set that Thetis brings him before he sets out for Troy, and the set that replaces the second, which has been taken by Hector. The three sets of armor trace the trajectory of Achilles's life from the comedy of childhood to the serious business of adulthood to the tragedy of his encounter with Hector, which is the prelude to his own death.[76]

These three compositions did appear together in other contexts, which might support the hypothesis that they were drawn from the same cycle. In the triclinium of the Casa delle Quadrighe (vii.2.25), there were compositions similar to the ones considered above: Hephaestus showing the shield to Thetis and Thetis carrying the armor across the sea (here the shield apparently bore the device of a dolphin), along with Hephaestus in the act of forging the shield.[77] Images of Thetis at the forge of Hephaestus and Thetis delivering the weapons are also found in the House of Meleager (vi.9.2), but in different rooms.[78] The House of the Dioscuri also has a painting of Thetis delivering the weapons.[79] The House of the Menander has a small cycle of images of the sack of Troy, and in the nearby room a painting that might have shown Thetis delivering the weapons.[80] One cannot conclude that the portico was the model for all these juxtapositions, but it is a likely influence on some of them.[81]

Another very interesting house for Trojan material is the Casa di Sirico (vii.1.25), which is the location of the painting of Apollo and Poseidon building the walls of Troy discussed in the previous chapter (see fig. 39). H. Diepolder thought that the posture of Apollo in that painting was identical to that of the figure I have tentatively identified as Machaon in Steinbüchel's drawing (see fig. 38); I concluded, however, that this parallel was not specific enough and that several of the pictures in the portico had figures in a similar, seated posture.[82] Perhaps that argument can be turned on its head: the frequency with which this seated posture is repeated in the portico cycle may be an indication that the painting of Apollo and Poseidon at Troy belongs to the Trojan cycle and was created by the same artist. This painting (see fig. 39) presents a contrast between the seated, higher-status Poseidon on one side of the image and the standing Apollo on the other, the very type of contrast that is one of the hallmarks of paintings from the Apollo portico. In the same room of the Casa di Sirico is an image of Thetis and Hephaestus similar to the one in the House of Achilles discussed above, along with Apollo and the Muses.[83] In another room of that house was an Achilles on Scyros, though one with a very different compositional scheme from that which I have attributed to the temple.[84] In yet another room of that same house was found a famous painting of the wounded Aeneas being treated by Iapyx, which is unique in that it depicts a scene from Virgil's *Aeneid*. The owner of this house was clearly interested in visual representations of epic, but that is perhaps all that can be said.

To sum up, there are three well-known Trojan images from houses in Pompeii that can be shown to have a connection with the Temple of Apollo and have some chance of having been adapted from that source. In decreasing order of certainty, these are the discovery of Achilles on Scyros, the removal of Briseis from the camp of Achilles, and Thetis in the forge of Hephaestus. It has been known for many years that several very similar versions of the first and third of those compositions were found all over Pompeii, but the obsession with inventing Greek originals has meant that the local model for these was never properly considered. Recent work has preferred to ignore the issue, perhaps assuming that appreciating each work of Roman art in its particular, local context is incompatible with the status of being a copy. I have argued, however, that the local meaning of a work of art in a community has to be interpreted in terms of the shared experience of that community. These domestic allusions to local public art derive part of their meaning from their intertextual network within the city of Pompeii, and a recognition of this fact generates richer readings of those works.

Metropolis and Periphery

If the Trojan cycle in the Temple of Apollo was so influential locally in Pompeii, it is natural to ask whether it was in turn a reflection of a Roman monument that was influential more globally. This question brings up what may be a more controversial application of the intertextual principle for reading Roman art. It may be well and

good to relate domestic art to public art; it is clear that everyone in Pompeii would have been acquainted with the Temple of Apollo and so would have had a framework for understanding local quotations therefrom. But the much larger question of the relationship between the Temple of Apollo and possible models in Rome is not so straightforward. Once again, there is a situation in which the methodological pendulum has swung to a position where any discussion of the role of local copying and metropolitan models may seem retrograde, undermining the importance of understanding Roman art with respect to its local context. The situation is the same, however: to understand the local meaning of the Temple of Apollo one must examine the way the temple adapted and modified cosmopolitan models. The language spoken by the Pompeian monument was not purely local but was designed to position the town within the Roman world, and it did this not only by its similarities to monuments in Rome but also by means of significant differences. Not everyone in Pompeii would have been to Rome so as to compare the local model with its exemplars, but the most influential citizens would have, and another important part of the intended audience would have been high-status visitors to Pompeii.

To reiterate: there is no proof or direct evidence connecting the Trojan cycle in the portico of the Temple of Apollo in Pompeii with the Trojan cycle in the Portico of Philippus in Rome. There is only circumstantial evidence, but it is highly suggestive. The Pompeian monument was built and decorated about two decades after the Roman one: does this coincidence demand an explanation? In the building of Eumachia, right across the Forum from the Apollo portico, there is a powerful parallel that demonstrates that precisely this sort of emulation of buildings in Rome did occur in Pompeii. As shown below, the magistrates responsible for the portico emulated Augustan models in other public works in the town.

It looks like more than a coincidence when a local temple adopts the same decorative program as a new Roman monument, but three immediate objections may be raised. First, the temple in Pompeii was dedicated to a different god than the one in Rome. This is in fact one of the differences that articulated the specifically Pompeian agenda of the building. Second, even if the idea of a Trojan cycle was adopted from Rome, the particular iconography of the paintings in Pompeii might have been quite different. This possibility must be admitted, but the *tabulae Iliacae*, which are so often the main parallels for the Pompeian paintings, and which were almost all found in the suburbs of Rome, suggest a common metropolitan model. I return to these considerations below, but first I must discuss in detail the third and most important objection to the connection posited here between Pompeii and Rome, which is the dating of the portico of the Temple of Apollo. According to the standard reference works, the portico was built long before the Augustan period, in the second century BC, and its painted decoration was in the fourth Pompeian style, which is dated well after the Augustan period, to the decades just before the eruption of Vesuvius. In other words,

the Pompeian portico would seem to have nothing to do with the time in which the portico in Rome was built and decorated. I must therefore demonstrate first that the portico was built around 10 BC and then that the fourth-style redecoration was only partial and continued to reflect the original theme.

Constructing the Portico

The usual second-century BC date for the Sanctuary of Apollo, including both the temple and its portico, derives from the work of the great Pompeian scholar August Mau, who assigned the entire complex to his "Tufa period."[85] This is uncontroversial for the temple itself. The floor of the cella bears a dedicatory inscription in Oscan whose decipherment finally led to the correct identification of the temple as belonging to Apollo, after having been called for so long the Temple of Venus:

> Ú. Kamp[aniis . kvaí]sstur kúmbenn[ieís tanginud] Appelluneís eítiu[vad.....
> úps]annu aaman[aff]ed
>
> (Oppius Campanius, as quaestor, by order of the council, with the funds of Apollo, contracted the construction of ...)[86]

It has been debated whether the missing word should indicate the temple or just the pavement. The god named in the inscription confirms the interpretation of the stone embedded in the cella floor as an omphalos. The language of the inscription confirms that the cella dates to the pre-Roman period.[87] This temple building was probably decorated with a pediment and frieze in terracotta featuring scenes of Apollo with Marsyas, the Muses, and others; these were later removed, possibly because of damage in the earthquake of AD 62.[88] With respect to the portico that surrounds the sanctuary and defines its boundaries, recent investigations have suggested that Mau was wrong and that there is very good reason to think that it was built much later, in the age of Augustus.

The crucial piece of evidence for this later phase of building is an inscription from the sanctuary of Augustan date recording that the city magistrates had purchased the right to block the light to an adjacent house and had a private wall built with public funds:

> M. Holconius Rufus d[uo]v[ir] i[uri] d[icundo] tert[ium], C. Egnatius Postumus
> d. v. i. d. iter[um] ex d[ecurionum] d[ecreto] ius luminum opstruendorum
> HS ∞ ∞ ∞ redemerunt parietemque privatum Col[oniae] Ven[eriae] Cor[neliae]
> usque ad tegulas faciundum coerarunt
>
> (Marcus Holconius Rufus, duumvir with judiciary authority for the third time, and Gaius Egnatius Postumus, duumvir with judiciary authority for the second time, in accordance with a decree of the council, purchased for 3,000 sestertii

the right to block off the light and caused a private wall to be built right up to the roof-tiles for the benefit of the colony of Pompeii.)[89]

It is generally agreed, even by Mau, that this must refer to the west side of the portico, as it perfectly explains two of the peculiarities on that side of the sanctuary: the strange jog in the street plan at the northwest corner and the presence of the blind alley behind the west wall.[90] Where the west side of the portico now stands there must once have been a street running north from the via Marina, which connected with the road that still runs north from the northwest corner of the sanctuary. The houses in the block to the west of the sanctuary would once have had windows and doors opening onto that street, but all that was left after the widening of the sanctuary was the tiny blind alley that many early visitors thought was a channel for water. For this reason, the municipal authorities must have paid to rebuild that private wall without doors and windows, for it now faces a blank portico wall; they also compensated the owners for the loss of light.

Recent archaeological investigations by J. Dobbins and his collaborators have tended to confirm the inference from the inscription that the entire surrounding portico was built in the Augustan period.[91] The excavators point out that that inscription only records the rebuilding of the wall adjacent to the west wall of the sanctuary because of the extraordinary use of public funds for a private construction; there was no need to record in the same way the building of the walls of the portico itself. The changes to the adjoining private block only make sense, however, in the context of a general modification of the boundaries of the sanctuary to include the road to the west. Therefore, the inscription that records the remodeling of the private block to the west of the portico can also give us a rough date for the building of the portico in its present state. Dobbins and his team of excavators dug several trenches around the portico, one of which established stratigraphic corroboration of an Augustan date for the west wall. Archaeological investigation on the east side was less conclusive but tended to support the probability that, with the exception of the earlier massive piers, the east side was built at the same Augustan date as the west side. They concluded: "Our saggi and the inscription *CIL* X.787 suggest a date of ca. 10 BC for a major Augustan project that expanded the sanctuary, introduced the tufa colonnade, and presumably included the installation of sills between the piers and the raising of the ground level in the new portico."[92] The approximate date of ca. 10 BC is derived from the same inscription, which names the duovirs, joint holders of the chief annual magistracy in Pompeii, who oversaw the work. It specifies that it was the third tenure of that office for Marcus Holconius Rufus, who was "without a doubt the most distinguished personage in Pompeii in the Augustan period."[93] He held it five times, and another inscription tells us that part of his fourth year-long term of office fell in 2 BC.[94] On the grounds that at least five years had to pass between terms of office,

the third duumvirate of Marcus Holconius Rufus is usually dated to around 10 BC, but this is a very rough guess.[95] The Portico of Philippus in Rome was probably built not long after the battle of Actium, perhaps around 28 BC, or about eighteen years earlier than the Pompeian portico. On the assumption that the cycle of paintings of the Trojan War attested to later by Pliny the Elder was part of the original decoration of that portico, there is a recent metropolitan model for the decorative theme of the Pompeian portico. Rome's Temple of Palatine Apollo, with its famous portico, had been dedicated around the same time, so that provides an additional model for a major refurbishment of Pompeii's Temple of Apollo, its oldest and arguably most important sanctuary. The ideology of Augustus, which highlighted his intimate connection with Apollo, made Pompeii's ancient connection with the god suddenly relevant.

This tendency to emulate Augustan models in the city of Rome is paralleled in other public buildings built in Pompeii under the magistrate Holconius Rufus.[96] The largest building project he undertook was a major renovation of the large theater at the private expense of himself and a close relative.[97] This was clearly modeled on the Theater of Marcellus built by Augustus in Rome and accordingly was dedicated to Augustus; a statue of Marcellus stood nearby.[98] Moreover, the theater in Pompeii attempted to replicate not only the architecture but also the ideology of the structure in Rome. Augustus passed legislation more strictly enforcing the separate seating in theaters of different ranks of the population, and this separation was reflected in the design of the Theater of Marcellus.[99] The same separation of social classes is evident in the new design of the theater in Pompeii.[100] As a token of the town's thanks to their benefactor, a statue of Holconius Rufus was later erected in front of the Stabian baths.[101] The statue was probably commissioned from Rome and was modeled on the cult statue of Mars Ultor in the Forum of Augustus.[102] No doubt Holconius, who had also been a priest of Augustus and patron of the colony of Pompeii, was pleased with the tribute, for it summed up his career as an intermediary between Augustan Rome and Pompeii. An important early step in that career would have been the building of a new portico for the local temple of Augustus's patron, Apollo, with its decorative program emulating the Portico of Philippus. The local *ludi Apollinares*, games in honor of Apollo, were of particular importance during the Augustan period; the magistrates organized events in both the amphitheater and the Forum, adjacent to the god's newly refurbished temple.[103]

If, as I argue in more detail later, the portico of the Temple of Apollo in Pompeii was designed to recall a mixture of two related Augustan monuments in Rome—the Temple of Palatine Apollo and the Portico of Philippus—an excellent parallel for that kind of mixing of Augustan models can be found directly across the Forum in Pompeii. The building of Eumachia seems to have been inspired in part by the Portico of Livia as a model for civic benefaction by a woman; both are dedicated to Concordia Augusta.[104] Its form does not, however, simply duplicate that model; the building of

Eumachia was a complex hybrid of various Augustan buildings. Aspects of the marble decoration have been compared with work on the Ara Pacis and may even have been ordered from a Roman workshop.[105] Most important, for my purposes, the facade of the building announced its debt to the ideological program of the Forum of Augustus. Statues of Romulus and Aeneas were placed along with verbatim copies of their honorary inscriptions.[106] This seems to have been to suggest that the niches inside, which were presumably intended for statues of local dignitaries, were the Pompeian equivalent of the statues of great men from Roman history that decorated the Forum of Augustus. It is most interesting that the Eumachia building quoted the statue and inscription of Aeneas, for that provides an exact parallel for the Trojan paintings, also featuring Aeneas, across the Pompeian Forum. Both buildings reproduce Augustus's efforts to link Rome to its Trojan past via the ancestry of his own family. In a way, the Eumachia inscription provides the sequel.[107] The Apollo portico began with the childhood of Aeneas and showed his duel against Diomedes; it possibly continued on to show his flight from Troy. The statue across the Forum likewise showed Aeneas carrying his father from the ruins of Troy. The inscription began from that point, but it went on to emphasize his achievement in crossing to Italy, founding Lavinium, ruling over it for three years, and ultimately ascending into heaven to be counted among the gods of Rome. The two monuments flanking the south end of the Forum allude to the two halves of Aeneas's life, with the fall of Troy as the turning point.

In 2 BC, the year that Holconius served as duumvir for the fourth time, his colleague was A. Clodius Flaccus, who was serving for the third time. An inscription records the spectacles put on for the people of Pompeii on the occasion of each of Flaccus's three duumvirates.[108] There were bullfights, boxing matches, and music and theatrical performances in the Forum and hunts and gladiatorial displays in the amphitheater. That inscription emphasizes that these lavish displays were put on at the festival of Apollo. The use of the Forum as the venue suggests that the festivities were closely connected with the newly renovated temple precinct. The prominence of the feast of Apollo in the Augustan period was presumably part of the same public spirit that led to the renovation of the sanctuary of the god. Also associated with Clodius Flaccus is the *mensa ponderaria* that was installed in his first term as duumvir on the Forum side of the false pillar at the northern end of the east wall of the Temple of Apollo.[109] This brought the weights and measures used in the city into line with those of the rest of the Roman world ruled by Augustus.

The efforts by Dobbins et al. to redate the portico of the Temple of Apollo to the Augustan period have not met with universal assent, even though the evidence of the inscription ought to be incontrovertible.[110] One counterargument has been made by P. G. Guzzo and F. Pesando, who adduce the testimony of the masons' marks that are found on stones used in the construction of various buildings and especially the city walls of Pompeii.[111] Some of these marks may have some relationship to the Oscan

alphabet, and Mau believed that their use was restricted to buildings constructed before Pompeii became a Roman colony.[112] The meaning of these marks is quite uncertain; it is not even known if they were used in the quarrying of the stone or the construction of the buildings. Since the marks appear to be arbitrary symbols and do not have any clear meaning as abbreviations, it would not be surprising if marks that happened to have an Oscan origin continued to be used into the Roman period, especially since they were not meant for public consumption. The masons' marks used in the portico of Apollo are, for the most part, obviously analphabetic and symbolic. The marks most commonly found in the portico are of a type that is distinctive and almost unique to that building: variants on a star formed with three straight lines.[113] This was probably just a mark from the quarry indicating that the block was intended for delivery to the portico. The only mark from this location that might yield any intrinsic sense is one that looks like the number eleven or nine, but this could have been in either Roman or Oscan numerals; the same mark is found on the steps of the Temple of Jupiter, which is likely to date to the Roman period.[114] It is clear that Mau's generalization that masons' marks in Pompeii were exclusively pre-Roman should be discarded.[115]

Another objection to the revised dating of the portico has been based on the presence there of a dedicatory inscription on a statue base that records in Oscan the name of Lucius Mummius, the Roman general who destroyed Corinth in 146 BC.[116] The inscription was concealed in antiquity with a coat of plaster that has only recently been removed to allow it to be read in full. It has been suggested that the base originally held a statue of Mummius himself, but it is more likely that it held a dedication by Mummius of an object from the vast amount of booty he took from Greece and is known to have distributed among the towns of Italy.[117] Martelli argues that the presence of this dedication supports a mid-second-century BC date for the portico. He observes that under several statue bases there is a raised platform in the step that runs around the inside of the columns on which the bases were located (see fig. 10, A–F). This implies that the portico was built with a view to providing a special place for several of the statues that were located there, including the Mummius dedication. This is all quite correct, but the implication for the dating of the sanctuary is quite the opposite: the portico must postdate the existence of the dedication. The Augustan portico was designed and custom-built to accommodate several preexisting dedications.[118] When Mummius gave his gift, it was presumably placed somewhere in the old sanctuary precinct surrounding the Temple of Apollo and was given an Oscan inscription. When the Augustan portico was built, a special place was provided for the preservation of this important dedication to the god, but the old inscription was plastered over as not in keeping with the Roman orientation of the portico.

Several other objections have been made to the new dating on the basis of other finds from the area, but these can all be related to earlier phases of the development of the sanctuary. Excavations were conducted in the sanctuary by A. Maiuri in the

1930s and 1940s but were only published in the 1980s by S. De Caro.[119] The surviving documentation did not include much stratigraphic information, but the prevalence of archaic votive deposits did confirm that this location had been a cult place since the earliest settlement. Excavations in 1980–81 for electric cables running outside the eastern and southern boundaries of the sanctuary found more votive material, suggesting that the sacred area was once larger, extending to the east and south of the present boundary, before the construction of the Forum and the via Marina.[120] It seems likely that there was an intervention in the mid-second century BC that systematized and reduced the size of the precinct of Apollo; Maiuri claimed that a wall under the *insula* to the west of the sanctuary was the original western boundary.[121] Around the same time, the eastern part of Apollo's sanctuary was appropriated as part of the new Forum, and the new boundary that was provided probably survives in the form of the pillars of the east wall of the portico. There was thus a coherent development of the Forum area in the second century BC that substantially reduced the early bounds of the very large sacred area of Apollo on at least three sides: east, south, and west.

It is ironic that the weight of Mau's authority has been responsible for the persistence of the second-century BC dating of the portico of Apollo, for he is the one who brilliantly articulated how all the sculpture found there can be explained in terms of the ideology of Augustus.[122] According to his reconstruction of the original positions of the various statues, they were organized in pairs. He implies that it was the statue of Venus from the portico that was originally on top of the base with the effaced Mummius inscription to the left of the entrance along the south side (see fig. 10, *A*). This fit with the new Augustan theme of the portico as an acknowledgment of the goddess from whom the Julian family traced its descent. If I am right in guessing that the Trojan cycle concluded to the left of the south entrance with the escape of Aeneas and Anchises from Troy, then the statue of Venus stood in front of them. The pairing of Apollo and Diana (see fig. 10, *C* and *D*) needs no explanation in a Temple of Apollo, and it is possible that these statues may be of Augustan date.[123] The appearance of a herm representing Mercury (see fig. 10, *F*) is more surprising. Mau suggests that it would have been paired with another herm representing Maia, mother of Mercury, on the basis of the connected worship of those two deities in Pompeii, whose worship was later connected with Augustus.[124] Mau adds that Augustus himself was linked with Mercury in Horace's Ode 1.2. The last piece of surviving statuary from the portico was a Hermaphroditus (see fig. 10, *B*), which brings us full circle, for he was the product of the union of Venus and Mercury. In addition to these Augustan connections noted by Mau, there is one other important thing these gods have in common: Apollo, Artemis, Aphrodite, and Hermes are all gods on the Trojan side in the *Iliad*.

Mounting the Paintings

The paintings that adorned the portico are generally ascribed to the fourth and final Pompeian style, which was in use in the last decades of the city's life.[125] How to reconcile the Augustan date of the construction of the portico with the later date of its painted decoration is obviously going to be crucial for my attempt to connect the ideology of the portico with the age of Augustus. It is necessary first, however, to examine the manner in which the paintings were affixed to the walls, for in a number of regards this was quite remarkable.

I begin by returning to the *tegulae mammatae* on the west wall, the presence of which was so frequently noted as a peculiar feature of the sanctuary in the early nineteenth century. These are the tiles that create a false wall for the painted plaster to adhere to, with a gap behind for air to circulate. The Romans used these tiles either to conduct hot air in the construction of baths or to provide a dry surface for the fixture of wall paintings in damp conditions. The first option is excluded, so the second must be correct, but it is not obvious where the moisture was coming from. The west wall was extremely well ventilated, better so than the north wall, which had rooms on the other side. The purpose of the dead space in the blind alley was to serve as insulation from dampness, sound, and vibration from the private accommodation in the adjacent *insula*; the tiny gap between tile and wall would have added no more protection of any significance.

There are two possible sources of moisture to consider, rising damp from the ground and penetrating damp through the wall. There are examples of precautions taken against rising damp in several houses in Pompeii, most notably in the House of the Faun. There, nailed lead strips were used at first; these are found under first-style decoration. Presumably this technique did not work very well, for a different one was used later; elsewhere in the house, under second-style decoration, were mounted tiles curved at the edges to stand free from the wall.[126] One possibility is that a source of rising damp was discovered along the west wall of the portico after it was built and that the tiles were added later when the decoration of the portico was renewed. It is strange, however, that it was so localized as to affect only the west wall of the portico and not, for example, the western ends of the north and south walls. A more likely explanation, therefore, is fear of penetrating damp. This was the reason that *tegulae mammatae* were employed in the House of Livia in Rome, for example, for walls that face the earth on the other side.[127] They were used to provide a dry surface for decoration on those walls that were dug into the Palatine hill. Clearly, those walls were always going to be moist and the tiling was a sensible precaution.

In the Temple of Apollo, by contrast, there was no immediate source of moisture behind the west wall, so it seems that the builders put this measure in place not because of existing damp but as a precaution. The blind alley was a potential source of trouble: it might fill up with debris that could block its drainage either gradually or suddenly, as the result of an earthquake. Since the alley was closed on every side,

it might fill with water unseen and unnoticed until it was too late and began seeping through the wall. It is not improbable to suggest that this is what happened after the earthquake of AD 62. The taking of such expensive precautions against the possibility of another failure of drainage in the blind alley suggests that the painted stucco that was intended for the west wall was of particular value and importance. The care and foresight taken in this public building for the long-term preservation of the painted plaster on the portico walls suggest that it was something more than an ephemeral feature to be replaced and repainted at the whim of the priests.

Another peculiarity about the relationship of the painting in the portico to the walls behind it is the presence noted in the previous chapter of unpainted blank spaces in the middle of several panels. I have already pointed out that there was an empty space where a figural painting should have been in the center of many of the pillar-style panels, on both the east and north walls. Were the painters simply interrupted before they could finish? Normal practice was for the figural paintings to be executed by a more accomplished artist after the rest of the panel had been painted. The largely geometric and repetitive patterns were painted by the less accomplished *parietarii* (background wall painters), and the *imaginarius* would come afterward to execute the figural centerpieces.[128] Pompeii was a massive building site with repairs from the seismic activity of the previous decade ongoing everywhere, so it is not surprising that there were several houses where repainting was in progress at the time of the eruption.[129] There are therefore domestic examples where the painting of a wall was incomplete, with a missing figural composition at the center.[130] Moreover, according to some authorities, the entire Temple of Apollo was undergoing a major postearthquake renovation at the time of the eruption. This view may, however, owe something to an earlier tendency to underestimate both the force of the pyroclastic surge that accompanied the eruption of Vesuvius and the extent of salvage operations immediately after the eruption; some scholars now believe that the postearthquake repairs to the Temple of Apollo had been largely completed.[131] Were the blank spaces simply a sign that the repainting was incomplete? The problem is that there are no other indications that the painting was an ongoing job. The other examples of incompletely painted walls tend to include the tools of the trade: scaffolding, lime, gypsum, pigments. That seems not to have been the case here: apart from the missing central panels, the decoration shows no sign of being incomplete.

As it happens, there are good domestic parallels for finding a blank space where a figural painting would be expected in the middle of an otherwise finished room. The explanation for this phenomenon is that the figural painting had been salvaged from an earlier version of the wall, mounted on wood, and then inserted back into the fresh plaster in the middle of the newly painted wall. When the wood carbonized or rotted away, there was nothing to keep the plaster attached to the wall, and the painting fell away. Here is an excellent account, which is worth quoting at length:

Il sistema di dipinti figurati su intonaco, incastrati in una cassetta lignea (*picturae excisae...inclusae in ligneis formis*; Vitruvio 2.8.9), eseguiti in bottega e inseriti poi nell'intonaco di una parete, si trova di rado: e venne applicato quasi esclusivamente in caso di restauri, per salvare un quadro «prezioso». (Il procedimento nacque peraltro per ragioni simili, quando cioè i Romani rubarono in Magna Grecia e in Grecia famosi o piacevoli originali, staccandoli dalle pareti, intelaiandoli e riappiccicandoli i muri nei templi di Roma.) Della decina di esempi attestati a Pompei, si sono conservati solo quelli in cui non s'era fatto uso del supporto ligneo; degli altri non resta che il vuoto dell'incassatura: il legno fondo del telaio, una volta marcio e polverizzato, causò evidentemente la caduta della pittura. A Pompei, sepolta da una pioggia di lapilli e ceneri condotti dal vento, il legno non si è salvato negli strati meno compatti, mentre ad Ercolano, immersa in una colata di fango induritasi poi fino a formare un banco tufaceo, il legno venne incluso e carbonizzato. Qui si sono trovati infatti un telaio di legno contenente un affresco con amorini, e altre tracce di legno carbonizzato in incassature.

(The system whereby figurative paintings on plaster are enclosed in a wooden box ["paintings cut out...enclosed in wood containers," Vitruvius 2.8.9], executed in the artist's studio and then placed in the plaster of a wall, is seldom found; it is applied almost exclusively in case of restoration, in order to save a valuable picture. [The procedure arose for similar reasons, when the Romans stole famous or pleasing originals from Magna Graecia or Greece, detaching them from the walls, framing them and attaching them to the walls of temples of Rome.] Of the ten or so attested examples in Pompeii, only those that did not make use of a wooden support have been preserved; of the rest, nothing remains but the empty space where the painting had been mounted. The rotting wooden undersurface of the frame will have turned to dust and caused the painting to fall. At Pompeii, which was buried by a rain of lapilli and ash carried by the wind, wood was not preserved by the less compact layers, while in Herculaneum, which was covered by a mudslide which hardened to form volcanic rock, charred wood was. Here, in fact, were found a wooden frame containing a fresco with cupids and other traces of charred wood used for mounting.)[132]

In addition to the passage of Vitruvius cited in the quotation above, which refers to the Roman practice of cutting out Greek painted plaster and mounting it on wood to take back to Rome as war booty, there is another passage in which Vitruvius seems to recommend a similar practice in more modest domestic contexts. The passage is obscure and possibly corrupt, but it seems to be describing the practice of cutting a figural painting out of an old wall, updating the decoration on the wall, and remounting the plaster with the old painting in the middle:

> itaque veteribus parietibus nonnulli crustas excidentes pro abacis utuntur, ipsaque tectoria abacorum et specularum divisionibus circa se prominentes habent expressiones.
>
> (Many people cut out the surfaces of old walls and use them as panels, and the division of the plasterwork itself into panels and raised structures lends it a three-dimensional quality.)[133]

The general sense is that sections of painted plaster were cut out of the old wall and reused on a new wall, being mounted so as to stand above it. In this way, the illusion of three-dimensionality and multiple textures is enhanced by the actual use of mounted panels: not real *pinakes* (paintings executed on wood), or panels of marble veneer, but reused plaster, which had been designed to emulate those more expensive items. It is clear that the embedding of artworks into plastered walls was an extremely common Roman practice.[134] An instance recorded by Pliny is particularly interesting, as it pertains to the decoration of a temple. He reports information from Varro that when the Temple of Ceres on the Aventine was rebuilt, the original paintings executed by the artists Damophilus and Gorgasus were cut from the walls, mounted in frames, and displayed in the new temple.[135] This is precisely what the people of Pompeii did when they redecorated parts of the portico of Apollo, and it shows the value they placed on the original Trojan paintings.

In fact, it is certain that there was one place in the sanctuary complex where a section of old plaster with a figural painting was mounted on top of a decorated wall: in the so-called priests' apartment, which was entered through a door in the north wall of the portico, the painting of Bacchus and Silenus, mentioned in passing in the last chapter, was mounted in this way. The painting survived because metal hardware and mortar rather than wood were used to remount the old plaster. Here is Gandy's description of the mounting of that painting, almost certainly copied from Gell's letters: "This fresco had been anciently removed from another situation to that it now occupies, and is fastened very neatly with iron cramps and cement, so as to require some examination to discover the circumstance."[136] Mazois provides confirmation, although once again the text was written by someone who was not on the spot; presumably his posthumous editors based this on his notes:

> Ce tableau avait déjà été détaché d'une autre muraille et rattaché en cet endroit par des crampons habilement cachés. En général, les peintures murales étaient isolées du mur et préservées de l'humidité au moyen de carreaux de terre cuite qui laissent subsister des vides où l'air pouvait circuler.
>
> (This tablet had already been removed from another wall and reattached in this place by cleverly hidden spikes. In general, the wall paintings were isolated from

the wall and protected from moisture by means of terracotta tiles that left gaps where air could circulate.)[137]

The "general" practice presumably refers to the *tegulae mammatae* on the west wall and not to the other figural paintings in the portico. I have been presuming that the surviving Trojan paintings in the portico, unlike the picture of Bacchus, were painted in fresh plaster applied to the wall itself. But is that right? Were any of the surviving Trojan pictures separately mounted?

Rochette, writing in 1840, strongly implies that all or some of the surviving Trojan paintings were mounted separately on the wall.[138] It is useful to have his confirmation that there were indeed blank spaces instead of figural paintings in the portico; he had first visited the temple in the mid-1820s, when there was still a fair bit of plaster on the walls. He returned to visit again in 1838, but by then the paintings in the portico were badly decayed.[139] Nevertheless, he is in a good position to confirm that Mazois's posthumous editors were correct in stating that the lithograph they published with the blank space in the center (see fig. 36) was an accurate representation rather than the result of some accident of drawing. Other aspects of Rochette's account need to be taken with a grain of salt, however. He was engaged in a polemic regarding the use of panel paintings on wood in ancient temples and had a motive to exaggerate. He claims that the blank spaces had been filled with panel paintings on wood that had perished in the eruption of Vesuvius, and that the surviving paintings on plaster were shoddy and temporary stand-ins for the original wood paintings. This is not a very convincing view, and it was clearly in Rochette's interest to insinuate that all the Trojan paintings on plaster were mounted separately as makeshift substitutes. When he does produce specific examples, he refers to Gell and Gandy's published discussion of the painting of Bacchus and Silenus and to Mazois's illustration of the panel with the blank space at its center. It is odd that he does not give more specific information about the mounting of the Trojan paintings if he had it. He also cites with approval the published claim by Rudolf Wiegmann, who had been in Pompeii around 1830, that "several" paintings in the Temple of Apollo were separately mounted.[140] But once again the presence of the *tegulae mammatae* on the west wall could be responsible for that claim. The implication that all or some of the surviving Trojan paintings were separately mounted is almost certainly untrue, for later elevations of the east wall that show the painting in the portico in an advanced state of decay do not show any discontinuities in the line of plaster breakage at the borders of the figural paintings in the southernmost two niches.[141] If there was a Trojan painting with an identifiable subject that was mounted separately, it seems likely that one of the sources would have explicitly mentioned the fact.

To conclude, Callet's elevation (see fig. 35) shows that there was at least one missing figural painting on the east wall, and the combination of Mazois's chromo-

lithograph (see fig. 36) and the cork model (see fig. 49) provides evidence that there were missing figural paintings on the north wall. The question that remains is whether those blank spaces were present before the eruption of Vesuvius or were the result of the eruption. If the former, then in AD 79 the people of Pompeii were waiting for some, but not all, Trojan paintings to be filled in. These would be replacements for those damaged in the seismic activity of the preceding years. If the latter, then the original Trojan paintings were salvaged where possible and mounted on wood for reuse. After the eruption, the wood decayed and the old plaster fell out. Of course, these two possibilities are not mutually exclusive. It is possible that plaster was salvaged and remounted where possible and, where the original figural paintings were too badly damaged to be saved, new copies were commissioned. Both explanations for the blank spaces lead to the same conclusion: the fourth-style decoration preserved, either through reuse of old plaster or through newly executed copies, a partially damaged, earlier cycle of figural paintings. This explains how a cycle of figural paintings that seem, ideologically, to be linked to the Augustan age came to be embedded in the middle of a decorative scheme executed many decades later. The most important conclusion to draw from the testimony of the blank spaces, therefore, is that the decorative, architectural scheme does not provide a date for the figural compositions within. A secondary conclusion to draw from the existence of the empty frames is that the original Trojan paintings were valued enough to be carefully preserved when possible.

Dating the Paintings
As noted above, the decorative elements in the wall paintings in the portico are routinely ascribed to the fourth Pompeian style, and thus to a period significantly later than Augustus. It would clearly be helpful to be able to determine an exact date on stylistic grounds. Unfortunately, such a procedure is unlikely to produce any consensus. The success of the categorization of Pompeian paintings into four distinct styles has prompted efforts to further subdivide them into subphases, but these have commanded less general assent. The fourth style has proved particularly resistant to efforts at chronological subdivision, and old ideas about the differences between pre- and postearthquake painting are no longer given the same credence.[142] Objective dates are few, and opinion regarding the start and end dates of the four styles varies alarmingly.

The basis for the common assertion that the paintings in the portico were of the fourth style must surely be the pillar-style panels, such as the ones illustrated in color lithographs by Mazois (see fig. 36) and Rochette (see fig. 5).[143] The problem here is that the distinction between pillar- and niche-style decoration in the portico has never been recognized. Are they both fourth style? The pillar style is an example of a motif that can clearly and unambiguously be identified as fourth style. The gaudy exuberance of the three-dimensional architecture along with its delicate insubstantiality makes it a textbook example. Many paintings in Pompeii are not textbook examples of one

of the four styles, however. In these cases, the certainty with which specialists assign these paintings to one style or the other can seem capricious, resting on the arbitrary privileging of one particular detail over another. The niche style on the east wall is an example of a decorative motif less obviously marked by the hallmarks of a particular style. It treats the surface of the wall as mostly two-dimensional, and many aspects of its decoration are fairly generic. There is, however, one element that appears only in the niche-style panels on the east wall that might identify it as also belonging to the fourth style. On the cork model and in the architectural elevations there seems to be trompe-l'œil architecture at the sides that might well be an example of fourth-style *Durchblicke*, narrow perspectival openings between the main fields.[144] Moreover, these openings seem, in Callet's elevation at any rate, to have some stylistic similarity to the pillar-style architecture. The way the two styles alternate on pillars and in niches on the east wall suggests an organic conception of the whole wall. So one may suppose that both pillar and niche styles, in the forms in which they are found on the east wall, are contemporary.

The strict alternation of motifs and the stylistic unity of the east wall would lead to the assumption that the portico was redecorated in the fourth style at one point in time. But the cork model, which shows the other walls as well, provides a more complex picture. Both the pillar style and the niche style appear there in different versions than on the east wall, and they do not alternate strictly. As noted earlier, the pillar style has a very different color scheme on the north wall, which explains the difference between Mazois's view of it and Rochette's. The niche style is also quite different on the north and south walls as compared to the east. The cork model shows just a large red frame surrounding a white field in which the figural painting is centered. Below that is the usual deep-red lower register. There is none of the elaborate flanking with trompe-l'œil elements in the plain variants. The red frame is simply bordered by thin columns. The fourth-style *Durchblicke* that are indicative of the ornate variant of the niche style on the east wall may be simplified on the cork model, but they are still present (see fig. 11). They are certainly absent on the north wall (see fig. 49), and the situation on the south wall is ambiguous (see fig. 67).

Thus the most significant difference between the east wall and the north and south walls is that the latter two fail to alternate the two styles. Just west of the middle of the north wall are two simplified niche-style panels side by side (see fig. 49; fig. 10, nos. 25, 26), and at the far west of the north wall the last two panels are likewise simplified niche style (see fig. 50; fig. 10, nos. 28, 29). On the east side of the south wall, there appears to be room for four generously spaced panels, and there are certainly niche-style panels at both ends; this implies a failure to observe alternation here, too (see fig. 67; fig. 10, nos. 36–38). One of the two panels in between also appears to be niche style, so once again there are two simplified niche-style panels next to each other. So the theory that the alternation in the fabric of the east wall inspired the alternation of

CHAPTER 4 **179**

styles, which was then continued on the other walls, requires modification. On the one hand, both the east wall and, from the little known about it, the west wall observed a strict alternation of niche-style and pillar-style panels. On the other hand, the north and south walls were composed mainly of a drastically simplified form of the niche-style panels, with the occasional appearance of a pillar-style panel.

If one is to take seriously the presence of very plain niche-style panels side by side on the north and south walls, an explanation presents itself. These are places where the original Augustan decoration of the portico, which once carried all the way around the four walls, can be seen (see figs. 49, 67). The occasional appearance of the blue-tinted variant of the pillar style marks places where seismic activity required repairs to the north and possibly the south walls, which were done in the fourth style, then current. At some other point, possibly due to a second seismic event, the east and possibly west walls required more extensive repainting. The undulating nature of the east wall together with the way the north wall already intermingled the very plain Augustan panels with the newer fourth-style panels suggested to the designers a scheme for the east wall that combined variants on these two elements. The Augustan scheme was updated to a similar but more ornate version, which was put in the niches of the east wall. For the pillars, the design of the newer panels on the north wall was kept but was adapted to a color scheme that better complemented the niches.

Can the simpler variant of the niche style as found on the north and south walls be considered of Augustan date on stylistic grounds? In fact, the second style, which overlapped with the reign of Augustus, is often very difficult to distinguish from the fourth style, which was in many ways a revival of it. For example, a typical feature of Augustan art in the aftermath of the conquest of Egypt is a fascination with Nilotic scenes, and such scenes form a part of the niche style in both its simplified and ornate forms. But Nilotic scenes and architectural landscapes also fit quite well into the fourth style.[145] So they could be a part of the Augustan original or the fourth-style revival or both. In fact, this plain variant of the niche style is so lacking in distinguishing features that it may be impossible to date; perhaps a more detailed rendering than what the cork model provides might help, but then again perhaps not. But that very simplicity fits better with an early date, before the *pinacotheca*, or "picture gallery," motif had become so elaborate and developed. On the north and south walls are a large number of figural paintings on a plain white ground, surrounded by large, unadorned red frames, sitting on a modestly decorated lower register, perhaps with a Nilotic or architectural frieze, each large frame flanked by a pair of thin columns. These seem more at home in the Augustan period than in the fourth style, even in its more restrained moments.

There are several advantages to postulating two phases of redecoration in the portico. This hypothesis helps to explain why the east wall is so regular while the north and south walls are not; and it explains why both design elements of the east wall are

found on the north wall but in variant forms. It also explains the paradox, observed by De Caro, that Maiuri discovered fragments of fourth-style plaster under the repaired pavement of the portico.[146] If there was only one seismic event and this led to the repainting of the walls and the repair of the pavement, the plaster under the repairs should have been pre-fourth style. But if there were at least two phases of repair and redecoration, this finding is to be expected. It is natural to expect that the major earthquake of AD 62 was accompanied by other seismic events. Two years later, for example, an earthquake destroyed the theater in Naples just after Nero had performed there (Tacitus, *Ann.* 15.34). It would not be surprising to find that a second shock had damaged the east and west walls while leaving the previously repaired north wall relatively unscathed. In an earthquake, walls parallel to the direction of the motion of the earth undergo shearing forces very different from the back-and-forth motion of walls perpendicular to it. The former walls tend to have large X-shaped diagonal fissures, which could remove most of the plaster; the latter may have only minor cracks.

A probable indication of the effects of one of these tremors can be seen in the wall on the north side of the portico. In general, the walls of the sanctuary are of *opus incertum*, stone rubble bonded with mortar. But in the middle of the north wall there is a section where there appears to be an ancient repair (i.e., not post-1943 bombardment) in a different fabric (fig. 73). From top to bottom there is a stretch of *opus vittatum mixtum*, in which two courses of brick alternate with a single course of stone, typical of repairs after the earthquake of AD 62.[147] The left side of the repaired patch is approximately at the midpoint of the rear of the temple cella and can be matched with paintings on the cork model. There, the middle of the cella stands approximately opposite a point on the north wall at the boundary between a blue-hued pillar-style panel on the east (see fig. 24; fig. 10, no. 24) and a stretch of the original Augustan decor on the west (see fig. 10, no. 25). So there was a fourth-style panel in the pillar style on top of the repaired section of the wall.[148]

On the basis of these arguments, I can postulate a hypothetical sequence of events that would accommodate all the evidence. The first tremor damaged the middle of the north wall so badly that it needed to be rebuilt. On that stretch of wall and in other places around the portico where the plaster had been badly damaged, the Augustan painting was replaced by panels more in keeping with contemporary taste: the blue variant of the pillar style. The result was a mixture of the old painting with a few new sections distributed here and there. Then another tremor shook the complex and did further damage, particularly to the plaster on the east and west walls. It was decided that these needed to be repainted in their entirety. As a result of the first earthquake, the drainage that had originally been put in place for the blind alley behind the west wall had failed, and in the period between the first and second tremors it had occasionally filled with water, which had penetrated to the inner face of the west wall, wetting and damaging the painted plaster. It was decided to put a course of *tegulae mammatae*

FIGURE 73 Central part of the north wall of the Sanctuary of Apollo, showing ancient, postearthquake repairs

in place to protect it from the same fate in the future. The east wall may originally have had a fairly uniform decorative scheme, but the fact that the portico now had two contrasting styles of painting suggests that the pillars and niches on the east wall would naturally accommodate contrasting motifs. For the niches, the original, very plain Augustan decor was updated to the more modern variant of the niche style; for the pillars, the recently adopted pillar style was still current enough to use, though in a slightly different color. As part of the second refurbishment, a new pavement in the portico was laid in *cocciopesto*, or crushed terracotta mortar, underneath which were buried fragments of painted plaster, including fourth-style painting that had been added in the first refurbishment but was damaged in the second tremor.

The blank spaces are the remaining piece of evidence that needs to be explained, and, as noted in the previous section, there are two possibilities, which are not mutually exclusive. The first explanation is that the figural paintings were left blank because

no local *pictor imaginarius* had the required composition in his repertoire and good local copies of these particular paintings were not available. If so, the wait to fill in some of the blanks was considerable, because blank spaces appear not only in the second phase of redecoration on the east wall but also in the first phase, on the north. Why would those responsible for the repairs have waited that long? Perhaps they were hoping to avoid the expense of having to bring an *imaginarius* from Rome or to send a local one there on a research trip. The original Augustan paintings may well have been executed by workers who had previously flocked to Rome to take part in the massive spurt of construction projects after Actium. They would have been familiar with the contents of the Portico of Philippus for the simple reason that they were involved in building and decorating it and related monuments. After a space of sixty years or more, meeting with a painter who had firsthand knowledge of that particular model would have been considerably less likely. Some painters may have had a repertoire that included the more iconic images, such as, for example, the quarrel of Achilles and Agamemnon, but it could well have been harder to replace the more obscure Iliadic episodes. Alternatively, the simpler and likelier explanation is that efforts were made to salvage the original figural paintings during both phases of redecoration, and that these were mounted on wood and embedded in the newly decorated walls. When the wood carbonized or decayed, the old plaster fell out.

This version of the development of the portico tries to account for all the evidence. Whatever the details of that process may have been, it is worth reiterating the most important conclusion: the presence of a certain amount of fourth-style decoration does not mean that the Trojan cycle was post-Augustan. If the Trojan theme had been added later, at a point when the portico was being comprehensively redecorated from scratch, one would expect the whole building to be as uniform as the east wall; but the cork model shows that this was not the case, no matter how one reconstructs the details of the repairs and repainting. The diversity and irregularity of decorative styles on the north and south walls suggest very strongly that the Trojan theme was not introduced suddenly and uniformly in the years just before the eruption.

It is sometimes assumed on the basis of domestic interiors that Roman wall painting on plaster was a thing of little value, to be replaced on a whim. But one should be wary of extrapolating from domestic contexts to the decisions that were made about one of the most important public spaces in the city. The priests might well have had a fairly free hand to replace in a new style the purely decorative elements that needed repair. But it is a very different thing to change the ideologically loaded figural elements. To create a hodgepodge by replacing at random the missing parts of a coherent and unified cycle would have invited ridicule. The figural paintings on plaster featured in the portico may have been cheap imitations of "real" panel paintings executed on wood, but that does not mean they were unimportant to the people of Pompeii. Even with Augustus gone, this building continued to play an important part in the town's

conceptualization of itself as Roman; it articulated imperial ideology and Pompeii's participation in that ideology. It is not surprising to find a very curatorial and conservative approach in the postearthquake repair and redecoration.

There is an unfortunate tendency on the part of some scholars to reify the four painting styles of Mau (which is to say, of Vitruvius) as if they actually existed as phenomena in and of themselves rather than being an occasionally useful heuristic tool.[149] One of the dangers of that approach is to focus too much on those particular decorative details that seem to be diagnostic for the purposes of dating: hence the confident assertion of scholars who have declared the paintings on the portico of Apollo to be fourth style, without any caveats or qualifications. In reality, there seem to be examples of postearthquake repairs that preserved plaster of an earlier decorative style, and that moreover seem to show a deliberately re-created version of that earlier style as an element in the new design, playing consciously upon the contrast. The view that as time went by one decorative style straightforwardly replaced another throughout Pompeii is clearly too simplistic. The situation is even more complex when it comes to figural painting. The four styles are based on the classification of decorative elements, but this has not prevented some scholars from attempting to date figural painting in Pompeii on stylistic grounds. I have shown, however, an extensive example of the Vitruvian practice of preserving earlier figural compositions for reinsertion in an updated decorative frame, and possibly also the commissioning of replacements for damaged figural works. The practice of building up a chronology of figural styles on the basis of the dating of decorative context is therefore of dubious legitimacy. There is in fact no good reason to believe that fashions in figural painting changed hand in hand with changes in decorative schemes, and the subjective and inconsistent results produced by efforts to date figural painting on stylistic grounds should be no surprise.[150] For the benefit of those who persist, despite these dangers, in asserting a strong chronology for the figural elements in Roman wall painting, one can provide early-Augustan parallels for the Portico of Apollo in the large figural compositions in late-second/early-third style, such as the Theseus panels at the Villa Imperiale in Pompeii or in Rome at the Casa di Livia or the Villa della Farnesina.[151]

The term *pinacotheca* is routinely used to designate the very common feature in Pompeian domestic painting whereby a set of figural paintings forms the centerpiece of a room. Thus the term has come to mean a fictive picture gallery, and the assumption has been that these ensembles are doubly fake, a pretend collection of faked copies of works that were themselves illusory views of reality.[152] The Apollo portico should help to break down this simplistic conceptual distinction between "real" high-status picture galleries and their humble Pompeian imitations.[153] The portico was one of the most important and prominent public spaces in the town, combining aspects of the real and the fictive *pinacotheca* in one unit. When a painting on plaster was cut out of the wall, preserved, and remounted in the newly plastered wall, was it

suddenly transformed from a "fake" plaster imitation in a "fake" provincial *pinacotheca* into a highly valued "real" piece of local art installed in a "real" local art gallery? The value placed by the people of Pompeii on the paintings in the Trojan cycle is shown by the way they attempted to conserve and repair them, instead of wiping the cycle clean at one sweep and replacing it with something new. This attitude of conservation shows how something that began its life as a simulacrum could develop its own worth in a particular context. Indeed, in the years after the construction of the portico, in about 10 BC, the resonance of its Trojan cycle would have increased through the canonization of Virgil's *Aeneid* as the Roman national epic. In chapter 6 I discuss the relationship between the Pompeian paintings and Virgil's Temple of Juno in Carthage, but for now it is enough to say that an ancient viewer contemplating the pictures in the Apollo portico could have seen it not only as an ersatz imitation of a "real" portico in Rome but also as a "real" version of an imaginary portico from the *Aeneid*.

Pompeii and Rome

I have accumulated a series of indications that the decoration of the Apollo portico dates to the Augustan period and reflects the ideology of that time and have pointed out how the emulation of Augustan models was a central theme of the career of Holconius Rufus, one of its builders. The sculptural program of the portico reflected Augustan ideology, and its pictorial cycle was integrated with the statuary. The successive phases of postearthquake restorations radically changed the overall appearance of the portico walls, but the Trojan theme of the Augustan monument was carefully maintained. In the next chapter I discuss a possible model for the Pompeian portico: the Portico of Philippus in Rome, which had been constructed two decades previously and which displayed a cycle of paintings of the Trojan War. But what evidence is there that Holconius Rufus and the people of Pompeii chose to emulate the particular content of the paintings in Rome rather than just the idea of a Trojan cycle generally? At this point I return to the three *tabulae Iliacae* which have been repeatedly seen to contain some very precise duplicates of the arrangement of figures in the portico paintings. All the tablets were found in the suburbs of Rome, so if they had a common model, it must have been in the capital city.

There are, of course, important differences between the two sets of objects. The tablets are reliefs rather than paintings; they are miniatures, while the paintings are on a large scale; the tablets include many more Iliadic scenes than the paintings and differ among themselves. The tablets are extremely complex objects, with riddling word games on the back. There has always been debate about their nature and purpose, with opinion varying very widely. There has been a recent resurgence of scholarly interest in these fascinating objects, but there is no need to be drawn away from the present topic into the details of these debates.[154] It is only necessary to establish that the tablets were complex objects created near Rome in the period after the construction of the Portico

of Philippus, and hence that it is plausible that they would have been influenced, in part, by the cycle of Trojan images there.[155] This is not to deny that there were other important sources for the iconography of the *tabulae Iliacae*, but it is natural to expect that a major public Roman monument of the Augustan period might have had an influence on expressions of the same theme made around the same place and time.[156]

All the ancient Homeric cycles, including the *tabulae Iliacae* and the other Pompeian Iliadic cycles excavated by Spinazzola, are too heterogeneous to be reduced to a single typology inspired by some Hellenistic Greek model, such as an illustrated text of Homer or a pattern book.[157] Within the mass of Homeric visual iconography, however, there are some striking examples of copying. A direct line connects the quarrel of Achilles and Agamemnon on the Capitoline tablet to the Pompeian portico and thence to the Houses of the Dioscuri and of the Tragic Poet. These are clearly and unmistakably depictions of the same composition. Amid the many influences that the *tabulae Iliacae* may have had, there must be one that can explain this connection.[158] There is no guarantee that it was the Portico of Philippus, but that is the best available possibility. Despite their difference in media and scale, the tablets link two very similarly conceived large-scale painting cycles in temple porticoes in Rome and Pompeii. This would not be the only place where the influence of a large-scale work of art from a major Augustan monument has been postulated for the Capitoline tablet. At its center is a depiction of Aeneas carrying his lame father upon his shoulder and leading his son by the hand as they escape from Troy. Visually, this seems a clear quotation of the famous sculptural group of these same figures from the Forum of Augustus.[159] If the tablet could quote in miniature form a large-scale sculptural group from a major metropolitan monument, it follows that, among many other influences, it could also have quoted the large-scale paintings from another important Augustan monument. Indeed, this seems the likeliest explanation for the remarkable similarities between the compositions on the tablets and in Pompeian paintings. The prominence of Aeneas in both the Pompeian portico and the *tabulae Iliacae* can be explained as a reflection of the cycle of paintings in Rome, or as the influence of the first book of the *Aeneid*, or, most likely, both. Finally, the Trojan temples the *tabulae* show are Roman in form.[160] The feature that dominates the depiction of Troy at the center of the Capitoline tablet is a series of very Roman-looking temple porticoes.[161] Was this a visual reminder of the Portico of Philippus, as the location of the Trojan cycle of paintings that was one of the main inspirations for the iconography of the scenes on the tablets?

Conclusions

The tendency to relate all similarities between Roman works of art to remote and hypothetical Greek models has blinded scholars for generations to the very lively and clear dynamics of copying within Pompeii and between Pompeii and Rome. This has also obscured the fact that the Trojan cycle in the Apollo portico was one

of the most important works of public art in the town and was certainly the most influential work of painting. At the same time, the contemporary tendency to look away entirely from the close relationships between image and image or image and text has impoverished the local meaning of these objects, by removing their capacity to function intertextually. The danger is that my investigation falls into that same trap in the next chapter, as it moves from Pompeii to Rome, from a fragmentary Trojan cycle to one that has disappeared completely. It would be an equally grave mistake to assume that, since the Pompeian cycle was based on the Roman one, it can stand in for it. But the Pompeian cycle was certainly a reinterpretation, and one must allow for the likelihood that many changes were introduced in that process of adaptation. Then there was the process of postearthquake remodeling, which, although motivated by an impulse of conservation, introduced more changes. Nevertheless, the Temple of Apollo in Pompeii can at least afford some idea of what the paintings in the Portico of Philippus might have looked like.

Before I move to Rome, however, I want to pause to consider the message the people of Pompeii meant to send by their version of the Trojan portico. On a basic level, they were echoing the Roman connection with Troy that had become such a major part of Augustan ideology. But they were also doing something more sophisticated than merely parroting a party line. Where this appears most clearly is that aspect of the adaptation that stands in starkest contrast to the Roman model. The Portico of Philippus surrounded the Temple of Hercules of the Muses in Rome, whereas the Trojan cycle in Pompeii was housed in a sanctuary of Apollo. This shift signaled a clear recognition on the part of the people of Pompeii of the complexities of the function of the Portico of Philippus in Augustus's building program, where it complemented the function of the Temple of Palatine Apollo, as is demonstrated in chapter 5.

The particularly local point that the new portico made was to emphasize Apollo's long-standing association with Pompeii. In Rome, Apollo was long seen as a somewhat foreign and Greek god, and he did not have a Republican temple within the *pomerium*, the sacred boundary of the city. Augustus's adoption of Apollo as his patron and his building of the sumptuous temple on the Palatine changed all that, however. In Pompeii, the situation was quite the opposite. Its Temple of Apollo was the oldest in the town and was located right in its heart, next to the Forum. By renovating that temple and providing it with a new portico in the Augustan period, the town was advertising the long-standing nature of their connection with the patron god of the emperor. The addition of an element drawn from the Portico of Philippus rather than the Temple of Palatine Apollo was an invitation to compare the situations at Rome and in Pompeii in the second century BC. In Rome, Fulvius Nobilior was compelled to house his Muses anomalously in a temple of Hercules, because Apollo, to whom they normally belonged, was still too much of a foreign and marginal presence. In Pompeii, by contrast, the town was during the same period building its most important shrine to that

god and decorating it with a pediment and frieze that featured Apollo and the Muses.[162] This much deeper and older integration of Apollo into the religious life of Pompeii thus casts him as a contrasting figure to Hercules, an opposition that resonated with the ideology of the recent civil war between Octavian and Mark Antony. The two sides fought under the banners of Apollo and Hercules, respectively, and this opposition may have been exploited in the iconography of the Temple of Palatine Apollo.[163] The civil war was long over, but it may be relevant that the neighboring rival town of Herculaneum loudly boasted of its founding by Hercules by means of cycles of paintings of his exploits in the main public monuments of the town, especially the so-called College of the Augustales and the so-called Basilica.[164] Wallace-Hadrill has recently argued that these buildings constituted the civic center of Herculaneum, which is to say the counterpart of the Forum area in Pompeii.[165] If that is right, then the Trojan cycle in Pompeii may be seen as a pointed riposte to the Hercules cycles from the public buildings in Herculaneum. The people of Pompeii may have seen it as opportune to emphasize that, for them, Apollo occupied the place that elsewhere in the region was held by Antony's erstwhile patron, Hercules. This speaks of an acute understanding on the part of the people of Pompeii of the ideological connections between multiple Augustan monuments and indeed the historical background in Rome that conditioned the particular nature of Augustus's building program. It is to the role of the Portico of Philippus in that program that I turn in the following chapter.

NOTES

1. Moormann 2011, 82.
2. As demonstrated by Hölscher 2004.
3. On the falseness of the analogy with textual criticism, see E. Perry 2005, 97–98, 109.
4. Bergmann 1995.
5. On the damage the "copy myth" has done to the study of Roman sculpture, see E. Perry 2005 and Marvin 2008.
6. See further E. Perry 2005, 50–77.
7. See Leen 1991 and Gazda 1995, 131.
8. E. Perry 2005, 90–96.
9. Lippold 1951, 77–87, on which see Gazda 2002, 2–11, esp. 7n18; see also Gazda 1995, and E. Perry 2005, 78–90.
10. See Gazda 1995.
11. For a good discussion of past attempts to theorize the choice of themes in Roman domestic painting, see Thompson 1961, 36–46.
12. See Scott 2003.
13. Not only at Pompeii: see, for example, the brief survey of the dissemination of the iconography of the Forum of Augustus by Geiger 2008, 193–97.
14. On the usefulness of this concept in Roman art, see Fullerton 1997, 437–40, and Fullerton 2003.
15. See Trimble 2002, 225, who discusses two of the three possible contexts in which these two paintings were paired.
16. On the paintings, see Richardson Jr. 1955, 135–39, who suggests that the painter was a master summoned from elsewhere, possibly even Rome.

17 For further details on these paintings, see Trimble 2002.
18 On literary treatments of the myth, especially the *Achilleid* of Statius, see Heslin 2005.
19 The brilliance of the juxtaposition has been discussed by Beard and Henderson 2001, 40, and Trimble 2002, 238–41.
20 Mau 1904, 81–82, suggests that the gaps between the pillars in the east wall would have been seen as the main entrance to the sanctuary, but the south entrance must also have been a privileged viewpoint.
21 On play across corners in Pompeian painting, see Bergmann 2007, 90–91.
22 On the *tablinum* as a focal point of the morning reception, see Wallace-Hadrill 1994, 45.
23 Richardson Jr. 1955, 12–15.
24 Thus Sampaolo in *PPM* 4:471, who suggests on the basis of other artifacts that the owner was an intellectual.
25 See Gowers 2010.
26 For a plan with the locations of the various pictorial elements, see Helbig 1868, no. 232, and more fully Caso 1989, 112, fig. 1, though both scholars go badly wrong in playing down the centrality of Apollo. For many more pictures, see *PPM* 4:470–524, figs. 55–90).
27 See *LIMC*, s.v. "Apollon/Apollo," 420, and Ling 1991, 127 and 130, fig. 132.
28 See Moormann 1983, 87–90. In this and some of the other alleged depictions of the star-contest scene at Pompeii, the judge at the center has been misidentified as Bacchus; for a refutation of that and for a skeptical view of the entire mythical identification, see Hijmans 1995.
29 See *LIMC*, s.v. "Apollon/Apollo," 420, and Moormann 1983, 84–91.
30 See De Caro 2007, 76–77, with fig. 6.3, and for more pictures but without this interpretation, Menotti de Lucia 1990.
31 *PPM* 4:470–524, fig. 64.
32 *PPM* 4:470–524, fig. 70, and Trimble 2002, fig. 10.9, with n62. There was also a mosaic of the three Graces in the same location.
33 See Allison and Sear 2002, 32–35, 70–72, with figs. 145–55.
34 Schefold 1957, 181.
35 Allison and Sear 2002, 35, 71. It is true that Schefold was probably influenced strongly by the parallels from the other buildings, and that those parallels would have encouraged him to look for traces that could have matched a figure from the quarrel scene. He must, however, have seen something that he thought was similar to Athena's gesture of restraint or Achilles drawing his sword across his body.
36 Schulz 1841, 106: "in mezzo l'Apollo e da un lato un guerriero colla lancia nella mano e l'elmo sulla testa, dall'altra a Pallade e suona le tibie."
37 Moormann 1983, 111, reckons it "molto probabile."
38 See the sketch of Allison and Sear 2002, fig. 150.
39 Trimble 2002, 246n58. For examples of very different compositional schemes for this scene, see the examples from the House of the Vettii and the Casa dei Postumii: Lorenz 2008, 214, fig. 95, and 373, fig. 186b.
40 Pliny, *NH* 35.139. Sometimes the original was attributed to Theon of Samos, on the basis of a very dubious interpretation of a passage in Aelian (*Varia Historia*, 2.44).
41 Ling 1991, 134.
42 For a convincing presentation of the skeptical position regarding Greek models that uses this very set of images, see Beard and Henderson 2001, 27–29.
43 Trimble 2002, 247; emphasis original.
44 See Bergmann 1994, 239, fig. 23, and for the original form of the two paintings, *PPM Disegnatori*, 118–19, figs. 61 and 62.
45 For an example of this backlash against the idea of ancient art reacting to canonical texts, see Small 2003, especially 97, where this move is linked to the discrediting of the methodology of *Kopienkritik*.
46 Bergmann 1994, 237.

47 See Bergmann 1994, 237, fig. 27.
48 Bergmann 1994, 246.
49 Bergmann, however, has a different take on the juxtapositions in the room; see Bergmann 1994, 232–46.
50 Thompson 1960, 68n2, and Bergmann 1994, 232n25, with 235, fig. 17.
51 See Bergmann 1994, 237 and 240, figs. 24 and 25.
52 Bergmann 1994, 245; for a different view of the parallel, see Beard 2009, 147.
53 Bergmann 1994, 232n23, with 234, fig. 14; see also Cook 1914–40, vol. 3.2, 1032–41, who thinks the scene is on Mount Ida in the Troad, which would provide another link with the judgment of Paris.
54 Bergmann 1994, 240, fig. 26; for later parallels see *LIMC*, s.v. "Amphitrite," 72, 73.
55 Lorenz 2008, 356.
56 As attested by the summary of Proclus (Photius, *Bibliotheca*, cod. 239).
57 On this passage, see Slatkin 1991, 55–56, 70–77, 96–98.
58 Edwards 1991, 196, points out that technically there may be no contradiction here, if it is assumed that Hera was acting at Zeus's behest. But it seems likely that Homer expected his audience to notice the difference between Thetis's view of her marriage and Hera's.
59 As reported by Philodemus (Hesiod, frag. 210, Merklebach-West).
60 Rodenwaldt 1909, 202; Bulas 1929, 80; Six 1917, 188.
61 Published by von Gozenbach 1975.
62 See Levi 1947, 46–49, 195–98. In particular, the mosaic of Briseis's farewell depicts one of the heralds in a strikingly similar fashion.
63 See Bianchi Bandinelli 1955, 55, fig. 42.
64 From the House of Aion: Levi 1947, pl. 43c.
65 For a closely related argument, see Fantuzzi 2012, 180–85.
66 Frangini and Martinelli 1981, 8–10.
67 Spinazzola 1953, and see also Brilliant 1984, 60–65. Celani 1998, 163, notes that the Iliadic scenes in the House of the Cryptoportico are roughly contemporary with those in the Portico of Philippus.
68 For a list, see *LIMC*, s.v. "Achilleus," 108 (the present typology) and 109–12.
69 For a comparison of this painting with the one in the House of the Dioscuri, see Beard and Henderson 2001, 26–29, with figs. 18–20, with color illustrations of all three images; see also Ling 1991, 132–34, with figs. 137–38.
70 Lorenz 2008, 294–95.
71 For a discussion of the typologies, see P. R. Hardie 1985, 18–20, with pls. 1a, b, c, who, following Scherf, calls the six similar paintings type A and the two variations, in which Thetis uses the shield as a mirror, type B. On the similarities between the type A images, see Bulas 1929, 87 ("presque identique").
72 P. R. Hardie 1985, 20.
73 This parallel is noted by Beard and Henderson 2001, 41. The spear of Achilles happens to be lacking in the version of the Scyros painting in the House of Achilles, but its presence in the original is confirmed by the other two close copies.
74 On the twist in which Thetis gazes at herself in the mirror, see P. R. Hardie 1985, 19; Beard and Henderson 2001, 42; and the wider speculations of Taylor 2008, 143–58.
75 S. G. Miller 1986.
76 See also the discussion of Brilliant 1984, 67–68.
77 Helbig 1868, 259, 1318, 1319.
78 Helbig 1868, 1317, 1320.
79 Helbig 1868, 1321.
80 See Lorenz 2008, 292–94; and Ling et al. 1997–2005, 2:72–76, who decides in the end that the badly damaged painting just showed a generic Nereid.
81 See Lewis 1973, 311, and Ling et al. 1997–2005, 2:72.

82 See Diepolder 1926, 70, and the discussion of the Machaon painting in the previous chapter.
83 See Helbig 1868, index, p. 479.
84 Helbig 1868, 1300.
85 For the traditional view of the architecture of the temple, see Richardson Jr. 1988, 89–95.
86 Quoted after Buck 1904, 241n6, who gives a Latin translation; see illustrations in *PPM* 7:301, figs. 24–26.
87 On the early history of the temple, see De Caro 2007, 73–78.
88 See Helbig 1868, 76–77.
89 *CIL* 10:787, on which see Dobbins et al. 1998, whose account of the evidence is followed here.
90 Mau 1904, 85–86.
91 See Dobbins et al. 1998 and Carroll and Godden 2000.
92 Dobbins et al. 1998, 756.
93 Castrén 1983, 69; on the career of Holconius Rufus, see Beard 2009, 206–10.
94 *CIL* 10:890.
95 See Mau 1904, 85–86.
96 See D'Arms 1988; Beard 2009, 209–10; and Zanker 1998, 107–14.
97 *CIL* 10:833–85.
98 *CIL* 10:832 and 842; D'Arms 1988, 54–55.
99 On the legislation, see Rawson 1987; I owe the point about the design of the Theater of Marcellus to a lecture by Edmund Thomas.
100 See Zanker 1998, 113–14.
101 *CIL* 10:830.
102 See Zanker 1981 and Welch 2007, 555–58.
103 See Zanker 1998, 80.
104 *CIL* 10:810. See Dobbins 1994, 647–61; Richardson Jr. 1978; and D'Arms 1988, 53.
105 Zanker 1998, 95–96.
106 *CIL* 10:808–9.
107 The dating of the building is contested, but the parallels suggest the late Augustan period; see Dobbins 1994, 647.
108 *CIL* 10:1074.
109 *CIL* 10:793.
110 See Dobbins 2007, 181–82n84; most recently Moormann 2011, 84–85, prefers the old dating, as does Wallace-Hadrill 2008, 131–33.
111 Guzzo and Pesando 2002.
112 *CIL* 4.5508.
113 *CIL* 4.5508.1–3 and Marriott 1895, 77.
114 *CIL* 4.5508.
115 Not only in the Portico of Apollo, but also in the triangular Forum, which is the main topic of Guzzo and Pesando 2002.
116 Martelli 2002.
117 Martelli 2002, 76–77.
118 Thus Dobbins 2007, 182n84, and see further Descoeudres 2007, 11.
119 De Caro 1986.
120 Arthur 1986. The deposits do not show much affinity with Apollo; one wonders if the area was dedicated to that god from the beginning.
121 Maiuri 1973, 131; this point is offered as an objection to the Augustan dating by Guzzo and Pesando 2002, 118–19.
122 Mau 1904, 87–90.
123 On the grounds of their alleged poor quality, the statues have been dated to the late first century BC: Zanker 1998, pl. 6.

124 Mau 1904, 89.
125 So, most recently, Moormann 2011, 73.
126 Adam 1999, 219, with fig. 515, and De Vos and De Vos 1982, 164.
127 Lugli 1957, 1:550.
128 On the terminology, see Clarke 1991, 57–59, and Bergmann 1995, 101.
129 See Beard 2009, 120–26.
130 As, for example, in the Casa del Sacello Iliaco and Casa dei Capitelli Colorati.
131 See Zanker 1998, 126, and Mau 1904, 80, 82–84. See also the disagreement of De Caro 1986, 17–18, 25, but his evidence of fourth-style painting found underneath the pavement can be explained by the hypothesis of multiple instances of seismic damage and consequently multiple phases of fourth-style redecoration. On the related question of the state of completion of repairs to the Forum, see the overview of Cooley 2003, 31–35.
132 La Rocca, De Vos, and De Vos 1976, 63. I am grateful to Felipe Rojas for independently drawing the passage of Vitruvius quoted herein to my attention.
133 Vitruvius 7.3.10. This is my own text and interpretation of a vexed passage. For the last phrase, Rowland and Howe 1999 give "have a particularly striking appearance" and Grainger 1931 has "furnishes images which seem to stand out from it," both of which make needlessly heavy weather of the last three words. For my interpretation of this phrase, see *TLL*, s.v. "expressio," II.B.1.b., and *OLD*, s.v. "expressio," 2. I have emended to *specularum* the transmitted *speculorum*, which has crept into the text here on account of the reference to the polishing of painted plaster and mirrors in the previous sentence (7.3.9). It is true that plaster could be polished to a very high finish, and indeed Vitruvius has just finished saying that very thing, but "mirror" is impossible to make any sense of in this new context. The origin of the confusion is the obscure metaphor Vitruvius is employing here, which is drawn from Roman board games. *Abacus* is the normal word for a wall panel but is also used for a playing board; the elevated part of that board where pieces might be kept in reserve was called by military metaphor the *specula*, or "lookout tower": thus *laus Pisonis* 199. By this analogy, Vitruvius punningly designates the structures elevated above the level of the *abaci* on the wall as *speculae*. In any case, it is clear that he is referring to the practice of cutting out and remounting old painted plaster when redecorating.
134 See the evidence cited by Bergmann 1995, 100.
135 Pliny, *NH* 35.154: "ex hac, cum reficeretur, crustas parietum excisas tabulis marginatis inclusas esse."
136 Gell and Gandy 1817–19, 216.
137 Mazois 1812–38, 4:39.
138 Rochette 1840, 195–98.
139 Rochette 1840, 197n1.
140 Wiegmann 1836, 81.
141 See Veneri's drawing of 1843 (*PPM Disegnatori*, 800–801, fig. 29a), which has a careful delineation of the breakage, and still later Chabrol's drawing of 1866 (Mascoli 1981, fig. 18).
142 Clarke 1991, 31, 65.
143 See, for example, Moormann 2011, 73–75.
144 See figs. 12, 18, and 11. On the alternation of *Vorhänge* and *Durchblicke* as a feature of the fourth style, see Ling 1991, 71–82.
145 Rostovtzeff 1911, 57–58, 73, 81–82, automatically discusses the Nilotic and architectural landscapes from the portico as reproduced by Gell and Gandy under the heading of the fourth style, as does M. De Vos 1980, 87, for the copy by Morelli (fig. 58).
146 De Caro 1986, 17–18.
147 See Richardson Jr. 1988, 379–81 ("nowhere that it [opus vittatum mixtum] occurs does it appear to be pre-earthquake"), with Adam 2007, 108, and Dobbins 1994, 637. There was bomb damage to the northeast corner of the portico in 1943, but it probably did not extend as far west as this.
148 See Sampaolo in *PPM* 7:290n6 for further difficulties entailed by supposing a single seismic event and a single redecoration.

149 On the contemporary reaction against the sterile obsession with linear chronology, see Bergmann 2001.
150 For a humorous view of the wildly inconsistent results of Schefold's "connoisseurship" as applied to these Iliadic paintings, see Moormann 2011, 80n113.
151 I owe this point to an anonymous reader.
152 See Leach 1982 and Leach 2004, 132–55.
153 On the tension, see Bergmann 1995, 99–102.
154 For some recent work see Petrain 2013; Squire 2011; Squire 2009, 135–39; Valenzuela Montenegro 2004; Salimbene 2002; and Kazansky 1997.
155 Almost all the tablets were found very near the city of Rome: Salimbene 2002, 27.
156 This was once an uncontroversial assertion. Lippold (RE, s.v. "Tabula Iliaca," 1895.1–33), building upon the fundamental work of Brüning 1894 in connecting the tablets with the Pompeian portico, emphasizes the role of the Portico of Philippus as a likely intermediary.
157 See Horsfall 1979.
158 The old thesis of Weitzmann 1959 that the tablets were closely based on a conveniently lost tradition of illuminated texts of Homer has rightly fallen from favor; on the iconographic eclecticism of the tablets, see Squire 2011, 129–48.
159 See Valenzuela Montenegro 2004, 306, and Squire 2011, 59, 148–58.
160 Sadurska 1964, 35–36.
161 Leach 1988, 82, compares the Portico of Octavia.
162 De Caro 2007, 76, with further pictures in Menotti de Lucia 1990.
163 See Zanker 1988, 33–77, with the reservations of Hekster 2004a, which do not, however, nullify the thesis. For an ideological interpretation of the terracotta plaques showing the contest between Apollo and Hercules for Delphi, which may have come from the Temple of Palatine Apollo, see Kellum 1985.
164 Thompson 1961, 58, compares the cycle of paintings of Theseus in the Theseion in Athens.
165 Wallace-Hadrill 2011a, 177–96, and Wallace-Hadrill 2011b.

Part II
ART AND POETRY IN ROME

Chapter 5

The Portico of Philippus

MOVE NOW TO ROME, to look at the Portico of Philippus (fig. 74), the hypothetical model for the building activity discussed in Pompeii. Unfortunately, there is no direct evidence at all to confirm what the cycle of Trojan paintings that hung there looked like, or what particular episodes were represented. All that is known is the name of the artist: according to Pliny the Elder, a man named Theorus depicted "the Trojan war in many paintings, which is at Rome in the Portico of Philippus."[1] One can, however, discover quite a bit about the purpose of the structure, its role in Augustus's building program, and its architecture.

When Holconius Rufus and his fellow citizens built Pompeii's new portico around the Temple of Apollo, they adapted elements of Augustan ideology into their local context. In a way, the Portico of Philippus in Rome itself was an evocation of another city's ideology, likewise adapted in light of local considerations. In the early years of Octavian's rule, the newly conquered city of Alexandria was still the greatest city of the Mediterranean. At its center was the monumental complex of the royal quarter, where the Ptolemies lived and which was also apparently the location of the Museum and Library of Alexandria.[2] After his return from that city, Augustus gave Rome its equivalent, but with careful regard for Roman sensibilities. He took the model of Alexandria's royal quarter, exploded it, and landed various of its aspects in different parts of Rome: libraries, a temple of the Muses, art galleries, a royal residence, a monumental dynastic tomb. It is only when one pieces together the disparate elements of the various building projects that their debt to Alexandria comes into view.

There were rumors that Augustus's adoptive father, Julius Caesar, had planned to build a great public library to rival Alexandria's.[3] Unlike Caesar, Augustus was careful never to appear to set himself up as an autocrat like the Ptolemies. This necessitated a series of changes to the Alexandrian model. In Egypt, the royal quarter of the city encompassed the magnificent dwelling of the rulers and the Museum (see page 2), which was an expression of the success of transplanting Greek culture into Egypt. This was articulated not only in the scholarly activities of those who worked there but also more explicitly in the scintillating panegyric poetry written there to celebrate the rulers of Hellenistic Egypt. To facilitate that work, and also to provide a concrete expression of the presence of the best of Greek culture in Egypt, the Greek library was created. Elsewhere in the city an Egyptian library played the same role with respect to

FIGURE 74 Author's plan, showing the Portico of Philippus and its environs. The lines and dots reflect the evidence of the Marble Plan, according to the reconstruction of Gianfilippo Carettoni et al., *La pianta marmorea di Roma* (1960), pl. 29. The light gray areas show the modern street grid, according to Google Earth (version 6.0.3.2197). The Marble Plan has been aligned to the modern city with the visible remains of the Portico of Octavia as a reference point. The darker gray shows some major features of the area, present and past. In particular, the dark gray area within the Portico of Philippus indicates the extent of the Renaissance church and monastery of Sant'Ambrogio della Massima.

indigenous culture.[4] The Ptolemies basked in the reflected glory of the monumental architecture, the great literature and scholarship produced at the Museum, and the cultural wealth represented by both libraries. At Pergamum, too, the great library was on the acropolis, adjacent to the royal palace and the Temple of Athena.[5]

All of this Augustus wanted for Rome, but as always he proceeded by stealth and misdirection. The main focus of his building program around Actium was the Temple of Palatine Apollo, which was simultaneously an evocation of a Hellenistic royal palace or royal quarter and an emphatic rejection of that model.[6] It was built in what was then largely a residential neighborhood, near the modest house in which Augustus already lived. The size, expense, and beauty of the temple highlighted the ostentatious simplicity in which he made a point of living. This massive project included a major Greek and Latin library, just as the Ptolemies had built both Greek and Egyptian libraries.[7] It was not, however, a "Museum," a temple of the Muses. It was a temple to Apollo, their leader, who was also the god whom Augustus had taken as his particular patron. That Apollo had two aspects, one warlike and the other concerned with the pursuits of peace and art, was a useful ambiguity. His temple looked backward, to Augustus's triumphs in the battles of Naulochus and Actium, and also forward, to the new golden age of peace that was promised. So much is well known, but what happened to the missing piece of the Alexandrian pattern? The royal palace had to disappear for obvious reasons, and Augustus had his own important reasons to associate his new cultural institution with Apollo, but what happened to the Museum?

Rome did not have a temple of the Muses, but it had something close, a Temple of Hercules of the Muses. At approximately the same time that the Temple of Palatine Apollo was built, this quasi Museum was fitted with a new portico around it by a very close relative of the emperor, L. Marcius Philippus the younger, who was both stepbrother and uncle by marriage to Augustus. The aim of the present chapter is to put the Portico of Philippus back in its rightful place as part of the building program of Augustus. Just as it served Augustus's purposes to associate his library with Apollo rather than with the Muses, it was convenient to have someone else's name on the rebuilding of Rome's de facto Museum. In this way, he could deflect the charge of wanting to set himself up as a Hellenistic despot, aping the buildings of the Ptolemies. Dividing the functions of the Alexandrian Museum into their separate parts served to disguise the model but may have been inconvenient for users. The fact that another library, dedicated to Marcellus, was built soon after in the more spacious Portico of Octavia, immediately next door to the Portico of Philippus, suggests that it might have been inconvenient for those meeting or working at the Roman Museum to head up to the Palatine every time a book had to be consulted; this would explain why the Severan Marble Plan, which is our main source of evidence for the layout, shows a corridor permitting direct access from one portico to the other (fig. 75, no. 13). It is possible that it was always the intention to build a library next door. The library was

FIGURE 75 Plan of the Portico of Philippus, based on Gianfilippo Carettoni et al., *La pianta marmorea di Roma antica* (1960), pl. 29

KEY TO FIGURE 75:
PLAN OF THE PORTICO OF PHILIPPUS

The gray background indicates surviving fragments of the Marble Plan; the rest is inferred from rough sketches made in the Renaissance of fragments that are now lost. The fragments are identified by double lowercase letters. The numbers correspond to features as follows:

1. Excavation under the porch of the church of Sant'Ambrogio, exposing the east wall of the portico podium.
2. Excavation in the courtyard, exposing the access corridor through the Augustan podium to the rear of the Fulvian temple.
3. Fulvian circular Temple of Hercules.
4. Extension of the podium, added in the Augustan period.
5. Arms extending forward from the new podium; the four wide platforms on each side could have accommodated eight of Fulvius's statues of the Muses, possibly surrounded by landscaping and fountains.
6. Perhaps a base for the statue of the ninth Muse (Calliope), or possibly a round altar. The shape makes it an unlikely candidate for the aedicula of the Camenae, as often suggested.
7. Apse at the rear of the podium.
8. Innermost row of dots, probably representing a portico on the lower level, possibly Fulvius's original portico or a reconstruction thereof. It has also been interpreted as a row of trees.
9. High wall separating the lower Fulvian level from the outer elevated portico added by Philippus. This will have served as the perimeter wall for the inner portico, which is one possible location for the hanging of paintings.
10. Middle row of dots, possibly representing the pillars of the arcade of the upper outer portico.
11. Perimeter wall of the upper outer portico; possibly a simplification of what was a colonnade.
12. Narrow alley between the Porticoes of Philippus and Octavia. Excavations show that the external wall of the Portico of Philippus was very tall and was decorated with stucco painted with geometric lines.
13. Passage allowing direct access between the Portico of Philippus and the Portico of Octavia with its library.
14. Dotted squares, of uncertain architectural interpretation.
15. Column midway between two dotted squares.
16. Peristyle beyond the north wall.
17. Continuation of dotted squares as attested by the drawing of fragment *ee*; see fig. 80.
18. Columns of the outer portico as attested by the drawing of fragment *ee*; see fig. 80.
19. Probable location of the remains of the portico visible in the Renaissance. This would not then have been a blank outer wall as shown but a colonnade continuous with the columns on the south side of the Portico of Octavia.
20. Main entrance to the Portico of Philippus from the Circus Flaminius must have been here.

put in the adjoining portico, under the patronage of a different member of Augustus's family; it was crucial to avoid at all costs giving the appearance of building a unified Museum-library complex on the Alexandrian model.

Augustus also wanted the reflected glory of the kind of literary culture that had grown up at the Museum in Alexandria. For this he used another intermediary to put a fig leaf over his autocracy: Maecenas, who served as the focus for literary patronage and provided a certain distance between Augustus and the poets. The presence of a great library and financial support were important factors in fostering a literary renaissance, but what was missing was an institutional framework. It is true that literary patronage was always informal at Rome and would continue to be so, but the renovation of Rome's temple of the Muses offered a focal point for literary culture. It was not nearly as elaborate as the Museum in Alexandria, but it was something, and it was a gesture of support for Rome's guild of professional poets, which met in the temple. Moreover, it was an invitation and a demand for those poets. The construction of the original Temple of Hercules of the Muses was intimately connected with the writing

of Ennius's epic, the *Annales*. It is clear that Augustus was canvassing for an epic of his own, and his remodeling of the old temple was a prompt for the poem he wanted.

How can one be sure that the Portico of Philippus functioned as part of a coordinated cultural scheme, along with the construction of the Palatine temple and the patronage of Maecenas? The proof lies in the way that the poets mingled the Temple of Apollo and the portico in their writings. They understood that they were two parts of the same project, and so did the people of Pompeii. When the Pompeians adapted the decorative scheme of the portico for their own Temple of Apollo, they were making a move that had already been authorized in the metropolis and showed themselves to be perceptive readers of its monumental ideology. In order to demonstrate how the portico functioned within Augustan propaganda, I first step back and look in some detail at the ideological import of the Temple of Hercules Musarum, for the later monument is in some ways a comment on the debates that surrounded its construction some 150 years earlier.

The Temple of Fulvius

The exact circumstances surrounding Fulvius Nobilior's construction of the Temple of Hercules of the Muses in the second century BC have been the subject of some debate. The problem is that the few ancient sources seem on the surface to contradict each other or at least to pull in different directions. This has led some scholars to dismiss the veracity of one or another part of the evidence, but this is an arbitrary way of proceeding. It turns out that all the ancient testimony can be reconciled, but it requires a fairly complex narrative; this reconstruction follows mainly from the work of Rüpke.[8] This was not an ordinary temple and the controversy over its construction illustrated fissures in the way the Roman Republic viewed itself. That it was dedicated not to the Muses but to Hercules of the Muses is an indication of the tension. Normally, one would expect the Muses on their own or accompanied by Apollo. Scholars have hunted down explanations for how it was that Hercules could be associated with the Muses, and these are valuable but do not change the fact that it was fundamentally a very peculiar dedication.[9] The introduction to Rome of the suspiciously Greek and potentially effete cult of the Muses among the triumphal monuments of the Circus Flaminius demanded a patron other than Apollo, who, despite the nearby Temple of Apollo Medicus, was still perhaps seen as a Greek god. Hence Hercules.

The most fundamental problem is who paid for the temple. It is repeatedly associated with the sack of Ambracia, the erstwhile capital of Pyrrhus, by Fulvius Nobilior in 189 BC. He brought a great deal of booty thence, including the representations of the Muses that he dedicated in the new Temple of Hercules of the Muses. This close association with war booty and the location of the temple on the Circus Flaminius have naturally tended to give the impression that it was built, like many of the temples

in that locale, with the proceeds of war. Cicero, in his speech *Pro Archia*, illustrates the harmony of poetry with manly military pursuits by referring to Ennius's participation in the Aetolian campaign of Fulvius and the consecration of the spoils of war (*manubiae*) to the Muses (27.4–5). This all seems to imply that Fulvius paid for the temple out of the spoils of his campaign.[10] But another source contradicts that impression. At the end of the third century AD, the rhetorician Eumenius delivered a speech that imitated and expanded upon the tropes of the *Pro Archia*. In it, he states that the temple was built *ex pecunia censoria*, which is to say out of public funds, when Fulvius was censor in 179, not out of his booty upon his triumphal return in 187.[11] Livy casts more doubt on the connection of the temple with the triumph, for he does not mention either the vow or the construction of the temple, as he normally would; this would be a unique omission.[12]

The best clue to resolving this conundrum has previously been overlooked. A statue base was found in the area of Fulvius's temple, inscribed with his name and recording his capture of Ambracia as proconsul.[13] It is very interesting that the statue mentions only his consulship and not his censorship.[14] Eumenius's information that the temple was built from censorial funds sounds as if it could well have come, ultimately, from an inscription at the temple.[15] One may reconcile these two apparently conflicting pieces of epigraphic evidence by deducing that Fulvius's temple was a secondary position for the statue base, which was originally designed for another context. One can also guess what that context was, for a very similar inscription was found on a statue base in Tusculum, the original home of the Fulvii.[16] This was not contemporary with Fulvius, however, but probably dates to the Augustan period.[17] It was found with a series of other statue bases and may have been part of a display of some of Fulvius's booty in the family villa. Perhaps the Muses, too, spent some time in Tusculum. They might well have been kept there in the decade between Fulvius's return from Ambracia and the dedication of the Roman temple. This would explain the omission of the censorship from Fulvius's titulature on the statue bases. Why would Fulvius have moved art in this way from his home to a temple? As it happens, this fits very well with what is known of the controversies that swirled around his triumph at Rome.

Livy says that on his return from Ambracia Fulvius met with extreme resistance from other members of the Senate, especially his archenemy, M. Aemilius Lepidus. At Lepidus's urging, the people of Ambracia sent an embassy to the Senate to complain of their treatment at the hands of Fulvius and of the looting of their temples. The Senate agreed:

> Signa aliaque ornamenta, quae quererentur ex aedibus sacris sublata esse, de iis, cum M. Fuluius Romam reuertisset, placere ad collegium pontificum referri, et quod ii censuissent, fieri.

> (Concerning the statues and the other objects which the Ambracians complained had been removed from their holy temples, it was decided that when Marcus Fulvius had returned to Rome it would be referred to the college of priests, and what they judged right would be done.)[18]

Upon his return, Fulvius had to rush his triumph in order to take advantage of the absence of Lepidus from Rome (Livy 39.5.12). The enmity of these two men continued for another decade until their public reconciliation and joint election to the censorship (Livy 40.45–56). In this context, it is likely that the construction of a commemorative temple in the aftermath of Fulvius's disputed triumph would have entailed insuperable difficulties. Aberson concludes, therefore, that the conflict and subsequent reconciliation with Lepidus explains the delay between the triumph and the building of its memorial.[19]

In the meantime, the looted artwork would have been on display in Fulvius's house, and this seems to have attracted the ire of Cato the Elder. He made a speech against the diversion of booty from the public sphere, in which he criticized those who displayed captured statues of the gods in their homes.[20] Was he thinking of the Muses, and other booty from Ambracia? It is not certain who the target of this attack was or when it was made, but Fulvius is the likeliest candidate. Cato certainly did criticize Fulvius for failing to capture Ambracia by force, and for taking the poet Ennius with him to Aetolia in the manner of a Greek dynast. He spoke against someone, again probably Fulvius, for misappropriating booty.[21] Thus the eventual construction of the Temple of Hercules Musarum was a pointed rejoinder to the criticisms of Cato.[22] Fulvius's monument was a restatement of the legitimacy of his earlier triumph, a public display of statuary to rebut the charge of appropriating public property, and a testament to the legitimacy of poetry and literary patronage as a part of Roman public life.

Another problem in the evidence is that Livy does not mention the construction of the temple among the censorial building projects of Fulvius, unless it is implicit in this list (40.51.4):

> et porticum extra portam Trigeminam, et aliam post naualia, et ad fanum Herculis et post Spei ad Tiberim <et ad> aedem Apollinis medici

> (a colonnade outside the Porta Trigemina, and another behind the dockyards, and at the shrine of Hercules, and behind the temple of Hope at the Tiber, and at the shrine of Apollo the Healer)

This bald mention of a portico at the shrine of Hercules has not seemed to scholars to fit very well with the construction of an entire sanctuary.[23] But perhaps Fulvius never did build a temple. If the Muses were uneasy visitors in Rome, perhaps they took shelter under the protection of Hercules in one of his already-existing shrines.[24] If Livy's

text is not corrupt, it may be that as censor Fulvius added a portico to an existing shrine of Hercules and rededicated the whole complex to Hercules of the Muses, but this would involve supposing an otherwise unattested temple of Hercules.[25] A simpler explanation is to suppose that Fulvius founded a completely new Temple of Hercules Musarum when censor and that Livy just omitted it from his list, perhaps because it had come to seem in retrospect more a triumphal than a censorial monument, on account of the booty from Ambracia that was belatedly moved into it.

Fulvius did not have the means to endow a real Museum along the lines of the one in Alexandria and is unlikely to have had the will to do anything so far-reaching. Augustus had both the will and the means but was far too careful of Roman precedent and of avoiding the explicit trappings of Hellenistic kingship. Even Fulvius, who was happier to invite Hellenistic parallels, did not actually build a Museum in the strictest sense: it is a temple not of the Muses but of Hercules as protector of the Muses. This bizarre compromise may have been due to his sense of what Roman religious sensibilities would tolerate, or to an explicit failure to get the Senate to authorize an *aedes Musarum* (temple of the Muses). But it is clear that the resulting dedication has the air of desperate improvisation. It gave the Muses nothing more than a "toehold" in a hostile environment.[26] Eumenius does say that Fulvius had found in Greece a cult of Hercules Musagetes. No doubt there was, somewhere, and interesting connections have been suggested with the Pythagorean milieu of Ennius.[27] But this is obviously a pretext. Everyone will have known that Hercules was an eccentric choice for the role of leader of the Muses. He was very much the right god, however, to occupy an ersatz-triumphal temple filled with booty on the Circus Flaminius.

Another interesting feature of the temple is that it contained, as Macrobius tells us, a copy of the Roman calendar, the *fasti*, along with a commentary.[28] It seems best to assume that this text was painted on the walls, like other Republican *fasti*, though some have claimed that it refers to a book deposited in the temple.[29] Macrobius is referring to a commentary on the names of the Roman months, so this clearly means a text that treated the cyclical Roman year. The question is whether it also included a year-to-year listing of the magistrates; the term *fasti* covers both types of calendar.[30] There is no direct evidence that this cyclical calendar of the months of the year was accompanied, as it regularly was in later examples, by a linear list of consuls and (possibly) censors from year to year, but the indirect evidence is sufficiently strong that many scholars have accepted that it was probably the case here, too.[31]

On the basis of this supposition that there was an annalistic element to the decoration of Fulvius's temple, many have explored the striking links between its ideological program and the epic *Annales* of Fulvius's protégé Ennius.[32] This connection between poem and temple was perhaps emphasized by Ennius himself: Skutsch asserts that the original edition of the epic culminated with Fulvius's triumphant return from Ambracia and his dedication of the temple, decorated with the representations of the

Muses that he had taken as booty.[33] Ennius was the first Roman epic poet to invoke the Greek Muses as the source of his inspiration, and later Roman poets characterized his poetic achievement as though he had triumphantly brought the Muses to Italy, so this metaphorical parallel with Fulvius's conquest may well go back to Ennius himself.[34] If Fulvius provided a physical home for the Muses in Rome, Ennius accommodated them in Latin poetry, displacing the native Camenae.[35] Thus both the *Annales* and the walls of Fulvius's temple were year-by-year records of Roman achievements and of the passing of Roman time: both were appropriate projects to entrust to the Muses, daughters of Memory.

What Fulvius provided Rome was not just a temple to accommodate the Muses, these newly arrived goddesses. It was a Museum, a cultural institution of the sort that a Hellenistic king might erect.[36] No wonder Cato did not approve. Perhaps even more controversially, it was a Roman *lieu de mémoire* (site of memory).[37] Monuments that frame the past are always sites of contestation, and this was no exception. On the one hand, there were Fulvius and Ennius, interpreting Roman history as a series of individual accomplishments and triumphs accruing to particular aristocratic families. These individual achievements were to be celebrated by poets like Ennius, preserving for posterity the famous deeds of their patrons, and by artists like those who built Fulvius's temple. Cato disagreed. He savagely attacked Fulvius's military achievements and his association with Ennius, even though Cato himself had once been on good terms with the poet.[38] If the Temple of Hercules Musarum was Fulvius's response to Cato's criticism of his disposition of war booty, it was not a submission to his views: there can be no doubt that the foundation of a temple for the Greek Muses would have seemed to Cato an act of reprehensible philhellenism, at least in regard to his calculated and somewhat grandstanding public posture as the custodian of Roman values against unsavory Greek influences.

Cato's most substantial response to the view of Roman history implicit in the work of Fulvius and Ennius was his *Origines*, the first work of history in Latin prose, which was begun in 168, the year after Ennius's death. It is likely that this work began with words forming a Latin hexameter, a feature regularly repeated by later Latin prose historians.[39] If so, this would have been a clear indication that Cato saw his work as a response to Ennius, who had essentially invented the Latin hexameter not long before. Famously, Cato omitted the names of the protagonists of Roman history, indicating individuals simply by their office.[40] This view of the Roman Republic as an anonymous corporate enterprise driven by *concordia* stands in stark contrast to Fulvius's and Ennius's conception that competition for individual fame, glory, and remembrance was the engine behind Roman military success.

The position of the temple proclaims its connection with individual triumph: the Circus Flaminius was the starting point for triumphal processions and hence there were a great number of votive temples founded by victorious generals in the vicinity.[41]

This same connection between triumph and temple was probably also articulated by Ennius. Timpanaro has suggested that the alliteration in Cicero's phrase "Martis manubias Musis consecrare" sounds distinctly Ennian; he suggests that Cicero is here quoting from the poet's *fabula praetexta* (a drama based on history or legend) on the siege of Ambracia.[42] The image of the victorious Fulvius forcibly dragging the Muses from Greece to Italy and putting them on display in a new temple becomes an extremely potent one for Latin writers. The refoundation of this Roman Museum by Octavian's party at the time of his return from Alexandria and his triple triumph was a replaying of the same theme.

The question of whether the Roman Republic was a monolithic corporate entity or a loose collection of competing individual interests would continue to be debated until the coming of Augustus. It was he who made the question moot by aligning the state with the interests of a single person and a single family. It is no coincidence, therefore, that one of his close relatives was behind the renovation of the Roman Museum. L. Marcus Philippus updated its decorative program in a way that reflected the new ideology, such that the sweep of Republican history was subordinated to the history of a single family. The *Annales* was not a suitable national epic from Augustus's point of view, and for different reasons it had come to seem unsatisfactory to many of Rome's poets as well. It is clear to many scholars that Augustus and his proxy, Maecenas, were actively soliciting poets to write a new epic, an effort that eventually gave us the *Aeneid*. The links between this new construction of Philippus and contemporary literature are just as intense as those between Fulvius and Ennius's building. The Augustan poets had a professional interest in the Temple of the Muses and responded in detail to the program of the renovated complex.

Philippus and Augustus

The Portico of Philippus is not a well-known monument, which may be the result of two assumptions: that it was an eccentric work of an insignificant and peripheral member of Octavian's circle and that it did not amount to a substantial building project. Both of these assumptions can be shown to be false. Architecturally, the Portico of Philippus formed a seamless unity with the porticoes of Octavia and (probably) Octavius that stood on either side of it, thereby serving to make the entire northern side of the Circus Flaminius a monument to Augustus's extended family. Ideologically, it was of a piece with everything that Augustus was doing in the aftermath of Actium.[43] Nor was the portico a minor project. It probably involved rebuilding from scratch all of Fulvius's sanctuary except for a small circular temple to Hercules at its center.

Both the Temple of Palatine Apollo and the Portico of Philippus were begun before Actium and completed afterward, and they both emerged from the years of struggle between the triumvirs. As noted earlier, Julius Caesar may have planned to build a major library for Rome, and as part of the struggle to lay claim to Caesar's

legacy Asinius Pollio provided Rome with its first public library when he rebuilt the Atrium Libertatis after his triumph in 39 BC. Rome's original temple to Apollo had been built by a member of the Julian family, and the god was now Octavian's patron, to whom he had started building a new temple on the Palatine. Thus Gaius Sosius's vow to restore Apollo's ancient temple after his triumph in 34 was a barely veiled gesture of rebuke to Octavian for failing to do the same instead of building his own temple.[44] In the end, Pollio bowed out of politics and Sosius was ostentatiously pardoned by Augustus after Actium. Sosius's temple was completed in such a way as to transform it from a gesture of independence into a loyal expression of the new ideology. Both the Portico of Philippus and the Temple of Palatine Apollo arose out of the context of triumviral rivalry but were completed as carefully designed and integral parts of the new Augustan city.[45]

In the early years of the decade before Actium, the building activity in Rome of Antony's lieutenants had notably outstripped Octavian's.[46] The Portico of Philippus was part of a concerted effort to catch up, which included the rebuilding of the Regia by Cn. Domitius Calvinus (triumph in 36), the building of the amphitheater of Statilius Taurus (triumph in 34), and the renovation of the Aventine Temple of Diana by L. Cornificius (triumph in 33/32).[47] In 34, L. Aemilius Lepidus Paullus, nephew of the triumvir Lepidus but ally of Octavian, completed the Basilica Aemilia that had been begun by his father, a work that was in turn a rebuilding of a structure by the censors Fulvius Nobilior and his ancestor M. Aemilius Lepidus. To this period also belongs the extraordinary aedileship of Agrippa in 33, when he undertook so much work on the water supply and drainage of the city. And of course the Temple of Palatine Apollo and the Mausoleum of Augustus were also presumably under visible construction around this time.

The date of the dedication of the Portico of Philippus cannot be fixed with precision, but it was probably around 28 BC. Tacitus and Suetonius both group Philippus with other lieutenants of Octavian who dedicated public works built from the spoils of their triumphs in this period.[48] It is known that Philippus celebrated a triumph *ex Hispania*, and the phrasing of both Suetonius and Tacitus suggests a connection between the building and the celebration of that triumph. The day of Philippus's triumph was April 28, but a lacuna in the *fasti triumphales* prevents direct confirmation of the year; as Shipley demonstrates, however, circumstantial evidence shows that it was almost certainly in 33.[49] Shipley goes on, "From the known data in regard to other monuments of the *triumphales* we may assume that the work consumed at least four or five years," which suggests a rededication of the temple on 30 June of 29 or 28.[50] Although the ostensible purpose of the portico was to commemorate the triumph of Philippus, it coincided chronologically with Octavian's return from Alexandria, his triple triumph in 29, and the dedication of the Temple of Palatine Apollo the following year. Thus the

chronological juxtaposition of the completion of these two structures suggests their connection as two aspects of the emulation of the Museum and Library of Alexandria. The renovation of the Temple of Hercules Musarum had a built-in association with Actium: Ambracia, the city from which Fulvius removed the Muses, was very close to the site of the battle.

No Roman would have been foolish enough to think that Philippus was acting independently. His father did carefully cultivate a public air of skepticism toward his stepson Octavian's ambitions, as reflected in the famous story that he advised him not to take up his inheritance from Caesar, but the facts belie this pretense of independence.[51] In particular, the careers of both the elder Philippus (praetor in 60 BC, consul in 56) and the younger (tribune in 49, praetor in 44, suffect consul in 38, *triumphator* in 33) over these decades must be the result of the patronage of first Caesar and then Octavian.[52] The closeness of the bond was reinforced by the marriage of the younger Philippus to the younger sister of Atia, Octavian's mother; this made him Octavian's uncle as well as stepbrother. It is most unlikely that this singularly well-connected young man, who ultimately "proved a nonentity," came up with the project of restoring and reorganizing the Temple of Hercules Musarum on his own initiative.[53] This hypothesis is confirmed by the way in which the project coheres both architecturally and ideologically with other aspects of Octavian's building program.[54] It was squeezed between the Portico of Octavius, whose rebuilding Augustus advertised as a personal achievement in his autobiography, the *Res gestae*, and the Portico of Octavia, which was ostensibly the work of his sister, but in the construction of which Octavian played a major role, as confirmed by Suetonius (*Aug.* 29.4). Philippus was wholly the creature of Augustus.

Over the course of the late 30s, Octavian seems to have moved methodically westward across the north side of the Circus Flaminius, first refurbishing the Portico of Octavius, then building the Portico of Philippus, then replacing the Portico of Metellus with the Portico of Octavia, and finally building the Theater of Marcellus at its eastern end. The first of these, the Portico of Octavius, had been erected in 168 BC by Cn. Octavius, who was possibly a very distant relative of Octavian. It is widely assumed that Dio (49.43) confuses the Porticus Octavia and the Porticus Octaviae; this would date this project to 33. Coarelli has demonstrated that the most likely place for the Portico of Octavius is on the western side of the Portico of Philippus, continuing and completing the northern edge of the Circus Flaminius.[55] In the *Res gestae* (19.1), Augustus makes quite a good joke about the fact that he had turned this area into a family monument, adopting Cn. Octavius as an ancestor in the process:

> porticum ad circum Flaminium, quam sum appellari passus ex nomine eius qui priorem eodem in solo fecerat Octaviam...feci.

> (I built...the portico near the Circus Flaminius, which I allowed to be called by the name of the man who had built the earlier one on that same spot—that is, the Portico of Octavius.)

The first part of the sentence is an elaborate but typical boast about how modest Augustus was in allowing this portico, as he often did, to retain the name of the original builder. Then, carefully withholding the name until the end, he gives us the punch line with the final word of the clause in hyperbaton, *Octaviam*. It is an entirely facetious profession of modesty, for it turns out that, in this case, the name of the original builder just happened—by purest coincidence!—to be the same as his own.[56] Augustus shows here a witty self-awareness of the paradoxical purposes of the *Res gestae*, whereby he shamelessly proclaims his modesty and advertises his lack of self-advertisement as a builder.

The location of the Portico of Octavia on the other side of the Portico of Philippus is well known, but its date is uncertain; it was probably built in the late 30s or early 20s.[57] The Marble Plan (see fig. 74) attests that the porticoes of Philippus and Octavia were congruent and together provided a uniform facade for the northern side of the Circus Flaminius; it even labels them jointly, as if the porticoes formed two parts of a whole. So it seems evident that in the latter half of the 30s, Octavian was engaged in a project to redefine the northern side of the Circus Flaminius by reconstructing three Republican structures with three porticoes in the names of three different members of his extended family. After the death of Marcellus, this line of porticoes would eventually culminate in the building of the theater named in his honor. Octavian's role in the building of the Porticoes of Octavia and Octavius is obvious; the same can be assumed for the Portico of Philippus, which was squeezed between these two and formed part of the same overall strategy. The integration of the Portico of Philippus within the ideological program of Augustus should now be clear.

One indication that Philippus largely built a new structure is given by Ovid, whose sixth and final book of the *Fasti* ends on June 30, highlighting this as the day of dedication of the Portico of Philippus. The poet thus concludes his *Fasti* with a building containing an early example of the official *fasti*.[58] He addresses the Muses in Callimachean fashion and asks them to explain who associated them with the unwonted figure of Hercules. The answer ought to be Fulvius, or perhaps even Ennius, but Clio responds in a highly misleading way (*Fasti* 6.799–802):

> dicite, Pierides, quis vos addixerit isti
> cui dedit invitas victa noverca manus.
> sic ego. sic Clio: "clari monimenta Philippi
> aspicis, unde trahit Marcia casta genus..."

(Speak, Muses, I asked; say who it was that connected you with this figure to whom a defeated stepmother unwillingly yielded [i.e., Hercules]? Clio responded: "You see the monument of noble Philippus, from whom chaste Marcia traces her descent.")

It is true that what one sees is the Portico of Philippus, but this is utterly disingenuous; Philippus was not the one who put the Muses under the protection of Hercules. Clio has effectively airbrushed Fulvius out of the history of the monument. It is particularly ironic that when asked a straightforwardly historical question, Clio, the muse of History, evades the point at issue and responds in the present tense. She simply points to the current appearance of the building and completely ignores the Republican past in favor of its contemporary renovator.[59] Ovid goes on to praise Philippus's daughter, Marcia, cousin of Augustus and friend of Ovid's wife.[60] It was therefore in Ovid's interest to downplay the role of Fulvius and expand that of Marcia's father. Furthermore, the effacing of Fulvius may have had a poetical motive, as this permits Ovid at the very end of the first installment of the *Fasti* to efface what was probably the ending moment of the first edition of Ennius's *Annales*: the founding by Fulvius of the Temple of Hercules Musarum and his placing the *fasti* there.[61] Ovid's *Fasti*, which in a sense rivals the *Annales* as the great poem of the Roman calendar, erases that foundation from the record and instead climaxes with the foundation of the temple's new Augustan incarnation, thus superseding Ennius's poem. On the one hand, the joke depends upon the reader knowing that Clio is not giving the full story here; on the other, this joke would have fallen flat unless the intervention of Philippus was indeed substantial enough to have given a new look to the structure. In the final couplet of the poem, Clio's nonanswer to Ovid's question is endorsed by her sisters and by Hercules himself, who sounds his lyre in a gesture that Ovid glosses as approval.[62] It is not merely a coincidence of the calendar that the *Fasti* ends with the Portico of Philippus. If, as argued below, that monument embodied a demand from Augustus for poetry that would support the ideology of the regime, then the *Fasti* is Ovid's ambiguous response.

Another aspect of Ovid's testimony that suggests the novelty of Philippus's building is the fact that its *dies natalis*, or date of dedication, was June 30. Boyle has pointed out that this cannot be the birthday of Fulvius's temple, because June had only 29 days before Julius Caesar's reform of the Roman calendar.[63] The Chronography of 354 records that the *natalis Musarum* was on the Ides of June (the 13th), which may be the original date of dedication of Fulvius's temple.[64] This information has tended to be overlooked, perhaps due in part to a resistance to viewing Philippus's intervention as large enough to entail giving the Republican temple a new birthday. This Augustan rededication implies that Philippus did more than simply build a portico around the existing temple.

The Layout of the Portico of Philippus

I now turn from the historical evidence for the foundation of the monument to the question of its physical appearance. The crucial evidence for the layout of the Portico of Philippus and the Temple of Hercules Musarum comes from several fragments of the Severan Marble Plan (see figs. 74 and 75), some of which are preserved only in the form of drawings made in the Renaissance. The temple is labeled by name and the Portico of Philippus is named jointly with that of Octavia next door.[65] Both the portico and the temple have unusual features, which has made the layout shown by the Marble Plan difficult to interpret. It could be doubted whether a plan made in the Severan period will accurately reflect the layout of the Augustan monument, especially given the number of serious fires in Rome in the intervening period. However, it is known that the Severan plan does not accurately reflect the Severan rebuilding of the adjacent Portico of Octavia but rather shows its Augustan phase.[66] So the plan here, too, is probably based on earlier, Augustan city plans.[67]

A few archaeological investigations of the Portico of Philippus were made in 1983, and although these were limited in scope, they revealed features that can be matched with the Marble Plan and have greatly helped to clarify it. I begin my discussion of the plan of the sanctuary, therefore, with the two main pieces of archaeological evidence. The first pertains to the outside perimeter wall of the portico. Under the porch of the church of Sant'Ambrogio were found remains that seem to belong to the east side of the portico (fig. 76), where it faced the side of the Portico of Octavia across a narrow alley (see fig. 75, no. 1).[68] This was a very tall wall, perhaps around three meters in height, and its eastern side was visible from that alley: its outer side was made from tufa blocks covered in stucco to emulate marble revetment, which was painted with geometric lines.[69] On the inner side of this elegant wall are parallel foundation walls in concrete, which are connected together at intervals. This part was not meant to be seen and must have been the substructure underneath the portico. The Portico of Philippus therefore towered over the Circus Flaminius, as did the Portico of Octavia.[70] The portico probably was built this way to defend against the frequent flooding of the Tiber.[71] It would not be surprising if the original temple of Fulvius had suffered damage from such floods, and if one important purpose of the renovation was to put that right.

The second dig to yield significant results was conducted in the garden area in the middle of the monastery cloister, where a narrow corridor was found between two parallel tufa walls with traces of marble facing (see fig. 75, no. 2).[72] The gap between the walls was about a meter wide and seems to have been originally paved in marble. At its southern end this narrow corridor ended by meeting at a right angle the remains of a curving wall made of *cappellaccio* blocks. This collection of elements has been interpreted as corresponding very well to an area shown on the Marble Plan (see fig. 75, no. 2), just north of the larger circular structure at the center. That circle has

FIGURE 76 Structures under the porch of the church of Sant'Ambrogio della Massima. Left: foundations in *opus caementicium* and *reticulatum*; right: ashlar tufa blocks of the exterior wall, which has been backfilled so that the stucco that was found on the outer face to the right is no longer visible

long been identified as part of Fulvius's original temple; this is uncontroversial, as the circle seems to have been the usual form for Republican temples to Hercules. The controversy has been over how much of the rest of the central area to attribute to Fulvius. The fact that the circular wall is made of a different building material suggests that it belongs to a different phase, and *cappellaccio*, a rough, gray local tufa, is consistent with a Republican date and very unlikely for an Augustan building.[73] The odd-shaped podium that surrounds the circular temple must, however, belong to the Augustan rebuilding, as an early Augustan date for this podium was confirmed by pottery fragments found in the fill.[74] This confirms the conclusions drawn earlier from the literary evidence, that the Portico of Philippus was more than just a portico thrown around the Fulvian sanctuary, that it was a thorough renovation of the whole complex.

Some earlier studies wanted to attribute the odd-shaped podium (see fig. 75, no. 4) to Fulvius, but this now seems impossible.[75] The circular temple (see fig. 75, no. 3) was his, but it had a new and presumably much larger podium around it. It may have been that inundation had damaged the lower part of the original podium or simply that the new podium was designed to make the circular temple part of a more imposing centerpiece for the new portico. Marchetti-Longhi has aptly suggested an analogous development of another small, circular Republican temple.[76] The circular Temple B at Largo Argentina, probably dedicated to Fortuna Huiusce Diei soon after 101 BC, was enlarged at a later date. The cella was demolished and a new cella was created

by filling in the spaces between the external columns; at this point the podium was enlarged by surrounding it with a larger ring.[77] The enlargement and elaboration by Philippus of the podium of the circular temple of Fulvius was a somewhat larger and more complex project, but not very different in kind. It is possible that its cella underwent an identical program of enlargement, and this would explain why, unusually, the Marble Plan does not indicate the existence of any columns around it.

The crenellated form of the podium is puzzling at first, but it can be explained. Two aspects of Fulvius's sanctuary had to be rehoused in the new complex: the nine statues of the Muses and the *fasti*. As it happens, the form of the podium is perfectly designed to accommodate both of these. The name Hercules of the Muses indicates that the temple was officially dedicated only to Hercules, and so only one cult statue should be expected. In any case, the cella of the circular temple was too small to accommodate ten statues, so the Muses were presumably arranged in front, as was often the case with Republican temples.[78] They may have stood on statue bases like the one discovered with the inscription naming Fulvius. His *fasti*, if it was like other Republican calendars, would have been painted on a wall.[79] It would have needed protection from the weather, but the inside of the temple would have been cramped. If the passage of Livy discussed earlier was referring to this structure, then Fulvius's temple also had a portico, which would have been the logical place for his *fasti* to be displayed.

The Augustan podium of the temple seems to have been designed to receive these Fulvian elements. The six niches on each side of the podium corresponded to the twelve months of the calendar, and Lundström and Coarelli place Fulvius's *fasti* here.[80] If this is right, the position, exposed to the elements, indicates that the calendar would have been inscribed in marble, typical for *fasti* in the Augustan period.[81] This would have been a replacement for the painted Republican calendar. If there was a list of annual magistrates to accompany the months of the year, these could have gone elsewhere, such as in the niches on the inside of the projecting arms of the podium. Those arms (see. fig. 75, no. 5) are another peculiar feature that can be explained as part of a design to deploy Fulvian elements. The arms stretch out in front of the temple, where the statues of the Muses in all likelihood originally stood. There are four places on each side where the arms widen and where a statue could have been placed.[82] This would account for eight Muses, and the ninth would have been placed on the circular podium in the middle (see fig. 75, no. 6). The odd number of the Muses is inconvenient from the point of view of architectural symmetry and required treating one of them differently. Since Hesiod, Calliope had been singled out as their leader, and this is routine in Augustan poetry.[83]

Not everyone will agree with this reconstruction. The small circular structure in front of the temple (see fig. 75, no. 6) has usually been identified as either an altar or the small shrine (*aedicula*) of the Camenae that Servius says Fulvius transferred to his new temple. On the other hand, a circular form would be somewhat unusual for an

altar and very strange indeed for an *aedicula*. As for the position of the Muses, Coarelli has ingeniously suggested that they are represented on the Marble Plan, where there is just barely room for nine dotted squares along the north wall (see fig. 74).[84] This would mean that the statues were moved far away from the Fulvian temple and put in the upper, outer portico along its north wall (see fig. 75, no 14).[85] This is possible, but unlikely. It would mean that all the Muses were displayed against a wall and that two of them were wedged very tightly into corners. An even stronger objection is that to move the Muses so far away from Hercules would make something of a mockery of the name of the temple. Philippus clearly meant to supersede Fulvius's monument, but it is unlikely that he would have made such a contemptuous gesture of expropriating and marginalizing his Muses. For what it is worth, Ovid clearly portrays Hercules as still in close dialogue with the Muses when he sounds his lyre to approve Clio's discourse. On Coarelli's hypothesis, he would be a distant figure, on a lower level, with his back to the Muses and with the rear wall of the cella standing between them. By contrast, if the Muses were arranged right in front of the cella, he could see them through the door and overhear Ovid's dialogue with them.

If the new podium and the circular element were designed to house the nine statues of the Muses, it was clearly a much more elaborate structure than was necessary. The best parallel on the Marble Plan for this sort of crenellated structure is in the Temple of Peace, which has a series of somewhat analogous lines in the courtyard: long, thin structures with rectangular indentations.[86] In comparison with the two arms stretching in front of Fulvius's temple, the indentations of the Temple of Peace are much farther apart and as a result the wide sections are much longer. Nevertheless, the fact that both structures are located within temple porticoes might suggest some form of kinship. This area of the Temple of Peace has recently been excavated, providing some idea of what these structures were. Evidence of drainage has been found, which suggests that they were fountains or pools, and that they were bordered by formal plantings of roses.[87] This fits with the literary testimony that this courtyard was one of the most beautiful places in the city.[88] The Temple of Peace was known for its collection of masterpieces of sculpture, so it may be that the long structures also served as bases for some of the sculpture known to be housed there.[89] Based upon the parallel from the Temple of Peace, the most likely guess is that the arms of the podium of Hercules Musarum supported statues and incorporated plantings of flowers and perhaps fountains. It would have been a most appropriate grotto-like environment in which to house the Muses. It may even be that the Flavian Temple of Peace took this Augustan courtyard of the Muses as its model, a place where sculpture, fountains, and flowers aided contemplation.[90]

At the rear of the podium, there is a semicircular niche (see fig. 75, no. 7), which some have thought to be a small theater for poetic recitals, but it is too small and the excavations gave no sign of that. One might instead expect it to provide a focal point

for a piece of statuary in the middle of the apse. At the center of the semicircle is the small corridor at the rear of the cella that was unearthed by the excavators, the purpose of which is unknown. It seems to be the only point at which the old Fulvian podium was exposed to view. It may be that the reason for this was as banal as to allow drainage from the cella. In its original form, it is unlikely that Fulvius's temple had any opening at the rear, but buildings on the alluvial soil of the Campus Martius did sometimes settle unevenly. If the cella had developed a slight rearward slope, the Augustan remodelers might well have left a small hole at the rear for drainage. If there was a statue or some other object in the apsidal niche, it would have concealed the drain and the glimpse of the old podium that the corridor exposed.

The Republican temple with its new podium was presumably built at ground level in Fulvius's day. That level would have risen considerably by the Augustan period and, as noted, the new portico was erected on a platform that rose still higher above the later ground level outside the enclosure. On the inside, therefore, the external portico must have towered over the inner courtyard in which the Republican temple was situated. This helps to explain another peculiarity of the plan, which is that the two lines of dots that surround the podium are not aligned (see fig. 75, nos. 8, 10) and a solid line runs along the inside of the outer row (see fig. 75, no. 9). This indicates that the structure cannot be a double portico, as in the Portico of Octavia next door, where the plan shows two rows of aligned dots with no lines between. The solid line must show the place where the high level of the portico ends, dropping down to the level of Fulvius's temple. So the outer row of dots along the line (see fig. 75, no. 10) marks the columns supporting the roof of the Portico of Philippus proper.

Different explanations have been offered for the unaligned dots on the inside (see fig. 75, no. 8), which must belong to the lower level. Some think that these are trees, which would fit well with the idea of fountains and flowers making a suitable abode for the Muses. It is not clear that the Marble Plan frequently marked trees in this way, however.[91] In recent years, improvements in excavation techniques have revealed that many sanctuaries in Pompeii were planted with trees, and the same was probably true in Rome.[92] The vast majority of trees were therefore not marked on the plan, and in fact the evidence seems to indicate that the trees of such sacred groves were planted to align with the columns of the surrounding portico, as is not the case here.[93] Given these problems with the tree hypothesis, a better explanation for the lack of alignment is that there were two different porticoes, on different levels. The inner ring of columns would thus support the roof of a second, inner portico on the lower level.[94] The outer wall of this inner portico would be the podium on which the Portico of Philippus rested, represented by the solid line on the plan (see fig. 75, no. 9). If the pavement of the outer portico was 3–4 meters aboveground, as the excavations suggest, the inner wall of its podium would have been high enough to serve as the outer wall of a portico at ground level. There would be no reason to expect the columns of

this portico to be aligned with those of the portico on the upper level, and the failure of the plan to show a means of access from one level to the other is not surprising, given its schematic nature.[95]

The Portico of Philippus itself is represented on the Marble Plan as having blank walls on the south, east, and west sides. If the fragment of the plan at the southwest corner (see fig. 75, *hh*) has been correctly positioned with respect to the Renaissance drawings that preserve the central part of the temple (see fig. 75, *eeff*), the fragment breaks off just before the midpoint of the wall without any sign of a monumental entrance (see fig. 75, no. 20). By contrast, the Portico of Octavia next door is shown with a monumental entranceway, which was then enlarged in the Severan period, the remains of which are visible today. It is unlikely that the Portico of Philippus was an inward-looking structure with a simple entrance from the Circus Flaminius, since the Portico of Octavia seems to have had a very open aspect toward the Circus in the Augustan period.[96] So one might suspect in any case that the blank walls shown by the Marble Plan are an oversimplification.[97]

On the north side, by contrast, the Marble Plan shows some architectural elaboration, represented in the form of small squares with dots in the center (see fig. 75, no. 14). These dotted squares were used to represent the monumental entrance to the Portico of Octavia, and it is possible that the whole north side of the structure was open.[98] I discuss possible explanations for these dotted squares in the next section. Beyond the north wall is a small peristyle (see fig. 75, no. 16), whose function is unknown.[99] Some distinctly nonsacred activity is associated with the portico: Ovid tells us that this was the neighborhood where you went to buy a wig.[100] Such activity must have been conducted just outside the portico, in a space such as this.[101]

The Architecture of the Portico

Over the years, only a few scanty remains of the Portico of Philippus have been unearthed, which is not surprising, given what was said in 1838 by the topographer Antonio Nibby:

> Avanzi sopraterra non ne rimangono, ma io che sono nato sulle sue rovine, e che vi ho abitato per ben quattro lustri posso accertare che dentro le cantine di tutte le case comprese nel circondario descritto di sopra, e quà e là dentro i muri delle case appariscono tali indizii, che se un giorno si sgombrasse il suolo e si demolissero i fabbricati come si fece al Foro Trajano si avrebbero risultati importanti per la Topografia antica di Roma e per le Arti.
>
> (No remains of it [the Portico of Philippus] are left aboveground, but I who was born upon its ruins and who lived there for two decades can affirm that in the cellars of all the houses in the area described above and in the walls of the houses here and there are indications that, if one day the ground were cleared

FIGURE 77 Giuliano da Sangallo (Italian, ca. 1445–1516), Drawing of the ruins of a Roman portico. Folio 1v of the Barberini sketchbook; Vatican Library, Cod. Barb. Lat. 4424. Image reproduced from Christian Hülsen, ed., *Il libro di Giuliano da Sangallo* (Leipzig 1910)

and the buildings demolished as was done in the Forum of Trajan, it would have important results for the ancient topography of Rome and for the arts.)[102]

Going back further in time, it is fairly certain that there were no significant visible remains of the architecture of the monument remaining in the eighteenth century, when Piranesi was comprehensively documenting the Roman ruins of the Campus Martius. He does identify one structure as the Portico of Philippus, but unfortunately he was mistaken. His engraving with this label shows an entirely different structure well to the west of the portico, near the church of Santa Maria in Cacaberis, which was demolished to make way for the via Arenula.[103] A vestige of these remains, which were once quite extensive, is still visible today in via di Santa Maria dei Calderari. Over the years these have been connected with various ancient buildings, but there is little agreement today on their identification.[104]

Still further back in time is a famous book of drawings, the Barberini sketchbook of Giuliano da Sangallo, which is now in the Vatican.[105] It contains a drawing of an otherwise unknown Roman portico near the Jewish Ghetto, along with a plan of the structure (fig. 77).[106] R. Lanciani first suggested a link between this structure and our fragment of the Marble Plan. The next step was made by Hülsen in his edition of Giuliano's notebook. Hülsen connected these drawings with a sketch in the Uffizi, traditionally identified as the work of Fra Giocondo, which shows an almost identical plan along with two small details of what seems to be the same structure (fig. 78).[107] Considerable doubt has grown up in recent years over the attribution of this group of drawings, but for convenience of reference I simply refer to them as Giocondo's rather than using a clumsy circumlocution.[108] The argument below would not be affected if these drawings were by another hand.

A very strong case can be made for the identifying the ruins sketched by Giuliano and Giocondo as the Portico of Philippus, but so far the idea has not met with general approval, so it is necessary to lay out the evidence in some detail.[109] The first question to address is whether Giuliano and Giocondo show the same structure. Hülsen had doubts, even as he made the connection between the drawings, alluding to differences in the plans and the measurements.[110] It is in fact clear that the plans are essentially identical with respect to the structures they show. There is just one very minor discrepancy: Giuliano shows the large pillars with half columns attached at the back as well as at the front. This may simply be because one or both of the architects did not bother or was not permitted to see what was on the other side of the pillar and made contrary assumptions about its symmetry. Access to the rear of the ruin may not have been easy to get.

The second issue Hülsen alludes to is potentially more serious: it seems that the measurements given by the two artists may be incompatible. Giocondo indicates quite a few measurements on his plan, Giuliano somewhat fewer. They both give dimen-

FIGURE 78 Plan and drawing of the ruins of a Roman portico, traditionally attributed to Fra Giocondo (Italian, ca. 1434–1515). Uffizi Museum, Florence (Arch 125r.). Image taken from Alfonso Bartoli (ed.), *I monumenti antichi di Roma nei disegni degli Uffizi di Firenze* (Florence 1914–22), vol. 1, pl. 43, fig. 71

sions for one important feature of the building: the spacing for the large pillars at the rear. Giuliano says that these large pillars were spaced at a distance of 8⅓ Florentine *bracci*, which is in theory supposed to equal 0.5836 meter, giving a length of 4.86 meters. Giocondo, on the other hand, apparently uses the Roman *palmo* and the *canna architettonica* of 10 *palmi*; he gives the spacing of these large pillars as 2 *canne* and 6½ *palmi*, which is to say 26½ *palmi*; at the standard conversion factor of 0.2234, the gap would be 5.9 meters.[111] A discrepancy of over a meter appears to be a serious problem, especially as both architects are so very careful to give minutely precise measurements of several other details of these ruins.[112]

In fact, it is easy to show that the measurements in the drawings of Giuliano and Giocondo routinely disagree in this way, even for buildings that still exist, as may be seen from comparing their plans of the Basilica of Maxentius in the Roman Forum. Giuliano's plan is in the same Vatican notebook, and the one attributed to Giocondo is in the same collection at the Uffizi; the latter drawings are clearly by the same hand, whether or not it was actually Giocondo.[113] Both artists use the same units of measurement as in their plans of the portico; once again Giuliano gives fewer measurements than Giocondo, but there are three aspects of the building that both men give lengths for. Since some modern treatments of the basilica do not have a plan with the precise measurements I need, I turn for a comparandum to a very detailed plan from 1682 by Desgodetz.[114] The measurements in this book are famously precise and the plan has the advantage of showing the basilica in a state similar to what it was in for the other two artists 150 years before. The results are given in table 1.

The general accuracy of Desgodetz's measurements is supported by modern reference works, which give the width of the nave as 25 meters.[115] Compared to Desgodetz's measurements, Giuliano's tend to be about 10 percent smaller, while Giocondo's are about 20 percent larger. The only exception to that pattern is Giuliano's measurement of the width of the nave, which looks to be an error.[116] In other words,

TABLE 1 Measurements of the Basilica of Maxentius

	GIULIANO	GIOCONDO	DESGODETZ
Nave width	48 *bracci* 28.013 meters	13 *canne* 6 *palmi* 30.382 meters	77 *pieds* 5.5 *pouces* 25.162 meters
West bay width	35.5 *bracci* 20.717 meters	13 *canne* 3 *palmi* 29.712 meters	70 *pieds* 3.5 *pouces* 22.834 meters
West archway width	10.67 *bracchi* 6.225 meters	4 *canne* 1 *palmo* 9.159 meters	22 *pieds* 4 *pouces* 7.255 meters

the Renaissance artists carried with them their own personal measuring units, which were not standardized to great precision: they were more interested in documenting relative dimensions and rough scale than precise absolute sizes of architectural features.[117] If I return to our monument and inflate Giuliano's measurements by 10 percent and decrease Giocondo's by 20 percent, they in fact agree that the large pillars were roughly 5 meters apart.

Finally, there is an even more serious discrepancy between the two artists' sketches. Rather than being evidence that they show different monuments, however, this discrepancy demonstrates that Giuliano's beautiful sketch is not completely to be trusted as documentary evidence: it combines archaeology with creative architecture, as was the artist's wont.[118] The strangest thing, architecturally, about his elevation is the narrowly spaced row of small arches in the foreground. The impost blocks above these columns seem enormous and out of proportion and look as though they belong to a much later period.[119] One might be tempted to say that this indicates that the monument shown could not be Augustan, except that the other plan of Giocondo clearly demonstrates that this part of the building was the product of Giuliano's fertile imagination. On his plan, Giocondo writes the words *architrave va qua* (an architrave goes here) in four places: running from the large pillars in the back to the smaller columns in front of them, and also between the three small columns in the front. By contrast, the wider space between the two rear pillars has words indicating that there was a semicircular arch between them.[120] This agrees perfectly with Giuliano's drawing, except in the treatment of the front, for he puts small arches where Giocondo says there was an architrave. The only plausible explanation for this flat contradiction is that what both artists saw was a series of columns in the front with nothing on top but fragments of something matching the transverse architraves. Giocondo quite sensibly concludes that there must have been an identical architrave across the front columns. Giuliano instead imaginatively reconstructs a series of arches springing from impost blocks that rather awkwardly had to match the design of the transverse architraves. The result shows the influence of his study of later Roman basilicas. One benefit of opening up the front elevation in this way is that it permitted Giuliano to show more of the barrel vault on the inside of the portico.

Once the series of smaller arches at the front has been dismissed as a speculative invention, the rest of the architecture is unproblematically Augustan. The ceiling of the portico consisted of a series of transverse barrel vaults springing from elaborate architraves connecting the columns attached to the rear pillars and alternating front columns.[121] The rear pillars themselves supported semicircular arches with the same span as the vaults, but these were considerably lower on account of not resting on the architrave and thus concealed the barrel vaulting.[122] The vaulting was also concealed at the front, where one must imagine a straight architrave, matching the transverse ones, resting atop the front row of columns.[123]

The Location of the Ruins

In his notebook, Giuliano gives a precise indication of the location of the ruins he had sketched:

> Questo è un edificio molto grande e cammina per molti modi e dicesi fu opera di Pompeo e comincia a piazza Giudea in Roma e va inverso la porta che va a San Paolo.
>
> (This is a very large building and it proceeds in many ways and it is said to have been the work of Pompey and begins at piazza Giudea in Roma and goes toward the gate that leads to San Paolo.)[124]

The allusion to the portico of Pompey's theater can be dismissed, for it is topographically impossible; its precise location was not yet known in Giuliano's day. The reference to San Paolo has proved very perplexing. Hülsen rightly saw that "the gate that leads to San Paolo" must mean St. Paul's Outside the Walls, even though it is very far away.[125] The idea that Giuliano would have indicated a southerly direction by reference to a far-distant landmark that would have been quite impossible to see from piazza Giudea is not plausible, however.[126] He did not have a modern map of Rome to tell him that St. Paul's was due south, and if he had wanted to indicate this, he could simply have said that the monument ran toward the Tiber or toward the island. The true meaning of this cryptic reference was first indicated by V. Lundström and was further developed by F. Castagnoli, who pointed out that there was a medieval road running along the old north side of the Circus Flaminius.[127] This route, once the via Tecta, had been turned in late antiquity into the Porticus Maxima, a long porticoed route through the southern Campus Martius.[128] This continued to be used as a thoroughfare through the Middle Ages, as attested to by a number of documents. For example, the first Einsiedeln itinerary, one of a set of eighth-century pilgrimage routes across Rome, describes a path from the Basilica of St. Peter to that of St. Paul, a route that can still be traced in the modern streets of Rome. It runs from the Vatican across the Aelian Bridge and south through Campo dei Fiori, past the Theater of Pompey, and through an unnamed portico up to the church of Sant'Angelo in Pescheria, which is inside the Portico of Octavia. The route then continues past the Theater of Marcellus, and onward along the curve of the Tiber toward Porta S. Paolo to the south.[129]

As Lundström perceived, this is why Giuliano said that the monument went in the direction of the gate that leads to St. Paul's. He was speaking not of direction as the crow flies but rather of direction along this important pilgrimage route from one basilica to another. In other words, he was saying that the monument ran along the modern-day via del Portico di Ottavia in the direction toward the Portico of Octavia and the Theater of Marcellus. If one remembers that around 1514 Giuliano and Giocondo (assuming that the Uffizi sketch is his), along with Raphael, had succeeded

Bramante in the joint task of designing the great new Basilica of St. Peter, it becomes easy to imagine why both of these men would have had plenty of occasions to walk past this monument and why they might have paused to sketch it.

This interpretation of the location of the monument is confirmed by the vaguer indication given in the sketch attributed to Fra Giocondo, in which he says that the portico is of or behind the Savelli.[130] This must mean the Theater of Marcellus, which in this period, before it came into the possession of the Orsini, was associated with the Savelli family.[131] Hülsen mistook the location of Giuliano's portico, so he took this as another indication that the two architects might have been sketching different monuments. In fact, it confirms my interpretation of the location. The road to the Basilica of St. Paul passed along the north side of piazza Giudea, and followed the route of the present-day via del Portico di Ottavia toward the Theater of Marcellus. So Giocondo's statement that the monument was behind the theater is fully in accord with Giuliano's information; he was just coming at it from the opposite direction. This indication eliminates another candidate, the Portico of Octavius, whose southern end probably ran along the northern side of piazza Giudea and continued to the northwest along the ancient route in the other direction, toward St. Peter's.[132]

The precise location of the monument is given in Giuliano's statement that it *started* at piazza Giudea before heading southeast. The irregular shape of the no-longer-extant piazza is well documented in early maps. It was a double piazza, shaped like two diamonds that touched at a narrow point in the middle, where the main gate to the Ghetto (locked at night) was located (see fig. 74). The pilgrimage route alluded to by Giuliano ran along its northeast face, just outside the boundary of the Ghetto. The ruins must have started at the east corner of the northern half of the piazza, which was outside the Ghetto proper: this point corresponds to the present-day intersection of via della Reginella and via del Portico di Ottavia. In 1824, the Ghetto was enlarged to include the place where the ruins had been, and an additional gate was constructed at this very spot.[133] This corner of piazza Giudea corresponds to the southwest corner of the Portico of Philippus. From there, Giuliano's monument ran along the route to St. Paul's, or toward the Theater of Marcellus. In other words, the monument drawn by both artists was located precisely where the Marble Plan says the southern side of the Portico of Philippus was found. I think this much is secure; but of course, that is no guarantee that these ruins come from the Augustan phase of the building. It might be a Severan rebuilding, or even part of the later Porticus Maxima.[134]

I now attempt to match the two Renaissance plans of the ruins both to the Marble Plan and to modern archaeological investigations. The first attempt to match Giuliano's ruin to the Marble Plan was made by Lanciani. He noted the unusual architectural arrangement whereby the columns in the front row are twice as closely spaced as the columns attached to the rear pillars, with every other column aligning (fig. 79).

Lanciani connected this with a feature visible in a drawing of a lost fragment of the Marble Plan that shows the north side of the Portico of Philippus (see fig. 75, *ee*).[135] This fragment (fig. 80) is evidence for the disposition of the dotted squares along the north side of the portico, discussed briefly above. In the standard reconstruction of G. Carettoni et al., the columns and pillars on either side of the north aisle of the portico show no alignment at all (see fig. 75, nos. 17, 18). But the Renaissance drawing on which this reconstruction depends shows a hint of alignment (see fig. 80). Of the three dotted squares shown along the north wall, the pair on the left are aligned somewhat with alternate dots from the row of columns just below. Admittedly, the match is far from perfect, but this is a rough copy on which the circles are rendered and positioned rather hastily.[136] Indeed, the Marble Plan itself can be careless in the spacing of columns, as can be seen in the existing fragment that shows the other part of the row of dotted squares (see fig. 75, *dd*).

It would be very helpful if the surviving marble fragments, rather than rough sketches, also showed the other row of columns so that they could be checked to see if they align alternately. Unfortunately, only one dot of that row survives on marble

FIGURE 79 Detail adjacent to fig. 77, showing Sangallo's plan of the structure depicted there; the plan stretches across folios 1v and 2r

FIGURE 80 Renaissance drawing of a lost fragment of the Marble Plan (frag. 31ee). Vatican Library, Cod. Vat. Lat. 3439, folio 22r.

(see fig. 75, no. 15). It is positioned more or less across from the midpoint between the two dotted squares opposite, which is consistent with an alternating alignment but is not conclusive. The lack of alignment between the very innermost ring of dots and the outer columns can be explained by the hypothesis that they belong to a much lower level of the complex, so there would be no reason for them to align. That argument cannot explain the apparent lack of alignment between the dots and dotted squares in the portico itself. The function of dotted squares in the Marble Plan is often controversial, as for example in the Portico of Pompey, but they might represent larger architectural features such as the pillars of the arcade. It is an interesting coincidence that Giuliano and Giocondo attest to just such a portico with widely spaced pillars across from narrowly spaced columns in this particular place. On the other hand, the north aisle of the portico was probably not visible to them. That part of the ancient plan is now occupied by the Renaissance structure that replaced the medieval monastery; it is unlikely that any ruins survived there.[137] Giuliano's connection of the ruins with piazza Giudea likewise points to the southern rather than the northern part of the portico.

Confirmation that the ruins visible in the Renaissance did correspond to the southern end of the portico can be sought from excavations in that area. In 1889 and again in 1911, during excavations for a sewer in the middle of via del Portico di Ottavia, a substructure with a row of six column bases was found.[138] P. L. Tucci has published the archival drawings of the architect in charge of the 1889 project, Domenico Marchetti, and has shown that they are more detailed and reliable than the notices of the find that were published at the time.[139] Marchetti's plan shows that the distance from the start of the first column to the end of the sixth is approximately 16 meters (52.5 ft.).[140] The spacing of the smaller columns on Giocondo's plan can be compared, for he gives the space between columns as 1 *canna* and 3 *palmi*, or 13 *palmi*; for the width of the column base he gives 4.5 *palmi*. To make up the distance along the colonnade measured by Marchetti requires 5 intercolumn spaces (5 × 13 = 65) plus 6 column widths (6 × 4.5 = 27) which is 65 + 27 = 92 *palmi*. Multiplying by the standard conversion factor of 0.2234 meters gives a length of 20.55 meters. This seems too large to match the excavator's 16 meters, until it is remembered that Giocondo's measurements of the actual basilica of Maxentius were consistently about 20 percent too large according to the standard conversion to meters. If 20 percent of 20.55, or 4.11, is subtracted, the result is 16.44 meters, which is quite close to the architect's rounded figure of 16 meters.[141] In view of the unstandardized nature of the measurements in the Renaissance drawings, the agreement is good. The position of the columns is also correct: Tucci points out that they lie on the same line as that described by the columns along the front of the Portico of Octavia.[142] This can be confirmed from satellite imagery: a line drawn across the surviving columns of the south face of the Portico of Octavia and continued along via del Portico di Ottavia to a point just before via della Reginella ends up running

about 6 meters from the north side of the street, which is just about where Marchetti located the excavation.[143] The Marble Plan shows that the porticoes of Octavia and Philippus were aligned here, so one may guess that these column bases belonged to the front elevation of the Portico of Philippus.[144] It is therefore plausible that Marchetti excavated the base of roughly the same part of the colonnade seen by Giuliano and Giocondo (see fig. 75, no. 19).

What of the other facade of the portico, the widely spaced arcade? Castagnoli investigated ancient remains embedded in a basement wall of a building on the north side of via del Portico di Ottavia.[145] The substructure has a wider part that seems to have been designed to accommodate a column or pillar. There are two columns embedded in the wall, but not in their original positions, so they cannot be used to get the distance between columns. There is only one wider part in the exposed portion of the wall, so its spacing cannot be compared with the spacing of the pillars of the arcade on the Renaissance plans. Marchetti gives the distance of the columns from the houses on the north side of the street as 6.5 meters, which should thus be roughly the width of the portico, though the underground remains seen by Castagnoli are down the street from the 1889 excavations, and the line of modern houses is not exactly parallel with the columns. But the Renaissance plans do not give clear indications of this measurement, and the artists may have not drawn the width to scale, in order to fit it more easily on paper; in particular, Giuliano's plan shows the portico as unfeasibly narrow.[146] Marchetti implies that the excavators left the column bases in situ in the middle of the road and routed the drain around it, and Castagnoli says that it was once possible to see more extensive remains in the basements of houses on via del Portico di Ottavia.[147] This suggests that it might be possible to define the width of the southern arm of the Portico of Philippus by means of a relatively inexpensive and minimally invasive archaeological investigation in the middle of the street.[148]

So far, there has been very good agreement between the Renaissance drawings and the findings of archaeology. The picture becomes less clear when I turn back to the Marble Plan, for my interpretation of the remains suggests that the plan contains not one type of error but two. The first, and easiest to justify, is that it shows a blank wall on the south aspect toward the Circus Flaminius where I have postulated a colonnade. This seems a routine and unproblematic simplification. More difficult to justify is the fact that the north side of the plan, if connected with the other evidence, seems to show the portico inside out. In other words, the dotted squares (see fig. 75, nos. 14, 17) could be read as showing an arcade joining large piers, and the inner row of more closely spaced dots (see fig. 75, nos. 15, 18) as showing the smaller colonnade. But this puts the arcade on the outside and the colonnade on the inside, which is the opposite of what Giuliano's drawing and the excavations lead one to expect. If the excavated colonnade corresponded to the inner side of the portico, the arcade side would be under the buildings on the south side of the street and the precise alignment between

the Porticoes of Philippus and Octavia as shown on the plan is in error. In that case, the excavated columns in the middle of the street would have to be explained as belonging to some other structure, such as the Porticus Maxima.[149]

Until further archaeological data are available, it seems wisest to rely on the clear fact identified by Tucci, that the excavated colonnade basis seems to be precisely aligned with the colonnade of the southern side of the Portico of Octavia, which strongly suggests that it was the south-facing facade, as shown by the mutual alignment of the porticoes on the plan. Tucci also notes that the intercolumnar spacing of the excavated colonnade is the same as for the Portico of Octavia, which gives further evidence of the coordinated planning of the Augustan family porticoes that defined the north side of the Circus Flaminius.[150] This implies that Giuliano's drawing shows the south elevation of the monument from the outside, looking north, which is as one would expect: the colonnade is on the outside and the arcade is on the inside. One is then left without an explanation of the dotted squares on the north side of the plan. But since these do not run around the circumference of the portico, it might in any case be problematic to identify them as the piers of the arcade.

There is one more feature of the Renaissance drawings that needs to be explained. Giuliano's plan shows a wall abutting the rightmost column, which extends down to the end of the sheet. This is also visible in his elevation, at the right side of the drawing, where the end of it is carefully finished, so it is not a fragment, but a very short wall. In my reconstruction, this fits very well as the left side of the main entrance into the Circus Flaminius, which must have been at the center of the southern part of the portico.[151] There is a gap in the Marble Plan where it would have shown this, probably by a simple break in the line marking the southern side of the portico (see fig. 75, no. 20). If this is right, the part of the building shown by Giuliano can be identified quite precisely: the southern elevation just to the left of the central entrance.

Now that I have reconstructed the Portico of Philippus as an elevated double portico, open on both sides, with an arcade on the inside and a colonnade on the outside, one might well wonder where all the art that Pliny describes was displayed. There would have been plenty of space for statuary but no blank walls on which to hang paintings. If there was a portico on the lower level, then there is a perfect place for the display of paintings against the inner wall of the high portico, under the roof of the inner portico. Alternatively, it is also possible that it was only open on the south side, or only on the north and south sides, with blank walls on the sides facing the adjacent porticoes. This would have afforded more wall space for paintings.

Before I leave the topography of the Portico of Philippus, the later history of the buildings on the site is worth a brief glance. Records indicate that this was probably the location of a monastery from early in the medieval period.[152] The present-day monastery of Sant'Ambrogio della Massima has a number of artifacts from the medieval phase of the building in its possession, and medieval structures were brought

to light by the recent excavations in the courtyard.[153] The epithet *della Massima* has been explained in a number of ways, but by far the most plausible guess is that it is a toponym derived from the nearby Porticus Maxima. This was part of the route that would have led pilgrims to the Basilica of St. Peter, which, as noted, ran along the via del Portico di Ottavia. The existing buildings of the monastery were erected primarily in 1568, having been designed by Giacomo della Porta; further work, including rebuilding the church, was undertaken in 1606, probably by Carlo Maderno.[154] The most conspicuous feature of Della Porta's monastery is a cloister surrounding a courtyard, the outlines of which can be seen in figure 74, where it is the dark gray area that surrounds the site of the Fulvian circular temple. Today the cloister is split into two parts: the south and west sides are used by the municipal government of Rome to house various offices and community groups, and a group of Benedictine monks occupies the north and east sides.[155]

The entrance at number 4, via di Sant'Ambrogio, provides access to the municipal offices housed in the former cloister. It leads immediately to a large stairway, in the walls of which are embedded architectural fragments of an older structure. These vary somewhat in form but are of a fairly uniform style. They are of a gray tufaceous stone, which appears to have been pricked to provide a key for plaster to stick to. What makes these bits of architectural salvage interesting is the curiously precise similarity they display to the architraves of the structure drawn by Giuliano and Giocondo. Figure 81 shows one of these objects side by side with one of Giocondo's details. The correspondence between the fragment and the lower part of the entablature in the drawing is remarkably close. Some of the other fragments in the stairway do not

FIGURE 81 Comparison of a feature of the drawing attributed to Fra Giocondo and a feature of the present building. Left, detail of fig. 78. Right: fragment of an older building embedded in the stairway of the municipal offices that once formed part of the Renaissance monastery on the site of the Portico of Philippus

exhibit such a close match, but they are of a similar general style, with articulated corners. Most of the embedded fragments display this feature, and the vaulting in the present structure makes some use of it, thus displaying a distant affinity with aspects of the ancient structure as drawn by Giuliano and Giocondo.

None of this is meant to imply that these stone fragments go back to the Augustan structure. Augustus boasted of having turned Rome into a city of marble, not of stucco-faced tufa.[156] It is true that plaster imitation of marble was used on the wall found under the porch of the church, but that was facing a dark and narrow service alley between the Porticoes of Philippus and Octavia (see fig. 75, no. 12) where it would have been wasteful to use large amounts of precious materials; and even there there was probably a course of marble skirting at the bottom.[157] One would expect marble to be used for the eye-catching architectural elements of the Portico of Philippus. The crudity of the carving also indicates a later date, and it seems likely that these fragments belong to the late-medieval phase of the monastery. The medieval structures may well have incorporated fragments of the classical structure, just as the Renaissance one did of the medieval structure. Since parts of the Augustan structure were still standing, they might well have influenced the design of the medieval buildings. It is also possible that parts of the Augustan portico were still standing when the late-Renaissance buildings of the monastery were erected. This would explain why there seem to be distant quotations of elements of the Augustan building's design present at the site today.

The Collegium Poetarum

I turn now from the physical fabric of Fulvius's temple and Philippus's portico to a very different issue. In order to understand fully the meaning of the Augustan monument, it is necessary to examine what the temple was used for. One important use, I argue, was as the headquarters and meeting place of the guild of poets at Rome, which explains why it would be a place of particular importance for them, quite apart from the symbolic and religious significance of the Muses. In renovating this structure, therefore, Augustus was sending a particular message to that group: a message of support but also a declaration of his expectations. The next chapter documents some of the textual responses of those poets.

The first point to note is that, although I have made the provocative choice to call the Portico of Philippus the Museum of Augustus in that it was the home of the Muses in Rome, this is only true in a very loose sense. Augustus clearly had no plans to set up an official institution for scholars equivalent to the Alexandrian Museum. He did have a literary program of Ptolemaic ambition but was careful to integrate it into the traditional Roman pattern of aristocratic patronage established by men like Fulvius and Ennius. Augustus's attention to renovating Fulvius's structure was therefore an important signal of his intent to provide indirect but clearly visible support to its poets, yet to work within the established institutions of Roman literary culture. The

evidence for the most important of these institutions, the guild of poets, or *collegium poetarum*, and its connection with the Temple of Hercules Musarum is scattered and seems contradictory and thus has been the subject of considerable scholarly debate. Nevertheless, some inferences can be drawn about the uses to which the *collegium* put the temple.[158]

Many treatments of the *collegium* have focused on the disparities and discontinuities in the evidence. The sources speak at first of a *collegium scribarum histrionumque* (guild of clerks and actors), at a later date of a *collegium poetarum*, and still later of a *collegium scribarum poetarum*. Are these the same *collegia* or different ones? In the most recent review of the evidence, Caldelli treats them as separate and emphasizes that there is no positive evidence for presuming they are the same.[159] This is quite true, but on the other hand there is something odd about the idea that different *collegia* with almost the same but slightly different names and with overlapping memberships kept appearing and disappearing throughout Roman history.[160] I think it is a more economical hypothesis to posit a single institution that made small changes to its name and to its meeting place as it evolved over the centuries in an effort to improve its image. These changes were driven by the initially low social status of poets and scribes and their efforts to ameliorate that condition. Other scholars may prefer to imagine separate *collegia*, and that would not make an enormous difference to the overall argument of this chapter, provided that the reader accepts that there was an important practical connection between the poets of Rome, their professional association(s), and the Temple of Hercules Musarum.

The history of the *collegium* has proved so contentious because the first piece of evidence is given a misleading interpretation, I believe, by the source that preserves it. The foundation of the *collegium* is attested in a passage in which Festus (p. 333 Lindsay) preserves information about an honor granted to the poet Livius Andronicus, whereby clerks (*scribae*) and actors (*histriones*) were given the right to meet and to make offerings in the Temple of Minerva on the Aventine. It has been demonstrated that this passage probably reflects the wording of a *senatusconsultum* (decree of the Senate) of around 207–200 BC that provided for the establishment of a *collegium* for such professions.[161] The strange thing is that Livius himself was not a clerk and only incidentally an actor. One would expect this to be a *collegium* for literary writers, especially since the honor was granted in return for a hymn written by Livius. Festus, or his source, Verrius Flaccus, therefore inferred that the word *scriba* must originally have meant not clerk but writer more generally. This is possible, but it runs against all other evidence for the word *scriba*, which never entails creative writing but always refers to documentary writing. This erroneous inference by Festus or Verrius has tended to start discussions of the *collegium poetarum* on the wrong track.

In spite of Festus's interpretation, it seems more likely that Livius, who acted in his own plays, was included by the Senate under the heading of *histrio*, not *scriba*;

thus *scribae* here simply means clerks, as always in Latin.[162] It is not surprising that the Senate deliberately eschewed the high-sounding Grecism *poeta* here, regardless of what the writers in the guild would have preferred to be called. The honor to Livius concealed a carefully calibrated snub, for the Senate made it clear that the *collegium* was designed not to elevate literary activities but to keep writers and actors on the very low level of performers and minor functionaries. The elliptical designation of the *collegium* would not have been a practical problem, for all professional poets in early Rome were by necessity also playwrights. The Senate would have been equally unconcerned about fine distinctions between playwrights and actors, which in any case were largely nonexistent in early theatrical ensembles.

The next information comes from an anecdote by Valerius Maximus (3.7.11) about a meeting of a *collegium poetarum* attended by the playwright Accius and the amateur tragedian Julius Caesar Strabo Vopiscus. The aged and famous Accius, who was the son of a freedman, refused to stand to greet the patrician Caesar Strabo, on the grounds that in this literary forum he was the more distinguished figure. This pride is reflected in the change of the guild's name, which had introduced the more elevated title of *poeta*. The actors (*histriones*), members of an incorrigibly disreputable profession, were no longer welcome as members; they went on to develop their own guilds.[163] This reflected the increasing specialization of labor and pride in the role of the playwright, who was no longer an actor who happened to write. Probably the name in this period was *collegium scribarum poetarum*, though that name is attested only later. It is simpler to assume that Valerius is using an abbreviated form when he refers to the *collegium poetarum*, rather than to suppose that *scribae* temporarily disappeared from the name of Livius's *collegium*, only to be reinserted again in the Augustan age, or to suppose a multiplicity of overlapping *collegia*.

Unfortunately, Valerius does not tell where this meeting happened, but Pliny the Elder says that Accius, who was of diminutive stature, set up a massive statue of himself *in Camenarum aede*.[164] Since there is good evidence from a later period that the meetings of the *collegium* came to be held in the Temple of Hercules Musarum, this must be a reference to that temple, though it has sometimes been denied.[165] I therefore infer that the *collegium* moved its seat from the Temple of Minerva to Fulvius's temple at some point before the death of Accius. Livius's guild had been granted the right to make dedications (*dona ponere*) in the Temple of Minerva, and this right would surely have passed to the Temple of Hercules Musarum when the *collegium* moved. Accius took advantage of that privilege or, rather, abused it. Both anecdotes imply that Accius's vanity was considered excessive, but even so, the prickly pride of this son of a freedman testifies to ongoing efforts by poets and scribes to elevate their status.

What was the occasion on which the writers and clerks switched from the patronage of Minerva to that of the Muses? The most natural assumption is that this

occurred immediately after the new temple was inaugurated, and that the temple was designed in part with this purpose in mind.[166] If Fulvius was a patron of the *collegium*, as seems likely, he would have been responsible for securing the Senate's approval for the transfer of its meeting place. In moving its seat, the organization made a further bid to distinguish itself from the more humble trade guilds that were associated with the cult of Minerva.[167] Ennius may or may not have been a member of the *collegium*, but he was clearly in full sympathy with Fulvius's efforts to raise the profile of the Muses at Rome; Ennius was also a crucial figure in efforts to raise the status of poets from debased hirelings to friends of the elite.[168] It is therefore fully in keeping with the Fulvian/Ennian project that the Temple of Hercules Musarum was designed as a new home for the poets of Rome as well as for the Muses. The government clerks who made up the other part of the membership of the guild were upwardly mobile to a similar degree. They were often ambitious freedmen, and by the late Republic, *scribae* were often drawn from a near-equestrian, freeborn milieu.[169]

Valerius makes it clear that Caesar Strabo did not belong in the gathering of this guild and that his presence required an improvised etiquette.[170] It is implied that he attended more than once, for Accius "never" stood up for him, but the tenor of the anecdote presumes that he was an occasional visitor rather than a regular member of the *collegium*. The fact that he came back implies that Strabo accepted in good humor the claim that, as a poet, he was junior in status to Accius; this further implies that he was attending as a tragedian, not a patron.[171] The anecdote documents the aspirational social status of the *collegium*; the guild of cobblers presumably never faced the puzzle over how to greet patrician guests who were there as fellow practitioners rather than as patrons. Nevertheless, the evidence points to membership that continued to be dominated by ambitious freedmen and their sons.[172]

The continuing existence of the *collegium* is confirmed by an inscription from probably the late-Republican or early-Augustan period.[173] It records the career of a freedman named P. Cornelius Surus who held a number of very responsible civil service posts, including "mag[ister] scr[ibarum] poetar[um]," or head of the guild of clerks and poets.[174] Presuming that Valerius wrote *collegium poetarum* as shorthand for *collegium scribarum poetarum*, this is the same institution. It may seem surprising that clerks and poets continued to share the same guild as they did in the day of Livius Andronicus, but it was probably a mutually beneficial arrangement. It may have started because the Senate contemptuously lumped clerks together with poets/actors as low-status but literate professionals, but once the actors were diverted into their own guild, clerks and poets shared a similar aspiration to respectability through writing. The fame of poets would have brought cachet to the *collegium*, but the clerks probably brought organizational ability, something poets are not well known for. From his career, Surus was clearly a clerk rather than a poet, and one can imagine that the poets left the business end of running the guild to men like him, while the clerks left

the recitations to the poets. Members who fell under both headings were probably rare, though I now turn to the case of one man who did.

The major poets of the Augustan period were mainly from the equestrian class and did not practice writing as a trade, so one should not imagine them as joining the *collegium*. On the other hand, if one of the Julii, the most blue-blooded family in Rome, could attend events as a guest, then surely an equestrian could, too. The equestrian Martial was a regular visitor, as I show below. Relatively little is known about the world of booksellers and the *collegium*, for poets were more interested in advertising themselves as part of the aristocratic literary milieu that surrounded the major patrons. But this more humble world must have also formed part of their life, all the more so for writers who could not count on invitations to the houses of Pollio, Messala, and Maecenas. The major exception to the rule of Augustan poets coming from the equestrian class is Horace, and it is no surprise that it is he who provides the most information about the *collegium*. As a young man he had an upper-class education, but because his father was a wealthy freedman Horace belonged just as easily in the world of the *collegium*. In fact, after Philippi, when he lost part of his inheritance, he bought a post as a clerk, a *scriba quaestorius*, which meant that he qualified for membership under both headings: *scriba* and *poeta*. There were various *collegia* of *scribae*, so we cannot be sure that the *collegium scribarum poetarum* is the one Horace belonged to, but it is surely the most likely candidate. Horace continued to be a member of the college even after his poetic success, when he would have rented out his scribal post to another man.[175] Thus, when he complains of returning from his Sabine farm to the city and being hassled by the *scribae* to attend to urgent business of mutual concern (*Sat.* 2.6.36–37), he is probably speaking of someone very like P. Cornelius Surus.

The first Horatian passage that has been linked to poetic activities in the Temple of Hercules Musarum is from the first book of *Satires* (1.10.37–39):

> . . . haec ego ludo,
> quae neque in aede sonent certantia iudice Tarpa
> nec redeant iterum atque iterum spectanda theatris.

> (. . . I play at these trifles, which are not the sort of thing to ring out as they compete in the temple in front of Tarpa as judge, nor return again and again to be seen in the theaters.)

According to Cicero, this Spurius Maecius Tarpa had been appointed by Pompey the Great to decide what plays should be put on in his new theater; it has been suggested plausibly that he was chosen because he was the head (*magister*) of the *collegium poetarum*.[176] He appears here, and again in Horace's *Ars Poetica* (387), as a quasi-proverbial

literary judge. Horace imagines that the contestants declaim their bombastic verses before him in a temple, which the scholia of Porphyry identify as "the temple of the Muses, where poets used to recite their poems." These scholia are not infallible, but there is little reason to doubt the information here.[177] If the temple was the meeting place of the *collegium* of poets, it is an unsurprising development that recitations and competitions came to be held there.

That is the last reference to poets making use of the Temple of Hercules Musarum before its restoration by Philippus and the construction of the Temple of Palatine Apollo, which happened only a few years after the publication of Horace's first book of *Satires*. Subsequent references tend to treat those two places as interchangeable parts of a unit. In the second book of Horace's *Epistles*, he looks back to an earlier day and another competition between poets. Horace does battle against an unnamed rival, who, as I have argued elsewhere, must certainly have been Propertius.[178] Once again, the setting of the poetic competition is a temple (*Epist.* 2.2.91–94):

> carmina compono, hic elegos: mirabile visu
> caelatumque novem Musis opus. adspice primum,
> quanto cum fastu, quanto molimine circum-
> spectemus vacuam Romanis vatibus aedem.
>
> (I compose lyrics, he elegies: ah, how brilliant!—a work embellished by the nine Muses. First, look at the arrogance and gravity with which we look around us to inspect the temple just waiting for Roman poets.)

Interestingly, the scholia are in contradiction over the identification of this temple: pseudo-Acro says it was the temple of Apollo, while Porphyrio says it was the temple of the Muses. This dispute has continued into the present day. Horace elsewhere notes the relative emptiness of the Latin side of the Palatine library, and some scholars take the present passage as another reference to that lack.[179] Others, starting with Bentley, have seen the mention of the nine Muses as a clear allusion to the Temple of Hercules Musarum. The goddesses participate in a metaphor whereby the work of the poets is compared to engraved, three-dimensional art, which may recall the physical representations of the Muses that Fulvius had brought back from Ambracia. In the context of statuary, perhaps one ought to remember that very real and massive statue of Accius. It likely was not the only memorial for a poet in the temple. Especially after Philippus's renovation of the space, there must have been room for more such honorific statues. Horace thus combines a metaphorical picture of the Palatine library having room for more books with a literal picture of the Portico of Philippus, Rome's Museum, having room for more statues of poets. Both scholia and both sides of the scholarly debate have an equal point. Horace has created

a picture of a hybrid Museum-library as the setting for a literary squabble, a Roman version of the Museum and Library of Alexandria, the squawking "birdcage of the Muses," renowned for such squabbles.[180]

This is not the only occasion for scholarly debate over whether a metaliterary passage of Augustan poetry refers to the Temple of Apollo or to the Hercules Musarum. These debates have continued to fester because of the existence of plausible evidence on both sides. What needs to be understood, however, is that after 28 BC the Augustan poets tended to view these two buildings as a conceptual unity, despite their horizontal and vertical separation in space, constituting two halves of the Museum-library complex that was the architectural symbol of Augustus's encouragement of and support for literary culture. In practice, literary gatherings might well have happened in either place, and the ambiguity of Horace's picture of the temple in which he faced off against Propertius was surely calculated.

There are a few references in the early imperial period to what is probably the same *collegium*. Martial twice refers to the *schola poetarum*, using the normal term for a meeting place of a *collegium*.[181] In the first passage, he is imagining the possible activities of Canius Rufus, a friend with literary interests; one possibility is that he is speaking in the *schola poetarum*, and the language suggests that he is reciting Catullan-style poetry of his own composition (3.20.8–11):

> An otiosus in schola poetarum
> lepore tinctos Attico sales narrat?
> hinc si recessit, porticum terit templi
> an spatia carpit lentus Argonautarum?
>
> (Is he at leisure, reciting in the poets' clubhouse with Attic elegance and wit? If he leaves there, does he walk in the portico of the temple or slowly stroll in the portico of the Argonauts?)

The transmitted text says that when Canius leaves the *schola* he walks through the "portico of the temple." Many editors have concluded that the text is corrupt, on the grounds that one needs to be told what temple is meant; but no convincing emendation has held sway. Since it must have been well known among readers of poetry that the meeting place of the *collegium poetarum* was the Temple of Hercules Musarum, this is an unambiguous reference to the Portico of Philippus that surrounded it: the text is sound.[182] In another epigram, the *schola poetarum* is simply the location for a chat between Martial and a friend (4.61.3). This does not necessarily imply that the equestrian Martial was a member of the *collegium*; it was a place where one could pass time in literary company.

In his satire on the depraved state of literary patronage in his day, Juvenal brings many of these threads together in an offhand reference to the temple of the Muses.

He warns a young poet that, if he leaves "the temples of the Muses and of Apollo" to cultivate a wealthy patron, he will find that his benefactor is a cheapskate, providing a tumbledown shack as a place to give a recital.[183] One can observe, first of all, that for Juvenal the Temples of Hercules Musarum and Palatine Apollo are still yoked together as a Museum-library unit to represent the bygone glory days of literary patronage under Augustus. The young poet is making an effort to move beyond the *collegium poetarum*, to break into the more rarefied world of aristocratic patronage. Unfortunately, this is no longer the Augustan age, so he will find this world of private patronage no better, or perhaps even worse, than what he has come from. The implication is therefore that the young poet, before seeking out a private patron, would regularly have recited at the Temple of Hercules Musarum or the Palatine library, presumably under the auspices of the *collegium*.

The evidence mentions a variety of different literary activities that occurred at the temple: meetings, recitations, poetic competitions. Alongside these there were also presumably the normal activities of guilds, such as sacrificing, banqueting, networking, and activities of mutual assistance and insurance.[184] Despite all these activities, there was clearly an enormous gulf between it and the Museum at Alexandria. Efforts to depict it as a grand literary salon have rightly met with skepticism.[185] There was no endowment to support scholars working on official literary projects. It was a very Roman institution. It worked within the norms of Roman culture: a guild that benefited from the particular patronage of aristocratic Romans like Fulvius and Philippus. So the name "Museum" can be misleading in two ways when applied to the Portico of Philippus: it must not suggest a larger level of centralized support for literature than was ever the case at Rome, and it must not imply that it was, on the level of cult, a temple of the Muses rather than a shrine of Hercules in which they were honored guests. Nevertheless, it is precisely this combination of attraction for and hostility to the overt forms of a major Greek institution that makes this Museum so quintessentially Roman. The refurbishment of the Temple of Hercules Musarum was a gesture that the poets of Rome surely appreciated, but it was only one project among dozens of Augustan temple renovations. The separation of the "Museum" from the library and the ruler's residence was at the same time an indication not to take the Alexandrian analogy too far. There would be support for literary culture in Augustan Rome, but indirectly and in traditional Roman form. In the face of Augustus's careful separation of the Museum from the library and from his own residence, the constant tendency of the Augustan poets to conflate the Portico of Philippus and the Temple of Palatine Apollo seems to be not only a convenient shorthand but also wishful thinking: that Augustan literary patronage should emulate the scale and largesse of Alexandria's.

The Art in the Portico

Now that I have established what I can about the architecture and function of the Portico of Philippus, I turn to the works of art contained within it. What one would most like to see, of course, is an indication of what the cycle of paintings of the Trojan War looked like. But there is no direct evidence for that at all: hence the effort made, in the first four chapters of this book, to reconstruct in as much detail as possible the decorative scheme of the portico of the Temple of Apollo in Pompeii, in the hope that it may provide an indication of what such a cycle in a temple portico might have looked like. Nevertheless, it is still useful to catalogue the works of art installed in the temple and portico, in order to get a better sense of the ideological function of the entire complex.

In the first place, the sanctuary was the home of many works of sculpture. Accius installed a grandiose statue of himself there, and one may suppose that there were memorials to other poets as well. The quantity of booty carried off by Fulvius from Ambracia became a scandal, and it is possible that much of it was displayed in the temple.[186] The most symbolically important part of that booty was, of course, the representations of Hercules and the Muses for which the temple was named. According to Pliny (*NH* 35.66):

> Zeuxis... fecit et figlina opera, quae sola in Ambracia relicta sunt, cum inde Musas Fulvius Nobilior Romam transferret. Zeuxidis manu Romae Helena est in Philippi porticibus, et in Concordiae delubro Marsyas religatus.

> (Zeuxis... also made works in terracotta, which alone were left in Ambracia when Fulvius Nobilior transported the Muses from there to Rome. At Rome by the hand of Zeuxis is the *Helen* in the Portico of Philippus, and Marsyas Bound in the Temple of Concord.)

I return to the *Helen* of Zeuxis in the next section; here I focus on the Muses. The first thing to be noted is that Pliny tells us nothing at all for certain about these objects he refers to. He is speaking of Zeuxis and some kind of work in clay, whether sculptures or painted pottery; the Muses are mentioned only in passing.[187] He does not say that they were by Zeuxis and he does not even say that they were statues. In fact, none of our sources explicitly say that these works were statues, and it has even been suggested that they might have been paintings instead.[188] On the whole, though, it seems probable that these were statues by an unknown hand and that the Hercules became the cult statue of the new temple.

To get a sense of what the statues of the Muses looked like, there are two potential sources. The first is a series of coins minted in 66 BC by a certain Q. Pomponius Musa, who made a pun on his name. The *denarii* have Apollo on one side, and on the other one of the nine Muses with their various attributes; the final

FIGURE 82 Denarius of Q. Pomponius Musa, 66 BC

coin, which has an image of Hercules playing the lyre, is labeled Hercules Musarum (fig. 82).[189] It has been argued that the coins show a jumble of different sculptural styles that are unlikely to come from a unified Ambracian monument.[190] The other possible source of evidence for the statues comes from a series of Arretine molds and fragments of the Augustan period made of *terra sigillata* (glossy red terracotta with relief decoration), which show Muses of a different appearance and a figure carrying a club rather than a lyre, labeled Heracles of the Muses (ΗΡΑΚΛΗΣ ΜΟΣΩΝ). The problem with the Arretine fragments is that they show an actor with a mask representing the figure of Heracles onstage rather than the god himself. It has therefore been suggested that the Ambracian monument was actually a choragic monument or a dedication by an actor with personifications of Comedy, Tragedy, and so forth, rather than the Muses.[191] But this would require thinking that the Romans were happy enough, or stupid enough, to treat a statue of an actor playing the role of Hercules as if it represented the god himself.[192] Furthermore, Ovid, in the passage of the *Fasti* discussed above, implies fairly strongly that the cult statue of Hercules was holding a lyre, as on the coin, not a club, as on the Arretine ware.[193] Either way, the evidence indicates that Fulvius willfully created the group of Hercules and the Muses, either by combining an eclectic set of Ambracian statues to create an ad hoc group of Muses or by purposely misreading a theatrical monument. This conclusion emphasizes that Fulvius's introduction of the Muses to Rome was part of a deliberate strategy rather than the accidental by-product of the nature of the statues he happened to appropriate.[194] Their fame seems to have been due not so much to their artistic merits as to the symbolic role they came to play in Roman culture. Fulvius's act of capturing the Greek Muses and hauling them back to Rome becomes a metaphor for Rome's efforts to usurp the role of the cultural center of the Mediterranean.

In addition to sculptures brought from Ambracia by Fulvius, which may well have been more numerous than the Muses and Hercules, there were a variety of paintings in the Portico of Philippus. Pliny tells about three artists represented there: Theorus, who painted the Trojan cycle; Zeuxis, whose masterpiece *Helen* was placed there; and Antiphilus, who was represented by paintings of Bacchus, Alexander as a boy, and Hippolytus fearing the approach of the bull.[195] It is worth noting that Pliny does not say whether these were part of the original Augustan conception or placed there later, but it seems reasonably safe to assume that they were original. The Trojan cycle would probably have been fairly extensive, so it is hard to imagine that it was appended as an afterthought. The *Helen* is, of course, closely linked with the Trojan theme. Furthermore, Valerius Maximus mentions it almost immediately after telling the story of Accius and the meeting of the *collegium poetarum*, which might suggest that he already knew it at the Portico of Philippus. The works of Antiphilus seem to be linked to works of his displayed in the Portico of Octavia next door, including a family portrait of Alexander and Philip.[196] All this suggests that the paintings reported by Pliny were part of the original decor.

The Trojan cycle and the *Helen* are clearly linked by theme, but what of the paintings by Antiphilus? Some scholars have suggested that these paintings extended the Trojan theme to articulate a larger theme of West vs. East in the aftermath of Actium.[197] Bacchus and Alexander are both conquerors of the East, but what of Hippolytus? Ritter argues that Phaedra's stepson, like Antony, was the victim of a crazed woman's desire, but it is most unlikely that Antony would have been equated with the chaste and innocent Hippolytus.[198] Even more problematic is the interpretation of the Trojan War as an East-West struggle, for in Rome the Trojans were not likely to have been considered strange Eastern foreigners. The solution to the problem may be indicated by the Pompeian portico. It had a painting of Bacchus and Silenus as well as a Trojan cycle, just as in Rome. If this were all that was known, it might be considered a sign of incoherence. In fact, it is known that the painting of Bacchus was in a separate room off the Trojan portico in Pompeii, so there is no problem of thematic inconsistency. The same situation probably obtained also in Rome. Pliny is simply listing works artist by artist; he is not cataloguing monuments topographically. It is entirely possible that the paintings by Antiphilus hung in places where it was immediately clear to viewers that they were peripheral to the main theme. Alternatively, it is possible that the original Augustan decorative scheme was modified subsequently, and this would explain the presence of paintings that do not fit so well with the Trojan theme.[199]

This brings me at last to what must have been, if only in sheer numbers, the dominant decorative feature of the Portico of Philippus, the Trojan cycle. According to Pliny (*NH* 35.144):

[pinxit] Theorus se inungentem, idem ab Oreste matrem et Aegisthum interfici, bellumque Iliacum pluribus tabulis, quod est Romae in Philippi porticibus, et Cassandram, quae est in Concordiae delubro, Leontium Epicuri cogitantem, Demetrium regem.

(Theorus painted a man anointing himself[?], Orestes killing his mother and Aegisthus, the Trojan War in many panels, which is at Rome in the Portico of Philippus, and Cassandra, which is in the Temple of Concord, Epicurus's follower Leontion sunk in thought, and Demetrius the king.)

Nothing else is known about Theorus, apart from this passing reference in Pliny's catalogue. From the list of subjects it has been inferred that Theorus may have lived around 300 BC, for this is the rough date for Epicurus's female student Leontion; this would fit with a painting of Demetrius the king (i.e., Demetrius Poliorcetes).[200] The obscurity of the name has caused some to want to emend Pliny's text to insert someone more famous. Theon of Samos, who is the next entry in Pliny's catalogue, has been a popular candidate.[201] Another possibility has been mooted that this is a syncopated form of Theodorus, the name associated with the *tabulae Iliacae*.[202] Theodorus can now be eliminated as a possibility, thanks to Squire, who has convincingly interpreted the name on the tablets as a pseudonymous reference to an archaic sculptor famed for working in miniature.[203] In fact, there is no legitimate reason to suspect Pliny's text here; Theorus is a rare but perfectly good name.[204]

In sheer number, the Trojan paintings must have dominated the portico, but Pliny makes it clear that the artist was not of the first rank. If his work did inspire the Pompeian portico, he had a gift for the composition of figures and was deeply thoughtful about Homer. I have already noted some motifs and compositional techniques that seem to run through the Pompeian cycle, and the most likely source for these is Theorus.[205] Even though Theorus may not have been one of the great names of Greek painting, the integration of such a large cycle of paintings into an Augustan monument would have brought its images to a wide public, which had a taste for paintings of Homeric subjects.[206] The Temple of Apollo in Pompeii may have contained a relatively close adaptation, but even the *tabulae Iliacae*, which are so different in scale, medium, and context, show the influence of Theorus's cycle, presumably alongside other influences that are harder to trace.[207]

If the Trojan cycle in its original Roman context ran around the walls of the lower inner portico, this would give an overall length of approximately 108 meters.[208] This is in fact smaller than the space available in the Pompeian portico, where, after subtracting the entrances into the Forum (see fig. 10), there is a total of approximately 150 meters. Of course, the alternation of piers and niches in the east wall of the Pompeian structure establishes a rather wide spacing for the figural paintings. In Rome,

the panel paintings would not have had to be subservient to a decorative theme and might have been hung more closely together. Or perhaps the east and west sides of the upper portico, which faced neighboring porticoes, were walled in instead of open; this would have afforded additional space for paintings.

The Pompeian portico demonstrates a particular interest in Aeneas, so the question arises as to whether this focus was already present in Theorus's original Hellenistic cycle, whether it was added when the cycle was mounted in Rome under Augustus, or whether it was a product of selection when the theme was reinterpreted in Pompeii. The image of the young Aeneas recorded by Rossini (see fig. 66) has compositional features very similar to those of the other paintings; it very much seems an integral part of the series. Likewise, the wounding of Aeneas by Diomedes with the aid of Minerva (see figs. 3 and 29) is a mirror image of Minerva restraining Achilles in his quarrel with Agamemnon, so this painting does not seem an afterthought, either. It may be that the attraction for Augustus of the cycle by Theorus was that this Hellenistic artist, though not well known, had already highlighted the role of Aeneas.

In contrast to Theorus, Zeuxis was one of the most famous figures in the history of Greek painting. Perhaps his most famous (and notorious) painting was his nude portrait of Helen of Troy, which hung alongside and complemented the theme of the Trojan cycle of Theorus. The fame of the artist, the beauty of the painting, and the iconic story of its composition all combined to make it a splendid offering to the Roman people. Nothing is known about the provenance of Theorus's paintings, but Poulle has convincingly reconstructed the history of Zeuxis's *Helen* to suggest that it arrived in Rome around the time of the construction of the Portico of Philippus.[209] This can therefore lend support to the presumption that the Trojan theme goes back to the Augustan phase of the monument. Zeuxis's painting was originally commissioned for display in the sanctuary of Hera Lacinia on a promontory outside the city of Croton.[210] In Cicero's lengthy discussion of the origin story of the painting at the start of the second book of *De inventione* (2.1), he implies that the painting in his day was still there.[211] That sanctuary did not survive the chaos of the ensuing civil wars intact. Poulle points out that according to Appian, Sextus Pompey, after the defeat of his fleet by Octavian at Naulochus, fled eastward toward Antony. On the way, he stopped off at the promontory of Lacinia and sacked the temple (*BC* 5.133).[212] The temple's most valuable work of art was surely Zeuxis's *Helen*, and it is safe to assume that Sextus did not leave it behind. He proceeded toward Mytilene, and thence to Asia Minor, where he was eventually killed by Antony's forces. Regardless of whether Sextus left his booty at his base on Lesbos or took it with him, and regardless of whether it passed through Antony's hands, it must have ended up in the possession of Octavian after Actium. This, as Poulle shows, explains how the *Helen* came to be displayed in Rome when the Portico of Philippus was inaugurated in the years just after Actium. Thus the Trojan theme of the paintings in the portico goes back to Augustus, which is in any case an overwhelmingly likely inference.

Conclusions

The importance of the Portico of Philippus in the Augustan ideological program is indicated by the fact that it was chosen to house one of the most famous paintings in Rome.[213] There were many masterpieces of Greek art in the city, of course, and Augustus added more. But important works of the greatest fifth-century artists were fairly rare and the *Helen* of Zeuxis was a painting of particular renown and notoriety.[214] The story of how Zeuxis created it as a composite portrait of several models was particularly famous, and I return to that story in chapter 6. In my introduction to this book, I looked at a lesser-known anecdote that Valerius Maximus told about the *Helen*. He reported that the artist (and there is no reason to suspect that it was not the artist to do so) inscribed on it several lines from Homer. In his *Laocoön*, Lessing said that the point of this gesture was to indicate that Homer did not, could not, describe Helen's beauty. To have done so would have merely rehearsed a catalogue of clichés. Whereas an enumeration of the parts of Helen's body would descend rapidly into farce for Homer, Zeuxis deliberately chose a variety of disparate models for the different parts of his figure, showing his skill in blending them into a whole greater than the sum of the parts. Homer had to resort to the indirect technique of describing Helen's effect on the old men of Troy as she approached. This literary evasion is the counterpart to the artistic failure of the sculptor of the Laocoön, who could not give words to the scream of his creation. The Portico of Philippus was an ideal location for staging this challenge to the primacy of textual modes of mimesis.

There was no Muse of the plastic arts. It is not clear how soon the Muses came to be firmly associated with separate and particular literary genres, but from a very early stage they were represented with implements from the world of texts. None held a brush or a chisel. To move Zeuxis's *Helen* to Rome's de facto temple of the Muses was thus an act of provocation and supplementation.[215] If the Muses claimed to symbolize the modalities of their mother, Memory, Zeuxis pointed to a major gap in their coverage. When read in the light of Zeuxis's bold challenge to the limits of Homer's tools, the cycle of Theorus also takes on a different aspect: no longer a mere set of illustrations of moments in the Iliadic cycle, but a complementary visual work with its own particular agenda. I have shown how the paintings in the Pompeian portico acted as a kind of critical commentary on the Homeric text, teasing out connections and contrasts that were hidden in it, making them visible in the arrangement of the figures. The Portico of Philippus may have been a meeting place for Rome's poets, but they met under the eyes of works of art that did not entirely admit the supremacy of text.

This tension between art and text was not an incidental aspect of the decoration of the Portico of Philippus; it was integral to its construction and to its place in Augustan ideology as a new, imperial *lieu de mémoire*, under the patronage of the daughters of Memory herself.[216] The portico's record of the Roman *fasti* probably narrated a

year-by-year history of Rome as the product of aristocratic ambition. If Philippus arranged to have these transcribed in a new medium, engraved in marble rather than painted, this would have underscored the sense in which the monument marked an end point of history, or at least of its Republican phase. In addition to connecting the Augustan present with the past, it drew a line under it. The Republic becomes history: Rome has a new calendar, and a new national narrative.

Cato and Fulvius had debated the role of individual glory within the Roman Republic, and Cato had lost the argument. The Temple of Hercules Musarum was a statement of the value of extolling and remembering individual achievement. The endless civil wars had put a different spin on that, however, and it was Augustus who transformed Rome into a truly corporate endeavor, though one that the elder Cato would never have recognized. In the new dispensation, the state was wholly subordinate to the glory not of the collective but of one individual, and the transformation wrought by the Portico of Philippus expressed that change eloquently. It is an irony of history that Marcia, wife of Cato the younger, was half sister to Philippus, builder of the portico.[217]

Fulvius's temple and Ennius's *Annales* were intimately connected: the building and the epic went hand in hand. When Augustus had his stepbrother-uncle rebuild the monument, the implicit demand of the poets of Rome was unmistakable. Just as the temple of Fulvius was no longer fit for its original purpose, neither were the *Annales*. Already the poetic generation of Catullus had found Roman annalistic epic turgid and dull.[218] Ennius's affectation of Alexandrian elegance and his claim to be the reincarnation of Homer came to be seen as emblematic of Roman gaucherie rather than of poetic ambition. Ennius's aesthetics were obsolete, and so, too, was his ideology. The emulous zeal of the great families of the Republic had long since ceased to drive expansion of the *imperium* and had generated instead endless rounds of civil war. The new ideology of the Augustan peace demanded a completely new kind of epic. Rebuilding Fulvius's temple was the signal. Augustus demanded a new Roman epic in the most public way possible.

Furthermore, the precise nature and structure of the new epic that Augustus demanded was articulated in the architecture of the Portico of Philippus. The monument had an annalistic Republican core surrounded by a new Trojan portico. At the center Philippus arranged the old circular temple, the *fasti*, and the statues of the Muses, all integrated as part of the new podium. Around that ran a narrative of the Trojan War with a focus on Aeneas. Aeneas was no longer a prelude to the Roman history that was articulated by the Republican *fasti*, as he was in Ennius's *Annales*. The encircling, controlling narrative of the monument changed from the history of the Republic to the Trojan myth, which was also the story of the Julian family. That story embraced and subsumed the list of magistrates in the middle. The Republic was thus represented as a phase, like the period of the Alban kings—an

important phase, but just one of many in the long history that joined Aeneas and Augustus. This view is reflected in the way the new portico encircled, towered above, and recontextualized the Republican monument and its narrative. The architecture of the *Aeneid* is very similar. The Ennian, annalistic parade of Roman history is merely a prophecy in Book 6 and an ecphrasis in Book 8. The controlling narrative is the link between Aeneas and the destiny embodied by his descendant, Augustus.[219] Philippus's building and Virgil's epic both announced that there was a new master narrative for Roman history and it was about the Julian family.

The parade of Roman heroes in Book 6 of the *Aeneid* has long been linked with Augustan monuments, especially the "hall of fame" in the Forum of Augustus.[220] The Forum was dedicated long after Virgil's death, so if one influenced the other, it must be Virgil that came first. It is in any case typical of classical scholarship to see the text always as primary and the material artifact as secondary.[221] My reading of the Portico of Philippus has the potential to challenge this preconception. The exact year the monument was dedicated is not known, but it was roughly around the time of the publication of Virgil's *Georgics*, in the years just after Actium. That is to say, the *Aeneid* was largely written after the dedication of the portico, and if there is a mutual influence it is far more likely that the building influenced the poem. One might go so far as to say that the Portico of Philippus already, before the writing of the *Aeneid*, which it called into being, suggested a form for the new Roman epic as driven by a Trojan narrative in such a way as to bracket Republican history as a digression. Thus the relationship between art and text can be turned upside down, and the *Aeneid* read as secondary to the really innovative art installation in the Portico of Philippus. A provocative gesture of interpretation such as this may be satisfying and long overdue, given the long history of subjugating art to text in the study of the classical world, but it would probably be equally unfair and unbalanced. It would also wrongly imply that the Augustan voice in the *Aeneid* is the only one we should hear. It would be fairer to say that, in the years immediately following Actium, poets, artists, and architects worked together to articulate, and indeed to critique, the ideology of the new regime.

I began this chapter by looking at the way in which the reestablishment of Rome's Museum by Augustus formed one piece of a comprehensive cultural program in emulation of Ptolemaic Alexandria. Augustus was careful, however, to not offend against traditional Roman ways and to avoid the appearance of setting himself up as a Hellenistic king with a coterie of paid flatterers. He kept distinct the components of the Museum-library complex and was particularly careful not to build anything that might look like a royal quarter. Nevertheless, the renovations of Fulvius's ersatz Museum sent a strong signal to Rome's poets: there would be imperial patronage, but within the traditionally ad hoc Roman framework. This decentralized approach has sometimes given the impression that there was no official cultural policy, but rather a set of disjointed initiatives from the likes of Maecenas, Philippus, and Agrippa.[222] On

some level, however, the poetry, art, and architecture of the Augustan age articulated a single, unified vision of the new regime. It would be easy at this point to slip into the fallacy of reading works like the *Aeneid* as nothing more than propaganda written to order. I hope that the next chapter shows that a fuller sense of the material context that prompted its writing leads to a greater, not a lesser, appreciation of the subtlety and independence of Virgil's response.

NOTES

1. "bellumque Iliacum pluribus tabulis, quod est Romae in Philippi porticibus": Pliny, *NH* 35.144.
2. See Strabo (17.1.8), who does not explicitly mention the library; but there is no good reason to suppose that it was not part of the Museum: Canfora 1990, 137–44. Recent underwater explorations have added to the meager knowledge of Alexandria's topography, but Strabo is still the best guide to the appearance of the city in Augustus's day.
3. Suetonius, *Jul.* 44.2.
4. I owe this point to Daniel Selden.
5. See Zanker 1988, 51, on the connection of the temple with the house and on the similarities with Alexandria and Pergamum. On the location of the Pergamene library, see Hoepfner 2002.
6. On the archaeological evidence, see Wiseman 2009, 529.
7. On the Palatine libraries, see J. F. Miller 2009, 189–90, and Balensiefen 2002.
8. See Rüpke 2006 and Rüpke 2011, 87–108.
9. On the background of the cult of Hercules Musarum, see Boyancé 1955 and Sauron 1994, 86–98, and, more briefly, Goldberg 1995, 130–31. On the unusual nature of the association with Hercules, see Sauron 1994, 84.
10. On the disposition of *manubiae*, see Shatzman 1972.
11. *Panegyrici latini* 9.7.3. On Eumenius's use of Cicero, see Nixon and Rodgers 1994, 159–60n31.
12. Aberson 1994, 205–6, and Martina 1981, 54.
13. *CIL* 6.1307: "M. Folvius, M. f. Ser. N. Nobilior Cos. Ambracia cepit"; illustrated by Rodríguez-Almeida 1986, 13, fig. 2. If this is an Augustan copy of the original, made for the reinstallation of the statues by Philippus, the argument does not change.
14. I owe this point to Edmund Thomas; see also Caldelli 2012, 139n38.
15. As suggested by Aberson 1994, 203–4.
16. On the Fulvii, see Cicero, *pro Planc* 20, and Pliny, *NH* 7.136.
17. *CIL* 14.2601: "M. Fulvius, M. f., Ser. N. Cos. Aetolia cepit."
18. Livy 38.44.5.
19. Aberson 1994, 213–14.
20. *Uti praeda in publicum referatur*; see Rüpke 2006, 490–91, and Martina 1981, 64.
21. See Sblendorio Cugusi 1982, *ad Or.* 18, 19, and 27; with Scullard 1973, 183–84; Astin 1978, 110; Jordan 1860, 94–95; Flower 1995, 185; and Sciarrino 2011, 99–100.
22. Martina 1981, 60–64, and Sauron 1994, 85–86.
23. Thus Walsh 1996, 173, and Briscoe 2008, 545, who prefer to equate this *fanum Herculis* with the temple in the Forum Boarium. Coarelli 1997, 456, suggests that there is a lacuna in the single manuscript that transmits Livy's fifth decade and rewrites the text here to add an explicit reference to the Hercules Musarum. I would suggest that Fulvius's association with the sanctuary of Hercules Musarum was so well known that there was no need to specify the *fanum* any further. If Fulvius's censorial project involved appropriating and renovating an existing temple to Hercules while constructing a new portico, this would fully explain the fact that Livy never credits him with founding a new temple, while the other sources, speaking more loosely, do.

24 Castagnoli 1961, 608, suggested that this was the shrine of Hercules Custos, but, as many have since pointed out, this is impossible as it continued to have an independent identity and *dies natalis* for Ovid (*Fasti* 6.209–12), and was in any case probably on the other side of the Circus Flaminius. See Coarelli 1997, 452–54, *contra* Olinder 1974, 59–64.

25 It would, however, help to explain Servius's implication that there was a preexisting temple of Hercules, to which Fulvius added things (*ad Aen.* 1.8): "his Numa aediculam aeneam brevem fecerat, quam postea de caelo tactam et in aede Honoris et Virtutis conlocatam Fulvius Nobilior in aedem Herculis transtulit, unde aedes Herculis et Musarum appellatur."

26 The expression is from Horsfall 1976, 85.

27 Boyancé 1955 and Martina 1981, 64–65. On the scanty evidence for an association between Heracles and the Muses in Greek cult, see Boardman in *LIMC*, s.v. "Herakles," 4.1.810–11, and Schauenburg 1979.

28 *Sat.* 1.12.16, the information presumably deriving from Varro: "nam Fulvius Nobilior in fastis, quos in aede Herculis Musarum posuit." See Rüpke 1995, 331–68 and, more briefly, Rüpke 2006, 499–503.

29 Rüpke 2006, 491–93; Michels 1967, 125n18.

30 Feeney 2007, 167–68.

31 Rüpke 1995, 346–52; Gildenhard 2003, 95; Feeney 2007, 170.

32 See Gildenhard 2003; Gildenhard 2007, 84–86; Rüpke 2006; Feeney 2007, 170; P. R. Hardie 2007, 138–39; in contrast, Zetzel 2007, 13n63, is skeptical.

33 See Skutsch 1968, 18–19, and *contra* Zetzel 2007, 13–14.

34 See Hinds 1998, 52–56, on Ennius, Lucretius, and Virgil, and P. R. Hardie 2007, 139–40, on Horace.

35 See Skutsch 1968, 3–5, and Hinds 1998, 56–63.

36 Flower 1995, 186.

37 On the concept, see Nora 1997.

38 For Cato on Fulvius, see Gellius, *NA* 5.6. See also Cicero, *Tusc.* 1.4, and Nepos, *Cato* 1.4, with Astin 1978, 16–17. Goldberg 2005, 10–12, argues convincingly that it was the production of the topical, partisan, and encomiastic drama *Ambracia* that was the immediate spur of Cato's ire against Ennius.

39 See Cardinali 1987; Churchill 1995, 100–102; and Sciarrino 2006, 468.

40 Nepos, *Cato* 3.4: "atque horum bellorum duces non nominavit, sed sine nominibus res notavit." See also Cicero, *Rep.* 2.2 (reporting Cato's view): "nostra autem res publica non unius esset ingenio, sed multorum, nec una hominis vita, sed aliquot constituta saeculis et aetatibus." On the crucial topos of "Rome as a collective state," see Griffin 1985, 178–80. For the possibility of a collectivist reading of the *Annales*, see Goldberg 2005, 28.

41 Thus Martina 1981, 62.

42 Timpanaro 1949, 198–200.

43 There has been some debate on the extent of the autonomy enjoyed by the builders who had triumphed just before Actium; see Gros 1976, 37–38. But Philippus is clearly a special case, due to his intimate family connections to Octavian.

44 For the argument that Sosius was restoring the old temple of Apollo rather than building a new one and for skepticism about the political meaning of this gesture, see Gurval 1995, 116–19.

45 La Rocca 1987.

46 Syme 1939, 241.

47 See Shipley 1931, 21–23, 24–25, 28–29, 30–32.

48 Tacitus, *Ann.* 3.72, and Suetonius, *Aug.* 29.4–5.

49 Shipley 1931, 28–29 See also Degrassi 1947: the lacuna in the *Fasti Capitolini* (pp. 86–87), which give the years, is here supplemented by the *Fasti Barberiniani* (pp. 342–43), which do not; in his notes Degrassi (pp. 569–70) agrees that Philippus's triumph must have been in 33.

50 Shipley 1931, 30. The day of the year is given by Ovid's *Fasti* (6.796–800). Many modern authorities give the year of the dedication unequivocally as 29, but Shipley 1931, 1 and 30n6, long ago pointed out that there is no evidence for this precision, and that it probably arose because Platner and Ashby

51. confused it with the citation of chapter 29 in Suetonius's *Life*. Despite Shipley's correction, and despite his correction of the frequent confusion of Philippus father and son, both errors stubbornly persist: see, e.g., Richardson Jr. 1992, 187.
51. See Syme 1939, 128, and Gray-Fow 1988, who argues that Octavian acquired from his stepfather his skill at keeping the senatorial aristocracy on his side while subverting it.
52. For the dates, see Shipley 1931, 29.
53. Quote: Gray-Fow 1988, 196; likewise Syme 1986, 403–4.
54. Thus Viscogliosi in *LTUR*, s.v. "Porticus Philippi," 4:146.
55. For the arguments, see Coarelli 1997, 515–28, and for a diagram, see Coarelli 2007, 268, fig. 65. Augustus (*RG* 19.1) and Pliny (*NH* 34.13) both put it *ad circum Flaminium* and Velleius 2.1 (*in circo*). More specific information is given by Festus (178): "Octaviae porticus duae appellantur, quarum alteram, theatro Marcelli propiorem, Octavia soror Augusti fecit; alteram theatro Pompei proximam Cn. Octavius Cn. filius, . . . quam combustam reficiendam curavit Caesar Augustus." The other, less likely, possibility is that it was on the short, western side of the Circus.
56. Commentators, e.g., Cooley 2009, 187, typically get the point but not necessarily the joke. For an exception, see O'Sullivan in *Bryn Mawr Classical Review* 6 (2004): 31.
57. Platner and Ashby 1926, 427, claim that the latter was built after 27, but this seems to be based on the assumption that Vitruvius, who still calls it by the old name of Portico of Metellus (3.2.5), was writing around then. But the internal evidence for the dating of Vitruvius's writing is notoriously problematic (see Rowland and Howe 1999, 3–5) and in his preface he seems to say that, although he waited until after Actium to publish his work, he had been writing for some time before. Presumably the dedicatory preface was the last thing written, so it is possible that the portico was rebuilt in the late 30s, and the reference to the Portico of Metellus reflects this earlier period of writing. After Marcellus's death, Octavia dedicated a library in his memory, but this could have been a later addition to the complex.
58. Boyle 2003, 242.
59. This irony is explored by Barchiesi 1997b, 269–70, and Newlands 1995, 215–16.
60. Littlewood 2006, 231, and Newlands 1995, 214.
61. See Barchiesi 1997a, 207, and Breed and Rossi 2006, 408, with n45.
62. On the ambiguity of the gesture, see Newlands 1995, 235, and A. Hardie 2007, 564–70.
63. Boyle 2003, 270, disproving the claim by Gros 1976, 33, that the Republican *dies natalis* was "sans doute identique."
64. Thus Martina 1981, 54–55, *contra* Degrassi 1963, 471.
65. A different reconstruction of this inscription was proposed by Richardson Jr. 1976, 63, but it has not found favor, except with Ackroyd 2000, 574–75.
66. Ciancio Rossetto 1996, 267–69.
67. Porcari 2008, 181.
68. Gianfrotta 1985, 382–84, Castagnoli 1983, 97–98.
69. This decoration is usually taken to be Augustan, but for an attempt to redate it to the Severan period, see Porcari 2008, 184. If this was the result of repairs after the fire that destroyed the Portico of Octavia, it does not necessarily follow that the Portico of Philippus was destroyed and rebuilt as well.
70. Ciancio Rossetto 1996, 267.
71. Gianfrotta 1985, 384.
72. In the plan shown by both Gianfrotta 1985, 379, fig. 3, and Castagnoli 1983, 95, fig. 2, it is unclear whether this find was at the spot marked *c* or *b*. I have assumed that it is *c*, since that location fits well with the indication of the north part of the circular temple on the Marble Plan when it is overlaid with a map of the area, as in fig. 74. But some comments in those articles make me wonder if that assumption is correct. If this find was at the place marked *b*, either my plan is wrong or the identification of this feature is mistaken.
73. As Amy Russell points out to me.
74. Castagnoli 1983, 96. It is puzzling that Coarelli 1997, 478–80, draws the opposite conclusion.

75 Tamm 1961, 162, suggesting the Temple of Fortuna Primigenia at Praeneste as an unlikely parallel; followed by Coarelli 1997, 480–81.
76 Marchetti-Longhi 1956–58, 71.
77 Stamper 2005, 77–78.
78 Next door, for example, the Republican predecessor to the Portico of Octavia was the quadriporticus of Metellus, which provided a space for the display of his booty, especially Lysippus's twenty-five equestrian statues of the companions of Alexander. For an example of a circular temple with statues arranged in front, see Largo Argentina Temple B with Pliny, *NH* 34.60.
79 Rüpke 2006, 492.
80 See V. Lundström 1929; Tamm 1961, 162; and Coarelli 1997, 482.
81 Rüpke 2006, 492.
82 The reconstruction of the Marble Plan given by Carettoni et al. 1960, fig. 31, has a small asymmetry on the east side of the east arm, due to the hasty drawing of fragment 31gg. This is clearly an error, however, and my reconstruction ignores it, as do most others; see Castagnoli 1983, 102n16.
83 "Καλλιόπη θ'· ἡ δὲ προφερεστάτη ἐστὶν ἁπασέων," *Theog.* 79. Calliope speaks on behalf of her sisters at Propertius, 3.3.37–51, and Ovid, *Met.* 5.337–40. Propertius twice pairs Calliope with Apollo in a way that might suggest that they represent the Portico of Philippus and the Temple of Palatine Apollo, respectively: see 2.1.3 and especially 4.6.11–12.
84 Coarelli 1997, 483. See also Marabini Moeus 1981, 46.
85 On the two levels of the sanctuary, see below, note 94.
86 See Lloyd 1982 and Anderson 1982, 105.
87 Rizzo 2001, 238–40, and Meneghini 2006, 150, fig. 19.
88 E.g., Pliny, *NH* 36.102, and Herodian 1.14.2–3.
89 Rizzo 2001, 240, is skeptical, however.
90 For other parallels, see La Rocca 2001, 101–6.
91 See Lloyd 1982 for an optimistic view.
92 See Carroll 2010.
93 See Carroll 2007, 41.
94 As suggested by T. Najbjerg in the text of the Stanford Digital *Forma Urbis Romae Project* website, under the heading "Porticus Philippi" (http://formaurbis.stanford.edu).
95 See Marabini Moeus 1981, 46.
96 Richardson Jr. 1992, 318, s.v. "Porticus Octaviae"; on the closing off of that open front in the Severan reconstruction, see Ciancio Rossetto 1996, 270–73.
97 Thus Gros 1976, 82.
98 Richardson Jr. 1992, 318, s.v. "Porticus Philippi."
99 Coarelli 1997, 475, suggests that it is a public latrine.
100 *Ars am.* 3.1167–68; Martial (5.49) makes a similar joke, on which see Rodríguez-Almeida 1986.
101 Richardson Jr. 1977, 361.
102 Nibby 1839, 2:609.
103 Piranesi 1972, pl. 29.
104 See Günther 1981; Tucci 1994–95; and Claridge 1998, 222, with fig. 102.
105 For Giuliano's drawings of antiquities, see in general Günther 1988, 104–38.
106 Hülsen 1910, fols. 1v, 2r. Giuliano guessed that it was the portico of Pompey, but that is incompatible with the information he gives that it started at piazza Giudea.
107 Bartoli 1914–22, vol. 1, pl. 43, fig. 71.
108 For bibliography on both sides of the issue, see P. N. Pagliara in *Dizionario biografico degli italiani*, vol. 56, s.v. "Giovanni Giocondo da Verona (Fra Giocondo)."
109 For a recent negative reaction, see Viscogliosi in *LTUR*, s.v. "Porticus Philippi," 4:146–47.
110 See Hülsen 1910, 2:6. Not knowing where our portico was located, Hülsen was wrong to connect this structure (pp. xxxv and 77) with a very different-looking portico destroyed by Pope Paul II, which

is shown in a plan of the Capitol published by Lanciani 1875, pls. 17, 18. That was far off on the other side of the Theater of Marcellus, the reference to which is the only thing the porticoes have in common.

111 For the conversion factors, see Martini 1883.
112 I assume this is the sort of thing Hülsen 1910, 2:6, means by "differenze delle misure."
113 See Hülsen 1910, fol. 63v, and Bartoli 1914–22, vol. 1, pl. 59, fig. 91.
114 *Les edifices antiques de Rome dessinés et mesurés très exactement* (Paris 1682); for a digital copy, see the University of Wisconsin Digital Library for the Decorative Arts and Material Culture (http://digital.library.wisc.edu/1711.dl/DLDecArts.EdiAnt). The plans of the monument given by Minoprio 1932 and Giavarini 2005 do not have the necessary measurements.
115 For the modern measurement, see Platner and Ashby 1926, 77, and Coarelli in *LTUR*, s.v. "Basilica Constantiniana," 1:172.
116 On the less-than-perfect accuracy of Giuliano's drawings, see Ashby 1911, 175.
117 On the variability of units of measurement, see Lotz 1979.
118 A practice that is called "reconstruction as design" by Cammy Brothers; see Brothers 2002.
119 I am extremely grateful to Amy Russell for making this point to me (comparing the inner ring of columns at Santa Costanza), and for doing it so stubbornly that she compelled me to rethink my interpretation of the drawings.
120 The exact words are difficult to make out, but I read it as "archo inarchato mezo circinus omicichlo [=emiciclo?] si come" or "arch arching half of a drafting-compass semicircle as if"
121 Giocondo's drawing shows a shadow rising from the corner of the rear pillar that might seem at first glance to be a groin, but if you compare the drawing of Giuliano, this must be showing the point where the larger rear arch came to rest on the large rear pillar. The outward step and shadow he shows would then correspond to the stepped articulation in that rear arch as shown by Giuliano. Giuliano's drawing clearly shows a barrel vault, and groin vaulting is incompatible with the transverse architraves that both artists document.
122 For a very close parallel for this arrangement of arch and vault, though without columns and employed for a different architectural purpose, see the drawing of the Augustan amphitheater at Nîmes at Adam 1999, 192, fig. 453.
123 If Bendinelli 1956–57, 559–63, is correct, which is very far from certain, that a terracotta plaque shows an elevation of the temple, then the arches shown behind the foreground portico would be an indication of the arcade behind and/or the barrel vaulting.
124 Hülsen 1910, fol. 2r; see fig. 79.
125 Hülsen 1910, 2:5.
126 Another interpretation of Giuliano's words has been put forward by Röll and Campbell in Campbell 2004, 1:295–96. They claim that the church in question is San Paolo alla Regola and the gate is the gate in the walls of the Ghetto leading to that church. The gate would have been the one roughly due southwest from the piazza, near where the present-day piazza delle Cinque Scuole meets the river. This is not impossible, but it would be very strange to indicate a southerly direction by referring to San Paolo alla Regola, which is some distance to the west. Röll and Campbell's argument is that Giuliano drew the structure in via di Santa Maria dei Calderari, but the plan of that structure is very different from the plan shown in the drawings of Giuliano and Giocondo.
127 See V. Lundström 1929, 108, with amplifications by Castagnoli 1983, 99–100; see also Borsi 1985, 43–45.
128 See Patterson in *LTUR*, s.v. "via Tecta," 5:145–46; and Coarelli in *LTUR*, s.v. "porticus Maximae," 4:130; for a skeptical view of the identity of these two roads, see Heyworth 2011, 44–47.
129 Lanciani 1891, 7, 76–81, and Hülsen 1907, 42–43.
130 "El portticho dd savelli": the abbreviation is either "dei" or, more likely, "dietro": Hülsen 1910, 2:6.
131 Röll and Campbell are quite wrong in Campbell 2004, 1:293, to link with Giocondo's drawing the arcades shown in a drawing by Dosio, which were on the opposite side of the theater, toward the Capitol.

132 Giuliano's drawing is tentatively connected with the Portico of Octavius by Tucci 1997; see Senseney 2011, 440n54.
133 See the map of Stow 2001, fig. 2.
134 See Porcari 2008, 180–81, who hypothesizes on the basis of some fairly thin evidence a Severan reconstruction of the Portico of Philippus after a major fire in the area. Fires are very unpredictable, and the Portico of Philippus might have endured nothing more than cosmetic damage, even though its neighbor, the Portico of Octavia, needed to be rebuilt.
135 See Lanciani 1897, 496–47, who erroneously associated this drawing with the Crypta Balbi and with the structure of disputed identity in via di Santa Maria dei Calderari.
136 On the errors in the Renaissance transcriptions, see Carettoni et al. 1960, 43–51.
137 For the remains of the monastery discovered in excavations, see Castagnoli 1983, 95.
138 These excavated columns are marked on Lanciani's *Forma Urbis Romae* and are put not in the middle of the street but in a building to the south. This may be due to his map showing the street before it was widened. He also gives a note in this position that reads "Ligorio Tor. XV.232," which I take to be a reference to the manuscripts of Pirro Ligorio in Turin, but which I have not been able to check.
139 Tucci 1993, 239–41, with fig. 19; for the excavation reports, see *Bullettino della commissione archeologica comunale di Roma*, 1890, 66–68, and 1911, 87–88.
140 The measurement is given apparently to the centimeter as 16.00 m, but all the other measurements he gives seem to be to the nearest 10 centimeters, so this should be treated as a rounded figure.
141 The adjustment factor from Giocondo's measurement of the west bay of the north aisle of the basilica ($22.834 \div 29.712 = 0.77$), would yield an even closer figure: $20.55 \times 0.77 = 15.8$ meters.
142 Tucci 1993, 239–40, and see also Castagnoli 1983, 99; by contrast, the columns are put outside the boundary of the Portico of Philippus in the plan of Gatti 1989, 177, fig. 10.
143 Confirmed via Google Earth, version 6.0.3.2197. Note that this procedure presumes that the columns of the surviving Severan version of the Portico of Octavia were along the same line as in its Augustan predecessor. Marchetti gives a distance of 6.5 meters from the houses on the north side of the street: Tucci 1993, fig. 19. This is a reasonable match for the approximate distance of 6 meters that can be deduced from the satellite picture.
144 This corresponds to the line on the Marble Plan that would run down the middle of the via del Portico di Ottavia: see fig. 74. It has already been strongly argued by Gros 1976, 82, that the Augustan porticoes on the north side of the Circus Flaminius must have presented a uniform, open colonnade.
145 Castagnoli 1983, 93–94, with figs. 3 and 4.
146 The width is labelled on Giocondo's plan with a "p" for *palmi* and then a symbol: a "5" or an "S" with dots before and after. As drawn, the width seems to be about 9 *palmi*, which would be quite narrow and considerably less than the distance between the side of the street and the excavations in the middle, but the plan may have been narrowed for convenience.
147 Tucci 1993, 241, and Castagnoli 1983, 94.
148 This could also clarify an apparent discrepancy in the depth below street level of the two sets of remains; it is not clear if the plans of Marchetti and Castagnoli are measuring from the same point of reference.
149 The excavation reports have a confused mention of a granite column being found, which would be post-Augustan, but given the vagueness of the information and the unreliability of the reports, it seems likely that this was an interloper from a later phase. Otherwise, the reports are of tufa foundations topped by a travertine strip on which were placed marble column bases.
150 Tucci 1993, 241.
151 If the inside-out reconstruction is preferred, this would have to be a stairway down into the interior, lower level.
152 Danti 1992, 50–64.
153 On the excavations, see Gianfrotta 1985, 378.
154 On the history of the Renaissance buildings, see Gurisatti and Picchi 1982.

155 I am very grateful to Father Ambrose, procurator general of the Subiaco Congregation of the Order of St. Benedict, for his generosity in taking me around the monastery and sharing his considerable knowledge of the history of the site.
156 Excavations found that the walls of the medieval monastery were of tufa with traces of whitewash: Gianfrotta 1985, 378.
157 Gianfrotta 1985, 383.
158 This discussion is based on the valuable survey of Horsfall 1976 but comes to very different conclusions. See also Tamm 1961; White 1993, 54–59; Badian 1972, 187–95; Gruen 1996, 86–90; and Coarelli 1997, 463–73.
159 Caldelli 2012, 135–36.
160 Jory 1970, 233–34, expressed skepticism that the Livian *collegium scribarum histrionum* could be the same thing as the *collegium poetarum* mentioned by Valerius, and his hyperskeptical approach was elaborated by Horsfall 1976. On the implausibility of the skeptical reconstruction, see Gruen 1996, 90n46.
161 Jory 1970, 226–27, and Horsfall 1976, 79.
162 As Horsfall 1976, 80, rightly says, "The terms of the *senatusconsultum* need not have referred to the authors by a designation which they would themselves have chosen"; but he is misled by Festus into thinking that the Senate designated the poets as *scribae*. If one prefers to credit Festus's information, then the argument below could still stand, but it would have to be modified to imagine that in Livius's day the word *scriba* could mean both clerk and poet, and that the word *poetarum* was simply added to the name of the *collegium* when that was no longer true.
163 Thus Badian 1972, 190–91n2; see also Jory 1970, 237–53.
164 On the history of the statue, see Cancik 1969, 324–25.
165 See Martina 1981, 52, with n19.
166 Badian 1972, 189.
167 See Ovid, *Fasti* 3.821–34.
168 See Gildenhard 2003, 109–11.
169 See Purcell 1983, esp. 142–46, and Badian 1989.
170 *Contra* Horsfall 1976, 82.
171 Badian 1972, 190, rightly sees that the anecdote implies that Caesar attended more than once but draws the incorrect conclusion that he was a patron of the *collegium*; if that were true, Accius's behavior really would have been intolerable.
172 For a different perspective on this paradoxical aspect of the evidence, see Gruen 1996, 90.
173 For the inscription, see More 1975 and Panciera 1986. It refers to the "stone theater," which dates it securely to the period when the Theater of Pompey was the only such structure; see Panciera 1986, 38–39, and *contra* Horsfall 1976, 88. It is unclear what event in the Theater of Pompey Surus was responsible for: Panciera 1986, 40.
174 On the asyndeton, see Horsfall 1976, 89–90.
175 Badian 1989, 590–91, 602–3.
176 Shackleton Bailey 1988, 66n127 *ad* Cic. *Fam* 7.1.1.
177 The skepticism of White 1993, 290–91n55, is excessive.
178 Heslin 2011, 66–68.
179 See Horsfall 1976, 83–84, and Brink 1963–82, 3:321–22.
180 Another Horatian passage that juxtaposes the Palatine library with the Muses is *Epist.* 2.1.216–18, where Helicon may be associated with the Palatine: Goldberg 2005, 203.
181 Horsfall 1976, 87, and White 1993, 55.
182 See Fusi 2006, 218–19.
183 *Musarum et Apollinis aede relicta*, 7.37.
184 For an overview of scholarship on Roman *collegia* in general, see J. S. Perry 2011; for the *collegia*, see

MacMullen 1974, 73–80, and Diosono 2007; for theoretical models, see Liu 2009, 1–28, and J. S. Perry 2006, 1–18.
185 See, e.g., White 1993, 58, and Horsfall 1976, 85.
186 On the scandal, see Livy 38.43–44.
187 On the Zeuxis terracottas, see the interesting comment of Rawson in Astin et al. 1989, 441.
188 Martina 1981, 49–50.
189 Crawford 1974, 437–39.
190 Marabini Moeus 1981, 12–14, and Ridgway 1990, 247.
191 Marabini Moeus 1981, 42–44, and Ridgway 1990, 247–52; *contra* Ritter 1995, 181–87.
192 This would be completely impossible for the cult statue, so this hypothesis presumably requires Fulvius to add this group to a separate cult statue or to a preexisting temple of Hercules.
193 Marabini Moeus 1981, 7–8, argues that Martial (5.49) depicts a potentially violent Hercules in this same temple, but his club is not mentioned or implied by Martial.
194 It is, strictly speaking, uncertain whether the cult statue of the lyre-playing Hercules also came from Ambracia, but it is a plausible assumption. On Heracles and the lyre, see Boardman in *LIMC* 4.1.810–17, s.v. "Herakles."
195 Pliny, *NH* 35.66, 114, 144.
196 Pliny, *NH* 35.114. See Celani 1998, 162.
197 See Ritter 1995, 133–34, and some related ideas were suggested independently by Poulle 2007, 38–39.
198 Thus Hekster 2004b, 236n14.
199 For speculation about subsequent modifications by Domitian, see Rodríguez-Almeida 1986.
200 See Lippold in *RE*, s.v. "Theoros (2)," 2244.37–38.
201 See P. Moreno in *EAA*, s.v. "Theon (2)"; Six 1917; and Celani 1998, 163n854.
202 See Sadurska 1964, 9–10; Valenzuela Montenegro 2004, 350; and Kazansky 1997, 60. For a fuller discussion, see É. Michon in Dar.-Sag., s.v. "Iliacae Tabulae," 3:380.
203 Squire 2010, 84–90.
204 See G. Lippold in *RE*, s.v. "Theoros (2)," 2244.63–2245.4, where he connects this Trojan cycle with the one in Pompeii; see also his article in *RE*, s.v. "Tabula Iliaca," 1895.19–33. Lippold 1951, 84–85, later changed his mind about that connection, having invented a chronology according to which the originals of the Pompeian paintings must have been painted around 350 BC. But nothing about that chronology rests on a secure foundation.
205 On the stylistic coherence of the paintings traced back to Theorus, see also Fornari 1916, 66–74.
206 For evidence of that taste, see Vitruvius, 7.5.2; Petronius, *Sat.* 29.
207 The variety of visual sources for the *tabulae* is documented by Brüning 1894. The claim by Weitzmann 1959 that the tablets reflect a tradition of illuminated papyri remains purely speculative; for an effort to explain the lack of evidence, see Horsfall 1979, 44–45. Sadurska 1964, 10n12, prefers to look to monumental painting for models but does not specify Theorus.
208 Using the scale given by Carettoni et al. 1960, fig. 31.
209 Poulle 2007. A late source attests to another portrait of Helen by Zeuxis in Athens, which may be a copy: Bergmann 1995, 92.
210 On the Crotonian context, see de Angelis 2005. If the speculations of Boyancé 1955 are correct that the association between Heracles and the Muses was a Pythagorean idea that arose at Croton, then the placing of a painting from that city in the Portico of Philippus was especially appropriate.
211 The language is open to ambiguity, but this is the most natural implication when Cicero says that some of Zeuxis's paintings were still in the temple; he surely would have noted it if the specific image he was talking about was an exception. See Celani 1998, 164, with n864.
212 Poulle 2007.
213 On the prominence given to similarly famous works by the fourth-century painter Apelles in Augustan Rome, see Bergmann 1995, 89–90.

214 See Celani 1998, 282.
215 Poulle 2007, 32, points out that the original location of the painting in the Temple of Hera in Croton was also provocative: a nude adulteress in a sanctuary of the goddess of marriage.
216 On the temple as a "Roman time machine," see Feeney 2007, 144. On the Forum of Augustus as a successor in this regard, see Gowing 2005, 138–45, and Geiger 2008, 11–12.
217 Syme 1939, 128n1.
218 E.g., Catullus 95. Cicero is a useful reminder that not everyone felt this way.
219 On Ennius and Anchises's catalogue, see P. R. Hardie 1993, 102–5, with Casali 2007, 110–15.
220 See Degrassi 1945 and Galinsky 1996, 210–12; for further bibliography, see Geiger 2008, 50n89.
221 For a recent example, see Most 2010, 333, who concludes, despite the thrust of his own chronology, that the Laocoön sculptural group must depend on the *Aeneid* and not vice versa.
222 For a critique of the idea of a monolithic Augustan culture, see Lowrie 2009.

Chapter 6

Imaginary Temples

NOW I TURN TO EXAMINE A VERY DIFFERENT type of monument: imaginary temples that serve as metaphors for a poet's own writing. Athough the history and architecture of the Portico of Philippus and the details of the paintings from the Pompeian portico must recede into the background here, there is nevertheless a very important connection between the material in this chapter and what went before. Starting with Virgil in the *Georgics*, Augustan poets began responding to the Portico of Philippus by characterizing their own work as metaphorical monuments in which they articulated their relationship with the regime. The full extent of this phenomenon, and the way it links together in a public dialogue the works of Virgil, Horace, and Propertius, becomes apparent only in light of what is now known about this important Augustan monument.

Many of the programmatic and metaliterary passages in Augustan poetry involve imaginary temples that bear features of the Portico of Philippus. In some cases the poet describes a fictional version of a sanctuary very like it; in other cases the poet likens himself to the priest of the Muses in their new home; in still others the poet alludes to the art that was displayed there. The reason for this should now be clear: the Portico of Philippus embodied a demand from Augustus for a new national epic as well as a blueprint for it, and in return a promise to support literary culture at Rome. A request of this sort from Augustus was not to be ignored, even by those who had other ideas for their own work. Since the building served as a material metaphor for an unwritten poem, it is unsurprising that the poets frequently invoked the same metaphor when defining and defending their own work. Accordingly, the building came to be used as a way of speaking about many different genres and different attitudes toward the regime. Poetic refusals to write an epic for Augustus bore the imprint of the Portico of Philippus just as strongly as did the *Aeneid*.

Apparently, Virgil gave Augustus what he wanted: a new national epic to embody the new imperial ideology. Or did he? The question of whether the *Aeneid* is really, deep down, a tale of glory is not one to be probed here, but a few preliminary observations must be made. Even if the reader believes that Virgil's epic muse diverges from official imperial policy, it must be admitted that the external forms of the *Aeneid* are ostensibly Augustan. This is not to say that the Augustan reading is the only one possible, but it is clearly an important option. Of course, the *Aeneid* is much more than

a work of ideology, written for hire. One place this can be seen is in the first book, when the hero encounters a temple with a portico decorated with paintings of the Trojan War, just like the Portico of Philippus. Virgil's meditation on the differences between art and text foregrounds the indeterminacy of interpretation. This becomes particularly clear when Aeneas's subjective response to the imaginary Trojan cycle is juxtaposed with the real Trojan cycle in Pompeii.

Virgil is the exception; the other Augustan poets are united in their unwillingness to write an epic to imperial order. A frequent topos in Augustan poetry is the *recusatio*: a declaration of unwillingness or incapacity to write an epic in honor of Augustus. The demand being refused in these passages is usually assumed to have taken the form of a discreet word to the poet from Maecenas. But why would a poet dare to give a public refusal to a private request? Once it is understood that Augustus had made a very public request to the poets of Rome by building the Portico of Philippus, it is clear why the public *recusatio* is such an important part of Augustan poetry. A number of these passages contain clear references to the iconography of the Portico of Philippus, which is natural enough if it was the external form of the question to which these poems give a negative answer. Sometimes, though, the answer is not entirely negative. Another possibility was to recast the poet's own work as a different kind of monument: a positive answer to the regime's demand for engagement with the new ideology, but cast into a very different generic form. Epic is not the only genre that flirts with monumentality in the Augustan age.

I examine under a new light a number of very famous passages in Latin literature, and it needs to be stressed that this study is limited to one very particular aspect. The Virgilian episode of Aeneas in the Temple of Juno at Carthage and the Roman Odes of Horace have a large bibliography and it would be impossible to do justice to either of them in the space available here. I hope it does not seem as though this discussion is slighting other approaches to such works; the perspective offered here is meant to be complementary. It is also worth noting that there are doubtless other passages in early imperial literature where the Portico of Philippus must lurk behind poetic discussions of the abode of the Muses or the topography of Mount Helicon or the Pierian spring. For example, in a recent discussion of the Roman fabulist Phaedrus, Champlin has shown that his claim to have been born on the Pierian ridge, where the Muses were born, nearly in their *schola*, means not, as most scholars have assumed, that Phaedrus was from Greece, but that he was born in Rome, near the Temple of Hercules Musarum.[1] One tip-off that Phaedrus was not talking about the real abode of the Muses is his reference to crossing their "threshold." As Champlin notes, this fits a temple much more than a mountain grotto.[2] One could multiply such passages. I was once puzzled by the way Statius begins his second epic by claiming that he does not knock on the grove of the Muses on Mount Helicon as a newcomer. What sort of fool knocks to gain admittance to an open, doorless grove?[3] These passages reveal the

way Roman poets had internalized the idea that the Roman portico and temple was a metaphor for Mount Helicon to the point of routinely giving features of a temple to the metaphorical mountain.[4] A systematic study of topographical references to the Muses in early imperial poetry in light of what has been established about the Portico of Philippus would be a very interesting project, but in the pages that follow I only have space to discuss a handful of the most important passages.

Virgil's Temple by the Mincius

The most important response to the literary challenge embodied in the construction of the Portico of Philippus was, of course, the one that came from Virgil, the improbable epicist. It is hard to put aside the knowledge that Virgil is the author of the great Roman national epic, but that is what one must do in order to understand the literary culture at Rome just after Actium. Virgil had begun his poetic career writing poetry in the most minor key possible, and in the bucolic *Eclogues* Apollo had explicitly warned his persona against writing about "kings and battles" (*reges et proelia*). His transformation into a writer of "battles and a hero" (*arma virumque*), and indeed into the quintessential writer of epic, is one of the most remarkable turnarounds in the history of literature.[5] The place where Virgil articulated this change of course and made it seem to later generations that it was a natural development is in the *Georgics*, which was being completed while the Portico of Philippus was under construction.[6] A work that began in a Hesiodic, which is to say non- or even anti-Homeric vein, builds up toward the end to test the waters of Homeric narrative in its final section. In the middle of the *Georgics*, at the start of the third book, Virgil makes a promise to write an epic for Augustus as his next work.

Virgil describes the project that will eventually become the *Aeneid* as a temple he will build for Augustus.[7] It has long been recognized that this metaphor needs to be understood in the context of Augustus's building program, but there has been some debate over which monument Virgil has in mind. Many have seen this passage as reflecting the Temple of Palatine Apollo, but a few have argued for the Temple of Hercules Musarum.[8] Despite the many explicit links to the Temple of the Muses documented below, one should not ignore the potential links to the Palatine temple, and the way forward should now be clear. As shown in the Horatian passages discussed in the previous chapter, the poets of Rome understood that the temple and library on the Palatine and the Museum in the Campus Martius were two halves of the same quasi-Alexandrian project.[9] Virgil's metaphorical temple combines aspects of both monuments, precisely because he understood that together they constituted Augustus's promise to emulate the support of literary culture found in Hellenistic Alexandria and Pergamum.

Virgil begins by evoking the collaborative project of Ennius and Fulvius as patron:

> ...temptanda uia est, qua me quoque possim
> tollere humo uictorque uirum uolitare per ora.
> primus ego in patriam mecum, modo uita supersit,
> Aonio rediens deducam uertice Musas;
> primus Idumaeas referam tibi, Mantua, palmas...
>
> (...I must attempt a path by which I too may rise from the earth and fly as a victor on the lips of men. I will be the first, if sufficient life remains for me, to bring the Muses back with me to my fatherland from the Aonian peak; I will be the first to bring palms from Edom back to you, Mantua...)[10]

Virgil uses the familiar Roman trope of evoking a predecessor at the very moment at which he makes an ironic claim for primacy.[11] He imagines himself as a metaphorical *triumphator*, bringing the Muses back from Greece and erecting a temple on his return, just as Fulvius had done. This metaphor is derived from Lucretius's tribute to Ennius:

> Ennius ut noster cecinit, qui primus amoeno
> detulit ex Helicone perenni fronde coronam...
>
> (As our Ennius sang, who first brought a crown of evergreen leaves from lovely Helicon...)[12]

Virgil's alliterative boast that he will live on the lips of men is adapted from the self-penned epitaph of Ennius himself. Virgil takes the Lucretian metaphor of Ennius carrying back the poetic crown from Greece and combines it with Fulvius's sack of the Muses. All this is well known. What needs to be appreciated is the way Virgil proclaims that he will be the new Ennius, with particular regard to the way the latter's poetry seamlessly complemented the building program of his patron, Fulvius. Virgil effaces from history the Temple of Hercules Musarum when he claims to be the first to bring the Muses to Italy from Greece. This act mirrors on a metaphorical level Philippus's complete redevelopment of the sanctuary, and it foreshadows Ovid's equally explicit effacing of the Republican temple at the end of the *Fasti*. Ennius's primitive hexameters have been thrown into the rubbish bin of history along with the rough *cappellaccio* blocks of Fulvius's temple. This attitude of programmatic condescension toward the *Annales* is, of course, highly self-serving, as Ennius's obsolescence is a necessary condition of the new generation's poetic ambitions. Virgil's true feelings about Ennius are better revealed in the vast amount he borrowed from him in the *Aeneid*.

There is an ambiguity about the word *patria* in the lines above. Does Virgil regard Rome or Mantua as his fatherland? Both? Italy in general? The setting for his metaphorical temple will be in Mantua, but it draws upon metropolitan models (*Georg.* 3.13–18):

> et uiridi in campo templum de marmore ponam
> propter aquam, tardis ingens ubi flexibus errat
> Mincius et tenera praetexit harundine ripas.
> in medio mihi Caesar erit templumque tenebit:
> illi uictor ego et Tyrio conspectus in ostro
> centum quadriiugos agitabo ad flumina currus.

(And on the green plain I will set up a temple of marble beside the water, where the vast Mincius meanders in lazy windings and fringes its banks with slender reeds. In the middle I will put Caesar, and he will possess the shrine. In his honor I, a victor resplendent in Tyrian purple, will drive a hundred four-horse chariots beside the river.)

The gleaming marble of the temple and the fact that Caesar will sit at its very center will rightly make one think of the Temple of Palatine Apollo, which was next to Augustus's residence and was famous for its use of marble. On the other hand, the position of the temple is not on a hill, but *in campo*. It stands at a bend in the winding river of Mantua, the Mincius. This would naturally make a Roman think of the Campus Martius, where the Portico of Philippus stood right at the bend in the Tiber. Even more evocative of that position is the picture of Virgil as *triumphator*, leading the triumphal procession beside the river. Roman triumphs began at the Circus Flaminius, right in front of the Portico of Philippus, and this was why Fulvius put his temple there, in order to recall his earlier Ambracian triumph.[13] Ennius may well have represented himself as similarly triumphant in his discussion of Fulvius's return from Ambracia with the Muses at the probable climax of the first edition of the *Annales*.[14]

The triumphal imagery continues as Virgil goes on to describe the games that will be held and the sacrificial offerings that will be made at the temple (19–23). He then describes the ivory and gold doors of the temple, which show scenes of Augustus's far-flung triumphs. This passage strongly anticipates the account of Octavian's triple triumph of 29 BC, which is depicted on the shield forged by Vulcan in Book 8 of the *Aeneid*.[15] On a banal level, these similarities may be accounted for by the fact that they were both probably inspired by the same event and the same building. But when Virgil in the *Aeneid* repeats language from the *Georgics*, as he does on a number of occasions, it is never out of laziness or automatism; these moments are significant intertextal connections and must be interpreted as such. The key difference between the two passages is that the *Georgics* emphasizes the start of the triumphal celebrations and then jumps right to the festivities at the temple without a parade in between. From a Roman perspective, Virgil's Mantuan triumphal procession short-circuits. It starts *in campo*, as if in a space like the Circus Flaminius, with the chariots beside the river, but

it goes nowhere, for the temple is also in the same plain by the river. This omission is rectified in the account in the *Aeneid*, which emphasizes the participation of the entire city of Rome in the celebrations and the length of the procession as it leads uphill to its end point at the Temple of Palatine Apollo.[16]

In the ecphrasis of Aeneas's shield, Virgil focuses attention on the way he has fulfilled the promise he made in the temple ecphrasis of the *Georgics* to praise Octavian's military triumphs in his next work. The position of the victory at Actium at the center of the shield (*in medio*, *Aen.* 8.675) and therefore of Roman history echoes the promise to put Caesar at the center (*in medio*, *Georg.* 3.16) of the metaphorical temple.[17] For the purposes of my discussion, the interesting thing is the way Virgil retrospectively creates an Actian triumphal procession that begins in Mantua in the *Georgics* ecphrasis and ends in Rome in the *Aeneid* ecphrasis. The combined picture is of a procession that begins by a river in a place that looks very like the Portico of Philippus in the Circus Flaminius, and that proceeds to another poem and thus through a wildly jubilant Rome to Augustus reviewing the parade in front of the Temple of Palatine Apollo. In other words, when the *Georgics* are read in isolation, Virgil's metaphorical temple looks like a Mantuan hybrid of the Portico of Philippus and the Palatine temple, but looking back from the point of view of the *Aeneid* passage, with its explicit ecphrasis of the Palatine temple itself as the end point of the triumph, what comes to seem more important is the position of the *Georgics* temple by a river as the starting point of the triumph, and thus its echoes of the Portico of Philippus. Virgil thereby creates another connection between the two halves of Augustus's Museum-library project, in that this half-real, half-imaginary triumphal procession begins at the Museum on the Circus Flaminius and ends at the library on the Palatine. Virgil makes clear the links between Augustus's triumph, his building program, and his literary program, of which the *Aeneid* itself is the culminating monument.

In connecting the temple by the Mincius with the shield of Aeneas, Virgil links the promise of a national epic to replace the *Annales* with its fulfillment. There is a strong parallel between the very historical, annalistic epic that the *Georgics* passage seems to promise and the very Ennian, annalistic narrative of the shield ecphrasis.[18] This highlights, by way of contrast, the fact that the *Aeneid* is not in fact a year-by-year panegyric of Roman military victories. Rather, it embeds Republican history in a Trojan framework just as the architecture of the Portico of Philippus takes the Republican *fasti* and surrounds them with a Trojan narrative. Transcending Ennius's project rather than continuing where he left off was always the plan. Virgil's independence lies elsewhere.

Virgil's Temple of Juno at Carthage

The preceding section shows that there is a complex relationship between fiction and reality in Virgil's temple ecphrases. One of the most influential studies of ecphrasis begins thus: "The earliest ekphrastic poetry describes what doesn't exist, save in the poetry's own fiction."[19] Hollander goes on to cite as an important example "the paintings of the Temple of Juno,... described with great regard to how Aeneas himself reads those images." As I noted in the introduction to this book, this established orthodoxy of ecphrasis as an exclusively literary and purely fictional phenomenon needs some modification. It is my contention that, when Aeneas gazes at length upon the scenes of the Trojan War in the temple, every Roman reader of Virgil would have recognized the kind of artwork described there from the Theorus cycle, either from having seen it in the Portico of Philippus or from its provincial imitations, of which the Pompeian temple portico must have been only one of many.[20] This is not to say that Virgil was engaged in a literal description of an actual, existing cycle of paintings. Even the description of the "real" triple triumph and the "actual" Temple of Palatine Apollo on the shield of Aeneas is far from a simple report of facts known to all of Virgil's readers. By contrast, his Temple of Juno is wholly imaginary and so is its art. An imaginary structure should not be expected to house real artworks. But it may well allude to them. The meaning of this ecphrasis can only be properly understood by taking into account all its intertexts in all media. One must examine, as far as possible, its similarities to and differences from the familiar monuments that would have formed the horizon of expectations for Virgil's readers. This is in principle no different from the entirely uncontroversial way one brings a knowledge of Homer, the cyclic epics, and other Greek literary texts to bear upon a reading of these Trojan images.

Knowing the sort of art installation that Virgil's audience would have had as a point of comparison for the fictional ecphrasis can help in two ways. The first is to permit a deepened reading of individual paintings within the Temple of Juno. Aeneas's response to them recalls some of the hermeneutic difficulties any viewer has in trying to ascertain what they represent. In other words, Virgil shows Aeneas as having some of the same interpretive difficulties I have already explored. Virgil's Roman readers knew from personal experience that the identification of these scenes is not always straightforward, particularly when taken out of narrative sequence, and that gave them a different perspective on Aeneas's confident reading. This brings up the second, broader benefit of reading this ecphrasis in light of the Pompeian portico. Aeneas claims to be an authoritative identifier of the images despite the self-evident fact that his response to them is highly subjective, emotional, and biased. Comparing a real portico with similar paintings permits one to see that not only is Aeneas a subjective interpreter; he is also, very probably, an unreliable one.[21] He is very good at identifying Trojans and Trojan allies with whom he is personally familiar, but he does less well with

other scenes. Crucially, he does not know what transpired in the Greek camp between Achilles and Agamemnon; he has not read the *Iliad*. This is one of the reasons he jumps around chronologically. Sequence helps the viewer identify individual scenes in the Pompeian portico, because he or she can compare the sequence of Homer's narrative. Aeneas does not know the full story of Achilles, and this will make all the difference in his future choices throughout the *Aeneid*.

In the *Georgics*, Virgil compared his forthcoming epic to the construction of a temple that had a number of similarities with the Portico of Philippus. In the *Aeneid*, the first temple encountered is likewise in the process of construction and has a decorative program similar to that of the Portico of Philippus. This must be an important programmatic signal. It has long been acknowledged that this ecphrasis is a *mise-en-abyme* of the *Aeneid* as a whole, in that it describes the representation of the Trojan story in art in the middle of an epic that is itself a Trojan narrative. Moreover, by foregrounding Aeneas's emotional reaction to that art, Virgil teaches how to respond to his poem. The Portico of Philippus was a physical metaphor for the great, unwritten Augustan epic, so by incorporating a version of it within his poem, Virgil highlighted the self-referentiality of this passage. In order to understand its particularities, a variety of comparanda must be remembered: the Homeric epics, the cyclic epics, the Trojan cycle in the Portico of Philippus, and Virgil's own Trojan narrative.

A number of caveats must be borne in mind before one can assume that it is possible to recreate, on the basis of the Pompeian portico, the expectations that Virgil's readers would have brought to his text on the basis of their experience, direct or indirect, of the Portico of Philippus. The first is that my claim that the Pompeian cycle descended from the Roman one rests on a hypothesis. Nevertheless, a link with Virgil's text is plausible enough to have been made in passing and in general terms by many scholars over the years. To give a recent example, Torelli writes:

> It is possible that Virgil had the "bellum Iliacum plurimis tabulis" in mind, a proper pictorial cycle, the work of the late classical painter Theoros, which decorated the early Augustan *porticus Philippi*, just as it is probable that the *Tabulae Iliacae*, which were fairly popular among aristocrats in the poet's day, were not unrelated to the composition of these famous Virgilian images.[22]

The second caveat is that, although the Pompeian portico was built and decorated a few years after the publication of the *Aeneid*, it was extensively restored after the earthquakes of the 60s, by which time the *Aeneid* had already become a classic. It is therefore not only possible but likely that the real Trojan portico in Pompeii was influenced by Virgil's imaginary one. It is not a completely independent witness to the real portico in Rome that inspired Virgil's fiction. Despite all these reservations, however, the Pompeian portico can provide some idea of the range of expectations of a Roman

reader of Virgil. It turns out that having a real-life Trojan cycle from a Roman temple is very useful as an object of comparison. It can highlight some surprising omissions from Virgil's imaginary temple, sow doubt as to the correctness of some of Aeneas's identifications, and illustrate a number of hermeneutic problems inherent in viewing this kind of monument.

Before I look at Virgil's paintings in individual detail, I must first clarify some basic issues regarding their physical form, location, and arrangement. The one thing scholars have agreed on is that Virgil's Temple of Juno, with its raised podium, is Roman rather than Greek in style. Though his description of the *picturae* in the temple has been the focus of a great deal of attention from literary critics, there has been considerable variance about their physical aspects. Scholars routinely refer to the images as relief sculpture, despite the fact that what Aeneas looks at is called a "picture" (*pictura*, 1.464), which can only with very great difficulty, or even perversity, be interpreted as anything but a painting.[23] Color features strongly in many of the images: the shining white color (*niveis*, 469) of the pristine, unused tents of Rhesus offsets the blood and gore (*caede cruentus*, 471) spilled by Diomedes. The gleaming gold (*aurea*, 492) belt worn by Penthesilea is set off against her bare breast, and her (implicitly) white skin contrasts with the black skin (*nigri*, 489) of Memnon in the next image. These are paintings, not sculptures. Perhaps the puzzling stubbornness with which modern readers have insisted on viewing these images as carvings despite every implication of Virgil's Latin is a result of the happenstance that ancient temple paintings, except in a few instances, have been lost, whereas many sculptures have survived the millennia.[24]

Another error is that modern critics frequently refer to a continuous frieze, or murals, even though Virgil's diction strongly implies that they are individual panel paintings (*singula*, 1.453).[25] Others refer to frescoes, but it is unlikely that Dido's temple should be thought of as decorated with a cheap substitute for genuine encaustic panel paintings on wood. Still other scholars have wrongly inferred from the difficulties of modern critics that this is a case of deliberate Virgilian ambiguity.[26] It is true that when literary critics disagree about the *Aeneid*, it is often because Virgil has left the interpretation open, but that is not the case here.[27] Virgil's account of the location of the paintings in the temple is clear enough when read carefully; the scale of scholarly misunderstanding is a reflection of the failure of literary critics to read the text closely in the light of material comparanda.[28]

Many critics imply that the images were on the temple building itself, but that runs against the grain of Virgil's description. Moormann rightly observes that Aeneas never enters the temple building proper before the arrival of Dido, which excludes a location in the cella, but he is misled into thinking that the phrase *sub ingenti templo* (1.453) must mean that the paintings were on the lower part of the exterior wall of the temple itself and so he excludes an arrangement in a portico such as that in Pompeii.[29] In fact, the word *templum* does not mean "temple" except when used loosely. The proper word for

the temple building itself is *aedes* and in contrast the strict meaning of *templum* is "sanctuary" or "sacred precinct." This encompasses the entire complex, including any portico and also the parts of the sacred area open to the heavens, for the word's original meaning is connected with the taking of auspices and with the sky.[30] *Sub ingenti templo* can thus be translated as "beneath the vast sanctuary." The word *below* (*sub*) may refer either to the sky above the sacred precinct or to the ceiling of the portico, or perhaps to both. The other phrase Virgil uses of Aeneas's location is *in luco* (1.450), or "in the grove." In the Roman world, the area between the portico and the temple building was often planted with trees and shrubs; archaeological techniques have only recently evolved to the point that this feature can be detected. It is now known that there was such a feature in several Pompeian temples, including the Temple of Apollo.[31] Of course, the paintings were not placed in the grove. By taking the reader into the grove, Virgil shows Aeneas moving away from the temple building itself and toward the boundary of the sanctuary. He first examines the exterior of the temple building and its doors (1.448–49), and in the next line moves into the grove of trees that surrounded the temple building (*in luco*, 450). Then he continues his movement and sees the paintings; he is still within the sanctuary but is separated from the temple building itself by a grove. As Sandbach has said, "A Roman could hardly help applying his own experiences and imagining them as adorning a colonnade enclosing the sanctuary; this was pointed out already by Heyne."[32] In his commentary, Austin notes the connection made by Sandbach and adds Pliny's information about the cycle of Theorus in the Portico of Philippus; he rightly glosses *sub ingenti . . . templo* thus: "Aeneas is now beneath the portico of the temple, looking up."[33] Virgil's readers, especially those familiar with the Portico of Philippus, would not have hesitated to infer that Aeneas was looking at a cycle of individual panel paintings arranged around the portico of the temple. It is worth noting that, in his imitation of this Virgilian passage, the poet Silius puts the paintings of the First Punic War, observed by Hannibal in a temple in Liternum, explicitly in the temple portico.[34]

Unlike the other important works of art described in the poem, no artist is named: no Daedalus, Vulcan, or even Clonus, who made the fatal baldric of Pallas. Indeed, they are credited to a plurality of artists (*artificumque manus*, 1.455), though this may be focalized through Aeneas's ignorance as a visitor. Perhaps this anonymity might be a comment on the status of Theorus, who was, unlike Zeuxis, no name to conjure with.[35] The value of his painting was not, one must suppose, in painterly craftsmanship of surpassing skill but in his handling of composition, characterization, and narrative and the intelligence of his commentary on Homer, as was seen on display in the Pompeian portico. Perhaps his cycle was attractive to Augustus because it already had a particular emphasis on Aeneas, though it is also possible that the Hellenistic cycle was supplemented with additional images at Rome. The anonymity of Theorus, especially when put in contrast with the notoriety of Zeuxis's nude *Helen*, makes him a peer of the nameless yet highly skillful Carthaginian artists.

Before the description of the individual paintings, which is strongly tinted with Aeneas's tears, Virgil gives a very pithy and objective description of the cycle as a whole, which is free from emotion and subjectivity (1.456–58):

> ...uidet Iliacas ex ordine pugnas
> bellaque iam fama totum uulgata per orbem,
> Atridas Priamumque et saeuum ambobus Achillem.

> (He sees the battles of Ilium in due order, the war already proclaimed by fame throughout the world, the sons of Atreus, and Priam, and Achilles, fierce in his wrath against both.)

The phrase "fierce in his wrath against both" is a brilliantly epigrammatic summary of the *Iliad* and the anger of Achilles that is its subject. It also happens to capture very well the iconic image from Pompeii of Achilles drawing his sword as he advances upon Agamemnon. If the distribution of surviving images in Pompeian houses is any indication, this was the most famous image from the Apollo portico; perhaps the same was true in Rome. Virgil begins with a teasing promise that the reader will see a representation of that painting and the rest of the paintings of that cycle. The appetite is whetted for a linear, objective account of the *Iliad* paintings, starting from the beginning of the quarrel between Achilles and Agamemnon and proceeding "in order" (*ex ordine*, 456) until the death of Hector. But that is not what Aeneas gives when he turns to the paintings.[36] The subsequent lines change the tone of the ecphrasis dramatically. Aeneas famously bursts into tears and the rest of the account is punctuated by his tears, groans, and longing. From this point on, Virgil gives a portrait of a disordered mind more than of an ordered portico. Knowledge of the Pompeian portico provides a much better sense of the degree to which Aeneas's subjective response subverts the reader's expectations and thus distorts his account of the cycle. One important difference, as noted, is that Aeneas himself appears to be completely ignorant of the quarrel between Achilles and Agamemnon that sets the plot of the *Iliad* in motion. Thus the promise of this brief tease is never fulfilled: Aeneas cannot react emotionally to the painting of the quarrel between the Greek leaders because he has no way of knowing what that painting was about. He does not know that Achilles was fiercely angry with Agamemnon and that he nearly killed him. Aeneas does not mention the presence of that painting, not because it is absent, but because it is meaningless and therefore invisible to him.

The most striking difference between the expectations set up by this short objective account of the cycle and the lengthy subjective description of the ecphrasis proper is the chronological disorder of the paintings, despite Virgil's plain and unambiguous statement at the outset that the Trojan War was described "in due order." Most readers have correctly seen that this apparent contradiction is a result of Virgil's subjective

filtering of the portico through Aeneas's tears.[37] He leaps from one scene to another as he recognizes familiar figures, and this accounts for the disorder. Other readers have wrongly thought that one should imagine that the paintings themselves are out of order. While it is true that ancient visual narratives often have discontinuities in strict chronological order, nevertheless ordering and proximity are important cues for identifying subjects. The smaller-scale Trojan cycles in Pompeii are mostly in order, with occasional jumps, just like the cycle in the Apollo portico, which seems to have been continuous on the east wall before jumping to the end of the epic on the north wall. In general, sequence is vitally important for reading visual narratives without textual labels. The disorder in Aeneas's pell-mell experience of the art in the Carthaginian portico contrasts strongly with Virgil's initial emphasis on the ordering of the visual narrative and with the reader's expectations of how such a portico would have been arranged. By jumping around from painting to painting, Aeneas has unmoored himself from one of the main cues to the identification of the subjects. Virgil thus presents not so much an ecphrasis as a description of one man's reaction to a work of art in which he has a very large emotional investment. In so doing, Virgil follows the lesson taught by Zeuxis's quotation of Homer in the Portico of Philippus: verbal artists are better advised to describe human reactions to visual phenomena than to attempt to describe those phenomena directly.[38] But Virgil also illustrates one of the limitations of visual art: its ambiguity.

A list of the paintings in the sanctuary of Juno demonstrates the disorder. It is not possible to give a definitive list, for there are several ambiguities in the account. First the Greeks are in retreat and then the Trojans. Common sense would seem to imply that these are separate paintings, but this is not made explicit. The dragging of Hector's corpse is mentioned in the pluperfect, which seems to imply that this act was not represented. Aeneas and Memnon are mentioned together in a way that might imply that they are in the same painting, but this may be due to the haste with which Aeneas passes over the representation of himself. Subject to those qualifications, Aeneas seems to identify nine paintings:[39]

1. Trojans rout the Greeks
2. Greeks, led by Achilles, counterattack
3. Death of Rhesus
4. Death of Troilus
5. Trojan women supplicate Pallas
6. Ransom of Hector's corpse
7. Aeneas in combat
8. Memnon
9. Penthesilea

At first glance these are quite drastically disordered. Even accounting for Aeneas's eyes leaping from one painting to another, it is hard to see how an episode from the *Cypria*, the death of Troilus, could pop up in the middle of the *Iliad*. Is one to imagine that Aeneas was running from one side of the portico to the other? It is no wonder that some readers have discounted Virgil's claim that the paintings were "in order." The difficulty in this passage is a result of the way Virgil has carefully overlaid two separate sources of disorder: Aeneas's emotional leaping from subject to subject and his complete misidentification of several scenes. There has been a large amount of scholarly work on the way the focalization of these paintings via Aeneas reveals his partisan bias and his tendentious misinterpretations.[40] Now that I have suggested a better idea of the expectations of Virgil's ancient readers by extrapolating from the Pompeian portico, a case can be made that Aeneas is not only biased in his interpretations but prone to outright misidentification.

Ancient artistic practice in labeling the names of figures was inconsistent. Some artifacts, such as many of the *tabulae Iliacae*, have nearly all the figures labeled, while others, such as the various miniature domestic Trojan cycles in Pompeii, do so occasionally. As far as is known, there were no labels on the Trojan paintings in the Temple of Apollo. The viewer would have been helped by the iconography and the fact that it followed the Homeric narrative quite closely. Nevertheless, it would have been something of a test of the viewer's knowledge of Homer. If you did not have that sort of information at your fingertips, there might have been priests or guides lurking in the portico who would have explained the art for a small financial consideration. Here in Carthage, by contrast, Aeneas and Achates are quite alone and are in any case magically invisible to any lurking *ciceroni*. Of course, Aeneas has the benefit of having lived through the events depicted in the paintings, so he thinks he has no need of labels or guides. One of the surprises of this passage is that Aeneas's personal perspective is less of an advantage than it might at first seem. His first specific reaction is to say "Look! Priam!," thus presenting himself as someone with intimate knowledge of the people represented there.[41] But his personal, subjective perspective from the Trojan side of the war is also a limitation.[42] For one thing, it causes him to begin not at the beginning of the story. He leaps past paintings that we as readers know ought to be there: Calchas explaining the plague to the assembly of the Greeks and the quarrel of Achilles and Agamemnon. To Aeneas those are meaningless paintings of episodes that he knows nothing about. His eye is drawn instead by familiar Trojan faces. A reader with knowledge of both Homer and the cycle of Theorus is in a better position than the hero to understand some of what he is seeing.

The first two paintings seem straightforward enough (1.466–68):

namque uidebat uti bellantes Pergama circum
hac fugerent Grai, premeret Troiana iuuentus;
hac Phryges, instaret curru cristatus Achilles.

(For he was seeing how, as they fought around Pergamon, in one place the Greeks were in flight with the Trojan youth pushing them back; in another place the Phrygians fled as Achilles in his crested helmet was pressing them close with his chariot.)

First the Trojans are successful; then the Greeks. This is an apt summary of the flow of battle in the *Iliad*. Presumably Aeneas could tell the sides apart by the difference in their armor. But this presents a problem. The tide of battle turns when Achilles, who is wearing his helmet, pushes the Trojans back. In the *Iliad*, by contrast, the tide turns when Patroclus, wearing Achilles's armor, pushes the Trojans back. How does Aeneas know who is under the helmet of Achilles in this scene? He cannot, and the fact that he simply assumes that the wearer of Achilles's helmet must be Achilles points to the limitations in his knowledge, owing to his position inside Troy. He does not have direct knowledge of anything that happened in the Greek camp. Aeneas does not know of the quarrel between Achilles and Agamemnon and its aftermath; all he knows is that at one point Achilles was absent from the battlefield and the Trojans started to gain ground. Then he seems to return and in Book 16 they lose what they have gained. There is never a grand announcement to the Trojans that it is Patroclus who has been wearing the armor of Achilles; the definitive revelation must be when Apollo knocks the disguise from him (16.793–804).[43] But for how long has he been wearing it? Homer never says what the Trojans infer retrospectively from this discovery; he certainly does not describe a moment in which the extent of the deception is revealed to all of them.[44] Aeneas therefore has no reason to suspect the truth behind the initial reappearance of Achilles's helmet on the battlefield. He is confident that a picture of the helmet of Achilles implies that Achilles was under it, but the reader ought to know that the matter is not so certain. This sets in relief his striking ignorance of what was happening in the Greek camp. He may have been at Troy, but we have read Homer and he has not.

In the next painting, Aeneas is in a much better position to identify the main figure, for it is Rhesus, an important Trojan ally (1.469–73):

nec procul hinc Rhesi niueis tentoria uelis
agnoscit lacrimans, primo quae prodita somno
Tydides multa uastabat caede cruentus,
ardentisque auertit equos in castra prius quam
pabula gustassent Troiae Xanthumque bibissent.

(Not far away from that he tearfully recognizes the tents of Rhesus with their snow-white canvas, which, betrayed in their first sleep, the blood-stained son of Tydeus laid waste with much slaughter; and he turned the fiery horses away to the Greek camp, before they could taste the grass of Troy or drink from the river Xanthus.)

Here is an episode of Greek perfidy that happened right next to the Trojan camp, and whose aftermath Aeneas would have witnessed personally. All the details here correspond closely to the narrative in *Iliad* 10, except that Aeneas is not mentioned there as a witness. Perhaps one is simply to presume his presence, or, more likely, to think of the pseudo-Euripidean *Rhesus*. In that drama, Aeneas plays an important role in the lead-up to the episode on the Trojan side: he is the one to prompt the sending out of Dolon as a spy. One difference here is that Virgil's Aeneas demonstrates knowledge of the prophecy that Troy could not be taken if Rhesus's horses were to pasture and drink at Troy, a story that is absent from both Homer and pseudo-Euripides. He does not know everything, however. Close attention to Aeneas's Latin implies that he attributes a purpose to the Greeks that is false: he thinks that Diomedes stole the horses because he was familiar with the prophecy of their importance to Troy's safety; but this is not the case in the *Iliad* or the *Rhesus*.[45] That is to say, Aeneas has important information about the Trojan side unknown to both Homer and Euripides, and he erroneously presumes that the Greeks also know this. At the very moment when Aeneas demonstrates his knowledge of important details of the Trojan story, he simultaneously reveals his ignorance of the motivations of the heroes on the Greek side, who we know do not have that knowledge.

Another gap in Aeneas's information is that he attributes the mission solely to Diomedes and omits mention of Ulysses. Diomedes is a Greek hero whose appearance Aeneas knew all too well, for he met him face-to-face in the duel in *Iliad* 5, where he was seriously wounded. He can identify Diomedes from that unpleasant experience, but he is unable to identify Ulysses, who must also have been present in that painting. It ought to have been Ulysses rather than Diomedes to lead away the horses of Rhesus (see *Il.* 10.498–501). Aeneas's own words imply the presence of two protagonists, one slaughtering the sleeping soldiers of Rhesus (*uastabat*), the other leading away the horses (*auertit*), for it is hard to see how Diomedes could do both at the same time. Because he cannot name the other figure in the painting, Aeneas attributes all of the action to Diomedes. Thus, once again, Aeneas reveals his ignorance at the same time that he demonstrates his intimate knowledge of the events and people depicted. The fact that Aeneas can recognize Diomedes is itself highly significant. He is the only Greek hero whom Aeneas recognizes in the paintings from firsthand knowledge. In the first painting he only recognizes Achilles's armor, and later he recognizes him because of the presence of Priam. When an ancient reader familiar with a visual cycle like the one in Pompeii considered why Aeneas can recognize that particular Greek hero, he or she might naturally think of the painting of Diomedes wounding Venus while she was saving the wounded Aeneas. Unlike the speech of Calchas or the quarrel of Achilles and Agamemnon, this is a scene that Aeneas could have recognized from personal experience. So that painting is another significant omission. Apart from the extremely vague reference a few lines later to seeing himself in the paintings, Aeneas

chooses, understandably enough, not to dwell upon the details of the representations of his own humiliation. By now the reader knows that Aeneas's experience of the paintings reveals not only ignorance but also his willful self-censorship.

The next painting makes the limitations in Aeneas's interpretations even more obvious. He pities young Troilus for being unequal to the challenge of meeting Achilles, but it was Aeneas himself whom the Pompeian portico showed as unequal to combat with Diomedes. Indeed, some depictions of the death of Troilus in Greek art show Aeneas vainly attempting to come to his rescue, so it was not only Troilus who was unequal in this meeting.[46] The bigger curiosity here is that the painting Aeneas confidently identifies as showing Troilus actually looks much more like the Pompeian painting of the dragging of Hector's body (1.474–478):

> parte alia fugiens amissis Troilus armis,
> infelix puer atque impar congressus Achilli,
> fertur equis curruque haeret resupinus inani,
> lora tenens tamen; huic ceruixque comaeque trahuntur
> per terram, et uersa puluis inscribitur hasta.
>
> (In another place Troilus, his armor flung away in flight—unhappy boy, and ill-matched in conflict with Achilles—is carried along by his horses and, having fallen backward, clings to the empty chariot, still clasping the reins; his neck and hair are dragged on the ground, and the dust is scored by his reversed spear.)

Virgil must have known the version of the myth of Troilus in which his death, like the theft of Rhesus's horses, embodied a prerequisite for the fall of Troy.[47] As scholars have long noted, however, this scene is completely different from all other representations of the death of Troilus in Greek and Roman art.[48] In the myth, Troilus goes off to water his horses, sometimes alone, sometimes with his sister Polyxena, but always without a chariot, when Achilles ambushes him. In art he is shown on horseback or leading a horse or both; he is not fighting from, or killed while riding, a chariot.[49] There is a tradition that Achilles is filled with desire when he sees Troilus at the ambush, pursues him, and kills him when his advances are rejected; this version makes the presence of a chariot even stranger. There are a number of visual representations of the death of Troilus that include Aeneas as a witness, but none of them look like this.[50] The only source with anything similar to this painting is the narrative of the myth by the late, anonymous compiler known as the First Vatican Mythographer; but that version surely derives from these lines of Virgil.[51] In the face of the complete idiosyncrasy of Aeneas's identification of this scene, the possibility that Aeneas is completely wrong here must be entertained. Virgil gives a hint of what

this painting really represents by alluding in these lines to Homer's description of the dragging of Hector's corpse.[52]

It is an interesting coincidence that viewers faced a very similar problem of identification in Pompeii, where there was an image of an inverted man tumbling or suspended from a chariot (see fig. 54). Many observers decided that this showed the dragging of Hector's body, but others have been sure that it shows a warrior falling out of a chariot. Some, on the basis of Virgil's text, have identified this as Troilus.[53] Perhaps there were debates among contemporary Romans in Pompeii as to whether this painting really showed the dragging of Hector or was some battle scene erroneously pressed into service to show that event; perhaps there were similar debates at the Portico of Philippus in Rome. In the absence of labels, there must have been room for debate. Hector is Troilus's older brother, so it is logical that they should look alike. The corpse's head is covered in dust and is upside down, so it would be no shame for Aeneas to fail to recognize his friend. The Pompeian painting as shown by Morelli does not completely agree with Virgil's description: the warrior does not seem to be holding the reins; his spear is more sideways than reversed; and there is an unexplained defeated Trojan sitting below. But perhaps the difficulty of understanding all the elements of that picture is precisely the point. Aeneas confidently misidentifies a contemporary painting in the Portico of Philippus of difficult interpretation, and so glides blithely over what may have been a notorious interpretive *crux* at Rome. In a moment it will become clear that Aeneas's memory of the dragging of Hector's body is very unreliable, so it is not improbable that he should misidentify a painting that in fact showed that event.

That it was at least the intention in Pompeii that this painting should show the dragging of Hector was demonstrated by its probable position on the north wall near Priam's supplication of Achilles. Having abandoned any effort at reading the paintings as a sequential narrative, Aeneas has now begun to misidentify even his close friends. It is poignant that Aeneas remembers Hector as a man young enough to be confused with Troilus. Once it is clear that Troilus has no real place here, the disordering of the paintings in the Carthaginian portico becomes much less drastic. If this is actually a painting of the dragging of Hector's body, then the first part of Aeneas's experience of the paintings reflects a mildly disordered encounter with a purely Iliadic cycle:

Books 7–15: Trojans push Greeks back to their ships
Book 16: Greeks, led by Patroclus in Achilles's armor, push Trojans back
Book 10: Rhesus
Book 22: Dragging of Hector's body
Book 6: Trojan women pray to Athena
Book 24: Priam ransoms Hector's body

It is still the case that Aeneas must be jumping backward and forward from painting to painting as he identifies, or thinks he has identified, various subjects from the plot of the *Iliad*. But the removal of Troilus as a spurious subject leaves a much more intelligible sense of Aeneas gazing at a portico not unlike the one in Pompeii.

The next passage returns to the city of Troy, and once more Aeneas is in a competent position to recognize the scene as an eyewitness (1.479–82):

> interea ad templum non aequae Palladis ibant
> crinibus Iliades passis peplumque ferebant
> suppliciter, tristes et tunsae pectora palmis;
> diua solo fixos oculos auersa tenebat.

> (Meanwhile, the Trojan women were going with flowing tresses to the temple of unjust Pallas, and they were humbly bearing her robe, mourning and beating their breasts with their hands: but the goddess turned away and kept her eyes fast upon the ground.)

At the start of Book 6, of the *Iliad*, Helenus has approached Aeneas and Hector to suggest that they rouse the Trojan troops and he further suggests to them both that Hector go into the city to get the women to make this offering of a peplum and a sacrifice to Athena in the hope that she will call off the attack of Diomedes.[54] Hector then goes on his own into the city to deliver the command, and the Trojan women make the offering that is then rejected. The scale of Aeneas's own involvement in this episode in Book 6 of the *Iliad* is similar to that in the *Rhesus* of Euripides. He is marginally involved, as a foil for Hector, and then disappears from view immediately. Virgil has carefully chosen another episode in which Aeneas is not a protagonist but rather a very, very peripheral presence: paintings of this sort he can identify reliably and without bias.[55] This painting would have been very near the wounding of Aeneas by Diomedes, which happened just before this, so once again there is a reminder of a significant absence from this account.

Now comes the climax of the *Iliad*, which is also the climax of Aeneas's emotional response (1.483–87):

> ter circum Iliacos raptauerat Hectora muros
> exanimumque auro corpus uendebat Achilles.
> tum uero ingentem gemitum dat pectore ab imo,
> ut spolia, ut currus, utque ipsum corpus amici
> tendentemque manus Priamum conspexit inermis.

> (Achilles had dragged Hector three times around the walls of Troy and was selling his lifeless body for gold. Then indeed from the bottom of his heart he

> heaves a deep groan, as he catches sight of the spoils, the chariot, and the very corpse of his friend, and Priam stretching out his weaponless hands.)

The description of Priam stretching out his hands corresponds perfectly to the scene of the ransom of Hector's body in the Pompeian portico (see fig. 55). The parallels from the *tabulae Iliacae* suggest that the missing right half of the picture would have shown the cart by which Priam brought the ransom and by which he would return his son's body to Troy.[56] Finally, Aeneas has correctly identified all the protagonists in a painting. But even here there is an error and a misunderstanding.

First, the error: Virgil goes out of his way *not* to say that Aeneas saw the dragging of Hector's body represented: that information is presented in the pluperfect, as background to the scene of Priam's ransom of the body.[57] In other words, a painting of that episode has been skipped over and the fact emphasized by mentioning it. The reader already knows why Aeneas does not view and react emotionally to a painting of that traumatic event: he has misidentified the painting that is supposed to show the dragging of Hector as showing the death of Troilus. Virgil further emphasizes the unreliability of Aeneas here by giving him a memory of the dragging of Hector's body at odds with Homer's canonical account. In the *Iliad*, Achilles chases Hector three times around the walls of Troy, and after he kills him he drags him straight from the battlefield to the Greek camp. He later drags Hector three times around the tomb of Patroclus, where Aeneas could not have seen it (24.16). If this statement is taken to be Virgil's, it is simply a case of his preferring to follow the Euripidean tradition, according to which the body was dragged around the walls of Troy.[58] But it seems more likely that this pluperfect statement is focalized, like the rest of the scene, through Aeneas's perspective. If Homer is taken to be more authoritative than Euripides on Trojan matters in the realm of epic, it seems as though Virgil is hinting that Aeneas's memory of events has been corrupted by other stories, other traditions. Aeneas could not have seen the continuing mistreatment of Hector's corpse in the Greek camp. He has heard rumors, however, and these have condensed into a false memory of having seen the body dragged around the walls. This realization in turn helps to explain in retrospect how Aeneas managed to misidentify as the death of Troilus the earlier painting that actually showed the dragging of Hector's body: he never saw either episode properly.

Now for the misunderstanding: Even though he was not present in Achilles's tent with Priam, Aeneas has no trouble identifying the scene. He recognizes Priam, the ransom, the Trojan king's gesture, and his surroundings, and that is enough to know where he is and what he is doing. So far, Virgil has strictly alternated paintings for which Aeneas has firsthand knowledge and those for which his ignorance leads him into serious error: he understands the Trojan success in the first painting but

misidentifies Achilles as leading the Greek counterattack in the second; he recognizes the killing of Rhesus near the Trojan camp but misidentifies the killing of Troilus; he identifies the prayer of the Trojan women, and now one might naturally anticipate another misidentification. The issue here, however, is more subtle and has to do with his ignorance of what was spoken in that tent between Priam and Achilles. All he knows is that Priam left Troy with a ransom and came back with Hector's body. As many readers have noted, Aeneas's characterization of the transaction as Achilles "selling" Hector's body back to Priam is very strongly focalized through his Trojan perspective and biased against the Greek hero. By emphasizing the financial side of the transaction, turning Achilles into a butcher selling meat, Aeneas reveals a much profounder ignorance of the *Iliad* than ever before. He may not have known who was under Achilles's helmet when he first reappeared on the field of battle; he may not be able to recognize Ulysses; he may not have been there when Troilus was killed or when Hector's body was mistreated; but these errors do not, in the final analysis, matter a great deal. Here he has made a correct identification from external appearances, but this only serves to emphasize his ignorance on a much more profound level. Priam did not tell him about everything that was said in that meeting with Achilles. Or perhaps he tried to tell Aeneas, but the latter was not in an emotional position to comprehend the humanity of Achilles. Priam and Achilles share a moment, the most important in the *Iliad*, when they grieve together and realize what they have in common. Achilles sees in Priam his own father, destined to die alone. Ultimately, he releases Hector's body as a gesture of respect toward the old man; the ransom is merely a routine formality and Zeus's command merely an externalization of Achilles's turn toward self-knowledge. Aeneas knows none of that.

There is a point to this parable of misreading the painting. Aeneas does not know that, immediately after the scene of Priam stretching out his hands at the feet of Achilles, the Greek hero takes him by those hands, raises him up, and bids him to sit. He does not know of the tears they shared, because he only knows the barest outline of the narrative; he does not know the text of Homer. Aeneas's failure to understand the moral lesson of the *Iliad* has enormous consequences for his own life. As many readers have seen, Aeneas's journey in the second half of the *Iliad* can be interpreted as his transformation into his nemesis, Achilles. The Sibyl makes a dire prediction of "another Achilles" (6.89), who seems at first to be Turnus; but as the Trojans turn from losers into winners, Aeneas, after the death of Pallas, his own Patroclus figure, is the better fit for that description. One striking feature of this transformation is the lack of self-awareness shown by Aeneas. Why does he not see that he is following in the footsteps of the hated Achilles? The scene in the Temple of Juno gives the answer and shows the limitations of Aeneas's perspective on the Trojan War. When the Sibyl warns Aeneas that the war is about to repeat itself in Italy, Aeneas's response is to wave away her concerns (6.103–5):

> incipit Aeneas heros: "non ulla laborum,
> o uirgo, noua mi facies inopinaue surgit;
> omnia praecepi atque animo mecum ante peregi."

(The hero Aeneas replied, "Suffering cannot come to me in any new or unforeseen form, o maiden; I have foreseen all this and gone over it in my mind.")

The reader knows, however, that this confidence is misplaced. Aeneas's failure to understand the Trojan paintings in Carthage shows that he has not fully understood the events of that war and he cannot foresee how he will repeat the tragedy of Achilles. Hence the tragic irony of his prediction that suffering cannot come to him in any new form. He will repeat the Trojan War, and his experience will be new to him, if not to the reader, as he repeats the events on the Greek side about which he is ignorant.

Despite Virgil's initial, objective indication as author that the paintings show "Achilles savage to both sides," Aeneas's subjective response shows clearly that he knows nothing of Achilles's wrath (μῆνις) toward his own commander nor of its terrible consequences for Achilles himself. For the Trojans, the fact that Patroclus happens to be wearing Achilles's armor when he is killed by Hector is one random and inexplicable detail among thousands, lost in the fog of war. This is why Aeneas does not recognize the pattern he is following in the latter books of the *Aeneid* after Pallas is killed. Furthermore, when Turnus kneels before Aeneas at the very end of the epic, grants all that he wants, and invokes the pity of his own father and the memory of Aeneas's father, the poem ends with an unmistakable failure to achieve precisely the momentary resolution with which the *Iliad* ends. Aeneas is ignorant not only of the journey Achilles has made before him but also of the lesson the Greek hero learned at its end.[59]

One school of Virgilian interpretation maintains that when he kills Turnus, Aeneas turns into Achilles; but it can be put in terms stronger than that. He does not turn into the Achilles we meet at the end of the *Iliad*, who makes a gesture of respect and reconciliation toward his sworn enemy. He turns into the non-Homeric Achilles of his very own half-ignorant, caricatured, one-sided interpretation of the Trojan paintings: Achilles as the remorseless butcher. Or so one school of thought might put it. Some view Aeneas as righteously exacting a debt owed to Evander that it would have been shameful to forgive. Others will view the killing of Turnus as a betrayal of the nobler Roman values urged by Anchises in the underworld and as the moment in which Roman civil strife gets its founding charter. Whether or not one thinks Aeneas is justified in the anger that leads him to kill Turnus, and there are strong and plausible views on both sides, one thing is clear: with the final lines of the epic Aeneas becomes defined by his anger just as, from the first word of the *Iliad*, Achilles is defined by his anger. In this respect, those who view the anger of Aeneas at the end of the epic

positively and those who view it negatively can agree on the importance of Aeneas recapitulating the role of Achilles in the final books of the epic. What makes this recapitulation possible is his ignorance of the plot of the *Iliad* as it unfolded in the Greek camp at Troy, regardless of whether one reads it as a glorious redemption of the Homeric model or as tragic blindness.

Turning back to the paintings, one finds that the post-Iliadic material puts Aeneas on firmer ground, or seems to. Virgil thus acutely illustrates how an observer confronted with an unfamiliar sequence of works of visual art may make progress in understanding one section, where several clues come together to illuminate a set of related images, while in another section the clues do not come together and the viewer remains baffled. Aeneas apparently identifies these post-Iliadic pictures correctly; they come one after another and are represented in very nearly the correct sequential order (1.488–93):

> se quoque principibus permixtum agnouit Achiuis,
> Eoasque acies et nigri Memnonis arma.
> ducit Amazonidum lunatis agmina peltis
> Penthesilea furens mediisque in milibus ardet,
> aurea subnectens exsertae cingula mammae
> bellatrix, audetque uiris concurrere uirgo.

> (He recognized himself, too, mingled with the Achaean chiefs, and the ranks of the East, and the armor of black Memnon. Penthesilea in fury leads columns of Amazons with their crescent shields and blazes amid her thousands, the warrior queen binding a golden belt below her naked breast: and she dares as a maiden to fight against men.)

This passage makes a transition from the end of the *Iliad* to the start of the *Aethiopis*. This cyclic epic began with the arrival of Penthesilea, and her death was followed by the arrival of Memnon. It is true that Memnon and Penthesilea occur in reverse order, but this merely serves to highlight Aeneas's tendency to jump around locally and his independence from the narrative order of the text.[60] If Aeneas's reaction to his own image is put aside for a moment, one sees that he can hardly fail to identify Memnon and Penthesilea, for two reasons. They were both important Trojan allies, who arrived after the action of the *Iliad* and would have fought side by side with Aeneas. They are also allies of utterly distinctive appearance. Memnon is the only black hero in the Trojan cycle and Penthesilea is the only female warrior. In case their race and gender were not apparent in the images, Virgil further alludes to the distinctive weaponry of both: Memnon's, like Achilles's, was forged by Vulcan.[61] Ending the ecphrasis with a run of correct identifications highlights by contrast the difficulty Aeneas has had with the Iliadic material, driven as that plot is by tensions within the enemy camp. The plot of the *Aethiopis*, by contrast, revolves around comings and goings of allies on

276 ART AND POETRY IN ROME

the Trojan side rather than internal dynamics on the Greek side. It is not, therefore, that Aeneas is a fool or a bad viewer of the art, but that his perspective is limited as much as enhanced by being an actor in the events at Troy.

Another way in which Aeneas's bias as an actor is evident is in his identification of himself in the paintings, where he tells suspiciously little.[62] The line about himself mixed in with the leading Greeks is by far the vaguest in the entire ecphrasis; it is not even clear if this is a separate painting or the same one in which Memnon appears. This vagueness has rightly attracted suspicion; some readers, as noted already by Servius, have seen this as an allusion to the tradition that Aeneas was in treacherous communication with the Greek enemy while at Troy.[63] That obscure story is an unlikely part of a pictorial cycle like this. Rather, this passage should be read as confirmation that Aeneas did indeed recognize the painting of his rescue from Diomedes (see fig. 29) and has been glossing over it.[64] This is not surprising; it is a thoroughly humiliating ordeal: his horses are stolen and he is only saved from certain death by the intervention of his mother, who, to compound the family ignominy, is wounded in the process. The other surviving scene from the Pompeian portico in which Aeneas appears shows him in an equally unheroic light. In that painting he is a boy of five, being handed over by his distant and as-yet-uncaring mother, who is taking him from the nymph who has raised him to the father he does not yet know (see fig. 66). Both his mother's distance and Aeneas's perpetual need of being rescued by her have just been reinforced by the previous scene in the *Aeneid*, in which Venus disguised herself while pointing out to Aeneas the way to Carthage. Aeneas's suppression of the details of this painting would have seemed to Virgil's readers an eloquent admission of the awkwardness of at least some of the moments in his own history. This tendency to overlook details that might reflect badly on oneself is only human, and it exemplifies the broader emphasis in this passage on the limitations of Aeneas's personal point of view on the paintings.[65] Perhaps this is a warning to be on guard when listening to Aeneas's narration of the fall of Troy at the palace of Dido. Does he show equal blindness to occasions for self-blame? Finally, Virgil's readers might also have noted other omissions from the portico, which is to say the absence of other famous scenes from Aeneas's account, such as the painting of the discovery of Achilles on Scyros, known from its popularity in Pompeii.[66] Aeneas would not be in a position to make any sense of that image if it were present, and moreover it would not fit with his one-sided view of Achilles as nothing but a butcher.

On the walls of Juno's temple in Carthage, Aeneas (mis)reads his own fate, just as unaware of the real meaning of the Iliadic story as he is oblivious to the images of Roman history in the epic's other extended ecphrasis, the shield forged for him by Vulcan. Or perhaps it is more correct to say that Aeneas is better served by the shield, which he cannot even begin to understand, than by the paintings, which he half understands but half misinterprets. Both descriptions promise narratives of war that will be "in order" (*Iliacas ex ordine pugnas*, 1.456; *pugnataque in ordine bella*, 8.629),

which ought to help Aeneas to understand them. In both cases, Aeneas should have a hermeneutic key: for the temple, his personal experience of the Trojan War; and for the shield, his personal meeting with the protagonists of Roman history in the underworld. Even though he has recently met the shades of Romulus and Augustus, he fails to recognize them on his shield. This is because he does not really have a good grasp of the narrative of Roman history and because he is not familiar with its iconographical language. The images of the she-wolf suckling the twins and of the Egyptian fleet in retreat mean nothing to him. So he gazes in uncomprehending wonder; but Virgil's description of the shield remains objective, ordered, annalistic. In Carthage, by contrast, Virgil's promise of narrative order is interrupted by Aeneas's impulsive and emotional attempt to read the images in isolation from Homer's narrative.

This double failure of ecphrastic hermeneutics should warn against facile interpretations of the fictional portico. The reader comes to the Temple of Juno, sees the parallel with the decorative scheme of the Portico of Philippus, and concludes that Virgil is hereby advertising his epic as the fulfillment of Augustus's demand for a new national epic. Then one immediately discovers that the key Aeneas claims to possess for interpreting the Trojan paintings, his participation in the events depicted, is less reliable than he thinks. Despite their being housed in the Temple of Juno, his sworn enemy, Aeneas interprets the paintings as if telling the Trojan tale from a perspective of sympathy for his side of the story.[67] He is shown to be unaware of the depth of the enmity of the goddess who has just tried to kill him, and he does not seem to understand that there might be another way of interpreting the story of the Trojan War.[68] The reader should therefore be wary of using the Portico of Philippus as a key to interpreting this scene. The *Aeneid* as a pro-Augustan national epic, with Virgil playing Ennius to Augustus's Fulvius, embedding the now-ended annalistic history of the Republic within the story of the Julian family—all this is an important aspect of the epic but is only one side of the story. Virgil stages a very concrete parable of interpretation. If Aeneas stands for Augustus here, as he so often does, then the Trojan paintings stand for the *Aeneid*, as many readers have already observed. Like Aeneas, Augustus will have approached this work confident of possessing a key to its interpretation. Augustus laid out the blueprint for the *Aeneid* in the decorative program of the Portico of Philippus and financed its writing. No doubt he had Virgil's personal word on his unhesitating support for the regime. But this parable of viewing teaches that one can be blinded by insight. Having a special key to the interpretation of a work of art can, and usually does, mean ignoring those things that do not fit and misconstruing others. This is not to say that the Augustan interpretation of the *Aeneid* is not vitally important, but it is not the whole story. The Temple of Juno in Carthage links the structure of the *Aeneid* to the architecture of the Portico of Philippus and thus seems to authorize an Augustan interpretation of the poem, but Aeneas's confident yet wildly inaccurate misinterpretation of that monument immediately undermines the authority of that reading.

Horace's Laurel Crown

Virgil was not the only poet to respond to the challenge of the Portico of Philippus. In the next few sections, I look at the reactions of Horace and Propertius to this same structure. Inevitably, these are strongly influenced by Virgil's metaphorical temple by the Mincius. Both of these poets defend their own choice of genre, lyric and elegy respectively, and decline the invitation to renew Ennian/Fulvian epic for Augustus. They differ, however, in the nature of the refusal. Horace represents his *Odes* as an answer to Augustus's call, but one that takes a very different literary/architectural form. In some places he offers lyric as a second-best substitute for epic; in others he hints that what the world reckons as inferior is, to one who knows, rather superior. In any case, he can fairly claim that the *Odes* were delivered more promptly than the *Aeneid*. Propertius, by contrast, flatly refuses the invitation to epic and casts his writing not as a substitute for but as an antithesis to what Virgil has promised Augustus. I argue that both poets comment upon the progress of the *Aeneid* in somewhat skeptical terms. Horace appears to speak in a spirit of friendly rivalry. There may be a sharper edge to Propertius's response, though opinions differ widely on his relationship to Augustan ideology. His most explicit allusion to the progress of the *Aeneid* can be taken in two different ways. When he says *nescio quid maius nascitur Iliade* (2.34.66), does he mean "something greater than the *Iliad* is being born," or just "something larger"? For a follower of Callimachus, who said "a big book is a big evil," bigger does not necessarily mean better.[69]

It is difficult to think one's self back to the days before the *Aeneid* was published, when it was still just a work in progress. While Horace was writing the first three books of the *Odes* and Propertius Books 2 and 3 of his elegies, the success of Virgil's epic in progress was not a foregone conclusion. They thought of him not as a writer of epic but as a writer who had begun his career with an orthodox neoteric/Alexandrian rejection of epic. The surprising about-face announced in the form of Virgil's Mantuan temple metaphor was still a recent memory and they will have heard only recited excerpts of his epic in progress, perhaps no more than scraps of Book 1. At this stage, the tension between Virgil's anti-epic past and his epic future was still an obvious paradox. It is not surprising that, in this narrow window of time, Virgil's contemporaries were reserving judgment about the outcome. Of course, once the *Aeneid* was published, matters changed. The fourth book of Horace's *Odes* and the fourth book of Propertius's elegies both look back on the *Aeneid* as an instant classic. They acknowledge that Virgil managed to reconcile all the apparently impossible contradictions that seemed earlier to stand in the way of its success: an epic encompassing the scope of both Homeric poems that nevertheless continued to adhere to a Callimachean aesthetic; a national epic on Roman history that managed to avoid the instant obsolescence of propaganda; a work for hire, whose architecture was dictated by an Augustan monument, but that

nevertheless spoke the truth to power. At the moment in time I am concerned with, however, all this lay in the future and the only thing that was evident was the scale of the problem Virgil had set himself.

The best place to begin discussing Horace's response to the invitation to Ennian epic embodied by the Portico of Philippus is at the end of the first collection of *Odes* (3.30):

> Exegi monumentum aere perennius
> regalique situ pyramidum altius.
>
> (I have constructed a monument more durable [or more Ennian?] than bronze, taller than the royal structure [or decay] of the pyramids.)[70]

Here Horace invokes the same metaphor that Virgil does in the *Georgics*: the poem as a monument, a metaphor that surely goes back to the intimate connection between Ennius's *Annales* and Fulvius's temple. Horace speaks here in the perfect tense of a completed construction, whereas Virgil speaks of the future. Virgil's Mantuan temple responded to the Portico of Philippus, especially in repeating the claim to have brought the Muses to Italy for the first time. Despite the difference in genre, Horace makes a parallel claim here:

> dicar, qua uiolens obstrepit Aufidus
> et qua pauper aquae Daunus agrestium
> regnauit populorum, ex humili potens
> princeps Aeolium carmen ad Italos
> deduxisse modos. sume superbiam
> quaesitam meritis et mihi Delphica
> lauro cinge uolens, Melpomene, comam.
>
> (Though of humble origin, I shall be spoken of where the fierce Aufidus roars and where Daunus, short of water, ruled over a rustic people, as the first with the power to have brought Aeolian lyric song to Italian measures. Accept the pride earned by our merits, Melpomene, and graciously encircle my hair with Delphic laurel.)

Horace does not claim to have dragged the Muses to Italy: for him the Camenae have always been here, as I point out when discussing Ode 3.4 below. He does make the more realistic, if still slightly exaggerated, claim to have been the first to bring Greek lyric poetry to Latin. The Muse is not far away, however, crowning Horace with laurel from Delphi at the end. Thus there is also an image of the poet as victor. The combination of these motifs—the poem as monument, being the first to take

something from Greece to Italy, the poet as *triumphator*, and the presence of the Muse—makes it certain that Horace is responding to Virgil's Mantuan temple and its engagement with the Portico of Philippus.[71] Virgil's future temple will sit proudly by the river of his hometown of Mantua; Horace is equally proud of his native land and its river. Whereas the Mincius flows lazily around a bend, Horace's river roars vigorously. There is a Callimachean contrast here between the wide but slow and sluggish, and so presumably silty, Mincius (*tardis flexibus*) and the small (*pauper aquae*) but vigorous (*violens*), and so presumably clear and cool, Aufidus. There may also be a glance at Virgil's slowness in fulfilling his promise to Augustus in contrast to Horace's prompt completion of the *Odes*.

Virgil promised a national epic, but Horace has actually delivered an Augustan work for the ages. The precise nature of the relationship of the completed *Odes* to the unfinished (and indeed never-to-be-finished) *Aeneid* is encoded by the reference to Delphic laurel. When Virgil pictures his triumph by the Mincius, he adorns his head with an olive wreath while leading the procession to his temple.[72] Virgil's references in this passage to Pindar's Olympian Odes make it clear that he specifically imagines himself as an Olympic victor, who wore crowns of olive.[73] The Olympic games were the most prestigious athletic contest in the Greek world, but another set of quadrennial games ran a close second in importance. These were the Pythian games held at Delphi, whose victors were crowned, like Horace, with laurel. So Horace is making a very precise statement about his relationship to Virgil's efforts to become the new Ennius. He is competing in a parallel but distinct competition: a Pythian victor in the present in contrast to Virgil's daydream of an Olympic victory in the future. Perhaps epic is the most prestigious genre, but lyric is not too far off, and at this point Horace is the victor, having run his race and earned his prize; Virgil's victory is still a fantasy by the Mincius. It was Virgil who set up the agonistic, athletic metaphor, so it is appropriate that Horace teases his friend by pointing out that he has crossed the finish line first.

When the Muse crowns Horace, she is not only paying him a personal compliment by commending his work as a lyric poet but also approving his strategy of engaging with the model of her Roman dwelling place, the Portico of Philippus. The superior durability of Horace's monument also brings to mind the Mausoleum of Augustus, as well as the pyramids of the pharaohs. This concluding poem of the first collection of *Odes* announces that, despite his rejection of the epic genre, Horace has hereby submitted his response to Augustus's call for the poets of Rome to replace Ennius's epic. Hence, perhaps, Horace calls his own version of this monument *perEnnius*, or thoroughly Ennian. It may not look it, says Horace, but my monument is just as worthy a replacement for the Roman national epic as any *Aeneid*.[74]

Horace as Priest of the Muses

The main vehicle Horace chooses for his alternative offering to Augustus consists of the so-called Roman Odes. These are a sequence of six poems at the start of the third book that stand out from the rest on account of their uniformity of meter, their addressees, who are the Roman people rather than individual friends, and their themes, which are on the grand public ambitions of the Augustan cultural program rather than private concerns. Horace begins by giving a clear sense of the new persona he is adopting in these poems:

> Odi profanum uolgus et arceo.
> fauete linguis: carmina non prius
> audita Musarum sacerdos
> uirginibus puerisque canto.

> (I hate the unholy crowd and keep them away. Do not break the propitious silence: as priest of the Muses, I sing for boys and girls songs not heard before.)

Horace speaks in these poems with a very specific identity: priest (*sacerdos*) of the Muses; this stands in pointed contrast to the identity he claimed in the last poem of the previous book: "prophet" (*vates*, 2.20.3), as Augustan poets frequently did. The claim made here is different and distinctive.[75] There is an enormous difference between the metaphor of a prophet, who may operate on his own account, and a metaphorical priest, who is thereby claiming a role in public, Roman state cult. This crucial distinction was emphasized prominently by Lyne, but it has often been ignored.[76] A *vates* implies no place of worship, no institutional support. A *sacerdos* in Roman religion must have a cult and a place of worship, which is generally a temple. The commentators hasten to point out that there was no cult of the Muses and hence, strictly speaking, no such role as priest of the Muses in Rome.[77] This is quite true, and it is important to acknowledge this: Horace would never have made a false claim in his poetry to be the priest of a real cult. There must have been, however, a real priest of Hercules of the Muses, and Horace's invented, metaphorical priesthood will surely have recalled that one in its newly renovated home.

In any case, Horace is not claiming to be the priest of Rome's ersatz temple of the Muses. He is claiming to be a metaphorical priest of a somewhat different temple, a proper sanctuary of the Muses, hence a true Museum. The point of this gesture is to situate the Roman Odes within an imaginary temple similar to, but importantly different from, Fulvius's renovated temple. In this, Horace follows the path of Virgil in the *Georgics*, who had created his Mantuan temple as a response to the demand for an epic embodied in the Portico of Philippus. The difference is that Virgil seemed to promise the delivery of an epic that, in form at least, was to be written to Augustus's specifications. Horace, by contrast, is resolute in the *Odes* that he is incapable of writ-

ing an epic. That does not mean, however, that he will not give Augustus something of different form that satisfies some of the same requirements. Horace carefully refrains from comparing his work, his *monumentum*, to a grand temple. By calling himself a priest of the Muses, Horace permits himself to engage with that metaphor, but at a distance. He will speak with the voice requested by the construction of the Portico of Philippus while rejecting that architectural metaphor. Horace is happy to speak as an official voice of the regime, but he will not adopt the poetic form it has demanded. Throughout the Roman Odes, Horace presents his work as a substitute for the national epic he has refused to write by simultaneously embracing and rejecting the call of the Portico of Philippus.

The parallel with Virgil's Mantuan temple is brought out in the same phrase in which Horace claims the mantle of priest of the imaginary Roman Museum. He says that here he will sing for a chorus of boys and girls songs that have never been heard before. In part this is a routine claim for primacy as an innovator in using Greek lyric meters in Latin, but it is also the familiar trope of evoking a predecessor at the very moment of claiming supreme originality. This is what Virgil did when he claimed to be the first to bring the Muses back to his native land, even while alluding to Fulvius's sack of Ambracia and Ennius's evocation of the Greek Muses in Latin for the first time. Horace is not the first to write lyrics in Latin, and the predecessor he simultaneously evokes and denies here is Livius Andronicus. Virgil evoked Ennius and the founding of the original Temple of Hercules Musarum in his Mantuan promise of a future epic, but Horace reaches farther into the past. He looks back to the founding of the *collegium poetarum* as a thank offering for the hymn Livius wrote, at the request of the Roman Senate, for a chorus of twenty-seven girls. The *collegium* subsequently moved to Fulvius's temple. With this gesture, Horace tops Virgil by reaching back beyond Ennius to Livius, and in so doing reminds the reader that epic is not the only literary genre that has been of service to the Roman state. Virgil's Mantuan temple was the starting point of a triumphal procession, and in this regard, too, Horace's model can provide an alternative. Livy (27.37) records that the occasion of the performance of Livius's hymn was a procession that set out from the Temple of Apollo near the Carmental Gate. This must have been the predecessor of Sosius's temple, very near the later site of Fulvius's temple. The procession made its way into the Forum, and thence up to the Temple of Juno on the Aventine. Virgil's analogy for the triumphal progress of his own poetry involves a procession from the Mantuan Circus Flaminius in the *Georgics* to the Temple of Palatine Apollo in the *Aeneid*; Horace's will run from the fictional hymn in this imaginary temple of the Muses on the Circus Flaminius to the subsequent singing of his actual *carmen saeculare* by a choir of boys and maidens on the Palatine and Capitol.[78]

Horace's poem goes on to survey the forms of human vanity, including a candidate for office campaigning in the Campus Martius (11), a reminder of the implicit

location of Horace's imaginary temple. The various follies of human ambition are catalogued, and a climax is reached with the hubris of the extravagant builder: one man is so unsatisfied with his land that he builds his house out in the sea (33–40). This leads into the final moral of the poem, which is that sorrow and care are not soothed by the use of expensive marble and other luxuries. The poet then turns to his own choices (45–48):

> cur inuidendis postibus et nouo
> sublime ritu moliar atrium?
> cur ualle permutem Sabina
> diuitias operosiores?
>
> (Why should I build a house in the latest style with an imposing courtyard and doorposts that will incite envy? Why should I exchange my Sabine valley for overwrought luxuries?)

Horace is not addressing Roman property developers.[79] His own dwelling place serves as an architectural metaphor for his work and brings the reader back to the imaginary temple whose priest he has declared himself to be. In contrast to Virgil's Mantuan temple for Caesar and the Muses with its marble, gold, and ivory, Horace's metaphorical structure will be made of less ambitious material. The "new style" of building Horace shuns is grandiose and epic; this is an implicit *recusatio*. The doorposts of the grand building that invite envy thus recall the brilliant, richly decorated doors of Virgil's Mantuan temple, on which the defeat of Envy herself is depicted (*Georg.* 3.37). Both of these passages thus refer back to the end of Callimachus's *Hymn to Apollo*, in which Envy expresses a preference for bombastic poetry. Horace here perhaps expresses some gentle doubt regarding Virgil's ability to write a grand epic that at the same time deflects the charge of bombast. Horace has a different strategy for reconciling the demands of Augustus and those of Callimachus. The modest Sabine farm Maecenas gave him stands in contrast to the building work done in the name of Philippus and also to the larger donations of wealth Augustus made to Virgil.[80] Horace is also echoing Virgil's praise at the end of the second book of the *Georgics* for the modest life of the farmer, who does not need a stately mansion.[81] He thereby points out the tension between that aspect of Virgil's Epicurean outlook and the grandiosity of the temple he has promised to build for the emperor. By expressing his preference for building a modest house, both in real terms and as a metaphor for his poetry, Horace thus aligns himself with the preferences of Augustus himself, who was ostentatiously modest in this regard.[82] Just as the house of Augustus was modest in comparison with the gleaming Temple of Apollo next door, so the professedly modest pretensions of Horace's *Odes* are set in relief by the ongoing construction of Virgil's *Aeneid*.

The next Roman ode (3.2), which (in)famously claims that it is "sweet and fitting to die for one's country," is less obviously concerned with metapoetic metaphors. Nevertheless, there may be some implicit reference to Horace's own choice of genre. At the end of the poem, he declares that he does not want to share a roof or a boat with a man who divulges the unsayable, such as the mysteries of Ceres, for fear that he may share in the punishment of the wicked (3.2.25–32). A metapoetic reading of these lines is suggested by the fact that they allude to two episodes from the life of the poet Simonides, whose words on the virtue of discreet silence Horace has just translated a few lines before. The Greek poet miraculously avoided death twice, once in a shipwreck and once in the collapse of the palace of a patron.[83] Thus Horace resolves not to share a roof or a ship with anyone who invites the punishment of the gods. The combination of the grand building (*trabibus*, 28) and the ship (*phaselon*, 29) unites Horace's two favorite metaphors for epic, and the reference to the punishment by Jupiter recalls the thunderbolt with which overbold sailors are punished at the end of the *propempticon* (farewell poem) to Virgil (1.3.39–40). Is Horace here making a tongue-in-cheek refusal to join Virgil both in his new temple and in the boat in which he is setting sail on the treacherous sea of epic?

With the next poem (3.3), the confrontation between Horatian poetics and the Augustan demand for epic returns to center stage. In this ode, Horace jocularly usurps Virgil's subject matter. Most of the poem is set in a council of the gods, a quintessential feature of epic since Homer. The matter under discussion is the admission of Romulus to heaven, and the poem is dominated by Juno's speech in which she sets aside her opposition with the proviso that Troy never rise again. If Horace's imaginary Museum, a fictional poetic analog of the Portico of Philippus, is considered the setting for the start of this poem, in which Horace continues to speak as priest of the Muses, one can identify what may be references to its decorative program in Juno's tirade. She begins her litany of grievance with the judgment of Paris and the adultery of Helen (19–20) and then turns to the perjury of Laomedon, who cheated Apollo and Neptune out of their payment for building the walls of Troy (21–22). I earlier showed that a painting from the Casa di Sirico of these two gods as they were building the walls (see fig. 39) has some stylistic similarities to the paintings in the Temple of Apollo and may have been related to that cycle. Next, Juno again mentions Paris and the adulterous Helen (25–26), and the reader may think of Zeuxis's *Helen*. Finally, she mentions how Hector was leading the Trojans to drive back the Greeks (27–28), which is the subject of the first painting that Aeneas sees in Carthage.

It is likely that parts of the *Aeneid* had been recited to members of Maecenas's circle before Virgil's death, and there is some evidence for this with respect to the first book of the epic. When Propertius mentions the progress of the epic in his second book (2.34.61–64), he clearly seems to allude to its opening lines.[84] Horace's *propempticon* for Virgil (1.3), regardless of whether one reads its account of the dangers of the sea as based

upon a genuine voyage or as a pure metaphor for writing epic, seems to have echoes of language not only from the *Georgics* but also of the storm that Juno sends against the Trojans in the first book of the *Aeneid*.[85] If one accepts that Horace knew at least some bits of the first book of the *Aeneid*, this speech of Juno can be taken as a correction, in the goddess's own words, of Virgil's representation of Aeneas's view of the Trojan War as expressed in her Carthaginian temple. Juno has no sympathy at all for the Trojans here. Aeneas's general interpretation of the sympathetic intention behind the cycle is as wrongheaded as his interpretation of the individual Iliadic scenes. The link between the two passages is provided by the Portico of Philippus, which is the Roman context evoked by both Virgil's imaginary temple and Horace's imaginary priesthood.

The other passage of the *Aeneid* with potential links to Ode 3.3 is the discussion between Jupiter and Juno at the end of the epic in which the goddess puts aside her enmity to Aeneas's people, at least for the moment (12.791–842). Jupiter begins by looking forward to the apotheosis of Aeneas rather than Romulus. Juno's price is the same: that the name and the ethnic distinctiveness of Trojans must disappear as they are mingled with the Latins. This seems to echo the most distinctive feature of Juno's speech in Horace's ode, which is the intensity of her insistence that Troy not rise again. If it is true that Horace has commented upon the first book of the *Aeneid* in progress in this ode, then perhaps Virgil has returned the compliment by alluding to Horace's ode in his final book. Horace's Juno stipulates that Troy must remain a ruin, with the sea lying between it and Rome. Her condition is this (3.3.58–60):

> ...ne nimium pii
> rebusque fidentes auitae
> tecta uelint reparare Troiae.

> (They [the Romans] must not, excessively pious and too trusting in their success, endeavor to repair the buildings of ancestral Troy.)

The vehemence of this particular point has puzzled critics. Who wanted to rebuild Troy in its original location? What does it mean to be excessively *pius*? The answer comes from this poem's engagement with and critique of the *Aeneid* and the prevalence of building as a metaphor for poetry in the Roman Odes. The end of Juno's speech should be read as a warning against rebuilding Troy in poetry, that is, of challenging Homer by writing the *Aeneid*, with its quintessentially *pius* protagonist.

Juno declares that, if Troy is rebuilt, she will destroy it (65–68):

> ter si resurgat murus aeneus
> auctore Phoebo, ter pereat meis
> excisus Argiuis, ter uxor
> capta uirum puerosque ploret.

> (If the bronze wall should rise for a third time with the help of Apollo, three times would it be destroyed, uprooted by my Greeks, three times the captive wife would lament for her husband and sons.)

If there is a metapoetic dimension to Juno's imperative that Troy not be built again, then the *Aeneid* should be viewed as potentially the third in the line of unsuccessful Roman attempts to emulate Homer. The first generation of builders, if this is not an indication of Homer himself, was those poets who wrote in native Saturnian meter, such as Livius Andronicus, who translated the *Odyssey*, and Naevius, who traced Roman history back to Aeneas and Troy. These were superseded by Ennius, who was the first to write Latin epic in Homer's meter. Even though he dreamed he was the reincarnation of Homer, a subsequent generation decided that this estimation was implausibly overoptimistic and found Ennius as backward as he had found his own predecessors.[86] So the two earlier efforts to rebuild Troy by writing a Latin epic to rival Homer had foundered. What of the third, Virgil's attempt? Precedent was not encouraging. It is difficult to rid oneself of the knowledge that the *Aeneid* was to become an unqualified success. At the time when Horace was writing Ode 3.3, Virgil had never attempted anything like the *Aeneid* in scale or in theme. It was a highly risky undertaking and one possible outcome was preordained Ennian obsolescence. The great poets of Hellenistic Alexandria had wisely refrained from challenging Homer directly, and the young Virgil had followed the examples of Theocritus and Aratus.

Horace concludes by addressing the Muse, as her poet and priest, scolding her for ignoring his own wise counsel of avoiding epic bombast (69–72):

> non hoc iocosae conueniet lyrae.
> quo, Musa, tendis? desine pervicax
> referre sermones deorum et
> magna modis tenuare paruis.

> (This is not suitable for my lighthearted lyre. Muse, where are you heading? Stop it, you naughty girl: don't report the speeches of the gods and diminish great deeds with these trivial measures.)

In the very act of reporting the words of Juno as she threatens those who would rebuild Troy by writing a Latin national epic, Horace is in danger of falling foul of that very same threat. So he renounces his claim to grand epic themes and reasserts that his own style of poetry is very different indeed. He does not renounce serious themes of national consequence, for he is only halfway through the Roman Odes. It is not Augustan topics but epic forms that Horace rejects. He thus contrives to have his epic cake and eat it, too, staging an epic council of the gods to authorize his rejection of epic.

Horace the priest continues to address the Muse in the next ode (3.4), and he continues to play with the incorporation of epic elements into this "extended lyric" (*longum... melos*, 3.4.2). He summons Calliope on the analogy of Greek lyric invocations, but also on the basis of his authority as her priest. She accompanies him in a song that recounts the protection that had been afforded Horace since he was a baby by the Camenae, the Latin nymphs who had become assimilated with the Muses. Thus Horace presents his special relationship with the Italian Muses as something that always existed. These are not Greek Muses who had to be captured by Fulvius Nobilior and brought back as booty; they are indigenous to Italy. The fulcrum of the poem is the stanza in which Horace turns from his own relationship to the Camenae to Augustus's relationship with them (3.4.37–40):

uos Caesarem altum, militia simul
fessas cohortes abdidit oppidis,
 finire quaerentem labores
 Pierio recreatis antro;

(You [Camenae] in your Pierian cave refresh great Caesar, who seeks an end to his toils after hiding his war-weary troops away in the towns.)

The moment in time is clearly marked: just after Actium, when Ocatavian had returned to Italty to celebrate his triple triumph and was settling his veterans.[87] In other words, this was the time when the Portico of Philippus was being dedicated, along with other monuments, such as the Temple of Palatine Apollo. In this context, with Horace as priest of the Muses, the Pierian grotto must allude to the Portico of Philippus. It was Augustus who renovated the Muses' home, but Horace inverts the conceit to claim that they, by way of returning the favor, refreshed him as much as he did them. The influence of the Muses was to bring the new age of peace that followed Actium. The rest of the poem alludes allegorically to that epochal struggle by describing the battle of the Olympian gods against the monstrous giants. Not only was this a regular metaphor for Actium in Augustan ideology; it was also a classic type of bad poetry in Hellenistic literary criticism. Thus Horace continues to demonstrate how his preferred lyric mode can accommodate even the largest subjects without bombast.

The next poem is the Regulus Ode (3.5), which might at first seem to have little in common with the themes I have been examining. It tells the story of the Roman general in the First Punic War who was captured by the Carthaginians and was sent back to Rome to negotiate the ransom of his men. When he arrived, he urged the Senate not to pay but to send him back to his own death. There are no Muses, no metapoetic temples, no epic motifs. But there is this (3.5.18–21):

> ..."signa ego Punicis
> adfixa delubris et arma
> militibus sine caede" dixit
> "derepta uidi"

("I myself have seen our standards mounted in Carthaginian temples and weapons surrendered by our soldiers," he said.)

Here is an account of the decoration of an early Carthaginian temple to challenge Virgil's. It is not adorned with paintings of the Trojan War; it has captured Roman standards and weapons for decoration. Once again, Horace seems to be critiquing Virgil's depiction of the Temple of Juno in Carthage and Aeneas's reading of it, when he took it as a sign of Carthaginian sympathy. In Ode 3.3, Juno gives her emphatic view of the Trojan War, in which all the blame attaches to the Trojan side. Here, it is the turn of the Carthaginians to speak via their temples. They do not care about Troy either way; their history is of war with Rome. Even in this passing reference to the *Aeneid*, Horace manages to insinuate that his lyric art is able to present a more realistic and indeed patriotic view of Roman history than is Virgilian epic. Whatever sense of duty Aeneas showed by leaving Carthage, Regulus showed far more by returning there. The episode of Regulus was probably narrated by Ennius, and the account of the Carthaginian practice of hanging up Roman spoils may go back to Livius Andronicus.[88] So once again Horace subsumes into his lyric project patriotic themes that might seem more at home in epic while subtly critiquing Virgil's approach in the first ecphrasis of the *Aeneid*.

The final Roman ode is the one most explicitly connected with the building works of Augustus and his program of temple renovation (3.6.1–4):

> Delicta maiorum inmeritus lues,
> Romane, donec templa refeceris
> aedisque labentis deorum et
> foeda nigro simulacra fumo.

(Though innocent, Roman, you will pay for the crimes of your forefathers until you have repaired the sanctuaries and the crumbling temples of the gods and the statues filthy with black smoke.)

The building of the Portico of Philippus was, of course, an important part of this project of paying renewed attention to the gods' shrines. In adopting the persona of priest of the Muses, Horace aligns his own poetic project with the architectural project of Augustan renewal. One expects, therefore, that the piety of the Augustan age will set all to rights and bring back a golden age of harmony between gods and men. The final stanza has therefore come as a surprise to many readers (45–48):

> damnosa quid non inminuit dies?
> aetas parentum peior auis tulit
> nos nequiores, mox daturos
> progeniem uitiosiorem.

(What does destructive time not diminish? The era of our fathers was worse than our grandfathers' and brought us forth, worse still, who are soon to give birth to even more depraved offspring.)

This Hesiodic vision of inevitable decay seems to render futile Augustus's project of renovation. Since the references to building and construction in the Roman Odes are linked, via Horace's persona as priest of the Muses, to the Portico of Philippus and thence to Augustus's search for a writer of epic, this ending of the Roman Odes can also be read on a metapoetic level. Does Horace hint here at three generations of progressive epic decline: Homer, Ennius, Virgil? The success of the *Aeneid* makes such an idea almost unthinkable to a modern reader, but it may not have been so to Virgil's contemporaries, even his friends.

Propertius's Cynthia and Zeuxis's Helen

So far, I have examined two positive responses to the program of the Portico of Philippus and its solicitation of a replacement for Ennius's *Annales*. Virgil promises and then delivers an alternative national epic structured around the Trojan heritage of the Julian family. Horace refuses the form of epic but offers the Roman Odes as an alternative, constructing them around a priestly persona inspired by the Portico of Philippus and reflecting a profoundly Augustan view of the Roman national project. I turn now to the response of Propertius, who was not so biddable. He, too, reacts to the Portico of Philippus, but in a way that constantly asserts his independence of genre, theme, style, and thought. He was not going to be told by Augustus what or how to write. At the start of his second book of elegies, he writes (2.1.3–4):

> non haec Calliope, non haec mihi cantat Apollo.
> ingenium nobis ipsa puella facit.

(It is not Calliope who sings these things to me, nor Apollo; my girlfriend herself creates my genius.)[89]

Whereas Virgil brought the Temple of Palatine Apollo and the Portico of Philippus together to inspire his Mantuan temple, Propertius brings Apollo and the Muses together to reject the notion of writing to imperial order. It is significant that Propertius's most extensive engagement with the art in the Portico of Philippus focuses upon Zeuxis's nude portrait of Helen of Troy rather than on the Trojan cycle. Thus

he contrives to have the Portico of Philippus inspire an elegy that, as is typical for Propertius, turns the Trojan War into a pretext, not for patriotic epic or lyric, but for a love poem.

Elegy 2.3 is a poem that has not fired much critical discussion, for it seems at first glance oddly unsatisfying and self-contradictory. The poet begins by lamenting his lack of success in living without his beloved, who is unnamed here but is presumably Cynthia, as usual (lines 1–8). Then he proceeds to explain the hold she has over him. He claims that it is not so much her beauty that is the source of her power, but nevertheless spends four couplets in a sort of *praeteritio* (announcement of what will be left out) that catalogues various of her physical charms (9–16). He is more smitten by her intangible qualities, her dancing, her singing, and her poetry (17–22). Propertius then goes on to assert that there is something uncanny and more than mortal about her, comparing her beauty to Helen's (23–32). This reference to Helen brings the poet to the Trojan War, and he can now understand how it could have been caused by one woman. He sympathizes with Paris and Menelaus and claims that Helen's beauty was worth Achilles's death. He concludes by urging painters to take his mistress as a model, if they wish to surpass the fame of the old masters. The contradiction readers have noted lies in Propertius's early emphatic rejection of Cynthia's beauty as her most important attribute in contrast to later in the poem, where he compares her at length to Helen, explicitly referring to her beauty (*forma*, 32).[90]

There is a hidden key that can resolve the contradiction and explain what Propertius is up to here; it is signaled at the end of the poem, where he moves from discussing Helen to invoking famous paintings by old masters. This makes it clear that in the preceding lines he was alluding to one painting in particular (33–40):

> hac ego nunc mirer si flagrat nostra iuuentus?
> pulchrius hac fuerat, Troia, perire tibi.
> olim mirabar, quod tanti ad Pergama belli
> Europae atque Asiae causa puella fuit:
> nunc, Pari, tu sapiens et tu, Menelae, fuisti,
> tu quia poscebas, tu quia lentus eras.
> digna quidem facies, pro qua uel obiret Achilles;
> uel Priamo belli causa probanda fuit.

(Should I now wonder if today's youth is aroused by her? Troy, for her you would more fittingly have perished. Once I used to wonder that a girl was the cause of so great a war at Pergamon for Europe and Asia. Now I see that both of you, Paris and Menelaus, were wise; the one because you wanted her back and the other because you were slow to give. Her face is worthy of causing the death of Achilles; as the cause of the war, she was approved even by Priam.)

As Goold has noted,[91] the Homeric model for the last couplet is the passage where Helen approaches the elders of Troy by the city walls (*Il.* 3.154–58):

> οἳ δ' ὡς οὖν εἴδονθ' Ἑλένην ἐπὶ πύργον ἰοῦσαν,
> ἦκα πρὸς ἀλλήλους ἔπεα πτερόεντ' ἀγόρευον·
> οὐ νέμεσις Τρῶας καὶ ἐϋκνήμιδας Ἀχαιοὺς
> τοιῇδ' ἀμφὶ γυναικὶ πολὺν χρόνον ἄλγεα πάσχειν·
> αἰνῶς ἀθανάτῃσι θεῇς εἰς ὦπα ἔοικεν·

> (Now when they saw Helen coming to the wall they softly spoke winged words to one another: "Small blame that the Trojans and well-greaved Achaeans should for a long time suffer misery for such a woman; she is marvelously like the immortal goddesses to look upon.")

Priam then greets Helen warmly and says that she was not the cause of the war. Propertius develops variations on the reaction of Priam and the Trojan elders to the beauty of Helen and their evaluation of her blame and makes several pointed contrasts, too. He highlights the reaction of young men (*iuuentus*, 33) to Cynthia rather than Trojan elders to Helen, and the elision of old men from the scene (apart from Priam) means that no one remains to cast any blame on Helen. Propertius also subtly modifies Priam's response: whereas in Homer he says that Helen is not to blame because the gods and not she are the real cause (αἰτίη, 164) of the war, this position would not suit Propertius's rhetoric. So he has Priam absolve her *even though* she is the cause (*causa*, 40). Nevertheless, the central aesthetic idea is the same in Homer and Propertius: the measure of the beauty of Helen (or Cynthia) is the effect it has had on the men around her.

As noted earlier, two of those lines from the *Iliad* were inscribed on Zeuxis's *Helen*. Since in the second book of Propertius "datable events fall between 28 and 25," this poem was written in the period immediately subsequent to the dedication and opening of the Portico of Philippus in which Zeuxis's painting was displayed to the public.[92] In case the reader did not immediately look beyond the Homeric reference to consider the link to Zeuxis, Propertius provides a hint in the subsequent couplet, which the large majority of editors have rightly identified as the ending of the poem (41–44):

> si quis uult fama tabulas anteire uetustas,
> hic dominam exemplo ponat in arte meam:
> siue illam Hesperiis siue illam ostendet Eois,
> uret et Eoos, uret et Hesperios.

> (If any painter wishes to outdo the ancient masters in fame, let him place my mistress as the model for his art. Whether he shows her to the West or to the East, he will set both East and West aflame.)

The reference to the public exhibition (*ostendet*, 43) of ancient paintings (*tabulas...uetustas*, 41) makes it certain that the allusion to the Homeric lines about Helen's beauty must be read in the specific context of their inscription in Zeuxis's painting.[93] Recall that, as Lessing understood, the inscription elucidated the limitations of verbal art in attempting to convey visual beauty. Once Propertius's poem is understood as a meditation on the difference between words and images, its internal contradiction resolves itself. Propertius begins by demonstrating the futility of trying to describe Cynthia's beauty, because it is impossible to convey in words. His minicatalogue of her physical charms becomes vague and pointless, as Zeuxis and Lessing knew it had to be. The end of the poem sees Propertius reverting to the model of Homer, by describing the effect of Helen's beauty on the men around her rather than by putting together a list of physical characteristics.

The argument of the poem now becomes clear. The introductory preface of four couplets sets up the dramatic situation of the elegy, and then comes the detailed catalogue of Cynthia's physical attractions, even as the poet rejects them (9–16):

nec me tam facies, quamuis sit candida, cepit
 (lilia non domina sunt magis alba mea;
ut Maeotica nix minio si certet Hibero,
 utque rosae puro lacte natant folia),
nec de more comae per leuia colla fluentes,
 non oculi, geminae, sidera nostra, faces,
nec si quando Arabo lucet bombyce papilla
 (non sum de nihilo blandus amator ego)

(It is not so much her face that has captured me, though it is beautiful—lilies are not whiter than my mistress: as if Scythian snow were to vie with Spanish cinnabar and rose petals float in pure milk. Nor is it her hair falling fashionably over her smooth neck, nor her eyes, those twin torches, my lodestars, nor if her breast occasionally gleams beneath Arabian silk—not for nothing am I a sweet-talking lover.)[94]

This list of Cynthia's visual attractions includes the fairness of her face (9–10), her hair (13), her eyes (14), and her figure (15). This is precisely what Homer does *not* do with Helen. In light of Zeuxis's comment on the difference between the ways poetry and painting achieve their effects, the problem with these lines is that Cynthia is dismembered until she is nothing but a pile of limbs sporting poetic clichés. This is precisely what Lessing objected to in poets who betray the strengths of their medium by trying in vain to ape painterly representations of physical beauty. He takes Ariosto to account for his catalogue of the physical attractions of Alcina:

> Was für ein Bild geben diese allgemeine Formeln? In dem Munde eines Zeichenmeisters, der seine Schüler auf die Schönheiten des akademischen Modells aufmerksam machen will, möchten sie noch etwas sagen; denn ein Blick auf dieses Modell, und sie sehen die gehörigen Schranken der fröhlichen Stirne, sie sehen den schönsten Schnitt der Nase, die schmale Breite der niedlichen Hand. Aber bei dem Dichter sehe ich nichts, und empfinde mit Verdruß die Vergeblichkeit meiner besten Anstrengung, etwas sehen zu wollen.
>
> (What kind of picture do these vague formulae suggest? In the mouth of a drawing master who wanted to call the attention of his pupils to the beauties of the academic model they might possibly mean something: one look at this model and they see the fitting bounds of the gay brow, they see the finely chiseled nose, the slenderness of her dainty hand. But in the poem I see nothing and I am annoyed by the futility of my best efforts to see something.)[95]

Lessing warns lesser poets not to try where Ariosto had to fail. What Propertius is rejecting at the start of his poem is not in fact Cynthia's beauty per se, but rather a particular mimetic strategy for attempting to convey the shattering force of that beauty—a strategy whose failure he demonstrates. Propertius is possibly reacting against a disembodied catalogue of limbs in a humorous epigram of Philodemus (*AP* 5.132), in which he completely objectifies an Oscan-speaking woman in this way. She is the antithesis of the elegiac woman, an *indocta puella*. Whereas they take Greek pseudonyms in Latin poems, she is given a Latin name, Flora, in a Greek poem. She cannot recite Sappho or even communicate in a civilized language, so she can be nothing more than an object, a collection of lovely limbs. The fact that Philodemus's Flora fails to make much of an impression on the reader despite the desperate accumulation of particulars is part of the joke. Cynthia is different.

It is not so much Cynthia's physical allurements (*nec... tam*, 9) that keep Propertius in bondage; even more captivating (*quantum*, 17) are her dancing and the poetry she sings and composes (17–22):

> quantum quod posito formose saltat Iaccho
> egit ut euhantes dux Ariadna choros,
> et quantum Aeolio cum temptat carmina plectro
> par Aganippaeae ludere docta lyrae,
> et sua cum antiquae committit scripta Corinnae
> carminaque Erinnae non putat aequa suis.
>
> (... as much as it is that she dances beautifully when the wine is served, like Ariadne leading the Bacchic troupe, and that she composes songs with the plectrum of Sappho, expert at playing songs equal to the Muses' lyre; and she com-

pares her writings to those of ancient Corinna, and does not think the songs of Erinna the equal of her own.)[96]

This is a very different list; it attempts to represent things that the visual arts cannot evoke so easily. Movement and dance pose difficulties for both media, but at least both the writer and the painter are on equally awkward ground. The voice, however, is the raw material of written representation just as visual appearance is the raw material of the pictorial. Propertius ought to be able to represent Cynthia's words, at least. This sequence—appearance, movement, voice—thus plays out a series of potential representational strategies. The first option illustrates an attempt to compete with painting on its own terms, and it fails, for the attempt to describe Cynthia's face, hair, eyes, and figure does not really allow the reader to visualize her at all. So then Propertius moves on to other aspects apparently more suited to verse. First he tries to describe her dancing, but this turns out to be just as hard to convey in words as in a painting. Finally, he turns to her poetry. In this case, Propertius might seem to have the option of showing Cynthia "as she really was," by actually quoting her own words. Cynthia is a poet, so he can quote her poetry, surely. But Propertius suggests that she mainly composes in meters other than elegiac, which conveniently rules out quotation.[97]

All efforts, therefore, to represent Cynthia's accomplishments in various media fail. So the next phase of the poem brings a different approach. The subsequent five couplets introduce Helen as the model for Cynthia, beginning with Love sneezing at her birth (23–24), which derives from Theocritus's portrait of Helen in Idyll 18.[98] In that poem, Menelaus's good luck in acquiring his bride is attributed to a lucky sneeze (18.16–17). The main technique Theocritus uses to limn Helen's beauty is to remind the reader of her birth from Zeus and to compare her to the chorus of Spartan girls, just as Propertius compares Cynthia to the Roman (29). Helen is singled out from her companions not only for her beauty but also for her skill with the lyre, which also anticipates Cynthia. The old men of Troy compare Helen to a goddess (Il. 3.158); but Propertius compares Cynthia to Helen (32). Finally, he gives up on his failed representational strategies and simply describes the effects of Cynthia's beauty on the youth of Rome, just as Homer had described Helen's effect on the old men of Troy (33).

The final, successful Homeric strategy of depicting the effects of beauty rather than vainly trying to describe its constituent parts results from applying Zeuxis's insight that poetry and painting operate in radically different ways. Propertius makes a paradox of this in the final lines of his poem, quoted above, where he suggests that modern painters should paint his Cynthia, just as Zeuxis painted Homer's Helen. In fact, East and West will be ablaze for her, just as Europe and Asia were for Helen—except, of course, that the Trojan War was not ignited by Homer's poem or Zeuxis's picture but by a "real" woman. But who is the "real" Cynthia? Here one can catch Propertius winking at the fictiveness of his own creation.[99] And indeed the

readers of Propertius collude in that fictiveness, for the beauty of Cynthia that has inflamed the youth of Rome is in their heads, reflecting whatever image they have summoned for her.

At this point, a further aspect of the closing couplet is worth examining.[100] It has obvious affinities with two passages from Ovid complimenting Cornelius Gallus, and the similarity has been plausibly attributed to a common ancestor in Gallus's own poetry.[101] The first Ovidian passage is from the *Amores* (1.15.29–30):

> Gallus et Hesperiis et Gallus notus Eois,
> et sua cum Gallo nota Lycoris erit.
>
> (Gallus will be known in the West and Gallus will be known in the East,
> and his Lycoris will be known with Gallus.)

The fame of Gallus's fictional Lycoris was different from that of Propertius's Cynthia, however. Gallus followed Catullus in teasing his readers by supplying a metrically equivalent name as a potential fig leaf for a real woman who was famous, indeed notorious, in her own right. Propertius's adoption here of a Gallan motif (if that is what it was) highlights how much more justly he can claim to have made his mistress famous, since she is wholly his own creation. Gallus had a much easier job of it, for he was embellishing a woman already well known to his audience. By contrast, when Propertius describes the effects of Cynthia on the populace of Rome, it is owing to the poet's talents alone, since she could not have been interpreted as a pseudonym for a well-known public personality.

Now one can appreciate the ultimate point of introducing Zeuxis's *Helen*. Propertius plays throughout this poem with staging the contrast between the representational powers of painting and poetry, but ultimately his interest in painting serves a literary purpose: to position himself with respect to his predecessor in elegy. Like Lessing, he understood Zeuxis's point but was less interested in continuing the dialogue with visual media than he was in turning it to the purpose of literary polemic. Lessing used Zeuxis's painting to abuse modern poets for being overly descriptive, contrary to the strength of verbal media. There may be an aspect of that sort of polemic in Propertius 2.3, too, since, as Lyne has brilliantly showed, its deliberately inept effort to describe Cynthia's beauty was a parody of Tibullus's description of Delia's appearance in his Elegy 1.5.[102] Beyond those polemics, Propertius takes advantage of another anecdote surrounding Zeuxis's painting to make a deeper point about the nature of his portrait of Cynthia.

What Zeuxis's painting was most famous for, both in antiquity and subsequently, was not the hubris of its Homeric inscription but the anecdote about the women who modeled for it. As told by a number of ancient sources, the story went that Zeuxis asked the people of Croton, who had commissioned the painting, to provide

a maiden of the town as model. They tried to put him off by showing him the beauty of their young men naked in the palaestra, suggesting that he extrapolate from them the beauty of their sisters. The painter insisted upon seeing the maidens of Croton and selected the five most beautiful, whom he used as a composite model for Helen, since no one individual was perfect. This anecdote was repeatedly used in antiquity to illustrate the nature of creativity and the relationship of art to nature, and the scene of Zeuxis choosing his models went on to be very popular with modern painters.[103] For the present purposes, however, what is most interesting is the nudity of the maidens. This is what made the story so titillating, and why the people of Croton were at first unwilling to comply.[104] Freeborn Greek maidens did not pose nude for painters, much less do so en masse. That was a job for prostitutes, and there were many examples of notorious courtesans posing as the models for images of nude goddesses. For example, the famous courtesan Phryne was said to have been the model for both the painting of Aphrodite Anadyomene by Apelles and the sculpture of Aphrodite of Cnidus by Praxiteles.[105]

So a distinctive feature of Zeuxis's nude painting of Helen was that it was modeled upon a range of free women, rather than on a single courtesan. This explains the sudden and rather bewildering shift at the end of Propertius's poem. After the couplet about ancient paintings and their models, which provides the most explicit pointer to Zeuxis's painting as the key to explaining the poem, the subsequent couplet alluding to Gallus seems an odd afterthought. But it is closely related, for Gallus took as the model for his fictional Lycoris a single courtesan, the notorious mime actress Volumnia Cytheris. She was the Roman equivalent of the Phryne who had posed for Apelles. Zeuxis, by contrast made a composite portrait of five different freeborn women. The implications for Cynthia are clear: she is also a composite portrait. Just as the artistry of Zeuxis surpassed that of Apelles in creating a more perfect woman than was available as a model, so Propertius's creativity surpasses that of Gallus because his creation is more than a fictionalization of a single notorious woman.

Maria Wyke has shown that, throughout Book 2 of his elegies, Propertius highlights the constructed, fictional nature of Cynthia.[106] The other Ovidian passage that seems to allude to the same Gallan couplet as does Propertius is from the *Ars Amatoria* (3.535–38):

> Nos facimus placitae late praeconia formae:
> Nomen habet Nemesis, Cynthia nomen habet:
> Vesper et Eoae nouere Lycorida terrae:
> Et multi, quae sit nostra Corinna, rogant.
>
> (We [poets] herald far and wide the beauty of our beloveds: Nemesis and Cynthia have their renown. The lands at the setting and the rising of the sun know Lycoris, and many people ask who is my Corinna.)

Ovid must be alluding not only to the Gallan original but to Propertius's imitation, and it seems unlikely to be a coincidence that Propertius's poem happens to mention the original Corinna, an ostensible fifth-century Greek poetess whose work has often been thought to be a later forgery.[107] Ovid apparently took the idea from Propertius 2.3 of adopting for his extravagantly fictional girlfriend the name of a poetess whose corpus was fake, or at the very least he justified his choice by reference to it. McKeown hit upon the exact truth without realizing it when he scorned the "prevailing modern opinion that Corinna, the mistress whom Ovid celebrates in the *Amores*, either did not exist or is, at best, a *Konzentrationsfigur*, compounded of several different women, a literary equivalent to Zeuxis' Helen."[108] The construction of Corinna, like Cynthia before her, is very precisely modeled upon the genesis of Zeuxis's *Helen*.

Propertius's second book ends with a list of Latin love poets and their mistresses: Varro and Leucadia, Catullus and Lesbia, Calvus and Quintilia, Gallus and Lycoris, and finally Propertius and Cynthia (2.34.85–94). As far as anything is known about those other women, they were ostensibly modeled upon real individuals.[109] Propertius puts himself and Cynthia at the end of that list, and in a sense they transcend it, for, in contrast to those artists, Propertius took the more difficult route of Zeuxis and created a more complex, composite portrait.[110] This helps to explain how Cynthia can seem at times a proud Roman matron, like the woman ostensibly behind Catullus's Lesbia, and at others a prostitute, like the woman supposed to lie behind Gallus's Lycoris. In this light, she emerges as a more impressive creation than Lycoris, not only because of the multiplicity of models, but also because the single model for Lycoris, Volumnia Cytheris, was already famous in her own right. One could reproach Gallus by saying that he simply had to represent her as the fascinating woman she evidently was (this is not to say that the reproach would be fair, for Gallus was surely doing far more than merely depicting biographical reality). Cynthia, by contrast, is a wholly literary creation from start to finish, a composite product of pure imagination.

Augustus wanted the poets of Rome to take the paintings in the Portico of Philippus as a model for their verse, and Propertius did just that, but in a willfully perverse manner. Elegy 2.3, which takes Zeuxis's *Helen* from the portico and makes it the model for Propertius's hybrid Cynthia, cannot be what Augustus had in mind. Throughout Propertian elegy, the Trojan War is treated as a tussle between rival lovers over a beautiful woman. This is typical of his engagement with the Augustan ideological program of renewal, at least before his fourth book: he subordinates it all to his own world.

Before leaving the second book of Propertius, I would like to take a quick look at the one poem in which he does discuss an aspect of Augustus's building program at some length. In Elegy 2.31, he describes, without any apparent cheek or sarcasm, the new Temple of Palatine Apollo. Here he is happy to praise the building, but in a way that is completely separate from his own poetic concerns. The pretext for this ecphrasis is to offer an excuse to his girlfriend. He explains that he is late for their

rendezvous, because he was gazing in amazement at the newly opened portico of Palatine Apollo. If, as is so often the case, Cynthia stands here as a symbol for the poet's own love elegy, then this poem is explicitly framed as a digression, a diversion from Propertius's usual habits, pleasures, and mode of writing. He seems to be saying that the Temple of Palatine Apollo, with its intimate connection to Augustus, may be beautiful to admire, but the only effect it will have on his poetry will be to detain him for a brief moment. In Elegy 2.31, Propertius gives Augustus what he has asked for by rendering his own temple back to him. If you ask Propertius to create a poetic monument for Augustus, this is what you get: nothing more. It is essentially a riposte to the ecphrasis at the start of *Georgics* 3: Propertius points out that Augustus does not really need Virgil's metaphorical marble temple, as he already has a very nice one of his own. By describing a real marble temple, Propertius avoids creating a metaphorical one himself; it is a very subtle *recusatio*. Propertius picks his battles with Augustan ideology carefully. He is happy to celebrate Palatine Apollo as Augustus's creation, but he will not model his own work on it or any other public monument. He has his own ideas about how the Muses ought to be worshipped at Rome, and this does not include writing a neo-Ennian national epic. This same attitude is found at the start of Book 3, where Propertius vigorously challenges Horace's reinterpretation of the role of the priest of the Muses at Rome.

The Un-Roman Elegies of Propertius

Virgil's reaction to Augustus's solicitation of a poet to play Ennius to his Fulvius was to accept the invitation, or at least to give the appearance of doing so. Horace turned it down but positioned his Roman Odes as an alternative offering, a different sort of Augustan monument, giving voice, as priest of the Muses, to some aspects of the new ideology but maintaining his independence. Propertius rejected the invitation much more bluntly, at least, perhaps, until his final book. His most sustained engagement with the Virgilian/Horatian metaphor of poetry as a monument comes at the start of his third book, which can be understood as a comprehensive rejection of any such official position. The Propertius who emerges from this discussion might seem to be anti-Augustan, but that would be an oversimplification. Throughout his career, Propertius defined himself as loyal to his own kind of elegy in contrast to the generic experimentation of Virgil and Horace. One can infer that he did not think Augustus had any business dictating the content and form of his poetry. He strongly rejects the poetic program of Augustus, but that need not imply a rejection of his political program. The clearest view of Propertius's political allegiances comes from his first book, in which he advertises with equal prominence his attachment to the family of L. Volcacius Tullus, a very important ally of Octavian, and also to Octavian's victims at Perusia.[111] Propertius must have been far from unique in his day in having close connections with people on both sides of the civil wars. In the discussion below, a very

recalcitrant Propertius emerges, but this refers not so much to his political position as to his explicit and sustained refusal to write a patriotic Roman epic.

The first five elegies of the third book of Propertius respond in detail to Horace's self-description as a priest of the Muses. These five poems, which are united in programmatic intent, have rightly been interpreted as a response to the Roman Odes.[112] They also engage in detail with other important passages discussed so far, such as Virgil's Mantuan temple and Horace's *monumentum*, and also with Ennius's *Annales*. In particular, the first elegy responds to Horace's self-definition as a Roman priest; the second responds to Horace's and Virgil's conceptualization of their poetry as an Augustan monument; and the third responds to Horace's confrontation with the epic muse. So clearly this series of elegies can also be read as a response to the Portico of Philippus and to the demands it made of Rome's poets. This is not to say that the un-Roman elegies of Propertius constitute a third imaginary temple, after Virgil and Horace: quite the opposite. It is rather the case that Propertius attempts to dismantle that particular metaphor for poetic immortality. The Muses, for him, are not subject to forcible appropriation and will always dwell not in a metropolitan Roman temple but in the Greek world. The un-Roman elegies of Propertius situate the Muses in a place that is the antithesis of the place where Horace and Virgil and Augustus and Ennius and Fulvius had put them.

In a clear echo of Horace, Propertius begins by calling himself a *sacerdos* (3.1.1–4):

Callimachi Manes et Coi sacra Philitae,
 in uestrum, quaeso, me sinite ire nemus.
primus ego ingredior puro de fonte sacerdos
 Itala per Graios orgia ferre choros.

(Spirit of Callimachus and sacred rites of Coan Philitas, permit me to come,
I pray, into your grove. I enter as the first priest from a pure spring to bear
Italian rites among Greek singers.)

The word "priest" (*sacerdos*) stands at the end of the third line of the first poem, just as in Horace's Roman Odes (3.1.3), and here, too, it is important to understand how different this is from the routine metaphor by which the poet identifies himself as *vates*. As it was for Horace, the metaphorical claim to be a *sacerdos* implies an imaginary cult and place of worship. This cult is, however, very different from the one conjured up by Horace. Horace imagined himself as a priest of an imaginary but conceivable Roman cult, which might have had a temple at Rome, but which, for historical reasons already examined, did not. Propertius, by contrast, does not say outright whose priest he is but rather implies the answer. Contrary to the claims of many commentators, he is careful not to call himself a priest either of the Muses or of Apollo, though those divinities are important presences in the poem.[113] In his

persona as priest, he addresses a prayer to the shades of the learned Hellenistic poets Callimachus and Philitas, thereby implying that he is a priest of their hero cult.[114] Hero cult was a feature of Greek, but not Roman, religion, especially when devoted to poets. Such cults, in which poets received honors more like those offered to gods than to deceased mortals, were a distinctive feature of the Greek world. Homer was the most frequent recipient, while the cult of Archilochus at Paros is the best attested.[115] Propertius's place of worship is a grove (*nemus*) with, presumably, a burial mound; it is very much not a Roman temple. This is the antithesis of the sacerdotal metaphor of Horace's Roman Odes.

Whereas Horace presents himself as a Roman priest, and thus an imaginary official of the Roman state, Propertius in his third book is a priest of an imaginary Greek cult. This profoundly changes the nature of the relationship between Greek and Roman culture here. Propertius's claim to be the first Italian to engage with Greek poetry in this way links him back to Virgil's Ennian/Fulvian kidnapping of the Muses, as well as to Horace's *exegi monumentum* ode, but again there is a crucial difference. Propertius is bringing an offering *to* Greece, rather than taking something *away from* it by force. He is carrying sacred objects from Italy to become part of a Greek sacred ritual. It is a pointed inversion of the Roman imperial vision that links Ennius's and Virgil's (and, to a lesser extent, Horace's) conception of Latin literature as an act of conquest. Propertius's pose as a suppliant and hierophant, bearing gifts to Greece from Italy, casts Ennius and Virgil and even Horace as grasping, venal, uncomprehending *conquistadores*. It is not the Muses whose location and cult place need to be adjusted; it is the attitude of Roman poets. When Propertius claims to be the first priest to come from a pure spring, he is not only participating in the trope of claiming primacy while imitating a predecessor but also implying that his predecessors were deficient in not bearing the pure water that Apollo approves of as an offering at the end of Callimachus's hymn to that god.[116] This may be an implicit criticism of the way his predecessor as a poetic *sacerdos*, Horace, evokes the beginning of that same Callimachean hymn at the start of his Roman Odes.[117] Propertius has no time for the notion that bombast like the Roman Odes or the *Aeneid* can have anything in common with Callimachus. You cannot erect your metaphorical temple on the breadth of the Circus Flaminius and claim to be following the narrow path.

Propertius continues his prayer, asking the shades of the two Greek poets a series of questions (5–6):

> dicite, quo pariter carmen tenuastis in antro?
> quoue pede ingressi? quamue bibistis aquam?

> (Tell me, in what cave did you both similarly refine your song? And with what foot did you enter? And what water did you drink?)

Just as Propertius's grove (*nemus*) stands in contrast to the Temple of the Muses implied as the context for Horace's ode, so, too, the cave (*antro*) here functions by way of contrast to that temple.[118] There is a quite straightforward answer to the first question. Philitas and Callimachus both worked as scholars and poets, not in a grotto or a cave, but in the rather more comfortable ambience of the Alexandrian Museum and Library. In fact, so little is known about the early history of the institution that one cannot be entirely sure about Philitas. But he was tutor to the son of the first Ptolemy, and subsequently the post of royal tutor was filled by the head of the library, so it seems likely that Philitas had at least some connection with that institution.[119] Callimachus, of course, was intimately associated with it, having famously catalogued the holdings of the library. So when Propertius asks in what cave the two men wrote their poetry, the answer is obvious: no cave, but the well-appointed surroundings of the Museum in Alexandria. In this way, Propertius points to the absence of a truly equivalent institution in Rome. The only Museum in Rome is not quite up to scratch: the Portico of Philippus is no well-endowed institution to support scholarship and literature. The absence of a Roman institution that would genuinely fill the role of the Alexandrian Museum and Library hangs over this poem like a silent reproach and functions as an unspoken justification for Propertius's refusal to entertain Augustus's wishes.

The other two questions asked of the shades of Callimachus and Philitas form a double allusion to the end of Callimachus's *Hymn to Apollo*, combining references to the foot and to drinking water. When Propertius asks with what foot they entered the Museum/grotto, the punning implied answer is that they both wrote chiefly in the elegiac meter.[120] When he asks what water they drank, the reference to Callimachus's hymn ensures that the answer is purest water from a sacred spring, and not from a muddy river. This looks forward to the end of Elegy 3.3, when Calliope touches Propertius's lips with water from the spring from which Philitas had once drunk. Propertius comes bearing water *puro de fonte* (from a pure spring), just as Callimachus and Philitas themselves had done, not from the Mincius, Aufidus, or Tiber.

In the next passage, Propertius revisits the triumphal imagery of Virgil's account of his temple by the Mincius, but with a large twist (7–14):

> ah ualeat, Phoebum quicumque moratur in armis!
> exactus tenui pumice uersus eat,—
> quo me Fama leuat terra sublimis, et a me
> nata coronatis Musa triumphat equis,
> et mecum in curru parui uectantur Amores,
> scriptorumque meas turba secuta rotas.
> quid frustra missis in me certatis habenis?
> non datur ad Musas currere lata uia.

(Ah, farewell, whoever delays Apollo in warfare! Let my verse run polished by fine pumice, by which lofty Fame lifts me from the earth, and the Muse born from me rides in triumph behind garlanded horses. And with me in the chariot are carried little Cupids, and a crowd of writers follows after my wheels. Why do you shake out your reins, vainly trying to overtake me? You can't take the highway to the Muses.)

Instead of captive statues, war chariots, and boxing matches, Propertius's triumphal procession will be made up of cupids and poets. Another crucial inversion of Virgil's triumph is that Propertius's Muse, instead of being a captive foreigner dragged from her homeland, stands in the place of the victorious general leading the triumph! Again, the paradigm of Roman imperialism is inverted, with a Greek female leading the parade; Propertius is merely one of the poets following in her train, though he is in the lead and will not be overtaken.[121] One who can be assumed to be among the crowd of writers vainly trying to overtake Propertius's chariot is Virgil, who represented his own poetic progress in very similar terms. This procession will not start, however, from the wide expanse of the Circus Flaminius but will run along a narrow, Callimachean path. The dismissal of poets of war in the context of an evocation of Virgil's Mantuan temple is a rejection of the *Aeneid* as an acceptable option for a poet who claims Callimachus as a model. No manubial temple, no military-style triumph, no Greek statues as war booty, no procession through the Circus. None of these are for Propertius; leave them for Virgil, Livy, and their ilk, alluded to in the next line (3.1.15): "Many, Rome, will add praise of you to the annals/*Annales*"; they are to continue the historical project of Ennius's epic.[122] The demand for a new Ennius that Augustus embodied in his Museum will have many takers, but Propertius will not be one of them.

Propertius then asks the Muses to crown him, not with Virgil's Olympic olive wreath nor with Horace's Pythian laurel wreath, but with a soft crown of flowers suitable for a delicate love poet (19–20). The rest of the poem goes on to argue that time will increase Propertius's fame, making use of examples from the Trojan War. The implicit point is that one should write for posterity rather than for the approval of those who happen to be in power. Homer did not write to flatter kings and heroes. After Augustus is dead, will people still want to read panegyrics addressed to him? Of course, it is Virgil's remarkable achievement that he managed to satisfy both Augustus and posterity, but Propertius will not have known that, not yet. What he does know is the failure of Ennius to fulfill the bold promise of his claim to be the Roman Homer. The odds were against Virgil succeeding where others had failed. The poem ends with Propertius's tombstone, which will not be treated with scorn, despite its small size. The reader thus comes back to the image at the beginning of the poem, where the poet was participating in the cult of Callimachus and Philitas. He gently hints at the end of the poem that future generations of Romans may offer Greek-style hero

cult to him, just as he has offered it to the Hellenistic poets. It is a small monument that, in contrast to the grandiose, imperial pretensions of Virgil's Mantuan temple and Horace's *monumentum*, depends on nothing more than the good wishes of future generations of readers to survive the centuries.

In the next poem, Propertius more explicitly compares the inferior durability of physical monuments with the immortality conferred by poetry. Just as Horace spoke metaphorically of the humility of his house at the end of the first Roman ode, Propertius does the same here (3.2.11–16):

> quod non Taenariis domus est mihi fulta columnis,
> nec camera auratas inter eburna trabes,
> nec mea Phaeacas aequant pomaria siluas,
> non operosa rigat Marcius antra liquor;
> at Musae comites et carmina cara legenti,
> nec defessa choris Calliopea meis.

> (My house is not propped up on columns of black marble, nor is my decor
> of ivory with gilded beams. Nor are my fruit trees the equal of the orchards
> of Phaeacia, nor does the water of Marcius irrigate overwrought grottoes
> for me. But the Muses are my friends and my songs are dear to their reader;
> nor is Calliope weary of my singing.)

In the course of conjuring up his imaginary temple, Horace said that his own home was not built high or of costly workmanship. Propertius picks up that theme, repeating Horace's word *operosa*.[123] Just as Horace highlighted in Ode 3.1 the tension between Virgil's praise of the humble household of the farmer at the end of the second book of the *Georgics* and his promise of a glittering temple for Augustus at the start of the third, Propertius turns that same issue against Horace. Even Horace's more modest *monumentum* is too grand for Propertius's principles. Propertius therefore collapses the distinction Horace draws between, on the one hand, the humility of his dwelling and, on the other, the grander scale of the imaginary temple of the Muses of which he is priest and the *monumentum* he claims to erect. Propertius is building neither a grand metaphorical temple nor a grand metaphorical dwelling.

In particular, Propertius's house has no *antrum* whose fountains are supplied from the aqueduct of the Aqua Marcia, recently renovated by Agrippa. In the previous poem, the word *antrum* referred to the workplace of Callimachus and Philitas, implying the Alexandrian Museum. A reference to the ersatz Roman Museum can be detected in the word *Marcius*. This is the family name of L. Marcius Philippus, the builder of the Portico of Philippus, whose legendary ancestor, the king Ancus Marcius, was supposed to have originally built the aqueduct; a member of the family restored it in the second century BC. The family liked to advertise the connection: a

coin picturing the aqueduct was minted by someone in the family, very probably the homonymous father of the builder of the Portico of Philippus.[124] On the analogy of the excavation of structures in the Temple of Peace that are represented similarly on the Marble Plan, I noted earlier the possibility that the crenellations in the podium around Fulvius's temple might have incorporated fountains. Thus the phrase "the water of Marcius irrigates no overwrought grottoes for me" (*non operosa rigat Marcius antra liquor*) has two meanings. The superficial sense refers to a generic water feature in any rich man's urban garden, but the name *Marcius* also evokes Philippus's new grotto for the Muses in the Circus Flaminius. Essentially, Propertius is saying that he does not have either a grandiose real home or a grandiose metaphorical poetic *monumentum* modeled upon the Portico of Philippus, but the Muses are nevertheless happy to attend him.

Propertius goes on to say that his poems, individually, will constitute many tiny *monumenta* to female beauty (17–18), which serves to trivialize Horace's use of that same metaphor. Horace makes the bold claim in Ode 3.30 that his small, varied, unpretentious lyrics can be viewed collectively as a rather grand, unified Augustan monument. Propertius's plural rejects that approach; his elegies are to be treated as distinct and particular. He then embarks on a detailed rebuttal of Horace's claim to immortality in Ode 3.30, pointing out that neither the pyramids, nor the Temple of Jupiter at Olympia, nor the tomb of Mausolus will endure forever. This elaborates the conceit of Horace's poem, though Propertius brings Augustus into the picture a bit more explicitly with the reference to the original Mausoleum of Halicarnassus. This puts a finer point on the argument of the preceding poem that monuments, both real and metaphorical (that is, panegyric written to order), are useless instruments for immortality.

The next poem (3.3) continues the engagement with the complex of poetic responses spawned by the Portico of Philippus and its demand for a new Ennius. At the start of the *Annales*, Ennius described a dream in which Homer appeared to him and declared that he had been reincarnated as the Roman poet. Propertius, on the contrary, has a nightmare in which he almost becomes a reincarnation of Ennius. He dreams that he has the power to write what sounds like a dreadfully tedious epic on early Roman history and the kings of Alba Longa. He then is about to put his lips to the spring of the Hippocrene, from which, Propertius says, Ennius had drunk. A deliberately bungled, highly disordered summary of Ennius's epic builds up the tension and is enough to make the reader fear the worst.[125] In the nick of time, Apollo stops the poet from drinking from the fount of epic and turns the nightmare into a more pleasant kind of dream. He orders the poet, reprising the role he plays in Callimachus's *Aitia* and in Virgil's *Eclogues*, to write less bombastic poetry. He also directs Propertius along a path to a different place, where he finally encounters the true dwelling place of the Muses.

It is crucial to understanding the topographical argument of this poem that the Muses are dwelling separately from the place where Ennius had drunk. This runs contrary not only to the Augustan ideology of the Portico of Philippus but also to Ennius's own self-presentation as intimately associated with the Muses stolen from Greece by Fulvius. The Muses are in a decorated cave (*spelunca*), which looks back to Propertius's use of *antrum* to suggest Museums in the previous two poems. Each of the nine Muses is in a different place, each holding her iconographic attribute, just as if they were statues in Fulvius's temple. But they prefer to live away from the world of Ennius. The isolation of the Muses' retreat and its separateness from the business of epic and war make it clear that this place is very different from the Portico of Philippus. One message of the poem is that Propertius, as a matter of personal talent and inclination, will not write poetry about warfare. Another is that Fulvius's temple and hence the Portico of Philippus are misconceived from the point of view of religion and topography. The Muses are peaceful goddesses and do not like to dwell in a place of war, such as the Circus Flaminius could be.

Propertius repeatedly addresses Augustus's demand for an epic in his series of un-Roman elegies, criticizing the responses of Virgil and Horace while maintaining his fidelity to his own vision. His critique takes several approaches. First of all, he does not accept Horace as a true priest of the Muses. For him that is a position that can never be a part of Roman state religion. The poet must listen to his own genius and not the dictates of the state. He rejects Horace's invocation of the model of Callimachus at the moment at which he declares himself official priest of the Muses. The Ennian poem demanded by Augustus and the aesthetics of Philitas and Callimachus are antithetical, and Horace's effort to reconcile them is fraudulent. The cult of Philitas and Callimachus of which Propertius is a priest is Greek, not Roman. Propertius has a lively awareness of the irony that Callimachus and Philitas enjoyed genuine and generous royal patronage in their day. Not only have Horace and Virgil prostituted their talents; they have failed to obtain a good price for them. The Portico of Philippus merely highlights the absence at Rome of a proper cultural institution like the Museum of Alexandria. Virgil is the next target: he has betrayed his own origins by turning toward the *Aeneid*. The image of the poet as a Roman *triumphator* is equally fraudulent. True poetry is the antithesis of Fulvius's theft of the Muses by force.

Propertius refuses to set up an alternative monument, because he views the entire architectural metaphor as flawed, as he makes clear in Elegy 3.1. The poetic monuments of Virgil and Horace have been erected with the assistance of Augustus. The poets claim that their textual monuments will outlive the physical monuments of the men of power. Propertius doubts that this is true, for the very act of submitting to the ideological needs of the regime means alienating one's own talent. In the second half of Elegy 3.1, the reader is reminded that Troy's fame depends on the genius of Homer, who was not dependent on the patronage of Agamemnon or Priam and was

free to record the folly of both. If he had been a poet for hire, would his Agamemnon and Achilles have had all the flaws that make them such compelling portraits of the blindness of power? The reputation of Homer has grown with time, and so will Propertius's: neither of them stooped to flatter kings but concerned themselves only with the timelessness of the poetry. Homer did not write for the patronage or political favor of those he wrote about, so Ennius represents not his reincarnation but his antithesis. With his tongue in his cheek, Propertius says "after death, the passage of time makes all things seem greater," but it is clear he does not feel that way about Ennius.[126]

The question Propertius asks is whether Virgil, Rome's leading poet, is about to become the new Homer or the new Ennius. Following in the steps of Ennius may be the route to the favor of Augustus, but it is equally the route to poetic oblivion. Virgil's praise of Augustus will seem to future generations as dull as Ennius's praise of Fulvius. The poetic monument of the *Annales* had decayed as much as Fulvius's temple had done, and while the temple may be renovated, not so the poem. The poetic monuments of Horace and Virgil will share the destiny of the Portico of Philippus and other physical monuments, for they were written not for posterity but for one man in the present day. For this reason, the tiny tombstone of Propertius has a better chance of withstanding the centuries; he writes for his readers and for them alone. Of course, this is a polemical view, bound to a time when the *Aeneid* was still largely unwritten.

Propertius accepted the friendship of Maecenas alongside Virgil and Horace. But his independence of spirit meant that he gives a very different account of their relationship.[127] Quite apart from the difficult question of his opinion about the new ideology of Augustus, he felt that he could not be true to his own genius if he were writing for the interests of the regime. Then again, both Philitas and Callimachus had benefited greatly from royal patronage and it did them no harm. In the end, both Virgil and Horace managed to pull off the trick of staying true to the principles of art while writing poetry that pleased the Augustan regime. Propertius's fourth book, in which he himself finally turns with uneven consistency to Augustan themes, is a tacit admission of their success. In that book, Propertius treats the *Aeneid* as an established classic and implicitly acknowledges that his earlier judgments were completely wrong about what kinds of compromise were possible between independent thought and service to the regime and about the prospective literary success of Virgil's epic. Virgil did manage to satisfy Augustus, the shades of Callimachus, and posterity. Still, it is worth remembering that this was a difficult trick to pull off and might hardly have seemed possible at the time. It may be, as I have noted, that even Horace had his doubts at the time. It was the difficulty of the task that made it such a point of controversy among the poets of Rome in the years after Actium.

When Propertius changes tack in his fourth book, he finally renders unto Augustus a proper poetic monument. In Elegy 4.6, he returns to the subject of the Temple of Palatine Apollo, but instead of an ecphrasis he gives an aetiology. He also returns

to ideas from the start of Elegy 3.1: a metaphorical priesthood, the shades of Philitas and Callimachus, and imitation of the latter's *Hymn to Apollo*. He begins by evoking the paraphernalia of sacrifice while declaring himself a priest (4.6.1). He invokes the names of Philitas and Callimachus once again, but this time they are not the objects of cult worship (3–4). Propertius addresses the Muse and asks her to assist him in singing of Apollo's temple. So has Propertius finally become a metaphorical priest of Roman state religion, endorsing the union of Apollo on the Palatine and Calliope on the Circus Flaminius? Opinions differ.

Here he is not a *sacerdos* (priest), not even metaphorically, but a *vates* (prophet), a word he repeats for emphasis (4.6.1 and 10). It is uncertain how much weight should be assigned to that, for the Augustan poets before Ovid avoided the metaphor of being a *sacerdos* of Apollo, which would have aimed too high; the fifteen priests (*quindecimviri*) associated with the Palatine temple, in particular, were of very noble status indeed.[128] Even Horace, when recalling the public, official role he played in composing the *Carmen Saeculare*, later refers to his role in that context as a *vates* (Ode 4.6.44). Tibullus teases us in the first line of Elegy 2.5 into thinking that he is claiming to be a metaphorical *sacerdos* of Apollo and thus erecting a metaphorical analogue of Augustus's great temple to top Horace's *monumentum*, but he is only joking. It turns out that the *sacerdos* is Messalinus, the son of his noble patron, who is becoming not a metaphorical priest but an actual *quindecimvir*.[129]

In any case, it is obvious that Propertius is in no way speaking in Elegy 4.6 as a metaphorical agent of the state; despite the very public content of the hymn, Propertius makes it clear that he is speaking in a private context: from his metaphorical grove (*luco*, 71) rather than from the temple itself. The end of the poem confirms that his celebration is in fact purely private, and the final couplet makes it seem as though the poet is very much alone at the end. It is hard to know what to make of this as "official" poetry, and interpretations have differed radically, from panegyric to parody. A less controversial avenue for characterizing the poetic program of Propertius's final book can be found in his famously disparaging reference to the rusticity of Ennius's "shaggy crown" (*hirsuta...corona*, 4.1.61). This goes back to the crown that Lucretius says Ennius took back from Helicon (1.117–19). In other words, that crown was yet another item of Roman booty, just like the Muses captured by his patron, Fulvius Nobilior. Even in his fourth book, Propertius continues to reject this imperialist model for Roman poetics; instead he asks Bacchus to offer him his ivy, freely.

Coda: Eumolpus as Viewer and Poet

There are probably many more passages in Latin poetry that deal with the Muses or the topography of Helicon where one might detect the subtle influence of the Portico of Philippus. I do not have space for a comprehensive survey of this kind, so I conclude instead with a brief look at a rather different text from a very different time and

genre, Petronius's *Satyrica*. In one passage of the novel, a fictional poet is inspired to song by an image of the Trojan War in a picture gallery very much like the Portico of Philippus, in a town very much like Pompeii. This episode illustrates the continuing relevance of the interaction between Trojan painting and poetry in a later age. Petronius's imaginary temple, situated as it is in a fictional town in Campania, brings the reader back to the world of Pompeii in which this book started. This is not to say that Petronius was commenting specifically on the Pompeian portico, but one can certainly link the theme of its Trojan paintings with Petronius's portrait of a typical Campanian town. Petronius, in the Neronian period, continued to find relevance in the Portico of Philippus and in its provincial variations. This helps to explain why, after the Temple of Apollo was damaged by earthquakes, the people of Pompeii made such an effort to salvage their original copies of the paintings of Theorus that had been placed there by Holconius Rufus and his collaborators decades before, rather than redecorating it from scratch with a different theme.

The protagonist of the *Satyrica*, Encolpius, distracted and upset by the infidelity of his lover, Giton, wanders into a picture gallery (*pinacotheca*, 83.1). Unfortunately, the passage just before this scene is fragmentary and it is not known if the gallery belonged to the portico of a particular deity. At the end of the episode, the place is identified as a portico and a temple (91.1), so it is clear that Encolpius is in a sanctuary of some kind. Here he finds pictures by the greatest names of Greek art: Zeuxis, Protogenes, and Apelles. Encolpius claims that they are originals (e.g., *Zeuxidos manus*, 83.1), but he is a very unreliable narrator and is prone to being misinformed on matters of high culture, so the reader should suspect the accuracy of this claim.[130] One might credit the presence of a single Greek old master in an anonymous Campanian town, but the list of masterpieces defies belief; such a collection is conceivable only in Rome. This must be a display much like that of the Apollo portico in Pompeii: a collection of good copies of works whose originals were probably on view in Rome. The paintings first described are all on the subject of the sexual pursuit of beautiful boys: the eagle abducting Ganymede, Hylas entrapped by a Naiad, Apollo contemplating the flower into which Hyacinthus has been transformed. The sense of loss in those works reflects the state of mind of Encolpius, and he takes comfort in the paintings, crying aloud that they show that the gods have suffered for love as he has. On the one hand, the scene of a narrator viewing a painting is integral to the genre of the ancient novel.[131] On the other hand, as Zeitlin has shown, Petronius is clearly evoking the solace that Aeneas took in the paintings in Carthage, for Encolpius similarly sees sympathy for his own suffering in the art: "It seems that even the gods are wracked by love."[132]

Because of his limited perspective from inside Troy and his lack of knowledge of the *Iliad,* Aeneas misinterprets the subjects of several of the paintings and indeed the overall sentiment of the Carthaginian cycle. Encolpius similarly misinterprets

the paintings he sees, but this is owing to plain ignorance and self-delusion. He thinks that Jupiter has betrayed no one by abducting Ganymede, forgetting Juno, who lists this as one of her grudges against the Trojans at the start of the *Aeneid* (1.28).[133] He thinks that the nymph who abducted Hylas would have ceased if she knew that he belonged to Hercules. This is highly improbable and is contradicted by the many extended accounts of the scene in both Greek and Latin poetry. Apollonius (1.1234–72), Theocritus (13.55–72), Virgil (*Ecl.* 6.43–44), and Propertius (1.20.49–50) all agree that the nymphs ignore Hercules's raging and his crying out of the boy's name, which they must have heard, following immediately upon the abduction. Encolpius implies a resurrection when Apollo turned Hyacinthus into a flower, in contrast to Ovid's tale of his tragic death and the god's sorrow at the failure of his art.[134] Thus Encolpius's ignorance of canonical, and especially hexameter, texts is as profound as Aeneas's ignorance of the *Iliad*, and far less excusable. The general conclusion Encolpius draws from the pictures is completely ridiculous: "all the lovers of Fable enjoyed Love's embraces without a rival."[135] That is the opposite of what most of the pictures demonstrate. Hercules and the nymphs were rivals for Hylas; Apollo and Zephyrus were rivals for Hyacinthus; both rivalries ended in death for the beloved boy.

The Trojan theme had already been introduced in the previous scene, when the abandoned Encolpius runs about the town armed with a sword, just like Aeneas during the sack of Troy (82).[136] The painting of Ganymede brings the Trojan context to the surface, and Encolpius's comical misreading of the paintings provides a humorous parody of Aeneas's tragic misreading of the paintings in the Temple of Juno. Petronius has more to say in connection with Troy and Carthage. Encolpius, still in the portico, meets a man named Eumolpus, to whom he tells the story of his heartache. From his appearance and his name, he is evidently a poet.[137] In order to comfort Encolpius, the poet tells an amusing story of one of his own amorous misadventures (85–87). While Eumolpus was the guest of a family in Pergamum, he attempted to seduce their handsome son. He put on an air of great moral superiority whenever pederasty was discussed and was soon given responsibility for the boy. He then seduced him by promising and then delivering gifts: first a pair of doves, then a pair of fighting cocks. He promises a much more expensive gift of a thoroughbred horse. The boy, having grown accustomed to receiving the gifts he has been promised, submits, but Eumolpus never makes good on his promise. It has long been recognized that this tale is a parody of the sack of Troy. The boy lives in Pergamum, which had become synonymous with Troy, and Eumolpus gains access to him by means of a deception involving a trick horse. In the end, however, having succeeded all too well, he finds himself worn out by the boy's enthusiasm for sex. Just like the Greeks, wrecked and scattered to the winds after sacking Troy, he finds that getting the object of his keenest desire is less satisfying than he had anticipated.[138]

The connection with the wooden horse is made explicit in the next scene. The two men are gazing at a picture of the sack of Troy, and it inspires Eumolpus to declaim a poem on that subject, in which the Trojan horse features prominently (89). This poem has been difficult for readers to get a handle on. On the one hand, it is dull stuff compared to Eumolpus's very funny and well-told story of his misadventure in Pergamum, and indeed the crowd in the portico throws stones at the poet during his recital (90.1). Encolpius threatens to do the same. So this internal audience clearly indicates that one is meant to view this poem as a terrible piece of work. On the other hand, its superficial characteristics are not so disastrous. On a formal level, it seems to be competent versifying in the style of Seneca in regard to meter and diction.[139] On the level of mythological narrative, it is nothing more than a disappointingly repetitive rehash of the much better and much more familiar version of the same events told by Virgil's Aeneas in Dido's palace. The strange thing is that Petronius has passed up what would seem to be a prime opportunity for comedy. A dubiously metrical, error-prone, and incompetent retelling of a famous passage of the *Aeneid* could be quite funny and entirely in keeping with Petronius's treatment of his protagonists. Instead he offers a slightly tedious and essentially unfunny poem. Why? As Beck says: "This is the problem, identified in essence by Arrowsmith in the notes to his translation, that the poems are neither bad enough nor so absurdly flawed as to rank as out-and-out parody or burlesque nor yet good enough to be taken as models of superior composition."[140] If the comparison with Virgil is the point of the joke, why drag in Seneca? Understanding the relationship of the *Aeneid* with the Portico of Philippus can help answer these questions, for Petronius is basing his parody upon the dynamic between poem and monument.

The incompetence of Eumolpus's poetic choices is evident in the way he pays no attention to the conventions of ecphrasis: there are no indications within the poem that it has any relation with a work of art.[141] Eumolpus's poor ecphrastic technique is also evident in his choice of genre and meter. Instead of Virgil's epic hexameter, he uses dramatic trimeter. This in itself is not a problem. But from the point of view of the conventions of tragedy, this poem is a messenger speech, which is, by definition, delivered by someone who is not a protagonist of the action but a minor and inconsequential figure.[142] This is the fundamental problem with Eumolpus's poem, as Elsner has pointed out.[143] The frame sets him up as an Aeneas viewing the pictures in Carthage. But that ecphrasis was fascinating because the paintings represented an alternative view of events in which the viewer personally had participated. When in the next book Aeneas tells the story of the sack of Troy to Dido, its vividness comes from the fact that it is an eye-witness account from a participant. Eumolpus fails to understand this, and his efforts to use the first person plural in order to identify himself with the Trojans only highlights the distance between himself and the events described.[144] His version is so dull because it is written from the point of view of a viewer rather than a participant.[145]

The vivid story of the Pergamene boy is a vital contrast. It is not just that "Eumolpus is a better raconteur than poet."[146] As Beck says, the prose narratives are interesting, funny, and well observed, whereas the poetry is formulaic, clichéd, and generic.[147] But one can put a finer point on that observation. The reason the erotic story works better is that it is told from a vivid first-person perspective. The reader follows the stages in Eumolpus's deception and then enjoys the surprise ending when he finds himself annoyed by the results of his own success. An apparent tale of triumph turns into a cautionary tale of the narrator's own comeuppance. The first-person perspective lends humor and sympathy to Eumolpus's description of his up-and-down feelings toward the boy. This is what is lacking in his bloodless effort to identify with the Trojan point of view in his account of the sack of Troy. What makes Virgil's version of those events effective storytelling is the investment of Aeneas as narrator in his own tale, not the armature of meter, rhetoric, poetic coloring, and cliché that Eumolpus deploys.

Petronius has fitted Eumolpus out with a technical competence in all the superficial formal techniques of mythological poetic composition, but this does not save him from the shower of abuse and stone throwing that greets his performance: the badness of his writing is to be located on a more profound level. He has poetic technique and he can be a good storyteller in prose, but he does not put the two together. When writing verse, he reverts to the schoolroom and leaves his native narrative talents at the door. This scene thus contains not just a parody but a critique of the bloodlessness of a certain type of mythological poetry, where the human element is removed and all that is left is rhetoric and erudition.[148] Petronius may intend to paint Seneca with that brush, as the model that Eumolpus wrongly chooses in place of Virgil. One also sees, by way of contrast, a deep appreciation of the artistry of Virgil, who succeeded where Eumolpus failed.

The failure of Eumolpus to compose a successful poem on the sack of Troy when confronted with a Trojan painting is designed as a comic counterpoint to Virgil's success. Petronius implicitly invites the reader to picture Virgil standing in the Portico of Philippus in front of a painting of the Trojan War, or particularly of the sack of Troy, and considering how to make that narrative vivid. Virgil looked at the images of Theorus and created a character to respond to them whose very personal experience makes the Trojan War seem like something other than dry-as-dust history. Eumolpus fails as a literary artist where Virgil and Petronius succeeded. He has not learned the lesson of Zeuxis and Lessing that the real power of verbal, as opposed to visual, art is to show the reactions of people to phenomena, like the Trojan elders responding to the beauty of Helen, rather than to describe those visual phenomena directly. Thus Virgil describes Aeneas's reaction to the Trojan paintings in Carthage rather than the paintings themselves. Eumolpus has not learned the first lesson of creative writing: "show, don't tell."

Eumolpus, standing in front of the Trojan painting in the temple portico, trying to decode it and to make a narrative out of it, becomes, in this perspective, a parody not only of Aeneas in Carthage but also of Virgil in Rome, making a Roman epic out of the images in the Portico of Philippus. On Petronius's reading of the *Aeneid*, Aeneas, trying to decode and create a narrative out of the Trojan paintings in Carthage, becomes here a stand-in not for Augustus but for Virgil, trying to make a poem out of the Homeric images displayed in the Portico of Philippus.[149] Petronius's comedic invention of Eumolpus as an anti-Virgil casts into relief the seriousness of the choices faced by the real Virgil as he stood in front of the paintings of Theorus arrayed by Augustus in the Portico of Philippus. This is a perspective worth considering: first Aeneas, then Virgil. Aeneas stood in the Temple of Juno and interpreted the representations of his past experiences as showing him to be a pitiable victim of the savage violence of Achilles. He understands these pictures only dimly and his knowledge of his own future is equally obscure. He does not realize that, in order to be no longer the victim but the victor, he must become Achilles, the very thing he hates. Is this a reflection of Virgil's own self-realization about his destiny?

After Actium, while completing the *Georgics*, Virgil may well have stood in the Portico of Philippus knowing that the Homeric paintings showed not his past but his future. The paintings in the Roman portico offered Virgil the prospect of becoming a propagandist for Augustus as Ennius had been for Fulvius Nobilior. To the extent that he lent his craft to Augustus's project of fashioning a Trojan ancestry for himself and of rewriting Roman history in terms of that ancestry, he did this; but at the same time he escaped the trap by following Homer in writing an epic in which human folly, selfishness, blindness, and anger play at least as large a role as panegyric. In that sense, the two great ecphrases of the *Aeneid* lay out two artistic options for the poet: the shield of Aeneas is an objective, well-ordered, annalistic, year-by-year, Ennian narrative of Roman history culminating in the triumph of Augustus; the Temple of Juno is a subjective, disordered, Homeric narrative by a suffering and confused participant.[150] Writing an epic that could be interpreted in the light of both of these ecphrastic paradigms was Virgil's great achievement.

In appearing to take up the neo-Ennian commission embodied in the Portico of Philippus, Virgil must have known that he could be charged with becoming the very thing he had ridiculed as a younger man: the singer of "kings and battles," or in other words, "arms and a man." The traditional view of Virgil's career, enshrined as the *rota Virgilii* of the Middle Ages, as a stately, inevitable, and preplanned ascent from humbler genres to heroic epic is a post hoc oversimplification. Virgil's ultimate success in negotiating the competing demands of his patron and his literary principles has often tended to blind readers to the way his career was in fact marked by a sharp U-turn. The poems in which Horace and Propertius rejected the terms of Augustus's monumental invitation belong to that short period before the success of the *Aeneid*

was established and so provide a glimpse of the risk it entailed. The difference between Virgil, contemplating the paintings of the Trojan War in the Portico of Philippus, and Aeneas, doing likewise in the Temple of Juno in Carthage, is that the poet understood, in a way that his fictional hero did not, that the path ahead would involve turning his back on his own past and all the things he had once stood for.

NOTES

1 Champlin 2005, 102–6.
2 Phaedrus, 3.Pr.16: *intrare si Musarum limen cogitas*, with Champlin 2005, 105: "The Muses are outdoor women, their home is in the mountains, on Pieria or Olympus or Helicon. If they do not live in a house, how can they have a threshold?"
3 Statius, *Ach.* 1.10: *neque enim Aonium nemus advena pulso,* with Heslin 2005, 77–78. The allusion to Propertius 3.3 that is noted there is what activates the potential connection with the Portico of Philippus, for that elegy is a response to the real monument and its imaginary analogues in Virgil and Horace.
4 For another example, see A. Hardie 2007, 581–82, on Virgil, *Aen.* 7.641: *pandite nunc Helicona, deae.* That article is an important effort to explain the significance of the Temple of Hercules Musarum for Roman poets.
5 See further Heslin 2010, 65.
6 All that can be said with certainty is that the publication of the *Georgics* and the dedication of the Portico of Philippus happened within a year or two before or after the dedication of the Temple of Palatine Apollo in 28 BC.
7 It is generally accepted that this temple, with Augustus at its center, represents the forthcoming *Aeneid*, which will have him at its center both literally (*Aen.* 6.792) and figuratively. For an alternative view, see Morgan 1999, 50–61, 97–101, and, for a different approach to the problem, Lowrie 2009. For an overview of the issues with a full bibliography, see Kirichenko 2013, 65–66.
8 Among those arguing for Hercules Musarum, see S. Lundström 1976, 176–77; Mynors 1990, ad *Georg.* 3.13; P. R. Hardie 2007, 137–39; and A. Hardie 2002, 194–200.
9 Indeed, A. Hardie 2002, 196, has already argued that Virgil is here conflating the Temple of Hercules Musarum and the Temple of Palatine Apollo.
10 *Georg.* 3.8–12.
11 See Hinds 1998, 54–55, on the irony entailed in making a claim for primacy by means of a trope repeated from that same author; on the likelihood that this claim went back to Ennius, see Skutsch 1985, 373–75.
12 Lucretius 1.117–18.
13 On the parallels between Octavian's triumph and Virgil's, see Balot 1998, 90–92.
14 P. R. Hardie 2007, 136–39.
15 8.714–28; for the verbal similarities, see Drew 1924, 195–98.
16 This endpoint must have been fictional, as the temple had not yet been dedicated, and all such processions ended at the Capitoline Temple of Jupiter; see J. F. Miller 2000, 409.
17 On the phrase, see Thomas 1983, 179–80.
18 On the Ennian promises of the *Georgics* passage, see Nelis 2004, 84.
19 Hollander 1988, 209.
20 See Celani 1998, 275n1489.
21 Kirichenko 2013, 67, makes many good points about Aeneas as "a rather unreliable beholder (after all, he completely misses the monument's obvious triumphal intention)" and about the way the focalization of the passage through Aeneas's viewpoint makes it difficult for the reader to visualize the arrangement of the paintings.
22 Lucretius 1.117–18.

23. Thus, emphatically, Simon 1982, 206–7, though many if not most readers have desperately tried to explain the word away. See, for example, Leach 1988, 318: "While Virgil's term *pictura* does not encourage our imagining a sculptured decoration, it does not wholly exclude it." See also the strange argument of Laird 1996, 88–89, that it refers to a "mental image."
24. C. G. Heyne argued that these must be paintings, despite his concern over the apparent anachronism in that Homer prefers to describe representational objects in the heroic world as being made of worked metal: see Wagner 1830–41, 2:247–48.
25. Admittedly, the nature of Aeneas's response to the images sometimes makes it unclear exactly how many paintings are described. Most recently, Kirichenko 2013, 66–67, correctly identifies the works as paintings but continues to use the unhelpfully vague term "mural."
26. Boyd 1995, 81–83.
27. E.g., Leach 1988, 312, quite wrongly: "No one of these conjectures is wrong or right. Virgil assigns no position or form to the pictures."
28. This is not to say that Virgil's paintings cannot be compared to temple sculptures. For example, Nagy 2008, 4:250–58, wishes Virgil's images to be relief sculptures in order to compare the north metopes of the Parthenon, but such intertextuality does not require the medium or architectural position to be the same.
29. Moormann 2011, 32.
30. See Varro, *de Ling. Lat.* 7.6–12, and Beard, North, and Price 1998, 22–23.
31. See Carroll 2010 and Carroll 2007 on the Temple of Venus, and Carroll and Godden 2000 on the Temple of Apollo.
32. Sandbach 1965–66, 29; the passage is quoted at slightly greater length at the start of my introduction.
33. Austin 1971, *ad* 453 and 456.
34. *porticibus* (Silius, 6.656), on which see Moormann 2011, 35–38.
35. Somewhat differently: Putnam 1998, 23, with 216n2.
36. For a good discussion of the contrast between the ordered narrative promised by Virgil and Aeneas's disordered experience of the images, see Kirichenko 2013, 67–68.
37. See Petrain 2006, 263–66.
38. Bettini 1999, 177–79, points out that Aeneas's tears in front of the paintings are analogous to Odysseus's tears when Demodocus sings of the Trojan War. So the parallel emotional effect of poetry and painting is highlighted from the start.
39. This list of subjects is roughly similar to those of Clay 1988, 202, and Petrain 2006, 264, apart from the problem of whether the tides of war are shown in two paintings or one and whether Aeneas and Memnon appear in the same painting. My view is that in both cases one is meant to imagine two separate paintings.
40. See Fowler 1991, 31–33, with bibliographical discussion.
41. *en Priamus! Aen.* 1.461, on which see Barchiesi 1999, 331.
42. This is evident in a more general way in Aeneas's (mis)reading of the entire cycle as a gesture of sympathy toward the Trojans: Barchiesi 1997c, 277, and D. Beck 2007, 536–40.
43. At *Il.* 16.543, however, Glaucus already seems to know that Sarpedon has been killed by Patroclus rather than Achilles.
44. On the uneasy integration of the disguise motif into the plot of the *Iliad*, see Janko 1992, 310–11.
45. The subjunctives *gustassent* and *bibissent* imply a purpose (see Austin 1971, *ad* 1.473), which, strictly speaking, according to both Homer and Euripides, neither Greek hero in fact had in mind. On the development of the story, see Gantz 1993, 619.
46. Galinsky 1969a, 18–19.
47. As in Plautus, *Bacch.* 954.
48. See the discussion of Williams 1960, 145–48.
49. See Kossatz-Deissman in *LIMC* 1.1.72–75, s.v. "Achilleus," and Gantz 1993, 597–98.
50. See Gantz 1993, 600, and Galinsky 1969a, 18–19, with figs. 14, 15, 97, 110.

51 See Zorzetti 1995, 118. The desperate search for parallels has led, e.g., Kossatz-Deissman, *LIMC*, s.v. "Troilos," 8.1.91, to suggest that Priam's inclusion of Troilus (*Il.* 24.257–60) among his sons killed in war attests to an alternative tradition in which he was killed in a proper battle rather than an ambush, but the Homeric passage does not require this.

52 Williams 1960, 148.

53 Six 1917, 191–92, suggested on the basis of Virgil that the Pompeian picture as reproduced by Steinbüchel might show the death of Troilus; the hypothesis is alluded to by Schefold 1957, 192, but Kossatz-Deissmann (*LIMC*, s.v. "Achilleus," 1.1.387) is rightly dubious.

54 For the representation of this scene on the *tabulae Iliacae*, see Brüning 1894, 149.

55 Virgil is still engaged with the issues of visual and verbal media, however. His version, in which the statue of Athena keeps her eyes fixed and averted, "corrects" the Homeric version in which the statue seems to be said to throw its head back in a gesture of refusal (ἀνένευε, *Il.* 6.311). See Graziosi and Haubold 2010, *ad loc.*, and Barchiesi 1998.

56 If *currus* has its normal meaning of "chariot" rather than "cart" here, perhaps the reader is meant to imagine Hector's body still tied to Achilles's chariot.

57 "The *dragging* is not represented in the picture, only the *selling*": Henry 1873–92, 1:720; also Leach 1988, 316.

58 See Euripides, *Andromache* 107–8.

59 On the verbal links between the death of Turnus at the end of the epic and Aeneas's response to Hector's body in this passage, see the brilliant discussion of Elsner 2007, 86, anticipated in some respects by Lowenstam 1993, 41.

60 Moving Penthesilea into the final position also has the effect, as is well known, of preparing for Dido, who makes her entrance immediately afterward; see Austin 1971, *ad* 493. If Dido is fated to follow the fate of the tragic Amazon, then Aeneas is already in the very next scene on his way to becoming the Achilles who causes her death despite loving her.

61 The African race of Memnon is frequently marked in Greek and Roman art with respect to skin color or features; see Snowden in *LIMC*, s.v. "Aithiopes," 1.1.418–19. But it is often the case that the nature of the medium makes distinctions in skin color difficult, as in vase painting, or that its conventions use skin color as a proxy for gender. Furthermore, Memnon's face and hair might be concealed by his helmet. In light of this potential for ambiguity, it is significant that Virgil explicitly specifies that Memnon is black in this painting and adds the additional distinguishing characteristic of his special armor.

62 For a compelling reading of this calculated ambiguity, see Kirichenko 2013, 70.

63 See Austin 1971, *ad* 242 and 488.

64 On the other hand, some scholars have pointed out that Aeneas is far from an unheroic character in the *Iliad*: Galinsky 1969a, 11–18.

65 For a parallel, see the discussion by Casali 1995 of how the ecphrasis of the Cretan tale on the doors of Daedalus's temple seems to end prematurely, just before mentioning Theseus's abandonment of Ariadne. Aeneas, who has just abandoned Dido, thus suppresses, in an ecphrasis focalized by him, an episode that would reflect uncomfortably upon himself.

66 Kirichenko 2013, 73–74, argues that the Trojan horse is one such obvious omission.

67 Note that Zeuxis's portrait of Helen originally hung in the Temple of Hera (i.e., Juno) in Croton. It would be interesting to know the original context of Theorus's cycle.

68 As Kirichenko 2013, 67, says, Aeneas is "seemingly unaware of Juno's presence." Is Aeneas unaware of the identity of the divinity to whom the temple is dedicated? The cella doors seem to be shut, so perhaps he is. Or is he unaware of the extent of Juno's hostility to him? Perhaps both.

69 For a rendering of these lines as a parody of Virgil, see Ezra Pound's "Homage to Sextus Propertius XII," with J. F. Miller 2009, 75–78.

70 Lucretius 1.117–18.

71 Nisbet and Rudd 2004, 376, think otherwise, but the differences they cite regarding the Virgilian passage are what make this a friendly challenge to Virgil.

72 "ipse caput tonsae foliis ornatus oliuae / dona feram," *Georg.* 3.31–32.

73 He also alludes to the Nemean and Isthmean games (*Georg.* 3.19–20).

74 This engagement with the Latin epic tradition and Horace's teasing skepticism toward the *Aeneid* in progress may help to explain why Ovid concludes his epic *Metamorphoses* (15.871–79) with such a prominent allusion to this lyric poem, including the Ennian pun (875).

75 On its significance, see Woodman 1984.

76 Lyne 1995, 184–85.

77 See Nisbet and Rudd 2004, 8.

78 J. F. Miller 2009, 270–88.

79 The joke is from Woodman 1984, 94.

80 Note Horace's posthumous attribution to the young Virgil of *studium lucri* (enthusiasm for money, Ode 4.12.25), though some scholars argue that this is not the same Virgil.

81 See *Georg.* 2.461: *foribus domus alta superbis*, with Nisbet and Rudd 2004, *ad* 3.1.

82 Thus Nisbet and Rudd 2004, 20.

83 See Nisbet and Rudd 2004, 30, 34.

84 See Heyworth 2007, 275.

85 See Harrison 2007, 31.

86 See Hinds 1998, 69–74.

87 Some commentators (e.g,. D. A. West 2002, 50–51) think this refers to an episode just after Actium when Virgil read the *Georgics* to Augustus, who was suffering from a sore throat. Horace is, however, talking about the power of art to do more than cure tonsillitis.

88 See Nisbet and Rudd 2004, 82 and *ad* 18–21.

89 Propertius is quoted mainly after the text of Barber, with a few changes, mentioned in the footnotes.

90 Spelman 1999 rightly builds his interpretation of this elegy around its apparent logical inconsistency, but his solution, which has recourse to a psychological explanation, is unconvincing. The contradiction in the elegy appears to be on the level of logic and sense rather than subconscious. Heyworth 2007, 118, agrees that there is "some incoherence" and correctly insists that it must be "tactical" rather than a sign of inattention. Here I attempt to explain the poetic strategy this tactic aims at.

91 See Goold 1990, 113n13.

92 Goold 1990, 2.

93 For a parallel hypothesis of a Latin poet alluding to a painting, see Goldberg 2005, 131–34, on Lucretius's Iphigenia.

94 See Heyworth 2007, 120–21, on the conjecture *papilla* for the vapid *puella* in 15.

95 *Laocoön*, chap. 20: McCormick 1962, 108.

96 For the emendation that supplies Erinna in the corrupt line 22, see Heyworth 2007, 122.

97 Cynthia is said to compose *Aeolio . . . carmina plectro* (19), which strongly suggests lyric, and she compares her work to Corinna's, which was also lyric. She also, if the emended text is correct, compares her work to that of Erinna, who was mainly known for her hexameter *Distaff*, though admittedly some epigrams in the *Greek Anthology* are attributed to her. It is interesting to note that the two "real" poetesses to whom Cynthia is compared in this poem have, like her, occasionally been appraised as literary fictions created by men. For Erinna, see M. L. West 1977, who adduces Athenaeus (7.283d) as an ancient skeptic. For Corinna, the difficulty is in reconciling the biographical tradition that makes her a rival of Pindar, and so puts her in the fifth century, with her language, which seems to be later. Propertius's phrase *antiquae . . . Corinnae* (21) is often cited as evidence that the fifth-century date was current among Roman readers (Allen and Frel 1972, 28, and M. L. West 1970, 279n3), but Propertius might just as well have been using the epithet in an ironic fashion to indicate that he knew precisely what was fictional about Corinna.

98 Schmidt 1972 tries unconvincingly to relate these lines instead to the fourth eclogue of Virgil.

99 See Wyke 1987.

100 As transmitted, the poem carries on for another ten lines, but many editors rightly think that line 45

and following belong to the beginning of the next poem. On the unreliability of the transmitted poem divisions (which is a somewhat separate question from the general reliability of the transmitted text), see Heyworth 1995.

101 For a different interpretation of this connection, see Cairns 2006, 97–99.
102 Lyne 1998, 538–44. Lyne was overly pessimistic in concluding that one cannot fully understand the point of this poem without Gallus's text; the point at issue here can be explained fully by the meaning of Zeuxis's painting with its inscription.
103 See, for example, the beginning of the second book of Cicero's *De inventione*; for the full range of ancient sources, see the thorough survey of de Angelis 2005. On the reception of the story in modern painting, see Mansfield 2007.
104 The nudity of the portrait and thus of the well-born maidens who served as models, which Cicero suppresses in his moralizing version of the anecdote, is attested by Dionysius of Halicarnassus (*De imitatione* 31.1).
105 See Athenaeus, *Deipnosophists* 13.59.
106 Wyke 1987.
107 As noted above, on my reading Propertius calls her "ancient" (*antiquae*, 2.3.21) out of irony, not gullibility. See M. L. West 1970 and M. L. West 1990; West does not, however, entertain the possibility that Propertius was joking.
108 McKeown 1987–98, 1:19.
109 Leucadia is a mystery; Lesbia was ostensibly based upon Clodia Metelli; Quintilia is also unknown, and that name does not at all sound like a pseudonym.
110 The information reported by Apuleius that the model for Cynthia was a certain Hostia simply shows how strong was the impulse among ancient readers, after Catullus, to interpret the elegiac *puella* as a cypher for a real woman. It is entirely possible that there was a Hostia in Propertius's life; but, if so, she must have been only one of several women he drew upon.
111 Many scholars emphasize one side at the expense of the other; on the political context of Propertius's first book, see Heslin 2010.
112 See Nethercut 1970.
113 E.g., Fedeli 2005, 49, and Heyworth and Morwood 2011, 98.
114 See Luck 1957.
115 See Clay 2004.
116 J. F. Miller 2009, 314–17.
117 Cf. Ode 3.1.1–2: "odi profanum uolgus et arceo. fauete linguis," with Callimachus, *Hymn Apoll.* 2 and 17: ἑκὰς ἑκὰς ὅστις ἀλιτρός and εὐφημεῖτ' ἀίοντες.
118 It also echoes Horace's *quibus antris* (Ode 3.25.3–4), a phrase that looks back to the Roman Odes.
119 Bulloch 1989, 4.
120 Heyworth and Morwood 2011, 99–100.
121 See Galinsky 1969b, 88–89.
122 "multi, Roma, tuas laudes annalibus addent"; for further allusions here to Lucretius's praise of Ennius, see Nethercut 1970, 391, and J. F. Miller 1983, 284. See also Woodman 1998 for the allusion to Livy's annalistic history.
123 Ode 3.1.48: Nethercut 1970, 387.
124 Crawford 1974, no. 425, attributes the coin to the son, evidently in error: his suggested date corresponds with the consulship of the father in 56 BC.
125 On the deliberate disorder, see Heyworth 1986, 200–202, and J. F. Miller 1983, 281–82.
126 "omnia post obitum fingit maiora vetustas," 3.1.23.
127 For opposing views of the nature of the relationship implied by the two poems that Propertius addresses to Maecenas, see Cairns 2006, 260–69, and the rebuttal by Heyworth and Morwood 2011, 103.
128 Compare Ovid's obviously unserious Propertian pastiche (*Am.* 3.8.23–24): "ille ego Musarum purus Phoebique sacerdos/ad rigidas canto carmen inane fores?" ("Am I, the pure priest of Apollo and the

Muses, the one to sing an idle song at locked doors?").
129 See J. F. Miller 2009, 234–47.
130 On Encolpius's and Eumolpus's lack of judgment on matters of high culture, see Slater 1990, 95; Elsner 1993, 39; and Walsh 2009, 183–5.
131 For example, at the start of Achilles Tatius's *Leucippe and Clitophon* (1.1–2); see Bartsch 1989, 40–79.
132 "ergo amor etiam deos tangit" (83.4), aptly compared by Zeitlin 1971, 60, with Virgil's "et mentem mortalia tangunt" (*Aen.* 1.462); see also Conte 1996, 17.
133 Connors 1998, 85; Rimell 2002, 64.
134 "pueri umbram revocavit in florem"; cf. Ovid, *Met.* 10.162–219, and see Connors 1998, 85.
135 "omnes fabulae quoque habuerunt sine aemulo complexus" (83.5). See Panayotakis 1995, 118.
136 See Zeitlin 1971, 59n1.
137 The name is ironic, given the poor quality of his poetry. Eumolpus was also the eponym of the hereditary family of hierophants in the Eleusinian mysteries, who, on one reconstruction, spoke the words handed down from the Muses via Orpheus; see Elsner 1993, 35, and Euripides, *Rhesus* 941–45, with Rimell 2002, 68n22, and A. Hardie 2002, 17.
138 This is the inverse of the moral of the myth of Tantalus, which introduces this section of the novel.
139 Walsh 1968, 209–10.
140 R. Beck 1979, 241; likewise Slater 1990, 99.
141 See Slater 1990, 96–97; Elsner 1993, 40; and Connors 1998, 88–89.
142 See Connors 1998, 87.
143 Elsner 1993, 40–41.
144 See Elsner 1993, 41, and Slater 1990, 188.
145 For a different view, see Rimell 2002, 67.
146 Slater in Gagarin and Fantham 2010, 5:235, s.v. "Petronius."
147 R. Beck 1979.
148 Compare the argument of Juvenal's first satire.
149 The way Aeneas combines here the roles of poet and emperor brings into view another model for this scene: Nero's singing of the fall of Troy while Rome burned, on which see Connors 1998, 93–99.
150 On the strict chronological order and the annalistic nature of Aeneas's shield, see P. R. Hardie 1986, 347; Barchiesi 1999, 334; and especially Barchiesi 1997c, 276–77: "The shield of Aeneas is a substitute for an alternative epic poem, a poem which could have been Ennian, historical, written in tableaux, in sequential order, and focused on praise."

Conclusion

Art, Architecture, and Poetry

BEGAN THIS BOOK BY LOOKING at the way in which G. E. Lessing used two contrasting ancient representations of characters from the Trojan War—the Laocoön sculpture and Zeuxis's portrait of Helen—to highlight the respective limitations of visual and textual media. According to Lessing, the Laocoön is handicapped by its inability either to represent the sounds and words of the cry of the Trojan priest or to reconcile a true expression of agony with the demands of visual aesthetics. If the weakness of visual art is in its treatment of ugliness and pain, the weakness of the verbal is in its treatment of beauty. Even the greatest poet, Homer, could give no more than an indirect sense of the beauty of Helen that Zeuxis could represent directly. One thesis of this book has been that Lessing uncovered the first hints of a large body of evidence suggesting that at Rome the Trojan story in particular was the locus for an intensely emulous rivalry between poets and visual artists. It is no coincidence, therefore, that Virgil and then Petronius represented the same scene depicted in the famous sculptural group of the Laocoön. Lessing rightly saw that Petronius's poem on the sack of Troy was doubly incompetent: it fails to describe a painting and it is an uninspired rehash of Virgil's narrative.[1] Lessing was handicapped, however, by his failure to see that this composition must be credited to Eumolpus rather than his creator. This highlights a major flaw, perhaps, for a student of classical antiquity, *the* major flaw in Lessing's essay: that he fails to see that all his important examples, including the Laocoön, Virgil's *Aeneid*, and Zeuxis's *Helen*, were created in antiquity as interventions in a self-conscious discourse about the relative strengths and weaknesses of visual and verbal media that already existed in the ancient world. Lessing's analysis did not invent that discourse but teased out aspects of a once-vigorous ancient discussion.

An awareness of that discussion can shed light on the important role played by ecphrasis in many ancient literary genres, from epic to the novel to rhetorical set pieces. It is not news to claim that ecphrasis is a key programatic figure of ancient thought.[2] What is more unusual is to claim that the literary aspect to ecphrasis is only one side of the story. It has become routine to assert that such passages are not actually descriptive and have nothing to do with real art. If what is meant thereby is the trivial point that ecphrastic passages are more than a simple, naive account of a particular work in the real world, fair enough. Usually, however, the claim goes further and isolates the ecphrasis in an artificial world sealed off from the real language

of visual iconography. Caught between the Scylla of Homer's shield of Achilles and the Charybdis of Philostratus's *Imagines*, the field has come to the conclusion that ecphrasis must always represent a purely imaginary work, untainted by associations with actual works of art. This extreme formulation is, however, self-evidently absurd. It is the map of Lessing's world, where the visual and the textual share a militarized frontier, only to be crossed by the hapless and second-rate. It is not the real world, however. Guests arriving in the atrium of the House of the Tragic Poet did not put aside their knowledge of Homer when viewing the paintings there, nor did Virgil's original audience refuse to think about the paintings in the Portico of Philippus, or its provincial variations, when reading about Aeneas stumbling into a temple portico decorated with a similar theme. Virgil is not describing an actual Roman temple, but he relies upon his audience's familiarity with that kind of monument and its ambiguities in order to undermine the reader's faith in Aeneas's confident interpretation of the paintings.

The original, primary model for the Portico of Apollo in Pompeii was the Portico of Philippus in Rome, but as the years went by, it must have seemed to the townspeople to be a representation not only of the Roman monument but also of its fictional analogue, the portico of Juno in Carthage. This would help explain why Pompeians continued to restore the portico to retain the original cycle of paintings after they were damaged by earthquakes. The increasing centrality of the *Aeneid* in Roman culture would have kept its relevance alive through the decades after the Augustan period. Take one example, considered in chapter 4: the detail of the shield of Achilles in the painting of Thetis in the forge of Vulcan, which recurs many times in domestic contexts in Pompeii. One way of thinking about that image of the shield is as follows. It is a domestic visual quotation of part of a public visual cycle in Pompeii that imitated a fictional ecphrasis in Virgil's *Aeneid* that was inspired by a visual monument in Rome in which there was a cycle of Hellenistic paintings that illustrated the text of Homer's *Iliad*, which itself contained an ecphrasis of that shield. Like the shield of Homer's Ajax, this humble domestic painting is made up of seven layers. Yet the richness of this dialogue between art and text is denied by the orthodox view that ancient ecphrasis has nothing to do with real works of art. Anyone, however, who took a stroll through the portico of Apollo in Pompeii armed with an equal knowledge of Homer and Virgil on the one hand and the visual representations of the Trojan War on the other would have been rewarded with the observation that she was walking through, on one way of looking at it, a fictional portico with real paintings in it.

If the Pompeian imitations of the painting of Thetis and Hephaestus are a reliable guide, when Theorus represented the shield of Achilles he did not attempt to visualize Homer's text, which would have been impossible. Instead, he represented the contents of the shield symbolically, via the signs of the Zodiac, rather than via visual mimesis (see fig. 72). In this way he reasserted the fundamentally textual nature of that shield

and refused, on principle, to rise to the bait of Homer's ecphrasis. Instead, he transformed it back into a different kind of text and showed how it should be read, taking a lesson from Homer. The poet cannot represent Helen's beauty visually, so instead he shows us the reaction of the old men of Troy. The painter cannot tell us how to read the shield textually, so instead he shows us the reaction of Thetis. Thetis's interest in reading the shield contrasts with Achilles's indifference to its contents in the *Iliad*. A figure in the background points at the symbols and the goddess starts in dismay. Hardie has convincingly argued that these star signs represent Achilles's horoscope and foretell his impending death.[3] In other words, Theorus responded to Homer's ur-ecphrasis with an anti-ecphrasis: not a work of visual art inscribed within a text, but a text of symbols inscribed within a work of visual art.

Literary scholars need to recognize that ecphrasis is only one side of the ongoing dialogue with visual representations, and that art does far more than meekly illustrate a master narrative provided by the text. At the same time, scholars of the visual need to stop fearing that to put images into a relationship with texts and indeed with other images is to relegate the object of their study to secondary status. Many art objects in the ancient world found their meaning by way of their intertextual relationship with canonical texts and objects. As demonstrated frequently by the Pompeian cycle, visual art was capable of representing literary narrative in a way that is just as playful, self-confident, and self-reflective as literary ecphrasis. Ignoring this half of the dynamic not only diminishes ancient art but also diminishes literary ecphrasis by overlooking its dialogue with visual art. Virgil's ecphrasis of the Temple of Juno in Carthage comments upon Theorus's visual commentary upon Homer's *Iliad*. The cycle of Theorus was given a new meaning by Augustus when it was moved to the center of Rome's literary life. Along with Zeuxis's *Helen*, it made a demand of Rome's poets. If these visual artists could rise to the challenge of Homer, why not they? To say that Virgil's ecphrasis is purely fictional misses all this context.

A related but separate anxiety about the potential secondariness of Roman art concerns the phenomenon of copying. Two major consequences of this anxiety have been a tendency to minimize (1) the impact of Roman monuments on provincial monuments and (2) the impact of local monuments on domestic interiors. These failures have made it difficult to understand the nature of the interrelationship of pictures of Trojan themes in Pompeii and how masterpieces of Greek painting came to be reinterpreted, refracted, and reconstituted in domestic contexts in Campania. It should be clear that, when decorating their homes, the Romans did not usually ask for copies, imitations, or reinterpretations of particular, specific masterpieces of Greek art. But images and iconography were copied from somewhere. How did this happen? The usual answer has been to invoke pattern books and the like, but there is no evidence whatsoever that visual culture was broadly diffused in this way. The underlying problem with this methodology, apart from the absence of evidence, is that is presumes

that Roman artists and patrons were passive drudges who reproduced Greek culture automatically and unthinkingly. Deviations from the pattern book are explained away as incompetence. When you go looking for nothing but stupidity, it is always easy to find; but such a methodology may blind you to the cleverness and creativity under your nose. If figural compositions in Campanian painting were derived from pattern books, you would expect much more cookie-cutter uniformity, and much less intelligence and wit, than you can find if you look for it.

The owner of the House of Apollo knew what he was doing when he decorated his garden refuge in such a way as to make it a witty allusion to a sanctuary: he asked for copies of the art in the local Temple of Apollo. Even more thought went on behind the creation of the atrium of the House of the Tragic Poet as a reflection on the difference between the self-control of gods and of men and on the central role played by Thetis in the early history of the world. It alludes both to literary texts and to Theorus's cycle and presumes an equal knowledge of text and monument. On a grander scale, the portico of the Temple of Apollo alluded to the familiar iconography of the Portico of Philippus and equally to its fictional reinterpretation by Virgil. It should be uncontroversial to assert that the people of Pompeii imitated what they saw and valued in their own environment, both texts and images. The factor that determined the most frequent and topical images in circulation, however, was not an art-historical perspective on the development of Greek painting. It was the reappropriation of masterpieces of Greek painting in the city of Rome. The fame of a particular artist had an impact on the reception of his images in Rome, of course, but there were many other factors. Hence this book's conclusion, which may well be controversial, that the most important Hellenistic painter at Pompeii, at least for Trojan subjects, was the obscure Theorus, whom Pliny calls a second-rater. The dissemination in Italy of images from famous Greek paintings was an accidental by-product of their appropriation in Roman monuments.

Understanding the impact of the Portico of Philippus in Pompeii should help to break down the prejudice that visual narratives were ideology for the masses, while texts were for the elite. The imagery of the Portico of Philippus in Rome had a very specific message for the poets of the city, who were part of a literary elite, but it was cast in public, architectural terms. That message may have been intended for a metropolitan audience in the first instance, but it was understood perfectly well in Pompeii. When Horace and Virgil combined the Portico of Philippus and the Temple of Palatine Apollo into a single metaphorical structure, they evoked an Alexandrian ideal of a unified Museum, library, and royal palace. When Holconius Rufus and the people of Pompeii effected the very same conflation in their real, tangible structure, they had a very different aim in mind: to emphasize the antiquity and centrality of their city's association with Apollo, and to highlight the contrast with Hercules, patron of their local rival. Nevertheless, the fact that the people of Pompeii could speak the

same ideological language as the Augustan poets and manipulate its symbols in the same way suggests that there was not one language for the elite and another for the populace at large.

A final conclusion regarding the Pompeian material is that there is still a large amount of unpublished visual material left to be exploited. In an era when news stories about Pompeii document its continuing collapse, it is all the more urgent to collect together the earliest archival testimony for the monuments, for the decay often set in very swiftly after excavation. The major sources of evidence are well known, and it is unlikely that the discovery of any single document will add to our knowledge at one stroke. But this book has shown that a minutely detailed collation and comparison of already-well-known sources can produce a surprisingly full picture, where none of the individual documents would seem to promise much in isolation. Even though the arrangement of the Trojan cycle in the Temple of Apollo had long been written off as lost, I have been able to reconstruct most, I believe, of what was visible when the temple was first excavated in 1817. One wonders how many other public monuments in Pompeii might benefit from similar treatment. What is crucial for making progress in this direction is the digitization of hard-to-access books and archival collections. Libraries and archives that make their materials freely available online are not just making life easier for researchers; they are making this kind of work possible for the first time, for it would otherwise be prohibitively time-consuming and expensive.

I have suggested that it looks like more than a coincidence that within a very short span of time, the approximately two decades from 28 BC to 10 BC, the Temple of Hercules Musarum, the Temple of Juno in the *Aeneid*, and the Temple of Apollo in Pompeii were all provided with porticoes having cycles of paintings depicting the Trojan War. The very strong iconographical connection between the the Pompeian portico and the *tabulae Iliacae* suggests a common metropolitan model, with the Portico of Philippus as the most likely candidate. What is found in Pompeii, therefore, is a structure reflecting in its original conception a monument that was a source for Virgil's ecphrasis but that in its continued relevance and renovation probably came to reflect Virgil's fictional temple as well as the real Roman monument behind it. At the very least, the Pompeian temple can provide an idea of how a Roman provincial audience visualized the temple that Aeneas visited in Carthage. More speculatively, the Pompeian portico may give partial access to certain aspects of the iconography of a Roman monument that was an important influence on Virgil's epic.

In any case, it can be shown that the Portico of Philippus was a project of major ideological significance. It is true that Augustus never mentions the Portico of Philippus in his *Res gestae*, and indeed the fact that it was built ostensibly as a triumphal monument for his stepbrother-turned-uncle suggests that he was cautious about evoking the model of the Museum of Alexandria too openly. Nevertheless, the impact of this monument on the poetry written in the decade after Actium was immense. Virgil's

Georgics and *Aeneid*, Horace's Roman Odes (3.1–6), and Propertius's un-Roman elegies (3.1–5) all dramatized their relationship with the Augustan regime by evoking it. These poets also responded to each other, but it is the monument that provides the unifying theme that makes the outlines of the literary tradition clear. The metaphorical evocation of the poem-as-temple which is found in so many of these passages encompasses a full range of responses: from Virgil's acceptance of the commission for an Augustan epic, to Horace's offering of a compromise, to Propertius's outright rejection. While there may have been political aspects to some of these responses, overtly the issues were aesthetic. Literary debates were not so much concerned with whether Augustus had restored the Republic as whether one could write an epic on themes from Roman history and yet remain true to the Roman reinterpretation of Alexandrian criticism that had been worked out in the generation of the neoteric poets. The ghosts that haunted these debates were not Brutus and Cassius so much as Catullus and the rebarbative annalistic epic of his nemesis Volusius.[4]

The reinterpretation of Roman Republican history as a subsidiary aspect of the history of the Julian family that was put on display in the Forum of Augustus already existed in the Portico of Philippus, decades earlier, in a more subtle form. The construction of a unified ideology in word and image around the figure of Aeneas was already well under way. The attendant demand on the poets of Rome to produce an epic to replace Ennius's was not merely a matter of a word in their ear from Maecenas. These public *recusationes* responded to a very public request. It would be wrong to assume that the intended audience of the Portico of Philippus was very narrow, limited to the poets who assembled there; Pompeii's Temple of Apollo refutes that assumption. The poets of Rome were under pressure, and all Italy could see it. The publication of the *Aeneid* showed that Virgil had heeded the public call to recast the Republican narrative within a frame dedicated to Aeneas. The *Aeneid* followed the design of the Portico of Philippus in its outer form, but if that were all it did, it would not have been such a success. The central paradox of Virgil's epic is that, on the one hand, it was apparently constructed to imperial specification, but, on the other, in order to fulfill its designated role as a truly immortal national epic to stand as a worthy rival to Homer's, it had to be something more than propaganda. This is why, when Aeneas comes face-to-face with a textual, fictionalized version of the Roman monument that provided the blueprint for the very poem in which he finds himself, he acts out a parable of the difficulties of interpreting a work of art, even, or especially, when the viewer or reader believes himself or herself to possess a special key to its meaning.

NOTES

1. Note to *Laocoön*, chap. 5: McCormick 1962, 170–75.
2. See Bartsch 1989, 3–39.
3. See P. R. Hardie 1985, 20, who supposes a "lost literary source," but that is an unnecessary hypothesis if the shield is interpreted as a thoughtful contribution by the painter to the interplay between visual and symbolic mimesis.
4. Catullus, 36 and 95; see Heslin 2011, 54.

Abbreviations Used in Notes and References

NOTE: Ancient texts are abbreviated according to the conventions of the *Oxford Classical Dictionary* (3d ed.; Oxford University Press, 2005).

CIL — *Corpus Inscriptionum Latinarum.* Berlin-Brandenburgische Akademie der Wissenschaften, 1863–.

Dar.-Sag. — *Dictionnaire des antiquités grecques et romaines d'après les textes et les monuments*, ed. C. Daremberg and E. Salgio. Paris: Hachette, 1877–1919.

EAA — *Enciclopedia dell'arte antica, classica e orientale.* Rome: Istituto della enciclopedia italiana, 1958–84.

LIMC — *Lexicon iconographicum mythologiae classicae.* Zurich and Munich: Artemis Verlag, 1981–.

LSJ — *A Greek-English Lexicon*, 9th ed., H. G. Liddell and R. Scott, revised by H. Stuart Jones. Oxford: Clarendon Press, 1940.

LTUR — *Lexicon Topographicum Urbis Romae*, ed. E. M. Steinby. Rome: Quasar, 1993– .

OLD — *Oxford Latin Dictionary*, ed. P. G. W. Glare. Oxford University Press, 1968–82.

PPM — *Pompei: Pitture e mosaici.* Rome: Istituto della enciclopedia italiana, 1990–2003.

PPM Disegnatori — *Disegnatori Pompei: Pitture e mosaici; La documentazione nell'opera di disegnatori e pittori dei secoli XVIII e XIX.* Rome: Istituto della enciclopedia italiana, 1995.

RE — *Real-Encyclopädie der classischen Altertumswissenschaft.* Stuttgart: Metzler, 1893–1980.

TLL — *Thesaurus linguae latinae.* Leipzig: Teubner, 1900–.

References

Aberson, M. 1994. *Temples votifs et butin de guerre dans la Rome républicaine*. Rome: Institut Suisse de Rome.

Ackroyd, B. 2000. "The Porticus Gai et Luci; the Porticus Philippi; the Porticus Liviae." *Athenaeum* 88:563–80.

Adam, J.-P. 1999. *Roman Building: Materials and Techniques*. London: Routledge.

———. 2007. "Building Materials, Construction Methods, and Chronologies." In *The World of Pompeii*, edited by J. J. Dobbins and P. W. Foss, 98–119. London: Routledge.

Allen, A., and J. Frel. 1972. "A Date for Corinna." *Classical Journal* 68:26–30.

Allison, P. M., and F. Sear. 2002. *Casa della Caccia antica*. Munich: Hirmer.

Anderson, J. C., Jr. 1982. "Domitian, the Argiletum and the Temple of Peace." *American Journal of Archaeology* 86:101–10.

Arthur, P. 1986. "Problems of the Urbanization of Pompeii: Excavations 1980–1981." *Antiquaries Journal* 66:29–44.

Ashby, T. 1911. Review of Hülsen's Edition of the Barberini Notebook of Giuliano da Sangallo. *Classical Review* 25:173–75.

Astin, A. E. 1978. *Cato the Censor*. Oxford: Clarendon Press.

Astin, A. E., et al., eds. 1989. *The Cambridge Ancient History: Rome and the Mediterranean to 133 B.C.* Vol. 8. 2d ed. Cambridge: Cambridge University Press.

Austin, R. G. 1944. "Quintilian on Painting and Statuary." *Classical Quarterly* 38:17–26.

———, ed. 1971. *P. Vergili Maronis Aeneidos liber primus*. Oxford: Clarendon Press.

Badian, E. 1972. "Ennius and His Friends." In *Ennius: Sept exposés suivis de discussions*, edited by O. Skutsch, 149–208. Geneva: Fondation Hardt.

———. 1989. "The *scribae* of the Roman Republic." *Klio* 71:582–603.

Baldassarre, I., ed. 1981. *Pompei 1748–1980: I tempi della documentazione*. Rome: Multigrafica.

Balensiefen, L. 2002. "Die Macht der Literatur: Über die Büchersammlung des Augustus auf dem Palatin." In *Antike Bibliotheken*, edited by W. Hoepfner, 97–116. Mainz: Philipp von Zabern.

Balot, R. K. 1998. "Pindar, Virgil, and the Proem to *Georgic* 3." *Phoenix* 52: 83–94.

Barber, E. A., ed. 1960. *Sexti Properti Carmina*. Oxford: Clarendon Press.

Barchiesi, A. 1997a. "Endgames: Ovid's *Metamorphoses* 15 and *Fasti* 6." In *Classical Closure: Reading the End in Greek and Latin Literature*, edited by D. H. Roberts, F. M. Dunn, and D. Fowler, 181–208. Princeton: Princeton University Press.

———. 1997b. *The Poet and the Prince: Ovid and Augustan Discourse*. Berkeley: University of California Press.

———. 1997c. "Virgilian Narrative: Ecphrasis." In *The Cambridge Companion to Virgil*, edited by C. Martindale, 271–81. Cambridge: Cambridge University Press.

———. 1998. "The Statue of Athena at Troy and Carthage." In *Style and Tradition: Studies in Honor of Wendell Clausen*, edited by P. E. Knox and C. Foss, 130–40. Leipzig: Teubner.

———. 1999. "Representations of Suffering and Interpretation in the *Aeneid*." In *Virgil: Critical Assessments of Classical Authors*, edited by P. R. Hardie, 3:324–44. London: Routledge.

Bartoli, A. 1914–22. *I monumenti antichi di Roma nei disegni degli Uffizi di Firenze*. Florence: Bontempelli.

Bartsch, S. 1989. *Decoding the Ancient Novel: The Reader and the Role of Description in Heliodorus and Achilles Tatius*. Princeton: Princeton University Press.

Beard, M. 2009. *Pompeii: The Life of a Roman Town*. London: Profile.

Beard, M., and J. Henderson. 2001. *Classical Art: From Greece to Rome*. Oxford: Oxford University Press.

Beard, M., J. A. North, and S. R. F. Price. 1998. *Religions of Rome*. Cambridge: Cambridge University Press.

Beck, D. 2007. "Ecphrasis, Interpretation, and Audience in *Aeneid* 1 and *Odyssey* 8." *American Journal of Philology* 128:533–49.

Beck, R. 1979. "Eumolpus *Poeta*, Eumolpus *Fabulator*: A Study of Characterization in the *Satyricon*." *Phoenix* 33:239–53.

Bendinelli, G. 1956–57. *Prospettive e architetture templari nell'arte imperiale romana*, 3:553–68. Milan: Ceschina.

Bergmann, B. 1994. "The Roman House as Memory Theater: The House of the Tragic Poet in Pompeii." *Art Bulletin* 76:225–56.

———. 1995. "Greek Masterpieces and Roman Recreative Fictions." *Harvard Studies in Classical Philology* 97:79–120.

———. 2001. "House of Cards." *Journal of Roman Archeology* 14:56–57.

———. 2007. "A Painted Garland: Weaving Words and Images in the House of the Epigrams in Pompeii." In *Art and Inscriptions in the Ancient World*, edited by Ruth Leader-Newby and Zahra Newby, 60–101. Cambridge: Cambridge University Press.

Bettini, M. 1999. *The Portrait of the Lover*. Berkeley: University of California Press.

Bianchi Bandinelli, R. 1955. *Hellenistic-Byzantine Miniatures of the "Iliad": Ilias Ambrosiana*. Olten: Graf.

Bonucci, C. 1827. *Pompei descritta*. Naples: R. Miranda.

Borsi, S. 1985. *Giuliano da Sangallo: I disegni di architettura e dell'antico*. Rome: Officina.

Bouquillard, J. 2000. *La résurrection de Pompéi: Dessins d'archéologues des XVIIIe et XIXe siècles*. Arcueil: Anthèse.

Boyancé, P. 1955. "Fulvius Nobilior et le dieu ineffable." *Revue de philologie* 29:172–92.

Boyd, B. W. 1995. "*Non enarrabile textum*: Ecphrastic Trespass and Narrative Ambiguity in the *Aeneid*." *Vergilius* 41:71–90.

Boyle, A. J. 2003. *Ovid and the Monuments: A Poet's Rome*. Bendigo: Aureal.

Breed, B. W., and A. Rossi. 2006. "Introduction: Ennius and the Traditions of Epic." *Arethusa* 39:397–425.

Brilliant, R. 1984. *Visual Narratives: Storytelling in Etruscan and Roman Art*. Ithaca, NY: Cornell University Press.

———. 2000. *My Laocoön: Alternative Claims in the Interpretation of Artworks*. Berkeley: University of California Press.

Brink, C. O., ed. 1963–82. *Horace on Poetry*. Cambridge: Cambridge University Press.

Briscoe, J., ed. 2008. *A Commentary on Livy, Books 38–40*. Oxford: Oxford University Press.

Brothers, C. 2002. "Reconstruction as Design: Giuliano da Sangallo and the 'Palazzo di Mecenate' on the Quirinal Hill." *Annali di Architettura* 14:55–72.

Brüning, A. 1894. "Über die bildlichen Vorlagen der Ilischen Tafeln." *Jahrbuch des Deutschen Archaeologischen Instituts* 9:136–65.

Bryson, N. 1983. *Vision and Painting: The Logic of the Gaze*. New Haven, CT: Yale University Press.

———. 1994. "Philostratus and the Imaginary Museum." In *Art and Text in Ancient Greek Culture*, edited by S. Goldhill and R. Osborne, 255–83. Cambridge: Cambridge University Press.

Buck, C. D. 1904. *A Grammar of Oscan and Umbrian*. Boston: Ginn & Company.

Bulas, K. 1929. *Les illustrations antiques de l'Iliade*. Lvov: Drukarnia Akademicka.

———. 1950. "New Illustrations to the *Iliad*." *American Journal of Archaeology* 54:112–18.

Bulloch, A. W. 1989. "Hellenistic Poetry." In *The Cambridge History of Classical Literature*. Vol. 1, Greek Literature, edited by P. E. Easterling and B. M. Knox, fasc. 4, 1–81. Cambridge: Cambridge University Press.

Cairns, F. 2006. *Sextus Propertius: The Augustan Elegist*. Cambridge: Cambridge University Press.

Caldelli, M. L. 2012. "Associazioni di artisti a Roma: Una messa a punto." In *L'organisation des spectacles dans le monde romain*, edited by K. Coleman and J. Nelis-Clément, 131–71. Geneva: Fondation Hardt.

Campbell, I. 2004. *The Paper Museum of Cassiano dal Pozzo. Series A, Antiquities and Architecture; Part 9, Ancient Roman Topography and Architecture*. London: Harvey Miller.

Cancik, H. 1969. "Zur Geschichte der Aedes (Herculis) Musarum auf dem Marsfeld." *Mitteilungen des Deutschen Archaeologischen Instituts, Römische Abteilung* 76:323–28.

Canfora, L. 1990. *The Vanished Library*. Berkeley: University of California Press.

Cardinali, L. 1987. "Le *Origines* di Catone iniziavano con un esametro?" *Studi classici e orientali* 37:205–15.

Carettoni, G., et al. 1960. *La pianta marmorea di Roma antica: Forma Urbis Romae*. Rome: Comune di Roma.

Carroll, M. 2007. "*Nemus et Templum*: Exploring the Sacred Grove at the Temple of Venus in

Pompeii." In *Nuove ricerche archeologiche nell'area vesuviana (scavi 2003–2006)*, edited by P. G. Guzzo and M. P. Guidobaldi, 37–45. Rome: Bretschneider.

———. 2010. "Exploring the Sanctuary of Venus and Its Sacred Grove: Politics, Cult and Identity in Roman Pompeii." *Papers of the British School at Rome* 78:63–106, 347–51.

Carroll, M., and D. Godden. 2000. "The Sanctuary of Apollo at Pompeii: Reconsidering Chronologies and Excavation History." *American Journal of Archaeology* 104:743–54.

Casali, S. 1995. "Aeneas and the Doors of the Temple of Apollo." *Classical Journal* 91:1–9.

———. 2007. "Killing the Father: Ennius, Naevius and Virgil's Julian Imperialism." In *Ennius Perennis: The Annals and Beyond*, edited by W. Fitzgerald and E. Gowers, 103–28. Cambridge: Cambridge Philological Society.

Caso, L. 1989. "Gli affreschi interni del cubiculo 'amphithalamos' della casa di Apollo." *Rivista di studi pompeiani* 3:111–30.

Castagnoli, F. 1961. Review of Carettoni et al., *La pianta marmorea di Roma antica*. *Gnomon* 33: 604–10.

———. 1983. "Porticus Philippi." In *Città e architettura nella Roma imperial*, edited by K. de Fine Licht, 93–104. Odense: Odense University Press.

Castrén, P. 1983. *Ordo populusque Pompeianus: Polity and Society in Roman Pompeii*. Rome: Bardi.

Celani, A. 1998. *Opere d'arte greche nella Roma di Augusto*. Naples: Edizioni scientifiche italiane.

Champlin, E. 2005. "Phaedrus the Fabulous." *Journal of Roman Studies* 95:97–123.

Churchill, B. J. 1995. "On the Content and the Structure of the Prologue to Cato's *Origines*." *Illinois Classical Studies* 20:91–106.

Ciancio Rossetto, P. 1996. "Rinvenimenti e restauri al portico d'Ottavia e in piazza delle Cinque Scole." *Bullettino della commissione archeologica comunale di Roma* 97:267–78.

Claridge, A. 1998. *Rome: An Oxford Archaeological Guide*. Oxford: Oxford University Press.

Clarke, J. R. 1991. *The Houses of Roman Italy, 100 BC–AD 250: Ritual, Space, and Decoration*. Berkeley: University of California Press.

Clay, D. 1988. "The Archaeology of the Temple to Juno in Carthage (*Aen*. 1.446–93)." *Classical Philology* 83:195–205.

———. 2004. *Archilochos Heros: The Cult of Poets in the Greek Polis*. Washington, DC: Center for Hellenic Studies.

Coarelli, F. 1997. *Il Campo Marzio: Dalle origini alla fine della Repubblica*. Roma: Quasar.

———. 2007. *Rome and Environs: An Archaeological Guide*. Berkeley: University of California Press.

Connors, C. 1998. *Petronius the Poet: Verse and Literary Tradition in the Satyricon*. Cambridge: Cambridge University Press.

Conte, G. B. 1996. *The Hidden Author: An Interpretation of Petronius' "Satyricon."* Berkeley: University of California Press.

Cook, A. B. 1914–40. *Zeus: A Study in Ancient Religion*. Cambridge: Cambridge University Press.

Cooley, A. 2003. *Pompeii*. London: Duckworth.

———. ed. 2009. *Res gestae divi Augusti: Text, Translation, and Commentary*. Cambridge: Cambridge University Press.

Crawford, M. H. 1974. *Roman Republican Coinage*. London: Cambridge University Press.

Cuciniello, D., and L. Bianchi 1829–33. *Viaggio pittorico nel Regno delle due Sicilie*. Naples.

d'Aloe, S. 1851. *Les ruines de Pompéi*. Naples.

Danti, A. 1992. "Una lastra a rilievo altomedievale dal monastero di Sant'Ambrogio alla massima." *Bollettino dei musei comunali di Roma* 6:47–54.

D'Arms, J. H. 1988. "Pompeii and Rome in the Augustan Age and Beyond: The Eminence of the Gens Holconia." In *Studia Pompeiana et Classica in Honor of Wilhelmina F. Jashemski*, edited by R. I. Curtis 1:51–73. New Rochelle: Caratzas.

de Angelis, F. 2005. "L'Elena di Zeusi a Capo Lacinio." *Rendiconti della Accademia Nazionale dei Lincei* 16:151–200.

De Caro, S. 1986. *Saggi nell'area del tempio di Apollo a Pompei: Scavi stratigrafici di A. Maiuri nel 1931–32 e 1942–43*. Naples: Istituto universitario orientale.

———. 2007. "The First Sanctuaries." In *The World of Pompei*, edited by J. J. Dobbins and P. W. Foss, 73–81. London: Routledge.

Degrassi, A. 1945. "Virgilio e il foro di Augusto." *Epigraphica* 7:88–103.

———. ed. 1947. *Inscriptiones Italiae*. Vol. 13(i): *Fasti consulares et triumphales*. Rome: Libreria dello Stato.

———. ed. 1963. *Inscriptiones Italiae*. Vol. 13(ii): *Fasti anni Numani et Iuliani, etc*. Rome: Istituto Poligrafico dello Stato.

Descoeudres, J.-P. 2007. "History and Historical Sources." In *The World of Pompeii*, edited by J. J. Dobbins and P. W. Foss, 9–27. London: Routledge.

De Vos, A., and M. De Vos. 1982. *Pompei, Ercolano, Stabia*. Rome: Laterza.

De Vos, M. 1980. *L'egittomania in pitture e mosaici romano-campani della prima età imperiale*. Leiden: Brill.

Diepolder, H. 1926. "Untersuchungen zur Komposition der römisch-campanischen Wandgemälde." *Mitteilungen des Deutschen Archaeologischen Instituts, Römische Abteilung* 41:1–78.

Diosono, F. 2007. *Collegia: Le associazioni professionali nel mondo romano*. Rome: Quasar.

Dobbins, J. J. 1994. "Problems of Chronology, Decoration, and Urban Design in the Forum at Pompeii." *American Journal of Archaeology* 98:629–94.

———. 2007. "The Forum and Its Dependencies." In *The World of Pompeii*, edited by J. J. Dobbins and P. W. Foss, 150–83. London: Routledge.

Dobbins, J. J., L. F. Ball, J. G. Cooper, S. L. Gavel, and S. Hay. 1998. "Excavations in the Sanctuary of Apollo at Pompeii, 1997." *American Journal of Archaeology* 102:739–56.

Drew, D. L. 1924. "Virgil's Marble Temple: *Georgics* III.10–39." *Classical Quarterly* 18:195–202.

Dyer, T. H. 1868. *Pompeii: Its History, Buildings and Antiquities*. London: Bell and Daldy.

Eden, P. T., ed. 1975. *A Commentary on Virgil, Aeneid VIII*. Leiden: Brill.

Edwards, M. W., ed. 1991. *The "Iliad," a Commentary: Vol. 5, Books 17–20*. Cambridge: Cambridge University Press.

Elsner, J. 1993. "Seductions of Art: Encolpius and Eumolpus in a Neronian Picture Gallery." *Proceedings of the Cambridge Philological Society* 39:30–47.

———. 2002. "The Genres of Ekphrasis." *Ramus* 31:1–18.

———. 2007. *Roman Eyes: Visuality and Subjectivity in Art and Text*. Princeton: Princeton University Press.

———. 2013. Review of Dufallo, *The Captor's Image: Greek Culture in Roman Ecphrasis*. Bryn Mawr Classical Review 2013.04.48.

Engelhard, J. D. W. E. 1843. *Beschreibung der in Pompeji ausgegrabenen Gebäude, etc*. Berlin: Reimer.

Fantuzzi, M. 2012. *Achilles in Love: Intertextual Studies*. Oxford: Oxford University Press.

Faulkner, A., ed. 2008. *The Homeric Hymn to Aphrodite: Introduction, Text, and Commentary*. Oxford: Oxford University Press.

Fedeli, P., ed. 2005. *Properzio: Elegie, Libro 2*. Cambridge: Cairns.

Feeney, D. 2007. *Caesar's Calendar: Ancient Time and the Beginnings of History*. Berkeley: University of California Press.

Fiorelli, G., ed. 1860–64. *Pompeianarum antiquitatum historia*. Naples.

———. 1875. *Descrizione di Pompei*. Naples: Tipografia Italiana.

Flower, H. I. 1995. "Fabulae Praetextae in Context: When Were Plays on Contemporary Subjects Performed in Republican Rome?" *Classical Quarterly* 45:170–90.

Fornari, F. 1916. "Ricerche sugli originali dei dipinti pompeani col mito di Achille in Sciro." *Bullettino della commissione acheologica communale di Roma* 44:55–77.

Fowler, D. P. 1991. "Narrate and Describe: The Problem of Ekphrasis." *Journal of Roman Studies* 81:25–35.

Frangini, G., and M. Martinelli. 1981. "Una scena della storia di Briseide: Il papiro Monacense 128 e la tradizione iconografica." *Prospettiva* 25:4–13.

Fullerton, M. 1997. "Imitation and Intertextuality in Roman Art." *Journal of Roman Archaeology* 10: 427–40.

———. 2003. "Der Stil der Nachahmer: A Brief Historiography of Stylistic Retrospection." In *Ancient Art and Its Historiography*, edited by A. A. Donohue and M. D. Fullerton, 92–117. Cambridge: Cambridge University Press.

Fusi, A., ed. 2006. *M. Valerii Martialis Epigrammaton liber tertius*. Hildesheim: Olms.

Gagarin, M., and E. Fantham, eds. 2010. *The Oxford Encyclopedia of Ancient Greece and Rome*. New York: Oxford University Press.

Galinsky, K. 1969a. *Aeneas, Sicily, and Rome*. Princeton: Princeton University Press.

———. 1969b. "The Triumph Theme in the Augustan Elegy." *Wiener Studien* 82:75–107.

———. 1996. *Augustan Culture: An Interpretive Introduction*. Princeton: Princeton University Press.

Gantz, T. 1993. *Early Greek Myth: A Guide to Literary and Artistic Sources*. Baltimore: Johns Hopkins University Press.

García y García, L. 2006. *Danni di guerra a Pompei: Una dolorosa vicenda quasi dimenticata; con Numerose notizie sul Museo pompeiano distrutto nel 1943*. Rome: Bretschneider.

Gatti, G. 1989. *Topografia ed edilizia di Roma antica*. Rome: Bretschneider.

Gazda, E. K. 1995. "Roman Sculpture and the Ethos of Emulation: Reconsidering Repetition." *Harvard Studies in Classical Philology* 97:121–56.

———. 2002. "Beyond Copying: Artistic Originality and Tradition." In *The Ancient Art of Emulation: Studies in Artistic Originality and Tradition from the Present to Classical Antiquity*, edited by E. K. Gazda, 1–24. Ann Arbor: University of Michigan Press.

Geiger, J. 2008. *The First Hall of Fame: A Study of the Statues in the Forum Augustum*. Leiden: Brill.

Gell, W., and J. P. Gandy. 1817–1819. *Pompeiana: The Topography, Edifices, and Ornaments of Pompeii*. London: Rodwell & Martin.

Gianfrotta, P. A. 1985. "Indagini nell'area della Porticus Philippi." In *Roma: Archeologia nel centro*, edited by A. M. Bietti Sestieri, 2:376–84. Rome: De Luca.

Giavarini, C. 2005. *La Basilica di Massenzio: Il monumento, i materiali, le strutture, la stabilità*. Rome: Bretschneider.

Gildenhard, I. 2003. "The 'Annalist' before the Annalists: Ennius and His *Annales*." In *Formen römischer Geschichtsschreibung von den Anfängen bis Livius: Gattungen, Autoren, Kontexte*, edited by U. Eigler, U. Gotter, N. Luraghi, and U. Walter, 93–114. Darmstadt: Wissenschaftliche Buchgesellschaft.

———. 2007. "Virgil vs. Ennius, or, The Undoing of the Annalist." In *Ennius Perennis: The Annals and Beyond*, edited by W. Fitzgerald and E. Gowers, 73–102. Cambridge: Cambridge Philological Society.

Ginouvès, R, and Roland Martin 1985–92. *Dictionnaire méthodique de l'architecture grecque et romaine*. Rome: École française de Rome.

Goldberg, S. M. 1995. *Epic in Republican Rome*. New York: Oxford University Press.

———. 2005. *Constructing Literature in the Roman Republic: Poetry and Its Reception*. Cambridge: Cambridge University Press.

Gombrich, E. H. 1957. "Lessing: Lecture on a Master Mind." *Proceedings of the British Academy* 43:133–56.

Goold, G. P., ed. 1990. *Propertius*. Cambridge, MA: Harvard University Press.

Goro von Agyagfalva, L. 1825. *Wanderungen durch Pompeii*. Vienna: Mörschner & Jasper.

Gowers, E. 2010. "Augustus and 'Syracuse.'" *Journal of Roman Studies* 100:69–87.

Gowing, A. M. 2005. *Empire and Memory: The Representation of the Roman Republic in Imperial Culture*. Cambridge: Cambridge University Press.

Granger, F., ed. 1931. *Vitruvius: De architectura*. Cambridge, MA: Harvard University Press.

Gray-Fow, M. J. G. 1988. "A Stepfather's Gift: L. Marcius Philippus and Octavian." *Greece and Rome* 35:184–99.

Graziosi, B., and J. Haubold, eds. 2010. *Iliad: Book VI*. Cambridge: Cambridge University Press.

Griffin, J. 1985. *Latin Poets and Roman Life*. London: Duckworth.

Gros, P. 1976. *Aurea templa: Recherches sur l'architecture religieuse de Rome à l'époque d'Auguste*. Rome: École française de Rome.

Gruen, E. S. 1996. *Studies in Greek Culture and Roman Policy*. Berkeley: University of California Press.

Günther, H. 1981. "Porticus Pompeji." *Zeitschrift für Kunstgeschichte* 44:358–98.

———. 1988. *Das Studium der antiken Architektur in den Zeichnungen der Hochrenaissance*. Tübingen: Wasmuth.

Gurisatti, G., and D. Picchi. 1982. "S. Ambrogio della Massima." *Quaderni dell'Istituto di Storia dell'Architettura* 27:49–60.

Gurval, R. A. 1995. *Actium and Augustus: The Politics and Emotions of Civil War*. Ann Arbor: University of Michigan Press.

Gustafson, S. E. 1993. "Beautiful Statues, Beautiful Men: The Abjection of Feminine Imagination in Lessing's Laokoon." *Proceedings of the Modern Language Association* 108:1083–97.

Guzzo, P. G., and F. Pesando. 2002. "Sul colonnato nel foro triangolare di Pompei: Indizi in un 'delitto perfetto'." *Eutopia* 2:11–21.

Harder, A., ed. 2012. *Callimachus, Aetia*. Oxford: Oxford University Press.

Hardie, A. 2002. "The *Georgics*, the Mysteries and the Muses at Rome." *Proceedings of the Cambridge Philological Society* 48:175–208.

———. 2007. "Juno, Hercules, and the Muses at Rome." *American Journal of Philology* 128:551–92.

Hardie, P. R. 1985. "Imago Mundi: Cosmological and Ideological Aspects of the Shield of Achilles." *Journal of Hellenic Studies* 105:11–31.

———. 1986. *Virgil's "Aeneid": Cosmos and Imperium*. Oxford: Clarendon Press.

———. 1993. *The Epic Successors of Virgil*. Cambridge: Cambridge University Press.

———. 2007. "Poets, Patrons, Rulers: The Ennian Traditions." In *Ennius Perennis: The Annals and Beyond*, edited by W. Fitzgerald and E. Gowers, 129–44. Cambridge: Cambridge Philological Society.

Harrison, S. 2007. "The Primal Voyage and the Ocean of Epos." *Dictynna* 4.

Heinze, R. 1993. *Virgil's Epic Technique*. London: Bristol Classical Press.

Hekster, O. 2004a. "Hercules, Omphale, and Octavian's 'Counter-Propaganda.'" *Babesch* 79:159–66.

———. 2004b. "The Constraints of Tradition: Depictions of Hercules in Augustus' Reign." In *Orbis Antiqvvs: Studia in honorem Ioannis Pisonis*, edited by C. Gazdac, L. Ruscu, and C. Roman, 235–41. Cluj-Napoca: Nereamia Napocae Press.

Helbig, W. 1868. *Wandgemälde der vom Vesuv verschütteten Städte Kampaniens*. Leipzig: Breitkopf & Härtel.

Henry, J. 1873–92. *Aeneidea: Or, Critical, Exegetical, and Aesthetical Remarks on the Aeneis.* London: Williams & Norgate.

Heslin, P. J. 2005. *The Transvestite Achilles: Gender and Genre in Statius' Achilleid.* Cambridge: Cambridge University Press.

———. 2010. "Virgil's *Georgics* and the Dating of Propertius' First Book." *Journal of Roman Studies* 100:54–68.

———. 2011. "Metapoetic Pseudonyms in Horace, Propertius and Ovid." *Journal of Roman Studies* 101:51–72.

Heyworth, S. J. 1986. "Notes on Propertius, Books III and IV." *Classical Quarterly* 36:199–211.

———. 1995. "Propertius: Division, Transmission, and the Editor's Task." *Papers of the Leeds International Latin Seminar* 8:165–85.

———. 2007. *Cynthia: A Companion to the Text of Propertius.* Oxford: Oxford University Press.

———. 2011. "Roman Topography and Latin Diction." *Papers of the British School at Rome* 79:43–69.

Heyworth, S. J., and J. Morwood, eds. 2011. *A Commentary on Propertius, Book 3.* Oxford: Oxford University Press.

Hijmans, S. E. 1995. "Sol or Hesperus? A Note on Two Unknown Fragments of the 'Sternenstreit' in the Archaeological Museum of Naples." *Mededelingen van het Nederlands Historisch Instituut te Rome* 54:52–60.

Hinds, S. 1998. *Allusion and Intertext: Dynamics of Appropriation in Roman Poetry.* Cambridge: Cambridge University Press.

Hoepfner, W. 2002. "Die Bibliothek Eumenes' II in Pergamon." In *Antike Bibliotheken*, edited by W. Hoepfner, 41–52. Mainz: Philipp von Zabern.

Hollander, J. 1988. "The Poetics of Ekphrasis." *Word and Image* 4:209–19.

Hölscher, T. 2004. *The Language of Images in Roman Art.* Cambridge: Cambridge University Press.

Hoogma, R. P. 1959. *Der Einfluss Vergils auf die "Carmina latina epigraphica."* Amsterdam: North-Holland.

Horsfall, N. 1976. "The Collegium Poetarum." *Bulletin of the Institute of Classical Studies* 23:79–95.

———. 1979. "Stesichorus at Bovillae?" *Journal of Hellenic Studies* 99:26–48.

Hülsen, C. 1907. *La pianta di Roma dell'anonimo einsidlense.* Rome: Loescher.

———, ed. 1910. *Il libro di Giuliano da Sangallo: Codice vaticano Barberiniano latino 4424 reprodotto in fototipia.* Leipzig: Harrassowitz.

Jadart, H. 1914. "Sur les ruines et les pertes causées à Reims par le bombardement de l'armée allemande, du 4 septembre au 6 octobre 1914." *Comptes-rendus des séances de l'Académie des Inscriptions et Belles-Lettres* 58:590–93.

Jahn, O., and A. Michaelis. 1873. *Griechische Bilderchroniken.* Bonn: Adolph Marcus.

Janko, R., ed. 1992. *The "Iliad," a Commentary: Vol. 4, Books 13–16.* Cambridge: Cambridge University Press.

Jay, M. 1993. *Downcast Eyes: The Denigration of Vision in Twentieth-Century French Thought.* Berkeley: University of California Press.

Johnson, W. R. 1976. *Darkness Visible: A Study of Vergil's "Aeneid."* Berkeley: University of California Press.

Jordan, H., ed. 1860. *M. Catonis praeter librum de re rustica quae extant.* Leipzig: Teubner.

Jory, E. J. 1970. "Associations of Actors in Rome." *Hermes* 98:224–53.

Kampen, N. B. 2009. Review of Elsner, *Roman Eyes*. *Classical Philology* 104:114–17.

Kazansky, N. N. 1997. *Principles of the Reconstruction of a Fragmentary Text: New Stesichorean Papyri.* Saint Petersburg: Institute of Foreign Languages.

Kellum, B. 1985. "Sculptural Programs and Propaganda in Augustan Rome: The Temple of Apollo on the Palatine." In *The Age of Augustus*, edited by R. Winkes, 169–76. Louvain: Oleffe.

Kirichenko, A. 2013. "Virgil's Augustan Temples: Image and Intertext in the *Aeneid*." *Journal of Roman Studies* 103:65–87.

Kockel, V. 1993. "Das Haus des Sallust in Pompeji." In *Rom über die Alpen tragen*, edited by W. Helmberger and V. Kockel, 135-48. Landshut: Arcos.

———. 2004. "Towns and Tombs: Three-Dimensional Documentation of Archaeological Sites in the Kingdom of Naples in the Late Eighteenth and Early Nineteenth Centuries." In *Archives and Excavations: Essays on the History of Archaeological Excavations in Rome and Southern Italy from the Renaissance to the Nineteenth Century*, edited by I. Bignamini, 143–62. London: British School at Rome.

Laird, A. 1996. "Ut figura poesis: Writing Art and the Art of Writing in Augustan Poetry." In *Art and Text in Roman Culture*, edited by J. Elsner, 75–102. Cambridge: Cambridge University Press.

Lanciani, R. 1875. "Il tempio di Giove Ottimo Massimo." *Bullettino della commissione acheologica communale di Roma* 3:165–89.

———. 1891. *L'itinerario di Einsiedeln e l'ordine di Benedetto canonico.* Rome: Accademia dei Lincei.

———. 1897. *The Ruins and Excavations of Ancient Rome.* London: Macmillan.

La Rocca, E. 1987. "L'adesione senatoriale al consensus: I modi della propaganda augustea

e tiberiana nei monumenti in Circo Flaminio." In *L'Urbs: Espace urbain et histoire*, 347–72. Rome: École française de Rome.

———. 2001. "La nuova immagine dei Fori Imperiali: appunti in margine degli scavi." *Mitteilungen des Deutschen Archäologischen Instituts, Römische Abteilung* 108:171–213.

La Rocca, E., M. De Vos, and A. De Vos. 1976. *Guida archeologica di Pompei*. Milan: Mondadori.

Leach, E. W. 1982. "Patrons, Painters, and Patterns: The Anonymity of Romano-Campanian Painting and the Transition from the Second to the Third Style." In *Literary and Artistic Patronage in Ancient Rome*, edited by B. K. Gold, 135–73. Austin: University of Texas Press.

———. 1988. *The Rhetoric of Space: Literary and Artistic Representations of Landscape in Republican and Augustan Rome*. Princeton, NJ: Princeton University Press.

———. 2004. *The Social Life of Painting in Ancient Rome and on the Bay of Naples*. Cambridge: Cambridge University Press.

Leen, A. 1991. "Cicero and the Rhetoric of Art." *American Journal of Philology* 112:229–45.

Levi, D. 1947. *Antioch Mosaic Pavements*. Princeton, NJ: Princeton University Press.

Lewis, S. 1973. "A Coptic Representation of Thetis at the Forge of Hephaistos." *American Journal of Archaeology* 77:309–18.

Ling, R. 1991. *Roman Painting*. Cambridge: Cambridge University Press.

Ling, R., et al. 1997–2005. *The Insula of the Menander at Pompeii*. Oxford: Clarendon Press.

Liou, B., M. Zuinghedau, and M.-T. Cam, eds. 1995. *Vitruve: De l'architecture, livre 7*. Paris: Belles Lettres.

Lippold, G. 1951. *Antike Gemäldekopien*. Munich: C. H. Beck.

Littlewood, R. J., ed. 2006. *A Commentary on Ovid's Fasti, Book 6*. Oxford: Oxford University Press.

Liu, J. 2009. *Collegia centonariorum: The Guilds of Textile Dealers in the Roman West*. Leiden: Brill.

Lloyd, R. B. 1982. "Three Monumental Gardens on the Marble Plan." *American Journal of Archaeology* 86:91–100.

Lorenz, K. 2008. *Bilder machen Räume: Mythenbilder in pompeianischen Häusern*. Berlin: Walter de Gruyter.

Lotz, W. 1979. "Sull'unità di misura nei disegni di architettura del Cinquecento." *Bollettino del Centro Internazionale di Studi di Architettura Andrea Palladio* 21:223–32.

Lowenstam, S. 1993. "The Pictures on Juno's Temple in the *Aeneid*." *Classical World* 87:37–49.

Lowrie, M. 2009. *Writing, Performance, and Authority in Augustan Rome*. Oxford: Oxford University Press.

Luck, G. 1957. "The Cave and the Source: On the Imagery of Propertius 3.1.1–6." *Classical Quarterly* 51:175–79.

Lugli, G. 1957. *La tecnica edilizia romana, con particolare riguardo a Roma e Lazio*. Rome: Bardi.

Lundström, S. 1976. "Der Eingang des Proömiums zum dritten Buche der *Georgica*." *Hermes* 104:163–91.

Lundström, V. 1929. *Undersökningar i Roms topografi*. Göteborg: Eranos.

Lyne, R. O. A. M. 1995. *Horace: Behind the Public Poetry*. New Haven: Yale University Press.

———. 1998. "Propertius and Tibullus: Early Exchanges." *Classical Quarterly* 48:519–44.

MacMullen, R. 1974. *Roman Social Relations: 50 B.C. to A.D. 284*. New Haven: Yale University Press.

Maiuri, A. 1973. *Alla ricerca di Pompei preromana: Saggi stratigrafici*. Naples: Società editrice napoletana.

Mansfield, E. 2007. *Too Beautiful to Picture: Zeuxis, Myth, and Mimesis*. Minneapolis: University of Minnesota Press.

Marabini Moeus, M. T. 1981. "Le Muse di Ambracia." *Bollettino d'arte* 66:1–58.

Marchetti-Longhi, G. 1956–58. "Gli scavi del Largo Argentina: Il Tempio B." *Bullettino della commissione acheologica communale di Roma* 76:45–118.

Marriott, H. P. F. 1895. *Facts about Pompeii: Its Masons' Marks, Town Walls, Houses, and Portraits, etc.* London: Hazell, Watson & Viney.

Martelli, A. 2002. "Per una nuova lettura dell'iscrizione Vetter 61 nel contesto del Santuario di Apollo a Pompei." *Eutopia* 2:71–81.

Martina, M. 1981. "Aedes Herculis Musarum." *Dialoghi di archeologia* 3:49–68.

Martini, A. 1883. *Manuale di Metrologia, ossia misure, etc.* Torino.

Marvin, M. 2008. *The Language of the Muses: The Dialogue between Roman and Greek Sculpture*. Los Angeles: J. Paul Getty Museum.

Mascoli, L., ed. 1981. *Pompéi: Travaux et envois des architectes français au XIXe siècle*. Paris: École nationale supérieure des beaux-arts.

Mau, A. 1904. *Pompeii: Its Life and Art*. New York: Macmillan.

Mazois, F. 1812–38. *Les ruines de Pompéi*. Paris: Didot.

McCormick, E. A., ed. 1962. *Lessing: "Laocoön," An Essay on the Limits of Painting and Poetry*. Baltimore: Johns Hopkins University Press.

McKeown, J. C., ed. 1987–1998. *Ovid, "Amores": Text, Prolegomena, and Commentary*. Leeds: F. Cairns.

Meneghini, R. 2006. "I Fori Imperiali: Ipotesi ricostruttive ed evidenza archeologica." In *Imaging Ancient Rome: Documentation, Visualization, Imagination*, edited by L. Haselberger and J. H. Humphrey, 145–61. Portsmouth, RI: *Journal of Roman Archaeology*.

Menotti de Lucia, E. M. 1990. "Le terrecotte dell' 'insula occidentalis': Nuovi elementi per la problematica relativa alla produzione artistica di Pompei del II secolo a.C." In *Artigiani e botteghe nell'Italia preromana*, edited by M. Bonghi Jovino, 179–246. Rome: Bretschneider.

Michels, A. K. 1967. *The Calendar of the Roman Republic*. Princeton: Princeton University Press.

Miller, J. F. 1983. "Ennius and the Elegists." *Illinois Classical Studies* 8:277–95.

———. 2000. "Triumphus in Palatio." *American Journal of Philology* 121:409–22.

———. 2009. *Apollo, Augustus and the Poets*. Cambridge: Cambridge University Press.

Miller, S. G. 1986. "Eros and the Arms of Achilles." *American Journal of Archaeology* 90:159–70.

Minoprio, A. 1932. "A Restoration of the Basilica of Constantine, Rome." *Papers of the British School at Rome* 12:1–25.

Mitchell, W. J. T. 1984. "The Politics of Genre: Space and Time in Lessing's *Laocoon*." *Representations* 6:98–115.

Moormann, E. M. 1983. "Rappresentazioni teatrali su scaenae frontes di quarto stile a Pompei." *Pompeii Herculaneum Stabiae* 1:73–117.

———. 2011. *Divine Interiors: Mural Paintings in Greek and Roman Sanctuaries*. Amsterdam: Amsterdam University Press.

More, J. H. 1975. "P. Cornelius Surus: Bureaucrat and Poet." *Grazer Beiträge* 3:241–52.

Morgan, L. 1999. *Patterns of Redemption in Virgil's 'Georgics.'* Cambridge: Cambridge University Press.

Most, G. W. 2010. "Laocoons." In *A Companion to Vergil's "Aeneid" and Its Tradition*, edited by J. Farrell and M. C. J. Putnam, 325–40. Chichester: Wiley-Blackwell.

Mynors, R. A. B., ed. 1990. *Virgil: "Georgics."* Oxford: Clarendon Press.

Nagy, G. 2008. *Homer the Classic*. Washington, DC: Center for Hellenic Studies.

Nelis, D. 2004. "From Didactic to Epic: *Georgics* 2.458–3.48." In *Latin Epic and Didactic Poetry: Genre, Tradition and Individuality*, edited by M. Gale, 73–108. Swansea: Classical Press of Wales.

Nethercut, W. R. 1970. "The Ironic Priest." *American Journal of Philology* 91:385–407.

Newlands, C. E. 1995. *Playing with Time: Ovid and the Fasti*. Ithaca, NY: Cornell University Press.

Nibby, A. 1839. *Roma nell'anno MDCCCXXXVIII*. Rome: Belle arti.

Niccolini, F., and F. Niccolini. 1854–96. *Le case ed i monumenti di Pompei disegnati e descritti*. Naples.

Nisbet, R. G. M., and M. Hubbard, eds. 1970. *A Commentary on Horace: "Odes," Book 1*. Oxford: Clarendon Press.

Nisbet, R. G. M., and N. Rudd, eds. 2004. *A Commentary on Horace: "Odes," Book 3*. Oxford: Oxford University Press.

Nixon, C. E. V., and B. S. Rodgers. 1994. *In Praise of Later Roman Emperors: The "Panegyrici latini."* Berkeley: University of California Press.

Nora, P., ed. 1997. *Les lieux de mémoire*. Paris: Gallimard.

Olinder, B. 1974. *Porticus Octavia in Circo Flaminio: Topographical Studies in the Campus Region of Rome*. Stockholm: Svenska institutet i Rom.

Olson, S. D. 2012. *The Homeric Hymn to Aphrodite and Related Texts: Text, Translation and Commentary*. Berlin: de Gruyter.

O'Sullivan, T. M. 2007. "Walking with Odysseus: The Portico Frame of the Odyssey Landscapes." *American Journal of Philology* 128:497–532.

Overbeck, J. A., and A. Mau. 1884. *Pompeji in seinen Gebäuden, Alterthümern und Kunstwerken*. Leipzig: Engelmann.

Panayotakis, C. 1995. *Theatrum Arbitri: Theatrical Elements in the "Satyrica" of Petronius*. Leiden: Brill.

Panciera, S. 1986. "Ancora sull'iscrizione di Cornelius Surus, magister scribarum poetarum." *Bullettino della commissione archeologica comunale di Roma* 91:35–44.

Perry, E. 2005. *The Aesthetics of Emulation in the Visual Arts of Ancient Rome*. Cambridge: Cambridge University Press.

Perry, J. S. 2006. *The Roman Collegia: The Modern Evolution of an Ancient Concept*. Leiden: Brill.

———. 2011. "Organized Societies: Collegia." In *The Oxford Handbook of Social Relations in the Roman World*, edited by M. Peachin, 499–515. Oxford: Oxford University Press.

Petrain, D. 2006. "Moschus' Europa and the Narratology of Ecphrasis." In *Beyond the Canon*, edited by A. Harder, R. F. Regtuit, and G. C. Wakker, 249–69. Leuven: Peeters.

———. 2013. "Closing the Ring: Epic Cycles in the *Tabulae Iliacae* and Other Roman Visual Narratives of the Trojan War." In *The Door Ajar: False Closure in Greek and Latin Literature*, edited by B. Acosta-Hughes and F. Grewing, 143–68. Heidelberg: Winter.

Piranesi, G. B. 1972. *Il Campo Marzio dell'antica Roma: L'inventario dei beni del 1778.* Rome: Colombo ristampe.

Platner, S. B., and T. Ashby. 1926. *A Topographical Dictionary of Ancient Rome.* Oxford: Oxford University Press.

Porcari, B. 2008. "Un restauro severiano della 'Porticus Philippi.'" *Bullettino della commissione archeologica comunale di Roma* 109:177–91.

Poulle, B. 2007. "De Crotone à Rome: Itinéraire et interpétations d'un tableau, l'*Hélène* de Zeuxis." *Latomus* 66:26–40.

Purcell, N. 1983. "The Apparitores: A Study in Social Mobility." *Papers of the British School at Rome* 51:125–73.

Putnam, M. C. J. 1998. *Virgil's Epic Designs: Ekphrasis in the "Aeneid."* New Haven: Yale University Press.

Rawson, E. 1987. "Discrimina Ordinum: The Lex Julia Theatralis." *Papers of the British School at Rome* 55:83–114.

Richardson, L., Jr. 1955. *Pompeii: The Casa dei Dioscuri and Its Painters.* Rome: American Academy in Rome.

———. 1976. "The Evolution of the Porticus Octaviae." *American Journal of Archaeology* 80:57–64.

———. 1977. "Hercules Musarum and the Porticus Philippi in Rome." *American Journal of Archaeology* 81:355–61.

———. 1978. "Concordia and Concordia Augusta: Rome and Pompeii." *Parola del Passato* 33:260–72.

———. 1988. *Pompeii: An Architectural History.* Baltimore: Johns Hopkins University Press.

———. 1992. *A New Topographical Dictionary of Ancient Rome.* Baltimore: Johns Hopkins University Press.

Richardson, N. J., ed. 2010. *Three Homeric Hymns.* Cambridge: Cambridge University Press.

Ridgway, B. S. 1990. *Hellenistic Sculpture I: The Styles of ca. 331–200 BC.* Madison: University of Wisconsin Press.

Rimell, V. 2002. *Petronius and the Anatomy of Fiction.* Cambridge: Cambridge University Press.

Ritter, S. 1995. *Hercules in der römischen Kunst von den Anfängen bis Augustus.* Heidelberg: Archäologie und Geschichte.

Rizzo, S. 2001. "Indagini nei Fori Imperiali: Oroidrografia, foro di Cesare, foro di Augusto, templum Pacis." *Mitteilungen des Deutschen Archaeologischen Instituts, Römische Abteilung* 108:215–44.

Rochette, D.-R. 1840. *Lettres archéologiques sur la peinture des Grecs.* Paris: Crapelet.

———. 1844–53. *Choix de peintures de Pompéi.* Paris: Imprimerie royale.

Rodenwaldt, G. 1909. *Die Komposition der pompejanischen Wandgemälde.* Berlin: Weidmann.

Rodríguez-Almeida, E. 1986. "Geryon, Marcial y la Porticus Philippi del Campo Marcio." *Gerion* 4:9–15.

Rossini, L. ca. 1831. *"Le antichità di Pompei" delineate sulle scoperte fatte sino a tutto l'anno 1830 ed incise dall'architetto L. Rossini e dal medesimo brevemente illustrate, etc.* Rome: Self-published.

Rostovtzeff, M. I. 1911. "Die hellenistisch-römische Architekturlandschaft." *Mitteilungen des Deutschen Archaeologischen Instituts, Römische Abteilung* 26:1–185.

Rowland, I. D., and T. N. Howe, eds. 1999. *Vitruvius: Ten books on Architecture.* Cambridge: Cambridge University Press.

Rüpke, J. 1995. *Kalender und Öffentlichkeit: Die Ge-schichte der Repräsentation und religiösen Qualifikation von Zeit in Rom.* Berlin: de Gruyter.

———. 2006. "Ennius's *Fasti* in Fulvius's Temple: Greek Rationality and Roman Tradition." *Arethusa* 39:489–512.

———. 2011. *The Roman Calendar from Numa to Constantine: Time, History, and the "Fasti."* Chichester: Wiley-Blackwell.

Rutledge, S. H. 2012. *Ancient Rome as a Museum: Power, Identity, and the Culture of Collecting.* Oxford: Oxford University Press.

Sadurska, A. 1964. *Les tables iliaques.* Warsaw: Państwowe Wydawnictwo Naukowe.

Salimbene, C. 2002. "La Tabula Capitolina." *Bollettino dei Musei Comunali di Roma* 16:5–33.

Salmon, F. 2000. *Building on Ruins: The Rediscovery of Rome and English Architecture.* Aldershot: Ashgate.

Sandbach, F. H. 1965–66. "Anti-antiquarianism in the Aeneid." *Proceedings of the Virgil Society* 5:26–38.

Sauron, G. 1994. *Quis deum?: L'expression plastique des idéologies politiques et religieuses à Rome à la fin de la République et au début du Principat.* Rome: École française de Rome.

Sblendorio Cugusi, M. T., ed. 1982. *M. Porci Catonis Orationum Reliquiae.* Turin: Paravia.

Schauenburg, K. 1979. "Herakles Musikos." *Jahrbuch des Deutschen Archaeologischen Instituts* 94:49–76.

Schefold, K. 1957. *Die Wände Pompejis: Topographisches Verzeichnis der Bildmotive.* Berlin: De Gruyter.

Schmidt, V. 1972. "Virgile et l'apogée de la louange de Cynthie (Properce II, 3, 23–32)." *Mnemosyne* 25:402–7.

Schulz, E. G. 1841. "Rapporto sugli scavi pompejani negli ultimi due anni 1839–1841." *Bullettino*

dell'Instituto di corrispondenza archeologica, 97–112.

Sciarrino, E. 2006. "The Introduction of Epic in Rome: Cultural Thefts and Social Contests." *Arethusa* 39:449–69.

———. 2011. *Cato the Censor and the Beginnings of Latin Prose: From Poetic Translation to Elite Transcription*. Columbus: Ohio State University Press.

Scott, S. 2003. "Provincial Art and Roman Imperialism: An Overview." In *Roman Imperialism and Provincial Art*, edited by S. Scott and J. Webster, 1–7. Cambridge: Cambridge University Press.

Scullard, H. H. 1973. *Roman Politics, 220–150 BC*. Oxford: Clarendon Press.

Senseney, J. R. 2011. "Adrift toward Empire." *Journal of the Society of Architectural Historians* 70:421–41.

Shackleton Bailey, D. R., ed. 1988. *Cicero's Letters to His Friends*. Atlanta: Scholars Press.

Shatzman, I. 1972. "The Roman General's Authority over Booty." *Historia: Zeitschrift für Alte Geschichte* 21:177–205.

Shipley, F. W. 1931. "Chronology of the Building Operations in Rome from the Death of Caesar to the Death of Augustus." *Memoirs of the American Academy in Rome* 9:7–60.

Simon, E. 1982. "Vergil und die Bildkunst." *Maia* 34:203–17.

Six, J. 1917. "Theon." *Mitteilungen des Deutschen Archaeologischen Instituts, Römische Abteilung* 32:172–99.

Skutsch, O. 1968. *Studia Enniana*. London: Athlone Press.

———. ed. 1985. *The "Annals" of Q. Ennius*. Oxford: Clarendon Press.

Slater, N. W. 1990. *Reading Petronius*. Baltimore: Johns Hopkins University Press.

Slatkin, L. M. 1991. *The Power of Thetis: Allusion and Interpretation in the "Iliad."* Berkeley: University of California Press.

Small, J. P. 2003. *The Parallel Worlds of Classical Art and Text*. Cambridge: Cambridge University Press.

Smith, P. M. 1979. "Notes on the Text of the Fifth Homeric Hymn." *Harvard Studies in Classical Philology* 83:29–50.

Spelman, C. C. 1999. "Propertius 2.3: The Chaos of Desire." *Arethusa* 32:123–44.

Spinazzola, V. 1953. *Pompei alla luce degli scavi nuovi di via dell'Abbondanza (anni 1910-1923)*, edited by S. Aurigemma. Rome: Libreria della Stato.

Squire, M. 2009. *Image and Text in Graeco-Roman Antiquity*. Cambridge: Cambridge University Press.

———. 2010. "Texts on the Tables: The *Tabulae Iliacae* in Their Hellenistic Literary Context." *Journal of Hellenic Studies* 130:67–96.

———. 2011. *The "Iliad" in a Nutshell: Visualizing Epic on the "Tabulae Iliacae."* Oxford: Oxford University Press.

Stamper, J. W. 2005. *The Architecture of Roman Temples: The Republic to the Middle Empire*. Cambridge: Cambridge University Press.

Steinbüchel, A. 1833. *Grosser antiquarischer Atlas; oder, Abbildung der vorzüglichsten Denkmähler der alten Welt zu einer wissenschaftlichen Begründung der Alterthumskunde, nach den Vorträgen im K. K. Münz- und Antiken-Cabinett zu Wien*. Vienna: J. Trentsensky.

Sternberg, M. 1999. "The 'Laokoon' Today: Interart Relations, Modern Projects and Projections." *Poetics Today* 20:291–379.

Stow, K. R. 2001. *Theater of Acculturation: The Roman Ghetto in the Sixteenth Century*. Seattle: University of Washington Press.

Syme, R. 1939. *The Roman Revolution*. Oxford: Clarendon Press.

———. 1986. *The Augustan Aristocracy*. Oxford: Oxford University Press.

Tamm, B. 1961. "Le temple des Muses a Rome." *Opuscula Romana* 3:157–67.

Taylor, R. M. 2008. *The Moral Mirror of Roman Art*. Cambridge: Cambridge University Press.

Thomas, R. F. 1983. "Virgil's Ecphrastic Centerpieces." *Harvard Studies in Classical Philology* 87, 175–84.

Thompson, M. L. 1960. "Programmatic Painting in Pompeii: The Meaningful Combination of Mythological Pictures in Room Decoration." PhD thesis. New York University.

———. 1961. "The Monumental and Literary Evidence for Programmatic Painting in Antiquity." *Marsyas* 9:36–77.

Timpanaro, S. 1949. "Note a Livio Andronico, Ennio, Varrone, Virgilio." *Annali della Scuola Normale Superiore di Pisa* 18:186–204.

Torelli, M. 1999. *Tota Italia: Essays in the Cultural Formation of Roman Italy*. Oxford: Clarendon Press.

Trimble, J. F. 2002. "Greek Myth, Gender, and Social Structure in a Roman House: Two Paintings of Achilles at Pompeii." In *The Ancient Art of Emulation: Studies in Artistic Originality and Tradition from the Present to Classical Antiquity*, edited by E. K. Gazda, 225–48. Ann Arbor: University of Michigan Press.

Tucci, P. L. 1993. "Nuove ricerche sulla topografia dell'area del circo Flaminio." *Studi Romani* 41:229–42.

———. 1994–95. "Considerazioni sull'edificio di via di S. Maria de' Calderari." In *Bullettino della commissione archeologica communale di Roma* 96:95–124.

———. 1997. "Dov'erano il tempio di Nettuno e la nave di Enea?" *Bullettino della commissione archeologica comunale di Roma* 98:15–42.

Valenzuela Montenegro, N. 2004. *Die "Tabulae Iliacae": Mythos und Geschichte im Spiegel einer Gruppe frühkaiserzeitlicher Miniaturreliefs.* Berlin: Dissertation.de.

Van Andringa, W. 2012. "Statues in the Temples of Pompeii." In *Historical and Religious Memory in the Ancient World*, edited by B. Dignas and R. R. R. Smith, 83–115. Oxford: Oxford University Press.

Van Buren, A. W. 1938. "Pinacothecae: With Especial Reference to Pompeii." *Memoirs of the American Academy in Rome* 15:70–81.

van der Valk, M. 1952. "Ajax and Diomede in the 'Iliad,'" *Mnemosyne* 5:269–86.

von Gozenbach, V. 1975. "Ein neues Briseïsmosaik." In *La mosaïque gréco-romaine II*, edited by H. Stern and M. Le Glay, 401–8. Paris: Picard.

Wagner, G. P. E., ed. 1830–41. *Publius Virgilius Maro: Varietate lectionis et perpetua adnotatione illustratus a Christ. Gottl. Heyne.* Leipzig: Hahn.

Wallace-Hadrill, A. 1983. "Ut Pictura Poesis?" *Journal of Roman Studies* 73:180–83.

———. 1994. *Houses and Society in Pompeii and Herculaneum.* Princeton, NJ: Princeton University Press.

———. 2006. "Roman Topography and the Prism of Sir William Gell." In *Imaging Ancient Rome: Documentation, Visualization, Imagination*, edited by L. Haselberger and J. Humphrey, 285–96. Portsmouth, RI: Journal of Roman Archaeology.

———. 2008. *Rome's Cultural Revolution.* Cambridge: Cambridge University Press.

———. 2011a. *Herculaneum: Past and Future.* London: Frances Lincoln.

———. 2011b. "The Monumental Centre of Herculaneum: In Search of the Identities of the Public Buildings." *Journal of Roman Archaeology* 24:121–60.

Walsh, P. G. 1968. "Eumolpus, the Halosis Troiae, and the de Bello Civili." *Classical Philology* 63:208–12.

———. ed. 1996. *Livy, Book XL.* Warminster: Aris & Phillips.

———. 2009. *Petronius: The "Satyricon."* Oxford: Oxford University Press.

Weitzmann, K. 1959. *Ancient Book Illumination.* Cambridge, MA: Harvard University Press.

Welch, K. E. 2007. "Pompeian Men and Women in Portrait Sculpture." In *The World of Pompeii*, edited by J. J. Dobbins and P. W. Foss, 550–84. London: Routledge.

West, D. A. 1990. *Virgil, The "Aeneid."* London: Penguin.

———, ed. 2002. *Horace "Odes" III: Dulce periculum.* Oxford: Oxford University Press.

West, M. L. 1970. "Corinna." *Classical Quarterly* 20:277–87.

———. 1977. "Erinna." *Zeitschrift für Papyrologie und Epigraphik* 25:95–119.

———. 1990. "Dating Corinna." *Classical Quarterly* 40:553–57.

White, P. 1993. *Promised Verse: Poets in the Society of Augustan Rome.* Cambridge, MA: Harvard University Press.

Wiegmann, R. 1836. *Die Malerei der Alten in ihrer Anwendung und Technik: Insbesondere als Decorationsmalerei, etc.* Hannover: Hahn.

Wilkins, H. 1819. *Suite de vues pittoresques des ruines de Pompeii.* Rome: [s.n.]

Williams, R. D. 1960. "The Pictures on Dido's Temple (*Aeneid* 1.450–93)." *Classical Quarterly* 10:145–51.

Wiseman, T. P. 2009. "The House of Augustus and the Lupercal." *Journal of Roman Archeology* 22:527–45.

Woodman, A. J. 1984. "Horace's First Roman Ode." In *Poetry and Politics in the Age of Augustus*, edited by A. J. Woodman and D. A. West, 83–94. Cambridge: Cambridge University Press.

———. 1998. "Propertius and Livy." *Classical Quarterly* 48:568–69.

Wyke, M. 1987. "Written Women: Propertius' scripta puella." *Journal of Roman Studies* 77:47–61.

Zanker, P. 1981. "Das Bildnis des M. Holconius Rufus." *Archäologischer Anzeiger* 96:349–61.

———. 1988. *The Power of Images in the Age of Augustus.* Ann Arbor: University of Michigan Press.

———. 1998. *Pompeii: Public and Private Life.* Cambridge, MA: Harvard University Press.

Zeitlin, F. 1971. "Romanus Petronius: A Study of the *Troiae halosis* and the *Bellum civile*." *Latomus* 30:56–82.

Zetzel, J. E. G. 2007. "The Influence of Cicero on Ennius." In *Ennius Perennis: The "Annals" and Beyond*, edited by W. Fitzgerald and E. Gowers, 1–16. Cambridge: Cambridge Philological Society.

Zorzetti, N. 1995. *Le premier mythographe du Vatican.* Paris: Belles Lettres.

About the Author

Peter Heslin is senior lecturer in the Department of Classics and Ancient History at the University of Durham. He is the author of *The Transvestite Achilles: Gender and Genre in Statius' Achilleid* (Cambridge University Press, 2005) and of articles on the poetry and topography of Augustan Rome. He is also the developer of *Diogenes*, open-source software for accessing legacy databases of Latin and Greek texts.

Index

NOTE: Page numbers in *italic* refer to figures.

Aberson, M., 204
Accius, 232
Achilles on Scyros image
 in Casa di Sirico, 165
 copy-criticism on, 150
 in House of Achilles, 161, *162*, 165
 in House of the Dioscuri, 144–47, *145*, 162
 pairing with Achilles-Agamemnon quarrel, 144–51, 161
 story represented in, 144–46
 in Temple of Apollo portico, proposed existence of, 144, 146, 150–51, 161, 165
actors, *collegium poetarum* and, 232
Aelius Aristides, 16, 19
Aemilius Lepidus, M., 203–4, 208
Aemilius Lepidus Paullus, L., 208
Aeneas
 as analog of Augustus, 260
 as focus of Pompeian Forum ideological program, 3, 170
 and *Iliad*, failure to grasp moral of, 274
 misinterpretation of Temple of Juno images by, 256, 265–74; consequences of, 274–75; echoes of in Petronius's *Satyrica*, 309–10; and failure to understand Achilles, 272–74; as general comment on hermeneutics, 261, 266, 276, 326; limits of individual knowledge and, 261–62, 265–66, 267–74, 276–77, 278; as metaphor for reading of *Aeneid*, 262, 277, 278; as product of emotional response, 1, 265–66, 267; willful self-censorship in, 268–69, 277
 shield of, inability to interpret, 277–78
 in Temple of Apollo paintings: Anchises receiving Aeneas, *53*, 128–33, *129*, *130*, 133–35, 138n51, 146; as frame of larger narrative, 135–36, 242; unflattering portrayals in, 277. *See also* Diomedes wounding Aphrodite, *under* Temple of Apollo Trojan War paintings
 transformation into Achilles, 274–75
Aeneas treated by Iapyx, in Casa di Sirico, 165
Aeneid (Virgil). *See also* Temple of Juno (in *Aeneid*)

Aeneas's shield: Aeneas's inability to interpret, 277–78; anticipations of in *Georgics*, 259–60; description of, 9
 Augustus's support of literary culture and, 207
 challenges overcome in writing of, 279–80
 as contemporaneous with Trojan War portico paintings in Rome and Pompeii, 3, 139, 325
 contemporary poets' responses to, 279
 and ecphrasis, 9–10, 19–20, 322, 323
 Georgics, 8, 257–60, 262, 280, 282, 299, 325–26
 intertexual play with Augustan ideology, 20, 245–46
 Petronius's *Satyrica* as commentary on, 309–10, 311–14
 popularity of, 2–3, 185
 as response to Augustus' call for epic, 178, 255–56, 259–60, 278, 325–26
 as temple built for Augustus, 257–60, 278
Aeschylus, 153, 156
Aethiopis, 276–77
agon of poetry and plastic arts
 in antiquity, 11–12, 15–19
 ecphrasis and, 322–23
 intensity of in Rome, 321
 Lessing and, 12–19, 23n38, 293–94, 296, 321
 in Petronius's *Satyrica*, 312
 Propertius on, 292–96
 Zeuxis portrait of Helen and, 19, 20, 242, 243, 321
Agrippa, 208, 304
Allison, P. M., 149
Ambrosian codex, 160
Amodio, Michele, 136n4
Amores (Ovid), 296
amphitheater of Statilius Taurus, as part of Augustus's building program, 208
Ancus Marcius, 304–5
Annales (Ennius)
 Augustus's desire to replace, 244
 Ovid on, 211
 parallels to Fulvian Temple of Hercules in, 2, 201–2, 205–6, 206–7, 211, 244, 259
 Propertius on, 305
Le antichità de Pompei (Rossini), *129*, 129
Antike Gemäldekopien (Lippold), 141

341

Antiphilus, 240
Apollo
 as foreign god in Roman Republic, 187, 202
 importance to Augustan ideology, 169, 170, 187–88, 199
 and plague in *Iliad*, 67–68, *68*
Apollo and Poseidon building the walls of Troy (image), at Casa di Sirico, 89–90, *90*, 165
Apollonius of Rhodes, 156
Appian, 242
architects' drawings of Temple of Apollo, 40–44, *42–43*. *See also* Callet, Félix-Emmanuel; Mazois, François
 details of Trojan War paintings visible in, 40–41, 44
 evidence for painting styles in, 51, *55*, 56
 fanciful *vs.* accurate renditions, 44
 and problem of parallax, 60
Ariosto, 293–94
Ars Amatoria (Ovid), 297–98
Ars Poetica (Horace), 234–35
Athenion of Maroneia, 150
Atrium Libertatis, 208
Augustus (emperor)
 building program of, 183, 199, 202, 208–9; and Alexandria, effort to recreate, 197–99, 209, 324; constraints of Roman tradition and, 197, 199, 201, 237, 245, 325; Horace on, 289–90; ideological program of, 244–46; intertextual play of *Aeneid* with, 20, 245–46; Propertius on, 298–99; and reconstruction of north side of Circus Flaminius, 207, 209–10
 call for Augustan epic: Horace's *Odes* as response to, 279, 280–90, 325–26; Portico of Philippus as, 202, 211, 244–45, 255–57, 324, 325, 326; Propertius's rejection of, 19, 279, 290–308, 325–26; Virgil's *Aeneid* as response to, 178, 255–56, 259–60, 278, 325–26
 ideological program, 243–46; centrality of Aeneas to, 244–45, 325; copies of Temple of Apollo images in private residences as response to, 142; importance of Apollo to, 169, 170, 187–88, 199; influence on Pompeian architecture, 169–70; Portico of Philippus and, 4, 187–88, 197, 207, 210, 240, 242, 243–46, 325; and Temple of Apollo portico (Pompeii), 5–6, 169, 170, 187–88, 202; Venus in, 172
 links between poetic and architectural patronage, 2, 244–45
 and literary culture, support for, 201–2, 207, 230, 236, 255–56; constraints of Roman tradition and, 230, 237; ideological agenda underlying, 244–46
 Roman influence on Pompeian architecture under, 169–70
Austin, R. G., 264
Aventine Temple of Diana, 208

Barchiesi, A., 7
Basilica Aemilia, as part of Augustus's building program, 208
Beck, D., 311, 312
Bergmann, B., 151–52, 153, 154
Bianchi, Lorenzo, 112
Briseis taken from Achilles (image)
 in 2nd-century mosaic, 158–60, *159*
 in House of the Tragic Poet, 151, *152*, 153, 157–58, 165; Temple of Apollo model for, 157–58, 160
 inconographic vocabulary of, 158–60
Brogi, Giacomo, 47, *48*, 107
Brüning, A., 62, 66, 76, 77, 99n9
Building of Eumachia (Pompeii), 166, 169–70
Building on Ruins (Salmon), 71

Callet, Félix-Emmanuel
 elevation of Temple of Apollo, 41, *42–43*, *55*, 56; east wall decoration, *83*, 83–86, *93*, 93–94, *94*, 109; east wall doorways, 80; image of Agamemnon-Achilles quarrel in, 60, *60–62*, *61*; image of Calchas addresses Achilles in, *55*, 63–66, *64*; image of Diomedes wounding Aphrodite in, 71–76, *72*, *73*, 77–79, 134; image of Menelaus and Machaon (?) in, *87*, 87–92; and missing figural paintings, 177; pygmies and landscapes in, 121
 on north wall paintings, 112
 on west wall, construction of, 124
Callimachus, 301–2, 303, 306, 308
Calvinus, Cn. Domitius, 208
Campanian painting, and copy-criticism, 5, 140–43
Campbell, I., 250n126, 250n131
Capitoline tablet (*tabula Iliaca Capitolina*)
 Calchas addressing Achilles on, *63*, 66–67
 Calchas pointing on, 67–68, *68*
 Hector dragged by Achilles on, 116
 as link between images of Temple of Apollo and Portico of Philippus, 186
 Priam's supplication of Achilles on, 118, *119*
 quarrel of Achilles and Agamemnon on, 62–63, *63*, 186
Carettoni, Gianfilippo, *198*, *200*, 225, 249n82
Caroline (princess of Brunswick), 29, 31–32
Casa della Caccia Antica (Pompeii), 148–50
Casa delle Quadrighe (Pompeii), 164
Casa di Livia (Rome), 184
Casa di Sirico (Pompeii), 165
Castagnoli, F., 223, 227, 247n24
Cato the Elder, 204, 206, 244
Catullus, 244, 326
Chabrol, François-Wilbrod, 41, 44
Choix de peintures de Pompéi (Rochette), 38–40, *39*
Cicero, 141, 203, 234, 242
collegium poetarum, 230–37
 evidence for, as scattered, 230–31
 founding of, 231

Horace on, 283
move to Temple of Hercules Musarum, 232–33
names of, 231, 232
professions included in, 231, 232, 233–34
social ambition of poets and, 231, 232, 233, 237
upper classes' participation in, 234
copies and models, relationship between
copy-criticism (*kopienkritik*) and, 140–43, 150, 186–87
iconography of Trojan War images and, 158–60
as issue, 139, 323–24
Temple of Apollo Trojan War paintings and, 184–85
copies of Temple of Apollo images in private residences, 57
Achilles and Agamemnon quarrel, 57, 144–53, 157–58, 160, 161, 186
Achilles on Scyros, 144–51, 161
at Casa della Caccia Antica, 148–50
in Casa di Sirico, 165
in House of Achilles, 161–64
in House of Apollo, 6, 147–48, 342
in House of the Dioscuri, 144–47, *145*
in House of the Menander, 164
in House of the Tragic Poet, 6, 151–58, 160, 186, 324
images' local influence and, 5, 6, 139, 141, 142, 324
as response to Augustan ideology, 142
sophisticated adaptations in, 142, 323–24
Thetis receiving Achilles' armor from Hephaestus, 161–64, *163*
copy-criticism (*kopienkritik*), 140–43, 150, 186–87
Cornificius, L., 208
Cuciniello, Domenico, 112
Cypria, 155, 156, 267
Cytheris, Volumnia, 297, 298

De Caro, S., 172, 181, 192n131
Diepolder, H., 89–90, *90*, 165
Dio Chrysostom, 11, 12, 18, 209
Dobbins, J., 168, 170
Domus Uboni. *See* House of Achilles
Dufallo, Basil, 8

Eclogues (Virgil), 106, 257
ecphrasis
critique of in Petronius's *Satyrica*, 311
interweaving of art, text, and reality in, 7–10, 19–20, 261, 321–23
subjective *vs.* objective types of, 9–10
in Virgil, 9–10, 19–20, 322, 323
Eisiedeln itinerary, first, 223
Elsner, Ja, 8–9, 311
Ennius. *See also Annales* (Ennius)
Augustan views on, 244
as bringer of Muses to Italy, 206
Cato on, 206

Cicero on, 203
collegium poetarum and, 233
Fulvius as patron of, 2, 204, 205, 206, 257–58
Horace on, 287, 289
Propertius on, 300, 301, 303, 305–6, 307, 308
Virgil on, 178, 257–58, 260, 283
Epistles (Horace), 235
Eumenius, 203, 205

Fasti (Ovid), 210–11, 239, 247n50
Forum (Pompeii), Augustan ideological program and, 170
Forum of Augustus (Rome), 186, 326
Fulvius Nobilior
and Basilica Aemilia, 208
and *collegium poetarum*, 233
as Ennius's patron, 2, 204, 205, 206, 257–58
ideology of, 244
and Muses, bringing of to Rome, 187, 202–4, 205–6, 207, 209, 233, 238
Ovid on, 210–11
and Temple of Hercules of the Muses, 2, 202–7, 211, 213, 233, 239, 244, 246n23
Virgil on, 257–58

Gallus, Cornelius, 296–98
Gandy, John Peter, 29–33, 49n7, 119, 176
Gell, Sir William. *See also Pompeiana*
on Bacchus and Silenus image, 176
as chamberlain to Princess Caroline, 29, 31–32
correspondence with Gandy, 29, 30–33, 49n7
documentation of Pompeii by, 29–33, *33*, 57, 59, 63
Forum measurements by, 82, 111, *111*
gout of, 31–32
on Nilotic landscapes in Temple of Apollo, 119, *120*, 133
on north wall paintings, 102, 111, 113
plan of Temple of Apollo, 33, *33*, 80, 82
on Temple of Apollo Trojan War paintings, 32–33, *33*
on west wall, 123, 124
Georgics (Virgil), 8, 257–60, 262, 280, 282, 299, 325–26
Giocondo, Fra, 219–24, *220*, 221t, 226, 229, *229*, 250n121
Giuliano da Sangallo, 218, 219–24, 221t, *225*, 226, 226–29, 250n126
Goldicutt, John, 41, 48, 71, 80, *123*, 123–24, *126*, 126–27
Gombrich, E. H., 12–19, *18*
Goold, G. P., 292
Goro von Agyagfalva, Ludwig, 124–25
Griechische Bilderchroniken (Jahn and Michaelis), 62, 63, 75, 78, 91
Guzzo, P. G., 170–71

Hardie, P. R., 163, 323
Helen
departure from Sparta (image), 153
Zeuxis portrait of (*see under* Zeuxis)

Herculaneum, celebration of Hercules in, 188
Hercules, Augustan ideological program and, 188
Hermaphroditus, in Temple of Apollo, *52–53*, 172
hero cults, Propertius on, 301
Heyne, C. G., 1, 264, 315n24
Holconius Rufus, Marcus, 168–70, 185, 197, 309, 324
Hollander, J., 261
Hölscher, Tonio, 5
Homeric cycles, heterogeneity of sources for, 186
Homeric Hymn to Aphrodite, 130–33
Horace, 234–35, 235–36. *See also Odes* (Horace)
 and *Carmen Saeculare*, 308
 propempticon for Virgil, 285–86
 Propertius's critique of, 300–301, 302, 303–5, 306
 rivalry with Virgil, 279, 281
House of Achilles (Pompeii), Trojan War images in, 161–64, *162*, *163*
House of Apollo (Pompeii), 6, 147–48, 324
House of Livia (Rome), 173
House of M. Loreius Tiburtinus (Pompeii), 137n27
House of Meleager (Pompeii), 164
House of the Dioscuri (Pompeii), 28, 144–47, *145*, 164
House of the Faun (Pompeii), 28, 173
House of the Menander (Pompeii), 164
House of the Tragic Poet
 atrium paintings, 6, 151–60, 186, 324
 excavation of, 28
Hülsen, C., 219–21, 223, 224, 249–50n110
Hymn to Apollo (Callimachus), 301, 308

Iliad (Homer)
 Aeneas's failure to grasp moral of (in *Aeneid*), 272–74
 shield of Achilles ecphrasis, 7–8
Iliadic tablets (*tabulae Iliacae*)
 artist of, 241
 Calchas addressing Achilles on, *63*, 66–67
 Diomedes wounding Aphrodite on, *75*, 76, 77–79, *78*
 Hector dragged by Achilles in, 116
 images in Portico of Philippus as source of, 139, 241
 issues surrounding, 185
 labeling of figures in, 267
 as link between images of Temple of Apollo and Portico of Philippus, 5, 166, 185–86, 325
 Menelaus and Machaon in, *91*, 91–92, *92*
 model(s) for, 185–86
 Priam's supplication of Achilles in, *118*, 118–19
 quarrel of Achilles and Agamemnon on, 62–63, *63*
 Roman-form temples portrayed on, 186
 variations in composition within, 92
 Virgil's Temple of Juno and, 262
image and text, relationship between. *See also* agon of poetry and plastic arts; intertextual play of images and texts
 as issue, 4, 6–7
 Lessing on, 12–19, 23n38, 293–94, 296, 321
 Western logocentrism and, 10–12
intertextual play of images and texts. *See also specific works*
 and allusions to real objects, 7–10
 ecphrasis and, 7–10, 19–20, 261, 322–23
 in House of the Tragic Poet, 151–60
 in Roman art, 5–6, 140, *141*, *143*
 and Roman connotative meanings within Greek denotative language, 3, 5, 96, 99, 143, 151, 165; in domestic quotation of Temple of Apollo images, 148, 323–24; iconography of Trojan War paintings and, 158–60
 Roman publics' ability to read, 324–25
 significant meanings contained in, 5–6, 7, 10, 186–88
 Squire on, 10–11
 wit of, 6, 148, 323–24

Jahn, Otto, 62, *63*, 68, *68*, *75*, *78*, 91
Judgment of Paris, in House of the Tragic Poet, 153
Julius Caesar, 197, 207–8, 209
Juvenal, 236–37

Kockel, Valentin, 46

Lanciani, R., 219, 224–25, 251n138
Laocoön (Lessing), 12–19, 243
Lessing, Gotthold Ephraim, 12–19, 23n38, 243, 293–94, 296, 321
Ling, R., 150
Lippold, G., 141
Livius Andronicus, 231–32, 283, 287, 289
Livy, 203–4, 204–5, 214, 246n23, 283
logocentrism, Western, 10–12
Lorenz, K., 154
Lucian, 12
ludi Apollinares, 169
Lundström, V., 223
Lyne, R. O. A. M., 282, 296

Maderno, Carlo, 229
Maecenas, 201, 202, 207, 256, 307
Maia, in Temple of Apollo, 172
Maiuri, A., 171–72, 181
Marble Plan, *198*, *199*, 210, 212–17, 219, 224–28, *225*, 249n82
Marchetti, Domenico, 226, 227, 251n143
Marchetti-Longhi, G., 213–14
Martelli, A., 171
Martial, 234, 236
Mau, August, 80–82, 167, 171, 172, 184
Mausoleum of Augustus, 208
Mazois, François
 on east wall doorways of Temple of Apollo, 52, 80, *81*

elevation of east wall, Temple of Apollo, 41, *42–43*, 47, 135; accuracy of, 41; evidence for painting styles in, *55*, 56, 83, 94; image of Achilles-Agamemnon quarrel in, *58*, 59–60; image of Calchas addressing Achilles in, *55*, 63–66, *64*; image of Diomedes wounding Aphrodite, 71, *72*; pygmies and landscapes in, 121

elevation of north wall, Temple of Apollo, 102–5, *103*, *105*, 125, *125*, 136n5

on mounting of Temple of Apollo images, 176–77

painting of fourth style pillar decoration with empty frame, 84–86, *85*, 109, 134–35, 177–78

plan of Forum, 80, *81*

plan of Temple of Apollo, *52*, 80

plans of Pompeii, 71

Les ruines de Pompéi, 34, 41, *42–43*, *52*, *81*, 84, *85*

on west wall, construction of, 125, *125*

McKeown, J. C., 298

Memnon, 276, 316n61

Mercury, in Temple of Apollo, 172

Metamorphoses (Ovid), 317n74

Michaelis, Adolf, *63*, *68*, *75*, *78*, *91*

Mitchell, W. J. T., 13–14

Moormann, E. M., 1, 2, 139, 263

Morelli, Francesco
 copies of House of the Tragic Poet paintings, 151, 152–53, 158
 copies of Temple of Apollo paintings, *35*, 35–36; Diomedes wounding Aphrodite, *35*, 35–37, 40, 73–74, *76*, 77–79; drawings beyond those in Naples archive, 37–38; Hector dragged by Achilles, *35*, 36, 113, *115*, 271; pygmies and landscapes, 119–21, *120*
 as source for Rochette, 38–40, 74
 as source for Steinbüchel, 34–37, 40, 73–74

Mummius, Lucius, 171

Muses
 Horace on, 280–81, 282–89
 Latin, Horace's evocation of in Roman *Odes*, 288
 as patrons of text-based arts, 243
 in Portico of Philippus, location of, 214–15
 Propertius on, 290, 300–301, 303–4, 305–6
 and Temple of Apollo (Pompeii), 187–88
 in Temple of Hercules of the Muses: appearance of, 238–39, *239*; association of Muses with Hercules in, 202, 205–7, 210–11, 253n210; as first arrival of Muses in Rome, 205–6, 207; ideological program of, 239, 243; as spoils from Ambracia, 202–4, 205–6, 207, 209, 238

Museum, definition of, 2

Naevius, 287

Nereides (Aeschylus), 153

New York tablet, Hector dragged by Achilles in, 116

Nibby, Antonio, 217–19

Niccolini, F., 47

Octavius, Cn., 209–10

Odes (Horace), response to Augustus' call for epic in, 279, 280–90, 325–26

Odyssey Landscapes (Rome), 3

Origines (Cato), 206

Ovid, 210–11, 215, 217, 239, 247n50, 296–98, 317n74

Padiglione, Domenico, 46, 101

Padiglione, Felice, *45*, 45–46, 101

Paris tablet, *118*, 118–19

Penthesilea, 276, 316n60

Pesando, F., 170–71

Petronius, 3, 308–14, 321

Pheidias, and agon of poetry and plastic arts, 11, *12*, 18

Philippus, L. Marcius, 199, 207–9, 211, 247n43, 304–5

Philitas, 301–2, 303, 306, 308

piazza Giudea, *198*, 223, 224, 226

pinacotheca, and "real" vs. copied images, 184–85

Pindar, 154–55

Piranesi, G. B., 219

Plastico di Pompei (Padiglione), 46
 accuracy of, 46, 47
 earlier model as basis of, 46, 101
 of Temple of Apollo portico: east wall doorways, number of, 80, *81*; and missing figural paintings, 177–78; north wall, 56, 101, 101–8, *107*, *108*, *110*, *112*; and painting styles, 51, 54, *54*, 56, *56*, *93*, 93–94, 179; south wall, 45–46, 133–34, *134*; and Trojan War paintings, *45*, 45–47, 56, 71; west wall, 122, 122–23

Platner, S. B., 248n57

Pliny
 on Accius, 232
 on Greek painting, 5, 140, 150, 151
 on Portico of Philippus, 23n46, 169, 197, 228, 240–41, 264, 324
 on reuse of temple paintings, 176
 on *tegulae mammatae*, 127
 on Temple of Hercules of the Muses, 238
 on Zeuxis's *Helen*, 238

Pollio, Asinius, 208

Polygnotus, 3

Pompeiana (Gell), 27–30, 32, 34. *See also* Gell, Sir William

Pompeii
 restrictions on visitor drawings, 28, 32, 34
 sources on, importance of access to, 325

Pompey, Sextus, 242

Pomponius Musa, Q., 238–39, *239*

Portico of Livia (Rome), 169–70

Portico of Metellus (Rome), 209

Portico of Octavia (Rome), *198*
 destruction of, 248n69, 251n134
 library in, 199–201
 location of, 226
 in Marble Plan, 212
 paintings in, 240

INDEX 345

renovation of, 207, 209–10, 228, 248n57
Portico of Octavius (Rome), 207, 209–10, 224
Portico of Philippus (Rome)
 and *Aeneid*'s Temple of Juno, intertextual play with, 19, 20, 245–46, 261, 262–63, 278
 and agon of poetry and plastic arts, 11, 12, 19
 archaeological evidence from, 212, *213*, 225–26, 251n138, 251n149
 architecture of, 217–22, *218, 220*
 art in, 228, 237–42
 as call for Augustan epic, 202, 211, 244–45, 255–57, 324, 325, 326; Horace's *Odes* and, 280–81, 282, 325–26; influence on Roman poetry, 255–57, 325–26; Petronius's *Satyrica* and, 308–14; Propertius's elegies and, 19, 279, 290–308, 325–26; Virgil's *Aeneid* and, 19, 20, 245–46, 261, 262–63, 278, 325–26; Virgil's *Georgics* and, 257–60
 as *collegium poetarum* headquarters, 235–37
 construction of, 199; Augustus's building program and, 199, 202, 208–9; dates of, 169, 208, 211, 245, 247–48n50; as major remodeling of Temple of Hercules of the Muses, 2, 207–11, 210–11, 213; struggle between triumvirs and, 207–8
 and construction work in Pompeii, 183
 fasti in, 214, 243–44
 ideological program of, 187–88, 197, 207, 210, 240, 242, 243–46, 325
 later site history, 228–29
 layout and appearance of, 212–17
 as *lieu de mémoire*, 243–44
 location of ruins, 223–40
 memorials for poets in, 235
 as model for Temple of Apollo portico, 165–66, 166–69, 170–72, 324–25, 326
 as monument to Augustus's family, 207, 209–10
 as Museum of Augustus, 230, 237
 as no-longer-existing structure, 2, 20, 217–19
 plan of, *198, 200–201*
 poets' conflation of with Temple of Palatine Apollo, 235, 257, 260, 324
 reinterpretation of Roman history in, 243–45, 325
 as source of Iliadic tablet images, 139
 statue of Accius in, 232, 235, 238
 Trojan War paintings in: as contemporaneous with *Aeneid* and Pompeian portico paintings, 3, 139, 325; as dominant decorative feature, 240–41; ideological program of, 2, 243–45; lack of direct evidence of, 238; as models for Temple of Apollo works, 5, 139, 143, 160, 238, 241, 242, 322; changes made in, 187; Iliadic tablets as link between, 166, 185–86, 325; painter of, 240, 241; sources for descriptions of, 169; space available for, 241–42
 Zeuxis's portrait of Helen in, 12, 23n46, 238, 240, 243; and agon of poetry and plastic arts, 19, 20, 242, 243, 321
Porticus Maxima, 224

Poseidon and Amphitrite wedding (image), in House of the Tragic Poet, 153–54
Poulle, B., 242
Praxiteles, 297
Prometheus trilogy (Aeschylus), 156
Propertius
 on *Aeneid*, 279, 285
 and agon of painting and poetry, 292–96
 assertions of artistic superiority by, 296–98, 303–4, 307
 Augustus's call for epic and, 19, 279, 290–308, 325–26
 critique of Roman arts patronage by, 302, 306
 on Ennius, 300, 301, 303, 305–6, 307, 308
 focus on Cynthia as assertion of artistic independence, 290–99
 on Homer, 306–7
 on Horace, 300–301, 302, 303–5, 306
 and intertextual play, 8
 on Muses, 290, 300–301, 303–4, 305–6
 political allegiances of, 299–300
 rejection of Roman identification of poetry and conquest, 300–306
 on Virgil, 300, 301, 302–4, 306, 307

Raphael, 223–24
Regia, rebuilding of, 208
Res gestae (Augustus), 209–10, 325
Rhesus, 268–69
Rochette, Désiré-Raoul
 on decay of Temple of Apollo paintings, 38–40
 on empty frames in pillar-style decoration, 84
 lithograph of Diomedes wounding Aphrodite (Athena encouraging a warrior), 38–40, *39*, 47, 56, 74, 109, 121, 134, 178
 on mounting of Temple of Apollo images, 177
Roman art. *See also* intertextual play of images and texts
 decorative painting styles: fourth style, difficulty of dating, 178; over-reliance on for dating, 184; second style as revival of fourth, 180
 iconography as basis of image similarities, 158–60
 market for, as theme-driven, 141, 142
 originality of, as issue, 4–5, 6, 140–43, 150–51, 323–24
 value of wall paintings, 183, 184–85
Rossini, Luigi
 engravings of Temple of Apollo, 44, 129; Anchises receiving Aeneas, *53*, 128–33, *129, 130*, 134–35, 138n51, 146, 242; north wall, 106–7
Rüpke, J., 202

Salmon, F., 71
Sampaolo, V., 128
Sandbach, F. H., 1, 264
Sant'Ambrogio della Massima monastery, 228–30, *229*

Sarti tablet, *75*, 76, 92, *92*
Satires (Horace), 234
Satyrica (Petronius), 308–14
Schefold, K., 149, 189n35
Schindler, Albert, 34
Schulz, E. G., 149
Seneca, 311, 312
Servius, 277
Shipley, F. W., 208
Silius Italics, 264
Simonides, 285
Skutsch, O., 205
Society of dilettanti, 29
Sommer, Giorgio, 136n4
Sosius, Gaius, 208
Spinazzola, V., 161, 186
Squire, Michael, 10–11, 241
Statius, 256–57
Steinbüchel von Rheinwall, Anton von
 background of, 34, 89
 catalogue of Temple of Apollo images, 128–29, 136n14
 drawings of Temple of Apollo scenes, 34–37, *36*; Achilles and Agamemnon quarrel, 57, *58*, 62–63, 96, 153; Bacchus and Silenus, *107*; Calchas addressing Achilles, *65*, 65–66, 157; as copies of Morelli drawings, 34–36, 40; Diomedes wounding Aphrodite, 35–37, *36*, 73–74; Hector dragged by Achilles, 109–10, 112, 113, *114*; Menelaus and Machaon (?), *88*, 88–89; Priam's supplication of Achilles, 109–10, 112, 117, *117*, 137n25, 158; as source, problems with, 34, 91
 on west wall, construction of, 125, 127
Stoa Poikile (Athens), 3
Strabo, 11
Strabo Vopiscus, Julius Caesar, 232, 233
Suetonius, 208, 209
Surus, P. Cornelius, 233, 234

Tacitus, 208
Tarentine tablet, Hector dragged by Achilles in, 116
Tarpa, Spurius Maecius, 234–35
Taurus, Statilius, 208
Temple by the Mincius (in Virgil's *Georgics*), 257–60, 279, 282, 283, 284, 300, 302–3
Temple of Apollo (Pompeii)
 correct identification of, 28
 early names for, 28, 29, 30, 31, 106, 119, 167
 entrance, principal, 57
 gods represented in, as supporters of Troy, 172
 history of as cult site, 172
 ideological importance of, 20, 183–84, 185
 modern interpretive changes at, 48
 photographs of, 47, 48, 104, 107, 136n4
 plan of, *52–53*
 sculpture in, *52–53*, 172
 sculpture of Apollo in (Apollo Saettante), 172; location and time of placement, *52–53*, 69, 70–71; mixture of local and metropolitan meanings of, 97; portico Trojan War paintings and, 68–70, *69*, 97
 sculpture of Artemis in, *52–53*, 70–71, 97, 172
 trees within portico of, 264
Temple of Apollo Medicus (Rome), 202
Temple of Apollo portico (Pompeii). *See also* Temple of Apollo Trojan War paintings
 Aeneas images in: as frame of larger narrative, 135–36, 242; unflattering portrayals in, 277. *See also* Diomedes wounding Aphrodite, *under* Temple of Apollo Trojan War paintings; painting of Anchises receiving Aeneas, *below*
 and Augustan ideological program, 5–6, 169, 170, 187–88, 202
 damage from World War II bombardment, 47–48
 date of construction, 166–69, 170–72
 decorative painting: dating of, 178–85; described, 37; layering of, seismic damage and, 49, 180–82, *182*; as mix of styles, 46–47, 178–85; Padiglione's Plastico di Pompei as evidence of, 46. *See also specific walls, below*
 east wall, 47–99; decorative style of, 47, *93*, 93–95, *94*, 179–81; niche construction, 51; niche painting style, *53, 54*, 54–56, *55*, *93*, *94*, 94–95; number of openings/doorways in, 48–49, 79–82; pillar construction and size, 51; pillar painting style, 51, *53, 54, 54, 55*, 56–57; Trojan War paintings on, *33, 33*, 51
 excavation of, 27
 niche style: definition of, 51–54; difficulty of characterizing, 179, 180; distinguishing of from pillar style, 178–79; on east wall, *53, 54*, 54–56, *55, 93, 94*, 94–95; variations in between walls, 179–80
 northeast corner, *56, 71, 80, 81*
 north wall painting, 45, 51, 54, 106–8, *107, 108*; decorative style of, 47, 179–81; erroneous identifications of subject matter, 113–14; figural paintings: locations of, 102, 106–13; subjects of, 113–19; Gell on, 102, 111, 113; Mazois elevation of, 102–5, *103, 105*, 125, *125*, 136n5; Plastico di Pompei model of, *56*, *101*, 101–8, *107, 108, 110, 112*; sources for reconstructing, 101–5; verbal reports on, 112–13
 painting of Anchises receiving Aeneas, *53*, 128–33, *129, 130*, 133–35, 138n51, 146
 painting of Bacchus and Silenus, 29, 37, 106, *107*, 176–77
 paintings of Nilotic pygmies and crocodiles, 29, 30, 32, 33, 35, 38, 51, 119–22, *120*, *121–22*, 124, 133, 180
 pillar style, 51; blue variation, 51, 86, 109, 180, 181; distinguishing of from niche style, 178–79; on east wall, 51, 87, *93*, 93–95, *94*; as fourth-style

INDEX **347**

scheme, 51, 178–79; on north wall, 107–8, 109; red variation, 51, 109; variations in between walls, 179–80

plan of, 52–53

Portico of Philippus as model for: dates of construction and, 166–69, 170–72; as issue, 165–66; and public legibility of symbolism, 324–26

southeast corner, 54; interplay of paintings and sculpture in, 68–70, 69, 97; as start of Trojan War series, 57, 95

south wall: decorative style of, 47, 54, 54, 179–80; figural paintings on, 133–35; in Padiglione's Plastico di Pompei, 45–46, 133–34, 134; as principal entrance, 57

symbolic meanings of, 187–88

Temple of Palatine Apollo (Rome) as model for, 169

west wall: blind alley behind, 124, 125, 127–28, 128, 167–68, 174–75, 181; double-wall construction of, 124–28, 125, 126, 128, 173–74, 181–82; in Padiglione's Plastico di Pompei, 45–46; painting on, 122, 122–24, 123, 180, 181

Temple of Apollo Trojan War paintings, 102. *See also* copies of Temple of Apollo images in private residences

Achilles-Agamemnon quarrel, 57–63; Callet drawing of, 60, 60–62, 61; central figure, as Nestor, 62–63; copies in private residences, 57, 144–53, 157–58, 160, 161, 186; Gell on, 29–30, 32–33, 57, 59; in *Iliad*, 57–59; location of, 30, 32–33, 33, 53; Mazois drawing of, 58, 59–60; mention of in guidebooks, 47; in narrative structure of Trojan War images, 95–98; pairing of with images of Achilles on Scyros, 144–51, 161; popularity of, 265; scepter held by Achilles in, 67, 96; Steinbüchel drawing of, 57, 58, 62–63; version of on Iliadic tablets, 62–63, 63

Achilles on Scyros, proposed existence of, 144, 146, 150–51, 161, 165

and Augustan ideological program, 5–6, 170

Briseis taken from Achilles, proposed existence of, 157–60, 165

Calchas addresses Achilles, 63–67; Callet drawing of, 55, 63–66, 64; Gell on, 57, 63; location of, 53; Mazois drawing of, 55, 63–66, 64; in narrative structure of Trojan War images, 95–97; object to which Calchas points, 67–71, 68, 69; previous identifications of figures in, 66, 99n9; scepter held by Calchas in, 67, 96, 100n38; as start of Trojan War sequence, 66–67; Steinbüchel's drawing of, 65, 65–66; version of on Iliadic tablets, 63, 66–67

as contemporaneous with *Aeneid* and Portico of Philippus paintings, 3, 139, 325

copies of: inaccuracy of, 40; by Morelli, 35, 35–36; by Rochette, 38–40, 39; in Steinbüchel's *Grosser antiquarischer Atlas*, 34–37

dates of, 3, 49, 139, 325

decay of, 27–28, 36–37, 41, 124, 127–28

Diomedes wounding Aphrodite (Athena encouraging a warrior; rescue of Aeneas), 71–79; Callet image of, 71–76, 72, 73, 77–79, 134; identification of figures in, 74, 77, 79; *Iliad*'s description of, 76–77; location of, 53, 71, 135–36; Mazois images of, 71, 72, 77, 104–5, 105, 136n5; Morelli drawing of, 35, 35–37, 40, 73–74, 76, 77–79; in narrative structure of Trojan War images, 92, 97–98, 242; Rochette lithograph of, 38–40, 39, 47, 56, 74; Steinbüchel drawings of, 35–37, 36, 73–74

empty frames: number and purpose of, 174–78, 182–83; pillar 16 (Diomedes and Athena?), 53, 82–86

evidence for reconstruction of: amount of, 28; architects' drawings of Temple, 40–44; Gell's descriptions, 33, 33; guidebooks, 47; new, 2, 20; Padiglione's Plastico di Pompei, 45, 45–47; photographs, early, 47; restrictions on visitor drawings and, 28, 32, 34; war damage and, 47–48

fourth-style renovations and, 49, 139, 180–82

Hector dragged by Achilles: Aeneas's misinterpretation of in Temple of Juno, 270–71; Gell on, 30, 32; Homer's account of, 115–16; identification of figures in, 113–17; in Iliadic tablets, 116; location of, 30, 53, 109–13; mention of in guidebooks, 47; Morelli painting of, 35, 36, 113, 115; Rochette on, 40; Steinbüchel drawing of, 109–10, 112, 113, 114

Hector's burial, location of, 53

influence of *Aeneid*'s Temple of Juno on, 1–2, 262, 322, 325

interplay of with temple sculpture, 68–70, 69, 97

locations of: Gell on, 30, 32, 33, 33; Padiglione's Plastico di Pompei as evidence of, 46

Menelaus and Machaon (?) [pillar 12], 87–92; early proposed identifications of characters, 89–91; identification of characters, 91–92; in Iliadic tablets, 91, 91–92, 92; location of, 53, 87; in narrative structure of images, 92

mounting method for, 174–78

narrative structure of, 92, 95–99, 146; ancient audience's ability to read, 95, 99, 266, 267, 271; and image of Briseis taken from Achilles, 157; importance of order and, 266; larger meaning of, 97–99; as mixture of local and metropolitan influences, 97, 99; preservation of through multiple repairs, 180, 183–84, 184–85, 187; wall-to-wall jumps in, 102, 266

nimbus-like use of shields in, 157–58

as no-longer-existing, 28

on north wall, 102, 106–13

number of, 95

order of, 66–67

and Pompeian Trojan War images, other sources for, 161
Portico of Philippus artworks as models for, 5, 139, 143, 160, 238, 241, 242, 322; changes made in, 187; Iliadic tablets as link between, 166, 185–86, 325
Priam's supplication of Achilles: Aeneas's misinterpretation of in Temple of Juno, 273–75; identification of figures in, 117–19, 137n25; in Iliadic tablets, *118*, 118–19; location of, *53*, 109–13
remounting of older images, 84, 174–78, 184–85
Rochette's description of, 38–40
Steinbüchel's drawings of, 34–37, *36*
subjects of (identified in guidebooks), 47
Thetis carrying armor to Achilles, proposed existence of, 164
Thetis receiving Achilles' armor from Hephaestus, proposed existence of, 161–64
value of to Pompeians, indications of, 174, 176, 178, 183–84, 186–87, 309, 322
visibility of immediately after excavation, 27
Temple of Ceres (Rome), 176
Temple of Hercules of the Muses (Rome)
addition of Portico of Philippus to, 199
associations with Actium, 209
as *collegium poetarum* headquarters, 230–35
construction of, 201–2, 202–7, 246n23
copy of Roman calendar (*fasti*) in, 205, 211
as effort to support literary culture, 201–2, 205–6, 207
Hercules sculpture in, 238–39, *239*
ideological program of, 205–6
Muses in: appearance of, 238–39, *239*; and association of Muses with Hercules, 202, 205–7, 210–11, 253n210; as first arrival of Muses in Rome, 205–6, 207; symbolic role of, 239; as war spoils, 202–4, 205–6, 207, 209, 238
as Museum, 206
and nature of Rome, debate on, 206–7, 244
poets' response to, 207
Portico of Philippus as complete remodeling of, 2
scholarly interest in, 2
Temple of Juno (in *Aeneid*), 261–78
intertextual play with Portico of Philippus, 19, 20, 245–46, 261, 262–63, 278
as *mise-en-abyme* of whole *Aeneid*, 262
as Roman-style temple, 263
Trojan War paintings in: as discrete paintings, 263; influence on Pompeian Temple of Apollo, 1–2, 262, 322, 325; and intertextual play, 9–10, 261; location of, 263–64; as ordered series, 265. *See also* Aeneas, misinterpretation of Temple of Juno images by
Temple of Minerva (Rome), 231, 232
Temple of Palatine Apollo (Rome)
construction of, struggle between triumvirs and, 207–8

contemporary conflation of with Portico of Philippus, 235, 257, 260, 324
ideological meaning of, 187, 188
as model for Temple of Apollo in Pompeii, 169
as part of Augustus's building program, 202, 208–9
Propertius on, 298–99, 307–8
in Virgil's *Aeneid*, 257, 259
in Virgil's *Georgics*, 257, 259
Temple of Peace (Rome), 215
theater (Pompeii), Roman model for remodeling of, 169
Theater of Marcellus (Rome), 169, *198*, 210, 223–24
Theocritus, 295
Theodorus, 241
Theorus, 197, 240, 241, 261, 262, 264, 322–23, 324
Thetis
in House of Achilles images, 161
in House of the Tragic Poet atrium images, 155, 156–57
quarrel of Zeus and Poseidon over, 154–56
Thetis carrying armor to Achilles, in House of Achilles, 164
Thetis receiving Achilles' armor from Hephaestus
in Casa di Sirico, 165
and ecphrasis, intertextual play in, 322
in House of Achilles, 161–64, *163*
Tibullus, 296, 308
Timpanaro, S., 207
Torelli, M., 262
Trimble, J., 144, 146, 148, 151
Troilus, Aeneas's misidentification of, 270, 273–75
Trojan War images
new meaning of, in Augustan context, 5
Pompeian sources for beyond Temple of Apollo, 161
and Roman agon of poetry and plastic arts, 321
ubiquity of in Roman world, 3
Tucci, P. L., 226, 228

Valerius Maximus, 16, 19, 232, 233, 240, 243
Venus, statue in Temple of Apollo (Pompeii), *52–53*, 172
Verona tablet, first, 77, *78*, 91, 91–92
Viaggio pittorico nel Regno delle due Sicilie (Cuciniello and Bianchi), 112
Villa della Farnesina (Rome), 184
Villa Imperiale (Pompeii), 184
Virgil. *See also Aeneid* (Virgil)
and agon of poetry and plastic arts, 321
and artistic challenge of *Aeneid*, 307, 313–14, 325
critique of in Horace's *Odes*, 283–90
Eclogues, 106, 257
on Ennius, 283
Georgics, 8, 257–60, 262, 280, 282, 299, 325–26
Horace and, 279, 281, 285–86
influence in Pompeii, 2–3

 Petronius on, 313
 Propertius on, 300, 301, 302–4, 306, 307
 self-identification as new Ennius, 178, 257–58, 260
 turn to epic poetry, 257, 279, 313–14
Vitruvius, 3, 127, 175–76, 184, 192n133, 248n57
Volusius, 326

Wallace-Hadrill, A., 188
Wiegmann, Rudolf, 177
Wood, Joseph, 124
Wyke, Maria, 297

Zeitlin, F., 309
Zeus and Hera wedding, in House of the Tragic Poet, 153–54
Zeuxis
 in Petronius, 309
 portrait of Helen by, 12, 15–19; and agon of poetry and plastic arts, 19, 20, 242, 243, 321; arrival in Rome, 242; display in Portico of Philippus, 12, 23n46, 238, 240, 243; intertextual play of Propertius's elegies with, 290–99; models for, 296–97; as prestigious work, 23n44, 242, 243
 works by, 238